SPACE, SITE, INTERVENTION

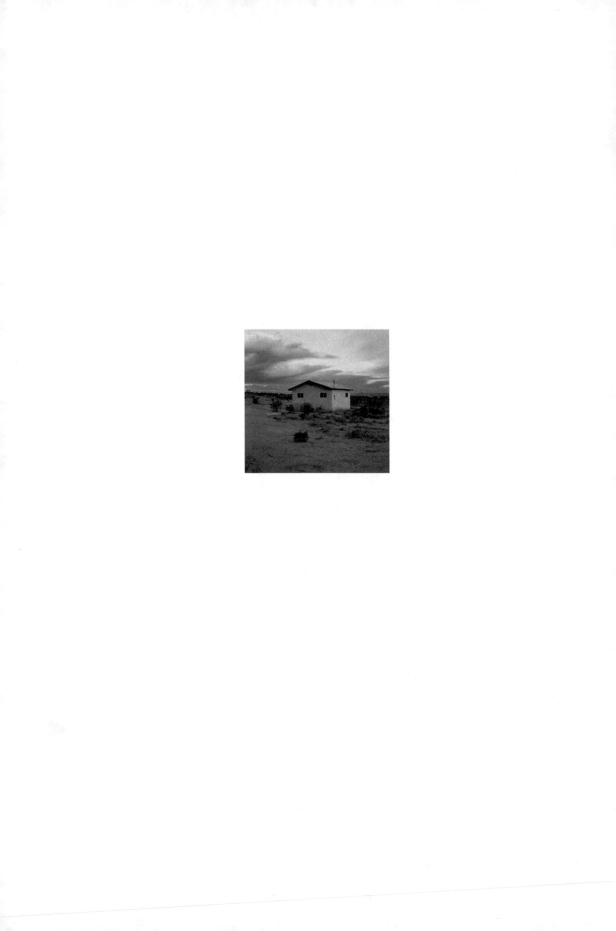

University of Minnesota Press / Minneapolis London

SPACE, SITE, INTERVENTION

situating installation art

Erika Suderburg, Editor

Contents

Acknowledgments
vii

Introduction: On Installation and Site Specificity
Erika Suderburg 1

1. The Functional Site; or, The Transformation of Site Specificity
James Meyer 23

2. One Place After Another: Notes on Site Specificity
Miwon Kwon 38

3. "Illiterate Monuments": The Ruin as Dialect or Broken Classic
Barbara Maria Stafford 64

4. Fountains and Grottos: Installation and the Neobaroque
Sean Cubitt 84

5. Garden Agon
Susan Stewart 100

6. Written on the West: How the Land Gained Site
Erika Suderburg 130

7. Hidden Economies in Los Angeles: An Emerging Latino Metropolis
Alessandra Moctezuma + Leda Ramos 143

8. Landscape(s) of the Mind: Psychic Space and Narrative Specificity (Notes from a Work in Progress)
John Coleman 158

9. Ordinary Gestures of Resistance

Ernest Larsen 171

10. Internal Exiles: The Interventionist Public and Performance Art of Asco

C. Ondine Chavoya 189

11. Scream IV

Laurence A. Rickels 209

12. Displacements, Furnishings, Houses, and Museums: Six Motifs and Three Terms of Connoisseurship

Kevin McMahon 220

13. Public Art and the Spectacle of Money: An Assisted Commentary on Art Rebate/Arte Reembolso

John C. Welchman 236

14. Video and Film Space

Chrissie Iles 252

15. The Machine in the Museum; or, The Seventh Art in Search of Authorization

Bruce Jenkins 263

16. "No Guarantees, They're Wolves": Structure, Movement, and the Dystopic in Diana Thater's *China*

Colin Gardner 275

17. The Space of Electronic Time: The Memory Machines of Jim Campbell

Marita Sturken 287

18. The Anthropologist's Shadow: The Closet, the Warehouse, the Lesbian as Artifact

Catherine Lord 297

19. Imaging Community: Video in the Installation Work of Pepón Osorio

Tiffany Ana López 317

20. The 1970s "Situation" and Recent Installation: Joseph Santarromana's Intersubjective Engagements

Amelia Jones 332

Contributors

347

Index

351

Acknowledgments

There are many editorial and contributing voices at work in this project to which I want to offer deep thanks. I would like to thank my editors at the University of Minnesota Press: Micah Kleit, who initiated the project and kept it afloat over many months with enthusiasm and commitment, and Jennifer Moore, who patiently and thoughtfully saw the project to its completion. I would like to thank the contributors for making the project possible and for expanding its boundaries a hundredfold. In addition, Amelia Jones offered her extraordinary editorial input, scholarly intelligence, grace, friendship, and support. Liz Kotz and Joan Hugo lent their expertise and knowledge to the project from its inception by suggesting numerous avenues and tangents that immeasurably broadened the book's scope. CindiLee and Jonathan Suderburg executed painstaking proofing and fast driving accompanied by encouraging words. Christian Merscheid and Georg Dietzler talked to me at great length about installation work in Germany and suggested writers and artists who will, sadly, have to wait to populate the next book. Jill Giegerich, Beverly O'Neill, and Robert and Elizabeth Suderburg all offered good company and conversation that let the book live and its editor breathe. Phyllis Gill ran interference for me with wit and aplomb and gave me the space to complete this project. And finally, special thanks go to Linda Besemer for love, support, Donald, Sophie, and paintings extraordinaire.

Introduction: On Installation and Site Specificity

Erika Suderburg

On the horizon, then, at the furthest edge of the possible, it is a matter of producing the space of the human species—the collective (generic) work of the species—on the model of what used to be called "art"; indeed, it is still so called, but art no longer has any meaning at the level of an "object" isolated by and for the individual.

—Henri Lefebvre, "Openings and Conclusions"

Location and point of view are constantly shifting at the apex of time's flow. Language, memory, reflection, and fantasy may or may not accompany the experience. Shift to recall of the spatial experience: objects and static views flash in the mind's space. A series of stills replaces the filmic real-time experience. Shift the focus from the exterior environment to that of the self in a spatial situation, and a parallel, qualitative break in experience between the real-time "I" and the reconstituting "me" prevails. As there are two types of selves known to the self, the "I" and the "me," there are two fundamental types of perception: that of temporal space and that of static, immediately present objects. The "I," which is essentially imageless, corresponds with the perception of space unfolding in the continuous present. The "me," a retrospective constituent, parallels the mode of object perception. Objects are obviously experienced in memory as well as in the present. . . . the constitution of culture involves the burdening of the "me" with objects. It is the mode of the relatively clear past tense. Space in this scheme has been thought of mainly as the distance between two objects. The aim of this narrative is to make space less transparent, to attempt to grasp its perceived nature ahead of those habitual cultural transformations that "know" always in the static mode of the "me."

—Robert Morris, "The Present Tense of Space"

The line between art and life should be kept as fluid, and perhaps indistinct as possible.

—Allan Kaprow, "The Event"

1

Sites/Texts/Moments

Great Sphinx, c. 2570–2544 B.C.
Newgrange, c. 2500 B.C.
Stonehenge, c. 2600–1800 B.C.
Stillbury Hill, c. 2660 B.C.
Nazca Line Drawings, c. 100
 B.C.–800 A.D.
Hadrian's Villa, Tivoli, 118–38 A.D.
Teotihuacán, c. 100–900 A.D.
Anasazi, *Sun Dagger of Fajada
 Butte,* Chaco Canyon,
 1000–2000 A.D.

1190
Sultan Muhammad of Ghur,
 Minaret of Jam

1500
Intihuatana (Sun Hitching Post),
 Machu Picchu, 1500–1600

1540
Pier Francesco Corrado Orsini,
 *Gardens of Bomarzo (Sacro
 Bosco),* 1540–84

1546
Grotto of the Animals, Villa Medici

1599
Ferrante Imperato, *Kunstkammer*

1613
Grotto of Orpheus, Hellbrunn,
 1613–19

1632
The Uppsala *Kunstschrank*

1646
Rembrandt van Rijn, *Holy Family
 with Curtain*
Athanasius Kircher, *Room for
 Projected Images*

1650
Ole Worm's Museum, 1650s

1651
Athanasius Kircher, *Museum
 Kircherianum*

1668
Gian Lorenzo Bernini, Fireworks,
 Piazza Farnese

1671
François d'Orbay, *Water Theater*

1689
Martin Charbonnier, *The Hedge
 Theater at Herrenhausen*

To suggest what might be included in a history of an art form is to postulate an archive that denies closure and scatters labels, an eccentric assembly that seeks to collect and inquire simultaneously.[1] *Space, Site, Intervention: Situating Installation Art* intends to chart the terms of discussion and debate that have surrounded installation and site-specific practices and to provide new critical frameworks that encourage a rethinking of their history. This examination takes place specifically in relation to various contexts in which this work has been experienced—art history, target communities, and art institutions—and in relation to viewers and makers addressing the question of how the medium offers theoretical and conceptual challenges to institutional, historical, and conceptual assumptions in art discourse.

I have invited practicing artists, writers, art historians, and hybrids of all of those disciplines to address some of the issues at stake in installation and site-specific art. This volume seeks to examine critically and explore the situation of these works within divergent and varied spheres of meaning, including community space, corporate space, architectural hybrids, multimedia, cyberspace, environmental action, public and private ritual, political activism, governmental and private patronage systems, and the compelling and problematized intersections created by all of these sites.

In this zone of maximum hybridity, definitions fall flat. It is only at the intersection of practices located both self-consciously historically and within contemporary frameworks of debate that a definition can be tentatively constructed to address installation activity in Europe, Japan, and the Americas. Thus, we could begin by saying that installation is informed by a multitude of activities, including *architecture douce* (soft architecture),[2] set design, the Zen garden, happenings, bricolage, *son et lumière,* spectacles, world's fairs, vernacular architecture, multimedia projections, urban gardens, shrines, land art, earthworks, trade shows, eighteenth- and nineteenth-century panoramas, Arte Povera, follies, and the visionary environments of "folk" artists.[3] Collectively the work of installation and site specificity engages the aural, spatial, visual, and environmental planes of perception and interpretation. This work grows out of the collapse of medium specificity and the boundaries that had defined disciplines within the visual arts beginning in the 1960s.

In 1973, Lucy Lippard would postulate the *dematerialization* of the object of art: "for lack of a better term I have continued to refer to a process of dematerialization, or a de-emphasis on material aspects (uniqueness, permanence, decorative attractiveness)."[4] Installation

art as genre, term, medium, and practice acts as the assimilator of a rich succession of influences. In installation the object has been rearranged or gathered, synthesized, expanded, and dematerialized. Daniel Buren has declared that *site-specific* as a term "has become hackneyed and meaningless through use and abuse."[5] Hal Foster, speaking of Richard Serra, says "for sculpture to harden into a thing-category would be for sculpture to become monumental again—for its structure to be fetishized, its viewer frozen, its site forgotten, again. In this light to deconstruct sculpture is to serve its 'internal necessity'; to extend sculpture in relation to process, embodiment, and site is to remain within it."[6] This volume hopes to counteract and complicate these paradigms and assertions by examining the definitions and legacies of site specificity and installation while articulating a broad range of theoretical, material, and conceptual practices.

Toward Definition

A more rigorously analytical reading of the history of modernist sculpture would have to acknowledge that most of its seemingly eternal paradigms, which had been valid to some extent in late nineteenth-century sculpture (i.e., the representation of individual, anthropomorphic, wholistic bodies in space, made of inert, but lasting, if not eternal matter and imbued with illusionary moments of spurious life), had been definitely abolished by 1913. Tatlin's corner-counter relief and his subsequent "Monument for the Third International" and Duchamp's readymades, both springing off the height of synthetic Cubism, constitute the extremes of an axis on which sculpture has been resting ever since (knowingly or not): the dialectics of sculpture between its function as a model for the aesthetic production of reality (e.g., its transition into architecture and design) or serving as a model investigating and contemplating the reality of aesthetic production (the readymade, the allegory). Or, more precisely: architecture on the one hand and epistemological model on the other are the two poles toward which relevant sculpture since then has tended to develop, both implying the eventual dissolution of its own discourse as sculpture.

—**Benjamin Buchloh,**
"Michael Asher and the Conclusion of Modernist Sculpture"[7]

We find ourselves presently at the tail end of an intriguing and sometimes baffling series of moments, movements, and gestures that cross-reference installation art. Seemingly inexhaustible numbers of

1730
Maharaja Sawai Jai Singh II, *(Observatory) Brihat Samrat Yantra*

1734
Father Louis Bertrand Castel, *Clevessin oculaire (Ocular Organ)*

1743
Joseph Saint-Pierre, *Ruin Theater at the Hermitage,* 1743–46

1750
Giovanni Battista Piranesi, *Views of Rome*

1780
François Barbier, house of Racine de Monville

1784
Étienne-Louis Boullée, *Monument to Isaac Newton* (unbuilt)

1785
Claude-Nicolas Ledoux, house of the Groundskeeper

1787
Robert Barker, *Edinburgh and Holyrood Castle,* panorama

1870
Frédéric Kastner, *Pyrophone (Color Organ)*

1876
Fidelis Schabet, *Grotto of Venus*

1879
Joseph Ferdinand Cheval, *Palais idéal,* 1879–1912

1880
Auguste Rodin, *The Gates of Hell,* 1880–1917

1884
Auguste Rodin, *The Burghers of Calais,* 1884–86
Sarah Pardee Winchester, mansion, 1884–1922

1886
Medardo Rosso, *The Kiss on the Tomb*

1887
Gustave Eiffel, *Eiffel Tower,* 1887–89

1890
Karl Junker, house, 1890–1912

1898
Paris Exposition

1900
Antoní Gaudí, *Parc Güell,*
1900–1914

1903
The Electric Tower, Luna Park,
Coney Island

1912
Pablo Picasso, *Still Life with Chair
Caning*

1913
Armory Show
Vladimir Tatlin, *Corner Counter-
Relief*

1914
Bruno Taut, *The Glass House,*
Werkbund exhibition

1916
Cabaret Voltaire

1917
Alexander Rodchenko, *Metal
Mobile*

1918
Gerrit Rietveld, *Red/Yellow/Blue
Chair*

1919
Bauhaus, Weimar and Dessau,
1919–33

1920
Kurt Schwitters, *Merzbau,* 1920–43
Vladimir Tatlin, *Monument to the
Third International*
Naum Gabo, *Kinetic Sculpture:
Standing Wave*
Man Ray, *The Enigma of Isidore
Ducasse*

1921
Tristan Tzara and Sonia Delaunay,
Le coeur à gaz
Simon Rodia, *Watts Towers,*
1921–54

1922
Oskar Schlemmer, *Triadic Ballet*
Ludwig Hirschfield-Mack,
Reflected Light Composition

1923
El Lissitzky, *Proun*
László Moholy-Nagy, *Light-Space
Modulator,* 1923–30

objects, environments, landscapes, cityscapes, mindscapes, and interventions could be filed under the terms *site specific* and *installation,* terms that have an equally complex history. *Site specific* derives from the delineation and examination of the site of the gallery in relation to space unconfined by the gallery and in relation to the spectator. As discursive terminology, *site specific* is solely and precisely rooted within Western Euro-American modernism, born, as it were, lodged between modernist notions of liberal progressiveness and radical tropes both formal and conceptual. It is the recognition on the part of minimalist and earthworks artists of the 1960s and 1970s that "site" in and of itself is part of the experience of the work of art. Robert Smithson's use of the terms *site* and *nonsite* to label his works that removed samples from exterior sites and placed them into the "neutral" space of the gallery demanded an expansion of what could be thought of as art. Content could be space, space could be content, as sculpture was extrapolated into and upon its site. It was an examination of the very foundations of modernism (gallery as "site"), and later, as earthworks claimed land as site, it was an examination of the foundations of landscape and the natural.[8] With earthworks artists and with Smithson in particular the sheer expanse of "the natural" became an extension of minimalism's delineation of what Robert Morris called "primary structure," which in turn suggested that artwork must be reactive to its site, informed by the contents and materials of its actual location, whether they be industrially, "naturally," or conceptually produced.

Installation is the noun form of the verb *to install,* the functional movement of placing the work of art in the "neutral" void of gallery or museum. Unlike earthworks, it initially focused on institutional art spaces and public spaces that could be altered through "installation" as an action. "To install" is a process that must take place each time an exhibition is mounted; "installation" is the art form that takes note of the perimeters of that space and reconfigures it. The ideological impossibility of the neutrality of any site contributes to the expansion and application of installation, where sculptural forms occupy and reconfigure not just institutional space but the space of objecthood as well. As Douglas Crimp has noted of installation's minimalist precursor:

> Minimal objects redirected consciousness back on itself and the real-world conditions that ground consciousness. The coordinates of perception were established as existing not only between spectator and the work but among spectator, artwork, and the place

inhabited by both. This was accomplished either by eliminating the object's internal relationships altogether or by making those relationships a function of simple structural repetition, of "one thing after another." Whatever relationship was now to be perceived was contingent on the viewer's temporal movement in the sphere shared with the object. Thus the work belonged to its site; if its site were to change, so would the interrelationship of object, context, and viewer. Such a reorientation of the perceptual experience of art made the viewer, in effect, the subject of the work, whereas under the reign of modernist idealism this privileged position devolved ultimately on the artist, the sole generator of the artwork's formal relationships.[9]

The site of installation becomes a primary part of the content of the work itself, but it also posits a critique of the practice of art-making within the institution by examining the ideological and institutional frameworks that support and exhibit the work of art. "To install" becomes not a gesture of hanging the work of art or positioning a sculpture, but an art practice in and of itself. Crimp goes on to discuss artists such as Daniel Buren, Hans Haacke, and Michael Asher—artists who expanded the original tenets of site specificity with materialist critiques.

Speaking of the infamous removal of Richard Serra's *Tilted Arc* from its public site, Crimp problematizes both the reception of the piece and also the recuperation of site specificity within art discourse to serve seemingly opposite claims of conceptual radicality and timeless aestheticism:

> The larger public's incomprehension in the face of Serra's assertion of site specificity is the incomprehension of the radical prerogatives of a historic moment in art practice. "To remove the work is to destroy the work" was made self-evident to anyone who had seen "*Splashing*'s" literalization of the assertion, and it is that which provided the background of "*Tilted Arc*" for its defenders. But they could not be expected to explain, within the short time of their testimonies, a complex history that had been deliberately suppressed. The public's ignorance is, of course, an enforced ignorance, for not only is cultural production maintained as the privilege of a small minority, but it is not in the interests of the institution's art and the forces they serve to produce knowledge of radical practices even for their specialized audience. And this is particularly the case for those practices whose goal is a materialist critique of the presuppositions of those very institutions. Such

1924
Francis Picabia, set for ballet *Relâche*
Gerrit Rietveld, *Schröder House*

1925
Marcel Duchamp, *Rotary Demi-Sphere*
Sonia Delaunay-Terk, matching room, coat, and car

1926
Piet Mondrian, *Salon de Madame B. à Dresden*
Alexander Calder, *Circus*
Sophie Taeuber-Arp, *Café Aubette*
Vladimir Mayakovsi, *Door Poem*

1927
Marcel Duchamp, *11, rue Larrey, door*
Theo van Doesburg, *Café Aubette*

1929
Naum Gabo, *Light Festival*, proposal
Vladimir Tatlin, *Letatlin*

1930
Giorgio De Chirico, *Bagni misteriosi*, fountain
Joseph Cornell begins boxes
Aw Boon Haw, *Tiger Balm Gardens*
Le Corbusier, roof garden for Charles Beistegui, 1930–31

1932
Alexander Calder, *The Motorized Mobile That Duchamp Liked*
Alberto Giacometti, *The Palace at 4 A.M.*

1933
Black Mountain College founded

1934
Bruno Munari, *Useless Machine*
Albert Speer, *Cathedral of Light*

1935
Constantin Brancusi, *Tirgu-Jui*, 1935–38

1938
Marcel Duchamp, *1200 Bags of Coal*
International Exhibit of Surrealism
Salvador Dalí, *Rainy Taxi*

1939
Norman Bel Geddes, *General Motors Futurama*

1940
Jean Dubuffet, *l'art brut* (raw art)

1941
Peggy Guggenheim Gallery, *Art of This Century*

1942
Marcel Duchamp, *First Papers of Surrealism,* exhibition

1946
Lucio Fontana, *Manifiesto blanco (White Manifesto)*
Marcel Duchamp, *Étant donnés,* 1946–66

1947
Isamu Noguchi, *Sculpture to Be Seen from Mars*

1948
Clarence Schmidt, *House on Ohayo Mountain,* 1948–71

1949
Lucio Fontana, *Black Light Environment*

1950
James Hampton, *Throne of the Third Heaven of the Nations Millennium General Assembly,* 1950–64

1952
John Cage, *Theater Piece no. 1*
Wiener Gruppe
John Cage, Robert Rauschenberg, David Tudor, and Merce Cunningham, *Untitled Event*

1954
Wolf Vostell, *Décollage no. 1*
Zero-kai (Group Zero), founded
Gutai Bijutsu Kyōkai (Gutai Art Association) founded

1955
Herbert Bayer, *Earth Mound*
Kazuo Shiraga, *Doru ni idomu (Challenging Mud)*
Experimental Outdoor Modern Art Exhibition to Challenge the Burning Midsummer Sun
Tadeusz Kantor, *Cricot 2,* Galeria Krzysztofory
Giuseppe Pinot Gallizio, *Experimental Laboratory of the International Movement for an Imagist Bauhaus (MIBI)*
Tressa Prisbrey, *Bottle Village*

practices attempt to reveal the material conditions of the work of art, its mode of production and reception, the institutional supports of its circulation, the power relations represented by these institutions—in short, everything that is disguised by traditional aesthetic discourse. Nevertheless, these practices have subsequently been recuperated by that very discourse as reflecting just one more episode in a continuous development of modern art. Many of "*Tilted Arc's*" defenders, some representing official art policies, argued for a notion of site specificity that reduced it to a purely aesthetic category.[10]

The trajectory from Smithson to Crimp traces the development of an art practice designated within a particular sphere of theoretical and conceptual boundaries that claim its radicality. The conclusion of sculpture is declared, with installation and site-specific art awkwardly occupying part of its terrain.

Updating Richard Wagner's original operatic definition, Walter Gropius theorized architecture as the *Gesamtkunstwerk,* or total work of art. Architecture was to assimilate all forms of the visual and performing arts into a single totalizing project that would define the twentieth century. The Bauhaus would attempt to resolve the split between art and craft as well as performer and audience, the alienation of the subject from art, and the artist's alienation from technology and commerce. In the totalized project of art, object-making, music-making, and building would form a singular modernist unity. Installation aspires to this continuum.

The material content and constitution of installation suggests ever more complex and varied sources and legacies, including everything from Neolithic standing stones to eighteenth-century human garden statuary up to contemporary video projects. Installation traverses upon and draws from disparate legacies, from Fidelis Schabet's *Grotto of Venus* built for "Mad" King Ludwig II in 1876 (which sported an interior, underground lake complete with swans) to Simon Rodia's *Watts Towers* (hand built from urban detritus in South Central Los Angeles between 1921 and 1954 and including a 102-foot-high central spire encrusted with glass bottles and crockery). The desires that motivate installation—to fabricate interior and exterior environments, to alter surfaces until they envelop the viewer, to construct "all-over" compositions utilizing natural and man-made objects, and to reallocate and disorder space—can be situated in relation to myriad historical art movements and smaller, sometimes private domestic actions. The artists of the dada, happenings, Fluxus,

situationist, and Arte Povera movements have all produced work indicative of these concerns, as have so-called visionary, environmental, or folk artists.

Located in the intersection of the collection, the monument, the garden, and the domestic interior, works of installation and site-specific practices can be posited in several locations that predate modernist genres and labels. I would suggest that both the *Wunderkammern,* or *cabinets de curiosité* (cabinets of curiosities or wonders), and the *Kunstkammern* (room-sized collections of art and intriguing objects) from the seventeenth and eighteenth centuries have more than a passing resemblance to the contemporary practice of installation. They were the personal and idiosyncratic collections of private individuals that predate the establishment of public museums in Europe and are often characterized as having laid the foundation for the establishment of the modern museum.[11]

Wunderkammern were composed of collections of items chosen not because of their historical value as antiquities or their monetary worth but because the collectors found the objects pleasing and demonstrative of the "wonders of the world," whether natural, spiritual, or man-made. The objects in a *Wunderkammer* were arranged according to circumference, height, weight, color, luminosity, transparency, or like geometries. A *Wunderkammer* might juxtapose a group of ostrich eggs with marble acorn garden ornaments, or a wooden bow with the thigh bones of an antelope. Barbara Maria Stafford, in one of several extensive explorations of the *Wunderkammer*'s placement in the historical discourse of the eighteenth century, recounts the reaction of neoclassical critics to the *Wunderkammer*'s "past crimes": "Lord Shaftesbury, the Abbé Batteux, Winckelmann, and Lessing excoriated conspicuously artificial and extravagant manufacture. They termed 'deformed' and 'unnatural' any egalitarian or truly interdisciplinary hybrids. These dissonant decorative mixtures graced the heteroclite *cabinet de curiosité.* According to unsympathetic critics the equivocal ornamental grotesque embodied everything that was excessive, contaminated, and 'monstrous' about the uncontrolled imagination."[12] This lack of homogeneity is precisely what makes the *Wunderkammer* such an intriguing precursor to installation art. It suggests as well a connectivity to acts of intimate material collection and repositioning such as curio or souvenir cabinets, personal altars, roadside and hiking memorials, and autobiographical mantelpiece groupings, all of which take the institutional scale of the *Wunderkammer* and dissolve and redistribute this passion for knowledge through the

1956
Juan O'Gorman, house, 1956–61
Saburō Murakami, *Sakuhin: Hako (Work: Box)*
Shōzō Shimamoto, *A Work to Be Walked On*
John Cage, New School for Social Research, class in experimental composition
Emery Blagdon, *Healing Machines,* 1956–84

1957
First Gutai Theater Art
The Situationist International
Sister Gertrude Morgan, *Everlasting Gospel Revelation Mission*
Peter Kubelka, *Schwechater,* 1957–58
Lina Bo Bardi, *Museu de Arte de São Paulo,* 1957–68
Sibyl Moholy-Nagy, *Native Genius in Anonymous Architecture*
Gaston Bachelard, *Poétique de l'espace*

1958
Jannis Kounellis, *Metamorphosis,* 1958–84

1959
Allan Kaprow, *18 Happenings in 6 Parts*
Red Grooms, *The Burning Building*
Pinot Gallizio, *La caverna dell'antimateria (Cave of Antimatter)*
Robert Rauschenberg, *Monogram*
Otto Piene, *Archaic Light Ballet*
Neo-concrete, manifesto
Gustav Metzger, *Auto-Destructive Art,* manifesto

1960
Lygia Clark, *Bichos (Animals),* 1960–66
Jean Tinguely, *Homage to New York*
Robert Whitman, *The American Moon*
Groupe de Recherche d'Art Visuel
Pierre Restany, *Nouveau réalisme,* manifesto
Jean-Jacques Lebel, *The Anti-Procès*
Howard Finster, *Paradise Garden,* 1960s–1970s
Arman, *Le plein*

1961
Allan Kaprow, *Yard*
Edward Kienholz, *Roxy's*
George Brecht, *Three Aqueous Events*
Jean Tinguely, Robert Rauschenberg, Jasper Johns, and Niki de Saint Phalle, *Homage to David Tudor*
Claes Oldenburg, *The Store*
Niki de Saint Phalle, *tir*
Yves Klein, *Le vide*
Masanobu Yoshimura, *Mr. Sadada's Drawing Room*
Piero Manzoni, *Base magica*

1962
Judson Dance Theatre
Ben Vautier, *Le magasin de Ben*
Carolee Schneemann, *Eye Body*
AKTUAL group
Edward James, *La Conchita*, Xilitla, 1962–84
Wolf Vostell, *dé-coll/age: Bulletin Aktuellen Ideen (Dé-coll/age: Bulletin of Current Ideas)*, 1962–69
Yves Klein, sale of a zone of *Immaterial Pictorial Sensibility*

1963
Hans Haacke, *Condensation Cube*
George Segal, *Filling Station*
Nam June Paik, *Exposition of Music—Electronic Television*
Stan Vanderbeek, *The Movie-Drome*
Franz Erhard Walther, *Wersatz*, 1963–69
Claes Oldenburg, *Bedroom Ensemble*
Gerhard Richter and Konrad Cveg, *Life with Pop: A Demonstration for Capitalist Realism*

1964
Yayoi Kusama, *Environment*
Robert Morris and Carolee Schneemann, *Site*
Hi Red Center, *Movement to Promote the Cleanup of the Metropolitan Area (Be Clean!)*
Edward Kienholz, *Back Seat Dodge '38*
Mark Rothko, *Rothko Chapel*, 1964–67

1965
Billy Klüver and Robert Rauschenberg, *Oracle*
Yoko Ono, *Cut Piece*
Wiener Aktionsgruppe (Viennese Action group)
Nam June Paik, *Magnet TV*

consumption and arrangement of objects on a more intimate scale across the everyday.

In their commitment to collection as the art form of arrangement and to a celebration of the wonders of the found object, *Wunderkammern* suggest a curious theoretical connection with the employment of chance operations in avant-garde modernist works such as Marcel Duchamp's *Three Standard Stoppages* (1913–14) or John Cage's *I Ching* generated musical compositions of the 1950s. These applied compositional systems relied on the designated "uncontrollable" event as a way to intervene in conventional notions of taste and authorship. This method was sanctioned precisely because compositional dissolution introduced into art processes a removal of individual authorship's perimeters of "control" and "original gesture." The liberating arbitrariness of chance operations might be likened to the obliteration of scientific classification exercised in these personal cabinets. *Wunderkammern* evoke (in retrospect) some of the foundational impulses, along with happenings and minimalism, for works of installation and site-specific art. Ben Vautier's *Living Sculpture* (1962), Alison Knowles's *Gentle Surprises for the Ear* (with Philip Corner and Bill Fontana, 1975), Yayoi Kusama's *Aggregation: One Thousand Boats* (1964), Ann Hamilton's *Palimpsests* (1989), Mona Hatoum's *Light Sentence* (1992), or David Wilson's ongoing *The Museum of Jurassic Technology* all employ the institutional room or adaptive domestic interior as a space of collection and dissection—cabinets of selection and display, objects arranged for evocation, bewilderment, and enchantment. Like their dadaist kin, they expanded the notion of collection and designation as a gesture of authorship in opposition to and/or in disregard of sanctioned systems of classification and historicization.

We can postulate the *Wunderkammer*'s "excessive" "monstrous" as linked to the phenomenon of the "folly." The term *folly* refers to structures built primarily between 1720 and 1850 by individuals outside the architectural institutional "norm"; follies were often defiantly and proudly antifunctional, existing cross-culturally beyond well-charted Euro-Western tangents.[13] Follies are indicative of a desire to construct a "unique" and signifying gesture privately inside one's home or publicly in yards and grounds surrounding one's residence. They have been postulated as motivated by a string of factors: a desire to be seen, a vision, perceived religious or civic witnessing, a desire to commemorate oneself or a designated population, and a desire to alleviate the maker's own sense of alienation in relation to his or her community.[14] Follies are literally "made by fools," outside

the architectural standard and often useless as shelter and baffling as monument.

Relegated to the ideologically questionable status of outsider or folk art, follies have no "use value" except as sites of tourism and cannot be recuperated as "fine art." *Outsider, folk, primitive,* and *visionary* are all terms that are the subject of deep scrutiny and present a quandary for writing about work designated as outside the modernist canon. Regional, urban, racist, and xenophobic bias can be reflected in the deployment of these terms, and they should be examined with a great deal of skepticism. This skepticism can be attached as well to the terms *high* and *low art,* terms that reflect some of the same problems and bear more than a passing resemblance to the oppositions set up between fine and folk art. Follies are vernacular architectural sites divorced from sanctioned art exhibition spaces and later rediscovered, as distinctions between "high" and "low" art came to be seen (by artists of the 1960s) as exclusionary obfuscations in need of eradication.

The work of the vernacular artist came to be reexamined in the context of the environments of happenings; follies and folk environments were fetishized as "pure" indicators of the direction the movement could take. The standard distinctions made between popular or folk culture and the fine arts, that is, "low" art versus "high" art, the unschooled naïf versus the trained artist, were broken down within the modernist avant-garde. Historically this is demonstrated in one direction as Die Brücke (the Bridge) assimilates German folk woodcuts in the early 1900s and in the other as the Bauhaus attempts to incorporate industrial mass production and eradicate the distinction between art and design in the 1920s and 1930s. Contemporaneously this collapse of distinctions is further complicated by the reemployment of historically "folk" antecedents, often of spiritual and metaphysical "use value," as revisioned, for example, in the work of Betye Saar, in various installation works like *Miti* (1973) and *Miti Receives* (1977) that evoke, invoke, and employ objects reconfigured from Haitian voodoo, West African altar practices, and Brazilian Santeria, objects derived from ritual and structured worship. Her installations riff on the "innate and accumulated aura of the individual object," sanctifying space through object.[15] "Folk" is rearticulated in material form, and the content and process of worship, celebration, guardianship, and protective commemoration is deployed by Saar as an integral, not merely referential, gesture. The distinction between folk or popular practice, the life of the everyday, sustenance, and its designation as "art" further compounds the

1965 (continued)
Paolo Soleri, *Arcosanti* begun
Alan Sonfist, *Time Landscape™*

1966
Robert Morris, *Steam*
John Latham, *Art and Culture*
Tony Conrad, *The Flicker*
John Cage, *Variations VII*, part of *Nine Evenings of Theater and Engineering*
Steve Paxton, *Physical Things*
Yvonne Rainer, *Carriage Discreteness*
Al Hansen, *Third Rail Gallery of Current Art*
Lucinda Childs, *Vehixe*
Takis, *Signals*
Yayoi Kusama, *Narcissus Garden*
David Tudor, *Bandoneon! (A Combine)*
Michelangelo Pistoletto, *Globe*
Experiments in Art and Technology (E.A.T.) group formed
Allan Kaprow, *Assemblage, Environments, and Happenings*

1967
Buckminster Fuller, *Floating Geodesic Spheres* (unbuilt but patented)
Udo Kultermann, *The New Sculpture*
Joseph Beuys, *Eurasianstaff*
Michael Fried, *Art and Objecthood*
Eva Hesse, *Repetition 19*
Robert Breer, *Floats*
Ian Hamilton Finlay begins garden
Maria Nordman, *Studio Pieces,* 1967–70
Otto Piene, *Fire Flower Power*
Richard Artschwager, *blps*

1968
Germano Celant, *Arte Povera, Azione Povera* exhibition
Imi Knoebl, *Raum 19 (Room 19)*
Eric Orr, *Wall Shadow*
Daniel Spoerri, *Le coin du Restaurant Spoerri*
Mira Schendel, *Objetos graficos*
Bruce Nauman, *Performance Corridor*
Richard Serra, *Splashing*
Lygia Pape, *Divisor*
James Seawright, *Electronic Peristyle*
Richard Long, *A Line Made by Walking*
Dennis Oppenheim, *Annual Rings*
Les Levine, *Iris*
Jack Burnham, *Beyond Modern Sculpture*
Jean Dubuffet, *Le jardin d'hiver*

1969

Frank Gillette and Ira Schneider, *Wipe Cycle*

Eva Hesse, *Contingent*

Earth Art exhibition

Gego, *Reticulárea (Ambientación)*

Jannis Kounellis, *Cavalli (Horses)*

Lothar Baumgarten, *Terra Incognita*, 1969–84

Dieter Roth, *Gartenskulptur (Garden Sculpture)*, 1969–83

Guerrilla Art Action group (GAAG), *Museum of Modern Art Action (no. 3)*

John Lennon and Yoko Ono, *Bed-in*

Lea Lublin, *Fluvio Subtunal*

Robert Smithson, *Nonsites* first exhibited

Allan Ruppersberg, *Al's Café*

Robert Morris, *Continuous Project Altered Daily*

Jan Dibbets, *Shadow Piece*

Michael Heizer begins *Double Negative*

Bruce Nauman, *Live/Taped Video Corridor*

Hans Haacke, *Fog, Water, Erosion*

German Celant, ed., *Arte Povera*

Harold Rosenberg, *Artworks and Packages*

Robert Filliou, *Permanent Creation Tool Shed*

1970

Robert Smithson, *Spiral Jetty*

Larry Bell, *The Leaning Room*

Jack Smith, *The Brassieres of Atlantis*

Robert Cumming, *Sentence Structures*

Willoughby Sharp, *Avalanche* journal, 1970–76

Bonnie Sherk, *Portable Parks*

E.A.T., *Pepsi Pavilion*, Osaka World's Fair

Terry Fox, *Cellar*

John Baldessari, *Cremation Project*

Gilbert and George, *Singing Sculpture*

Peter Hutchinson, *Paricut Volcano Project*

Wolf Vostell, *Aktionen, Happenings und Demonstrationen seit 1965*

Edward Ruscha, *Chocolate Room*, 1970–95

Bas Jan Adler, *Light Vulnerable Objects Threatened by Eight Cement Bricks*

collapse of distinctions. A work such as Victor Grippo's *Construction of a Traditional Rural Oven for Making Bread* (1972), in which the artist and a rural worker baked bread for onlookers on a Buenos Aires street, made manifest the opposition of urban and rural, labor and "culture." The action solidified a refusal of boundary between culture and the quotidian, a defining modernist trope that installation claims as partial definition. The happenings artists' interest in vernacular American folk artists fundamentalizes this tradition. Allan Kaprow can be justly credited with pointedly erasing high/low oppositions in his book *Assemblage, Environments, and Happenings* (1966), in which he makes no distinction between Clarence Schmidt's recycled dwelling/folly/environment and a performance happening by Wolf Vostell. From the inverted cone of the nineteenth-century *Mad Jack's Fuller's Folly* in Dallington, England, to Grandma Prisbrey's *Bottle Village* (1955–88) in Simi Valley, California, follies served as personal landmarks and/or ingenious ways to house collections that had gotten out of hand. Grandma Prisbrey constructed a series of dwellings from discarded materials—a pencil house, a dollhouse, a shrine of all religions, a schoolhouse, a shell house, and a rumpus room fabricated out of thousands of intact bottles carefully laid in cement. Her compound held all the requirements of a village, a model and manageable universe of recyclables, safely enfolding the domestic. When asked how *Bottle Village* got started, Mrs. Prisbrey simply said that she needed a place to house her pencil collection.[16] These projects remain within the idiosyncratic; their dependence on fetish, repetition, found objects, enclosure, assemblage, and the aesthetic of refuse prompt their inclusion in our wildly burgeoning definition of "installation art." With the folly, the cabinet can miraculously grow into architecture and beyond.

Within art history, installation art (a solely Western art-historical construct) is generally seen as having originated at a moment of revelation, as a sanctioned modernist chance encounter, or a collision of folly with the surrealist revolution. Ferdinand Cheval's *Palais idéal* (constructed between 1879 and 1912 in the rural village of Hauterives, south of Lyons, France) was a structure built around a found object, a piece of indigenous tufa stone happened upon while Cheval walked his postal route in Drôme, France. His daydream of the *Palais idéal* relieved the boredom of his postal journeys. Rising from the suggestiveness of the shape of his first tufa stone, Cheval built antler and tree-branch steeples, fanciful beasts, his own tomb, and towers of stalagmite-like forms. Myriad shapes were intricately woven into supporting walls and crossbeams, molded into a massive

interconnected structure of sheer fancifulness.[17] André Breton iden-
tified this tufa explosion as the surrealist moment—the found object
releasing the phantasm. His *Manifesto of Surrealism* (1924) demand-
ed an end to logic, and the *Palais idéal* became an icon in the surreal-
ist pantheon, an explication of the call to disorder the senses. The
grottoes and winding staircases of *Palais idéal* mine space in a way
that suggests site-specific practice, excavating the natural site and
casting it anew based on materials uncovered and reconfigured. A
single site-specific found element becomes the catalyst for construct-
ing an environmentally all-encompassing, self-reflexive, and multi-
focused work. The *Palais idéal* was an environment that required
witnessing, exploration, and domestic occupation, actions funda-
mentally in contradistinction to the contemplation of an object iso-
lated in neutral space. With the *Palais idéal*, "neutral space" could be
quietly retired. Less than a century later, Lygia Clark's *Ar e pedra* (Air
and stone) (1966), a work literally formed around a bag of air cradled
between cupped hands that floats a smooth round stone, speaks of
another private site of origin, the sculptural resonance of the found
object fashioned to body scale. Clark forms a hand-held portable
installation, a macrocosm of Cheval's monumentality. *Ar e pedra* in-
corporates the corporal as site, grafting the inanimate unto flesh and
vice versa. Clark installs herself around a catalyst of air and stone, as
air and stone mold themselves to her shape.[18] Site is occupied and
engendered through found object, as it is reshaped and animated
through space and occupier of space.

Kurt Schwitters's *Merzbau* (1920–43) exemplifies this mutation
of object into environment. Growing from an earlier assemblage,
Column of Erotic Misery, which Schwitters constructed in his living
room, *Merzbau* was literally a living installation, occupied as it was
by Schwitters, his wife, and his children, who must have devised in-
ventive ways to become one with assemblage. *Merzbau*'s walls were
carved into and then plastered over, doorjambs were extended, and
runways for a guinea pig were constructed under ceiling planes that
had been lowered at jarring cubist angles. Cubist collage and expres-
sionism cohabitated somewhat precariously in Schwitters's domestic
experiment. Thwarted by lack of space, at one point he moved the
upstairs tenant out, cut the ceiling free, and extended *Merzbau*
through the floor above. A hand-built cubist assemblage, *Merzbau*
was irretrievably bombed into oblivion by Allied forces during
World War II, a technological obliteration of space perhaps symbol-
ic of the passing of the hand-built into the machine-made.

Into this indexed time line is interjected a more portable vehicle

1971
Charles Simonds, *Dwelling*
Maria Nordman, studio installations
Cildo Meireles, *Insertions into Ideological Circuits, Coca-Cola Project*
Charles Ross, *Star Axis* begun
Christo, *Valley Curtain*
Hanne Darboven, *One Century in One Year*
Daniel Buren, *Presence-Absence*
Robert Irwin, *Fractured Light—Partial Scrim Ceiling—Eye-Level Wire*
Lili Dujourie, *American Imperialism*
Joseph Kosuth, *The Eighth Investigation, Proposition One*
Walter De Maria, *The Lightning Field*, 1971–77
Bruce Nauman, *Green Light Corridor*

1972
Alice Aycock, *Maze*
Conrad Atkinson, *Strike at Brannon's*
Womanhouse
Christo and Jeanne-Claude, *Running Fence*, 1972–76
Jonathan Borofsky, *Age Piece*
Vito Acconci, *Seed Bed*
Peter Campus, *Interface*
Jochen Gerz, *Exhibition of Jochen Gerz in Front of His Exhibition*
George Maciunas, *One Year (128LB)*
E.A.T.: Billy Klüver, Julie Martin, and Barbara Rose, eds., *Pavilion*
Harold Rosenberg, *The De-Definition of Art: Action to Pop to Earthworks*
Gyorgy Kepes, ed., *Arts of the Environment*
Roger Cardinal, *Outsider Art*
Ursula Meyer, *Conceptual Art*

1973
Peter Weibel, *Die Kruzifikation der Identität*
Alice Aycock, *Low Building with Dirt Roof*
Nancy Holt, *Sun Tunnels*, 1973–76
Judy Chicago, *The Dinner Party*, 1973–79
Ana Mendieta, *Silueta Series*, 1973–80
Lucy Lippard, *Six Years: The Dematerialization of the Art Object from 1966 to 1972*
Gregory Battcock, *Idea Art: A Critical Anthology*

1974

Michael Snow, *Two Sides to Every Story*

Beryl Korot, *Dachau*

Charles Simonds, *Niagara Gorge: Excavated and Inhabited Railroad Tunnel Remains and Ritual Cairns*

Gordon Matta-Clark, *Splitting*

Robert Morris, *Steam*

Susan Hiller, *Dream Mapping*

Ant Farm, *Cadillac Ranch*

Joseph Beuys, *I Like America and America Likes Me*

Walter De Maria, *Darmstadt Earth Room*

Carolee Schneemann, *Up to and Including Her Limits*, 1974–76

Nam June Paik, *TV Garden*, 1974–78

Bonnie Sherk, *"The Farm," Crossroads Community*, 1974–80

James Turrell, *Roden Crater*, 1974–present

Henri Lefebvre, *The Production of Space*

Adrian Henri, *Environments and Happenings*

1975

Gordon Matta-Clark, *Conical Intersect*

Marcel Broodthaers, *La salle blanche*

Ant Farm, *Media Burn*

Michel Thévoz, *Art brut*

Shigeko Kubota, *Nude Descending a Staircase*

Dan Graham, *Two Viewing Rooms*

Nancy Buchanan, *Twin Corners*

Alison Knowles (with Philip Corner and Bill Fontana), *Gentle Surprises for the Ear*

Hans Haacke, *Framing and Being Framed: Seven Works*, 1970–75

David Ireland, house begun

Robert Irwin, *Black-Line Volume*

1976

Jody Pinto, *Spotted Bundle*

Shigeko Kubota, *Three Mountains*, 1976–79

Feminist Art Workers, 1976–80

Robert Wilson, *Spaceman*, 1976–84

Judy Baca, *The Great Wall of Los Angeles*, 1976–present

Dieter Roth, *Flachen Abfall (Flat Trash)*

1977

Mary Beth Edelson, *Fire Ring*

Jack Baker, *The Museum of Neighborhood Phenomena*

of spatial occupation: László Moholy-Nagy's *Light-Space Modulator* (1923–30), which was a kinetic machine/sculpture that sat in the middle of an enclosed space. It was designed to have a specific film projected onto it, thereby throwing light and pattern onto the walls of any room. It transformed interiors by casting geometric shadows as different levels of the machine spun in front of the film's projection beam, leaving sections of the room alternately light and dark. It was parlor machine projecting the veneer of technology's geometry over the domestic interior. *Light-Space Modulator* serves as a template for issues of projection, temporal content, and spatial reorientation within video and film installation and related "multimedia."

Apparatuses that disrupt exhibition or private space play an important role in this definition of installation as a machine of realignment. Marcel Duchamp's *Mile of String* was designed to impede the viewing of the paintings at the 1942 surrealist exhibition in New York.[19] Its installation made impossible normative viewing of the art object, and only by literally destroying *Mile of String* could the viewer recapture the traditional relationship between viewer and object. It altered the terms of public art exhibition in much the same way that his domestic readymade *Door: 11, rue Larrey* (1927) had redefined private space. As a door that could only shut off one room or the other, but never simultaneously offer closure to both, *Door: 11, rue Larrey* bisected domestic safety and made a mockery of privacy and containment. Duchamp reorganized the space of occupancy and exhibition, installing a designated artwork that is equally functional and a dysfunctional door that can be redesignated at will as art. The audience/visitor chooses which aspect will be "installed" at what time. These works made ephemeral allusion to the absence and presence of space and to the notion of space as an unfixable entity, as illusionary and mutable. On an epic scale (appropriate to its desire to miniaturize the viewer in relation to absolute power), Albert Speer's *Cathedral of Light* (1934) was a circumference of columns made up entirely of spotlights. Designed to illuminate Nazi stadium rallies, they existed as temporarily blinding monuments, occupying airspace and the newly claimed Fascist public sphere. *Cathedral of Light* and *Light Ram Modulator* represent the quandaries of the machine-age fetish and political nuance and serve as markers for multimedia, technology-based art forms that negotiated the confines of domestic and public space.

Many years later, in the late 1950s, Yves Klein sells shares of gallery air, continuing in the footsteps of Duchamp's *Monte Carlo Bond* (1924) and its playful twisting of art and commerce. Attention

to the ideological and commercial implication of making a work of art combines with performative aspects as the artist becomes a character in the work of art, conceptually and figuratively. The gallery space itself becomes material, sold off as shares in the promise of art. The Gutai group in Japan in the 1950s and Allan Kaprow's performance process pieces of the 1950s and 1960s continue this exploration of the artist as performer-author; they expand the space defined by turning assemblage and action painting into environment through interjecting the author as performer and instigator.[20] The Gutai group sculpted earth with bodies, erected and disassembled dwellings, and destroyed paintings' spatial illusion by violently penetrating their surfaces with arrows and leaping bodies, thereby reconfiguring the space of art-making through bodily interventions and spatial disassembling. The artist is implicated in the work of art, as he or she becomes content, material, *and* process. These actions move the artist into public and institutional space—a space that includes Marcel Broodthaers, Daniel Buren, and Michael Asher's deconstructive museum and gallery "augmentations." These are actions that define the environs of installation as practice, reconfiguring notions of occupancy, material forms, and the body's relationship to the space it occupies and incessantly reformulates. It is also a space defined by Gordon Matta Clark's *Splitting: Four Corners* (1974), the revealing of architectural skeleton and a reorientation of perspectival solidity through the bisecting of a two-story house down the middle with a chain saw. This trajectory is too inclusive to be conclusive, but somewhere between standing stones, follies, and *Wunderkammern* are some clues to a crooked but inviting path that is erratically signposted.

This Site

The authors whose texts are included here explore various installation projects in relation to their "siting" via a varied set of methodologies addressing issues of class, sexuality, cultural identity, race, and gender (and redefinitions and disruptions of these constructs). They expand the definition of installation and site-specific work outside the confines of its primarily Western modernist delineation while interrogating and riffing on that very definition. The project includes contributions by a variety of writers, including curators, artists, art historians, and critics working from a variety of disciplines, methodologies, and points of view. This collection endeavors to explore how the visual arts practices of installation and site-specific art resonate

1977 (continued)
Mary Lucier, *Untitled Display System, Laser Burning Video*
Suzanne Lacy and Leslie Labowitz, *In Mourning and in Rage*
Walter De Maria, *New York Earth Room*
Michael Asher, *Installation Münster*
Mary Miss, *Perimeters, Pavilions, Decoys*, 1977–78
Kerry Trengrove, *An Eight-Day Passage*
Rosalind Krauss, *Passages in Modern Sculpture*
John Beardsley, *Probing the Earth: Contemporary Land Projects*

1978
Robert Longo, *Sound Distance of a Good Man*
SITE Projects, Inc., *Ghost Parking Lot*
Theresa Hak Kyung Cha, *Passages Paysages*

1979
Andy Lipkis, TreePeople founded
Mario Merz, *Igloo*
Joan Jonas, *Upside Down and Backwards*
Nancy Holt, ed., *The Writings of Robert Smithson*
Rosalind Krauss, *Sculpture in the Expanded Field*
Dieter Roth, *Triptychon*

1980
Ira Schneider, *Time Zones*
Douglas Hollis, *Field of Vision*
Tom Van Sant, *Reflections from Earth: Shadow Mountain Eye*
Jenny Holzer, *The Living Series*
Juan Downey, *Venus and Her Mirror*
Huayco Eps, *Sarita Colonia*
Barbara Steinman, *Le couple dormant*
Michael Schuyt, Joost Elffers, and George R. Collins, *Fantastic Architecture: Personal and Eccentric Visions*

1981
Richard Serra, *Tilted Arc*
Cecilia Vicuña, *Antivero*
Kim Abeles, *Pilgrimage to the Wedge*, 1981–87
Ilya Kabakov, *The Man Who Flew into Space from His Apartment*, 1981–88
Group Material, *People's Choice/ Arroz con mango*
Jean-Pierre Raynaud, *Espace zéro*

1982

Agnes Denes, *Wheatfield*

Joseph Beuys, *Aktion 7000 Eichen (Action 7000 Oaks)*

Nils-Udo, *Wasser-Haus (Water House)*

1983

Mary Lucier, *Ohio at Giverny*

Terry Allen, *Rooms & Stories*

Tina Keane, *Demolition/Escape*

Reinhard Mucha, *Hagen-Vorhalle*

Ann Hatch founds Capp Street Projects

Alan Sonfist, *Art on the Land: A Critical Anthology of Environmental Art*

Michael Asher, *Writings 1973–1983 on Works 1969–1979*

Lucy Lippard, *Overlay: Contemporary Art and the Art of Prehistory*

1984

Border Art Workshop/Taller de Arte Fronterizo founded

Thierry Kuntzel, *Nostos II*

Dolores Hayden founds Power of Place

Stuart Marshall, *A Journal of the Plague Year*

Studio Azzurro, *Due piramidi*

David Wilson founds The Museum of Jurassic Technology

Marie Jo Lafontaine, *A las cinco de la tarde*

1985

Bill Viola, *Theater of Memory*

Douglas Davis, *TV Is Great Because When You Close Your Eyes, It Sounds Like Radio*

Krzysztof Wodiczko, *South African Embassy*

Jorge Rodriguez and Charles Abramson, *Orisha/Santos*

Bernard Tschumi and Jacques Derrida, *Parc de la Villete*

Brian Eno, *Video Painting*

The Guerrilla Girls founded

Marina Abramović and Ulay, *Terra degli Dea Madre*

Madelon Hooykaas/Elsa Stansfield, *From the Museum of Memory*

Burning Man festival begun

1986

Francesc Torres, *The Dictatorship of Swiftness*

Marcel Odenbach, *As If Memories Could Deceive Me*

Alfredo Jaar, *Rushes*

Adrian Piper, *My Calling Card*

Yolanda López, *Cactus Heart/ Barbed Wire Dreams: Media Myths and Mexicans*

within history as well as in relation to contemporary culture and society and how these practices have altered, engaged, and influenced aspects of contemporary visual culture. In the two opening essays in this volume, James Meyer and Miwon Kwon investigate theoretical and conceptual issues surrounding the very definition of installation and site-specific art that can only be briefly touched upon in this introduction. They investigate what is at stake in such definitions and what is at stake in radical positionality vis-à-vis the bending of the structures of exhibition and reception. They bring the debates about installation and site specificity full circle and examine their efficacy and application both in their historical context and in their impact on 1990s art discourse. James Meyer discusses the "functional site" and the "literal site" as processes that are rearticulated and reconfigured via contemporary artists' nomadic narratives. Miwon Kwon examines the notion of the discursive and the physical in relation to "site" in the works of nascent institutional critique and the "unhinging" of site specificity away from its origins in "the pure idealist space of dominant modernisms."

Barbara Maria Stafford, in her contribution to this volume, delves into the existence of a libertine anticlassic and antiacademic aesthetic as documented in the attitude expressed toward so-called Druidic monuments. Focusing on the dispute—revived during the first quarter of the eighteenth century—between the Palladian Inigo Jones and the Epicurean Walter Charleton concerning the interpretation of Stonehenge, Stafford develops an important antithesis for architectural and sculptural monuments between classical, or "literate," monuments and barbaric, Gothic, or "illiterate," memorials. Sean Cubitt writes about constructions of grottoes, gardens, and fountains in relation to absolute power and allegory, as evidenced in what he terms the neobaroque. He outlines how the baroque and subsequent periods theorize sound, smell, and sight and the "immanent collapse of meaning," constructions he reads across the contemporary work of Judith Goddard, Susan Trangmar, Chris Meigh-Andrews, Douglas Gordon, Daniel Reeves, Keith Piper, Stellarc, Mona Hatoum, and Ian Hamilton Finlay. He charts the transfiguration of the natural—however sensuously reconfigured—into monumental artifice.

Ian Hamilton Finlay's *Little Sparta* (1966-present) is the sole subject of Susan Stewart's meditation on the allegorical impulse, poetic structure, and nature as both subject and embattled site. She postulates a teleology of death contained in making gardens and in making war, both modes conspiring toward a fundamental transfor-

mation of nature. Stewart traces how these tropes manifest themselves in Finlay's elegiac defense of poetry, the poetic object, and memory. My essay searches for a definition of "the natural" as evidenced in earthworks, photography, and site-specific "monuments" situated in the southwestern deserts of North America, sites fraught with political, utopian, and fantastical interpretive projections. The desert topos serves as subject matter and location for projects by John Divola, Nancy Holt, Walter De Maria, Dennis Oppenheim, and Jean Tinguely. The essay skews the intersections of these topographical investigations and proposes several different constructions of "the natural" within site specificity as practice in the late twentieth century, as prescribed by decayed sublimity, codes of landscape, the erasures of use value, and land development within site specificity as practice.

Alessandra Moctezuma + Leda Ramos uncover issues of site specificity in the urban topography wherein they perform architectural interventions, mapping Latinos' and women's cultural histories upon the urban fabric to investigate dislocation, memory, and language. They outline their work as a collaborative dialogue between Mexican, Central American, and (Los) Angelino architectural sites, from storefronts to historical landmarks—found, designated, and restructured through objects and action. Moctezuma + Ramos are fascinated with "Latinos' alternative semiotic landscape" as found in religious and commercial signage—street vendors, mobile markets, festivals, and other urban, vernacular aesthetic topologies. John Coleman also discusses the dimensions of memory and personal narratives that occupy the space of installation. By situating his own work, *A Prayer for My Son and Myself* (1997), in relation to the work of David Hammons, Ed Kienholz, and Nancy Reddin Kienholz, he discusses how storytelling, object-making, and witnessing inform his installation practice. His use of first-person narratives shapes the structure of the essay itself while illustrating his essential attraction to installation as a form, a form he finds resonant with autobiographical gesture because it "exists within both physical and psychic space." The collapse of alternative spaces, the poetic structures of Charles Bukowski, journal entries, and witnessed political climates all serve as metaphors and markers of Coleman's process, a process mirrored in the form of the essay itself as he interleaves these disparate sources to augment the work of the artists he utilizes in order to delineate a center within his own autobiographical project. Ernest Larsen examines the strategy of the "found object" as urban detour. The "everyday" object disrupts and becomes a singular and

1986 (continued)

Buky Schwartz, *Three Angles of Coordination for Monitoring the Labyrinthian Space*
James Luna, *The Artifact Piece*
Nan Hoover, *Light/Video Installation*
James Lee Byars, *The Spinning Oracle of Delfi?*
Rita Myers, *Rift △ Rise*
Celia Alvarez Muñoz, *Tolido*
John Ahearn, *Bronx Sculpture Park*, 1986–91

1987

Border Art Workshop/Taller de Arte Fronterizo, *911: The House Gone Wrong*
Richard Long, *Stonefield*
Peter Fischli and David Weiss, *Haus*
Andy Goldsworthy, *Isle of White*
Ulrike Rosenbach, *Or-phelia*
Dara Birnbaum, *Damnation of Faust*
Chris Burden, *The Reason for the Neutron Bomb*
Antonio Muntadas, *The Board Room*
Skulptur Projekte Münster, exhibition
James Wines, *De-architecture*

1988

General Idea, *The Public and Private Domains of the Miss General Idea Pavilion*
Group Material, *Education and Democracy*
Ann Hamilton, *The Capacity of Absorption*
Barbara Bloom, *Seven Deadly Sins*
Amalia Mesa-Bains, *Altar for Dolores del Rio*
May Sun, *L.A./River/China/Town*
Lydia Schouten, *A Civilization without Secrets*
Klaus vom Bruch, *Radarraum*
Keigo Yamamoto, *The Burning Sea*
Juan Boza, *The Greater Ceremonies*
Wolfgang Laib, *The Passageway*
Betye Saar, *Secrets and Revelations*
Katsuhiro Yamaguchi, *Zampini*
Lothar Baumgarten, *AMERICA Invention*, 1988–93
Joseph Kosuth, *A Grammatical Remark* begun
Victor Lucena, *Space Shock*, 1998–91

1989

Maureen Connor, *The Bachelor Pad*

Sophie Calle, *The Blind*

Tadashi Kawamata, *Toronto Project*

Guillermo Gómez-Peña, *Border Wizard (Border Brujo)*

Sheila Levrant de Bretteville and the Power of Place, *Biddy Mason: Time and Place*

Jennifer Steinkamp, *Gender Specific*

Gran Fury, *Kissing Doesn't Kill*

Houston Conwill, *The Cakewalk Humanifesto*

Mike Kelley, *Frankenstein*

Martha Rosler, *Housing Is a Human Right*

Adrian Piper, *Out of the Corner*

Group Material, *AIDS Timeline*

Louise Bourgeois, *Cell (Arch of Hysteria)*, 1989–93

Anna O'Cain, *Our Starland*

Wulf Herzogenrath and Edith Decker, eds., *Video-Skulptur: Retrospektiv und aktuell 1963–1989*

John Beardsley, *Earthworks and Beyond*

Chris Dercon, *Theatergarden Bestiarium*

Anish Kapoor, *Void Field*

1990

Rachel Whiteread, *Ghost*

Mel Chin, *Revival Field*, 1990–1993

David Hammons, *Central Park West*

Viet Ngo, *Devil's Lake Wastewater Treatment Plant*

Nicola Oxley and Michael Petry found The Museum of Installation

Michael C. McMillen, *Pavilion of Rain*

Christian Boltanski, *The Missing House*

Cai Guo Qiang, *Project for Extraterrestrials nos. 3, 9, 10, & 14*

James Luna, *A.A. Meeting/Art History*

Gary Hill, *Beacon (Two Versions of the Imaginary)*

Hachivi Edgar Heap of Birds, *Building Minnesota*

Louis Hock, Scott Kessler, Elizabeth Sisco, and Deborah Small, *America's Finest?*

Betye and Alison Saar, *House of Gris Gris*

1991

David Hammons, *Rousing the Rubble*

Vong Phaophanit, *Tok tem edean kep kin bo dai (What Falls to*

personal "accident" on a city street. Through a chance encounter with Ilya Kabakov's *Monument to a Lost Glove* (1997), Larsen postulates the spatial and temporal monumentality of the body in relation to architectural, economic, and urban topographic space. The deployment or the installation of this "found" object in a culturally specific posture and in an alien site extends chance into happenstance. His encounter leads him to knit the work of Simon Leung, Gary Hill, and Sherry Millner into a personal essay that grafts autobiographic narrative over the systemic realities of New York art-world real estate, the politics of difference, and the collapse of monumentality. His is a system—and a flaneur's ramble—that is topographically detoured via the object.

C. Ondine Chavoya writes about the early performance-based interventions of the Los Angeles group Asco, who in the 1970s politicized the public sphere through the performance of body, action, and tableau, adapting the transgressive via urban and ethnic *détournement*.[21] Chavoya writes of Asco's spatially politicized aesthetics as critical resistance, actions that postulate real and metaphorical occupations of urban sites. By positioning Asco as essentially outside the tenets of the Chicano art movement, Chavoya problematizes the historical reception and contemporary narrativizing of that movement while underscoring Asco's employment of the transgressive via public site, engendering community response and advocating social change through spatial resistance. Laurence A. Rickels tabulates disparate sources to disinter a genealogy of media, the public space of commerce, and art's "entombment." Examining the connective synapses between Stig Sjölund's *Titanic II* (1988), installed in the courtyard of Wilhelmina von Hallwyl's Hallwylska Museet in Stockholm; America's first serial killer's Chicago "Castle"; and Sarah Winchester's San Jose "Mystery Mansion," Rickels posits the connectivity and cross talk between the collection, modern technological invention, what he terms "sci-fi modernism," and its resting place in melancholia, the vampiric, and catastrophe.

Kevin McMahon examines how contemporary works of architecture, advertisement, and domestic and museum interiors align with and resite public space. By interweaving the Case Study Houses, Martha Stewart, modern architectural exhibition space within the museum, and the future of housing and dwelling, McMahon delves into homes without sites—the displacement of architecture within urban site and museum void. Southern California housing developments, installation art as fodder for ahistorical museum re-creation, and nature domesticated and folded into house (as part of the "thea-

ter of objects") inform McMahon's critical meditation on home, house, installation, and institution. John C. Welchman's essay on the Art Rebate/Arte Reembolso project (1993) examines a contemporary site-specific work in San Diego by Louis Hock, Liz Sisco, and David Avalos that relies on a continuation of Duchamp's debunking of and simultaneous employment of commodity fetish. He explores how a neodadaist gesture is applied in the urban sphere of exchange value for overt political purposes. Momentarily located in the politics and economics of migrant labor and its border site, Welchman places Art Rebate/Arte Reembolso within a series of contexts and methodologies through which twentieth-century art has engaged with the theory and practice of money and the systematic and social operations of market capitalism.

Expanding upon multi-media and technology-based installation, Chrissie Iles examines the architectural matrix of the gallery and museum and how these sites have been reformulated as works of projected light and movement that reconfigure perceptual and temporal axes of space. Identifying three historical phases of video and film installation—the phenomenological performative, the sculptural, and the cinematic—she uncovers the theoretical phenomenological bases of the work of Dan Graham, Bruce Nauman, Peter Campus, Vito Acconci, Joan Jonas, and Les Levine while outlining the projected environments of Gary Hill, Stan Douglas, Douglas Gordon, and Liisa Roberts within concepts of the panorama, multimedia environments, and the cinematic.

Bruce Jenkins also examines the museum and the machine, exploring how works of film installation have been received and theorized within the context of their "installation" as determined by issues of temporality and filmic "presence." He explores how the existence of film has redefined the very way in which we understand the work of art. More than fifty years after Walter Benjamin's death and nearly a hundred years after the birth of cinema, Jenkins contends that film continues to reside—now in the company of video, holography, and new forms of computer-based imaging—on a fault line discernible only well below the surface of the art-world infrastructure. Jenkins positions the film object in relation to issues of site, temporality, and historicity across works that range from Joseph Cornell to Chantal Akerman.

Colin Gardner offers a close reading of Diana Thater's video installation *China* (1996). His reading questions the theorizing of site specificity through the dialectical tenets of minimalism, namely the spatial and temporal interrelationship between the object, the viewer,

1991 (continued)
the Ground but Cannot Be Eaten)
Lorna Simpson, *Five Rooms*
Joseph Kosuth, *Art after Philosophy and After: Collected Writings, 1966–1990*
Sophie Calle, *The Hotel Series*

1992
Coco Fusco and Guillermo Gómez-Peña, *The Year of the White Bear (Two Undiscovered Amerindians Visit Madrid)*
María Fernanda Cardoso, *Flag*
Mona Hatoum, *Light Sentence*
Anselm Kiefer, *Women of the Revolution*
Richard Jackson, *1,000 Clocks*
Katharina Fritsch, *Rat King*
Tadashi Kawamata, *Project on Roosevelt Island*
Herman Prigann, *Ring der Erinnerung (Ring of Memory)*
Raúl Ruiz, *All the Evil in Men*
Pepón Osorio, *Scene of the Crime (Whose Crime?)*
Patrick Werkner, *Land Art U.S.A.*
Houston Conwill, Estella Conwill Majozo, and Joseph de Pace, *Stations of the Underground Railway*

1993
Johannes Mashego Segogela, *Burial of Apartheid*
Mierle Laderman Ukeles, *A Blizzard of Released and Agitated Materials in Flux*
Nils-Udo, *Hain, Romantic Landscape*
Nobuho Nagasawa, *Toyo Miyatake's Camera*
Andrew Benjamin, ed., *Installation Art*
Jan Butterfield, *The Art of Light and Space*
Gilles A. Tiberghien, *Land Art*
Jochen Gerz, *Vivre*
Derek Jarman, *Blue*

1994
Portia Munson, *Pink Project Table*
Pinaree Sanpitak, *Confident Bodies*
Marcel Odenbach, *Make a Fist in the Pocket*
Anna O'Cain, *The Room That Was My Family*
Fred Wilson, *Insight: In Site: In Sight: Incite: Memory*
Chris Marker, *Silent Movie, 1994–95*
Nicolas de Oliveira, Nicola Oxley, and Michael Petry, *Installation Art*

1995

Hiroshi Teshigahara, *Monumental Ikebana*

Keith Piper, *Reckless Eyeballing*

Sheila Levrant de Bretteville, Sonya Ishii, and Nobuho Nagasawa, *Omoide no shotokyo (Memories of Little Tokyo)*

Annetta Kapon, *Math or Myth*

Kay Hassan, *Bundles*

Anton Karstel, *Ephraim*

Susan Silton, *You May Already Be a Winner*

Andy Goldsworthy, *Red Pool (Dumfriesshire)*

Baile Oakes, *Sculpting with the Environment: A Natural Dialogue*

John Beardsley, *Gardens of Revelation: Environments by Visionary Artists*

Suzanne Lacy, ed., *Mapping the Terrain: New Genre Public Art*

Dolores Hayden, *The Power of Place*

1996

Atelier Van Lieshout, *Modular House Mobile*

Marjetica Potrč, *Suburbia*

Huang Yong Ping, *Trois pas, neuf traces (Three Steps, Nine Paths)*

Peter Fischli and David Weiss, *Empty Room*

Antony Gormley, *European Field*

Vito Acconci, *House up a Building*

Tadashi Kawamata, *Bridge Walkway*

Juan Muñoz, *Plaza (Madrid)*

Kim Soo-Ja, *Deductive Object*

Susan Silton, *The Flying Malflora*

1997

Mark Dion, *Grotto of the Sleeping Bear (Münster)*

Isaiah Zagar, *Grotto South Street Studio*

Thomas Hirschhorn, *Prekäre Konstruktion (Precarious Construction)*

Alfredo Jaar, *The Rwanda Project*

Louise Bourgeois, *Passage dangereux*

Jane and Louise Wilson, *Stasi City*

Haim Steinbach, *The Trial*

Tomoko Takahashi, *Authorized for Removal*

Ahmad Shukri Mohamed, *Insect Diskette II*

Huang Yong-Ping, *Handle with Care*

Iran do Espírito, *Pounds*

Ai Weiwei, *72 Standard*

Rosemarie Trockel and Carsten Höller, *A House for Pigs and People*

and the overall context. He deconstructs these traditional boundaries, which he articulates as Hegelian, through a resort to nondialectical theoretical sources, particularly Gilles Deleuze and Félix Guattari's becoming-animal and becoming-machine. Marita Sturken focuses on technology, as well, and its relation to memory, space, and time specifically across the works of Jim Campbell. Campbell's machines of controlled randomness and mediated memory form the basis of an essay that focuses on the paradox of memory in the electronic realm, suggesting as it does both the passing nature of memory and its "haunting." Technological apparatus, autobiography, and the shifting form of electronic media delineate the basis of Campbell's project, integrating the "object" of technology into the site while reconfiguring constructions of memory, the mimetic, and the sublime, ultimately arriving at closure only through the viewer's completion of the loop of production and reception.

Catherine Lord's essay inserts lost subjectivity and authorship back into the archive, constructing a modern-day *Wunderkammer* as a counter to historical erasure. Focusing on her collaborative project with Millie Wilson, *Something Borrowed* (1995), a site-specific installation/public art project that addressed issues of a fictive queer community and lesbian visibility/invisibility, Lord writes of the collaborative process as a way to develop and register a lesbian presence in a setting of varied conservatisms: the avant-garde art world, the setting of a historical museum, and the Catholic state. She locates their interest as coauthors at the intersection of homosexuality in relation to anthropology and proposes *Something Borrowed* as a site that would both record and invent a lesbian community as constructed through a subcultural insistence on appropriating and redefining dominant codes outside heterosexuality's borders. Tiffany Ana López examines Pepón Osorio's elaborate barbershop collections and narrative rearrangements as interpreters and constructors of community. Both Lord and López explore the absented and the removed, focusing on works of art that reinstall "disappeared" histories. Osorio employs fabricated environments made up of found commercial objects and constructed "evidence," which he uses to stage theatrical installations that, López asserts, reflect and interrogate the social and ideological constructions of Latino popular culture, familial relationships, and community. This essay specifically focuses on a shift within Osorio's work engendered by the use of video and its connection to the body as performative matrix. Controversy and debate surrounding issues of accessibility to mainstream institutions and what this does to the politics of identity within the

work of art are examined in conjunction with issues of visibility and the relationship between representations of the body (imaging) and the imagining of community. Amelia Jones traces the legacy of minimalism and examines it in light of questions of subjectivity and situational aesthetics in relation to works of contemporary installation, which, she argues, move the body into site as subject. She explores the intersection between body art and installation as these two types of practice came together in the late 1960s and early 1970s *through* a model of spatial politics revolving around the gallery as a "community" space. Jones traces the impact of phenomenology on the work of artists and theoreticians such as Robert Morris, Michael Fried, Vito Acconci, Joseph Santarromana, and Adrian Piper as they pose or suppress questions of intersubjective desires and assumptions that play off the artists' and the audiences' assumed identities. By reconstructing and revisiting the debates surrounding installation as a practice growing out of minimalism's aegis, Jones promises a complex and problematized rendering of installation art and its relation to myriad sites of shifting subjectivities.

Artists investigate urban topographies as sites of resistance, the human form is configured and employed as ideologically resonant, and spatial rearrangements compel a reassessment of perceptual boundaries. Given the dearth of serious critical and theoretical attention that installation as a visual arts practice has garnered, this book is designed to fill the gap between its identification as a medium of artistic expression and as a site in which to expand the definition of the artwork. This anthology proposes itself as a conceptual and temporal site of exchange, *détournement*, detour, assessment, play, and speculation.

> A *space* exists when one takes into consideration vectors of direction, velocities, and time variables. Thus space is composed of intersections of mobile elements. It is in a sense actuated by the ensemble of movements deployed within it. Space occurs as the effect produced by the operations that orient it, situate it, temporalize it, and make it function in a polyvalent unity of conflictual programs or contractual proximities. On this view, in relation to place, space is like the word when it is spoken, that is, when it is caught in the ambiguity of an actualization, transformed into a term dependent upon different conventions, situated as an act of a present (or of a time), and modified by the transformations caused by successive contexts. In contradistinction to the place, it has thus none of the univocality or stability of a "proper." In short, *space is a practiced place.*[22]

1998
Andrew Cao, *Glass Garden*
Jeffrey Kastner and Brian Wallis, *Land and Environmental Art*
Billboard Liberation Front, *Think Doomed*
Ilya and Emilia Kabakov, *The Palace of Projects*
Annette Messager, *En balance*
Ann-Sofi Sidén, *Who Told the Chambermaid?*
Christian Boltanski, *Die Winterreise*
Roxy Paine, *SCUMAK (Auto Sculpture Maker)*
Superflex, *Biogas in Africa*
Claude Wampler, *Jumbo Shrimp*
Johan van der Keuken and Jeroen de Vries, *The Central Body*
Massimo Bartolini, *Head no. 7— Garden*
Francisco Ruiz de Infante, *Habitación de lenguajes (Bestario no. 3) (Room of Languages, Bestiary no. 3)*
Tatsuo Miyajima, *Sea of Time*
Wolfgang Laib, *Nowhere-Everywhere*
Sarah Sze, *Second Means of Egress*
Tobias Rehberger, *Within Views of Seeing*
Rirkrit Tiravanija, *The Social Capital*
Wenda Gu, *Temple of Heaven*

1999
Cai Guo Qiang, *Borrowing Your Enemy's Arrows*
Simon J. Ortiz, *What Indians?*
Danae Stratou, *Water Perspective*
Vittorio Messina, *A Village and Its Surroundings*
Carsten Höller, *The New World Race*
Wang Jun Jieh, *Little Mutton Dumplings for the Thirteenth Day*
Lix Bachhuber, *Nest*
Luis González Palma, *La mirada crítica (The Critical Gaze)*
Bruce and Norman Yonemoto, *Silicon Valley*
José Bedia, *Me Coballende (My Silent Lazarus)*
Issey Miyake, *Jumping*
Trinh T. Minh-ha and Lynn Kirby, *Nothing but Ways*
Georges Adéagbo, *La Geomanci*

I would like to situate this book within de Certeau's "practiced space," juxtaposing installation alongside ongoing political and cultural activities—as a practice and a medium allied with and paralleled by other current critical and artistic discourses.

I hope to create an ongoing site of exchange, pleasure, interrogation, phantasm, and investigation that can address one of the most elusive but dominant forms currently at play in the field of the visual.

Notes

1. For a concise and thoughtful introduction to the history of installation art, see Michael Archer, "Towards Installation," in *Installation Art,* ed. Nicola de Oliveira, Nicola Oxley, and Michael Petry (London: Thames and Hudson, 1994); see also Peter Selz, "Installations, Environments, and Sites," in *Theories and Documents of Contemporary Art: A Sourcebook of Artists' Writings,* ed. Kristine Stiles and Peter Selz (Berkeley: University of California Press, 1996).

2. As defined by George R. Collins, "Soft Architecture . . . refuses to use the processes of production, industrial procedures, and division of labor. . . . That is, soft architecture tried to establish new relationships between producer and user (often the same person). It is involved in new relations between Man and Nature in its respect for ecosystems, and its refusal to squander energy and materials; it pursues autonomy. It proposes itself as a possibility of poetic expression and total realization which permits an individual to recover his integrity by non-specialized work, rejecting any division between the intellectual and manual. In its methods of production it must be artisan, and for obvious reasons it is often self-built; it replaces the project about space—making by the process of space-making; it wishes to be anti-monumental, not rhetorical, but poetic." The journal *Architecture d'Aujourd'hui* as quoted in *Fantastic Architecture: Personal and Eccentric Visions,* ed. Michael Schuyt and Joost Elffers (New York: Abrams, 1980), 11. Originally published as *Phantastische Architektur* (Cologne: DuMont Buchverlag, 1980).

3. See time line alongside Introduction text.

4. Lucy Lippard, *Six Years: The Dematerialization of the Art Object from 1966 to 1972* (New York: Praeger, 1973), is a conceptual art object in and of itself. In her insistence on curatorial point of view identified as political and ideologically constructed, Lippard invents a document that is a period-specific autocritique of art criticism as act. The book as object enacts a radicalization of form that is germane to our study of installation as it enacts a disruption of chronology and linear index. As Lippard states of the project: "The anti-individualistic bias of its form (no single artist's sequential development or contribution can be traced without the help of the index) will hopefully emphasize timing, variety, fragmentation, and interrelationships above all. In fact, I have included some of the work here because it illustrates connections to or even exploitations of other, stronger work, or repetition of ideas considered from very different viewpoints, or how far certain ideas can be taken before they become exhausted or totally absurd. In any case, I enjoy the prospect of forcing the reader to make up his or her own mind when confronted with such a curious mass of information" (6).

5. Daniel Buren, "Like a Palimpsest; or, The Metamorphosis of an Image," in *Contemporary Sculpture Projects in Münster, 1997,* ed. Klaus Bussmann, Kasper König, and Florian Matzner (Münster: Verlag Gerd Hatje, 1997), 79.

6. He continues by identifying sculpture's expansion into site and the space that is unleashed and circumscribed within site specificity. "This paradox *qua* sculpture is focused in the problem of site. 'The biggest break in the history of sculpture in the twentieth century,' Serra

has remarked, 'occurred when the pedestal was removed,' which he reads as a shift from the memorial space of the monument to the 'behavioral' space of the viewer.' Yet as a dialectical event this break opened up another trajectory as well: with its pedestal removed, sculpture was free not only to descend into the materialist world of 'behavioral space' but also to ascend into an idealist world beyond any specific site." Hal Foster, "The Un/making of Sculpture," in *Richard Serra: Sculpture, 1985–1998,* ed. Russell Ferguson, Anthony McCall, and Clara Weyergraf-Serra (Los Angeles: The Museum of Contemporary Art and Göttingen: Steidl, 1998), 17–18. Foster is quoting Serra from "Interview with Richard Serra," in *Richard Serra: Torqued Ellipses,* by Richard Serra (New York: Dia Center for the Arts, 1997), 26.

7. Benjamin Buchloh's "Michael Asher and the Conclusion of Modernist Sculpture," in *Performance Text(e)s & Documents,* ed. Chantal Pontbriand (Montreal: Parachute, 1981), alongside Rosalind Krauss's "Sculpture in the Expanded Field," in *The Originality of the Avant-Garde and Other Modernist Myths* (Boston: MIT Press, 1985), serves as an indispensable opening up of the discourse of sculpture. Both texts definitively and fundamentally alter the terms of reception of the art object and propose installation as identity and gesture outside and in contradistinction to prior descriptors of modernist sculptural discourse.

8. For collections of writings and images specific to land art and earth art, see Alan Sonfist, ed., *Art in the Land: A Critical Anthology of Environmental Art* (New York: Dutton, 1983); John Beardsley, *Earthworks and Beyond* (New York: Abbeville Press, 1989); Gilles A. Tiberghien, *Land Art* (New York: Princeton Architectural Press, 1995); Francisco Asensio Cerver, *Landscape Art* (Barcelona: World of Environmental Design Press, 1995); and Jeffrey Kastner, ed., *Land and Environmental Art (Themes and Movements)* (London: Phaidon Press, 1998).

9. Douglas Crimp, "Redefining Site Specificity," in *On the Museum's Ruins* (Cambridge: MIT Press, 1993), 154.

10. Ibid., 153.

11. There are several intriguing works that deal in depth with the *Wunderkammer* from a historical perspective; see Barbara Maria Stafford, *Body Criticism: Imaging the Unseen in Enlightenment Art and Medicine* (Cambridge: MIT Press, 1991) and *Artful Science: Enlightenment Entertainment and the Eclipse of Visual Education* (Cambridge: MIT Press, 1995). For its application to David Wilson's extraordinary contemporary project, *The Museum of Jurassic Technology,* see Lawrence Weschler, *Mr. Wilson's Cabinet of Wonders* (New York: Pantheon, 1995). For a specific discussion of the *Kunstkammer,* please see Horst Bredekamp's *The Lure of Antiquity and the Cult of the Machine* (Princeton, N.J.: Markus Wiener, 1995).

12. Stafford, *Body Criticism,* 29.

13. Schuyt and Elffers, eds., *Fantastic Architecture,* 243–44.

14. See John Beardsley, *Gardens of Revelation: Environments by Visionary Artists* (New York: Abbeville Press, 1995).

15. Lowery S. Sims, "Betye Saar: A Primer for Installation Work," in *Betye Saar: Resurrection: Site Installations, 1977–1987* (Fullerton: California State Art Gallery, 1988), 1. See also Ishmael Reed on Betye Saar's employment of recycled aura and material decay and their relation to "folk" in "Saar Dust: An Interview with Betye Saar," in *The Art of Betye and Alison Saar: Secrets, Dialogues, and Revelations* (Los Angeles: University of California, Wight Art Gallery, 1991), 32: "Methane gas, the stuff that emanates from junk, is used in the process of making diamonds. It could be said that the Saars take the dust of things and, from this dust, create works of art. Betye Saar's work often has the glitter of diamonds. Saar Dust. Life arising from mud. From 'garbage.' From 'junk.' Dust to dust. Her work is about the processes of life—the energetic high-tech materials that entered her work during her stint at MIT as well as the materials of decay, of fading memories, of nostalgia. Oldies, but goodies. She makes a strong statement for resurrection. For renewal."

16. John Beardsley, *Gardens of Revelation: Environments by Visionary Artists*, 157–59.

17. Ibid., 35.

18. For a further examination, see Guy Brett, "The Proposal of Lygia Clark," in *Inside the Visible: An Elliptical Traverse of Twentieth-Century Art*, ed. M. Catherine de Zegher (Cambridge: MIT Press, 1996).

19. See Amelia Jones's discussion of *Mile of String* and *1200 Bags of Coal* in *Postmodernism and the Engendering of Marcel Duchamp* (Cambridge: Cambridge University Press, 1994), 77–79.

20. For a discussion of body and performance art in relation to the object, especially in regard to the Gutai group, American and German happenings, and performance art of the 1970s, see Paul Schimmel, ed., *Out of Actions: Between Performance and the Object, 1949–1979* (New York: Thames and Hudson; Los Angeles: Museum of Contemporary Art, 1998). See as well Amelia Jones, *Body Art/Performing the Subject* (Minneapolis: University of Minnesota Press, 1998).

21. *Détournement* was one of several practices employed by the Situationist International, a movement of artists, filmmakers, and intellectuals in France that constructed situations— political disruptions via media, street actions, film, and manifestos. "Short for: détournement of preexisting aesthetic elements. The integration of present or past artistic production into a superior construction of a milieu. In this sense there can be no Situationist painting or music, but only a Situationist use of these means. In a more primitive sense, détournement within the old cultural spheres is a method of propaganda, a method that testifies to the wearing out and loss of importance of those spheres." As defined in Elisabeth Sussman, ed., *On the Passage of a Few People through a Rather Brief Moment in Time: The Situationist International, 1957–1972* (Cambridge: MIT Press, 1989), 199.

22. Michel de Certeau, *The Practice of Everyday Life* (Berkeley: University of California Press, 1984), 117 (emphasis in original).

1. The Functional Site; or, The Transformation of Site Specificity

James Meyer

To Kim Paice

The word critique has attained a bad name in the 1980s. The way in which the work was deployed was only in reference to that which beats its opponent into submission. But if we think about criticality as embracing a more expansive field of reading, I would think of my work as being a critique of *site-specificity*. The site-specific seems to be grounded in a very particular location and a particular time, and all information is related to this. But when you take any of these coordinates, space and time, and you compound them, the model doesn't seem to hold up.

—Stephen Prina

In recent years, the exploration of site has again become a privileged investigation. The current fascination with the art of the 1960s and early 1970s, a phenomenon of scholarship and practice, has resuscitated the idioms of pop, scatter work, identity-based activist art and performance, modes of conceptualism, and minimalism's serial syntax; contemporary explorations of site recall the legacies of earth art and institutional critique. In these practices, the languages and strategies of now historical activities are hybridized and displaced. The comparative interest of such work lies, in part, in the "success" of these revisitations—whether the adaptation of previous modes to emerging content has resulted in something unexpected or in a project that seems uninformed, awkward, or, frankly, dull. The necessity to make such a determination is, I think, a pressing task of the critic of contemporary work.

How, then, to assess one subset of recent work—the site explorations of Mark Dion, Andrea Fraser, Tom Burr, Renée Green, Christian Philipp Müller, and Ursula Biemann, for example? How have these producers addressed or (as I will argue here) transformed the notion of site specificity as it emerged during the early years of

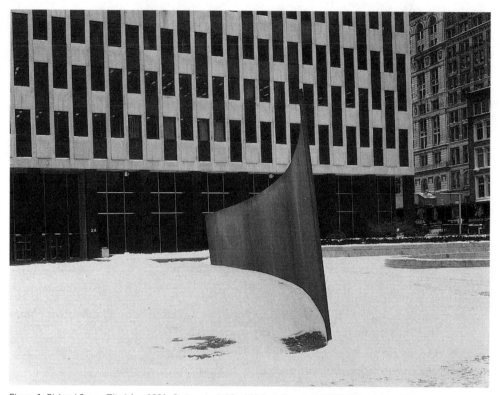

Figure 1. Richard Serra, *Tilted Arc,* 1981. Corten steel, 12 x 120 feet. Copyright 1999 Richard Serra/Artists Rights Society (ARS), New York. Courtesy of Gagosian Gallery.

institutional critique and earthworks, revising the assumptions implicit in this model to reflect upon the globalized, multicultural ambience of the present day? How do we assess this work within a broader field of activity that explores institutional frameworks and locations? The present discussion will pursue these questions.

The primary distinction I wish to make concerns two notions of site: a *literal* site and a *functional* site. The literal site is, as Joseph Kosuth would say, in situ; it is an actual location, a singular place.[1] The artist's intervention conforms to the physical constraints of this situation, even if (or precisely when) it would subject this to critique. The work's formal outcome is thus determined by a physical place, by an understanding of the place as actual. Reflecting a perception of the site as unique, the work is itself "unique." It is thus a kind of monument, a public work commissioned *for* the site. The civic sculptures of Richard Serra exemplify this approach. As Serra has observed, "The specificity of site-oriented works means that they are conceived for, dependent upon, and inseparable from their location."[2] In the case of *Tilted Arc,* we have, in place of a traditional monument (a memorial to an event or person) or the decorative monument of late modernism (the Calder dominating a corporate plaza), a critical monument with claims to resistance. Inextricable from its location in Federal Plaza, a setting it overwhelmed, Serra's sculpture imbued the premise of site specificity with a newfound monumentality. Serra was "making a permanent work" for "a specific

place."[3] Reversing the terms of his early splashings and pourings, which thematized their transience through a motivation of process,[4] *Tilted Arc* was designed to stand in Federal Plaza in perpetuity, much like the neoclassical courthouse it faced. It sought to counter Federal Plaza's symbology of transcendent order with a real-time bodily experience of the literal site.

In contrast, the functional site may or may not incorporate a physical place. It certainly does not *privilege* this place. Instead, it is a process, an operation occurring between sites, a mapping of institutional and textual filiations and the bodies that move between them (the artist's above all). It is as an informational site, a palimpsest of text, photographs and video recordings, physical places, and things: an allegorical site, to recall Craig Owens's term, aptly coined to describe Robert Smithson's polymathic enterprise, whose vectored and discursive notion of "place" opposes Serra's phenomenological model.[5] It is no longer an obdurate steel wall, attached to the plaza for eternity. On the contrary, the functional work refuses the intransigence of literal site specificity. It is a temporary thing, a movement, a chain of meanings and imbricated histories: a place marked and swiftly abandoned. The mobile site thus courts its destruction; it is willfully temporary; its nature is not to endure but to *come down*.

Certainly, earlier institutional critique did much to expose the functional or informational character of the gallery and museum.[6] In this sense, artists like Dion, Müller, Green, Fraser, and Burr have merely developed the inquiry introduced in the work of Hans Haacke, Marcel Broodthaers, Daniel Buren, Mel Bochner, and Michael Asher, which displaced the phenomenological site of the minimalist installation into a critical reflection on the gallery itself.[7] However, these activities were, for the most part, site specific; the force of their critiques was due, in part, to their confinement to a particular place.[8] What were the benefits of this literal orientation? To begin with, site specificity was understood, in its very constitution, as a mode of refusal of the system of art's commodification. Locating its critique within the gallery or museum, the site-specific work exposed this space as a material entity, a no longer neutral place, a backdrop for the merchandising of portable art objects. For, as Douglas Crimp argued, the modern museum developed in concert with the production and consumption of "homeless" works of art, whose aesthetic and commercial value it affirmed. It was claimed that site specificity would impede this process:

> The idealism of modern art, in which the art object *in and of itself* was seen to have a fixed and transhistorical meaning, determined the object's placelessness, its belonging to no particular place, a no-place that was in reality the museum—the actual museum and the museum as a representation of the institutional system of circulation that also comprises the artist's studio, the commercial gallery, the collector's home. . . . Site specificity opposed that idealism—and unveiled the material system it obscured—by its refusal of circulatory mobility, its belongingness to a *specific* site.[9]

Twenty-five years after the first installations of Buren, Haacke, and Asher, we might begin to question the efficacy of such claims (the valorization of site specificity by its

postmodernist supporters has yet to occasion a critical reply):[10] to what extent site specificity accomplished the desired disruption of the commodity system through its vaunted "refusal of circulatory mobility," and moreover whether a practice grounded in a materialist analysis alone remains practicable or even desirable today. But let us first consider another claim made on behalf of site specificity, which concerned the viewer. Deferring attention from the portable modernist work to the gallery, the site-specific installation was said to render one conscious of one's body existing within this ambience. The body of site specificity was a physicalized body, aware of its surroundings, a body of heightened critical acuity. The viewer of the modernist work, in contrast, was purportedly blind to its ideological nature.[11] Thus the premise of site specificity to locate the work in a single place, *and only there,* bespoke the 1960s call for Presence, the demand for the experience of "being there." An underlying topos of Merleau-Ponty's phenomenology, of the happening and performance, Presence became an aesthetic and ethical cri de coeur among the generation of artists and critics who emerged in the 1960s, suggesting an experience of actualness and authenticity that would contravene the depredations of an increasingly mediated, "one-dimensional" society.[12] An antidote to McLuhanism, to popular culture's virtual pleasures and blind consumerism, the aesthetics of Presence imposed rigorous, even puritanical demands: attendance at a particular site or performance; an extended, often excruciating duration.[13]

Thus the notion of site specificity allied a New Left critique of the "System" with a phenomenology of Presence, a spectatorship that unfolded in "real time and space." Here we see the origins of site specificity in the aesthetics of minimalism. Buren's canvas installations, the wall displacements of Asher and Lawrence Weiner, and Bochner's *Measurements* built upon the phenomenological inquiries of artists like Robert Morris and Dan Flavin, who exposed the viewing conditions of the "white cube" through a solicitation of Presence. As Crimp observed, "Minimal sculpture launched an attack on the prestige of the artist and artwork, granting that prestige instead to the situated spectator, whose self-conscious perception of the Minimal object in relation to the site of its installation produced the work's meaning."[14] This displacement from work to frame, from the portable modernist sculpture to an environmental practice located in the literal space of the viewer, Michael Fried characterized as the distinction between "art" and "theater."[15] According to Fried, this revelation of the viewer's presence within the literal site of the gallery blurred the distinction between an ideal aesthetic space and real space, between art and not-art. Yet minimalism and the site-specific practices that followed in its wake took the literal site as the very locus, or precondition, of advanced work.

Site specificity had a more implicit, and less recognized, source: the modernist impulse of reflexivity. Modernist reflexivity was a reflection on medium, a task Clement Greenberg compared to Kant's call for Reason to reflect on the conditions of its immanence.[16] Minimalism displaced the object of reflection another degree—from the work's medium to its ambient space, from its optical and tactile qualities as painting

and sculpture to the perceptual conditions of its display. Institutional critique caused a further displacement, from the exposure of the "white cube" as phenomenological space to a critical exposure of the art institution. In the work of Asher or Buren, the phenomenological site of Morris and Flavin was revealed as a discursive place grounded in socioeconomic relations. Yet, for all its radicality, its materialist commitment, this work still operated within a Kantian cognitive model of reflexivity: it still confined its analysis to the "frame." The criticality of such work was perspicuous only within the physical confines of, or in close proximity to, the gallery site.[17]

The functional work explores an "expanded" site: the "art world," in this activity, has become a site within a network of sites, an institution among institutions. To be sure, previous institutional critique demonstrated the financial and ideological ties of the gallery to greater economic and political structures. The System Aesthetics of Haacke posited a vectored and constitutive relationship between the museum and its corporate patrons and trustees, while Asher's well-known interventions in the *Museum as Site: 16 Projects* show at the Los Angeles County Museum (1981) and in the *Seventy-fourth American Exhibition* at the Art Institute of Chicago (1982) revealed the nationalist agendas of these institutions. But the final focus of this work was the art system as such. Today, much practice explores an expanded site, enlarging its scope of inquiry into contingent spheres of interest, contingent locations.[18] This expanded institutional critique is as much at home in natural history and anthropological collections, in zoos, parks, housing projects, and public bathrooms, as in the art gallery or museum; it may engage several sites, institutions, and collaborators at once. The ostensible subject of *Platzwechsel,* an exhibition organized by the Zurich Kunsthalle in 1995, was the Platzspitz Park, a green space located in the city's center. The show itself occurred at a number of locations: the Swiss National Museum, which borders the park (both the turrets on the upper floor and the loggia below); the Kunsthalle; and the apartment of a local dealer. Devoid of a unique place, *Platzwechsel* led the viewer on a "tour" from one landmark to the next. Moreover, the collaborative nature of *Platzwechsel,* which included work by Dion, Biemann, Müller, and Burr, resulted in a project that reflected four distinct points of view. The "work" was thus not a single entity, the installation of an individual artist in a given place. It was, on the contrary, a *function* occurring between these locations and points of view, a series of expositions of information and place. As the visitor toured the "show" in its different venues, gleaning information from project to project, he or she accumulated a broadening knowledge of the Platzspitz's past. And in the course of this viewing the history of Zurich itself began to unfold.

For some time now, artists, inspired by feminist, postcolonial, and psychoanalytic writings, by the social philosophy of Michel Foucault and cultural studies, have analyzed a spectrum of public institutions and places. However, the exploration of an "expanded" site may produce differing results: projects reflect the specific interests, educations, and formal decisions of the producer. While some artists who work in this vein do so from a functional understanding of site, still others reveal a literal site

orientation. Fred Wilson's well-known installation *Mining the Museum* at the Maryland Historical Society in Baltimore (1992–93) was a striking commentary on this city's racist past. In preparing the show, Wilson used only the artifacts and galleries of the particular institution. Praised in the popular press, *Mining the Museum* was attacked by critics who claimed the show reproduced the conventions of ethnographic analysis (the outside researcher, invited by local authorities, briefly visits the place, collects the data, presents the results, then moves on). They claimed that Wilson failed to address his own position as a "critical artist," or as an African American invited to "represent" the African American community of Baltimore.[19] In recent years, a similar critique has developed in European cities in response to the current wave of site critique. Only a local artist, an artist whose identity purportedly reflects the constituency being represented, these critics argue, should be invited to produce such work.[20] Now a functional practice, insofar as it traces the artist's movements through and around the institution, often reflecting on the character of the commission itself, inscribes his or her subjectivity within the work. In this meeting of producer and site, fixed identities blur; the insistence of a tautological correspondence of the subjectivities of the artist and community is questioned; the premise of a stable authorial self is troubled. Indeed, in the most thoughtful work, the artist-traveler or "nomad" is a thoroughly historicized subject.[21] Fraser and Müller's project for the Austrian Pavilion at the 1993 Venice Biennale considered the nationalist protocols of the international art fair, which traces its origins to nineteenth-century trade shows.[22] In the ad campaign announcing their participation, the artists posed in traditional Austrian costume in a Viennese café, counterfeiting and ironizing the Biennale's premise of national cultural representation (neither Müller nor Fraser is Austrian). Müller, in his own project, further estranged the notion of Austrianness. Traveling across Austria's borders to each of its neighboring countries without the proper visas, he enacted a series of illegal immigrations, marking these crossings with postcards mailed to his Vienna dealer from these frontier stations. Simulating the illegal immigrant's trials, Müller's gesture thematized the blurring of national identity at this historical moment of internationalism and late capitalist organization, when nationalist ideologies have returned with a vengeance.

The mobile site suggests a distinct genealogy: Happenings, situationism, Richard Long's walks, On Kawara's postcards, Tadashi Kawamata's temporary shanty towns and scaffoldings, and André Cadere's *Barres de Bois Rond,* which the artist installed temporarily in galleries and other locations throughout Paris.[23] More recently, ACT UP examined the various authorities connected with the AIDS epidemic as a sequence of site-specific critiques. Traveling to the Centers for Disease Control, the National Institutes of Health, Wall Street, and other sites, AIDS activists developed a critical practice that traversed a spectrum of medical, political, religious, and financial institutions. For ACT UP, "place" had a symbolic, as well as literal, meaning: one journeyed to each institution not simply to protest its operations, but to expose these to the media's attention. As much as any recent practice, AIDS activism demonstrated

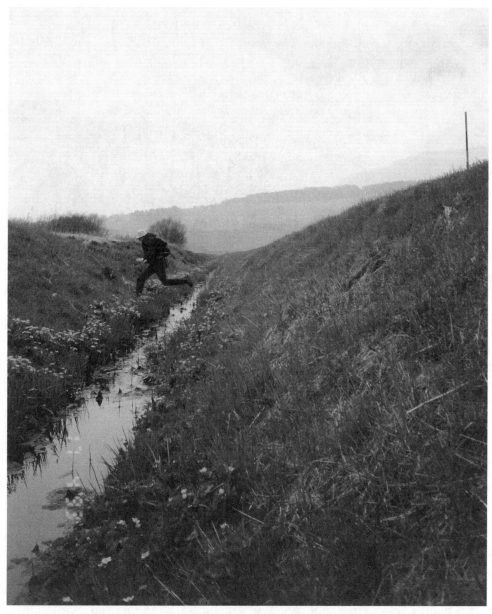

Figure 2. Christian Philipp Müller, *Illegal Border Crossing between Austria and Principality of Liechtenstein,* 1993.
Courtesy of the artist and American Fine Arts, Co., New York. Photograph by Petra Wunderlich.

the postmodernist premise, associated with, for example, the writings of Foucault and
the art of Kruger and Holzer, that information is material.[24] As Simon Watney, Cindy
Patton, Paula Treichler, and others have argued, the physical facts of AIDS are inextri-
cable from their representation.[25] And one of the effects of this Foucauldian assump-
tion was that place could not be purely experienced (like the literal site of minimalism
or Richard Serra), but was itself a social and discursive entity.[26]

The work of Robert Smithson bears particular mention here. In the allegorical

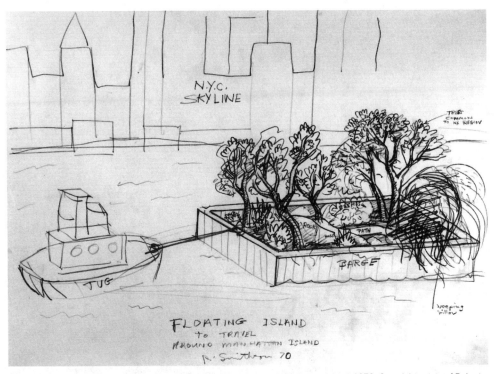

Figure 3. Robert Smithson, *Study for Floating Island to Travel around Manhattan Island*, 1970. Copyright estate of Robert Smithson. Licensed by VAGA, New York; used by permission of VAGA, Inc.

practice of Smithson described by Owens, the work exists in the overlap of textual account, photographic and filmic recording, guided tours by the artist, and the literal site. Place, for Smithson, is a vectored relation: the physical site is a destination to be seen or left behind, a "tour" recalled through snapshots and travelogues. It is only temporarily experienced (the Yucatan quicksand does not allow for dillydallying), if it is seen at all (*Spiral Jetty* sank soon after its completion). Site as a unique, demarcated place available to perceptual experience alone—the phenomenological site of Serra or the critical site of institutional critique—becomes a network of sites referring to an *elsewhere.* In the Smithson nonsite of the mid-1960s, the maps and rock containers point to the quarries from which the materials have been drawn. Inversely, the site refers to the gallery or magazine context of the nonsite. *Spiral Jetty,* completed in 1970, fractured the dialectical model of the earlier nonsites into a multipartite sequence of representations and literal sites. "Like the non-site, the *Jetty* is not a discrete work, but one link in a chain of signifiers which summon and refer to one another in a dizzy spiral," Owens writes. "For where else does *Spiral Jetty* exist except in the film which Smithson made, the narrative he published, the photographs which accompany that narrative, and the various maps, diagrams, drawings, etc., he made about it?"[27]

At *Platzwechsel,* the installations and texts set up a semantic chain that traversed physical borders; the Kunsthalle itself was transformed into an elaborate nonsite, a fabric of allusions. A concrete plinth built by Müller recalled a monument to the

Swiss Romantic poet Salomon Gessner located in the park; a wooden "surveillance booth" above referred to the turrets of the Swiss National Museum (once used by the police to monitor the park's notorious drug scene); the medieval Hardturm, Zurich's oldest tower, on which their design was based (just down the street, Hardturmstrasse, from the Kunsthalle itself); an observation station across the river from the Platzspitz, also used to survey the drug trade; and an art dealer's apartment in which the turrets' windows, removed from the tower, were placed. The lines' location of private and public life, of observer and observed, of historical and present-day experience was vectored and intertwined.

Burr's displacement of flora and earth from the Platzspitz to a container in the Kunsthalle recalled the park as it existed in the 1970s—the seemingly placid interlude before the onslaught of the drug culture during the 1980s, a period when the Platzspitz was known principally as a site of gay male assignation. The oral accounts of the park's visitors of those years, assembled by Burr in the Kunsthalle, reinscribed the park in personal and discursive history. For these individuals the Platzspitz was less a physical place than an object of memory, a symbol of a "quieter" time before liberation and AIDS. For gay men in their twenties, whose accounts were also recorded, it had none of these associations, however: they could only remember the park as a drug market.

The mobile site is an in-between site, a nonplace, a ruin. Whereas the critical monument of Serra wishes to dominate a civic plaza, Smithson's "monument" is entropic, a run-down factory, a polluted marsh, a wasteland stretching between city and

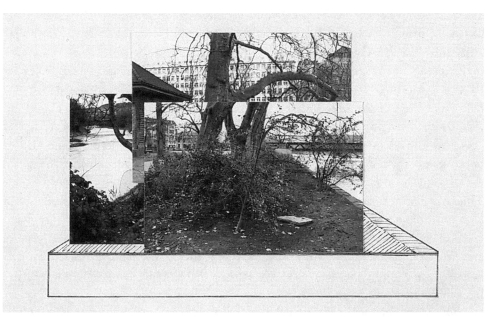

Figure 4. Tom Burr, *Circa 1977,* 1995. Landscape displacement from the Platzspitz, Zurich, to the Kunsthalle Zürich. Plywood container with soil, plants, trees, and rocks, 4 X 4 meters. Courtesy of the artist and American Fine Arts, Co., New York.

country, a "slurb." The Platzspitz park is such a "monument." Once at the edge of the baroque city, it is now Zurich's center. Yet it is an empty center, a not-quite-usable place between industrial, civic, and natural boundaries (the National Museum, the train station, the Limmat and Sihl Rivers, the warehouses and factories beyond). It has remained willfully unassimilated to official life: "The Platzspitz became a place of refuge for various fringe groups in the 20th century," we read in a recent account. "The revival attempts of the most varied kinds [including the restoration of 1991] were able to do little to change this" because of its "isolated location."[28] It is the kind of space that the philosophers Gilles Deleuze and Félix Guattari have described as nomadic, a shifting or deterritorialized site at odds with sedentary, striated space, the organized ambience of the polis; a space inhabited by nomadic peoples or "fringe groups." The nomad "goes from one point to another . . . ," Deleuze and Guattari write. "Every point is a relay and exists only as a relay. A path is only between two points, but the in-between has taken on all the consistency and enjoys both an autonomy and a direction of its own."[29] For all its renovations—the official attempts to evacuate unwanted groups—the park resists territorialization. During the period of its most recent restoration, in the early 1990s, the Platzspitz was closed. Yet the drug culture merely changed its location (hence the exhibition title, *Platzwechsel*), penetrating to less visible zones. The function of the Platzspitz as *nomos* has continued *after* the abandonment of the literal site. In other words, the *nomos* remains at the heart of the polis, a fact the polis politely ignores. "What counts for me is that what you don't see is OK," as one official put it.[30]

Much current work explores a mobile notion of site and a nomadic subjectivity. The travel snapshots of Martha Rosler; the vectored gallery critiques of Stephen Prina; Gabriel Orozco's floating balls, hammocks, and yellow scooters; Rikrit Tiravanija's tents and dinners (which, performed from one gallery to the next, mark the artist's peregrinations); and the practices of Burr, Fraser, Müller, Dion, and Green have surfaced at a time of unprecedented globalization and multinational mergers, of instantaneous satellite transmission and the Internet, when terms like *synergy, linkage,* and *flow* are the new corporate mantras. The shabby traveling salesman of yesteryear has devolved into an international flaneur who moves through VIP lounges and airport hotels in a perpetual motion.[31] Concurrently, a relative democratization of travel and the dissolution of formerly closed borders have fostered a more universal itinerancy. Thus the displacement from the literal site of the 1960s, grounded in the verities of phenomenological experience, to a mobile, mediated placement follows the global reach of capitalism itself, the triumph of the free market predicted by Ernest Mandel and Fredric Jameson in now classic studies. At the turn of the century, the late capitalist culture inaugurated in the 1960s—the culture that site specificity sought to resist—has achieved a new apogee.[32]

The most convincing site-related work not only represents, or enacts, this mobility, but also reflects on these new parameters. *Secret,* a work by Renée Green produced for two different shows, *Project Unité,* curated by Yves Aupetitallot at Firminy, France,

Figure 5. Renée Green, *Secret,* 1993 Courtesy Pat Hearn Gallery, New York.

in 1993, and a group exhibition in New York, documented the artist's peripatetic existence in a globalized art ambience. Structured as an autobiographical narrative, Green's installation recounted the artist's experience working within the confines of Aupetitallot's site-specific schema, located in Unité d'Habitations, a housing project designed by Le Corbusier. Assigned a small apartment, like the other participants, she installed a tent that served as her sleeping quarters for the show's duration. This shelter within a shelter alluded to the nomad artist's plight of never standing still. As Green suggests, to be a working practitioner today is to be constantly on the move. The conditions of context-based work are hardly optimum. The artist must work within the parameters of often unfocused curatorial concepts and is often not paid for his or her efforts. The interaction of the local community and art-world interlopers can range from hostile to indifferent, and indeed *Secret* speaks of a lack of contact between the artists at Unité and the building's working-class Algerian inhabitants, as well as Green's identity as an African American artist working in a diasporic housing project. Her re-presentation of *Secret* at American Fine Arts in New York a few months later created a vectored relationship between the two venues. A box containing copies of Emile Zola's novel *Germinal,* which discusses the working-class society of nineteenth-century Firminy, referred both to Unité's blue-collar inhabitants and Green's own experience of having read Zola's account of Firminy while working there, while allusions to fellow participants Dion and Burr and to the show's curators brought the narrative full circle.[33]

Let me conclude with two other examples. Fraser's *Cologne Presentation Book* (1990) and Müller's 1994 installation *Inter-pellations* tell the story of German-American cultural relations in parallel fashion. Produced for her first show in Germany, Fraser's volume records the history of this exchange since World War II, interspersing accounts of political events (the implementation of the Marshall Plan and opening of the U.S. Information Agency, anti–Vietnam War protests, and the fall of the Berlin Wall) with cultural ones (the importation of the MoMA's *New American Painting* in 1958, the triumph of pop at *Documenta IV,* and so on), a narrative that concludes with Fraser's entrance as a participant in the 1990 Cologne Art Fair. Müller's installation, presented at American Fine Arts Gallery in New York, was a sequence of vitrines containing German and English guidebooks to SoHo. Produced before the gallery district's recent decline, Müller's textual interpellations swiftly guide the tourist to American Fine Arts and other "hot" galleries, as well as boutiques and restaurants, with ironic expediency, quenching the German art lover's thirst for the new (for what does America represent but rapid innovation?). A related project by Müller, a "bookcase" presented in New York a few years earlier, told this story in reverse. Not an actual bookcase but a wooden solid, it was covered in wallpaper depicting rows of European "classics," an allusion to the old American fantasy of Europe as High Culture's guardian. Inserting catalogs of his previous shows in slats between the depicted volumes, Müller offered himself as the latest European import in a longer history of cultural exchange. Though executed for specific shows, the projects of Green, Fraser, and

Müller explored the cross-cultural fantasies of the other in a period of rapid globalization. Alluding to other points of departure and return, they posited a model of place that is, like the subject who passes through it, mobile and contingent. In so doing, these works suggest nothing less than a displacement of the 1960s-generated notion of "site specificity."

Notes

This text is an expanded version of an essay produced for the exhibition catalog *Platzwechsel: Ursula Biemann, Tom Burr, Mark Dion, Christian Philipp Müller* (Zurich: Kunsthalle Zürich, 1995) and republished in *Documents* 7 (fall 1996): 20–29 and *Springer* (December 1996– February 1997): 44–47.

1. See Joseph Kosuth, "1975," in *Art after Philosophy and After: Collected Writings, 1966–1990,* ed. Gabriel Guercio (Cambridge: MIT Press, 1991), 134.

2. Richard Serra, *Writings, Interviews* (Chicago: University of Chicago Press, 1994), 203. On the critical claims of Serra's work and the model of site specificity that it presupposes, see Douglas Crimp, "Serra's Public Sculpture: Redefining Site-Specificity," in *Richard Serra/ Sculpture,* ed. Rosalind Krauss (New York: Museum of Modern Art, 1986), 41–55.

3. Julia Brown, quoted in ibid. It would be inaccurate to suggest that all of Serra's civic works have been conceived to last indefinitely: for every *Tilted Arc* there is a temporary construction like *St. John's Rotary.* Yet *Tilted Arc's* claims of permanence, and its great scale, would suggest that, by the 1980s, Serra's notion of site specificity had taken on a monumental character. Serra himself admits that his large-scale works are "often referred to as being oppressive and monumental," even if he disagrees with this characterization, noting that his work does not "memorialize any person, event, or place." See ibid., 170.

4. On this reversal in Serra's work, see Douglas Crimp's comments in ibid., 135.

5. See Craig Owens, "Earthwords," in *Beyond Recognition: Representation, Power, and Culture* (Berkeley: University of California Press, 1992), 40-51. To be sure, the phenomenological viewer of Serra is as mobile as Smithson's tourist, and the fact that the artists were close friends—Smithson was one of the first viewers of *Shift,* and Serra was involved in completing *Amarillo Ramp*—would seem to suggest a sympathy of views. See Rosalind Krauss, "Richard Serra: A Translation," in *The Originality of the Avant-Garde and Other Modernist Myths* (Cambridge: MIT Press, 1985), 260–74, and Yve-Alain Bois, "A Picturesque Stroll around *Clara-Clara,*" in *October: The First Decade,* ed. Annette Michelson et al. (Cambridge: MIT Press, 1987), 342–72. Even so, Smithson's and Serra's notions of place were ultimately distinct. Asked to compare his work to land art, i.e., Smithson's, Serra observed: "If you build a piece in the desert, you have the possibility of remaining private while working on a large scale, and then bringing your private concerns back to the public in the form of documentation. I have never found that satisfying. I would rather have the actual experience of the work at urban scale. . . . What most people know of Smithson's *Spiral Jetty* is an image shot from a helicopter." Quoted in Serra, *Writings, Interviews,* 129. In other words, where *Spiral Jetty* could, indeed must, be accessed through representational means, Serra's work could only function as a phenomenological encounter.

6. The writings of Daniel Buren in particular described the art world's institutions as "functions." See "The Function of the Studio," in *October: The First Decade,* ed. Michelson et al., 201–20; "Function of the Museum," *Artforum* 12, no. 1 (September 1973): 68; and "The Function of an Exhibition," *Studio International* 186, no. 961 (December 1973): 216.

7. This is the argument of Benjamin Buchloh's important essay, "Michael Asher and the Conclusion of Modernist Sculpture," in *Performance Text(e)s Documents* (Montreal: Parachute, 1981), 55–65. On Buren's displacement of the minimal installation, see Alexander Alberro, "The Turn of the Screw: Daniel Buren, Dan Flavin, and the Sixth Guggenheim International Exhibition," *October* 80 (spring 1997): 57–84.

8. As Benjamin Buchloh has pointed out to me, this was not always the case. For example, Buren's stripes could appear on buses and park benches, integrating his museum critique within a vectored urban fabric, while Bochner's *Measurements,* consisting of a standardized duct tape, were transportable between installations. However, these were exceptions: underlying most Buren, Asher, and Haacke installations is a presumption of site specificity.

9. Douglas Crimp, *On the Museum's Ruins* (Cambridge: MIT Press, 1993), 17. On the opposition of the site-specific work and the nomadic, modernist sculpture, see Rosalind E. Krauss, "Sculpture in the Expanded Field," in *The Originality of the Avant-Garde and Other Modernist Myths* (Cambridge: MIT Press, 1985), 280.

10. An exception to this rule is Rosalyn Deutsche, "Uneven Development," in Diane Ghirardo, *Out of Site: A Social Criticism of Architecture* (Seattle, Wash.: Bay Press, 1991), which questions the "critical" claims made on behalf of Serra's *Tilted Arc.* Among postmodernist writers, Craig Owens must also be singled out: although he too would be an advocate of site specificity (in the essay "From Work to Frame"), it will be argued here that his reading of Smithson led to an allegorical understanding of site that ultimately subverts the premise of site specificity.

11. For this distinction, see Annette Michelson, *Robert Morris: An Aesthetics of Transgression* (Washington, D.C.: Corcoran Museum of Art, 1969), and Rosalind E. Krauss, *Passages in Modern Sculpture* (Cambridge: MIT Press), 201–42.

12. The classic account of this loss of "authentic" experience is Herbert Marcuse, *One-Dimensional Man* (Boston: Beacon Press, 1964).

13. On the phenomenological aesthetics of literal time/space, see Robert Morris, "Notes on Sculpture I and II" (1968), in *Minimal Art: A Critical Anthology,* ed. Gregory Battcock (New York: Dutton Press, 1968), 222–35; Michelson, *Robert Morris;* and Krauss, *Passages in Modern Sculpture,* 201–42.

14. Crimp, *On the Museum's Ruins,* 16–17.

15. See Michael Fried, "Art and Objecthood," in Gregory Battcock, *Minimal Art: A Critical Anthology* (New York: Dutton, 1968), 116–47.

16. See Clement Greenberg, "Modernist Painting" (1960), in *Clement Greenberg: The Collected Essays and Criticism,* ed. John O'Brian, vol. 4 (Chicago: University of Chicago Press, 1993), 85–93.

17. See Crimp, *On the Museum's Ruins,* 21–23.

18. For a discussion of this tendency, see James Meyer, "The Expanded Site: (Beyond Reflexivity)," in *What Happened to the Institutional Critique?* exhibition catalog (New York: American Fine Arts Co. and Paula Cooper Gallery, 1993), 14–16. More recently, Hal Foster has characterized this expansion in structuralist terms: on one hand, a thematic and spatial, "synchronic" expansion; on the other, a diachronic or "vertical" expansion of medium or genre. See "The Artist as Ethnographer," in Hal Foster, *The Return of the Real* (Cambridge: MIT Press, 1996), 199–200.

19. See "On Site Specificity," roundtable discussion, *Documents* 2, nos. 4/5 (spring 1994): 11–22. On the reproduction of ethnographic conventions in site-specific work, if not necessarily Wilson's, see Foster, "The Artist as Ethnographer." In discussion with the curator of *Mining the Museum,* Lisa Corrin, I was informed that Fred Wilson, in preparing the show, had spent as much as a year living in Baltimore, a period in which he had a sustained interaction with the various communities the show could be said to "represent." But it is certainly the case that Wilson's project did not comment on his own participation.

20. Reported in conversation with Christian Philipp Müller, New York, January 6, 1995.

21. This is my argument in James Meyer, "Nomads," *Parkett* 50/51 (May 1997): 205–9.

22. For a description of this project, see Peter Weibel, ed., *Österreichs Beitrag zur 45. Biennale von Venedig 1993,* exhibition catalog (Vienna, 1993). The third participant was the "authentically" Austrian artist Gerwald Rockenschaub.

23. On Kawamata's nomadic structures, see Yve-Alain Bois, "Keep Out: Construction Work," in *Kawamata Project on Roosevelt Island* (Tokyo: Gendaikikakushitsu, 1993), 63–72, which also establishes an opposition with Serra's site specificity. On Cadere, see Ann Goldstein and Anne Rorimer, *Reconsidering the Object of Art, 1965–1975* (Los Angeles: Museum of Contemporary Art, 1996), 98–99.

24. The best discussion of ACT UP's methods is Douglas Crimp with Adam Rolston, *AIDS Demographics* (Seattle, Wash.: Bay Press, 1990).

25. See Simon Watney, *Policing Desire: Pornography, AIDS, and the Media* (Minneapolis: University of Minnesota Press, 1987); Cindy Patton, *Sex and Germs* (Boston: South End Press, 1985); and Douglas Crimp, ed., *AIDS: Cultural Analysis, Cultural Activism* (Cambridge: MIT Press, 1988).

26. Hal Foster considered the limits of the phenomenological installation with the advent of postmodernism in "The Crux of Minimalism," in *The Return of the Real,* 35–70.

27. Owens, "Earthwords," 47. It is, I think, no coincidence that a number of artists working in this vein, including Fraser, Dion, Biemann, and Burr, were students of Owens. On the role of Owens's pedagogy in the development of these artists' work, see Meyer, "Expanded Site," 14–16.

28. Judith Rohrer, "Platzspitz Zürich," *Anthos* 1 (1994): 17.

29. See Gilles Deleuze and Félix Guattari, *A Thousand Plateaus: Capitalism and Schizophrenia,* trans. Brian Massumi (Minneapolis: University of Minnesota Press, 1987), 351–423. For a previous application of this analogy to Müller et al., see Chantal Mouffe, "For a Politics of Nomadic Identity" in *Andrea Fraser/Christian Philipp Müller/Gerwald Rockenschaub: Österreichs Beitrag zur 45. Biennale von Venedig 1993,* ed. Peter Weibel (Cologne: Buchhandlung Walther König, 1993), 239–56. On the relevance of Deleuze and Guattari's nomadism within an urban context, see Anthony Vidler, *The Architectural Uncanny* (Cambridge: MIT Press, 1993), 206–14.

30. Monika Stocker, director of Zurich's Social Affairs Department, quoted in *New York Times,* March 12, 1995.

31. See Martha Rosler, "In the Place of the Public: Observations of a Frequent Flyer," *Assemblage* 25 (1995): 61–79.

32. See Ernest Mandel, *Late Capitalism* (London: New Left Books, 1975), and Fredric Jameson, *Postmodernism; or, The Cultural Logic of Late Capitalism* (Durham, N.C.: Duke University Press, 1991).

33. *Secret* appeared in yet another incarnation in an installation at Louisiana, Denmark. The theme of travel is long-standing in Green's work, as suggested by such projects as *Anatomies of Escape* (1990), which concerned the Hottentot Venus's circulation around nineteenth-century Europe; *Vista/Vision: Landcapes of Desire* (1991), a reflection on Theodore Roosevelt's hunting safaris; *Import/Export Funk Office* (1992), which traced the cross-cultural fantasies of the German and American intellectuals Dietrich Diedrichsen and Angela Davis; *World Tour,* an installation at the Los Angeles MoCA and the Dallas Museum of Art in 1993; and *Partially Buried* (1997-98), which documented the artist's "search" for Smithson's legendary 1970 *Partially Buried Woodshed* at Kent State University in Ohio. In many of these projects, a reassemblage of the installation in a new form in a subsequent venue highlighted the vectored nature of the work itself.

2. One Place After Another: Notes on Site Specificity

Miwon Kwon

Site specificity used to imply something grounded, bound to the laws of physics. Often playing with gravity, site-specific works used to be obstinate about "presence," even if they were materially ephemeral, and adamant about immobility, even in the face of disappearance or destruction. Whether inside the white cube or out in the Nevada desert, whether architectural or landscape-oriented, site-specific art initially took the "site" as an actual location, a tangible reality, its identity composed of a unique combination of constitutive physical elements: length, depth, height, texture, and shape of walls and rooms; scale and proportion of plazas, buildings, or parks; existing conditions of lighting, ventilation, traffic patterns; distinctive topographical features. If modernist sculpture absorbed its pedestal/base to sever its connection to or express its indifference to the site, rendering itself more autonomous and self-referential, and thus transportable, placeless, and nomadic, then site-specific works, as they first emerged in the wake of minimalism in the late 1960s and early 1970s, forced a dramatic reversal of this modernist paradigm.[1] Antithetical to the claim, "If you have to change a sculpture for a site there is something wrong with the sculpture,"[2] site-specific art, whether interruptive or assimilative, gave itself up to its environmental context, being formally determined or directed by it.[3]

In turn, the uncontaminated and pure idealist space of dominant modernisms was radically displaced by the materiality of the natural landscape or the impure and ordinary space of the everyday. The space of art was no longer perceived as a blank slate, a tabula rasa, but a *real* place. The art object or event in this context was to be singularly *experienced* in the here-and-now through the bodily presence of each viewing subject, in a sensorial immediacy of spatial extension and temporal duration (what Michael Fried derisively characterized as theatricality), rather than instanta-

neously "perceived" in a visual epiphany by a disembodied eye. Site-specific work in its earliest formation, then, focused on establishing an inextricable, indivisible relationship between the work and its site and demanded the physical presence of the viewer for the work's completion. The (neo-avant-garde) aspiration to exceed the limitations of traditional media, like painting and sculpture, as well as their institutional setting; the epistemological challenge to relocate meaning from within the art object to the contingencies of its context; the radical restructuring of the subject from an old Cartesian model to a phenomenological one of lived bodily experience; and the self-conscious desire to resist the forces of the capitalist market economy, which circulates artworks as transportable and exchangeable commodity goods—all these imperatives came together in art's new attachment to the actuality of the site.

In this frame of mind, Robert Barry declared in a 1969 interview that each of his wire installations was "made to suit the place in which it was installed. They cannot be moved without being destroyed."[4] Similarly, Richard Serra wrote fifteen years later in a letter to the director of the Art-in-Architecture Program of the General Services Administration in Washington, D.C., that his 120-foot, Cor-Ten steel sculpture *Tilted Arc* was "commissioned and designed for one particular site: Federal Plaza. It is a site-specific work and as such not to be relocated. To remove the work is to destroy the work."[5] He further elaborated his position in 1989:

> As I pointed out, *Tilted Arc* was conceived from the start as a site-specific sculpture and was not meant to be "site-adjusted" or . . . "relocated." Site-specific works deal with the environmental components of given places. The scale, size, and location of site-specific works are determined by the topography of the site, whether it be urban or landscape or architectural enclosure. The works become part of the site and re-structure both conceptually and perceptually the organization of the site.[6]

Barry and Serra echo one another here. But whereas Barry's comment announces what was in the late 1960s a new radicality in vanguard sculptural practice, marking an early stage in the aesthetic experimentations that were to follow through the 1970s (i.e., land/earth art, process art, installation art, conceptual art, performance/body art, and various forms of institutional critique), Serra's statement, spoken twenty years later within the context of public art, is an indignant defense, signaling a crisis point for site specificity—at least for a version that would prioritize the *physical* inseparability between a work and its site of installation.[7]

Informed by the contextual thinking of minimalism, various forms of institutional critique and conceptual art developed a different model of site specificity that implicitly challenged the "innocence" of space and the accompanying presumption of a universal viewing subject (albeit one in possession of a corporeal body) as espoused in the phenomenological model. Artists such as Michael Asher, Marcel Broodthaers, Daniel Buren, Hans Haacke, and Robert Smithson, as well as many women artists, including Mierle Laderman Ukeles, have variously conceived the site not only in physical and spatial terms but also as a *cultural* framework defined by the institutions

of art. If minimalism returned to the viewing subject a physical corporeal body, institutional critique insisted on the social matrix of class, race, gender, and sexuality of the viewing subject.[8] Moreover, while minimalism challenged the idealist hermeticism of the autonomous art object by deflecting its meaning to the space of its presentation, institutional critique further complicated this displacement by highlighting the idealist hermeticism of the space of presentation itself. The modern gallery/museum space, for instance, with its stark white walls, artificial lighting (no windows), controlled climate, and pristine architectonics, was perceived not solely in terms of basic dimensions and proportion but as an institutional disguise, a normative exhibition convention serving an ideological function. The seemingly benign architectural features of a gallery/museum, in other words, were deemed to be coded mechanisms that *actively* disassociate the space of art from the outer world, furthering the institution's idealist imperative of rendering itself and its hierarchization of values "objective," "disinterested," and "true."

As early as 1970 Buren proclaimed, "Whether the place in which the work is shown imprints and marks this work, whatever it may be, or whether the work itself is directly—consciously or not—produced for the Museum, any work presented in that framework, if it does not explicitly examine the influence of the framework upon itself, falls into the illusion of self-sufficiency—or idealism."[9] But more than just the museum, the site comes to encompass a relay of several interrelated but different spaces and economies, including the studio, the gallery, the museum, art criticism, art history, the art market, etc., that together constitute a system of practices that is not separate from but open to social, economic, and political pressures. To be "specific" to such a site, in turn, is to decode and/or recode the institutional conventions so as to expose their hidden yet motivated operations—to reveal the ways in which institutions mold art's meaning to modulate its cultural and economic value and to undercut the fallacy of the "autonomy" of art and its institutions by making apparent their imbricated relationship to the broader socioeconomic and political processes of the day. Again in Buren's somewhat militant words from 1970:

> Art, whatever else it may be, is exclusively political. What is called for is the *analysis of formal and cultural limits* (and not one *or* the other) within which art exists and struggles. These limits are many and of different intensities. Although the prevailing ideology and the associated artists try in every way to *camouflage* them, and although it is too early—the conditions are not met—to blow them up, the time has come to *unveil* them.[10]

In nascent forms of institutional critique, in fact, the physical condition of the exhibition space remained the primary point of departure for this unveiling. For example, in works such as Haacke's *Condensation Cube* (1963–65), Mel Bochner's *Measurement* series (1969), Lawrence Weiner's wall cutouts (1968), and Buren's *Within and Beyond the Frame* (1973), the task of exposing those aspects that the institution would obscure was enacted literally in relation to the architecture of the exhibition space—

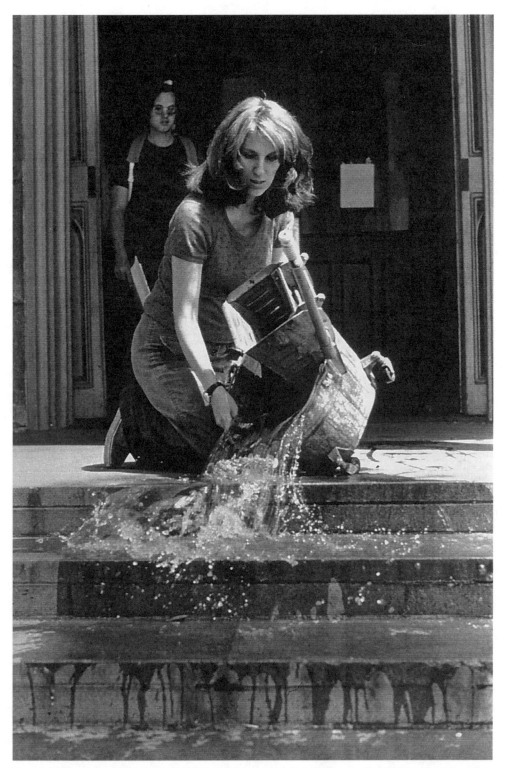

Figure 1. Mierle Laderman Ukeles, *Hartford Wash: Maintenance, Outside* from the series *Maintenance Art Activity,* at the Wadsworth Athenaeum, Hartford, Connecticut, 1973. Photograph courtesy of Ronald Feldman Fine Arts, New York.

highlighting the humidity level of a gallery by allowing moisture to "invade" the pristine minimalist art object (a mimetic configuration of the gallery space itself); insisting on the material fact of the gallery walls as "framing" devices by notating their dimensions directly on them; removing portions of a wall to reveal the base reality behind the "neutral" white cube; and exceeding the physical boundaries of the gallery by having the artwork literally go out the window, ostensibly to "frame" the institutional frame. Attempts such as these to expose the cultural confinement within which artists function—"the apparatus the artist is threaded through"—and the impact of its forces upon the meaning and value of art became, as Smithson had predicted in 1972, "the great issue" for artists in the 1970s.[11] As this investigation extended into the 1980s, it relied less and less on the physical parameters of the gallery/museum or other exhibition venues to articulate its critique.

In the paradigmatic practice of Hans Haacke, for instance, the site shifted from the physical condition of the gallery (as in the *Condensation Cube*) to the system of socioeconomic relations within which art and its institutional programming find their possibilities of being. His fact-based exposés through the 1970s, which spotlighted art's inextricable ties to the ideologically suspect if not morally corrupt power elite, recast the site of art as an institutional frame in social, economic, and political terms, and enforced these terms as the very content of the artwork. Exemplary of a different

Figure 2. Michael Asher, installation at Claire Copley Gallery, Los Angeles, 1974. Viewing through gallery toward office and storage areas. Courtesy of the artist.

approach to the institutional frame are Michael Asher's surgically precise displacement projects, which advanced a concept of site that was inclusive of historical and conceptual dimensions. In his contribution to the *73rd American Exhibition* at the Art Institute of Chicago in 1979, for instance, Asher revealed the sites of exhibition or display to be culturally specific situations generating particular expectations and narratives regarding art and art history. Institutional siting of art, in other words, not only distinguishes qualitative and economic value, it also (re)produces specific forms of knowledge that are historically located and culturally determined—not at all universal or timeless standards.[12]

In these ways, the "site" of art evolves away from its coincidence with the literal space of art, and the physical condition of a specific location recedes as the primary element in the conception of a site. Whether articulated in political and economic terms, as in Haacke's case, or in epistemological terms, as in Asher's, it is rather the art institution's *techniques* and *effects* as they circumscribe the definition, production, presentation, and dissemination of art that become the sites of critical intervention. Concurrent with this move toward the dematerialization of the site is the ongoing de-aestheticization (i.e., withdrawal of visual pleasure) and dematerialization of the art-work. Going against the grain of institutional habits and desires, and continuing to resist the commodification of art in/for the marketplace, site-specific art adopts strategies that are either aggressively antivisual—informational, textual, expositional, didactic—or immaterial altogether—gestures, events, or performances bracketed by temporal boundaries. The "work" no longer seeks to be a noun/object but a verb/process, provoking the viewers' *critical* (not just physical) acuity regarding the ideological conditions of that viewing. In this context, the guarantee of a specific relationship between an artwork and its "site" is not based on a physical permanence of that relationship (as demanded by Serra, for example), but rather on the recognition of its unfixed *impermanence,* to be experienced as an unrepeatable and fleeting situation.

But if the critique of the cultural confinement of art (and artists) via its institutions was once the "great issue," a dominant drive of site-oriented practices today is the pursuit of a more intense engagement with the outside world and everyday life—a critique of culture that is inclusive of non-art spaces, non-art institutions, and non-art issues (blurring the division between art and non-art, in fact). Concerned to integrate art more directly into the realm of the social, either in order to redress (in an activist sense) urgent social problems such as the ecological crisis, homelessness, AIDS, homophobia, racism, and sexism, or more generally in order to relativize art as one among many forms of cultural work, current manifestations of site specificity tend to treat aesthetic and art-historical concerns as secondary issues. Deeming the focus on the social nature of *art*'s production and reception to be too exclusive, even elitist, this expanded engagement with culture favors "public" sites outside the traditional confines of art in physical and intellectual terms.[13]

Furthering previous (at times literal) attempts to take art out of the museum/gallery space-system (recall Buren's striped canvases marching out the gallery window

Figure 3. Mark Dion, *On Tropical Nature,* 1991. In the field, Orinoco River basin outside Caracas, Venezuela. Photograph by Bob Braine. Courtesy of the artist and American Fine Arts, Co., New York.

or Smithson's adventures in the wastelands of New Jersey or isolated locales in Utah), contemporary site-oriented works occupy hotels, city streets, housing projects, prisons, schools, hospitals, churches, zoos, supermarkets, etc., and infiltrate media spaces such as radio, newspapers, television, and the Internet. In addition to this spatial expansion, site-oriented art is also informed by a broader range of disciplines (including anthropology, sociology, literary criticism, psychology, natural and cultural histories, architecture and urbanism, computer science, and political theory) and is sharply attuned to popular discourses (such as fashion, music, advertising, film, and television). But more than these dual expansions of art into culture, which obviously diversify the site, the distinguishing characteristic of today's site-oriented art is the way in which the artwork's relationship to the actuality of a location (as site) *and* the social conditions of the institutional frame (as site) are both *subordinate* to a *discursively* determined site that is delineated as a field of knowledge, intellectual exchange, or cultural debate. Furthermore, unlike previous models, this site is not defined as a *precondition.* Rather, it is *generated* by the work (often as "content"), then *verified* by its convergence with an existing discursive formation.

For example, in Mark Dion's 1991 project *On Tropical Nature,* several different definitions of the site operated concurrently. First, the initial site of Dion's intervention was an uninhabited spot in the rain forest near the base of the Orinoco River outside Caracas, Venezuela, where the artist camped for three weeks collecting specimens of various plants and insects, as well as feathers, mushrooms, nests, and stones. These specimens, picked up at the end of each week in crates, were delivered to the second site of the project, Sala Mendoza, one of the two hosting art institutions back in

Caracas. In the gallery space of the Sala, the specimens, which were uncrated and displayed like works of art in themselves, were contextualized within what constituted a third site—the curatorial framework of the thematic group exhibition.[14] The fourth site, however, although the least material, was the site with which Dion intended a lasting relationship. *On Tropical Nature* sought to become a part of the discourse concerning cultural representations of nature and the global environmental crisis.[15]

Sometimes at the cost of a semantic slippage between content and site, other artists who are similarly engaged in site-oriented projects, operating with multiple definitions of the site, in the end find their "locational" anchor in the discursive realm. For instance, while Tom Burr and John Lindell have each produced diverse projects in a variety of media for many different institutions, their consistent engagement with issues concerning the construction and dynamics of (homo)sexuality and desire has established such issues as the "site" of their work. And in projects by artists such as Lothar Baumgarten, Renée Green, Jimmie Durham, and Fred Wilson, the legacies of colonialism, slavery, racism, and the ethnographic tradition as they impact on identity politics has emerged as an important "site" of artistic investigation. In some instances, artists, including Green, Silvia Kolbowski, Group Material, and Christian Philipp Müller, have reflected on aspects of site-specific practice itself as a "site," interrogating its currency in relation to aesthetic imperatives, institutional demands, socioeconomic ramifications, or political efficacy. In this way different cultural debates, a theoretical concept, a social issue, a political problem, an institutional framework (not necessarily an art institution), a community or seasonal event, a historical condition, and even particular formations of desire are deemed to function as sites now.[16]

This is not to say that the parameters of a particular place or institution no longer matter, because site-oriented art today still cannot be thought or executed without the contingencies of locational and institutional circumstances. But the *primary* site addressed by current manifestations of site specificity is not necessarily bound to, or determined by, these contingencies in the long run. Consequently, although the site of action or intervention (physical) and the site of effects/reception (discursive) are conceived to be continuous, they are nonetheless pulled apart. Whereas, for example, the sites of intervention and effect for Serra's *Tilted Arc* were coincident (Federal Plaza in downtown New York City), Dion's site of intervention (the rain forest in Venezuela or Sala Mendoza) and his projected site of effect (discourse of nature) are distinct. The former clearly serves the latter as material source and "inspiration," yet does not sustain an indexical relationship to it.

James Meyer has distinguished this trend in recent site-oriented practice in terms of a "functional site": "[The functional site] is a process, an operation occurring between sites, a mapping of institutional and discursive filiations and the bodies that move between them (the artist's above all). It is an informational site, a locus of overlap of text, photographs and video recordings, physical places and things. . . . It is a temporary thing; a movement; a chain of meanings devoid of a particular focus."[17] Which is to say, the site is now structured (inter)textually rather than spatially, and its

Figure 4. Group Material, *DaZiBaos,* poster project at Union Square, New York, 1982. Photograph courtesy of Group Material; reprinted with permission of Doug Ashford.

model is not a map but an itinerary, a fragmentary sequence of events and actions *through* spaces, that is, a nomadic narrative whose path is articulated by the passage of the artist. Corresponding to the pattern of movement in electronic spaces of the Internet and cyberspace, which are likewise structured to be experienced *transitively,* one thing after another, and not as synchronic simultaneity,[18] this transformation of the site textualizes spaces and spatializes discourses.

A provisional conclusion might be that in advanced art practices of the past thirty years, the operative definition of the site has been transformed from a physical location—grounded, fixed, actual—to a discursive vector—ungrounded, fluid, and virtual. But even if the dominance of a particular formulation of site specificity emerges at one moment and wanes at another, the shifts are not always punctual or definitive. Thus, the three paradigms of site specificity I have schematized here—phenomenological, social/institutional, and discursive—although presented somewhat chronologically, are not stages in a linear trajectory of historical development. Rather, they are competing definitions, overlapping with one another and operating simultaneously in various cultural practices today (or even within a single artist's single project).

Nonetheless, this move away from a literal interpretation of the site and the multiplicitous expansion of the site in locational and conceptual terms seems more accelerated today than in the past. And the phenomenon is embraced by many artists and critics as an advance offering more effective avenues to resist revised institutional and market forces that now commodify "critical" art practices. In addition, current forms of site-oriented art, which readily take up social issues (often inspired by them) and

which routinely engage the collaborative participation of audience groups for the conceptualization and production of the work, are seen as a means to strengthen art's capacity to penetrate the sociopolitical organization of contemporary life with greater impact and meaning. In this sense the possibilities to conceive the site as something more than a place—as repressed ethnic history, a political cause, a disenfranchised social group—is a crucial conceptual leap in redefining the "public" role of art and artists.[19]

But the enthusiastic support for these salutary goals needs to be checked by a serious critical examination of the problems and contradictions that attend all forms of site-specific and site-oriented art today, which are visible now as the artwork is becoming more and more "unhinged" from the actuality of the site once again— unhinged both in a literal sense of physical separation of the artwork from the location of its initial installation and in a metaphorical sense as performed in the discursive mobilization of the site in emergent forms of site-oriented art. This "unhinging," however, does not indicate a retroversion to the modernist autonomy of the siteless, nomadic art object, although such an ideology is still predominant. Rather, the current unhinging of site specificity is reflective of new questions that pressure its practices today—questions engendered by both aesthetic imperatives and external historical determinants, which are not exactly comparable to those of thirty years ago. For example, what is the status of traditional aesthetic values such as originality, authenticity, and uniqueness in site-specific art, which always begins with the particular, local, unrepeatable preconditions of a site, however it is defined? Is the artist's prevalent relegation of authorship to the conditions of the site, including collaborators and/or reader-viewers, a continuing Barthesian performance of "death of the author" or a recasting of the centrality of the artist as a "silent" manager/director? Furthermore, what is the commodity status of anti-commodities, that is, immaterial, process-oriented, ephemeral, performative events? While site-specific art once defied commodification by insisting on immobility, it now seems to espouse fluid mobility and nomadism for the same purpose. But curiously, the nomadic principle also defines capital and power in our times.[20] Is the unhinging of site specificity, then, a form of resistance to the ideological establishment of art or a capitulation to the logic of capitalist expansion?

Mobilization of Site-Specific Art

The "unhinging" of site-specific artworks first realized in the 1960s and 1970s is a separation engendered not by aesthetic imperatives but by pressures of the museum culture and the art market. Photographic documentation and other materials associated with site-specific art (preliminary sketches and drawings, field notes, instructions on installation procedures, etc.) have long been standard fare of museum exhibitions and a staple of the art market. In the recent past, however, as the cultural and market values of works from the 1960s and 1970s have risen, many of the early precedents in

site-specific art, once deemed so difficult to collect and impossible to reproduce, have reappeared in several high-profile exhibitions, such as *L'art conceptuel, une perspective* at the Musée d'art moderne de la ville de Paris (1989) and *The New Sculpture, 1965–75: Between Geometry and Gesture* (1990) and *Immaterial Objects* (1991–92), both at the Whitney Museum.[21]

For exhibitions like these, site-specific works from decades ago are being relocated or refabricated from scratch at or near the location of their re-presentation, either because shipping is too difficult and its costs prohibitive or because the originals are too fragile, in disrepair, or no longer in existence. Depending on the circumstances, some of these refabrications are destroyed after the specific exhibitions for which they are produced; in other instances, the re-creations come to coexist with or replace the old, functioning as *new* originals (some even finding homes in permanent collections of museums).[22] With the cooperation of the artist in many cases, art audiences are now offered the "real" aesthetic experiences of site-specific copies.

The chance to re-view "unrepeatable" works such as Serra's *Splash Piece: Casting* (1969–70) or Alan Saret's *Sulfur Falls* (1968) offers an opportunity to reconsider their historical significance, especially in relation to the current fascination with the late 1960s and 1970s in art and criticism. But the very process of institutionalization and the attendant commercialization of site-specific art also overturn the principle of

Figure 5. Richard Serra, *Splashing,* installation at Castelli Warehouse, 1968. Molten lead thrown against wall and floor. Copyright 1999 Richard Serra/Artists Rights Society (ARS), New York. Photograph courtesy of Leo Castelli Gallery, New York.

place-boundedness through which such works developed their critique of the ahistorical autonomy of the art object. Contrary to the earlier conception of site specificity, the current museological and commercial practices of refabricating (in order to travel) once site-bound works make transferability and mobilization new norms for site specificity. As Susan Hapgood has observed, "The once-popular term 'site-specific' has come to mean 'movable under the right circumstances,'"[23] shattering the dictum that "to remove the work is to destroy the work."

The consequences of this conversion, effected by object-oriented *de*contextualizations in the guise of historical *re*contextualizations, are a series of normalizing reversals in which the specificity of the site is rendered irrelevant, making it all the easier for autonomy to be smuggled back into the artwork, with the artist allowed to regain his or her authority as the primary source of the work's meaning. The artwork is newly objectified (and commodified), and site specificity is redescribed as the personal aesthetic choice of an artist's *stylistic* preference rather than a structural reorganization of aesthetic experience.[24] Thus, a methodological principle of artistic production and dissemination is recaptured as content; active processes are transformed into inert objects once again. In this way, site-specific art comes to *represent* criticality rather than perform it. The "here-and-now" of aesthetic experience is isolated as the signified, severed from its signifier.

If this phenomenon represents another instance of domestication of vanguard works by the dominant culture, it is not solely because of the self-aggrandizing needs of the institution or the profit-driven nature of the market. Artists, no matter how deeply convinced of their anti-institutional sentiment or how adamant their critique of dominant ideology, are inevitably engaged, self-servingly or with ambivalence, in this process of cultural legitimation. For example, in spring 1990, Carl Andre and Donald Judd both wrote letters of indignation to *Art in America* to publicly disavow authorship of two sculptures, attributed to each of them, that were included in a 1989 exhibition at the Ace Gallery in Los Angeles.[25] The works in question were re-creations: Andre's forty-nine-foot steel sculpture *Fall* from 1968 and an untitled iron "wall" piece by Judd of 1970, both from the Panza Collection. Because of the difficulties and high cost of crating and shipping such large-scale works from Italy to California, Panza gave permission to the organizers of the exhibition to refabricate them locally following detailed instructions. The works being industrially produced in the first place, the participation of the artists in the refabrication process seemed of little consequence to the director of the Ace Gallery and to Panza. The artists, however, felt otherwise. Not having been consulted on the (re)production and installation of these surrogates, they denounced each of the refabrications as "a gross falsification" and a "forgery," despite the fact that the sculptures appeared identical to the "originals" in Italy and were reproduced as one-time exhibition copies, not to be sold or exhibited elsewhere.

More than a mere case of ruffled artistic egos, this incident exposes a crisis concerning the status of authorship and authenticity as site-specific art from years ago

find new contexts in the 1990s. For Andre and Judd, what made the refabricated works illegitimate was not that each was a reproduction of a singular work installed in Varese, which in principle cannot be reproduced anywhere else anyway, but that the artists themselves did not authorize or oversee the refabrication in California. In other words, the re-creations are inauthentic not because of the missing site of its original installation but because of the absence of the artist in the process of their (re)production. By reducing visual variations within the artwork to a point of obtuse blankness and by adopting modes of industrial production, minimal art had voided the traditional standards of aesthetic distinction based on the handiwork of the artist as the signifier of authenticity. However, as the Ace Gallery case amply reveals, despite the withdrawal of such signifiers, authorship and authenticity remain in site-specific art as a function of the artist's "presence" at the point of (re)production. That is, with the evacuation of "artistic" traces, the artist's *authorship* as producer of objects is reconfigured as his or her *authority to authorize* in the capacity of director or supervisor of (re)productions. The guarantee of authenticity is finally the artist's sanction, which may be articulated by his or her actual presence at the moment of production-installation or via a certificate of verification.[26]

While Andre and Judd once problematized authorship through the recruitment of serialized industrial production, only to cry foul years later when their proposition was taken to one of its logical conclusions,[27] artists whose practices are based in modes of "traditional" manual labor have registered a more complex understanding of the *politics* of authorship. A case in point: for a 1995 historical survey of feminist art titled *Division of Labor: "Women's Work" in Contemporary Art* at the Bronx Museum, Faith Wilding, an original member of the Feminist Art Program at the California Institute of the Arts, was invited to re-create her room-sized site-specific installation *Crocheted Environment* (also known as *Womb Room*) from the 1972 *Womanhouse* project in Los Angeles. The original piece being nonexistent, the project presented Wilding with a number of problems, least of which were the long hours and intensive physical labor required to complete the task. To decline the invitation to redo the piece for the sake of preserving the integrity of the original installation would have been an act of self-marginalization, contributing to a self-silencing that would write Wilding and an aspect of feminist art out of the dominant account of art history *(again)*. But on the other hand, to re-create the work as an independent art object for a white cubic space in the Bronx Museum also meant voiding the meaning of the work as it was first established in relation to the site of its original context. Indeed, while the cultural legitimation as represented by the institutional interest in Wilding's work allowed for the (temporary) unearthing of one of the neglected trajectories of feminist art, in the institutional setting of the Bronx Museum and later at the Los Angeles Museum of Contemporary Art, *Crocheted Environment* became a beautiful but innocuous work, its primary interest formal, the handicraft nature of the work rendered thematic (feminine labor).[28]

But even if the efficacy of site-specific art from the past seems to weaken in its re-

presentations, the procedural complications, ethical dilemmas, and pragmatic head-aches that such situations raise for artists, collectors, dealers, and host institutions *are* still meaningful. They present an unprecedented strain on established patterns of (re)producing, exhibiting, borrowing/lending, purchasing/selling, and commissioning/executing artworks in general. At the same time, despite some artists' regression into authorial inviolability in order to defend their site-specific practice, other artists are keen on undoing the presumption of criticality associated with principles such as im-mobility, permanence, and unrepeatability. Rather than resisting mobilization, these artists are attempting to reinvent site specificity as a *nomadic* practice.

Itinerant Artists

The increasing institutional interest in site-oriented practices that mobilize the site as a discursive narrative is demanding an intensive physical mobilization of the artist to create works in various cities throughout the cosmopolitan art world. Typically, an artist (no longer a studio-bound object maker, primarily working on call) is invited by an art institution to execute a work specifically configured for the framework provided by the institution (in some cases the artist may solicit the institution with a proposal). Subsequently, the artist enters into a contractual agreement with the host institution for the commission. There follow repeated visits to or extended stays at the site; re-search into the particularities of the institution and/or the city within which it is located (its history, constituency of the [art] audience, the installation space); consideration of

Figure 6. Christian Philipp Müller, *Illegal Border Crossing between Austria and Czechoslovakia* (Austrian contribution to the Venice Biennial), 1993. Courtesy of the artist and American Fine Arts, Co., New York.

the parameters of the exhibition itself (its thematic structure, social relevance, other artists in the show); and many meetings with curators, educators, and administrative support staff, who may all end up "collaborating" with the artist to produce the work. The project will likely be time-consuming and in the end will have engaged the "site" in a multitude of ways, and the documentation of the project will take on another life within the art world's publicity circuit, which will in turn alert another institution for another commission.

Thus, if the artist is successful, he or she travels constantly as a freelancer, often working on more than one site-specific project at a time, globe-trotting as a guest, tourist, adventurer, temporary in-house critic, or pseudoethnographer[29] to São Paulo, Munich, Chicago, Seoul, Amsterdam, New York, and so on. Generally, the in situ configuration of projects that emerge out of such a situation is temporary, ostensibly unsuitable for re-presentation anywhere else without altering its meaning, partly because the commission is defined by a unique set of geographical and temporal circumstances and partly because the project is dependent on unpredictable and unprogrammable on-site relations. But such conditions, despite appearances to the contrary, do not circumvent the problem of commodification entirely, because there is a strange reversal now wherein the artist approximates the "work" instead of the other way around, as is commonly assumed (that is, artwork as surrogate of the artist). Perhaps because of the "absence" of the artist from the physical manifestation of the work, the *presence* of the artist has become an absolute *prerequisite* for the execution/presentation of site-oriented projects. It is now the *performative* aspect of an artist's characteristic mode of operation (even when collaborative) that is repeated and circulated as a new art commodity, with the artist functioning as the primary vehicle for its verification, repetition, and circulation.[30]

For example, after a year-long engagement with the Maryland Historical Society, Fred Wilson finalized his site-specific commission *Mining the Museum* (1992) as a temporary reorganization of the institution's permanent collection. As a timely convergence of institutional museum critique and multicultural identity politics, *Mining the Museum* drew many new visitors to the society, and the project received high praise from both the art world and the popular press. Subsequently, Wilson performed a similar excavation/intervention at the Seattle Art Museum in 1993, a project also defined by the museum's permanent collection.[31] Although the shift from Baltimore to Seattle, from a historical society to an art museum, introduced new variables and challenges, the Seattle project established a repetitive relationship between the artist and the hosting institution, reflecting a broader museological fashion trend—commissioning of artists to rehang permanent collections. The fact that Wilson's project in Seattle fell short of the Baltimore "success" may be evidence of how ongoing repetition of such commissions can render methodologies of critique rote and generic. They can easily become extensions of the museum's own self-promotional apparatus, and the artist becomes a commodity with a purchase on "criticality." As Isabelle Graw has noted, "[T]he result can be an absurd situation in which the commissioning insti-

tution (the museum or gallery) turns to an artist as a person who has the legitimacy to point out the contradictions and irregularities of which they themselves disapprove." And for artists, "[s]ubversion in the service of one's own convictions finds easy transition into subversion for hire; 'criticism turns into spectacle.'"[32]

To say, however, that this changeover represents the commodification of the artist is not completely accurate because it is not the figure of the artist per se, as a personality or a celebrity à la Warhol, that is produced/consumed in an exchange with the institution. What the current pattern points to, in fact, is the extent to which the very nature of the commodity as a cipher of production and labor relations is no longer bound to the realm of manufacturing (of things) but is defined in relation to the service and management industries.[33] The artist as an overspecialized aesthetic object maker has been anachronistic for a long time already. What they *provide* now, rather than *produce,* are aesthetic, often "critical-artistic," services.[34] If Richard Serra could once distill artistic activities down to their elemental physical actions (to drop, to split, to roll, to fold, to cut . . .),[35] the situation now demands a different set of verbs: to negotiate, to coordinate, to compromise, to research, to organize, to interview, etc. This shift was forecasted in conceptual art's adoption of what Benjamin Buchloh has described as the "aesthetics of administration."[36] The salient point here is how quickly this aesthetics of administration, developed in the 1960s and 1970s, has converted to the administration of aesthetics in the 1980s and 1990s. Generally speaking, the artist used to be a maker of aesthetic objects; now he or she is a facilitator, educator, coordinator, and bureaucrat. Additionally, as artists have adopted managerial functions of art institutions (curatorial, educational, archival) as an integral part of their creative process, managers of art within institutions (curators, educators, public program directors), who often take their cues from these artists, now function as authorial figures in their own right.[37]

Concurrent with, or because of, these methodological and procedural changes, there is a reemergence of the centrality of the artist as the progenitor of meaning. This is true even when authorship is deferred to others in collaborations, or when the institutional framework is self-consciously integrated into the work, or when an artist problematizes his or her own authorial role. On the one hand, this "return of the author" results from the thematization of discursive sites that engenders a misrecognition of them as "natural" extensions of the artist's identity, and the legitimacy of the critique is measured by the proximity of the artist's personal association (converted to expertise) with a particular place, history, discourse, identity, etc. (converted to thematic content). On the other hand, because the signifying chain of site-oriented art is constructed foremost by the movement and decisions of the artist,[38] the (critical) elaboration of the project inevitably unfolds around the artist. That is, the intricate orchestration of literal and discursive sites that make up a nomadic narrative *requires* the artist as a narrator-protagonist. In some cases, this renewed focus on the artist leads to a hermetic implosion of (auto)biographical and subjectivist indulgences, and myopic narcissism is misrepresented as self-reflexivity.

This being so, one of the narrative trajectories of all site-oriented projects is consistently aligned with the artist's prior projects executed in other places, generating what might be called a fifth site—the exhibition history of the artist, his or her vitae. The tension between the intensive mobilization of the artist and the recentralization of meaning around him or her is illustrated by Renée Green's 1993 *World Tour,* a group reinstallation of four site-specific projects produced in disparate parts of the world over a three-year period.[39] By bringing several distinct projects together from "elsewhere," *World Tour* sought to reflect on the problematic conditions of present-day site specificity, such as the ethnographic predicament of artists who are frequently imported by foreign institutions and cities as expert/exotic visitors. *World Tour* also made an important attempt to imagine a productive convergence between specificity and mobility, where a project created under one set of circumstances might be redeployed in another without losing its impact—or, better, finding new meaning and gaining critical sharpness through recontextualizations.[40] But these concerns were not available for viewers whose interpretive reaction was to see the artist as the primary link between the projects. Indeed, the effort to redeploy the individual site-oriented projects as a conceptually coherent ensemble eclipsed the specificity of each and forced a relational dynamic between discrete projects. Consequently, the overriding narrative of *World Tour* became Green's own creative process as an artist in and through the four projects. And in this sense, the project functioned as a fairly conventional retrospective.

Just as the shifts in the structural reorganization of cultural production alter the form of the art commodity (to services) and the authority of the artist (to "reappeared" protagonist), values like originality, authenticity, and singularity are also reworked in site-oriented art—*evacuated from the artwork and attributed to the site*—reinforcing a general cultural valorization of places as the locus of authentic experience and a coherent sense of historical and personal identity.[41] An instructive example of this phenomenon is *Places with a Past,* a 1991 site-specific exhibition organized by Mary Jane Jacob, which took the city of Charleston, South Carolina, as not only the backdrop but also a "bridge between the works of art and the audience."[42] In addition to breaking the rules of the art establishment, the exhibition wanted to further a dialogue between art and the sociohistorical dimension of places. According to Jacob, "Charleston proved to be fertile ground" for the investigation of issues concerning "gender, race, cultural identity, considerations of difference, . . . subjects much in the vanguard of criticism and art-making. . . . The actuality of the situation, the fabric of the time and place of Charleston, offered an incredibly rich and meaningful context for the making and siting of publicly visible and physically prominent installations that rang true in [the artists'] approach to these ideas."[43]

While site-specific art continues to be described as a refutation of originality and authenticity as intrinsic qualities of the art object or the artist, this resistance facilitates the translation and relocation of these qualities from the artwork to the place of its presentation, only to have them *return* to the artwork now that it has become integral to the site. Admittedly, according to Jacob, "locations . . . contribute a specific

identity to the shows staged by injecting into the experience the uniqueness of the place."[44] Conversely, if the social, historical, and geographical specificity of Charleston offered artists a unique opportunity to create unrepeatable works (and by extension an unrepeatable exhibition), then the programmatic implementation of site-specific art in exhibitions like *Places with a Past* ultimately utilizes art to *promote* Charleston as a unique place. What is prized most of all in site-specific art is still the singularity and authenticity that the presence of the artist seems to guarantee, not only in terms of the presumed unrepeatability of the work but in the ways in which the presence of the artist also *endows* places with a "unique" distinction.

Certainly, site-specific art can lead to the unearthing of repressed histories, provide support for greater visibility of marginalized groups and issues, and initiate the re(dis)covery of "minor" places so far ignored by the dominant culture. But inasmuch as the current socioeconomic order thrives on the (artificial) production and (mass) consumption of difference (for difference's sake), the siting of art in "real" places can also be a means to *extract* the social and historical dimensions *out* of places to variously serve the thematic drive of an artist, satisfy institutional demographic profiles, or fulfill the fiscal needs of a city.

Significantly, the appropriation of site-specific art for the valorization of urban identities comes at a time of a fundamental cultural shift in which architecture and urban planning, formerly the primary media for expressing a vision of the city, are displaced by other media more intimate with marketing and advertising. In the words of urban theorist Kevin Robins, "As cities have become ever more equivalent and urban identities increasingly 'thin,' . . . it has become necessary to employ advertising and marketing agencies to manufacture such distinctions. It is a question of distinction in a world beyond difference."[45] Site specificity in this context finds new importance because it supplies distinction of place and uniqueness of locational identity, highly seductive qualities in the promotion of towns and cities within the competitive restructuring of the global economic hierarchy. Thus, site specificity remains inexorably tied to a process that renders particularity and identity of various cities a matter of product differentiation. Indeed, the exhibition catalog for *Places with a Past* was a "tasteful" tourist promotion, pitching the city of Charleston as a unique, "artistic," and meaningful place (to visit).[46] Under the pretext of their articulation or resuscitation, site-specific art can be mobilized to expedite the *erasure* of differences via the commodification and serialization of places.

The yoking together of the myth of the artist as a privileged source of originality with the customary belief in places as ready reservoirs of unique identity belies the compensatory nature of such a move. For this collapse of the artist and the site reveals an anxious cultural desire to assuage the sense of loss and vacancy that pervades both sides of this equation. In this sense, Craig Owens was perhaps correct to characterize site specificity as a melancholic discourse and practice,[47] as was Thierry de Duve, who claimed that "sculpture in the last 20 years is an attempt to reconstruct the notion of site from the standpoint of having acknowledged its disappearance."[48]

The bulldozing of an irregular topography into a flat site is clearly a technocratic gesture which aspires to a condition of absolute *placelessness,* whereas the terracing of the same site to receive the stepped form of a building is an engagement in the act of "cultivating" the site. . . .

This inscription . . . has a capacity to embody, in built form, the prehistory of the place, its archeological past and its subsequent cultivation and transformation across time. Through this layering into the site the idiosyncrasies of place find their expression without falling into sentimentality.

—Kenneth Frampton, "Towards a Critical Regionalism"

[T]he elaboration of place-bound identities has become more rather than less important in a world of diminishing spatial barriers to exchange, movement and communication.

—David Harvey, "From Space to Place and Back Again"

It is significant that the mobilization of site-specific art from decades ago is *concurrent* with the nomadism of current site-oriented practices. Paradoxically, while foregrounding the importance of the site, they together express the dissipation of the site, caught up in the "dynamics of deterritorialization," a concept most clearly elaborated in architectural and urban discourses today.

Within the present context of an ever-expanding capitalist order, fueled by an ongoing globalization of technology and telecommunications, the intensifying conditions of spatial indifferentiation and departicularization exacerbate the effects of alienation and fragmentation in contemporary life.[49] The drive toward a rationalized universal civilization, engendering the homogenization of places and the erasure of cultural differences, is in fact the force against which Frampton proposes a practice of Critical Regionalism as already described—a program for an "architecture of resistance." If the universalizing tendencies of modernism undermined the old divisions of power based on class relations fixed to geographical hierarchies of centers and margins, only to aid in capitalism's colonization of "peripheral" spaces, then the articulation and cultivation of diverse local particularities are a (postmodern) reaction against these effects. Henri Lefebvre has remarked: "[I]nasmuch as abstract space [of modernism and capital] tends towards homogeneity, towards the elimination of existing differences or peculiarities, a new space cannot be born (produced) unless it accentuates differences."[50] It is perhaps no surprise, then, that the efforts to retrieve lost differences, or to curtail the waning of them, become heavily invested in reconnecting to "uniqueness of place"—or more precisely, in establishing authenticity of meaning, memory, histories, and identities as a *differential function* of places. It is this differential function associated with places, which earlier forms of site-specific art tried to exploit and the current incarnations of site-oriented works seek to reimagine, that is the hidden attractor in the term *site specificity.*

It seems inevitable that we should leave behind the nostalgic notions of a site as being essentially bound to the physical and empirical realities of a place. Such a conception, if not ideologically suspect, often seems out of sync with the prevalent description of contemporary life as a network of unanchored flows. Even such an advanced theoretical position as Frampton's Critical Regionalism seems dated in this

regard, for it is predicated on the belief that a particular site/place exists with its identity-giving or identifying properties always and already *prior* to what new cultural forms might be introduced to it or emerge from it. In such a pre- (or post-) poststructuralist conception, all site-specific gestures would have to be understood as reactive, "cultivating" what is presumed to be there already rather than generative of new identities and histories.

Indeed the deterritorialization of the site has produced liberatory effects, displacing the strictures of fixed place-bound identities with the fluidity of a migratory model, introducing the possibilities for the production of multiple identities, allegiances, and meanings, based not on normative conformities but on the nonrational convergences forged by chance encounters and circumstances. The fluidity of subjectivity, identity, and spatiality as described by Gilles Deleuze and Félix Guattari in their rhizomic nomadism,[51] for example, is a powerful theoretical tool for the dismantling of traditional orthodoxies that would suppress differences, sometimes violently.

However, despite the proliferation of discursive sites and "fictional" selves, the phantom of a site as an actual place remains, and our psychic, habitual attachments to places regularly return as they continue to inform our sense of identity. And this persistent, perhaps secret, adherence to the actuality of places (in memory, in longing) is not necessarily a lack of theoretical sophistication but a means for survival. The resurgence of violence in defense of essentialized notions of national, racial, religious, and cultural identities in relation to geographical territories is readily characterized as extremist, retrograde, and "uncivilized." Yet the loosening of such relations, that is, the destabilization of subjectivity, identity, and spatiality (following the dictates of desire), can also be described as a compensatory fantasy in response to the intensification of fragmentation and alienation wrought by a mobilized market economy (following the dictates of capital). The advocacy of the continuous mobilization of self- and place-identities as discursive fictions, as polymorphous "critical" plays on fixed generalities and stereotypes, in the end may be a delusional alibi for short attention spans, reinforcing the ideology of the new—a temporary antidote for the anxiety of boredom. It is perhaps too soon and frightening to acknowledge, but the paradigm of nomadic selves and sites may be a glamorization of the trickster ethos that is in fact a reprisal of the ideology of "freedom of choice"—the choice to forget, the choice to reinvent, the choice to fictionalize, the choice to "belong" anywhere, everywhere, and nowhere. This choice, of course, does not belong to everyone equally. The understanding of identity and difference as being culturally constructed should not obscure the fact that the ability to deploy multiple, fluid identities in and of itself is a privilege of mobilization that has a specific relationship to power.

What would it mean now to sustain the cultural and historical specificity of a place (and self) that is neither a simulacral pacifier nor a willful invention? For architecture, Frampton proposes a process of "double mediation," which is in fact a double negation, *defying* "both the optimization of advanced technology and the ever-present tendency to regress into nostalgic historicism or the glibly decorative."[52] An analogous

double mediation in site-specific art practice might mean finding a terrain between mobilization and specificity—to be *out* of place with punctuality and precision. Homi Bhabha has said, "The globe shrinks for those who own it; for the displaced or the dispossessed, the migrant or refugee, no distance is more awesome than the few feet across borders or frontiers."[53] Today's site-oriented practices inherit the task of demarcating the *relational specificity* that can hold in tension the distant poles of spatial experiences described by Bhabha. This means addressing the differences of adjacencies and distances *between* one thing, one person, one place, one thought, one fragment *next* to another, rather than invoking equivalencies via one thing *after* another. Only those cultural practices that have this relational sensibility can turn local encounters into long-term commitments and transform passing intimacies into indelible, unretractable social marks—so that the sequence of sites that we inhabit in our life's traversal does not become genericized into an undifferentiated serialization, one place after another.

Notes

This essay is part of a larger project on the convergence of art and architecture in site-specific practices of the past thirty years, especially in the context of public art. I am grateful to those who provided encouragement and critical commentaries: Hal Foster, Helen Molesworth, Sowon and Seong Kwon, Rosalyn Deutsche, Mark Wigley, Doug Ashford, Russell Ferguson, and Frazer Ward. Also, as a recipient of the Professional Development Fellowship for Art Historians, I am indebted to the College Art Association for its support.

1. Douglas Crimp has written: "The idealism of modernist art, in which the art object *in and of itself* was seen to have a fixed and transhistorical meaning, determined the object's placelessness, its belonging in no particular place. . . . Site specificity opposed that idealism— and unveiled the material system it obscured—by its refusal of circulatory mobility, its belongingness to a *specific* site" (*On the Museum's Ruins* [Cambridge: MIT Press, 1993], 17). See also Rosalind Krauss, "Sculpture in the Expanded Field" (1979), in *The Anti-Aesthetic: Essays on Postmodern Culture,* ed. Hal Foster (Port Townsend, Wash.: Bay Press, 1983), 31–42.

2. William Turner, as quoted in Mary Miss, "From Autocracy to Integration: Redefining the Objectives of Public Art," in *Insights/On Sites: Perspectives on Art in Public Places,* ed. Stacy Paleologos Harris (Washington, D.C.: Partners for Livable Places, 1984), 62.

3. Rosalyn Deutsche has made an important distinction between an assimilative model of site specificity—in which the artwork is geared toward *integration* into the existing environment, producing a unified, "harmonious" space of wholeness and cohesion—and an interruptive model in which the artwork functions as a critical *intervention* into the existing order of a site. See her essays *"Tilted Arc* and the Uses of Public Space," *Design Book Review,* no. 23 (winter 1992): 22–27, and "Uneven Development: Public Art in New York City," *October* 47 (winter 1988): 3–52.

4. Robert Barry, in Arthur R. Rose [pseud.], "Four Interviews with Barry, Huebler, Kosuth, Weiner," *Arts Magazine,* February 1969, 22.

5. Richard Serra, letter to Donald Thalacker, January 1, 1985, published in *The Destruction of "Tilted Arc": Documents,* ed. Clara Weyergraf-Serra and Martha Buskirk (Cambridge: MIT Press, 1991), 38.

6. Richard Serra, "*Tilted Arc* Destroyed," *Art in America,* May 1989, 34–47.

7. The controversy over *Tilted Arc* obviously involved other issues besides the status of site specificity, but, in the end, site specificity was the term upon which Serra hung his entire defense. Despite Serra's defeat, the legal definition of site specificity remains unresolved and continues to be grounds for many juridical conflicts. For a discussion concerning legal questions in the *Tilted Arc* case, see Barbara Hoffman, "Law for Art's Sake in the Public Realm," in *Art in the Public Sphere,* ed. W. J. T. Mitchell (Chicago: University of Chicago Press, 1991), 113–46. Thanks to James Marcovitz for discussions concerning the legality of site specificity.

8. See Hal Foster's seminal essay, "The Crux of Minimalism," in *Individuals: A Selected History of Contemporary Art, 1945–1986,* ed. Howard Singerman (Los Angeles: Museum of Contemporary Art, 1986), 162–83. See also Craig Owens, "From Work to Frame; or, Is There Life after 'The Death of the Author'?" in *Beyond Recognition* (Berkeley: University of California Press, 1992), 122–39.

9. Daniel Buren, "Function of the Museum," *Artforum,* September 1973.

10. Daniel Buren, "Critical Limits," in *Five Texts* (New York, 1973), 38.

11. See "Conversation with Robert Smithson," ed. Bruce Kurtz, in *Writings of Robert Smithson,* ed. Nancy Holt (New York: New York University Press, 1979), 200.

12. This project involved the relocation of a bronze replica of an eighteenth-century statue of George Washington from its normal position outside the entrance in front of the Art Institute to one of the smaller galleries inside devoted to eighteenth-century European painting, sculpture, and decorative arts. Asher stated his intention as follows: "In this work I am interested in the way the sculpture functions when it is viewed in its 18th-century context instead of in its prior relationship to the façade of the building. . . . Once inside Gallery 219 the sculpture can be seen in connection with the ideas of other European works of the same period" (quoted in Anne Rorimer, "Michael Asher: Recent Work," *Artforum,* April 1980, 47). See also Benjamin H. D. Buchloh, ed., *Michael Asher: Writings 1973–1983 on Works 1969–1979* (Halifax, Nova Scotia: The Press of the Nova Scotia College of Art and Design; Los Angeles: Museum of Contemporary Art, 1983), 207–21.

13. These concerns coincide with developments in public art, which has reprogrammed site-specific art to be synonymous with community-based art. As exemplified in projects such as *Culture in Action* in Chicago (1992–93) and *Points of Entry* in Pittsburgh (1996), site-specific public art in the 1990s marks a convergence between cultural practices grounded in leftist political activism, community-based aesthetic traditions, conceptually driven art borne out of institutional critique, and identity politics. Because of this convergence, many of the questions concerning contemporary site-specific practices apply to public art projects as well, and vice versa. Unfortunately, an analysis of the specific aesthetic and political problems in the public art arena, especially those pertaining to spatial politics of cities, will have to await another venue. In the meantime, I refer the readers to Grant Kester's excellent analysis of current trends in community-based public art in "Aesthetic Evangelists: Conversion and Empowerment in Contemporary Community Art," *Afterimage,* January 1995, 5–11.

14. The exhibition, *Arte Joven en Nueva York,* curated by José Gabriel Fernandez, was hosted by Sala Mendoza and Sala RG in Caracas, Venezuela (June 9–July 7, 1991).

15. This fourth site, to which Dion would return again and again in other projects, remained consistent even as the contents of one of the crates from the Orinoco trip were transferred to New York City to be reconfigured in 1992 to become *New York State Bureau of Tropical Conservation,* an installation for an exhibition at American Fine Arts Co. See the conversation "The Confessions of an Amateur Naturalist," *Documents* 1/2 (fall/winter 1992): 36–46. See also my interview with the artist in the monograph *Mark Dion* (London: Phaidon Press, 1997).

16. See the roundtable discussion "On Site Specificity," *Documents* 4/5 (spring 1994):

11–22. Participants included Hal Foster, Renée Green, Mitchell Kane, John Lindell, Helen Molesworth, and me.

17. James Meyer, "The Functional Site," in *Platzwechsel,* exhibition catalog (Zurich: Kunsthalle Zurich, 1995), 27. A revised version of the essay appears in *Documents* 7 (fall 1996): 20–29. Meyer's narrative of the development of site specificity is indebted, as mine is, to the historical and theoretical work of Craig Owens, Rosalind Krauss, Douglas Crimp, Hal Foster, and Benjamin Buchloh, among others. It will become clear, however, that while I concur with Meyer's description of recent site-oriented art, our interpretive analyses lead to very different questions and conclusions.

18. Despite the adoption of various architectural terminology in the description of many new electronic spaces (Web sites, information environments, program infrastructures, construction of home pages, virtual spaces, etc.), the spatial experience on the computer is structured more as a sequence of movements and passages and less as the habitation or durational occupation of a particular "site." Hypertext is a prime example. The (information) superhighway is a more apt analogy, for the spatial experience of the highway is one of transit between locations (despite one's immobile body behind the wheel).

19. Again, it is beyond the scope of this essay to attend to issues concerning the status of the "public" in contemporary art practices. On this topic, see Rosalyn Deutsche, *Evictions: Art and Spatial Politics* (Cambridge: MIT Press, 1996).

20. See, for example, Gilles Deleuze, "Postscript on the Societies of Control," *October* 59 (winter 1992): 3–7, and Manuel Castells, *The Informational City* (Oxford: Basil Blackwell, 1989).

21. For an overview of this situation, see Susan Hapgood, "Remaking Art History," *Art in America,* July 1990, 115–23, 181.

22. *The New Sculpture, 1965–75: Between Geometry and Gesture* at the Whitney Museum (1990) included fourteen re-creations of works by Barry Le Va, Bruce Nauman, Alan Saret, Richard Serra, Joel Shapiro, Keith Sonnier, and Richard Tuttle. Le Va's re-creation of *Continuous and Related Activities: Discontinued by the Act of Dropping* from 1967 was then purchased by the Whitney for its permanent collection and subsequently reinstalled in several other exhibitions in many different cities. With some of these works, there is an ambiguous blurring between ephemerality (repeatable?) and site specificity (unrepeatable?).

23. Hapgood, "Remaking Art History," 120.

24. This was the logic behind Richard Serra's defense of *Tilted Arc.* Consequently, the issue of relocation or removal of the sculpture became a debate concerning the creative rights of the artist.

25. See the March and April 1990 issues of *Art in America.*

26. Sol LeWitt, with his *Lines to Points on a Six Inch Grid* (1976), for example, serialized his wall drawing by relinquishing the necessity for his involvement in the actual execution of the work, allowing for the possibility of an endless repetition of the same work reconfigured by others in a variety of different locations.

27. See Rosalind Krauss, "The Cultural Logic of the Late Capitalist Museum," *October* 54 (fall 1990): 3–17.

28. For Faith Wilding's description of this dilemma, as well as her assessment of recent revisits of 1960s feminist art, see her essay "Monstrous Domesticity," *M/E/A/N/I/N/G* 18 (November 1995): 3–16.

29. See Hal Foster, "Artist as Ethnographer," in *The Return of the Real* (Cambridge: MIT Press, 1996), on the complex exchange between art and anthropology in recent art.

30. It may be that current modes of site-oriented practices can be mapped along a gene-

alogy of performance art, too. Consider, for example, Vito Acconci's comments on performance art as a publicity-oriented, contract-based practice: "On the one hand, performance imposed the unsaleable onto the store that the gallery is. On the other hand, performance built that store up and confirmed the market-system: It increased the gallery's sales by acting as window-dressing and by providing publicity. . . . There was one way I loved to say the word 'performance,' one meaning of the world [sic] 'performance' I was committed to: 'Performance' in the sense of performing a contract—you promised you would do something, now you have to carry that promise out, bring that promise through to completion." Acconci, "Performance after the Fact," *New Observations* 95 (May–June 1993): 29. Thanks to Frazer Ward for directing my attention to this text.

31. See Fred Wilson's interview with Martha Buskirk in *October* 70 (fall 1994): 109–12.

32. Isabelle Graw, "Field Work," *Flash Art* (November/December 1990): 137. Her observation here is in relation to Hans Haacke's practice but is relevant as a general statement concerning the current status of institutional critique. See also Frazer Ward, "The Haunted Museum: Institutional Critique and Publicity," *October* 73 (summer 1995): 71–90.

33. See Saskia Sassen, *The Global City: New York, London, Tokyo* (Princeton, N.J.: Princeton University Press, 1991).

34. Andrea Fraser's 1994–95 project in which she contracted herself out to the EA-Generali Foundation in Vienna (an art association established by companies belonging to the EA-Generali insurance group) as an artist/consultant to provide "interpretive" and "interventionary" services to the foundation is one of the few examples I can think of that self-consciously play out this shift in the conditions of artistic production and reception both in terms of content and structure of the project. It should be noted that the artist herself initiated the project by offering such services through her "Prospectus for Corporations." See Fraser's *Report* (Vienna: EA-Generali Foundation, 1995). For a more general consideration of artistic practice as cultural service provision, see Andrea Fraser, "What's Intangible, Transitory, Mediating, Participatory, and Rendered in the Public Sphere?" *October* 80 (spring 1997): 111–16. Proceedings of working-group discussions organized by Fraser and Helmut Draxler in 1993 around the theme of services, to which Fraser's text provides an introduction, are also of interest and appear in the same issue of *October*.

35. Richard Serra, "Verb List, 1967-68," in *Writings Interviews* (Chicago: University of Chicago Press, 1994), 3.

36. Benjamin H. D. Buchloh, "Conceptual Art, 1962–1969: From the Aesthetics of Administration to the Critique of Institutions," *October* 55 (winter 1991): 105–43.

37. For instance, the *Views from Abroad* exhibition series at the Whitney Museum, which foregrounds "artistic" visions of European curators, is structured very much like site-specific commissions of artists that focus on museum permanent collections, as described earlier.

38. According to James Meyer, a site-oriented practice based on a functional notion of a site "traces the *artist's* movements through and around the institution"; "reflect[s] the specific interests, educations, and formal decisions of the producer"; and "in the process of deferral, a signifying chain that traverses physical and discursive borders," the functional site "incorporates the body of the artist." See Meyer, "The Functional Site," 29, 33, 31, 35; emphasis added.

39. The installation consisted of *Bequest,* commissioned by the Worcester Art Museum in Massachusetts in 1991; *Import/Export Funk Office,* originally shown at the Christian Nagel Gallery in Cologne in 1992 and then reinstalled at the 1993 Biennial at the Whitney Museum of American Art; *Mise en Scène,* first presented in 1992 in Clisson, France; and *Idyll Pursuits,* produced for a group exhibition in 1991 in Caracas, Venezuela. As a whole, *World Tour* was exhibited at the Museum of Contemporary Art in Los Angeles in 1993, then traveled to the

Dallas Museum of Art later the same year. See Russell Ferguson, ed., *World Tour,* exhibition catalog (Los Angeles: Museum of Contemporary Art, 1993).

40. This endeavor is not exclusive to Green. Silvia Kolbowski, for instance, has proposed the possibility of working with sites as generic and transferability as specific in projects. See her *Enlarged from the Catalogue: "The United States of America"* (1988). See the project annotations and Johanne Lamoureux's essay, "The Open Window Case: New Displays for an Old Western Paradigm," in *Silvia Kolbowski: XI Projects* (New York: Border Editions, 1993), 6–15, 34–51.

41. This faith in the authenticity of place is evident in a wide range of disciplines. In urban studies, see Dolores Hayden, *The Power of Place: Urban Landscapes as Public History* (Cambridge: MIT Press, 1995). In relation to public art, see Ronald Lee Fleming and Renata von Tscharner, *PlaceMakers: Creating Public Art That Tells You Where You Are* (Boston: Harcourt Brace Jovanovich, 1981). See also Lucy Lippard, *The Lure of the Local: The Sense of Place in a Multicultural Society* (New York: New Press, 1997).

42. See *Places with a Past: New Site-Specific Art at Charleston's Spoleto Festival,* exhibition catalog (New York: Rizzoli, 1991), 19. The exhibition took place May 24–August 4, 1991, with site-specific works by eighteen artists, including Ann Hamilton, Christian Boltanski, Cindy Sherman, David Hammons, Lorna Simpson and Alva Rogers, Kate Ericson and Mel Ziegler, and Ronald Jones. The promotional materials, especially the exhibition catalog, emphasized the innovative challenge of the exhibition format over the individual projects, and foregrounded the authorial role of Mary Jane Jacob over that of the artists.

43. Ibid., 17.

44. Ibid., 15.

45. Kevin Robins, "Prisoners of the City: Whatever Can a Postmodern City Be?" in *Space and Place: Theories of Identity and Location,* ed. Erica Carter, James Donald, and Judith Squires (London: Lawrence and Wishart, 1993), 306.

46. Cultural critic Sharon Zukin has noted, "[I]t seemed to be official policy [by the 1990s] that making a place for art in the city went along with establishing a marketable identity for the city as a whole." Zukin, *The Culture of Cities* (Cambridge: Blackwell, 1995), 23.

47. Addressing Robert Smithson's *Spiral Jetty* and the *Partially Buried Wood Shed,* Craig Owens has made an important connection between melancholia and the redemptive logic of site specificity in "The Allegorical Impulse: Toward a Theory of Postmodernism," *October* 12 (spring 1980): 67–86.

48. Thierry de Duve, "Ex Situ," *Art & Design* 8, nos. 5/6 (May–June 1993): 25.

49. See Fredric Jameson, *Postmodernism; or, The Cultural Logic of Late Capitalism* (Durham, N.C.: Duke University Press, 1991); David Harvey, *The Condition of Postmodernity* (Cambridge, Mass.: Blackwell, 1990); Margaret Morse, "The Ontology of Everyday Distraction: The Freeway, the Mall, and Television," in *Logics of Television: Essays in Cultural Criticism,* ed. Patricia Mellencamp (Bloomington: Indiana University Press, 1990), 193–221; Michael Sorkin, ed., *Variations on a Theme Park: The New American City and the End of Public Space* (New York: Noonday Press, 1992); and Edward Soja, *Postmodern Geographies: The Reassertion of Space in Critical Theory* (London: Verso Books, 1989). For a feminist critique of some of these urban spatial theories, see Rosalyn Deutsche, "Men in Space," *Strategies,* no. 3 (1990): 130–37, and "Boys Town," *Environment and Planning D: Society and Space* 9 (1991): 5–30. For a specific critique of Sorkin's position, see Miwon Kwon, "Imagining an Impossible World Picture," in *Sites and Stations: Provisional Utopias,* ed. Stan Allen and Kyong Park (New York: Lusitania Press, 1995), 77–88.

50. Henri Lefebvre, *The Production of Space,* trans. Donald Nicholson-Smith (Oxford: Blackwell, 1991), 52.

51. Gilles Deleuze and Félix Guattari, *A Thousand Plateaus: Capitalism and Schizophrenia,* trans. Brian Massumi (Minneapolis: University of Minnesota Press, 1987).

52. Kenneth Frampton, "Towards a Critical Regionalism," in *The Anti-Aesthetic,* ed. Hal Foster (Port Townsend, Wash.: Bay Press, 1983), 21.

53. Homi K. Bhabha, "Double Visions," *Artforum,* January 1992, 88.

3. "Illiterate Monuments":
The Ruin as Dialect or Broken Classic

Barbara Maria Stafford

A libertine anticlassic and antiacademic aesthetic is documented in the attitude expressed toward so-called Druidic monuments. Focusing on the dispute—revived during the first quarter of the eighteenth century—between the Palladian Inigo Jones and the Epicurean Walter Charleton concerning the interpretation of Stonehenge, I will develop the important antithesis for architectural and sculptural monuments between classical, or "literate," monuments and barbaric, Gothic, or "illiterate," memorials. This polemic hinges on an associative and speculative etymology for the term *rune*.

My point will be that from this debate arises the opportunity for conjoining conceptually, visually, and linguistically *runae* with ruins, that is, for bringing together "worn-out" and "forgotton" letters with fragmented stone monuments that were not "absolutely dumb," but that spoke in a "more obscure dialect." By extension, the powerful aesthetic challenge to classicism of the grotesque, multiple, shattered form will be seen as undermining the legible, fixed, static articulation susceptible to a single, undeviating interpretation—a fundamental tenet of academic theory both in France and in England.

Finally, I will indicate that this is the nub of a much larger issue, namely the rise of modern landscape painting to the forefront of the pictorial arts from its traditional lowly position in the academic hierarchy of the genres. This ascent is due to a dynamic view of nature, one in which matter creates in a libertine, humanly uncontrolled fashion. Further, this free and vitalistic behavior heralds the birth of a deanthropocentrized worldview in which each thing—both natural and artificial—is permitted to speak its own individual vernacular.[1]

In 1797, the German writer and critic Friedrich Schlegel, in his synoptic assessment of ancient and modern poetics, *Die Griechen und Römer: Historische Versuche*

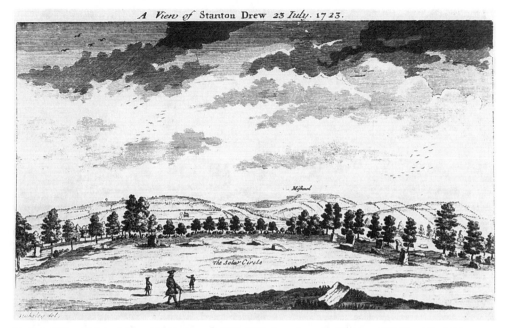

Figure 1. William Stukely, *A View of Stanton Drew*, July 23, 1723, from *Itinerarium Curiosum*, (1776), vol. 2, pl. 77. Photograph of engraving by the author.

über das klassische Alterthum, extended the language of seventeenth-century skeptics and Epicureans to the sphere of art. In contrasting the immutable "wholeness" of Greek poetry with the "fragmentary," "interesting," "piquant," and "individual" qualities of national or vernacular literature, he avails himself of a fundamental metaphor. Schlegel states that if one surveys the entirety of modern aesthetic production, "its mass appears like an ocean of battling forces *(Kräfte)* in which the elements of ruined Beauty, the fragments of ruptured art, make themselves felt confusedly as the melancholy debris of a former unity." Echoing Johann Joachim Winckelmann on the question of the imitation of nature, Schlegel, like his distinguished predecessor, maintains that the ancients inhabited a different landscape: an intact, perfect moral and physical topography, whereas the moderns had to be content with a "chemically dissolved," anatomized, and "separated" reality.[2]

Schlegel's "Synfonismus der Fragmente," his praise of potentiality, chaos, the ugly, and "das Nichts," is fundamentally related to his radical distinction between the grotesque and the naive or classical. In other words, in a series of essays published in the *Athenaeum* (1798–1800), he opposes an "empirical, Lockean" modern style, predicated on change, the eternally arbitrary, and the accidental, to a normative canon based on the principle of *utile et dulce* and on the belief that form and matter match naturally, harmoniously.[3]

Schlegel's definition of metamorphic modernism attacks one of the most important and codifying documents in the Renaissance classicizing tradition: the chapter titled "The *Idea* of the Painter, the Sculptor, and the Architect chosen from the Higher

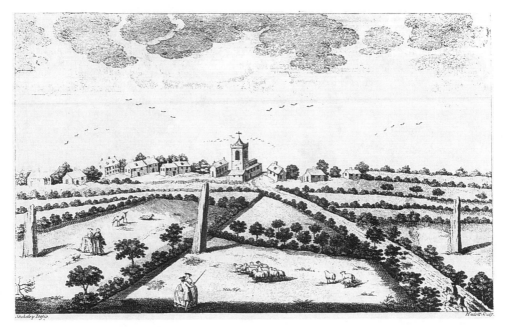

Figure 2. William Stukely, *Devil's Arrow,* 1725, from *Itinerarium Curiosum,* (1776), vol. 2, pl. 90.

Natural Beauties of Nature," from Giovanni Pietro Bellori's *Lives of the Modern Painters, Sculptors, and Architects* (1672). Bellori's faith in the perfection of ancient art is expressed with fervor. The modern architect

> [m]ay be certain to find the Idea established and based on the examples of the an-
> cients, who as a result of long study established this art; the Greeks gave it its scope
> and best proportions, which are confirmed by the most learned centuries and by the
> consensus of a succession of learned men, and which became the laws of an ad-
> mirable *Idea* and final beauty. This beauty, being one only in each species, cannot be
> altered without being destroyed. Hence those who with novelty transform it, regret-
> tably deform it; for ugliness stands close to beauty, as the vices touch the virtues.
> Such an evil we observe unfortunately at the fall of the Roman Empire, with which
> all the good arts decayed, and architecture more than any other; the barbarous
> builders disdained the models and the Ideas of the Greeks and Romans and the most
> beautiful monuments of antiquity, and for many centuries frantically erected so
> many and such various fantastic phantasies of orders that they rendered it monstrous
> with the ugliest disorder.[4]

This uniformitarian notion of beauty—safe from historical change—had consider-
able influence on the thinking of the Royal Academy of Painting and Sculpture in
France (founded in 1648) and, even earlier, on the Palladian theories of Inigo Jones
and his followers in England.

In contrast to Bellori, Schlegel's ironic stance vis-à-vis the monotony of Absolute
Beauty, and his thesis that only the supreme formal agility of the arabesque/grotesque

(functioning as a principle of structure) can be adequate to the infinite diversity of nature and the varieties of lived experience, may be taken as exemplary for a larger class of Romantics: E. T. A. Hoffmann, Jean Paul Richter, Victor Hugo. Especially noteworthy is John Ruskin's construct of the natural grotesque, which for him is close to a total, comprehensive art capable of bringing into conjunction the multiple oppositions of this world: the one with the many, the divine with the monstrous.[5]

Significantly, the anticlassical and, hence, antiacademic aesthetic, which simultaneously negates anthropocentrism because it questions the existence of an ideal, superimposable canon based on perfected human form, can be documented in the attitude expressed toward so-called Druidic monuments. These "pillar" and "rocking" stones, menhirs and cromlechs, baetyls, herms, and dolmens litter the downs of Cornwall, Wiltshire, and Brittany. Henry Rowlands in *Mona antiqua restaurata* (1766), William Borlase in *Antiquities of Cornwall* (1769), William Stukeley in *Itinerarium Curiosum* (1723), Baron d'Hancarville in *Recherches sur l'origine, l'esprit, et le progres des arts de La Grece* (1785), Richard Payne Knight in *Symbolical Language of Ancient Art* (1818), and Baron Grimm in *Teutonic Mythology* (1835–36) all discuss unfabricated or rude rock memorials and circles as if they were inseparable from the chaotic continuum of the desolate districts from whose depths they seem to surface.[6]

Moreover, I would like to suggest that there is an additional, an etymological, clue as to why the particular reality of such unimproved monuments remained mute

Figure 3. Godfrey Higgins, *Celtic Druids, Brimham Craggs,* 1829, pl. 35, lithograph.

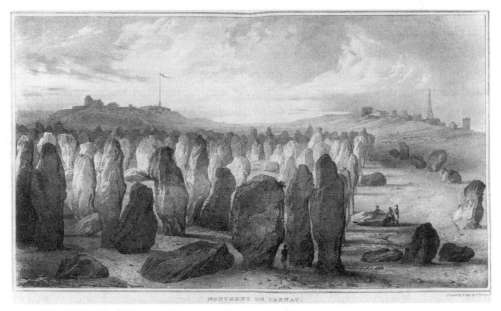

Figure 4. Godfrey Higgins, *Celtic Druids, Monument of Carnac,* 1829, pl. 43, lithograph.

for a classicizing sensibility. On this point, Walter Charleton, in his *Chorea Gigantum; or, The Most Famous Antiquity of Great Britain, vulgarly Called Stone-Heng, Standing on Salisbury Plain, Restored to the Danes* (first published in 1663 and subsequently in a second and then in a third edition in 1725), takes up arms against Inigo Jones's *The Most Notable Antiquity of Great Britain.*

At this point, I would like to pause in order to introduce the somewhat confusing cast of characters in this acrimonious debate. John Webb, Inigo Jones's pupil and relation by marriage, compiled after Jones's death in 1651 a book on Stonehenge, written as if by his revered master but actually reconstructed by Webb on the basis of "some few indigested notes." At the core of Jones's architectural thinking is the belief that design is a rational affair of number, of procedure by natural subdivision. To this absolute mathematical control all invention and, therefore, the art of building are subordinate. The ancient orders were and continue to be controlled by the module. Hence Jones's curious elucidation (via Webb) of the rebus of Stonehenge. When challenged by James I, who was staying, on a progress through the country, with the earl of Pembroke at Wilton in 1620, Jones declared Stonehenge to be Roman. Having surveyed the monument and plotted its plan (he was surveyor-general of England at the time), he had found it to be based on four intersecting equilateral triangles. Not surprisingly, given his affections, this was precisely the diagram that Palladio had deduced, from Vitruvius's account, to be the basis of the ancient type of Roman theater. Therefore, Stonehenge, notwithstanding the barbaric crudity of its masonry, issued, according to Jones, from a Roman mind.[7] This theory, as I mentioned, was developed and published as a book by John Webb with a syncretistic overlay of his own scholarship.

Shortly after the appearance of Webb's compilation of Jones's notes *(Stone-Heng*

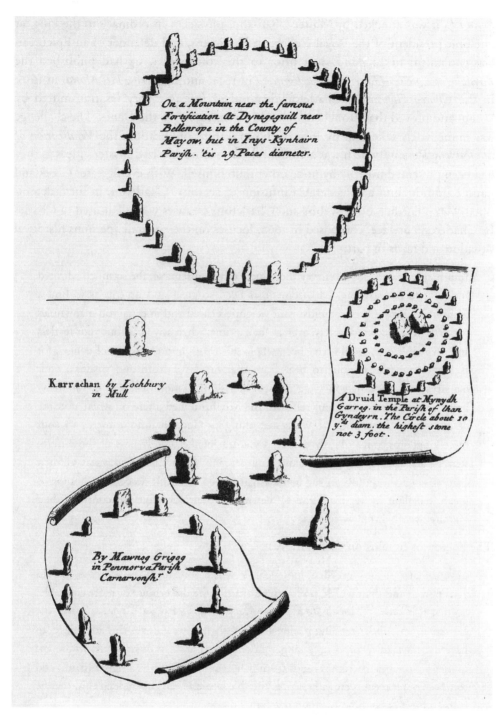

On a Mountain near the famous
Fortification At Dynegeguill near
Bellenrope in the County of
Mayow, but in Inys-Kynhairn
Parish. 'tis 29.Paces diameter.

Karrachan by Lochbury
in Mull

A Druid Temple at Mynydh
Garreg. in the Parish of than
Gyndeyrn. The Circle about 10
y.ds diam. the highest stone
not 3 foot.

By Mawnog Grigog
in Penmorva Parish
Carnarvonsh.r

Figure 5. William Stukely, *Plans of Druid Temples,* 1723, from *Itinerarium Curiosum* (1776), vol. 2, pl. 80.

Restored), it was attacked by Walter Charleton, physician-in-ordinary to the king, at one time president of the Royal College of Physicians, and defender of an Epicurean Gassendianism in England. Just prior to the controversy, he had published the *Physiologia Epicuro-Gassendo-Charltoniana* in 1654, and *Epicurus, His Morals* in 1656. In the *Chorea Gigantum,* Charleton demolished Jones's theory (as transmitted by Webb) and proved that Stonehenge should be "restored" to the Danes. The challenge was immediately taken up by John Webb in a third publication, the *Vindication of Stone-Heng Restored,* which was an ardent defense of his idolized master's ideas as they had been presented initially by none other than himself. With even greater Greek and Latin erudition, and a considerable infusion of acerbity, Charleton, in turn, demolished Webb. Further, both Webb's and Charleton's treatises were dedicated to Charles II. Charleton's preface, composed in 1662, focuses on the concrete, perilous historical situation and reads in part:

> Your majesty's curiosity to survey the subject of this discourse, the so much admired antiquity of Stone-Heng, hath sometimes been so great and urgent, as to find a room in your royal breast, amidst your weightiest cares; and to carry you many miles out of your way towards safety, even at such a time, when any heart but your fearless and invincible one, would have been wholly fill'd with apprehensions of danger, for as I have had the honour to hear from that oracle of truth and wisdom, your majesty's own mouth, you were pleased to visit that monument, and, for many hours together, entertain Your self with the delightful view there of, when after the defeat of your loyal army at Worcester, almighty God, in infinite mercy to your three kingdoms, miraculously delivered you out of the bloody jaws of those monsters of sin and cruelty, who taking counsel only from the heinousness of their crimes, sought impunity in the highest aggravation of them; desperately hoping to secure rebellion by regicide, and by destroying their sovereign, to continue their tyranny over their fellow-subjects.

The doctor, in conclusion, leaves his case

> to your majesty's most excellent judgment, in which you are no less supreme, than in your power; and than which, none can be either more discerning, or more equitable. So that if it prove so fortunate as to receive your approbation, I need not fear the censure of any understanding reader; If not, I shall however gain this advantage, to have my mistake rectify'd by a king, whose reasons are demonstrations, whose enquiries are the best directions unto truth, whose assent always is a sign of truth, and to whose other regal prerogatives an admirable wisdom had superadded this, that he is less subject to be imposed upon than any other man.[8]

In spite of the flattery, the emphasis is on the persuasiveness of rational argument, not on the naked power of unquestioned authority.

But Webb was not going to be outdone if unstinted praise could move the king. He begins his dedication thus and in a characteristic universal and *Latin* vein:

Augustus Caesar will be ever glorious, for leaving Rome a city of marble, which he found ignobly built. Titus, Trajan, Adrian, are eternized for practising all liberal sciences. Henry Le Grand, your heroeick maternal grandfather, designed as well palaces as battels, with his own hand. And your majesty, without doubt, will be no less glorious to future ages; for your delight in architecture, esteem of arts, and knowledge in design, which must be confessed so great as no prince, now living, understands a drawing more knowingly: Not of architecture civil only, but that that conduceth to make your empire boundless, as other your fame immortal, military and maritime also. This I deliver in the simplicity of truth, from experience, by your majesty's royal encouragement of late.[9]

In confuting Charleton, Webb felt constrained to exalt the experience and knowledge of Jones in regard to architecture and, especially, antiquities. Note the ancient bias so obvious from the preface. It is here, too, that Webb terms his master not just the "English Vitruvius," as Charleton had done, but the more timeless "Vitruvius of the Age." He also attempts to explain Jones's potentially incongruous (given his rigorous classicism) admiration for the Tuscan Doric order—the most primitive of the canonical orders (Doric, Ionic, and Corinthian) and the closest to the vernacular. This affection helps to explain his positive attitude toward that even more raw and primitive, or almost "natural," construction of Stonehenge. Jones's apologia (à la Webb) begins by rejecting the traditional association of the mysterious monoliths with the Druids, a pastoral people with no architecture to speak of. Both the proportions of the building and the mechanical sophistication necessary to move and erect its huge stones lead him to conclude that its origin is Roman and its original order, the favored Tuscan. His interpretation stems from a profound conviction that Britain is the true heir of Roman culture, that even in its darkest epoch it continued to speak, as it were, in a classical idiom. This is a point to which I will return. He devised a severe and elegant reconstruction of the building as a temple to the oldest god of the classical pantheon.[10] Parenthetically, it should be noted that in the first two editions, these drawings are rendered by crude woodcuts; the 1725 publication contains elegant engravings.

The purest and noblest example of Roman architecture is thus, paradoxically, established in Britain. Jones's thesis about Stonehenge contains a striking assertion of Renaissance faith. He both classicizes and Christianizes the monument, creating a reformed and purified edifice consecrated to the worship of an autonomous God the Father and the concomitant single, absolutist, ruling authority of the classical tradition in matters of building style.

Let us now examine the argument more closely and understand the seriousness of its implications. To date, the major modern critics who mention this polemic (Sir John Summerson, Roy Strong, J. Alfred Gotch) dismiss it as an aberration in an otherwise impeccably rational career. As we have seen, Jones, the first professional English architect, the founder of academic theory in Britain, the passionate proponent of Vitruvian classicism, sees "beautiful" Roman proportions, a commingling of the rude

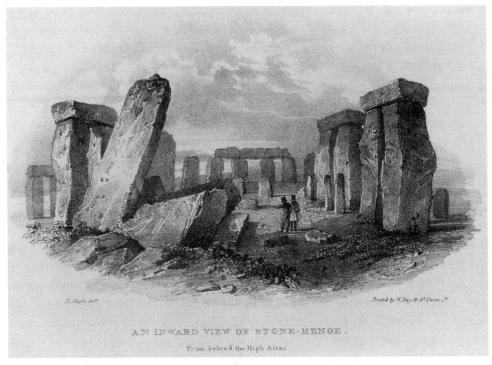

AN INWARD VIEW OF STONE-HENGE.
From behind the High Altar

Figure 6. Godfrey Higgins, *Celtic Druids, Stonehenge*, 1829, pl. 5, lithograph.

Tuscan and the elegant Corinthian orders, evident in Stonehenge. Comparing these "mighty and unwrought" stones to the remnants of Diocletian's Baths, the Theater of Marcellus, and the Circus of Maxentius, he asserts that these "lofty ruins" must once have constituted a stately round temple *(tholos)* that lay uncovered without roof and portico *(dipteros hypaethros)* and that was dedicated to the god Coelus (Uranus).[11] Far from being "a huge and monstrous piece of work, such as Cicero termeth *insanam substructionem* [outrageous, excessive foundation]," Jones concludes that the aspect of these ruins perfectly reveals "the magnificence of the stately empire of the Romans," not the barbarism and illiteracy of the British Druids.[12]

The contrast between the Italianate architect committed to a worldview based on "good authority," "sound judgment," "undoubted truth," and the Epicurean-Gassendian outlook of the sometime president of the Royal College of Physicians could not be plainer. Whereas Jones sails, as he says, "in the Vast Ocean of Time, amongst the craggy rocks of Antiquity, steering [his] course betwixt anciently approved customs, and convincing arguments,"[13] at home with an idealized vision of the perfection of the past, Charleton, as a cultural relativist in the tradition of Epicurus, Lucretius, Montaigne, and the French skeptics and libertines,[14] discusses its present appearance, from which he inductively arrives at its past purpose as indigenous monument and as an ancient Court of Parliament. It is notable that, although Jones surveyed Stonehenge, he rarely mentions its current ruinous condition. Whereas Charleton refers to Charles II's specific and historic visit to the monument, Jones con-

jures up the memory of Alexander the Great, thus looking through a transparent present into a significant past.

Charleton "restores" these "rudely magnificent structures" to the barbaric Danes when they held England in subjugation. This lèse-majesté outraged Webb, who derisively termed the coarse Scandinavian stone circles "tennis balls" and—alluding to Charleton's Epicureanism—"meer atoms." How could this venerable pile of noble lineage be compared to something that looks like that rubbish? Charleton, persisting in obstinacy, returns this type of building to the larger class of "speaking" monuments (significantly prior to late-eighteenth-century discussions of *architecture parlante*) to which it rightfully belongs. Opposing Jones's classical certitude and citing Festus (Sextus Rufus, *De Historia Romana*), Charleton notes that monuments are "inanimate remembrancers," infinitely varied according to the diversity of peoples and customs and the various circumstances of time, place, fortune, and occasion, "so that no wonder if these (as all the works of man) are vastly different among themselves in matter, form, magnitude, artifice, cost, magnificence, situation, and design."[15] Further, citing Varro's *De Lingua Latina*, Charleton notes that the word *monumentum* (translated from the Greek *kenotaphos*) is derived from the roots *moneo* and *memoria,* translatable as "admonition by putting in remembrance." Thus, to be a monument means literally to "speak" clearly to posterity either, first, as memorials declaring that men's "names survive their funerals" (Cicero, *Tusculanum Disputations*) or, second, as a public summons and an ocular testimony "which set before men's eyes" (as a demonstration) the glorious examples of their predecessors.[16]

Yet so acute is Charleton's perception of the difference between past and present that he notes that owing to the vicissitudes of time, the mutations of religion, and other revolutions of fate undergone by monuments even of one and the same nation, it is difficult for posterity to search into the intentions of their founders: "History is silent or full of uncertainty concerning their originals." So true it is "that monuments themselves are subject to forgetfulness even while they remain; and that when neither the writings of men in the same age, or not long after their erection, nor uncorrupted tradition has concurred to give them life, they usually stand rather as dead objects of popular wonder and occasions of fables, than as certain records of antiquity." If you harbor any doubt, he continues, gaze upon Stonehenge: "wonderful" in its "strangeness" of form, "vastness" of rocks, yet such is its fate "that it hath outlived itself and buried as well the names as the bones of those worthies to whose memory it was consecrated."[17]

It is in this speculative philological context that Charleton discusses an odd inscription found on a metal tablet (now lost) but originally buried near Stonehenge, and which William Camden had described in his *Chorographical Description of Wiltshire* (1610, 1637). The English historian insists that it could not have been left by the Romans, who, wherever they went, generally wrote all their memorials "in their own language" and "whose character hath long outlived their Empire, continuing the same in all ages."[18] In a nutshell, of course, this is the paradigmatic definition of what it

means to be classical: the imposition of a timeless and superior beauty on a faulty, entropic nature. This changeless idiom remains identical to itself and persists over time. On the contrary, Charleton—basing his hypothesis on Olaf Wormius's 1643 illustrated treatise on Scandinavian stone circles and barrows[19] and on the Danish scholar's volume on runic writing, the *De Literis Runicis*—concludes that these marks had to be "barbarous" characters: "Literae runae sive gothicae," in other words, the runic or Gothic characters that took their name, he supposed, from the Cimbrians, Dacians, and Goths called Runians. He states that, in his day, this original language had become a hieroglyphic understood only in Iceland. Then follows a key passage: "Elsewhere they have become unintelligible by the mixture of the language with that of the New Invaders, or now worn out and forgotten as the ancient natives were civilized." We may conclude: as with runic letters, so with ruined stones: "time has left only a piece of antiquity," has allowed only "the skeleton or bones of this giant to stand so long . . . and soon extinguished the life or story of it."[20]

My point is that with this equation there arises the opportunity for conjoining conceptually, visually, and linguistically *runae* with *ruins,* that is, of bringing into contiguity eroded and broken monuments that were not "absolutely dumb" with fragmentary letters that spoke in a "more obscure" dialect of nongeometrical figures. By extension, this association contrasts the barbarous, illegible, monstrous, polyvalent, shattered form with the cultured, legible, fixed, classical articulation susceptible to a single invariant interpretation. Moreover, according to Wormius, this runic script had been employed from antiquity on "rocks, stones, wood, horns, bones, or in needleworkes." Stonehenge, however, and its undecorated kin, Charleton insists, have no inscriptions on their upright stones. Therefore, he declares this "forgetful heap" to be a monument "illiterata," that is, inaccessible to conventional formal reading.[21]

Bearing Varro's derivation of the term *monument* in mind, translatable as "admonition by putting in remembrance," it becomes apparent that from antiquity onward, to be a classical monument signified to be *literata,* that is, to seek to deliver plainly "remembrance of some notable action to future generations" or to "incite men to hazardous undertakings." Bereft of "diverse engravements" and "worn out," or shapeless by any classical canon, Stonehenge and analogous "deformities" are, by contrast, I would like to suggest, doubly ruinous: first, because they are modern, that is, unmoored from the past and, hence, from the Jones-Webb point of view, illegible or extinguished from human memory; and, second, because they are grotesque, that is, not possessing a preestablished formal and rational connotation. Thus they are open to constant interpretation and, therefore, always new.

It is not surprising, then, that such primitive artifacts, for which all evidence that they were worked upon (if at all) by human ingenuity is erased, elicited a new and significant form of representation in the eighteenth century.[22] In the combinatorial *capriccio* or *veduta ideata* of Mario and Sebastiano Ricci, Giovanni Paolo Pannini, and Francesco Guardi, classical ruins resemble the disparate letters of the alphabet. Juxtaposed on a unifying surface, they behave as if they were interchangeable and readable

parts combined into an idealized medley of antiquity according to an ornamental principle displaying the operations of the artist's fancy. By contrast, "illiterate" stones are "real" grotesques. Their monstrous fragmentariness coincides with the actual violence done to their initial proportions by the passage of time. Or, to cite Schlegel on the grotesque: they are the ugly details "of a great unity that eludes us."[23] Thus, by virtue of exhibiting itself as a portion of a wholly material and developmental reality, the now-naturalized *macchia*—or artful sketch still in the state of becoming, existing perpetually in the state of the *nonfinito*—and the truly natural ruin or specimens of the earth's history reveal the metamorphic strata lodged within the seemingly most intact of elements. These wild *bozzetti*, existing simultaneously as ruin and as sketch, signify both the destruction of a "mythical" ancient and once complete morphology and the endlessly dissolving processes of nature's temporal operations from which no work is exempt.[24] By definition, the world is constituted of divided aspects, of multiple dialects; it is a protean sea of active matter randomly casting off single exemplars but never supplying the total picture.

The emphasis laid in natural history accounts on the barbaric or shifting phenomenal actuality, on the accidental, on disorder, as that which is truly typical of nature rather than on the stasis of the rule-bound or the civilized, establishes a link between sandy flats on which venerable rock fragments of equivocal origin rise and fall and a forthrightly undomesticated landscape. This is the nub of a much larger issue, namely, the development of modern landscape painting and the rise of an environmentalist aesthetic, that is, of a worldview in which each thing is permitted to speak its own genuine dialect. I cite a single, but telling, example of how an inhuman, "monstrous," or grotesque natural phenomenon achieved aesthetic recognition, that is, became legible. The wracked area surrounding Sicily's violent volcanoes offers a prime instance of a seared and fractured field (represented as furrowed by waves of burning lava) in which the savage and uncontrollable creative operations of the world receive an adequate, and nonpicturesque, representation, that is, are not constrained to speak a rational or geometrical language. My point is that, along with other traditionally defined "aberrant" or irrational effects (eclipses, comets, floods, earthquakes, mountains, in short, the entire "deformed" repertory of nature's nonclassical shapes or vernaculars), volcanoes—as "accidents" within an ideal Nature of perfect forms—provide evidence for the shaping power of matter. The clearings lying near the broken foundations of Vesuvius and Etna mirror the Empedoclean battle waged between man-made fertility and indifferent destruction perpetually going on in the seemingly mild South Italian district. William Hamilton's trenchant descriptions and Peter Fabris's handsome aquatints of the eruptions of Vesuvius observed in 1767, 1776, 1777, and 1779 chronicle the heroic dimensions of this struggle between annihilating nature and shattered culture. Patrick Brydone, in his *Tour through Sicily and Malta* (1770), corroborates the British consul's and amateur vulcanologist's awareness of cosmic battle. Atop Vesuvius, he marvels to see "in perpetual union, the two elements that are at perpetual war; an immense gulph of fire forever existing in the midst of

Ex Museo D. Io. Iacobi d'Annone, Ph. & I. V. D. Basileens.

Figure 7. George Wolfgang Knorr, *Petrified Wood*, from *Recueil des monuments des catastrophes* (1768–75), vol. 3, pl. 3, hand-colored engraving.

snow that it has not power to melt and immense fields of snow and ice for ever surrounding this gulph of fire, which they have not the power to extinguish." Jean Houel, standing on the same summit, is less paradoxical. He itemizes the different degrees of transformation endured by every earthly substance: "Thus all is change: that solid and sterile ice ceases to be such through the fluctuations of temperature in the atmosphere." Crater walls "shatter and the mouth of the volcano alters its position. . . . Hence this shifting opening spews forth its terrifying issue in all directions, and forms

in the end, after having shifted several times, mountainous heaps greatly varied in shape and size, and all the more diverse because the energy that produces them on one side destroys them on the other." Houel's aquatints, like those of Fabris, focus on the battered contours of these colossal fragments that are literally thrust out of, while simultaneously still at one with, an ocean of molten matter and are captured in the very moment of deconstruction. Thus eighteenth-century vulcanology provided additional documentation of the earth's unsettled condition and corroborated the theory that all contemporary phenomena are broken wholes.[25]

But it was Déodat de Dolomieu—after whom the mineral dolomite was named—who, in *La philosophie minéralogique* (1798), provided the most unequivocal statement concerning stones as secular ruins left by change. Coincident with Schlegel's insights about the characteristic, singular, and segmented creations of modern art—the notion with which this essay began—he asserts that history can express itself not only culturally but naturally. And the expression, in both cases, is fragmentary: modern dialects, notes, tesserae, shards, of an original, pristine language now irretrievable. In fact, like the archaeologist scrutinizing discordant physical remains or the artist observing the tide of human affairs (for which there is no certain beginning or end), what the mineralogist confronts in the field is, according to Dolomieu, a "sea of fragments." One never encounters the perfect crystal, only an imperfectly realized, historically determined specimen.

Or, to quote the great French crystallographer, the Abbe Häuy (from the *Essai d'une théorie sur la structure des cristaux,* 1783), although the laws of "crystalline architecture" are such that every substance in crystallizing has a tendency to assume a regular geometrical shape, this particular figure "is liable to be altered by circumstances affecting the process of its formation."[26] This want of mathematical perfection, this deviation from the straight line, this digression from the classical atemporal ideal or primitive nucleus and from the rectilineal or rational, produces "pseudomorphoses" (that is, bodies that have a false and deceitful appearance: the shells and fossils mentioned earlier) or, more generally, "amorphous and confused crystallizations."[27] The polymorphous solids that result, and that "diverge from a common center" when crystalline molecules disseminated in a liquid experience obstacles that affect their tendency to reunite in conformity to the laws of their mutual affinity, constitute a formal muffled alphabet of mutants whose "edges are blunted, . . . faces are curved, pyramids are obliterated." These "grotesque accumulations" can be fascicular, capilliform, globular, or fibrous. To give such unideal and monstrous aggregates a local habitation one has only to look about in nature, according to Häuy, since they constitute the earth's mutating petrifactions and incrustations, the irregular and transversely fractured basaltic columns of Staffa and the Giant's Causeway, the stalactites and tufas of innumerable caverns: "the figures of which vary ad infinitum."[28]

It is precisely this grasp of a general principle of flux, this sense of the primacy of impediment and error, this skeptical awareness of the remnants of matter and the fragility of human beings viewed as discrete units grounded in the inescapable necessities

Figure 8. George Wolfgang Knorr, *Heart-Shaped Shell,* from *Recueil des monuments des catastrophes* (1768–75), vol. 2, pl. 1.

Figure 9. George Wolfgang Knorr, *Petrifaction,* from *Recueil des monuments des catastrophes* (1768–75), vol. 1, pl. 31, hand-colored engraving.

Figure 10. George Wolfgang Knorr, *Dendrites,* from *Recueil des monuments des catastrophes* (1768–75), vol. 1, part 1, pl. 8, hand-colored engraving.

Ex Museo Excell. Dn. Doct. & Confil. Aul. Cafimir Christophori Schmidel.

Georg. Carol Leinberger ad nat. pinxit.

Figure 11. George Wolfgang Knorr, *Marble from Salzburg,* from *Recueil des monuments des catastrophes* (1768–75), vol. 2, pl. 2, pl. 9, hand-colored engraving.

of the conditions of existence, that determines Constable's *Hadleigh Castle.* After the death of his wife Maria in November 1828, he fully developed the motif of two vestigial towers of a "worn-out" fourteenth-century fortress overlooking the Thames estuary. The effect of stormy restlessness, of an environment in transformation—involving the use of broken strokes, palette knife, and divided colors (a shattering of classical order at the pigment level)[29]—is complemented by the presence of "illiterate" fragments, or "whispers" from the past. The derivation is from *ruin-rumor,* an indistinct and informal statement without any known authority for its garbled message. Like runes, these ruins too are the shapeless antithesis of the classical utterance, that well-founded speech which asserts truth clearly and publicly with the full force of antiquity's *auctoritas.* Instead, they have become components in a private language, elusive and allusive metaphors of personal grief scarcely audible at a distance. Architectural remains, still actively being worn down by the ongoing material verge of the present, are also evident in the tumulus *Old Sarum* (1829), in which a once functional and purposed (i.e., literate) city has turned into a naked or monstrous land. Thus human and nonhuman "erasures" are part of the sequence of nature.[30] And in the pensive late watercolor of *Stonehenge* (1836), we note again this dynamic mixture—originally recognized by Charleton—of highly individuated forms arising from vicissitudes: the artifact, man, and the natural phenomenon are debris—stray samples cast down from the past, damaged wholes unmoored from a transcendant standard of absolute beauty and from a single canonical authority. They function both as modern and as barbarous vestiges, stammering the illimitable dialects of an incessantly fabricating earth, liberated at last from the academic illusion of stasis and from a superior, classical, ready-made totality.

Notes

1. Paolo Rossi, "Nobility of Man and Plurality of Worlds," in *Science, Medicine, and Society in the Renaissance,* ed. Allen G. Debus (New York: Heineman, 1972), 2:131, 162.

2. The Schlegel passage is cited in H. R. Jauss, *Literaturgeschichte als Provokation* (Frankfurt am Main: Suhrkamp, 1970), 81–82.

3. Friedrich Schlegel, *Die Griechen und Römer: Historische Versuche über das klassische Alterthum* (Munich: Hauser, 1979), 223–24.

4. Giovanni Pietro Bellori, *Le Vite de' pittori, scultori e architetti moderni,* ed. Evelina Borea (Turin: Einaudi, 1976), 23–24.

5. G. H. Harpham, *On the Grotesque: Strategies of Contradiction in Art and Literature* (Princeton, N.J.: Princeton University Press, 1982), 185.

6. See Barbara Maria Stafford, *Voyage into Substance: Art, Science, Nature, and the Illustrated Travel Account, 1760–1840* (Cambridge: MIT Press, 1984), chap. 2, "The Natural Masterpiece," and *Symbol and Myth: Humbert de Superville's Essay on Absolute Signs in Art* (Cranbury, N.J.: Associated University Presses, 1979), chap. 6, "Sculpture: From Baetyl to *Apollo Belvedere."*

7. John Summerson, *Inigo Jones* (London: Oxford University Press, 1966), 15, 71, 73, 89. It should be noted that when, early in 1725, a new edition of Jones's *Stone-Heng Restored* was published, it helped to reinforce the Roman "Rule of Taste" of the neo-Palladians Lord Burlington and William Kent. It also heralded the decline of Colen Campbell's career and of

the more ecumenical tastes evident in the *Vitruvius Britannicus* volumes on native architecture. See Eileen Harris, "'Vitruvius Britannicus' before Colen Campbell," *Burlington Magazine* 127 (May 1986): 345–46.

8. J. Alfred Gotch, *Inigo Jones* (New York: Blom, 1968), 19.

9. Ibid., 20.

10. Summerson, *Jones*, 107–10; John Harris, Stephen Orgel, and Roy Strong, *The King's Arcadia: Inigo Jones and the Stuart Court* (London: Arts Council of Great Britain, 1973), 185.

11. Inigo Jones, *The Most Notable Antiquity of Great Britain, vulgarly Called Stone-Heng, on Salisbury Plain* (London, 1725), 45–50.

12. Ibid., 21–22; Roy Strong, *Britannia Triumphans: Inigo Jones, Rubens, and Whitehall Palace* (London: Thames and Hudson, 1980), 61–64. Strong connects the Solomonic iconography of Rubens's Banqueting House ceiling (whose program he attributes to Jones) to Juan de Herrera's Solomonic Escorial and, finally, to the mystical geometry of Stonehenge—which Jones supposed was a Roman temple dedicated to the god Coelus.

13. Walter Charleton, *Chorea Gigantum; or, The Most Famous Antiquity of Great Britain, vulgarly Called Stone-Heng, Standing on Salisbury Plain, Restored to the Danes* (London, 1725), 72.

14. Richard Kroll, "Locke's Relation to Gassendi," *Journal of the History of Ideas* 45 (1984): 345–46.

15. Charleton, *Chorea Gigantum*, 3–4. Also see John Webb, *A Vindication of Stone-Heng Restored: In Which the Orders and Rules of Architecture Observed by the Ancient Romans Are Discussed* (London, 1725), 164.

16. Charleton, *Chorea Gigantum*, 2–3.

17. Ibid., 5.

18. Ibid., 22.

19. Olaus Worm, *Danicorum Monumentorum libri sex* (Hafniae, 1643), figures pages 8, 63, 147, 215, 332, 350.

20. Charleton, *Chorea Gigantum*, 10.

21. Ibid., 28.

22. On the monstrous in the sublunar world and the necessity of imperfection, diversity, and error in nature, see Tomaso Garzoni, *Il seraglio degli stupori del mondo . . . cioè de mostri prodigi, prestigi, sorti, oracoli, sibille, sogni, curiosità, miracoli, maraviglie* (Venice, 1613), 64–66.

23. Jauss, *Literaturgeschichte*, 123.

24. Michael Hattaway, "Bacon and 'Knowledge Broken': Limits for Scientific Method," *Journal of the History of Ideas* 39 (1978): 184, 194–96.

25. For the notion that eclipses, floods, earthquakes, comets, and volcanoes are all monstrous effects *(effetti)* generated by matter, which in their ugly imperfection stand in opposition to the Beautiful, see Garzoni, *Il seraglio,* 170. For the inversion of the Renaissance idea that the monstrous is nature unadorned and stands in opposition to the artificial, see Stafford, *Voyage into Substance,* chap. 3, "The Fugitive Effect," in which I argue that such "accidents" were no longer seen as "vices" or "sins" but as the norm and, hence, possessed intrinsic aesthetic value.

26. Frederick Accum, *Elements of Crystallography, after the Method of Häuy; with or without Series of Geometrical Models, Both Solid and Dissected* (London, 1813), 4–5.

27. Ibid., 300–301, 307, 316.

28. Ibid., 299, 305.

29. Malcolm Cormack, "In Detail: Constable's *Hadleigh Castle*," in *Portfolio* (summer 1980): 39–40.

30. Martin Rudwick, *The Meaning of Fossils: Episodes in the History of Paleontology* (New York: Macdonald, 1976), 101.

4. Fountains and Grottos: Installation and the Neobaroque

Sean Cubitt

*Here the path begins gradually to ascend beneath a depth of shade, by the side of which is a
small bubbling rill, either forming little peninsulas, rolling over pebbles, or falling down small cas-
cades, all under cover, and taught to murmur very agreeably*
—Ian Hamilton Finlay

Preamble

We inhabit a new baroque, "at once a technique of power of a dominant class in a
period of reaction and a figuration of the limits of that power" (Beverley 1993: 64). As
in the old, the arts add layer on layer to the geology of allegorical significances, and si-
multaneously discover the vortex of instability at the heart of allegory itself, the native
rock that splinters the palazzo's facade at the Trevi Fountain in Rome. Like the theo-
logical allegorists of the seventeenth century, our phenomenologists throw their hands
up in amazement at the raw immensity of sensuous experience. For them and us,
globalization has produced not wealth but crisis and a retreat from mercantilism into
a quasi-aristocratic distantiation from the world (see Nehrlich 1987), a chaotic splurg-
ing of the superabundant fruits of overproduction in spectacular transformations of
the natural into artifice, and the thoroughly mediated interactivity of audience partici-
pation in the spectacle of its own rule (see Maravall 1986: 75). Though the centers of
each culture are regions of absolute power sequestered from the masses, court, or cor-
poration, their cultural effect is centrifugal and turbulent. Its characteristic forms are
the *cabinet des merveilles* (Stafford 1994: 217–79), the treatise on everything (Ellul
1964: 39–40), the picaresque in the baroque, the road movie, the CD-ROM, the DJ
set (Toop 1995), and the chaotic mosaic of the trip as the apotheosis of transcendental

and infinite communication (Calabrese 1992) in the accelerated modernity of the late twentieth century.

The vernacular literatures of the fourteenth century and the printing presses of the fifteenth should have brought about a new communicative democracy, but the Latin clerisy hung on to the old international language as the measure of their intellectual caste. Just so global English, in a curiously abstracted form (kept apart from rapidly differentiating spoken dialects, in the process of becoming new tongues), provides engineering, transport, and Internet with a lingua franca divorced from local intercourse. That abstraction from the social propels us toward the accretion of ornament and, within that transfiguration of the natural into monumental artifice, toward a rage to control: to gather the entirety of the natural into the artifice of the human. For the baroque, this took the form of the explosion of nature into the human world: for us, its central metaphor is the virus, the irruption of the unholy into symbiosis with the administered efficiency of the modern. Like the baroque, we like to believe that we live in the emergent moment of a new and global civilization, when in fact we live entirely inside the crisis of a culture that, faced with the sudden reality of its other (the "savage" for them, the cyborg for us), is unable either to discover or to disengage its eyes from the empty grounds on which it has built its meanings. The ornamentation of design and manufacture masks our disembodiment, our immaterialism. An obsessive fascination produces the familiar unhappiness, the inability to choose what path to take: the road of absolute power or the woods of utter anarchy. Our arts, like theirs, are the expression of the strife between total order and abject chaos.

Of all the arts, music is most sensitive to the vicissitudes of order. John Cage's response to the crisis in composition provoked his determination to open the edifice of formal music to the entropic, the aleatory, the unconfined. The absolutes of duration and extension, themselves codified by Kant from the logic of Cartesian geometry, Cage subjected to the accidents of an unscorable acoustic world. Yet this represents not only an openness to the other, but a controlling gesture toward the musicalization of the world, a restructuring of contingency around the structured listening of the musical ear. Music has become hegemonic, so that we hear even that which is least musical as though it were "stripped of its associative attributes, a minimally coded sound existing in close proximity to 'pure' perception and distant from the contaminating aspects of the world" (Kahn 1992: 3). The attempt to include the extramusical within music, far from reconnecting music with the world, abstracts the world's sounds from their materiality, bringing them into a world of pure meaning, but a world that, because of its very purity, can no longer signify. This satisfactorily Zen conclusion, however, generates only a central void, around which the musicalized objectivity of the world is forced to evolve its ever more arcane extrusions of noise over silence. In what follows, I want to suggest that the baroque had found certain techniques of working with both sound and the immanent collapse of meaning; techniques that inspire material aesthetics, indicating exits from the impasses of accelerated modernity's new baroque.

The Emblem in the Garden

The absurd, the obscene, and the mysterious return as the repressed of the enlightenment, the necessary resistance spawned by domination. As modernism ascends the Kantian path of medium specificity in Greenberg's account (1965: 193), so it generates surrealism, propaganda, and pornography. Neoclassicism and the neobaroque are the oscillatory poles of the contemporary as it navigates through the aporias of community: one thinks of Jeff Koons. In the contemporary, and for much of the century, we have eschewed allegory as bloodless abstraction and favored either abstraction itself or realism or iconographies without definite semantic reference. But despite the materialist claims of these strands of modern practice, abstraction, realism, and surrealism have shifted toward a kind of metaphysics, a displacement of meaning toward an elsewhere that is only compounded when cultural relativism sites it in an audience or a culture. The notorious Paris exhibition *Les magiciens de la terre* can function as exemplary neobaroque in its metaphysics, its immaterialism, its deferral of meaning to the place of the other, and its enchantment with the sensory superficies beneath which it presumes an enduring but always absent monad. Shamanism has become the chinoiserie of the late twentieth century.

As musical serialism and later minimal art sought, through multiples and rule-governed series, to annihilate the hierarchies that guaranteed the domination of the semantic, semantics as domination, they posed the question, increasingly pressing for a potentially globally networked society, not of meaning, but of the conditions under which meaning may become possible. Deprived of metaphorical thought, they reach a bleak plateau of insignificance. Stressing the techniques by which they produce themselves, their democracy becomes the fragmentation of the encyclopedia, but allied to a baroque sensuality of the pure object, its eroticism (see Lippard 1968), and, in the endlessly repeated fetishism of the thing, the minimal and serial achieve a decoration of the void. But these Eurocentric traditions of late modernism fail to negotiate the complex interweaving of the sensual and the conceptual, and in the binary opposition of these categories, are debarred from apprehending what it is to inhabit meaning, and be inhabited, in an age that has apparently abandoned it.

Ian Hamilton Finlay's garden at Little Sparta in Lanarkshire can suggest some initial understandings of what might be sublimated from the crucible of the baroque if the prejudices against ancient forms can be sloughed off. Stephen Bann (1977) notes of some of Finlay's print works that they are powerful reincarnations of an aesthetic that advancing rationalism had plowed under: the tradition of the emblem. These succinct combinations of image and motto throve in the baroque and are still apparent, however etiolated, in the language of corporate logos, albeit, as E. H. Gombrich notes of public architectural usage, by the nineteenth century "they had acquired the faculty of making themselves as invisible as the abstractions they were supposed to symbolize" (Gombrich 1972: 183).

Gombrich unearths the roots of the emblematic in a sermon given in 1626 by a

teacher of rhetoric, Christophoro Giarda, which describes how God, unable to make visible to the dull senses of men the radiance of His virtues, "spoke—and with a word all the elements, and within the elements all the species of things . . . He turned into so many Symbolic Images, as it were, of those perfections and made and designed them all at once and presented them in the Library of the Universe, or if you prefer so in this theatre, to the contemplation of man" (cited in Gombrich 1972: 148). In the emblem, the representation of an animal, a tool, an effect of the weather becomes an allegory of potentially stunning complexity, rising up from the most sublunary to the most sublime, its very simplicity a Platonic marker of its approximation to the divine. Finlay's one-word poems of the 1960s paved the way for his remaking of this tradition in the context of his secular, ecologically informed remaking of the poetry garden.

At Little Sparta, among the ponds, plants, and trees are small, mainly stone ornaments and inscriptions (photography tends to give them a monumentality they do not in general possess). Many of them pursue Finlay's self-proclaimed "neoclassical" interest in the history of European rationalism. Others, more germane to the topic at hand, carry simpler evocations. On one tall, slender tree is the plaque "I SING FOR THE MUSES AND MYSELF," a phrase quoted by the apostate emperor Julian from the musician Ismenias, at once a traditionalist statement of dedication to the muses, an act of independence, and a statement on behalf of the tree itself. It is possible (though I can find no documentary evidence) that Finlay is a believer in the actuality of the Muses. What is clear is that the plaque acts to emblematize the tree. The tree is no longer purely itself, though it retains its living sap and its discrete position in the garden as itself. It has acquired in addition the function of meaning, and in payment for this burden of signification, the song of the wind in its branches has become an art.

Another plaque, in a grove of birches, reads "THE SEA'S NAVE/THE WIND'S SHEAVES." Here the punning of sea and tree familiar throughout the garden, of architecture and harvest, are woven into an auditory pun, in which the onomatopoeia becomes integral to the susurrus of the leaves. Finlay so involves his garden not only in the restitution of the lost art of the emblem, but also in the reintegration of sound and word, sound and image, sound and referent. Heard from the position of Douglas Kahn cited earlier, this suggests also a retrieval of a further art outside the hegemony of music. The baroque garden was a place of water, of fountains throwing rainbows in the sun, of gurgling, bubbling rills, splashes and plashing, drips and trickles: Finlay's trees, and his own fountains and streams, articulate not only a remaking of the ancient arts of hydraulic spectacle, but their articulation with the word as spoken and heard. This is no logocentrism. These are the voices not of the reader, certainly not of the poet, but of the grove itself and, in its rhyming with sea and field, of the wider ecology beyond.

Such emblems have four elements: the carved word, the living tree, and the sounds of tree and word. Here the tree and its sound are "real," neither recordings nor representations. But both are artificial in the most ancient sense, crafted so that we may experience them as filled with a human, if not a commodifiable, meaning. In fact, the very humanity of their significance deprives them of associations with a creator, if

not with the sacred, and links them to Andrew Marvell's oceanic "green thought in a green shade" ("The Garden," line 48; Marvell 1976: 101) and Ben Jonson's dreamy pastoral where "The soft birds quarrell in the Woods / The Fountaines murmure as the streames doe creepe, / And all invite to easie sleepe" ("The Praises of a Countrie Life," lines 26–28; Jonson 1954: 252). I do not want to interpret Finlay's work, certainly not as linked to the pastoral unconscious of the English baroque, but to point out a specifically rhetorical aesthetic here in which the emblematization of the living wood allows us to hear it likewise neither as music nor as nature, but as an element of a metaphorical ensemble in which the imagination of the real becomes a poetic zone, "commencing in delight and ending in wisdom." This stands at a stage between the (Cagean) myth of a naive and pure perception and the mediation of a recording, photo- or phonographic, a critique of the natural or the industrial sublime.

The word of the emblem opens a channel between mark, sound, voice, and image. In supplanting image with green things, Finlay's garden renders a meditative, pleasant and instructive space in which these orders of knowledge are not so much challenged as invited to play in a different mode of reverberation and echo. This is a sound art that restores the renaissance sense of "wit" to "Alberti's dictum that *statuae ridiculae* (humorous or funny statues) were appropriate for a garden [where] play combined with the unexpected" (Lazzaro 1990: 152). For Nicola Salvi, architect of the Trevi fountains in Rome, fountains and their waters "can be called the only everlasting source of continuous being" (cited in Moore 1994: 49): since Heidegger, our being has become becoming, and the everlasting conquered by the fleeting. Salvi claimed indefinite wisdom: at Little Sparta, the fountain has been appropriated to wit, where Finlay's best-known exemplar is cut in the shape of a dripping aircraft carrier on which, occasionally, some waterfowl perches. The intermittent trickling sound surrounds the stone ship with an other world, the unexpectedness, the hard illumination of metaphor.

The Monstrous and the Monstrance

Freud recounts the story of a man who finds sleep after his son's death and who dreams that *his child was standing beside his bed, and caught him by the arm and whispered to him reproachfully: "Father, don't you see I'm burning?"* (Freud 1976: 652; emphasis in original). Among the functions of the dream, for Freud, is the apparent return of the son to life and to his father's side. When he awakes, he finds a candle has fallen onto the bier and the boy's winding-cloths are alight. Flame, fire, raises the dead, if only for an instant: the instant before we wake.

What does the Wimshurst generator, central device of Judith Goddard's installation *Reservoir* (1993), resemble, in silhouette, in its moment of stillness, if not the monstrance, the golden sunburst about a crucifix in which the Blessed Sacrament of Catholicism is carried when it is shown (Latin: *monstrare*) in the ceremony of benediction? The monstrous nature of the Eucharist is its categorical impossibility, a com-

bination of bread and Godhead, the sacramental presence of the divine in the humblest of foodstuffs, and that the Son of God would have died to return to his Father. In its baroque solidification of light into gold, it tempts with transgression of divine boundaries. The monstrance of the Wimshurst arcs, and in its light we seem to see the momentary passion of God for his creation, which is all and more than we can stand of God's love. "The conquest of the superfluous gives a greater spiritual excitation than the conquest of the necessary. Man is a creation of desire, not need" (Bachelard 1967: 34). This is the relation of the secular to the sacred.

It is monstrous that God should devote his love to us: it defeats our understanding of nature and insults reason. But such too is the flash of the senses in the senseless moment of conception to which all dreams of fire, following Freud, are condemned to refer us. And monstrous to demonstrate that impossibility, a Faustian travesty of nature to make fluid electricity from static, to mime the crack of creation from the rubbing of resins, to make a miniature of the awesome lightning of God's hand, the thunder of his voice pronouncing the first words: "Let there be light," the words that Edison first dreamed of recording when, in Villiers de l'Isle-Adam's 1881 story *L'Eve future,* he preempts the cinema with his talking automaton (see Michelson 1984; Bellour 1986). The *logos* is sound giving birth to light: in recording, their simultaneity is their magic; in the emblem, their disjunctive concatenation is their poetry.

But here, as the millennium turns, the divine is as remote from us as from the graving needle of the phonograph. Marina Benjamin describes Goddard's installation succinctly:

> In a white space, a Wimshurst machine enthroned in a perspex case faces a projection of a waterfall whose deep roar fills the air. The Wimshurst's majestic stillness is broken only when the beam-breaking viewer crosses an invisible threshold. Then it comes to life, with a smart industrial snap, producing electric sparks, that are instantly magnified and projected in place of the water from the Villa d'Este. In a black space a trio of ceiling mounted water drips release droplets one by one onto a metal tray passing time. When the beam-breaking viewer triggers a strobe, the light transforms the water drops into iridescent jewels that appear by turn to be suspended in space and to travel upwards in defiance of gravity. To one side of the space a trio of 3" LCD monitors broadcast the familiar trace of an ECG, the human equivalent of the disembodied spark, and every so often the transient, flickering image of a gender reassignment operation wipes over the three screens. (Benjamin 1996: 68)

We think of accidental things: the contingent storms striking obliquely on the accidental slime that first knit molecule to molecule at the threshold of life. Or more erratically trace our primal tale to Mary Shelley's Promethean (forever overlaid with James Whale's psychopathic) Dr. Frankenstein among the swagging clouds, beckoning the spark of life into his ill-assembled New Man from the tumult overhead. The electrical spark, the flash of an instant fecund with futurity, is our most powerful emblem of beginnings: not fear, but terror, reason's complement.

The beginning of video was monstration, the act of showing, as it was for the cinema (see Gunning 1990; Burch 1990: 162–85). The exhibition is exhibitionist. But in *Reservoir*'s space, the showing includes, as cinema does not, the illumination of the visitor, instantly promoted from spectator to participant, not because by breaking the beam she triggers new actions, but because projected light illumines and makes visible the viewer with the viewed. Video drags us back from the darkness into the originary light. Meanwhile the sudden whirling of the machine, the clattering of the strobe, the spark and its amplification in light and sound become again emblems, rhetorical moments of a complex never quite in sync with itself.

Here are not just flowing images of water, electronically mediated, but actual water, and electronics operating in the same space, signaling danger because they are dangerous. But wet electricity is the elementary human body, which the installation draws into audible visibility, even as it unpacks its sources: it is our bodies, at their conception and in their workings, that are dangerous, and whose delicate waterproofing is at risk and in question.

Of all our emotions, fear keeps us most profoundly in touch with the world, even as it teaches us to flee from some part of it. Afraid, we no longer contest the world's claims over us, and so recognize the materiality of our bodies, the *physis* we share with the world, even when it appears sometimes so alien and far away. At the same time, though, you realize that the world is not as innocent or natural itself, but is already changed by its contact with our species. If I were tempted to psychoanalysis of water, and to the sort of daydreams that an angler has beside a deep, slow stream, seeking the maternal metaphor to pair with God's paternal roar, I'd have to disturb my charm with the reflection that in this work are no rivers or lakes, but only fountains, the artificial taming of the flow.

The articulate and organized flow of water is the human world manifesting itself in imitation and recreation of the natural, and thus an even fitter metaphor for the currents that power the machinery of the piece, not harnessed so much as poured into conduits, channels, flows. And interrupted. A curtain of water in video projection and the three drips whose fall, every now and then, is interrupted by the stroboscope and reversed are transmutations of water through the fire of electricity, and in their combination is the germ from which begins the process culminating in the viewer (viewed).

Dispersed among these elements, the body is itself no longer legible as the origin, which for so much of contemporary Western society it has become. This body too can be dissolved, as easily as your attention and sense of self can be dissolved into the flow of water projected in the first chamber of the work. Mesmerized by the flow of water and images, dissolving in their ambiguous motion up or down, the body is no longer anchored. In the second chamber, the droplets, like the *stella maris,* ascend in spite of gravity into the empyrean, emblems of the Mother Gods.

Transverse, the flash of creation as it slashes across the continuum of mat(t)er; transverse the heartbeat of the electrocardiogram, though held in its place by wires in vertical tension echoing the fall and rise of water, and flashing once and once again

the documents of the human hermaphrodite, the vulnerability and instability of sexual identity before the surgeon's knife. The ease with which at first you want to make a sexual sense of this primal scene disperses as it is delayed, like the sound of the drips caught, amplified, delayed, and treated, difference deferred as identities are multiplied, not endlessly, but enough, at the place that coy doctors call "the waterworks."

No understanding can come from within. Knowledge is dependent on the interplay of the world and us, and for that knowledge to have power and meaning, we cannot split it between us and the world, subject and object. We must put our own existence on the line, if we would learn from the green world or what we have made in it. Then knowledge, too, should fill us with holy dread and prescient fear, as it did our first parents in the Garden. That garden, too, was super-natural, nature made orderly and laid out for its creatures, an Eden that the gardens of the Villa d'Este, like so many others, yearned to evoke. But where they sought to tame nature into suitable guise for humans' consumption, Goddard's garden of electronic delights seeks to reorganize perception into the shape suited to these objects.

If technology can be accused of placing a medium between us and the world, still we must accept that experience, upon which all knowledge must be built, continues, and that that experience must be an experience of the technological. There is a technology that has shaped the woods and fields as much as the roads and houses, each mired in deep with history—a quality of time of which nature was always by definition ignorant. Indeed, if anything, only ignorance is natural—and to be avoided as such. The same technology that makes the landscape picturesque and birds sing has shaped our own perception. Not only our world but the frame through which we look at it are technological, and it behooves us thus to undertake a prolonged and difficult meditation upon what the technologies of experience and perception are, not in pursuit of some lost pastoral or religious moment of natural ignorance, but because we must recognize the possibility of constructing that relationship anew. It's no novelty to argue that even our own bodies have been technologized, or that sexuality has been instrumentalized and remade in the image of a world order in which oppression can be mapped from class to gender or vice versa. To unfix the social ordering of sex, the still potent mythologies of gendered creation and origin, to re-create the creation of subjectivity in the technological: these are good works to undertake, better to achieve.

The roar of a cascade at Tivoli is transformed not only by recording but by the specific acoustics of the space in which *Reservoir* is installed, as is the sound of the three drips. The sound art of water "taught to murmur" is modified in the age of recording, amplification, and broadcasting, seeming to secure a sense of purpose even in the pursuit of tranquility. Here the amplification and the transport of sound from one place to another is anchored to the physical presence of sound sources, not to diminish the recorded, but to place it as itself a mode of flow, across which the sudden crack of arcing voltages functions in a complex allegory of the natural and the scientific, the rational and the metaphoric. In its way, it too is a garden: not a retreat, to

paraphrase Finlay's *Unconnected Sentences on Gardening,* but an attack. It assaults the human body, splitting it abruptly into its emblematic constituents, and inducing its sense of terror with surgical exactitude in the secular mystery of the living auditor.

Electricity, Scent, and Sound

The emblematic inhabits Rachel Whiteread's *House* (1994), an *impresa* also in the literal sense of an imprint made of the interior of a house subsequently demolished. The intensity of memory evoked in touching the meticulous trace of weathered interiors, like the cellular memory you have of furniture from childhood or of forming chords on a much-loved but forgotten musical instrument, locates the specificity of this house as the beginnings of an allegorical exploration of the metaphorical structure of the concept "house." Similarly, it washes through the connection between water and electricity in the exposed cabling of installations by Susan Trangmar and Chris Meigh-Andrews.

In Meigh-Andrews's *Streamline* (1991), where structures of intertextual connotation are played as malleable memories, the flow of images and electrons is mimicked in the reversing flow of water along a stream of monitors. But here a problem in the aesthetics of sound recording becomes urgently apparent. When the image reverses direction, the sound retains its linearity. At this point, it is severed from its indexical function, which it shared with both recording and the photographic: "What we have is a new space-time category: spatial immediacy and temporal anteriority, the photograph being an illogical conjunction between the *here-now* and the *there-then*" (Barthes 1977: 44). That illogicality is uncoupled in the leap the sound makes away from the image. The metaphorical structure breaks down. The piece is condemned to comment on and resist a logic of representation and intertextuality, rather than build a new metaphor.

A related failure dogs the epic construction of Douglas Gordon's *24 Hour Psycho* (1996), in which Hitchcock's 1960 *guignol,* transferred to video, is slowed down to fill a day, projected on a big, translucent screen so you can walk around it, see its obverse, and contemplate the minutiae of its mise-en-scène with the attention of an iconologist. The artist (in conversation) explains that he wanted specifically to use only domestic equipment to build the image, ruling out the possibility of slowing the sound track to match. As a result, not only do we lose the pursuit of the cry in Bernard Herrmann's score (see Kalinak 1992: 3–16; Chion 1992: 135–37) and the constructions of interiority and eavesdropping that power the film (see Weis 1984); we are also plunged into Maxim Gorky's "realm of shadows" (appendix to Leyda 1983), the primal scene of the movies as simulacrum, ghosts without color or sound, pure signifiers on a fatally linear course. Again, like *Streamline, 24 Hour Psycho* can only, as a result, elaborate a metacommentary on the movies, without dispersal of slowed-down sound into its constituent rumbles and, specifically, without an inversion of the sound track comparable to the reversal of the image, so losing the serialist democratization of the

image-sound hierarchy as well as the possibility of investigating the metaphorical structure of recording. (For an example of such a metaphorical structure in amplification of performance art, see my analysis of Laurie Anderson in Cubitt 1994).

The resources available to us include refusal of the notion of modernity, and especially the conception of modernity as crisis. As an aesthetic strategy, the result can be astounding: the work of Daniel Reeves, an American resident in Scotland, is able to draw on that most secular of religions, Buddhism, to define a natural organization of space and time, through the use of organic materials (wood, stones, rice, water) and images of landscapes and animals. The result, as in his 1990 installation *Eingang/The Way In,* is of time and space in harmony: impassive, gorgeous, it looks and smells delicious, and returns to the gallery the possibility of an ecological relation to the world from which too much of modernity has severed most of us. One thinks of Wilfrid Thesiger, the great traveler, for whom the only invention worth taking on his explorations was the camera, or of Sam Peckinpah, for whom the modern world's only saving discoveries were cinematography and six guns. A sense of nobility disengages itself from the work, a sense compounded by the Rilke poem on which it draws, which reads in part, "Whoever you are; some evening take a step / out of your house which you know so well. / Enormous space is near, your house lies where it begins" (Rilke 1981). Unburdened by Rilke's philosophical engagement with the "death of metaphysics," Reeves can read the poem as a modern route to the unknowable sublime, immanent as the sky is omnipresent. Reeves's work is a grotto in the garden, a place of retreat.

A second route involves a change of direction within the problematic of modernism. The German critical theorist Jürgen Habermas formulates the issue thus in his critique of the philosopher of history Michel Foucault: "To be sure, as long as we only take into account subjects representing and dealing with objects, and subjects who externalise themselves in objects or can relate to themselves as objects, it is not possible to conceive of socialisation as individuation" (Habermas 1987: 292). If a central characteristic of Western modernity has been the construction of a self-reflexive subjectivity, a human thought that can reflect upon its own rationality and in doing so take itself as object, and if in doing so, such a subjectivity is also bound into a dialectic of subject and object in all its dealings, not only with itself but with the world, then it is incapable of genuinely understanding the processes of modernity as relationships between subjects, between people. Such is the philosophical kernel of the aesthetics of art's autonomy from Kant to Greenberg and the source of its impasse at the high point of modernist art practice. One can either move backward toward the magical recovery of a lost union with the world or one can move forward by insisting that the production of such a subjectivity is a historical and therefore a social construction.

At the moment that you recognize the existence of another subjectivity, you enter the realm of the ethical. In Keith Piper's *Trade Winds* (1992), in which packing cases reveal the dismembered body of an African bound to the diaspora of the slave trade and migration, the notion of identity is itself put through the mill of ethics. To cry

out for a postmodern amorality seems to me premature, and dangerously so. In Piper's work we see globalization as the continuation of empire by other means, a continuity unmarked by epistemological breaks or historical rupture. Like Reeves's *Eingang,* Piper's *Trade Winds* filled the gallery with the smell of wood, but where Reeves used monumental sections of trunks from storm-damaged trees, Piper's were splintery, rough-finished packing crates, their smell not the promise of a persistent nature awaiting our return but the fading scent of home as it is turned into another exportable commodity, like the scent of spices fading in Rita Keegans's *Cycles* (1992). Piper's installation mourns the disintegration of African roots in the process of diaspora, equating the dispersing scent with the constantly fading phosphorescence of his digital images. But it may also be read—against the grain—as a variant on the fountain, as the splattering scintillation of light and scent into a world outside the rough-hewn boxes, and with a more complex understanding of the genocidal as the unnecessary, contingent, brutal condition of a modern subjectivity, a modern ethics.

To the extent that the work thrives on its odor, part of the sensorium we have yet to mechanize, its scent hauls us into the present's ephemerality; to the extent that it collides recorded and manipulated images and sounds with the haptic and the internal organs of the sense of smell, it matches the material with its histories. Those histories include an act of global barbarism that made the modern and that forms the unavoidable conditions for the existence of the work. It is in such a moment of dark meditation that the material technology of metaphor makes itself apparent. The neobaroque has made its own the old baroque's disjuncture from the world, yet in the debris of history it is still possible to make a bricolage from the shards of a forgotten art, itself ruptured by Platonism, to discover in its efficacy ways we might understand our new relationships.

The Future Sounds

Vaucanson built a duck. It was the talk of Europe in 1741. It ate, defecated, walked, and quacked like a duck. It was an automaton, and with his flute player and whistling drummer boy, was one of the most celebrated of a day that reveled in aimless invention. Vaucanson was something of a celebrity, and rather than lose him to Frederick the Great, Cardinal Fleury gifted him with the inspectorate of silkworks. Vaucanson not only accepted the sinecure: he set about improving the silk mills, his inventions forming the basis of the Jacquard loom of 1804, itself, with its punch-card-governed machinery, a prototype of the computer (Giedion 1948: 34–36). Like Babbage's difference engine in an age of swift returns, Vaucanson's mill failed to take root under the Catholic and absolute monarchy. He survives more frequently in histories of automata and simulation. Yet there is something remaining in D'Alembert's homage to him of the marvelous materiality of the things he made. The proof of these Cartesian devices was their breath: their ability to sound.

Such was the apogee of fountain design: that fountains might neither merely emu-

late the natural nor guide it toward artifice, but give to the garden the voices of instru-
ments and people. Hidden devices transformed the running water into cunning repli-
cations of hunting horns and laughter. In an age without recording, they formed a
fixed, repeatable repertoire of sounds, in the meeting of water and air where the voice
is. Elaborated beyond the sound arts of Tivoli, the fountain became an element of
technique, a site for marveling at the ingenuity of men and the wealth of their pa-
trons, a commitment of the fountain to the arts of music. So the fountain began to
lose the structural power of metaphor, to tumble into the banality of abstraction, and
its moment at the cusp of crisis, between the human and the natural, dissolved.

With electricity, we have again a miracle in our midst. That light, music, TV, and
the telephone have become all but necessities of urban life cannot remove the wonder
that can still overwhelm us when, faced with Goddard's *Reservoir,* we glimpse the un-
earthly powers that snake through our conduits and weave themselves into our most
intimate lives. Only the fear we have of nuclear power stations still recalls the awe
with which the 1920s viewed the Battersea power station or Edison's laboratory. Yet we
have not, since the days when the roar of Nikola Tesla's arc generators could be heard
ten miles away, discovered the fountain's equivalent for this mysterious force. Perhaps,
like our forebears, we find this fluid so precious that we content ourselves with electri-
cal and electronic irrigation. The marvels of the shopfront display and Coney Island
have faded into our background: perhaps because they existed only to celebrate wealth,
not themselves (see Williams 1982; Schivelbusch 1988; Marvin 1988), they came to dis-
enchant not only the night but metaphor itself. Nowadays, we turn to the archaic,
baroque chinoiserie of the firework for our most spectacular celebrations. And where
the electric still amazes us—perhaps approaching an oil refinery at night, or in some
crazy laser display—it is the vision, not the sound, that catches our breaths.

The claims of the radio arts (see Kahn and Whitehead 1992; Strauss 1993; Augaitis
and Lander 1994; Weiss 1995) are powerful incentives to an understanding of the ways
in which distribution technologies have altered our relation to the electrical. But the
conditions under which both radio and electricity have been delivered to us as largely
domestic and even individualized consumer goods have curtailed their possibilities.
Radio has become largely a medium for distributing materials produced beyond
broadcasting: a medium for discrete programs, just as electricity is the medium en-
slaved to devices that replicate older machines—cookers, brooms, candles, typewriters,
pianolas. The tyranny of the Cartesian walkman and the in-car stereo has transformed
sound's distribution into consumption. As with computing networks, the struggle is
not just to gain access (access to what?) or to remedy the content (why create a better
Price Is Right?), but to reengineer the machinery that defines consumption as con-
sumption, as technique of individuation and domestication enforced by the headset
and the multiple private radios that populate so many homes.

How are we to know that we are in the broadcast world? The telephone and radio
monopolies bifurcated over the cartelization of one-to-one and one-to-many trans-
mission: there is no many-to-many. We want the Internet to be this democratized zone,

but anyone knows how it reproduces the formats of magazines, TV, and library cata-logs, how impoverished its soundscapes are, how narrow its solo windows at the ter-minal. We do not know what a network sounds like. You might buy white goods—fridges, say—on the basis of their hum: not many do. We are happy to select them for their efficiency and looks, but not their sounds, which we will live with for decades. But then, with other, more carefully marked machines, we have an aesthetic: the purr of a well-tuned bicycle or a 16mm projector, the precision of a clicked shutter are plea-surable things that have their own beauty. The machines that tend to be so marked for us are the machineries of transport and communication, the sounds of networks, however mundane—even the flush of a WC can satisfy. What we hear is the perfect functioning of the support.

And its opacity. Critically, the support is a physical entity, as the frame, the moni-tor, the walls are integral content of installation art. In effect, the support is a system, the conditions for the existence of the work. Before hearkening to its semantics, a critic should refer to the conditions of a work's meaning, its systemic positions in the webs that make it possible. The sounds that support networked distribution—boot-up warnings, error signals, the hum of the hard drive—are extrinsic. Not only do we not listen to them: they are terminal sounds, not network sounds. Alternatively, the hum-ming and thrumming that electromagnetic activity induces in cables are extrinsic in that they are present at neither terminal. Stellarc's *Ping Body* performance (1996), like other of his recent networked body pieces, begins to point in a direction that might make these connections sound. The artist's body becomes a feedback loop integrated with the network, responding to and emitting signals attuned to the bulk, rather than the semantic content, of network traffic, the body wired to connectivity, systemic. An indication of the missing sound support, the hyperamplified and distributed whine of the central nervous system in *Ping Body* argues that the elements of a body are already a webwork and connected to galactic powers.

The obverse of Stellarc's optimism is audible in Mona Hatoum's installation *The Light at the End* (1988). This is a pared-down, near-minimal work, a narrow passage, the end of it illuminated by fine vertical electric filaments that, as you approach, are warm, hot, burning; that give off the odor of that burning household dust which is sloughed-off human skin cells; that hum. That Hatoum is a Palestinian woman in exile makes you draw on lived experience, establishing the viewer's innocent-yet-knowing connivance in its structure. But the suddenness with which illumination be-comes threat unleashes an aesthetic double bind that leaves the work reverberating with the unlivable but inescapable dialectic of the torturer. This too is an emblem, a metaphoric structure built on the finest possible statement of its theme, elliptical as a motto is elliptical. It speaks of its support, of electricity as the web in which we are caught, that same fluid that illuminates our art and burns their skins, the prison at the end of the tunnel. This is one of the rare works that integrates the senses into a punc-tual nub, and so insists on the finitude of embodiment, its weakness, its vulnerability. Against the body, any body, that uninterruptible, unchanging, incorruptible certainty

of electrical supply. If any single work can endstop the endless dragging of the banal into the light, it is this cul de sac where the light scorches and the frame has become the art, an art of framing, of holding within the frame the innocent viewer who has only come to seek entertainment and has become art's victim.

I want to end with a note of hope, with some sense that we are, after all, only at the beginning of a networked world, that the sins of globalization (only, after all, a polite name for imperialism?) may not be visited on the heads of the children. I find it hard. The Internet itself should be the installation that we seek: immense, global, collaborative. But its spaces have become like land parceled up and ready to be allocated to the homesteaders. Hatoum's dark electric wall severs us from the infinite extension of space that so transfixed the baroque and sent the seventeenth century spiraling upward through trompe l'oeil ceilings illuminated by the sudden naturalism of God's and Galileo's universe: her mid-1990s video projections precipitate instead a fall into the floor. There is the terrible pessimism that murmurs of all that we have not yet heard and may never hear, the burial of evolution under the vast certainty of business and administration. There is the terrible fear that the net is a snare and we are flies in a world wide web, that they will pave over the carefully nurtured garden to speed the traffic of juggernauts on the superhighway.

What is there beyond this Alexandrian repository of dead knowledge and printed phone calls? Certainly there will be technical advances, and equally certainly the system will be buried under what it contains, its lines of potential encrusted with ornamentation. It is no longer the soul in nature but bodies in the network that must occupy us. It is now that we have to ask of the electric, electronic, and distributed world, what is it that you want? The answer will come back to us, if we can learn to listen, as metaphor, or rather, as a structure of metaphor. The splendor has gone out of the world since Frances Quarles could write in 1635, "Before the knowledge of letters God was known by Hieroglyphicks: And, indeed, what are the heavens, the Earth, nay every Creature, but Hieroglyphicks and Emblemes of His Glory?" (cited in Martin 1977). What God was, our networks are. If we are to entertain the dream of entering them, the dream of a mediated world in which people are the medium, then we must escape the commodity fetishism that assures us that the world is a relation between things. But before that great installation can be commenced, there are immense and practical arts of the social to be achieved. We have yet to secure the free flow of water to the world. If we can handle water, perhaps we will be allowed to handle electricity.

References

The epigraph comes from the inscription on a garden bench by Ian Hamilton Finlay at The Leasowes in Wiltshire, with a text derived from Robert Dodsley's *A Description of The Leasowes*, his 1764 account of the garden made there by William Shenstone, the poet-gardener.

Augaitis, Daina, and Dan Lander, eds. 1994. *Radio Rethink: Art, Sound, and Transmission.* Banff, Canada: Walter Phillips Gallery.

Bachelard, Gaston. 1967. *La psychanalyse du feu.* Paris: NRF.

Bann, Stephen. 1977. "Heroic Emblems." In *Ian Hamilton Finlay: Collaborations,* 9–11. Cambridge: Kettles Yard.

Barthes, Roland. 1977. "The Rhetoric of the Image." In *Image-Music-Text,* ed. and trans. Stephen Heath, 32–51. London: Fontana.

Bellour, Raymond. 1986. "Ideal Hadaly." Trans. Stanley E. Gray. *Camera Obscura,* no. 15 (fall): 111–34.

Benjamin, Marina. 1996. "Reservoir." In *A Directory of British Film and Video Artists,* ed. Dave Curtis. London: Arts Council of England.

Beverley, John. 1993. *Against Literature.* Minneapolis: University of Minnesota Press.

Burch, Noël. 1990. *Life to Those Shadows.* Ed. and trans. Ben Brewster. London: BFI.

Calabrese, Omar. 1992. *Neo-Baroque: A Sign of the Times.* Trans. Charles Lambert. Princeton, N.J.: Princeton University Press.

Chion, Michel. 1992. *Le son au cinéma.* Nouvelle edition. Paris: Cahiers du Cinéma, Collection Essais.

Cubitt, Sean. 1994. "Myth, Management, and Platitude: Laurie Anderson." In *Art Has No History! Essays on Post-War and Contemporary European and North American Art,* ed. John Roberts, 278–96. London: Verso.

Ellul, Jacques. 1964. *The Technological Society.* Trans. John Wilkinson. New York: Vintage.

Freud, Sigmund. 1976. *The Interpretation of Dreams.* Trans. James Strachey. Harmondsworth: Pelican Freud Library.

Giedion, Siegfried. 1948. *Mechanisation Takes Command: A Contribution to Anonymous History.* New York: Norton.

Gombrich, E. H. 1972. "Icones Symbolicae: Philosophies of Symbolism and Their Bearing on Art." In *Symbolic Images: Studies in the Art of the Renaissance II,* 123–95. London: Phaidon.

Greenberg, Clement. 1965. "Modernist Painting." *Art and Literature,* no. 4 (spring): 193–201.

Gunning, Tom. 1990. "The Cinema of Attractions: Early Film, Its Spectator, and the Avant-Garde." In *Early Cinema: Space, Frame, Narrative,* ed. Thomas Elsaesser, 56–67. London: BFI.

Habermas, Jürgen. 1987. *The Philosophical Discourse of Modernity: Twelve Lectures.* Trans. Frederick G. Lawrence. Cambridge: Polity Press.

Jonson, Ben. 1954. *The Poems of Ben Jonson.* Ed. George Burke Johnston. London: Routledge and Kegan Paul.

Kahn, Douglas. 1992. "Introduction: Histories of Sound Once Removed." In *Wireless Imagination,* ed. Douglas Kahn and Gregory Whitehead, 1–29. Cambridge: MIT Press.

Kahn, Douglas, and Gregory Whitehead, eds. 1992. *Wireless Imagination: Sound, Radio, and the Avant-Garde.* Cambridge: MIT Press.

Kalinak, Kathryn. 1992. *Settling the Score: Music and the Classical Hollywood Film.* Madison: University of Wisconsin Press.

Lazzaro, Claudia. 1990. *The Italian Renaissance Garden: From the Conventions of Planting, Design, and Ornament to the Grand Gardens of Sixteenth-Century Italy.* New Haven, Conn.: Yale University Press.

Leyda, Jay. 1983. *Kino: A History of the Russian and Soviet Film.* 3rd ed. London: Allen and Unwin.

Lippard, Lucy R. 1968. "Eros Presumptive." In *Minimal Art: A Critical Anthology,* ed. Gregory Battcock, 209–21. Berkeley: University of California Press.

Maravall, José Antonio. 1986. *Culture of the Baroque: Analysis of a Historical Structure.* Trans. Terry Cochran. Minneapolis: University of Minnesota Press.

Martin, John Rupert. 1977. *Baroque.* Harmondsworth: Pelican.

Marvell, Andrew. 1976. *Andrew Marvell: The Complete Poems.* Ed. Elizabeth Story Donno. Harmondsworth: Penguin.

Marvin, Carolyn. 1988. *When Old Technologies Were New: Thinking about Electric Communication in the Late Nineteenth Century.* New York: Oxford University Press.

Michelson, Annette. 1984. "On the Eve of the Future: The Reasonable Facsimile and the Philosophical Toy." *October* 29: 3–21.

Moore, Charles W. 1994. *Water + Architecture.* London: Thames and Hudson.

Nerlich, Michael. 1987. *Ideology of Adventure: Studies in Modern Consciousness, 1100–1750.* Trans. Ruth Crowley. 2 vols. Minneapolis: University of Minnesota Press.

Rilke, Rainer Maria. 1981. *Selected Poems of Rainer Maria Rilke.* Trans. Robert Bly. New York: Harper Colophon.

Schivelbusch, Wolfgang. 1988. *Disenchanted Night: The Industrialization of Light in the Nineteenth Century.* Trans. Angela Davies. Berkeley: University of California Press.

Stafford, Barbara. 1994. *Artful Science: Enlightenment, Entertainment, and the Eclipse of Visual Education.* Cambridge: MIT Press.

Strauss, Neil, ed. 1993. *Radiotext(e). Semiotext(e)* #16, vol. 6, no. 1. New York: Semiotext(e).

Toop, David. 1995. *Ocean of Sound: Aether Talk, Ambient Sound, and Imaginary Worlds.* London: Serpent's Tail.

Weis, Elisabeth. 1984. *The Silent Scream: Alfred Hitchcock's Sound Track.* Rutherford: Farleigh Dickinson University Press.

Weiss, Allen S. 1995. *Phantasmatic Radio.* Durham, N.C.: Duke University Press.

Williams, Rosalind. 1982. *Dream Worlds: Mass Consumption in Late Nineteenth-Century France.* Berkeley: University of California Press.

5. Garden Agon

Susan Stewart

He who makes a garden, his own unmaking makes.

A garden is the wresting of form from nature. In this sense, making a garden is synonymous with work, in that it intervenes in nature, and more particularly with art as a kind of work, in that it produces form. Making a garden, like making other works of art and unlike practicing agriculture, involves producing form for its own sake. One might harvest the garden, but to do so or not to do so will not determine the status of the space as a garden. In making a garden one composes with living things, intervening in and contextualizing, and thus changing, their form without determining all aspects of their development or end. The garden thereby is linked to other means of ordering life: codifying and ritualizing social time and space and creating political orders and social hierarchies—including the organization of military order, or structures of force. In this latter feature resides the long-standing connection between making gardens and making war. The garden has, by definition, an articulated boundary. That boundary must be held or defended against wilderness on one side and interiority or an excess of subjective will on the other. The garden can only be used to pursue an agenda of organic growth by maintaining a posture of defense.[1] Yet war is as well the antithesis of the garden, for the ends of war are the destruction of life and the undoing of order. Gardens and war share a teleology of death, but the garden promises cyclical time in which living things might extend beyond their makers and death remains in its season. In the garden, death becomes the seedbed of birth. If natural history repeats itself, then that is the nature of more than human history. War short-circuits nature; it is the outcome of acts of human will that risk the destruction of human time and, increasingly in this century, the destruction of Nature herself. The harvest of war

is early death; the garden as "lachrymae musarum" is dedicated to the shepherd, hunter, and poet stricken by war.

Any work, including the work of art, is subject to contingency; in the garden contingency is dominated by the indeterminacy of weather. A garden involves composition with living things; it can also involve composition with inert matter—walls, rocks, stones, bricks, gravel, walkways, statues, urns, and other material artifacts. But such inert matter is thereby made meaningful by its juxtaposition to living forms. When we find the encroachment of moss on a brick or thyme on a rock appealing, we are pleased by the contrast between the fixity of the inert and the mutability of its natural frame. When we find an obelisk in a field of weeds or, as with Wallace Stevens's jar in Tennessee, we place a fixed form in a wilderness, an analogous pleasure arises from the opposite relation of figure to ground. Stone will endure; the sundial will orient us in time and space—this is the sensibility of the Enlightenment and the cult of order. Water will wear stone away; all the fixed world will decay—this is the sensibility of the Romantic and the cult of ruin. Such issues of work, form, mutability, and contingency have been for almost thirty years the focus of the Scottish poet Ian Hamilton Finlay. Born in 1925 in the Bahamas, Finlay served from 1944 to 1947 with the Royal Army Supply Corps and was sent to Germany, where he was witness to the fighting at the end of the war. On his return he worked for a period as a shepherd on the Orkney Islands. Since 1966 he has made his garden an important aspect of his life and work—a garden he has built around himself with the help of his wife Sue Finlay and many collaborators.[2] Extending across a four-and-one-half acre site in the Pentland foothills at Dunsyre, Lanarkshire, approximately twenty-five miles southwest of Edinburgh, the garden stands where there was originally a farm croft called Stonypath that was part of a larger estate belonging to Sue Finlay's family. The garden was renamed Little Sparta in 1983 when it was twice the scene of struggles with the Strathclyde regional government over the status of a building at the site called the "Garden Temple." Since 1978 the artist has wanted the building rated as a religious building; the local authorities considered it to be a gallery and decided to seize a number of Finlay's artworks on February 4, 1983, as payment for back taxes. Finlay and his supporters staged a resistance to the seizure that was both symbolic and real. Armed with water pistols, garden hoses, Finlay's old horse,[3] and what has been described as the world's longest string-and-tin-can telephone system, the group, calling themselves the Saint-Just Vigilantes, met the police and authorities while members of the press served as witnesses.[4] Finlay's group flew a flag of Apollo's lyre (for inwardness) juxtaposed with an oerlikon gun (for action)—the gun substituting for the god's usual bow.[5] The sheriff officer was not successful in confiscating works. Finlay struck a commemorative medal of the battle and installed a monument at the entrance to "the battlefield." On March 15 the sheriff officer returned and removed works from the Garden Temple. Some of these belonged to Finlay, but many had been commissioned by, or sold to, other individuals and institutions. The works were placed in a bank vault and most were never recovered. Finlay closed Little Sparta for a year. In 1984

Figure 1. Protest group of Finlay supporters at the Scottish Arts Council, 1983. Image courtesy of the J. Paul Getty Museum.

the Vigilantes removed two of Finlay's neoclassical stone reliefs from Scottish Arts Council headquarters and installed them in the Garden Temple as war spoils; the garden was again opened.[6]

The two "Little Sparta Wars" were only the first of several "battles" Finlay has had with the arts establishment and the state. Before the 1983 wars, Finlay had conducted a mail campaign to discredit the Fulcrum Press after it published one of his works as a first edition; the work had, in fact, already appeared seven years before in a first edition and had been reprinted in a second edition. The "Follies Battle" of 1987 was another quarrel conducted by pamphleteering and through postcards and posters; in this case, the argument centered on a planned *National Trust Book of Follies,* which included an inauthentic description of the garden at Stonypath. The book was criticized by many artists and scholars for its inaccuracies and careless categorization of monuments.[7] But perhaps the most difficult struggle in which Finlay has been engaged was his loss of a commission he had been given by the French government in April 1987. This commission was to install a garden commemorating the Declaration of the Rights of Man on the site of the Assembly Hall in Versailles. Finlay was a more likely choice for this commission than might be at first evident, for throughout the 1980s his art had been concerned with issues of neoclassicism and the French Revolution. But

within a few months of the culture ministry's announcement, an editor of the Paris magazine *Art Press,* Catherine Millet, led a public campaign to have Finlay denied the commission after she saw that he had used the Nazi SS sign, or lightning image, in his work *OSSO.* This work was on display in an unrelated exhibition at the gallery ARC in Paris during the same period. The ministry withdrew the commission in March 1988, announcing that "the detestable climate of opinion created by a campaign led by certain personalities and organs of the press" made it impossible to pursue the Finlay project. Finlay eventually won a libel suit in the French courts against his detractors and was awarded a symbolic one franc in restitution.[8]

These events, replete with contention and multiple rhetorical frameworks, might be seen not so much as interruptions in Finlay's career, but as integral aspects of his dialectical art. We are reminded of all the meanings accruing around the term *agon*— a place of games, lists, courses; a national assembly of contests; a struggle for life and death; a battle; an action at law or trial; the argument of a speech; agony or anguish of the mind; the contest of the rhapsode; the struggle to assert oneself.[9] Finlay has not designed or intended the specific shape such battles will take. And certainly the cancellation of the Versailles commission was a catastrophe for him, as it was for contemporary art more generally. But as Finlay's body of work has developed, the issue of strife and the pursuit of strife are key elements to his aesthetic. His work explores, in an open-ended and speculative way, the relations between art, thought, law, and war—the garden is quite literally a *defense* of poetry, a memory and vatic exercise at once on the meaning of war and on the meaning of making and unmaking more generally. There is an element of isolation, defensiveness, and misinterpretation deriving from the circumstances of his method of producing art that would seem to lead inevitably to trouble. The difficult rhetorical task of moving a public audience to ethical action, the inevitable stress involved in collaborative work and the recognition of individual ego, the harsh conditions under which the garden has been built—all are factors that make Finlay's art simultaneously intransigent and sublime.

The garden is not about nature, but is rather a transformation of nature.

The theme of Finlay's garden is not nature. In this Finlay follows closely the worldview of the pre-Socratics: "In front of man stands not Nature, but the power of the gods, and they intervene as easily in the natural world as in the life of men."[10] As Anaximander linked seasonal repetition or periodicity to a law of time, so does Finlay link the reappearance of phenomena in history to the periodicity of the garden. Finlay called a series of works he made with Nicholas Sloan and David Paterson in 1980 *Nature Over Again after Poussin,* inverting Cézanne's dictum "Poussin over again after nature." When Finlay strategically places inscribed stone signatures in the garden landscape—as he has with Dürer's *AD* beside the temple pool, evoking Dürer's *Great Piece of Turf (Das Grosse Rasenstuck),* and the names of Poussin, Claude (Lorrain), Friedrich, and Corot elsewhere in the garden—he reminds us that our perception of

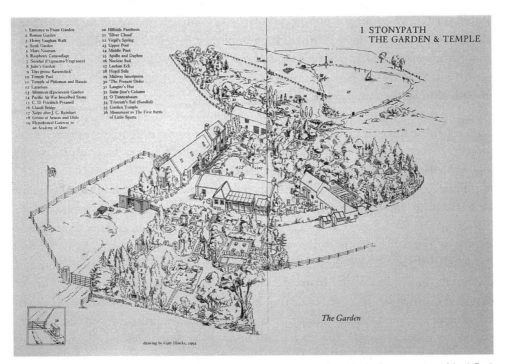

Figure 2. Ian Hamilton Finlay. Map of Stoneypath/Little Sparta 1992. Drawing by Gary Hincks. Image courtesy of the J. Paul Getty Museum.

the landscape is framed historically.[11] Although the garden is very much bound up with issues of pictorialism and framing more generally, we do not derive from it a picture of, or story about, nature that is separable from an account of human nature. More specifically, we find history presented as both an expression of human nature and the sister of memory. The viewer of the garden is confronted with the realization that all space here has been made *semantic* space—the garden speaks the gardener's intention; there is no "background" or "backdrop" per se; there is the imposition of boundary, which is a task constantly reimposed on the viewer.

The Pentland Hills are within the edge of Roman dominion, between the walls of Hadrian and Antoninus,[12] yet they also are a particularly hostile, northern environment for the revival of neoclassical ideals that Finlay proposes. Finlay follows, within an agenda of what might be called "neo" neoclassicism, the project of the Enlightenment's revival of classical order, a revival already both hampered and enabled by its distance from, and incommensurability with, the classical world. The *tone* of Finlay's use of allusion continually fluctuates between fervent idealism and the ironic distance of parody—a layering that results in multiple, yet specific, interpretations. In Finlay's account, historical events are simultaneously tragedy and farce; this is not a matter of the relativity of points of view—indeed it is directly opposed to such relativism. Rather, to see both tragedy and farce is an outcome of a sustained and moral meditation on history.

The overall structure of the garden is articulated by the heavily bounded and hedged front garden before the house; the large middle garden behind the house, with

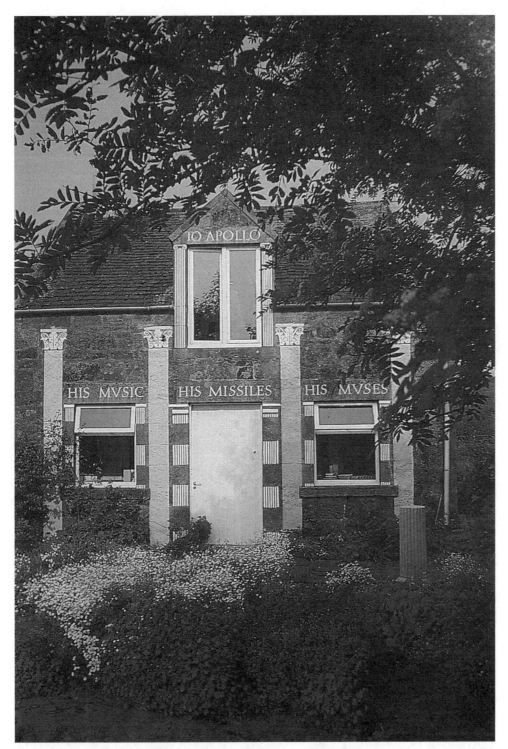

Figure 3. The Garden Temple, Little Sparta, 1982. Image courtesy of the J. Paul Getty Museum.

a pond and water plants and the Garden Temple; and the woodland area beyond with its many small glades and groves and eventual vistas over the larger ponds. One's progress through the garden mirrors the historical progress of the making of the garden: with significant exceptions, one moves temporally from older to newer projects, spatially from density to wilderness, and thematically from interiority to public forms. This tripled and dialectical structure appears as well in the architecture of the Garden Temple: a Main Room designed as an homage to the classical and pastoral themes of the French Revolution, the "idyll of Rousseau"; an Intermediary Room of themes of Virtue, Terror, and Revolution; and a Dark Room, used in 1984 to store the stone reliefs conceived as war trophies.[13]

The plants in Finlay's garden include rowans, ash, conifers, wild cherries, yellow elderberry, varieties of *cornus,* and ground plants such as geraniums, strawberries, *lamium, ajuga, alchemilla,* astilbes, *brunnera,* campanulas, hellebores, hostas, *nepeta,* saxifrages, sedums, and thymes; flowering plants include lilies, lupines, irises, *astrantia,* foxgloves, verbenas, yellow water iris and bulrush, soft rush, reeds and kingcups, and water lilies.[14] Finlay uses cherries as emblems of Rousseau, citing a famous passage in the philosopher's autobiography,[15] and he uses birches, which are difficult to grow at the site, as emblems of both extinction and discipline—"Bring back the birch" reads a stone inscription planted in a little grove of birches. But with these exceptions, the plants are not allegorical; they are, as Finlay explains, "whatever will grow." This philosophy of planting might be compared to a constructivist—or, more simply put, abstract—practice in painting, for plants are chosen on the basis of their

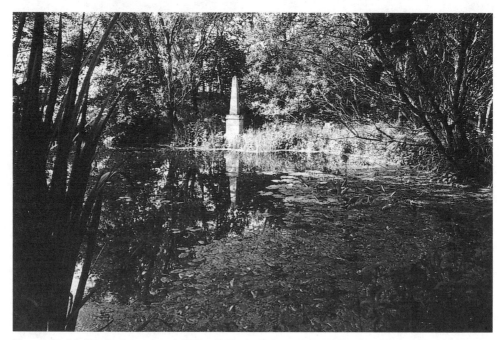

Figure 4. Obelisk, Little Sparta, upper pool, 1982, with Nicolas Sloan inscription "Il Riposo do Claudio." Photograph by David Patterson. Used by permission of Ian Hamilton Finlay.

Figure 5. Buried Capital, Little Sparta (on path to upper pool), n.d. Photograph by Peter Davenport. Used by permission of Ian Hamilton Finlay.

horizontal and vertical relation to the overall composition, for textural reasons that are not engaged with celebrating the specificity of site. The plants are employed within a dialectic of shade and light, conifer versus perennial, that is associated with issues of the geometry of time. In the catalog for a 1984 exhibit, *Talismans and Signifiers* at the Graeme Murray Gallery in Edinburgh, Finlay cited Proclus on Euclid: "We should also accept what the followers of Apollonius say, that we have the idea of line when we ask only for a measurement of length, as of a road or a wall. And we can get a visual perception of line if we look at the middle division separating light from shaded areas, whether on the moon or on the earth." The "site" of Little Sparta is the descent of Western culture from the classical world. More specifically, the garden is built upon layers of allusion to the history of gardens, from the Gardens of the Hesperides to Blenheim, in juxtaposition to the history of revolutions and war.

The garden is a product of mind. Nature has no interest in the garden.

Underlying the landscape of Finlay's garden is the allusion to Arcadia, the domain of Pan, Apollo, fauns, nymphs, and dryads. Described by Polybius in his *Historiae* as a "poor bare, rocky, chilly country," Arcadia is gradually, through the writings of Virgil,

transfigured from this "bleak and chilly district of Greece . . . into an imaginary realm of perfect bliss."[16] Apollo and Pan rule over Little Sparta as the gods of law and play, as Apollo was the tutelary god of the Spartan legislator-prince Lycurgus and the object of worship of the mythical people of a northern paradise, the Hyperboreans.[17] When Finlay links the lyre of Apollo with a weapon, he is following Heraclitus, who contended that "they do not apprehend how being at variance it agrees with itself: there is a connection working in both directions, as in the bow and the lyre."[18] Renato Poggioli explains in his book on pastoral that the qualities of Apollo and Pan are both separate and interwoven: "Apollo is a very human deity, and this explains why he is the patron of shepherds; far more so than Pan, who lives in Arcadia as a symbol rather than as a tutelar god. It is just for being a dreamland that Arcadia cannot be the land of myth. . . . When Arcadia ceases being pastoral, it turns into wild and reckless nature."[19] Virgil's model of the transformation of site through text, through inscription and reading, is an important prototype for Finlay's work at Little Sparta, but Finlay goes on to take up the Apollonian theme in its later manifestations as well: the tradition of Dürer as an Apollo who brought classical light to the North, of Saint-Just as the Apollo of the French Revolution, of Walter Pater's "Apollo in Picardy," [20] and, not least significant, the contemporary Apollo missile. The inscription over the entrance to the Garden Temple reads: "To Apollo, His Music, His Missiles, His Muses." Finlay's Apollo carries an oerlikon gun, the World War I weapon that in fact helped destroy Picardy.[21]

Edinburgh's eighteenth- and nineteenth-century efforts to style itself as the "Athens of the North" culminated in the plans made in the 1820s for a monument to commemorate the Scottish dead of the Napoleonic Wars. The National Monument on Calton Hill was designed to be a reproduction of the Parthenon. The citation to ancient Athens was intended to symbolize the victory of democracy over tyranny. The monument was never finished and therefore, ironically, appears as a strangely recent ruin, its melancholy aspect gracing many prints and postcards as if it had been a place of worship for ancient Scots. Little Sparta—sited in a geographical relation to the "Athens of the North" as ancient Sparta was to ancient Athens—corrects the facile allegory of the National Monument by providing the prehistory of Napoleon's rise to power: the garden presses upon us a memory of the violence preceding, underlying, and resulting from the classical ideal.

In his concern with these themes, Finlay has many predecessors, and the garden itself becomes a living repository of the history of gardens in their poetic and philosophical aspects. We might consider Hadrian's architectural reconstructions and models at his rural retreat outside of Rome when we see Finlay's pyramid, grotto, bridges, pantheon, columns, temple, and model of the Abbé Laugier's hut. And Marvell had described in "Upon Appleton House" how Thomas Fairfax laid out his flower garden like a fortress that would recall his military career: "when retired here to Peace / His warlike Studies could not cease; / But laid these Gardens out in sport / In the just Figure of a Fort." Like Pope's "Twickenham," Little Sparta gives the poet "a place to

stand."[22] Pope's "The First Satire of the Second Book of Horace Imitated," with its celebration of virtue and translation of the martial into garden images, provides an additional gloss on Little Sparta: "And HE, whose lightning pierc'd th'Iberian Lines, / Now forms my Quincunx, and now ranks my Vines."[23] The garden's earthworks resemble battlements, yet Peterborough in retirement is seen as pursuing a purer, more virtuous, form of action.

The themes of justice and virtue extend from classical literature to seventeenth-century meditation to the great English philosophy gardens of the eighteenth-century that, in addition to Twickenham, have so influenced Little Sparta: Shenstone's The Leasowes, Stowe under Lord Cobham and William Kent, and Stourhead as it developed in the mid-eighteenth century. Significant also is the nearby garden of Sir John Clerk at Penicuik, constructed in the 1730s, an early Scottish instance of the use of poetic and historical allusion to shape a landscape. By contrasting a pastoral landscape with the dark, tortuous, and horrid entrance to a grotto at the Cave of Hurley, at Penicuik, Clerk purposely recalled the Cumaean Sibyl's cave near Naples, and by allusion suggested Aeneas's quest for a new country.

In scale Little Sparta follows William Shenstone's *ferme ornée*, The Leasowes. Shenstone ornamented his small grazing farm with views meant to copy the landscapes of Claude, Salvator Rosa, and Poussin. With his use of inscriptions and dedicated statuary, Shenstone juxtaposed his own era to the Gothic and classical past. He created a steep wooded ascent to a Temple of Pan designed to be followed by a descent into Virgil's Grove and a seat dedicated to the memory of James Thomson.[24] Following Shenstone's "Unconnected Thoughts on Gardening," Finlay has put together a series of *Unconnected Sentences on Gardening, More Detached Sentences on Gardening in the Manner of Shenstone,* and several other series of detached sentences about pebbles, stiles, and friendship.[25] Among Finlay's garden aphorisms are "A garden is not an object but a process" and "Certain gardens are described as retreats when they are really attacks."

As the garden at Stourhead in Wiltshire developed over thirty years in the middle of the eighteenth century (approximately 1740–70), the River Stour was used to form a series of ponds, including eventually a large lake designed to be seen from a high prospect. Around the lake were placed a sequence of buildings, including a Temple of Flora, a grotto with a circular domed chamber that included springs channeled to cascade beneath a sleeping nymph, and a river god's cave that included a copy of the figure of Tiber in Salvator Rosa's painting *The Dream of Aeneas*. Inscriptions at the grotto entrance and on the Temple of Flora refer to the *Aeneid*. Other buildings include a Pantheon built in 1754—a domed rotunda with a recessed portico within which are placed Michael Rysbrack's *Hercules*, a five-arched bridge, and a Temple of Apollo built in 1765. Henry Hoare's original intention at Stourhead was to honor the source of the River Stour in the pagan manner. The younger Pliny had described such a situation at Clitumnus in Umbria, a place Hoare may have visited in his travels.[26] One of Finlay's early inscribed works for the garden is a large stone reading "HIC JACET PARVULUM

Figure 6. L'Idylle des Cerises, Little Sparta, 1987. Image courtesy of the J. Paul Getty Museum.

QUODDAM EX AQUA LONGIORE EXCERPTUM."[27] Finlay's inscription marks the consequence of the flow of time rather than its origins. The idea of the pond as "excerpt" links it to the aphoristic and fragmented quality of the garden's "parts" and adds to the elegiac quality of the garden as a whole.

Another important influence upon Little Sparta is the seventeenth-century garden at Stowe in Buckinghamshire, revised by Richard Temple, Lord Cobham (1675–1749), after his alienation from the court of George II and opposition to Walpole resulted in his dismissal from the army.[28] Cobham, with his architect Sir John Vanbrugh, decorated the garden with temples and other architectural furniture, making a pun on the family motto "Templa quam dilecta."[29] With consequent help from William Kent, Capability Brown, and others, Cobham laid out a little valley called the Elysian Fields, which includes a Temple of Ancient Virtue and a "Grecian valley." The Temple of Ancient Virtue contains four niches with full-length statues of Lycurgus, Socrates, Homer, and Epaminondas, each inscribed with a Latin motto praising its subject's achievements. This temple is contrasted to the Temple of British Worthies, containing busts of sixteen British luminaries. The effect, as John Dixon Hunt has noted, following William Gilpin's contemporary description, is to juxtapose a handsome classical building, representing the antique, with a deliberately ruined structure containing truncated or abbreviated forms, representing the modern.[30]

These philosophy gardens are replete with literary allusions and devices of memory. They are private spaces addressing a public audience; each has a discursive trajectory, designed to lead the visitor through prospects and commentaries as surely as a well-crafted speech uses rhetoric to conduct the listener to right opinions. If the contrast between ancient and contemporary virtue at Stowe borders on the ironic, it nevertheless proposes clear models of conduct. Little Sparta borrows the philosophy garden's techniques of allusion and rhetoric, but it presents a more complex and dialectical picture of reference, questioning assumptions of historical knowledge as a model for virtuous action as it asserts the necessity of historical knowledge as a model for virtuous action.

Nature, as the manifestation of a contingent will that cannot be known to us, is a source of terror.

If we return to *OSSO*, the work that prompted the campaign for the revocation of Finlay's Versailles commission, we find a stark exploration of this very point. *Osso*, the Italian word for bone, out of the Latin *os*, is here inscribed on stone fragments emphasizing the palindromic aspect of the word. The central *s*'s are written in a calligraphy that reproduces the lightning symbol of the SS—the Nazi Schutzstaffel, Hitler's elite troops. Finlay constructs an allegory in which the long *s*'s of the eighteenth century, a symbol of civilized script, are transformed into the runic double-lightning stroke of SS uniforms and banners as culture devolves into barbarism.[31] He traces the lightning symbol from the pre-Socratics to eighteenth-century law to twentieth-century terror: fire in

the philosophy of Heraclitus is the "thunderbolt" steering all things and associated with the possibility of human wisdom; the French word for lightning, *eclair,* is part of the etymology of Enlightenment; and the Nazi symbolism of lightning evokes the link between Nazi ideology and German Romanticism. Yet, given the dialectical impulse of his thought, Finlay's allegory reminds us of the synonymity of law and terror in the absence of moral reason. We find here, of course, a continuation of the simultaneous promotion and critique of Enlightenment undertaken by the Frankfurt School. In Finlay's 1989 work with Keith Brookwell and Andrew Townsend, *Adorno's Hut,* a direct allusion is made to this philosophy regarding the terrible consequences of technological thought. But Finlay is drawing on a related, iconographical, genealogy of lightning as well: lightning appears throughout the history of Western art and literature as a kind of literal emblem of the eruption of contingency—nature and death—against which human culture is motivated to protect and create itself.

In the iconography of the French Revolution, the symbol of the law is often the round-headed tablet and, by the time of the Terror, the law is associated with the biblical notion of law as retributive. The guillotine as the "ax of the law," with its diagonal blade, comes to be associated with the swiftness of lightning, and a number of revolutionary prints employ lightning imagery. A print by Louis-Jean Allais commemorating the Constitution of 1793 displays a caption that says, "The republican constitution, like the tablets of Moses, comes from the heart of the mountain in the midst of thunder and lightning." A color print by Pierre-Michel Alix shows "a pair of fiery tablets sending down bolts of lightning against the enemies of the Revolution while members of a patriotic crowd dance around a liberty tree."[32]

Aeneas and Dido first consummate their love in a cave as they flee a thunderstorm, an event Finlay commemorates in his Grotto of Aeneas and Dido with its monogram rhyming Dürer's signature at the Temple pond. In the most popular poem in English of the eighteenth century, James Thomson's *The Seasons,* the spectacular account of a thunderstorm in "Summer" describes "th'unconquerable" lightning that shatters trees and "blasts" cattle as they stand in the open fields. Here we find the "blasted tree" that Wordsworth would use in the immortality ode to symbolize the Terror's destruction of the liberty tree and the ancient oak ruined by lightning that serves as a central symbol of doomed technology in Mary Shelley's *Frankenstein.*[33] Thomson's account of the storm builds to the story of the happy lovers Celadon and Amelia caught in its violence. Just as Celadon assures Amelia that "'Tis safety to be near thee sure," Amelia is struck "a blacken'd corpse" to the ground.[34] The bone turned to ash and the figure turned to stone are found as well in Poussin's *Landscape with Pyramus and Thisbe,* with its prone body of Pyramus, his arms outstretched in death. Here shepherds and herd pursue a line of flight paralleling the bolt of lightning still evident in the sky.[35] And in J. M. W. Turner's well-known painting of Stonehenge in a storm, we witness the devastation of a shepherd and his flock by lightning on Salisbury Plain.

In his use of these allusions, Finlay draws a continuous and cumulative relation

between the terror of primitive man in the presence of nature, the terror of the Greeks and Romans in the presence of their gods, the terror of the French Republic in the presence of a self-inflicted violence, and the terror of the victims of the Nazi regime in the presence of its machinery of death. Walter Benjamin's important aphorism on the mutuality of civilization and barbarism provides a gloss on this genealogy, as does Giambattista Vico's cyclical theory of history. Like Milton, Finlay is a master of the serious pun: thus when he links the regime of the demonic Pan with the German panzer tank we are meant to remember both terms at once and to consider the historical course of the implication.

The imitation of nature is an attempt to master terror. Art and war are imitations of nature: the first an imitation of nature's making; the second an imitation of nature's destruction.

The related defensive methods of containment and reversibility are central to many of the modes of Finlay's art. Finlay's garden is imagined as a kind of island of history in a vast sea of contemporary life and as itself a sea within which objects appear to a viewer on a horizon alternately near and distant. One is constantly aware of the relation between placement, position, and movement. What is rooted is also growing; what is in motion is seen from a position that is itself in motion; what is inscribed will be reordered; what is unintelligible will become increasingly clear.

If we trace this iconography, we find it has myriad dimensions. First, Finlay has used, since his early days as a concrete poet, imagery of the inland garden as a sea. A model of the atomic submarine, USS Nautilus, emerges from a stand of firs as if from the ocean. At the edge of the garden a solitary ash tree is inscribed with the name Mare Nostrum, the Roman tag for the Mediterranean, in order to emphasize the sound of wind in the tree in its echo of the sound of wind on the sea.[36] The front garden includes a sequence of diamond-shaped paving stones, each inscribed with the names of kinds and parts of boats such as brig, keel, schooner, and ketch. In *Silver Cloud*, an homage to sailing ships is inscribed in a marble monument on an island Finlay made in the Top Pond in 1973. The garden as a representation of the sea is not merely, however, a theme; this representation takes the most sublime, the most violent and unencompassable, of nature's phenomena and contains it within a knowable boundary. Unlike a painting of the sea, the garden/sea is in motion and is an image of nature made by nature. As Finlay uses the mirror effects of clouds and inscriptions viewed by means of their reflections in water,[37] containment and reversibility are devices of multiplication and difficulty as well as comprehension. And by extension, the garden encompassing an image of the sea is analogous to the garden encompassing an image of war—for war as the harnessing and unleashing of nature's forces is the only activity within human scale comparable to the dimensions of the sea's power.

After 1971, the contemporary warship began to replace the small boat in Finlay's iconography. Parallel to Finlay's imagery of the sea and World War II is a set of associations he makes with the Field of Mars. These link the Roman Campus Martius and

the French Champs de Mars as scenes of festivity and violence. Finlay has placed a Hypothetical Gateway to an Academy of Mars at the entrance to the upper area of the garden. The gateway consists of piers topped with grenadelike capitals. The notion of the Field of Mars reminds us that once the Bastille was razed, a Field of Nature was created in its place.[38] After the Massacre of the Champs de Mars of 1791 when a Republican demonstration was broken up,[39] pastoral revolutionary festivals were held there. Parades were held in which "animals of warfare were excluded, with only peaceful cows and doves permitted." As Ronald Paulson has pointed out in his study of revolutionary imagery, "in the depths of the Terror the dream was held by Girondin and Jacobin alike of a peaceful island in the midst of the stormy sea, and the festivals represented places for refreshment and rest in the navigations of life."[40] Finlay has continued this iconography in his references to Rousseau's original burial place, surrounded by poplars, on the "Ile des peupliers" at Ermenonville.[41] Close to the bank of the garden's Lochan Eck, Finlay has made a small island with a stone memorial to Rousseau, and he would have emphasized this connection with an homage to Rousseau in plantings of poplars and cherries in the Versailles project.

The sudden terror of lightning spurred, according to Vico, the creation of metaphors of explanation and so the beginning of cultural work on the part of early forest dwellers. In Little Sparta, the answer or response to terror is the creation of shelters— the grotto, cave, or hut that is the site of creative rebirth: the cave where Aeneas receives advice from the Cumaean Sibyl, the grotto where Aeneas and Dido hide from the storm, and the hut where society begins to take form. Following Vitruvius and Rousseau in constructing a genealogy of dwellings, Abbé Laugier wrote that men were driven from caves and compelled to make dwellings because of their need for sight: "man wishes to make himself a dwelling that covers him without burying him."[42] The amalgam of buildings and spaces at Little Sparta reminds us of the cyclical and dialectical structure of this tradition of architectural history: early man, frightened by tempests, seeks shelter in the forest; when the forest does not offer adequate protection, he retreats to the cave; when the cave proves dark and unhealthy, he builds a roofed structure; when this structure proves vulnerable to the elements, he builds a hut within which the family and, eventually, extended social relations develop; as society takes shape, buildings become institutional and monumental. Gradually structures to differentiate and contain social elements are created; these institutional structures become imprisoning—created under the implied threat of force, they themselves evoke violence in response. They are torn down, as in the case of the Bastille; the garden on the site of the destroyed prison becomes a return to nature, but one now deeply inflected by human history.[43]

Containment and reversibility are also implicit in Finlay's use of anagrams, puns, and rhymes. Here alternatives to a given form of order are concealed within the order itself; this Hegelian idea shows that the outcome of reading or interpretation will be both preservation and cancellation. Perhaps nowhere is this point made more vividly than in Finlay's monumental stone inscription made with Nicholas Sloan of the

words of Saint-Just: "The present order is the disorder of the future." The words, including the name of Saint-Just, are inscribed individually on stones, each weighing approximately a ton. Anagrams reveal a concealed interpretation. Puns and rhymes show semantic and aural simultaneity in both conflict and harmony. Finlay's inscription "curfew/curlew" on a sea boulder placed in the moorland by the upper pond links the bird's evening song with the transformation of light at day's end.[44] A shell, inscribed "goddess" and "caddis," hides a hose that animates the water at Temple Pond. The shell commemorates both the birth of Aphrodite and the shell of the larva of the caddis-fly that lives in the pond. The caddis shell is composed of tiny pieces of stone and grit and seems to glisten like gold in the water.[45] Carp within, and models of submarines around, the Temple Pool remind the viewer that both are bottom feeders. The drum of the martyred boy revolutionary Joseph Barra, commemorated by David, reappears in allusions to neoclassical column drums. The shell of a tortoise is visually and verbally linked to the helmet of the German panzer, in turn linking Pan to both pansy and *pensée*. The French Revolutionary calendar month Arrosoir reappears as a literal watering can and as the flight of Apollo's arrow at evening.

The genres of the pastoral, the eclogue, and idyll are created as well through articulating a boundary and reordering time. Renato Poggioli explains that Virgil's *Eclogues* are "excerpts, in the original sense," and Theocritus's *Idylls* are "little pictures." The idyll is *eidos*'s diminutive.[46] The diminutive appears constantly as a rhetorical form in Finlay's work. His correspondence, his drawings, and his writings make frequent use of the Scottish adjective "wee," for example, and he makes extensive use of models and toys. One of his earliest exhibitions was a display of toys, and he has often made models of World War II airplanes and ships from the stock available at Woolworth's.[47] When we play at war, war counts in a different way; the boundary between the game and the world is absolute. But as time passes, we might recreate, in order to contain, what was once real, and in the future the reapplication of the game may turn serious: what seemed to be only a game might turn out to be a form of practice, as it is when real armies play war games.[48] Temporality and an exaggeration of scale can create transformations both desired and unwanted. By an ongoing practice of modeling war, Finlay constantly reminds us of the permeability of event and memory.

Garden-making, an activity of art and war, is a kind of work. Yet because such work is not subsumed by utility, it is as well a transformative process of play. The work of the garden is the cultural work of the trope.

The Temple of British Worthies at Stowe divides its venerable figures into those who followed a life of contemplation, who "sought Virtue in her Retirement," and those who followed a life of action, "who left Retirement to the cool Philosopher, entered into the Bustle of Mankind and pursued Virtue in the dazling Light in which she appears to Patriots and Heroes. Inspired by every generous Sentiment, these gallant Spirits founded Constitutions, stemmed the Torrent of Corruption, battled for the State,

ventured their Lives in the Defence of their Country, and gloriously bled in the Cause of Liberty."[49]

This separation between the *vita activa* and the *vita contemplativa* that formed such an important part of Renaissance, baroque, and Enlightenment aesthetics finds its resolution in the garden form. The garden as retirement from the field of war proposes contemplation as both the consequence of action and as the prerequisite of virtuous action in the public realm. And the experience of the garden visitor, who must traverse the "work," both moving and thinking at the same time, recapitulates this dialectic. Contemplative gardens have a theatrical aspect, requiring the viewer to see them as an intended *scene,* yet this aspect as well is characterized by the scene as site of future action. The viewer is asked to both reflect upon and project human action.[50]

Finlay's Little Sparta specifically evokes the relation between contemplation and action in his use of inscription embedded within scenes of natural transformation. Gavin Keeney has insightfully described this tension in Finlay's proposal for the Versailles project as "the vegetative veil of sorts covering and softening the 'gravitas' of the more assertive (emphatic) mineral forms."[51] The grotesque in its original connection to the grotto is important here. As Paulson has described the use of the grotesque in the imagery of the French Revolution:

> [The grotesque] was a perfect revolutionary paradigm in that, based on the decorative patterns of metamorphosing plant and human forms, it showed either the human emerging triumphantly from nature or the human subsiding or regressing into nature—or ambiguously doing both. Similar transitions or sequences involve the movement from dark to light, but as the grotesque is all in all the dominant aesthetic mode of the period the movement tends to be cyclic and repetitive, toward undifferentiation.[52]

Yet the grotesque as mutation is the counterpart of the inscribed stasis of the law. As the organic moves toward lack of differentiation, the mineral inscription moves toward articulation and universality.

Finlay's inscriptions are for the most part in English, with some use of Latin, German, and French. Although over his career many forms of calligraphy have been used, the recent work emphasizes Roman lettering style, recalling not just eighteenth-century classicism, but a particular static quality in the Latin style itself. Finlay draws on this tradition of nature-inscription descended from the votive or commemorative epigram. It is a tradition long linked to burial inscription, but by the eighteenth century the graveyard is as well a major scene of nature sentiment and nature is itself a kind of graveyard[53]—aphorisms stemming from pastoral themes such as those of Gray's "Elegy," the flowering of archaeology, and a new awareness of the transitory fortunes of civilizations.

The inscription is fixed; one must go to it and one must leave it. It speaks with the authority of the universal, the aphoristic, or the genius of place and not with the particularity of subjective voice. When Finlay quotes a particular source, as in the al-

lusions to Saint-Just, it is the ideology of Saint-Just that bears his name, and not his person: Saint-Just, who proclaimed, "La nature est le point de justesse et de verité dans les rapports des choses, ou leur moralité" and "La nature finit ou la convention commence,"[54] is for Finlay, as he was for his contemporaries, the embodiment of Apollo. Finlay's statuary images of the revolutionary cite with heavy irony the romanticized picture presented in Nesta Webster's notoriously xenophobic and anti-Semitic narrative, *The French Revolution: A Study in Democracy*: "St. Just *[sic]* alone retained his habitual calm. The voluminous cravat was gone, leaving his neck bare for execution, but the delicate chamois-coloured coat still remained unspotted, the wide expanse of white waistcoat still fresh and uncrumpled, whilst in his buttonhole there glowed a red carnation. So with head erect St. Just, that strange enigma of the Terror, passed to his death, a marble statue to the last."[55] By citing Webster, a so-called enthusiast of "democracy" who also promoted a form of paranoia throughout the 1920s, Finlay undermines any idealization of the Apollonian. And Finlay recounts how Saint-Just himself as well embodies the Terror's paradoxical adaptation of Rousseau. Saint-Just's Virgilian motto "Une charrue, un champ, une chaumière . . . voila le bonheur" envisages a pastoral republic, yet one where every dimension of life is under state control. The brutal contradictions inherent in the name Saint-Just, in the ideas attached to Saint-Just, in the images under which the figure is made visible, invite his words as laws to be reviewed and not simply absorbed.

This hermeneutic of suspicion, rooted in Enlightenment rationality, is here applied *to* Enlightenment rationality. In order to create such a hermeneutic Finlay has reached back to the didactic, yet unresolvable, form of the emblem.[56] We might see the emblem at work most clearly if we focus on a particular example. Finlay has constructed several works based on the Battle of the Midway of June 1942. In a 1977 exhibition on the subject, fruit trees were meant to represent the Pacific and seven Renaissance-style beehives represented aircraft carriers as an "actual emblem." In the actual Battle of the Midway the fleets never saw each other. The fighting was done by Japanese carrier-based flights and American land- and carrier-based flights. The American ships, the Hornet, the Enterprise, and the Yorktown, are contrasted to the Japanese carriers, Akagi, Kaga, Soryu, and Hiryu. Finlay envisaged honey spilling out of the hive doors as representing the spilling gasoline—just as smoke drives bees from the hive, so do the ships in flames send out their planes. The history of emblems has displayed the bee as a symbol of industriousness and enterprise; the hornet is a warrior bee, but industriousness here also plays on the linking of industry, technology, and the horror of war.

These connections are already complex, but further meanings can be read in Finlay's Midway emblem. The *Midway Inscription,* a large slate medallion made with Michael Harvey at Little Sparta, reads "Through A Dark Wood / Midway." Finlay thereby links the Battle of the Midway to the famous "middle" theme of the opening of Dante's *Divine Comedy,* where midway in life the poet finds himself in a dark wood with Virgil as his guide. The Horatian imperative of "in medias res" also holds: a dialectical art would have to begin in the middle. But further, the Enterprise's nickname,

the "Big E," comes into full play as well. Plutarch's *Moralia* contains in its fifth volume a discussion of "the E at Delphi." Among the inscriptions at Delphi there was a representation of the fifth letter of the Greek alphabet, epsilon *(E),* which in its written form denotes the number five and is also both the word for "if" and the word for the second person singular of the verb "to be": "Thou art." Plutarch explores the meaning of these three referents ("five," "if," and "thou art") and concludes that the letter became associated with the rites of Apollo at Delphi: one approached the god, using "if" to ask what might happen and, at the same time, addressing the god in terms of the certainty of his being: "thou art." He traces the number five to Pythagorean symbolism: "Five is a 'Marriage' on the ground that it was produced by the association of the first male number and the first female number [and] there is also a sense in which it has been called 'Nature,' since by being multiplied into itself it ends in itself again." As the epsilon compels the pilgrim to Delphi to address Apollo, "Thou art," so does another inscription compel the god to welcome the pilgrim with the message "Know thyself." Plutarch writes that "everything of a mortal nature is at some stage between coming into existence and passing away and presents only a dim and uncertain semblance and appearance of itself,"[57] and continues, "And if Nature, when it is measured, is subject to the same processes as is the agent that measures it, then there is nothing in Nature that has permanence or even existence, but all things are in the process of creation or destruction according to their relative distribution with respect to time."[58] We of course by now remember that IF is the monogram as well of Ian Finlay.

Against the fixity of the inscription and the material stasis of the emblem form are the play and transformation of interpretation—the work of the trope. The trope is celebrated in Finlay's ongoing homage to Ovid, whom he calls the poet of camouflage. In a 1989 letter to Mary Ann Caws, Finlay wrote: "Dryads are traditionally represented in terms of metamorphosis, leaves for fingers, skin turning into tree-bark and so on. For our time (age) it seems preferable to dress the dryad in a camouflage smock." Finlay sought to critique the contemporary picture of a benevolent nature with a view of "nature as something formidable." He quotes Heraclitus: "Nature loves to hide," an aphorism implying the strategy of concealment, surprise, and mutability implicit in all his garden works.[59] The garden's most prominent citation to Ovid is the Temple of Philemon and Baucis. Philemon and Baucis in their old age find that the visitation of the gods results in their small hut being changed into a temple—marble columns take the place of wooden supports, the thatch yellows into gold. In Ovid's version of their story, "It is not only their hospitality but the very purity of their souls that earns for Philemon and Baucis the grace of the gods. Jupiter and Mercury will grant them their wish, which is to die at the same time, and will change them into two trees, with mutually supporting trunks and interwoven branches."[60] The two become one and the one is two, preserved and canceled by the miracle of simultaneity. Nature transformed into culture, culture transformed into nature: this is the Ovidian dialectic, the imaginative reworking of history. Yet it is typical of Finlay's rigorous relation to cultural allusion that he does not stop with this version of the story. In part 2 of

Goethe's *Faust* the story is rewritten out of Ovid and eerily forecasts the brutality of the Nazi regime: Philemon and Baucis refuse to exchange their poor plot for the rich farm that Faust offers. He wants to remove the old couple from the marshland he plans to reclaim for his own sake as well as for what he purports to be the benefit of the human race. When Faust's henchmen try to evict them forcibly, Philemon and Baucis die together in the blaze of their hut, victims of Faust's will to power.[61]

Work and death are the objects of memory.

Death is a Reaper, a folding card Finlay made in 1991 with Gary Hincks, presents images of a scythe with a blade that progressively turns into the Nazi lightning bolt. These images are placed next to a quote from Abraham a Santa Clara: "I have seen that Death is a Reaper, who cuts down with his scythe not only the lowly clover, but also the grass that grows tall; I have seen that Death is a Gardener, who does away with the climbing larkspur as well as the violets that creep along the earth; I have seen that Death is a Player, and indeed a naughty one, for he knocks down the skittles and does not set them up again, and he takes the king as well as the pawns; I have seen that Death is a thunderbolt that strikes not only the tumble-down straw huts, but also the splendid houses of monarchs."[62] If the Ovidian story changes the pastoral hut into the golden temple and so narrates an account of virtue rewarded, it is contrasted in Finlay's work to Sebastien Chamfort's revolutionary pronouncement of 1789: "Guerre aux chateau, paix aux chaumières!"[63] Wherever there is resolution into law, there is also the seed of the corruption of the law; wherever there is peace there will inevitably be war, as Heraclitus had claimed in his aphorism, "War is father of all and king of all."[64]

In following Poussin, Finlay practices a particular method of historical reference. As he paints Arcadia, Poussin follows the Roman tradition of Arcadia as an immemorial past, a kind of spiritual landscape derived from ideals rather than any historical antecedents. Yet he emphasizes that such scenes are temporally distant.[65] Finlay's most extensive quotation from Poussin has been in his many reworkings of *Et in Arcadia Ego*—Poussin's two paintings on Arcadia and mortality. These paintings have an important antecedent in Guercino's work on the same theme. In Guercino's work, two Arcadian shepherds are halted in their wanderings by the sight of a human skull on a moldering piece of masonry, accompanied by a fly and a mouse, popular symbols of mortality. One of the Poussin paintings is in the Devonshire collection at Chatsworth, the other in the Louvre. Erwin Panofsky's famous essay on the paintings, "*Et in Arcadia Ego*: Poussin and the Elegiac Tradition," explores the tension between two interpretations of the Latin phrase: "I, too, lived in Arcady," and "I [Death] am as well in Arcady." Panofsky contends that the latter translation, more accurately conforming to Latin syntax and made famous by an ad hoc interpretation provided by George III of a painting with the same inscription by Joshua Reynolds, was originally what Guercino and Poussin, in his early work, had in mind. Yet by the time of the meditative classicism of the Louvre version, Poussin was thinking of the more particular

meaning, "The person buried in this tomb has lived in Arcady," so that "what had been a menace has become a remembrance."[66] Finlay appropriates the images of the shepherds reading the inscription but, through a series of substitutions and permutations, arrives at a German tank in the place of the tomb, thus placing a menace that is also a remembrance into Arcadia.

Finlay plays on Marvell's "mower" as well as the folk theme of "the grim reaper" in his concrete poem "Mower is less." The allusion is to the ax of Robespierre, the guillotine, but it also refers back to the theme of lightning and the depiction of Cromwell in Marvell's "Horatian Ode": "like the three fork'd Lightning, first / Breaking the Clouds where it was nurst, / Did thorough his own Side / His fiery way divide." As Geoffrey Hartman has explained, "a 'bleeding Head' is once again and ironically the prerequisite for the body politic's wholeness. . . . The new order is forced to unify by the sword, by division, by a rape of time."[67] Apollo as musician sends forth his messages of music; as "far-shooting archer," his messages of death.[68]

Virtue and justice are the objects of making.

Military metaphors and the rhetoric of moral philosophy, from Laurence Sterne's Uncle Toby to Samuel Johnson's Stourbridge school poem "Festina Lente," were inseparable in the eighteenth century,[69] and Finlay has evoked in the neo-neoclassicism of Little Sparta many of the connections between military metaphors and ethics. Among his garden inscriptions, he includes a 1977 stone plant trough inscribed "Semper Festina Lente"[70] and accompanied by a relief of a minesweeper. The same warning is translated into German, "Achtung Minen," in Finlay's *New Arcadian Dictionary*.[71] Yet the yoking of a militaristic ethical rhetoric to imagery of the garden has an even older genealogy. The golden apples of the Hesperides were the ornament and reward of Hercules' virtue, a virtue that was made evident not by Hercules' nature, but by his actions—his choice of the right path. The Norman invasion of Sicily produced the tradition of rewarding French kings with orange cuttings, the "storied reward of Herculean might."[72] In the sixteenth century the Villa d'Este used the story of Hercules' choice at the crossroads to structure the paths and fountains in their dedication to "honest pleasure," and Cosimo de' Medici's Castello showed Hercules subduing Antaeus in an enclosed garden bounded by the four seasons and lined with emblems of the virtues of the Medici.[73] Finlay inadvertently, and then markedly, made an allusion to the Villa d'Este when he inscribed on the bases of stone representations of aircraft carriers at Stonypath, "Homage to the Villa d'Este." Later, he learned of the avenue of stone ships at the villa and came to consider this coincidence to be evidence of the classical tradition as an enduring, if not always conscious, experience.[74]

Sir Thomas Browne's 1658 treatise *The Garden of Cyrus or the quincuncial, lozenge, or network plantations of the ancients, artificially, naturally, mystically considered* is another key text for understanding Little Sparta.[75] Browne, who admits in his opening paragraphs that he is not a gardener, traces the importance of order in the gardener's

Figure 7. Aircraft Carrier, Bird Table, and the Temple Pool, Little Sparta, 1972. Photograph by David Patterson. Used by permission of Ian Hamilton Finlay.

art. "Disposing his trees like his armies in regular ordination," the Persian king Cyrus came to be known as "the splendid and regular planter" (141). Browne links the quincuncial form of Cyrus's planting to the Greek letter X and to the crosses and crucifixion of Christian iconology and the anointing of Hebrew priests in the form of an X (142–43). Although unmentioned, the relation to Hercules at the crossroads also emerges.[76] Browne does mention that Aristotle uses a singular expression concerning the order of vines, delivered by a military term representing the orders of soldiers, and that the Roman battalia, too, was ordered by means of an alternating form of groups of five and four horizontally arranged. He concludes with a discussion of the appearance of quincuncial forms in nature and with "the ancient conceit of five, surnamed the number of justice, as justly dividing between the digits, and hanging in the centre of nine described by square numeration . . . [in] that common game among us wherein the fifth place is sovereign and carrieth the chief intention—the ancients wisely instructing youth, even in their recreations, unto virtue, that is early to drive at the middle point and central seat of justice" (183–84). Browne emphasizes only the order, or what might be called the poetic justice, of the analogy between the garden and war. A relentless structuralist, the poet sees the quincunx wherever he looks and, like the pre-Socratics, finds nature yoked to laws like those that bind human nature. But the purer and more abstract the rule of law, the more insistently does the particular make itself apparent; what has been unified begins to split. The trope falls back into its elements; the materiality of history asserts itself against the periodicity of history.

He who makes a garden, his own remembering makes.

Finlay's three occupations—soldier, shepherd, and poet—are completely bound up with the forms of knowledge Little Sparta proposes. Although he finds little value in biographical and autobiographical interpretation, Finlay has written of the particular relation between Little Sparta and World War II:

> In wartime the British were encouraged to grow their own food ("DIG FOR VICTORY"), and the phrase Wartime Garden was almost certainly used to denote the purposes the garden might then serve. My work, then, treats the garden, *not* as an idyll or pastoral, but as a kind of model for the Heraclitean or Hegelian understanding. . . . in the same way . . . I have treated the French Revolution as a pastoral or idyll: "The French Revolution is a pastoral whose Virgil was Rousseau."[77]

At Little Sparta the family clothesline is called the "Siegfried Line," in memory of the British song from World War II: "We're going to hang out our washing on the Siegfried Line. / Have you any dirty washing, Mother dear?"

In a garden of sublime, yet sinister, images, the Nuclear Sail, a stone monument designed to look like a nuclear conning tower protruding by Little Sparta's Lochan Eck, the large pond named after one of Finlay's children, starkly calls to mind the horrific potential of instruments of war and not simply their past. The U.S. Polaris sub-

marine base is at Holy Loch, Scotland, on the other side of Glasgow,[78] and Finlay's garden is in a strategic part of the country frequently crossed by Royal Air Force Phantom jets on maneuvers.[79] In deflating the naive and ultimately narcissistic optimism of evolutionary thought, Finlay asks us to consider the moral framework and potential consequences of any historical idea. In tracing the tension between order and disorder through the pre-Socratics to Nietzsche and Hegel, he has presented a relentlessly dialectical context for thinking about the relations between human culture and nature. Finlay's garden as a paradise of philosophy constantly reminds us of the agon between forms of thought, the simplemindedness of monumentality, and the fragile boundary between art and war. Little Sparta is a work, both made and evolving, that explores the dangers of facile apprehension and ready enthusiasm. The garden refuses to allow the viewer to identify naively with its individual themes and symbols; Finlay argues that when individuals pursue an unthinking identification with power and sentimental ideals, terror and catastrophe ensue.

In 1995–96, a further conflict with the Strathclyde regional government compelled Finlay to close the garden once again. More recently, the regional government itself was dissolved by the state.

Notes

1. For an introduction to these issues, see James Fenton, "War in the Garden," *New York Review of Books* 40, no. 12 (June 24, 1993): 23–26. James Elkins has provided an overview of the paradigms of garden scholarship in his essay "On the Conceptual Analysis of Gardens," *Journal of Garden History* 13, no. 4 (winter 1993): 189–98. Craig Clunas's recent work on Chinese gardens suggests important cultural and historical variations in the tensions between agricultural and aesthetic functions of gardens: *Fruitful Sites: Garden Culture in Ming Dynasty China* (London: Reaktion Books, 1996).

2. In providing an account of the garden I have noted sources whenever relevant. Any unattributed details are from my notes and sketches made during a visit to Little Sparta on June 20, 1993. Much of the material for this essay was gathered from the Ian Hamilton Finlay archives at the Getty Center for the History of Art and the Humanities, Santa Monica, California. All photographs are courtesy of the Getty Center archives. I am grateful to Mr. Finlay for making possible my tour of the garden and for his ensuing conversation and correspondence, although I do not believe he will concur with every argument I have made here. I also thank the Getty Center for extensive support in May and June 1995, during my tenure there as a visiting scholar.

3. In 1962 Finlay founded the journal *Poor. Old. Tired. Horse,* published by the press he had founded with Jessie McGuffie in 1961, Wild Hawthorn Press.

4. See "A Bridge Too Far: The First Battle of Little Sparta," *Poetry Nation Review,* February 4, 1983.

5. See Finlay, "Reflections on the French Revolution," Getty MSS, box 18. Although the media coverage of this event emphasized its "mock" quality, Finlay has written that "a very delicate, and dangerous, line was established; it was a case of a real rather than imaginary garden with very real police. The wonder was that we were not in prison." Correspondence, November 29, 1995.

6. Yves Abrioux, *Ian Hamilton Finlay: A Visual Primer,* with introductory notes and commentaries by Stephen Bann (London: Reaktion Books, 1992), 7–13. This is the second edition, much expanded and revised from a first edition in 1985. Abrioux's work and the essays of Stephen Bann, the latter following Finlay's career closely and providing an ongoing commentary on developments in his art, are the most important and extensive introductions to Finlay's work. Gavin Keeney's "Noble Truths, Beautiful Lies, and Landscape Architecture" (master's thesis, Department of Landscape Architecture, Cornell University, January 1993) provides an interpretive discussion of Finlay's 1988 *Un jardin revolutionnaire* proposal and locates this project within the fuller context of Finlay's work. I am grateful to Mr. Keeney for sending me a copy of his essay and for his more general comments on Finlay's work offered in correspondence.

7. Alan Powers, "Neo-Classical Rearmament," *Spectator,* September 12, 1987, 39–40. For a collection of critiques of the *National Trust Book of Follies,* see "Blast Folly, Bless Arcadia," ed. Patrick Eyres, *New Arcadians' Journal,* no. 24 (Winter 1986).

8. See Patrick Marnham, "Up the Garden Path," *Independent Magazine,* August 8, 1992, 19–25, and Peter Day, "Ian Hamilton Finlay: The Bicentennial Proposal: The French War: The War of the Letter," pamphlet (Toronto, Canada: Art Metropole, 1989). The most considered account of Finlay's loss of the Bicentennial Commission is by Yves Abrioux, "Vichy Revisited: The Cancellation of a Public Commission to Celebrate the Bicentenary of the French Revolution and the Declaration of the Rights of Man" (talk given at the Sorbonne, photocopy).

9. *A Greek-English Lexicon,* compiled by Henry Liddell and Robert Scott, 9th ed., vol. 1 (Oxford: Clarendon Press, 1940).

10. Quoted from Charles H. Kahn, "Anaximander's Fragment: The Universe Governed by Law," in *The Pre-Socratics: A Collection of Critical Essays,* ed. Alexander P. D. Mourlatos (Garden City, N.Y.: Anchor Press, 1974), 99–117.

11. See the discussion in Claude Gintz, "Neoclassical Rearmament," *Art in America,* February 1987, 110–13.

12. Stephen Bann, "A Description of Stonypath," *Journal of Garden History* 1, no. 2 (1981): 113–44, at 133.

13. Abrioux, *Finlay,* 13.

14. The plant list is partial, gathered from my notes and from plants listed in Graham Rose, "The Garden of Unrest," *Observer* color supplement, 1986, 55 (no further date or pages; see materials in Getty MSS, box 21).

15. "L'Idylle des cerises," described in pamphlet from the Wild Hawthorn Press by Finlay and Michael Harvey (Getty MSS, box 24): "*gean,* a grove of gean or wild cherry trees. On a small fluted column among the trees is a bronze or stone basket of cherries with the words *l'idylle des cerises.*" The phrase is inspired by Finlay's reading of the following passage from Jean-Jacques Rousseau's *Confessions,* as cited in Renato Poggioli, *The Oaten Flute* (Cambridge: Harvard University Press, 1975), 14, 273: "I climbed into a cherry tree, and threw bunches of cherries down to the girls, who then returned the cherry stones through the branches. Seeing one of the girls holding out her apron and tilting her head, I took such good aim that I dropped a bunch into her bosom. 'Why are my lips not cherries,' I thought, 'How gladly I would throw them there, too!'"

16. Quotes from 297–300 of Erwin Panofsky's account of the development of the Arcadian concept in "Et in Arcadia Ego: Poussin and the Elegiac Tradition," in *Meaning in the Visual Arts: Papers in and on Art History by Erwin Panofsky* (Garden City, N.Y.: Doubleday Anchor, 1955), 295–320.

17. The Hyperboreans ("those who carry over") wrapped their offerings in wheat straw and requested their neighbors to pass them from nation to nation until they arrived at Delos.

Their home is a region beyond the north wind, a paradise like the Elysian plains, which cannot be reached by land or sea.

18. *Heraclitus: The Cosmic Fragments,* ed. G. S. Kirk (Cambridge: Cambridge University Press, 1975), quote at 203, discussion at 214–15.

19. Poggioli, *Oaten Flute,* 238.

20. Walter Pater, "Apollo in Picardy," in *Miscellaneous Studies* (London: Macmillan, 1910), 142–71; see Stephen Bann, "Ian Hamilton Finlay: An Imaginary Portrait," in *Ian Hamilton Finlay,* exhibition catalog (London: Serpentine Gallery, 1977), n.p., and Finlay's 1986 card with photography by Marius Alexander, "Apollo in Strathclyde," with its inscription: "The wine-dark sea, the turnip-marbled field. / The Hyperborean Apollo of Walter Pater's *Apollo in Picardy.* / In Little Sparta he is identified with Saint-Just."

21. Bann, "Finlay," n.p.

22. See Maynard Mack, *The Garden and the City* (Toronto: University of Toronto Press; London: Oxford University Press, 1969), 232.

23. Alexander Pope, "The First Satire of the Second Book of Horace Imitated," in *Pope, Poetical Works,* ed. Herbert Davis (Oxford: Oxford University Press, 1978), 340–45. See John Dixon Hunt, *The Figure in the Landscape: Poetry, Painting, and Gardening during the Eighteenth Century* (Baltimore, Md.: Johns Hopkins University Press, 1976), 77–78, for a discussion of Pope's grotto at Twickenham in relation to this passage. Dixon Hunt explains that "the grotto at Twickenham was linked to Egeria, wife of a legendary philosopher-king Numa to make this connection explicit: for according to both Livy and Plutarch, Numa and Egeria 'entertained familiar conversation with the Muses [in their grotto] to whose teaching [Numa] ascribed the greatest part of his revelations.'" (77). In *Broken Tablets: The Cult of the Law in French Art from David to Delacroix* (Berkeley: University of California Press, 1993), Jonathan Ribner mentions that the same legend was influential in French revolutionary thought: "The divinely inspired legislator played a large role in late eighteenth and nineteenth century French culture. That the Spartan Lycurgus enjoyed the blessings of Apollo and that Numa, the legendary second king of Rome, gained legislative wisdom from conversing with the nymph Egeria was known from Plutarch's *Parallel Lives*—a work firmly integrated into the French tradition by Jacques Amyot's classic translation (1559)" (4).

24. See Marjorie Williams, *William Shenstone: A Chapter in Eighteenth Century Taste* (Birmingham: Cornish Brothers, 1935), 37–39, and E. Monro Purkis, *William Shenstone, Poet and Landscape Gardener* (Woverhampton: Whitehead Brothers, 1931).

25. William Shenstone, "Unconnected Thoughts on Gardening," in *The Works in Verse and Prose of William Shenstone.* 3 vols. (London: J. Dodsley, 1791), 2:111–31. For selections from Finlay, see Abrioux, *Finlay,* 40.

26. Kenneth Woodbridge, *The Stourhead Landscape* (Plaistow: National Trust, 1978), 5. See also two pamphlets: *Stourhead* (Plaistow: National Trust, 1971) and *Stourhead/Wiltshire* (London: Country Life Limited, 1952).

27. "This little pool is excerpted from the longer water."

28. *Stowe,* text by G. B. Clarke (St. Ives: Photo Precision, 1971), 11.

29. "What pretty temples!"

30. John Dixon Hunt, "Ut Pictura Poesis, ut Pictura Hortus, and the Picturesque," *Word and Image* 1, no. 1 (January-March 1985): 87–197, at 92–93: "It is as if that Temple of British Worthies, elaborately provided with inscriptions, is offered in only partial competition with its classical counterpart across the river of death." See also William Gilpin, *A Dialogue upon the Gardens at Stowe* (Los Angeles: William Andrews Clark Memorial Library, University of California, 1976), Augustan Reprint Society, no. 176. For an additional eighteenth-century account of Stowe, see George Bickham, *The Beauties of Stow* (1750) (Augustan Reprint Society,

1977), publication nos. 185–86 (William Andrews Clark Memorial Library, University of California, Los Angeles).

31. See the booklet titled *SF,* printed at Finlay's Wild Hawthorn Press with George L. Thomson in 1978, Finlay archives, Getty Center (see Abrioux, *Finlay,* 283, for a reproduction of the relevant page); and Christopher McIntosh, *Coincidence in the Work of Ian Hamilton Finlay,* exhibition catalog (Edinburgh: Graeme Murray Gallery, 1980), n.p.

32. These examples are from Ribner, *Broken Tablets,* 13–15. For further discussion of issues of unusual weather and tempests in Revolutionary iconography, see Ronald Paulson, *Representations of Revolution* (New Haven, Conn.: Yale University Press, 1983), 5, 8, 44 n. 19, 69, 75.

33. Mary Shelley, *Frankenstein* (New York: Signet, 1965), 40: "as the dazzling light vanished, the oak had disappeared, and nothing remained but a blasted stump. . . . It was not splintered by the shock, but entirely reduced to thin ribbons of wood. I never beheld anything so utterly destroyed." See also 153, Victor Frankenstein after the disaster of his experiments: "But I am a blasted tree; the bolt has entered my soul."

34. *The Seasons by James Thomson with The Life of the Author by Dr. Samuel Johnson* (Philadelphia: H. Taylor, 1790), 90–94, lines 1083–1231.

35. See Sheila McTighe, "Nicholas Poussin's Representations of Storms and *Libertinage* in the Mid-Seventeenth Century," *Word and Image* 5, no. 4 (October–December 1989): 333–61, at 350. This essay provides an illuminating discussion of Poussin's paintings as representations of his political and moral philosophy, especially his ideas regarding nature and fate. In *Nicolas Poussin: A New Approach* (New York: Abrams, 1966), Walter Friedlaender discusses Poussin's stoicism, especially the influence of Seneca regarding the necessity of a resolution to resist accidents of fortune and death.

36. See Bann, "Description of Stonypath," 123, 126. Finlay's use of vegetative background in light and shade to evoke the sea might also be linked to the "staging" of mythological scenes by means of classical sculptures in a sea of vegetation in the gardens of the Villa Medici, now the French Academy, in Rome.

37. See two of Finlay's pieces in particular: *Cloud Board,* an early work from 1968 in which a bisected tub was set into the ground with one side reflecting clouds as they passed by and the other planted with aquatic plants such as waterlilies designed to imitate the form of the passing clouds, and *Angelique et Medor,* an inscription of the names of the lovers from Ariosto's *Orlando Furioso,* designed to be read in the water of a pond. Their story, set in the context of Charlemagne's wars, includes an account of their honeymoon in the woods; when Orlando, who has been enamored of Angelica, comes upon their retreat by chance and learns she has married the Moor Medoro, he is seized with madness. Orlando runs naked through the country, destroying whatever he encounters, and returns to Charlemagne's camp. As in Finlay's complex re-creations of painted landscapes, both following and critiquing eighteenth-century conventions of the re-created picture, here he presents a fictional story in what could be its real setting, but reminds us of our doubled relation to the mutually implicated fictional and real by showing us the names in a mirror.

38. Eventually, in 1793, in the empty space where the prison had been, an enormous statue of Nature in the form of a Sphinx was erected. See Paulson, *Representations,* 41.

39. See ibid., 17.

40. Ibid., 75.

41. Rousseau's remains were removed in 1794 to Sainte-Genevieve in Paris. Finlay has also made a series of prints with Gary Hincks, *Tombeau de Rousseau au Pantheon,* which juxtaposes the original neoclassical design with its torch of Truth and an arm holding a machine gun protruding from the tomb door, representing Action or Nature. See Abrioux, *Finlay,* 297. The Marquis de Girardin's tribute to Rousseau is itself an "island" of English taste in the French

gardening tradition. See Day, "Finlay: Bicentennial Proposal," 15: "In successfully blending aesthetics, politics, Arcady and Husbandry, the English created a highly successful and at the same time individual form of garden that had little in common with the mathematical, pleasure and water-gardens of eighteenth-century French court life. As such, the English political garden is as foreign to French eighteenth-century life as the French garden itself differs from the English. The English political garden was alien to the nature and conception of French garden design and thinking, except in the noteworthy case of the Marquis de Girardin, the late eighteenth-century anglophile gardenist."

42. See Anthony Vidler, *The Writing of the Walls: Architectural Theory in the Late Enlightenment* (Princeton, N.J.: Princeton Architectural Press, 1987), 18, and Wolfgang Herrmann, *Laugier and Eighteenth-Century French Theory* (London: Zwemmer, 1962). Herrmann writes, "The story of primitive man and his hut may have appealed to the average reader because of the then fashionable interest in the life of the savage, but Laugier had undoubtedly chosen it for a different reason: he thus traced the architectural lineage back as closely as was possible to nature itself. He calls the hut 'a rough sketch which nature offers us'" (from Laugier's *Essai* 2: 12 and 1: 10, quoted in Herrmann, *Laugier,* 43). See also the discussion of the hut as both picturesque and "a center of concentrated solitude" in Gaston Bachelard, *The Poetics of Space,* trans. Maria Jolas (Boston: Beacon Press, 1969), 31–32.

43. A connection between the neoclassicism of the French Revolution and the destruction of the Bastille is made as well in Finlay's references to the neoclassicism expressed in the pastoral and prison etchings of Piranesi.

44. See Bann, "Description of Stonypath," 138.

45. Ibid., 128.

46. Poggioli, *Oaten Flute,* 3. See also Geoffrey Hartman, "'The Nymph Complaining for the Death of Her Faun': A Brief Allegory," in *Beyond Formalism: Literary Essays, 1958–1970* (New Haven, Conn.: Yale University Press, 1970), 173–92, at 177–78: "Those acquainted with the poetry of the Pleiade will remember the impact of the Anacreonta and the Greek Anthology (mediated by the Neo-Latin poets) on Ronsard, Du Bellay, and Belleau, who began to develop an alternate tradition to the high style of the great ode which had been their main object of imitation. Not odes but odelettes, not epics and large elegies but little descriptive domestic or rural poems. . . . A strange riot of diminutives and diminutive forms begins. The word *idyll* in fact was commonly etymologized as a diminutive of *eidos,* a little picture" (177).

47. See Abrioux, *Finlay,* 2: "Exhibition of toys [in 1963] at the home of the publisher John Calder." Finlay's model-making is discussed in Day, "Finlay: The Bicentennial Proposal," 19.

48. See, for example, H. G. Wells, *Little Wars: A Game for Boys from Twelve Years of Age to 150 and for That More Intelligent Sort of Girls Who Like Boys' Games and Books; with an Appendix on Kriegspiel* (London: Frank Palmer, 1913). Miles Orvell, "Poe and the Poetics of Pacific," in *Ian Hamilton Finlay: Collaborations* (Cambridge: Kettle's Yard Gallery, 1977), 17–22, describes "Pacific," a war game like draughts that Finlay invented, involving the progress of airplane and carrier models across a board. Finlay has also studied, and based a concrete poem ("little fields / long horizons") upon, the prison garden of Albert Speer at Spandau, contending that the Nazi architect's assemblage of concrete, debris, and plants there—far from being a benign hobby—was a re-creation of his memories of party rally scenes such as the Zeppelinfield. See Graham Rose, "The Garden of Unrest," Getty MSS, box 21, and Stephen Bann's commentary "The Speer Project," in Abrioux, *Finlay,* 288–89.

49. Gilpin, *Dialogue upon the Gardens at Stowe,* 29–30.

50. See Dixon Hunt's discussion of theatricality in the perspectival garden scene in "Ut Pictura Poesis," 93.

51. Keeney, "Noble Truths," 163.

52. Paulson, *Representations,* 7.

53. See Hartman, "Wordsworth, Inscriptions, and Romantic Nature Poetry," in *Beyond Formalism,* 206–30, at 210–11.

54. See Louis-Antoine de Saint-Just, *Théorie politique: Textes établis et commentes par Alain Lienard* (Paris: Editions du Seuil, 1976), 139–40.

55. Nesta H. Webster, *The French Revolution: A Study in Democracy* (New York: Dutton, n.d.). See also Webster's *Secret Societies and Subversive Movements* (London: Boswell, n.d.), *The Socialist Network* (London: Boswell, 1926), and *World Revolution: The Plot Against Civilization* (London: Constable, 1921). For a brief discussion of Webster's influence on this "classic paranoid anti-semitism" as yoked to French modernism, see Louis Menand's review of Anthony Julius's *T. S. Eliot, Anti-Semitism, and Literary Form* (Cambridge: Cambridge University Press, 1995) in "Eliot and the Jews," *New York Review of Books* 43, no. 10 (June 6, 1996): 34–41. In a continuation of the anti-Semitic and anti-Freemason conspiratorial speculations of the eighteenth-century Jesuit Abbé Augustin Barruel, Webster constantly argues that the Terror is the root of all later anarchic and subversive social movements. (See the discussion of French anti-Semitism during the Enlightenment by Leon Poliakov, *The History of Anti-Semitism,* trans. Miriam Kochan [New York: Vanguard/Routledge, 1975], 3:70–156.) Webster's mode of "history" writing insinuates that the "other" (here Jews and revolutionaries) is the hidden *cause* of whatever is to be designated as a "problem." There is no end to the growth of the irrational attribution that ensues; Webster's elaborately manic taxonomies, graphs, and lists of names horribly anticipate the Nazi bureaucracy and the McCarthy era. Paranoia is the method of such anti-Semitism, as it is today in neo-Nazi and other extreme right movements.

56. In a letter of January 29, 1975, to Michael Harvey on his plans for a Battle of the Midway emblem, Finlay explains: "Obviously, the emblem or medallion or impresa form appeals to me because it conjoins words and pictures. It also makes something of an issue of *brevity.* But perhaps even more relevant is the element of *wit.*"

57. Finlay plays on the duality of the Greek word χαιρε, meaning both "hail" and "farewell" in the sense of a salute to the dead, particularly in his one-word poem "WAVE/ave."

58. See "The E at Delphi," in *Plutarch's Moralia in Sixteen Volumes,* trans. Frank Cole Babbitt, vol. 5 (Cambridge: Harvard University Press, 1969), 253.

59. Personal letter to Mary Ann Caws, April 30, 1989, 3, Getty MSS, box 7.

60. Quoted from Poggioli, *Oaten Flute,* 12. In this theme of a simultaneity that will reveal the couple as in fact one, we find Finlay's interest in recording the names of pairs of lovers: Aeneas and Dido, Apollo and Daphne, Angelica and Medoro, and others who are brought together or torn apart by strife and in their separation are yet joined by time or dissolved into nature, as Dido is into fire or Daphne is into wood.

61. See Poggioli, *Oaten Flute,* 30.

62. Quoted in Abrioux, *Finlay,* 291.

63. Maurice Pellisson, *Chamfort: Étude sur sa vie, son caractère, et ses écrits* (Geneva: Slatkine Reprints, 1970; reprint of 1895 Paris edition), 218.

64. Heraclitus, *Cosmic Fragments,* 245.

65. See David Carrier, *Poussin's Paintings: A Study in Art-Historical Methodology* (University Park: Pennsylvania State University Press, 1993), 171–72.

66. Panofsky's final revision of the essay is in *Meaning in the Visual Arts,* 295–320; see 316–17. The paintings are in fact a kind of emblem of art history scholarship, posing a number of conflicts in interpretation. See, for example, Carrier, *Poussin's Paintings,* 30–174, which surveys the competing versions of Panofsky's essay in light of larger considerations of Poussin's landscapes; Louis Marin, "Towards a Theory of Reading in the Visual Arts: Poussin's *The Arcadian Shepherds,*" in *Calligrams,* ed. Norman Bryson (Cambridge: Cambridge University

Press, 1988), which uses the deictic aspect of the Louvre painting to propose a theory of reading in painting; and Jean-Louis Schefer, "Thanatography, Skiagraphy (from *Espèce de chose melancolie*)," trans. Paul Smith, *Word and Image* 1, no. 2 (April–June 1985): 191–96, which sees the painting as a kind of allegory of reading more generally, where the painting represents the onset of interpretation made possible by the loss of the body as a lived relation.

67. Hartman, "'Nymph Complaining,'" 191.

68. Letter from the philosopher Edward Hussey to Finlay in 1977, quoted in Bann, "a Description of Stonypath," 134.

69. See Paul Fussell, *The Rhetorical World of Augustan Humanism, Ethics, and Imagery from Swift to Burke* (Oxford: Clarendon Press, 1965), 143.

70. Abrioux, *Finlay,* 224.

71. Excerpts from *A New Arcadian Dictionary* are reprinted in McIntosh, *Coincidence,* n.p.

72. Terry Comito, *The Idea of the Garden in the Renaissance* (New Brunswick, N.J.: Rutgers University Press, 1978), 9–12.

73. Ibid., 14–15.

74. See McIntosh, *Coincidence,* n.p. (p. 3 of text).

75. Sir Thomas Browne, *Religio Medici, Hydriotaphia, and the Garden of Cyrus,* ed. R. H. A. Robbins (Oxford: Clarendon Press, 1972). All page numbers in parentheses refer to this edition, although I have also consulted *Hydriotaphia, Urne-Buriall; or, A Discourse of the Sepulchrall Urnes lately found in Norfolk. Together with The Garden of Cyrus, or the Quincunciall, Lozenge, or Net-work [p]lantations of the Ancients, Artificially, Naturally, Mystically Considered. With Sundry Observations,* by Thomas Browne, D. of Physick (London: printed for Hen. Brome at the Signe of the Gun in Ivy-lane, 1658).

76. Susan Howe, in an early essay on Finlay's concrete poetry, "The End of Art," *Archives of American Art Journal* 14, no. 4 (1974): 2–6, discusses Finlay's use of the cruciform in works like "Fisherman's Cross," a concrete poem where eight clusters of the word *seas* surround a central "ease": "again the cruciform, icon of redemption in continuity— . . . a poem whose visible form is identical to its structure." Howe quotes Henry Vaughn, "Death is a Crosse, to which many waies leade, some direct, and others winding, but all meet in one center."

77. Letter to Mary Ann Caws, April 30, 1989, 3.

78. See G. G. Giarchi, *Between McAlpine and Polaris* (London: Routledge, 1984).

79. See Day, "Finlay: Bicentennial Proposal," 18.

6. Written on the West: How the Land Gained Site

Erika Suderburg

Making an Aerial Run/Ruin

"I'll tell you what this is. This is an art project, not a peace project. This is a landscape painting in which we use the landscape itself. The desert is central to this piece. It's the surround. It's the framing device. It's the four part horizon.

"It's so old and strong. I think it makes us feel, makes us as a culture, any technological culture, we feel we mustn't be overwhelmed by it. Awe and terror, you know. Unconducive"—and she waved a hand and laughed—"to industry and progress and so forth. So we use this place to test our weapons. It's only logical of course. And it enables us to show our mastery. The desert bears the visible signs of all the detonations we set off. All the craters and warning signs and no-go areas and burial markers, the sites where debris is buried."

—Klara Sax, a character in Don DeLillo's *Underworld*

If I were to begin a novel, listing a series of related events, images, and vistas, I would structure the plot around spaces of unarticulated aridity, defined by and dependent on the hidden life of objects and their ruins, myriad surface etchings across the material and conceptual space of desert(s). My tracings would begin with a series of sites: marked plateaus, incised embankments, ancient geoglyphs, hard and soft vistas, exploded pockets and remote jeep trails. (A Las Vegas–Elvis Chapel–shotgun wedding of Reyner Banham's *American Deserta* and the entropic sculptured circuitry of Robert Smithson as imploded by a Michael Heizer depth charge and tacitly witnessed by the receding figure of Walter De Maria in a hot air balloon.)[1]

The romance of absence, and the solitary contemplative figure, defy narrative linearity and tabulation. Site specificity wallows in absence and inference, qualities

intrinsically reworked through the use of desert as site. Site specificity is a way of working at ground zero. As a desert practice, it presupposes an attachment to the possibility of removal and infinity. The desert floor as foundation speaks to origins and geological timelessness, simultaneously destroying and enforcing a sense of human scale. These sites elicit the desire to mark, to excavate, to connect, to chart, to contemplate, to bomb, to assume solitariness, to nest, to become cowboy, to homestead, to pioneer, to hide, to conquer, to occupy, and to leave behind. They raise up a hollow but placating sense of timelessness, a test of tailgate survival and arid sensibilities. These marks of human transgression engender suspicion, speculation that these site-specific desert "artworks" play into some American frontier romance or teeter on geologic essences. This sense of timelessness, both monumentally and discretely rendered, is incontrovertibly linked to a Euro-Western notion of the standardized "natural," the origins of which can be traced to the found poetics of genteel landscaping and mimicked in the Enlightenment illusion of a controllable nature and in the Romantics' desire for a wilderness submersion as transcendent apotheosis.

Site-specific works on the desert topos translate certain indices partially extrapolated and partially divorced from these origin myths and filtered through minimalism's reductive liberatory promise. The works share a sense of perfunctory and/or immovable mark making, with aspirations of duration and nonerasure: entropic scratchings that suggest decay but also surreptitiously promise edifices of permanence. The Romantics were prompted to define beauty emotionally, in relation to a far-off wild vista, which could not be contained in the sublime fabricated neoclassical ruin or framed in a tinted view prescribed by the proscenium arch or the carved golden frame.

Mausoleum and Genealogy

My novel would begin by describing a visit to the Nazca line drawings in Peru. Perfect lines can be seen from mountain peak to plain. Spirals, trapezoids, monkeys, and concentric rings were drawn by removing dark surface rock on the surface crust. The protagonist of my novel would marvel at the amount of time the three hundred square miles of lines have lasted, how they look almost recently swept, how the mineral composition of the soil preserves these marks, and how a visitor's hiking boots may make an imprint as long lasting as human boots on the moon.[2] Nancy Holt says of her purchased Utah desert floor that "being part of that kind of landscape, and walking on earth that has surely never been walked on before, evokes a sense of being on this planet, rotating in space in universal time."[3]

The Nazca line drawings, including what Robert Morris terms "spiritual irrigation" channels and a hummingbird with a two-hundred-foot wingspan, were carefully etched into a Peruvian desert plain sometime between 100 B.C. and 700 A.D. These geoglyphs were rendered by the removal of a surface coat of stony earth, uncovering a lighter layer below.

Many deserts beyond, the British army digs an elaborate, zigzag sandbagged trench to foil direct gunfire in the Suez Canal in 1916. In 1942, the retreating German army plows up its airfield in Ghindel, Libya, creating an intricate series of earth spirals, which render the airfield useless.[4] The atomic bomb haunts Isamu Noguchi in 1947 as he fabricates a scale model for the proposed desert piece *Sculpture to Be Seen from Mars,* a plaintive, geometrically abstracted face looking upward, the nose section larger than an Egyptian pyramid. Noguchi's unrealized project is so massive that its only proper viewing distance would be from outer space. Michael Heizer blasts *Double Negative* out of rock face in the Nevada desert in 1969. It is visible via high-altitude aerial photography.

In 1968, Walter De Maria inscribes a cross five hundred by one thousand feet on the El Mirage Dry Lake in Nevada. In the early 1990s Viet Ngo plans Lemna-plant-fueled water reclamation projects in the deserts of Egypt and Nevada, projects that produce art *and* water.[5] This genealogy of constructions, whether motivated strategically, arrogantly, or spiritually, illustrates that the desert has repetitively and obsessively been reinscribed. Picture Lillian Gish, insane and beautiful, scrubbing her dinner plates clean with sand in Victor Sjostrom's 1928 film *The Wind,* a frenzied view of death from lack of water. The desert becomes articulated, gains "site," (in) site: it is home to both monumentality and planned dissolution to marking, becoming, and erasing.

My novel's main character, a grizzled desert rat of indeterminate age, with vague lapsed geologic credentials, has two images hanging above her sink in her hand-built solar adobe. They include David Roberts's 1836 lithograph of the yet to be fully excavated Temple of Ramses II, circa 1250 B.C., statuary adrift in interior dunes; and a half-melted slide sheet containing John Divola's series of desert landscapes called *Isolated House.* She came into possession of the latter solely because Divola had trespassed on her land while trying to photograph her lime green sheep shack. From time to time, when the swamp cooler fails, she holds her 35mm *Isolated House* up to hot light and watches while the transparency folds into and superimposes itself over the dusty scrub of her backyard. She installs these housescapes daily, an entertaining kaleidoscope of home site and captured landscape.

Absence Drawings

All it really is—is absence.

—Michael Heizer

Dennis Oppenheim and Walter De Maria work in deserts making annotations of measurements, producing symbolic signals in which, in any case, the modification of the natural environment is mitigated by temporal and meteorological components: the territory is only temporarily changed and the environment can recover its own naturalness even only by the action of the wind.

—Gianni Pettena, "From the Revisited Desert to the Invisible City"

The flatness that so invites drawing on the desert floor counteracts the more pressing need to erect shelter; the dusty etching plate supersedes finding shade. The impetus to inscribe impels Dennis Oppenheim's *Reading Position for Second Degree Burn* (1970), in which he (sun)burns into the surface of his chest the outline of a book titled *Tactics: Cavalry and Artillery.* Oppenheim's project, unlike those of Heizer and De Maria, insists on the inscription of personal data on landscape as an expansion of minimalism's evocation of a desire for "primary forms." His chest is primary. Oppenheim speaks of this piece as learning what it feels like to become red. He marks the surface of his body with sun and a text; he becomes a desert floor waiting to be marked. Literally inscribed, Oppenheim receives a sun imprint, employing the surface of his body as land art's site. He can draw himself or burn himself. In *Whirlpool Eye of the Storm* (1973), he directs a skywriting plane to trace a white smoke whirlpool in the sky over El Mirage Dry Lake, constructing the state of water over absence of water, promise over lack. It dissipates in approximately one-half hour.

In Black Rock Desert, Nevada, Michael Heizer digs a series of rectangles, which he then lines with wood. *Dissipate (Nine Nevada Depressions 8)* (1968) is based on the arbitrary dropping of a series of matchsticks—Duchampian stoppages made incendiary.[6] The rectangles will be photographed over the years to document their dissolution. Walter De Maria, with the help of Heizer, draws two parallel lines, four inches wide and one mile long, twelve feet apart in the Mojave. After he has finished *Mile Long Drawing* (1968), he lies face down on the left-hand line, a scale marker, aligned not with Nazca but with the far mountain range. Horizontality is truncated by the human form, which impedes the two lines' employment as landscape indicators. This photograph is a document of a humanizing gesture that will later be superseded by these artists' forays into monumentality.

At this moment, however, one imagines a pickup truck, a water cooler, an overheated black Labrador, a few shovels (borrowed from our novel's protagonist), and a fervent horizontal posse, as Heizer, De Maria, and Oppenheim perform site ablutions beyond the east of the art world, "out West." Our role as witness/viewer depends on a projection into this famous photograph of *Mile Long Drawing* of a lizard's-eye view of the desert floor, our tail lined up to a distant vista. The image is of a face pushed into the dusty gravel. This aligned face positions us on the horizontal, a chastened life form hugging surface prime. Unlike Heizer's later, monumental *Complex One* (1972–74), this horizontal axis will become the primary structure for *Five Conic Displacements* (1969) in Coyote Dry Lake, where he digs shallow round pits in the surface of the Mojave Desert. As artworks, they now exist solely as photographic images, taken before their dissolution, shallow but perfect evacuations filled with water. The act of photographing activates the displacements. The photographed water delineates mass and body within shallow circular excavations, etching a topographic boundary while the mirrored surface suggests the illusion of infinity.

Heizer's fascination with the removal and displacement of mass, which would lead to more epic earth shifts, is sketched out on Dry Coyote Lake in his series *Primitive*

Dye Paintings 1 (1969). Pigment replaces water. The surface is drawn with color, contoured around the circle, the zigzag, and the ellipse, marks not indicative of organic progression but sloppy and handmade, deliberate and stained in powdered color, often in deep black and ochre, as if referencing the remains of a scorching. Overlays of white in startling relief suggest the potential residue of powdered bone.

These specific works long for a vista that recaptures the geophysical epic while focusing on the intimately microscopic. In the three focal planes of desert site—sky, distant land mass, and desert floor—each of these works exploits a given parameter of site. The desert landscape, though not a white cube, becomes an extrapolation of that minimalist trope of reductive purism bounded by the promise of geological layering and imperceivable depths. The site(ness) of the work can only be a skin of surface tension eliciting promises of what is below, as geologic strata expand the white cube. Oppenheim stands slightly aside from the primaries in his insistence on the suggestion of a personal narrative scale, either through weather occurrences or in bodily identity. Heizer and De Maria, ever the systems men of Duchampian proportion, choose expanse as drawing pad. With explosives, Heizer reveals a perspectival mass and excavates a sculptural archaeology, while De Maria opts for precise incision and imposes geometric order over indefinable distances. These artists devised extension tools that allowed them to become land scribes. Their writing on the land was intended to be seen from space *and* to be seen over the bridge of a nose, dusty nostril scraping the desert floor.

Not Home: Building Cartographic Skins

[S]ince immense is not an object, a phenomenology of immense would refer us directly to our imagining consciousness. In analyzing images of immensity, we should realize within ourselves the pure being of pure imagination. It then becomes clear that works of art are the by-products of this existentialism of the imagining being. In this direction of daydreams of immensity, the real product is consciousness of enlargement. We feel that we have been promoted to the dignity of the admiring being.

—Gaston Bachelard, *The Poetics of Space*

Not an escape, rather a moment of meditation on one's own origin, a job of reconstruction, by means of simple symbolic actions, of one's own language, a re-elaboration of one's own conceptual schemes and of the ways of materializing one's own desires. In this way, it was discovered that the desert was the "place" of the nomad, a place of "complete emptiness" for he who comes from the city but, at the same time, a place of "complete fullness" for he who lives it or has lived it. But the desert, archetypal condition, "natural" situation for the nomad, is no longer natural for those who travel through it after him; and it becomes quite simply his "architecture," that which the nomad has left behind, nature made "historical," and therefore a type of architecture: a place visited, known, thought about and used as one's own environment.

—Gianni Pettena, "From the Revisited Desert to the Invisible City"

To gain control of the immense, to elicit a sense of proportion, inscribed and defined within site, becomes a feature of the objects collected in this essay. As desert viewers and inhabitants we attempt interpolation—a fence, a sign, a monument, a tar-paper shack, a ring of stones that break up the site and collapse an infinitesimal corner of immensity. This gesture echoes late-seventeenth- and early-eighteenth-century aesthetic philosophy's casting of the sublime, as a mode of "being in awe" created by an experience of vastness, sometimes also defined as being *with fear.* This awe explains our need to construct a container that would regulate a point of view and facilitate the temporary removal of our bodies from landscape, mitigating this fear of being caught uncovered.

Notions of cartographic and celestial precision impart systems to the unsystematic. Nancy Holt's engineers chart when the summer and winter solstices will align with *Sun Tunnels* (1973–76), determining the siting of these tunnels. The viewer, or burrower, is housed in a massive industrial pipe structure that lies on the surface of the Utah desert. The pipes are aligned in a four-part cross that implies a pancultural tradition of celestial orientation, ancient astronomy, and shamanistic intervention. A single viewer retires to *Sun Tunnels* in a meditative retreat, continuing a contemplative tradition thereby intrinsically linked to site; this retreat is divorced from material purpose and/or shelter. Ironically, the viewer is also contained in an industrial-strength concrete water pipe, her or his retreat now mediated by decommissioned technology.

The individual images of John Divola's *Isolated House* series (1995–97) utilize for their titles codes that indicate their cartographic designations, seemingly cool identificatory marks that locate a series of solo desert houses. These houses are distinct from Holt's industrial encasements in their fragility. They are situated squarely in southwestern desert landscapes defined by the color atmospherics and the refraction of light and grounded by overt horizons. To our presence as viewers, the chosen dwellings give scale, pathos, and "meaning" in a narrative construct as we momentarily inhabit the frame implied by Divola's vantage point. Our position in relation to the house in the frame is dependent on dual impulses: a desire to be alone and a desire never to be alone again—a set of desires that is made apparent in the space of deserts.

The *Isolated House* dwellings both interfere with and depend on the plain of landscape as a designated and agreed-upon locus of "natural" beauty. These houses are not nomadic, but rooted, lightly adhering to the skin of the desert floor. The photographs delight in the fragility, pathos, and audacity of installing an outer skin to seal out the void. These houses mark the passage from nomad to dweller. They imply intimacy unhinged, a structure adrift and in dissent from its supporting field. These are not low-impact, underground solar dwellings, but rather vertically and defiantly overt—part and parcel of the grafting of the man-made unto the surface of the "natural." They signify the reverse of Heizer's incising or Oppenheim's branding. Divola's houses signal an alienation from the natural environment that is ultimately usurped by the promise of entropy, as tropical pink crackles into creosote brown. Walter De Maria's desert mile will maintain shape in his lifetime. But Divola's *Isolated Houses* have a

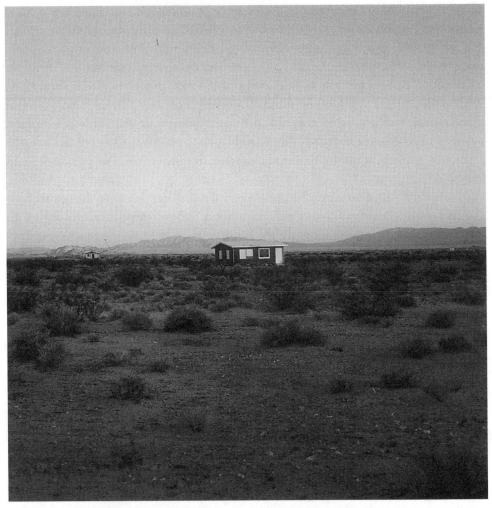

Figure 1. John Divola, *N 34°07.301' W 115°51.412' Looking North,* from *Isolated House* series, 1995–97. Copyright John Divola; photograph courtesy of the artist.

fragility and a vulnerability that erase a promise of the ageless, suggesting that full occupation of this territory could never be possible. Can a tourist ever occupy what a nomad leaves behind?

Holt sets up a hard-shell industrial observatory while Divola maintains the improbability of sheltering, perhaps the entire impossibility and seduction of the photographic process itself as a form of "knowing," as an extension of philosophical inquiry. These works posit a reason to seek containment as a form of definition. Each house is maintained at a precise compositional distance. An oddly respectful distance—conscious of land rights, armed occupants, angered dogs, the simple implication that individual space grows within immensity and our romantic desire—still privileges the monastic individual. Longitude and latitude and which direction the camera is facing are Divola's notational titles. In these precise descriptors one might project clinical de-

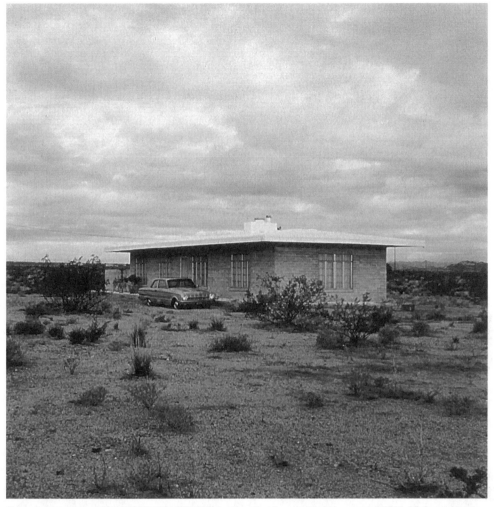

Figure 2. John Divola, *N 34°07.324' W 115°49.825' Looking West,* from *Isolated House* series, 1995–97. Copyright John Divola; photograph courtesy of the artist.

tachment when, in fact, they serve to delineate the situation of body and container. If immensity is an inherent part of desert craving, the converse—agoraphobic retreat— is what Divola chooses to represent.

The *Isolated House* project raises a number of questions: what drawing the shades means when no one is outside, how the process of editing enforced the project's isolation, and the position of photography in relation to the sublime landscape. The frame often includes equal parts sky and desert floor, a familiar and a consistent horizon. The houses, brief interventions into the earth/sky matrix, are marked by their precise cartographic location on the surface of the planet. We install the *Isolated House,* facing north, southeast, or northwest, on the wall of our house—the image of another's dwelling gracing our own creating a ludicrous but perfect closure: a silvered ruin waiting to happen.

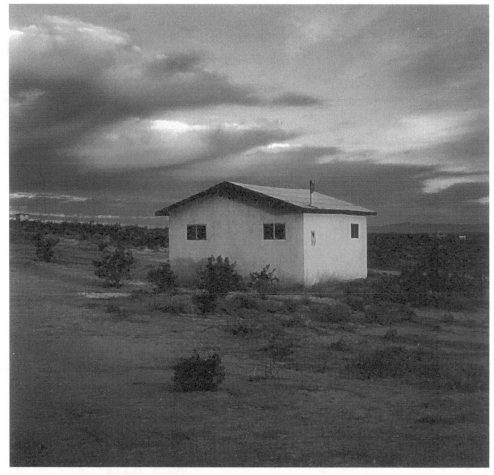

Figure 3. John Divola, *N34°11.185' W 116°06.725' Looking Northwest,* from *Isolated House* series, 1995–97. Copyright John Divola; photograph courtesy of the artist.

Blasting Caps, Flares, and Scar Tissue

After all you can make a sculpture by bombing it from the air. It's a form of carving. But to just bomb it is not the intention.

—Isamu Noguchi describing *This Tortured Earth* (1943)[7]

For Statics

Everything moves continuously. Immobility does not exist. Don't be subject to the influence of out-of-date concepts of time. Forget hours, seconds and minutes. Accept instability. LIVE IN TIME. BE STATIC—WITH MOVEMENT. For a static of the present moment, resist the anxious fear to fix instantaneously, to kill that which is living. Stop insisting on "values" which cannot but break down. Be free, live. Stop painting time. Stop evoking movements and gesture. You are movement and gesture. Stop building cathedrals and pyramids which are doomed to fall into ruin. Live in the present; live once more in Time and by Time—for a wonderful and absolute reality.

—Jean Tinguely, 1959

True to his manifesto—which explains a fundamental belief in both modernism's cleansing potential and dadaist irreverence[8]—Jean Tinguely constructed the penultimate time-canceling machine, putting an end to a consideration and enshrinement (in spectacle) of the art object. His was a project of anti-timelessness, destroying all pretenders and pretense via mechano-lust, while operating in a continuum of exploding objects, insanely high tricycles, and painting machines. In 1962 Tinguely performed *Study for the End of the World no. 2* twenty-five miles south of Las Vegas in a carefully chosen portion of the desert near a nuclear test site. His project was undertaken specifically at the behest of an executive at NBC, who thought it would make a nice segment for the program *David Brinkley's Journal.* The executive knew a good potential TV spectacle when he saw one. This event was undertaken specifically and solely for the TV camera. Mushroom clouds gave way to exploding refrigerators stuffed with feathers under the orchestration of an amiable Swiss man who labeled art "a distortion of an unendurable reality."[9]

This modernist doomsday absurdity, a motif common to Tinguely's self-destructing machine sculptures, was deliciously enforced by a coded landscape: nuclear test site, salt flat, and dead lake. All the while television waited for the money shot of total extinction. Tinguely constructed sections of the end of the world in the parking lot of the Flamingo Hotel in Las Vegas and trucked them out to the site, where he attached sticks of dynamite, blasting caps, and electric wire. There was talk of the "composition's" horizontal emphasis, which would thereby reinforce the inescapable monumentality that the desert topography imparts to any object (from stinkbug to pyramid). But basically observers were just waiting for it to blow. The wires and dynamite charges were connected to a crude plywood control board with black knobs, scrawled sequences, and circuit breakers. It was destruction lodged somewhere between the effects of nuclear annihilation and Rube Goldberg. Tinguely is suggesting that, by using such violent means to assist the machine in killing itself, one could momentarily triumph over the violence and brutality of the world itself through "play." He often employed the word *play* to replace the word *art.* Like Noguchi, modeling *Sculpture to Be Seen from Mars* in the nuclear shadow, Tinguely is determined to invoke the power of the unspeakable without technological arrogance but with a trickster's love.

In the late afternoon, Tinguely parks himself behind the control board and starts the machine up, and each part begins performing its mechano-collapse. *Study for the End of the World no. 2* is running off the same generator that is powering NBC. When it is discovered that the generator can only handle either the end of the world or the cameras, but not both, the electricians and other workers rally against powering the cameras to ensure that the choreographed destruction continues unimpeded. NBC gets zero footage as Tinguely rushes into the fray to nudge along a reluctant dynamite charge. He completes his shepherding task as each component extinguishes itself in pointillistic explosions, bursts of flame, and grinding metal sparks. In interviews after the event, he is asked about the technical snafus and the sacrificial death of NBC's

cameras. Tinguely answers with evident pleasure: "It's not to be expected that the end of the world will be exactly as it's been imagined."

Seven years later in 1969, Michael Heizer would remove 240,000 tons of earth to make *Double Negative.* In his words, it was a site "constructed of its own substance, leaving a full visual statement and an explanation of how it was made. . . . there is the implication of an object or form that is not there. . . . metaphysically a double negative is impossible."[10] Heizer separates himself from Tinguely's trickster nihilist by making this gesture toward the irreversibly inconceivable. The remaining two-part incision focuses the viewer in a minimalist perspectival gap, a funneled channel game in which the viewer is dwarfed by the exploded landscape. *Double Negative's* two huge slashes are readily evident from miles above. Is Heizer a "static" in the land of tricksters?

For the 1923 filming of *The Ten Commandments* Cecil B. DeMille and sixteen hundred workers built 110-foot-tall hieroglyph-covered walls, twenty-one sphinxes, and four statues of Ramses II weighing five tons each in the dunes outside Guadalupe, California. To thwart marauding rival movie studios, after completing the shooting DeMille ordered that the entire set be toppled and buried. John Parker and Peter Brosnan painstakingly excavated the remnants of the set in hopes of making a documentary before the seventy-fifth anniversary of the film in 1998. Rational men seek mark making, while other rational men deal in an archaeology of gesture. Women, it seems, live in parched water pipes—waiting.

My novel's nameless protagonist is reading today's *Los Angeles Times* searching for a good ending. Under the headline "Exploding Deserts," it's reported that, in 1942, General Patton spent a good deal of time flying over the deserts of California, Nevada, and Arizona searching for the perfect munitions testing ground.[11] After all, he mused, few people *lived* there. He saw the desert as "vacant," and he filled that vacancy with a Desert Training Center spanning 16,200 square miles. Currently there are innumerable tons of unexploded ordnance between Needles and Barstow, waiting to incise topographically and to maim corporally.

Tinguely and Heizer worked below and above this same surface. They made works in a period in which they could still name absence and expect the landscape site to deliver something other than tract house vistas. Tinguely leaves us with photographic ennui and toasted souvenirs, Heizer with an extracted reverse monument. Divola selects and catalogs discrete edifices of occupation, Oppenheim marks the systems that illuminate the desert landscape, while Ngo attempts to repopulate the topography of drought. Holt aerates and aligns, cosmetically altering the concrete bunker, to produce a campsite for the end of the world.

These nonstatic desert rats are operating in a perpetuity of burrowing, mounding, strafing, and digging that questions the very definition of mark (art) making and the "timeless." These works force the viewer to grapple with declining sublimity, codes of landscape, erasures of use value, and land development within site specificity. Henri Lefebvre, defining "space" in contemporaneous usage, states that "history is experienced as nostalgia, and nature as regret—as a horizon fast disappearing behind

us."[12] The proverbial "we" is still tethered to conservation and excavation: hence the desert becomes inexhaustible or exhausted, a resource upon which we practice identity inscriptions—hoping to make sense of scale—seeing ourselves at the edge of the curve of the earth, or in the aluminum glint off Patton's wingtips.

Notes

1. Reyner Banham, *American Deserta* (Salt Lake City, Utah: Gibbs Smith, 1982), 224. This remains the classic text on the desert landscapes of the American Southwest. It is an extraordinary account of the visuality of a space lovingly encountered and "learned" over a lifetime; it situates the possibilities of looking alongside the impossibility of textually analyzing seeing.

2. The Nazca line drawings were introduced to the American art world by Robert Morris in "Aligned with Nazca," first published in *Artforum* 14, no. 2 (October 1975). The impact that this article had cannot be overemphasized. As artists moved beyond minimalism's fascination with "nonsites" into an exploration of issues of site specificity divorced from sanctioned art spaces, Morris connected earthworks to a much larger archaeological history. By dealing with the tenets of archaeological timescapes, Morris effectively blew the lid off an expanded studio practice and problematized the scope of the entire earthworks project. He articulates this throughout *Continuous Project Altered Daily* (Cambridge: MIT Press, 1993), which collects his essays laying the foundation for any subsequent work on space, site and the expanded sculptural field.

3. Nancy Holt, quoted in Francisco Asensio Cerver, *Landscape Art* (Barcelona: World of Environmental Design Press, 1995), 68.

4. These images are collected in David Bourdon, *Designing the Earth: The Human Impulse to Shape Nature* (New York: Abrams Press, 1995).

5. Viet Ngo's land art consists of a series of water reclamation systems based on the installation and maintenance of the Lemna, a patented plant that removes pollutants from water supplies and that can also be used as an alternative food source. Ngo's project epitomizes much of international contemporary land art's ecological commitment and helps define artwork that is identified with ecological action and the politics of Green and Gaia movements throughout the world. Baile Oakes, *Sculpting with the Environment: A Natural Dialogue* (Van Nostrand Reinhold, 1995), covers a wide range of work, including Ngo's (178–80), that is ecologically based, coming out of the intersection of systems theory and land art existing after earthworks as a movement. See also James Swan and Roberta Swan, *Dialogues with the Living Earth: New Ideas on the Spirit of Place from Designers, Architects, and Innovators* (Wheaton, Ill.: Quest Press, 1996), and Suzi Gablik, *Conversations before the End of Time* (London: Thames and Hudson, 1995), as well as the journal *Whole Earth Review.*

6. The work's compositional structure was based on a chance operation: "The matchsticks were employed as a dispersing device. They were dropped from two feet above a sheet of paper and taped down. The photograph of this dispersal became the drawing for *Dissipate.* (Matches are always applied to disintegrative tasks; the original drop-drawing could catch fire at any time)"; Michael Heizer, "The Art of Michael Heizer," *Artforum,* December 1969, as quoted in Gilles A. Tiberghien, *Land Art* (Princeton, N.J.: Princeton Architectural Press, 1995), 23. This action is related to Marcel Duchamp's *Three Standard Stoppages* (1913–14), which was a series of "rulers" whose shape was determined by dropping pieces of string. The "stoppages" were then used as arbitrary units of measurement and shape for Duchamp's painting *Network of Stoppages* (1914).

7. Noguchi's unrealized project was inspired by photographs he had seen of WW II battle zones.

8. See Heidi E. Violand-Hobi, *Jean Tinguely* (Munich: Prestel Press, 1995).

9. Violand-Hobi, *Jean Tinguely*, 111.

10. Tiberghien, *Land Art*, 70. For the definitive contemporaneous contextualization of *Double Negative* and its minimalist family, see Rosalind Krauss, "The Double Negative: A New Syntax for Sculpture," in *Passages in Modern Sculpture* (New York: Viking Press, 1977).

11. Diana Marcum, "Desert's Deadly Secrets," *Los Angeles Times,* July 3, 1998, A1, A21.

12. Henri Lefebvre, *The Production of Space* (Oxford: Blackwell Press, 1991), 51.

7. Hidden Economies in Los Angeles: An Emerging Latino Metropolis

Alessandra Moctezuma + Leda Ramos

Since 1995, the artist team Alessandra Moctezuma + Leda Ramos has been investigating the terrain between art and architecture, community issues, public space, and popular culture through installation and site-specific art and design. Alessandra Moctezuma is originally from Mexico City and Leda Ramos's El Salvadoran parents immigrated to L.A. in 1958. Both individual and collaborative work explores themes of dislocation, language, memory, home, representation of Latinos and women, and documentation of the urban landscape. Our shared individual, cultural, educational, and professional backgrounds are to a great extent fundamental elements contributing to our continued work as an artist team.

Histories: Moctezuma + Ramos

While still completing her MFA at UCLA in 1992, Alessandra Moctezuma cofounded ADOBE LA (Architects, Artists, and Designers Opening the Border Edge of Los Angeles) with several artists and architects who joined together to create an awareness of Latino contributions in art and architecture in Los Angeles. With ADOBE LA she developed public art projects, designed exhibitions, contributed to publications, and lectured widely on issues of art, Latino cultures, and vernacular architecture until her departure from the group in 1996.

Her personal work focuses on her experience as a woman and an immigrant and uses humor to deal with the complexity of gender relations and the contrasts in Mexican and U.S. cultures. In 1994, she received an MFA from UCLA, where she concentrated in painting and printmaking. As a member of the multidisciplinary arts collective Collage Ensemble she has performed in the United States, Mexico, and

Japan and has produced videos and exhibitions. She manages public art projects for Metro Art of the Los Angeles Metropolitan Transit Authority and has worked extensively with the Latino community in Boyle Heights.

Leda Ramos graduated with an MFA from Rutgers University in 1995. Her primary explorations in object-making and installation art led her to the Princeton School of Architecture, where she attended various seminars while in graduate school. When she returned to Los Angeles in 1995 she joined ADOBE LA, where she met cofounder Alessandra Moctezuma, thus beginning collaborative endeavors in art and architecture both within ADOBE LA and subsequently as an artist team when both decided to leave the group in 1996.

In 1996–97, Leda was the first College Art Association Fellow in studio art at the Getty Research Institute, where she designed a prototype community exhibition series exploring the notion of Los Angeles archives and collections. During that time, she was active in the dialogue of Getty visiting scholars focused on Los Angeles: Perspectives, Narratives, Images, and Histories seminars. Several collaborative projects with scholars emerged from that year, in particular with visiting scholar Raul Villa, whose work *Heterotopias of the Latino Cultural Landscape* encompassed much of Moctezuma + Ramos's research and installation projects.

Concurrent with art-making and teaching, Leda is director of technology and education at the Central American Resource Center (CARECEN) in Los Angeles and For Families coordinator at the Museum of Contemporary Art, Los Angeles.

Since 1995 both have been coteaching at the Southern California Institute of Architecture, early on with ADOBE LA and currently as an art team.

Collaboration: Strategies

Our work together is intentional. We both bring to the collaborative a wealth of experiences both Mexican and Central American. We enjoy the humor and the intellectual stimulation of dialogue. Our current professional work also creates a dynamic communication network with other artists, academics, administrators, community historians, garment workers, street vendors, and recent immigrants. We both speak and write Spanish, giving us access points to various communities and individuals. In addition, we are invested in the exploration of an inclusive Los Angeles history. Working together also simply lets us divide the workload while we work full-time schedules in various professional settings.

The installations are directed at multiple audiences, both inclusive of recent immigrants and art audiences and placed in diverse locations, to engage the viewer in a dialogue about art, L.A. history, diverse cultures' sharing of space, and the innovative ways individuals create meaning and a sense of community.

Our installation "sites" vary from the traditional art museum/gallery context to the appropriation of historic landmarks and everyday storefront windows to "theoretical" design studios at the Southern California Institute of Architecture. These include

The Bus/Civil Rights, Architecture of Tolerance/Continuance, Housing for People with AIDS, Hybrid Marketplaces in the Montage City, Between House and Home: Theorizing Architecture as a Cultural Practice, and *Las Mil Mascaras of L.A. Land/Insurgent Urbanism.*[1]

All the installations, moreover, have invited and involved the participation of students, academics, architects, union members, family, friends, other artists, and community groups.

Installation as Case Study

In her article "Contesting the Public Realm: Struggles over Public Space in Los Angeles," Margaret Crawford discusses the role of recently arrived immigrants in re-shaping urban space:

> Looking around the city, we can discover innumerable places where new social and economic practices reappropriate and restructure urban space. Arenas for struggle over the meaning of social participation, these new public spaces are continually in flux, producing constantly changing meanings. Streets, sidewalks, vacant lots, parks, and other places of the city, reclaimed by immigrant groups, the poor, and the homeless, have become sites where public debates about the meaning of democracy, the nature of economic participation, and the public assertion of identity are acted out on a daily basis.[2]

The three installations that we describe as case studies are based on extensive research and documentation of the cultural landscape of Spanish-speaking Los Angeles, a "Latino metropolis" of 3.5 million people. They explore the "hidden" or "informal" economies of everyday urban existence as well as the populist strategies by which immigrants contest dominant culture. "Documentation" includes photography, video, and interviews specific to each project.

The major spatial practices that we document are (1) Latinos' alternative semiotic landscape: religious and commercial signage as well as graffiti, "tagging," and labor/employment signs; (2) the street as a performance space: street vendors, *taco-trocas,* mobile markets, orange sellers near freeway exits, and front-yard sales and celebrations; and (3) vernacular aesthetics and design.

The Cultural Landscape

Los Angeles is "a forest of signs." Driving through nondescript streets and minimalls indicates an urban district's cultural identities. On Broadway, north of Sunset, signs advertise ginseng cures in Chinese characters. To the south, a marquee at the Million Dollar Theater displays the words "Jesus Saves" in Spanish.

In the densely populated neighborhoods throughout Los Angeles, the city dweller is struck by the profusion of homemade signs dangling on chain link fences along

empty lots, sides of buildings, homes, and small shops. They constitute an integral part of the informal economy of the city. Everywhere we encounter the "Yellow Pages" of the streets.

Crudely painted on pieces of discarded plywood, these sometimes plaintive signs display, along with phone numbers, messages such as "Need a handyman? painting, stucco" or "Real save roofing." A sign cut to resemble a bathtub reads "bathtub reglazing," and there are English-and-Spanish signs for "plumber, *plomero.*"

On corner stores in residential areas, small cardboard signs (sometimes in incorrect phonetic Spanish) rest on glass windows—"Se acen reparaciones de bastillas, siperes, sierres y toda clase de costura" (we fix hems, zippers, and do all type of alterations). A humorous sign on an empty building states in large letters, "Se renta para oficinas o tiendas o para lo que quiera" (we rent for offices or stores or for whatever you want).

Flyers posted on telephone poles, small signs on clandestine factories working out of converted garages, and even a sign for piecework that reads "Aqui se cose" (we sew) dramatize the insatiable demand for *costureras* (seamstresses) for the largest garment industry in the country.

In many Latino neighborhoods the products prominently painted on a store's walls—*rotulos*—serve to advertise what is sold inside. Giant boxes of detergent, fruits, Mexican products, cleaning supplies, and milk remind us of pop art or comic-book images. Humorous depictions of TV sets walking into repair shops with sad faces and stepping out with a happy grin accompany more sinister images of little pigs cooking people in large pots found in the *carnecerías.* Other culturally hybrid images indicate the transformative nature of L.A.'s communities—for example, an image of a young Latina in a *quinceañera* dress appears next to an African American boy with a flattop and tuxedo in an area traditionally African American (Central Avenue and Olympic Boulevard) but now primarily Central American.

Stores hire local immigrant sign painters, or *rotuleros,* to do lettering, to paint images, or to create more elaborate pictorial scenes. Most *rotuleros* learn this traditional Mexican craft in their hometown or village. This commercial pictorial tradition dates back to the turn of the century, when taverns that sold *pulque,* an alcoholic drink made from the maguey plant, hired artisans to paint scenes on walls.

> *Pulquerías* had two characteristic features: colorful walls and exotic names. Even the humblest corner tavern . . . might be painted pink, bright red, or sky blue. Interior walls were "painted in lurid colors" that depicted "low, bacchanalian scenes."[3]

Pictorial art also adds considerable charm to customized street-vending carts, *taco-trocas,* and mobile markets, while simultaneously communicating regional and national attachments. In addition to the already mentioned surfaces, we have observed the growing number of ocean scenes and mermaids on *mariscos* (seafood) restaurants and landscapes, or *paisaje,* depicting village life in local eateries.

Mexican and Central American religious iconography erupts everywhere in the

urban environment. The Virgen de Guadalupe, the patron saint of Mexico, blesses the walls of hundreds of *tiendas, panaderías, carnecerías,* muffler shops, schools, and community centers. La Morenita, a term of endearment that refers to her brown complexion, embraced the indigenous people and became their protector and maternal figure. In Los Angeles, she is venerated by both Mexican and Central American communities. Her image is always a sacred space, and *placas* and other forms of tagging carefully avoid desecration.

Another popular religious icon is the small shrine placed high atop a business's entrance or in a front yard behind an elaborate wrought-iron fence, in both instances adorned with flowers and other small offerings. The most simple gesture is sometimes the most touching, such as an image of the Virgin printed on a piece of paper nestled in the crevice of a tree trunk.

This wealth of signage served as inspiration for the *Living Room* installation at the *L.A. Freewaves* exhibition. Our intent was to bring the popular and significant form of communication of the streets into the realm of the art institution, in this case a museum.

Living Room

Living Room was an installation for the L.A. *Freewaves Video Festival/Exhibition* at the Geffen Museum of Contemporary Art, Los Angeles, in August 1996.[4] In Latino neighborhoods the front yard redefines the street landscape and culturally identifies it. On the West Side of Los Angeles the empty and well-manicured lawns are passive borders, a glacis to keep others away. By contrast, the yards and porches of East L.A., Echo Park, and South Central are used for celebrations and other activities. Front yards, occupied by lawn chairs, furniture, and plants, extend the "private" home into the public street and allow for highly interactive spaces, with fences for neighbors to lean on.[5] We created a surreal and ambiguous private space—front yard, backyard, and cultural landscape—in the form of a life-size interactive "Monopoly" game.

The game-board paths were painted directly on the museum floor and were surrounded by green astroturf. Each path was divided into squares, some of which were randomly numbered. Some squares incorporated images of the painted products seen on storefronts or the signs offering services found in the landscape. On different squares were household items: an old Singer sewing machine, a ceramic image of the Virgen de Guadalupe, a red wagon, a bird cage with a live parakeet, and other domestic objects. Some referred to the traditional role of Latinas at home; others verged on the sentimental and kitsch.

In a darker vein, we also included a yellow "CAUTION" sign seen on the sides of the San Diego Freeway in San Clemente; the INS checkpoint just north of the Mexico-U.S. border. This terrifying sign shows a man, a woman, and a young girl in black silhouette running for their lives. As a matter of fact, many immigrants cross to avoid being caught by the INS and have been killed inadvertently, like "roadkill."

An industrial sewing machine was prominently displayed at the center of this

artificial field, and on top of it rested a small black-and-white monitor that played the video program. At intervals during the exhibition Leda Ramos sat down at the machine repetitively sewing pieces of fabric and occasionally glancing at the monitor. To the viewer the woman laboring in front of her machine floated in the midst of a dream game. She was like the many women who do piecework at home to support their families while simultaneously minding children.

Like a surreal documentary, our installation depicts complex elements of the contemporary Latino urban and social landscape in the form of a dreamscape. It evoked the *lucha por la vida,* composed in equal amounts of humor, courage, and resourcefulness, as well as pain, fatigue, and danger.

We Are Vendors, Not Criminals/Somos Vendedores, No Criminales

We Are Vendors, Not Criminals/Somos Vendedores, No Criminales was an installation project for the Full Moon Gallery exhibition *Architectural Interventions,* curated by the Foundation for Art Resources, at Pershing Square, downtown Los Angeles, from March 28 to May 23, 1997. The following is our artists' statement that was displayed on the storefront window site for the exhibition. In order to include a Spanish-speaking audience, the text was in English and Spanish:

> We are expanding the notion of architecture to address cultural and social relationships in Los Angeles rather than putting emphasis on "form" or the "built environment."
>
> Pershing Square is a border, an intersection. Just one block west is the command center of the new Pacific Rim economy: towering skyscrapers of glass, steel and marble. One block east is Broadway, the thriving commercial street of the Latino immigrant community.
>
> The Square was once an oasis of trees and fountains where all classes, and all ideas, intermingled. Now it is an abstract concrete desert, carefully designed to keep the homeless and the poor out of the face of power.
>
> Street Vendors subvert this logic of walls and borders. They humanize the harsh streetscapes by selling oranges, fruit, or corn on street corners, parks and freeway on-ramps. "Somos vendedores, no criminales" is the slogan of the Asociación de Vendedores Ambulantes, an organization seeking acceptance and understanding of street vending.[6]
>
> The oranges that the vendors sell on the street are a product of the Southern California citrus industry. This industry played a significant role in the creation of California myths: crate labels representing a romantic past—the home of Ramona— and racial stereotypes of the farm workers from Mexico, Philippines, Japan and China. Today, we still know very little about those who work in the fields or those orange sellers who populate our streets.

In this storefront installation we contrasted the consumer experience of shopping in the Thrifty Store, which closed in the 1980s, with the everyday "illegal" selling of

oranges on street corners and traffic islands. Shopping in a conventional store is markedly different from purchasing from a street vendor. We wanted to emphasize the dignity of street vending, which city policies and city planning often criminalize.

The installation featured racist orange-crate labels reproduced from the Huntington Library Ephemera Collection. Labels included "Lazy Peon Avocados," depicting a Mexican laborer asleep under a gigantic sombrero; "Rosita," complete with a very Anglo-European-looking "senorita"; and the Ruff Skin orange brand—"Ugh, poor looker outside, but heap fine taste inside"—which juxtaposes a "mean" and "menacing" Indian with feather with a "happy" and smiling Indian. These labels were contrasted with photographs of hardworking men and women orange vendors whom we interviewed around downtown Los Angeles.

In addition, we placed iconic imagery and objects representing varying degrees of southern California myth perceptions. We included a sea of terra-cotta Spanish tiles serving as both floor and roof of the storefront window, reproductions of tourist postcards, a Spanish mantilla, an orange tree with strangely formed oranges, and on the window the words "We Are Vendors, Not Criminals/Somos Vendedores, No Criminales" in the format of official street signage.

Between Home and Work

Between Home and Work, for *Hidden Labor: Uncovering L.A.'s Garment Industry,* was a project in collaboration with Common Threads Artists Group and UNITE (Union of Needletrades, Industrial, and Textile Employees, AFL-CIO). Occupying nine storefront windows at the historic May Company Building in downtown Los Angeles, *Hidden Labor* was a year-long installation project (May 1997 to May 1998) that highlighted the significance and history of the Los Angeles garment industry and its workers. [7]

The design of *Between Home and Work* was preceded by eight months of research into the garment industry, attendance at union meetings, and interviews with garment workers. Our department store window installation included personal narratives, memory of place, and demographics and explored the contribution of Latinas to a hidden economy in the urban landscape of Los Angeles.

We devoted our window to the personal stories of Latino and Latina garment workers. During interviews with them, conducted in Spanish, we gained an increasing appreciation of the resourcefulness and courage of their daily lives: the difficulties finding work to support their families and the abuses they were subjected to in their places of employment. An excerpt from a letter to the Martínez family in Oaxaca, Mexico, describes a typical situation:

> I got a job as a seamstress without knowing how to use a sewing machine. The first week I earned $20. It was just enough for the bus fare. The following week I earned $50. Then there was no work so they let me go. I found another shop where I earn

$50. They pay me 5 to 8 cents per piece and even though I try real hard I can't do any more pieces. But it's better than staying home and not earning anything. I have to pay $100 for food and rent. Gaby has been lending me for food.[8]

Many of the women regularly send money to relatives in Mexico or Central America as well as supporting families here in Los Angeles. "Home" in this double sense is the constant referent in their lives. Memories and mementos, as well as letters and photographs, emphasize the continuing link, sentimental and material, to places of origin. At the same time workers struggle to create new homes in L.A. and build supportive relationships through friends, church, and, in our particular case, the union.

We asked the workers to bring personal objects, letters, and family photographs to display in the window for the duration of the exhibit. All the donated items were carefully placed on shelves of varying sizes and at different heights on the back wall of the storefront window display. This participatory element was one of the most successful moments of all three installations. During the dedication all those who had donated items felt included in the making of the piece and the retelling of their stories.

The installation was designed to be as visually appealing as a department store window. Ironically, a few years ago, these same windows displayed clothes laboriously made by workers exploited by the garment industry.

A slightly larger than life *quinceañera* dress stands as a centerpiece of the window. Fifteen-year-olds celebrate the passage from girlhood into womanhood with a *quinceañera* party. Maps and demographics provided the fabric for this *quinceañera* dress. The torso was a collage of *Thomas Guide* pages, with ruffles made out of doilies. The skirt's satin was a census map detailing Latino income levels and poverty in Los Angeles County. The poorer areas matched immigrants' communities.

The dress, surrounded by contemporary photographs and objects, faced a TV monitor that played a video documentary about the garment industry in Los Angeles in the 1970s.[9] Viewing images from two decades ago and reading current letters from the garment workers, one realizes that their conditions have scarcely improved.

A sewing machine on a pile of bricks, sewing patterns, measuring tape, and hundreds of spools of thread complete the window. Ultimately, the most compelling element and the most satisfying part of the process was the participation of the workers through their letters, objects, and photographs and their review, critique, and ultimate celebration of the piece.

Collaborative Work: Juntos Creamos la Ciudad

Documentation of the Latino urban landscape serves as a blueprint of the daily interventions and inventions of immigrants as they contribute to the constant transformation of streets, neighborhoods, and the city. Each attempt of a store owner, a family, or

a vendor to reshape an establishment, home, or cart in order to re-create home is captured and added to our collection of photographs. Each gesture—enlivening a store with colorful paint, stuccoing a facade, creating a garden shrine—changes our perception of a neighborhood. In *Living Room* we acknowledged this vernacular architecture and design by representing them within the museum.

The inverse of this act of bringing the "Latino public sphere" into an art institution is exemplified by *Somos Vendedores* and *Between Home and Work*. These storefront windows featured the street-vending debate and sweatshop conditions, but the true protagonists were the street vendors and the garment workers directly involved in the final piece. The collaborative process and the exchange that evolved between the artist and the participants were essential elements in these two projects.

In our photo documentation we are observers filtering the urban landscape through the camera lens; in a collaboration we become participants in an urban narrative. Our car pulls in front of a street vendor. He races toward the car to sell us some fruit. We turn off the engine. There's a look of suspicion. Are we the police, the *migra*, reporters? Then we introduce ourselves in Spanish, explain our project, and ask him some questions. A sigh of relief. We proceed with the interview. He is curious about our project and asks us questions.

The vendors we interviewed were paid the hourly minimum wage, nine hours a day, six days a week, or they were given a commission depending on the number of orange bags they sold. One whole family is in business, driving to local farms, piling oranges on open trucks, and then parking them at choice locations along major streets to sell.

A woman in Echo Park made barely enough money to support herself and her son. She sat every day on a traffic island, a thin blue tarp her only protection from the sun and rain. Her nine-year-old son attends a nearby school. She tells us that he helps her sell oranges when he is off from school. In most cases the vendors we interviewed would allow us to take their pictures. We then included these portraits in the installation: hardworking men and women stood next to historic, and often racist, orange-crate labels. Some labels represented California as the "promised land," but what most immigrants found were low wages and hard labor in the land of sunshine.

Formal interviews with the garment workers were organized through UNITE. The goal of the Common Threads Artists Group was to create public awareness of conditions in the garment industry through posters, the storefront installation, and participation in rallies and protests.

Soon we learned that working conditions in the Los Angeles sweatshops were no better, or maybe even worse, than those of vendors in the streets. Piecework makes it impossible for workers to earn minimum wage. When some of the workers attempted to unionize they were fired. Still they were eager to keep on with the fight. As she sewed, Sandra Hernandez, a twenty-seven-year-old woman we interviewed, would sing:

Figures 1 and 2. *Living Room,* installation at Museum of Contemporary Art, L.A. *Freewaves* exhibition. August 1996. Photographs courtesy of Willie Garcia.

> La Marina tiene barcos,
> el patrón tiene un avión,
> nosotros lo que queremos
> es pertenecer a la unión.

[The Navy has ships, the shop owner has a plane, what the workers want is to belong to the union.]

In the accounts relayed to us of their daily struggles their voices would become a little softer, their eyes sadder when they reminisced about home. Many came here to earn money to help families back home. Many mothers, fathers, and children are separated for years. The Thai women enslaved in El Monte, the Salvadoreans, Mexicans, and Guatemalan women who did piecework at home while taking care of children— all missed their countries, families, and friends while struggling to send money home every month. It was this aspect of memory and home that we felt compelled to present. We asked them to participate in our piece by contributing their own personal letters, photographs, and meaningful objects. These were the constant reminders of a "cariño" that kept them going when times were hard.

In both pieces we hoped that the interviews, photographs, and memories of home would convey the human side of an economic and social injustice. The visual imagery, such as the orange-crate labels and the *quinceañera* dress, provided an aesthetic framework that informed the viewer within a poetic context. We wanted the beautiful nature of our "look" to seduce viewers into the piece, where they would find a social and political message about the complexity of Los Angeles history.

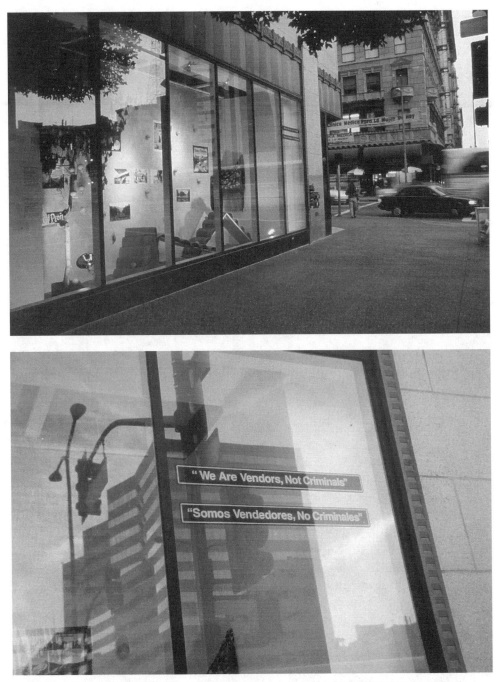

Figures 3 and 4. *We Are Vendors, Not Criminals/Somos Vendedores, No Criminales*, installation for *Architectural Interventions* exhibition, March 1997. Photographs courtesy of A. Moctezuma.

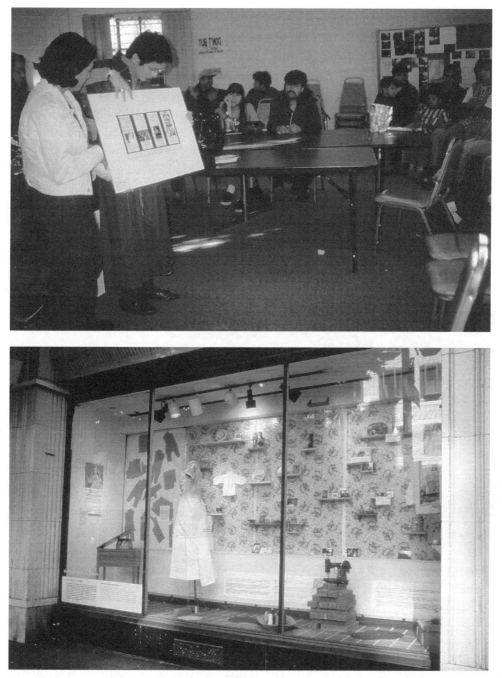

Figures 5 and 6. Leda Ramos performance in *Between Home and Work*, installation from *Hidden Labor: Uncovering L.A.'s Garment Industry*, May 1997–May 1998. Photographs courtesy of Judy Branfman and A. Moctezuma.

Participation, Multiple Audiences, and Different Reflections

The participatory element evolved into collaborative art-making. The public setting established a relationship with multiple audiences.

During the creation of *Between Home and Work,* we collaborated with Common Threads Artists Group, UNITE, garment workers, family, and art students from California State University Northridge (CSUN), where we were doing an artist's residency. Before the unveiling of the piece, those who had contributed objects were not sure of the "art" purpose they would serve, but as soon as they saw the completed installation they realized that the power of our window relied on the stories and images they had provided.

People from various classes, occupations, cultures, and life experiences experienced the installations, especially the storefront windows, every night and day. The locations in downtown Los Angeles, vacant historical buildings along major streets, were ideal for heavy pedestrian and bus ridership traffic.

People's experience of the piece depended on their relationship to the subject and their interpretation of our artwork. The bilingual Spanish-English presentation of all the pieces facilitated accessibility to a wide range of viewers, including those who had contributed to the pieces.

In addition to presenting the work to passersby, we also formally shared the work with students. We invited the youth at the Central American Resource Center to see the *Somos Vendedores* window, and while we were conceptualizing the piece, Occidental College students visited our studio and interviewed us. We talked and showed slides of *Between Home and Work* to the art students at CSUN and at the UCLA Chicano Studies Center. Other organizations we presented to were Asociación Vendedores Ambulantes (Street Vending Association) and El Rescate.

In conclusion, the work discussed in this essay helped expand how we continue to define and redefine ourselves as artists. It added to the dialogue about art and architecture, social issues, and Latino representation in the city, and it engaged different audiences in the process. Continuing in this vein, our next project includes working with high school youth from Esperanza Community Housing Corporation, exploring family histories, music, and street sounds and featuring their discoveries on KPFK, a public radio program.

Notes

1. Design Studios taught collaboratively: *The Bus/Civil Rights,* instructors Alessandra Moctezuma, Leda Ramos, Mike Davis; *Architecture of Tolerance,* instructors, Norman Miller, John Chase, John D'Amico, Leda Ramos; *Hybrid Marketplaces,* instructors Moctezuma, Ramos, with ADOBE LA; *Between House and Home,* instructor Leda Ramos; and *Las Mil Mascaras,* instructor Leda Ramos, with ADOBE LA.

2. Margaret Crawford, "Contesting the Public Realm: Struggles over Public Space in Los Angeles," *Journal of Architectural Education* 49, no. 1 (September 1995): 4–9.

3. Michael Johns, *The City of Mexico in the Age of Diaz* (Austin: University of Texas Press, 1997), 51.

4. Assistance by Ulises Diaz and Holly Harper of ADOBE LA; curated by Anne Bray and Joe Lewis.

5. This discussion is indebted to James Rojas's pioneering work on East L.A., "The Enacted Environment: The Creation of 'Place' by Mexicans and Mexican Americans in East Los Angeles," (master's thesis, Department of Architecture, Massachusetts Institute of Technology, 1991).

6. Robert Lopez, "Vendors Protest against LAPD," *Los Angeles Times,* August 2, 1994, B3.

7. Common Threads Artists Group is part of Common Threads, an organization dedicated to supporting the Garment Workers Union UNITE in Los Angeles. Participating Common Threads artists in *Hidden Labor* include Roxanne Auer, Judy Branfman, Eva Cockcroft, Leslie Ernst, Mary Linn Hughes, Alessandra Moctezuma, Sheila Pinkel, and Leda Ramos. This project was funded in part by a grant from the Community Redevelopment Agency Downtown Cultural Trust Fund.

8. One of the original letters in the archive of Larry Siems, author of *Between the Lines: Letters between Undocumented Mexican and Central American Immigrants and Their Families and Friends* (Tucson: University of Arizona Press, 1992).

9. The documentary *Garment Industry of Southern California* by Susan Racho, first shown on the Boston PBS television show *Realidades,* which aired in the 1970s. This was one of the first television shows focused on the representation of Latinos and their communities on television. Loaned by the L.A.-based National Latino Communication Center.

8. Landscape(s) of the Mind:
Psychic Space and Narrative Specificity
(Notes from a Work in Progress)

John Coleman

Each of us exists within a visceral world. We are wrapped among a simultaneity of physical experiences: our perceptions of sound, light, temperature, touch: our responses to the threat of danger, or the expression of a desire become memory: entering into a shifting fabric of what we have known. The specificity of a particular site/location is, I believe, a woven container of associations . . . a fluid mix of the physical, emotional, personal, social, and political. This fabric is nonlinear; extending inward, and out. The present is written upon by its inhabitants: all of us containers ourselves.

Within the body of this rumination, I will speak to two installations that help to shape my own sense of the range of narrative possibilities within this medium: David Hammons's *Jesus Is the Light* and Ed Kienholz and Nancy Reddin Kienholz's *Sollie 17*. As I gather and organize these ideas, I am myself preparing a project to be installed in October 1997 at Randolph Street Gallery (RSG) in Chicago, in conjunction with the exhibition programming for *Trace*. Notes from a work in progress are presented as a map of my process specific to the installation, *A Prayer for My Son and Myself.*

(Journal entry: July 1997)
This project is part of a series of offerings to my son Ayo. At each location that he visited in the first year of his life, I am constructing a piece in his honor. We were in Chicago when he was about ten weeks old and my son and I spent three days walking the streets. I was moved by the number of black folks that stopped in traffic, rolled down their windows, and shouted: "Go 'head, baby, you let him know who his daddy is!" At RSG, I will develop an intimate sound installation that focuses upon my own recommitment to the spiritual and human development within myself as I struggle to become a more complete model and guide for him. I am approaching the entire space as a psychic landscape with-

in which love, hope, possibility, and struggle reverberate. I will explore some of the tools that my father armed me with for survival and growth: the self-reliance and resilience, while also speaking through some of the distance and pain that I hope not to pass on.

In August 1991, I had the opportunity to join an installation crew for the La Jolla Museum of Contemporary Art (MoCA). A sizable collection of David Hammons's work had been compiled in an exhibit titled *Rousing the Rubble.* This exhibit began at the Institute for Contemporary Art P.S. 1, went through Philadelphia, then came on to San Diego. David made it a practice to request that African American artists, crafts-people, and students be included in the preparation for his projects, so there I was, along with performer-poet-painter Patricia Payne. Hammons's work has always con-sidered the specificity of a particular cultural and political space, in relationship to a specific historical moment. In 1991, then as now, most museums in the United States remained primarily white institutions. The most consistent black faces one tends to see are those of the guards. It is into this conceptual space that Hammons brought his deification of basketball: an urban black street game of grace, power, strategy, and pipe dreams. He constructed backboards and hoops from discarded materials found in an

Figure 1. Installation view of *A Prayer for My Son and Myself,* 1997. 900 square feet. Materials include splayed rubber skins, circle of black-eyed peas, bicycle inner tubes, oak frame, enamel bucket, found men's ties, lead houses, treated chairs, slate chalkboard, a field of soil, beeswax, tar paper and treated wood. Not pictured are the sounds of spoken prayer (see text), layered talking drums, cicadas, crickets, distant laughter, birds, and traffic. Photograph by Tom Van Eynde. Courtesy of the artist.

urban landscape and recast them as ritual objects of resistance, healing, and cele-
bration. An entire gallery within the La Jolla MoCA was inscribed as sacred space: a
court situated between opposing emblematic "hoops." At this site, a gathering of black
men charged, slid, spun, and faded: placing jump shots in the game. David conduct-
ed an improvised musical invocation à la Sun Ra, or Jameel Moondoc and the Jus
Grew Orchestra at courtside. The marks from the ball and skids from high-tops re-
mained as evidence. This ritual event was itself a descendant of another project titled
Higher Goals, composed of basketball hoops and boards set absurdly high on top of
telephone poles skinned with geometric patterns of bottle caps: metaphoric carrots
dangling from very high sticks. These objects were installed on streets in Brooklyn
and Harlem. The content of this narrative is dependent upon the context of a larger
framework of U.S. popular culture: urban black culture, recruitment practices of the
NCAA, and of course the NBA (a fabric of very specific social spaces).

I just finished reading Ernest Gaines's *A Lesson before Dying.* In a 1940s Louisiana
parish, a young black man, Jefferson, accepts a ride from a couple of buddies hell-bent
on finding another taste. The fellas, Brother and Bear, stop off at a liquor store at the
side of the road hoping to obtain a bottle. Their cash is short, and they request that
the storekeeper float them the difference, knowing that he would be paid as soon
as they were. The elderly storekeeper (addressed as Mr. Gropé) refuses the "boys."
The fellas persist, and a fight ensues and results in the shooting deaths of Mr. Gropé,
Brother, and Bear. Jefferson is at the wrong place at the wrong time. Two white men
walk in and find him standing there in shock, with a bottle in his hand.

At the trial, the defense attorney (in all his benevolence) assumes a patronizing
tone as he asks the good men of the jury to consider the obvious fact that this poor
dumb creature is incapable of planning and enacting anything, let alone the charges:

> Gentlemen of the jury, look at him—look at him—look at this. Do you see a man
> sitting here? Do you see a man sitting here? I ask you, I implore, look carefully—do
> you see a man sitting here?[1]

The attorney goes on to describe Jefferson as a "cornered animal" descended from
what he referred to as "the deepest jungle of blackest Africa."

Within the spaces of Gaines's narrative, I discovered a means to convey my expe-
rience of Hammons's ephemeral installation *Jesus Is the Light* (included in the *Rousing
the Rubble* exhibition). The piece is deceptively simple: a bare plywood box set upon
the floor within the gallery. The structure's walls measure fifteen by fifteen feet, with a
twelve-foot ceiling. There is one entrance, a doorway covered with a (light-tight)
heavy black curtain. Step from the well-lit space of the gallery, through the curtain,
and you are now standing in a velvet darkness. As your eyes adjust, you become aware
of a faint glow; a series of soft spots of light floating just out of reach above your head.
These spots are fading slowly. They seem to move and sway. And the interior is even
darker now. Over your left shoulder, you hear the whirring blades of an old electric
fan oscillating on its pivot: an arc of breezes moving from right to left and back again.

Then there is the unseen voice of Aretha Franklin singing "Jesus Is the Light." She fills the room: rising, falling, flying. Darkness envelops you: it is the light touch of a caress. A soft embrace . . . The space expands.

Abruptly, a bare lightbulb hanging from an old cord at the center of the small room floods the space with yellow-white light. Now you see the peeling, pressed-tin ceiling and walls, a flimsy shelf with the dusty fan, a boom box in the corner. Above your head hang dozens of cheap plastic figures of Jesus on the cross (straight from the bodega). You are squinting in the glare. And you discover that there are other people with you there, also shading their eyes from the harsh light. Again your eyes adjust, as you look at the simple details. Then the light clicks off. The dark falls hard, and the dream space opens up before you: stars brilliant now, and dancing in the night sky. Aretha soars.

All of the elements were laid out: very limited materials, limited space, simple construction; yet the synergy of the components existing in relationship to each other resulted in this state of flux and possibilities. Elegance: articulate and visceral. Transmutation: "all progress is a returning home" (the Kybalion).[2]

> Gentlemen of the jury, be merciful. For God's sake, be merciful. He is innocent of all charges brought against him.
>
> But let us say he was not. Let us for a moment say he was not. What justice would there be to take this life? Justice, gentlemen? Why, I would just as soon put a hog in the electric chair as this.[3]

The attorney completes his final arguments. The jury is released to its deliberations and returns the guilty verdict after lunch. Jefferson's posture is that of internalized defeat. He is convinced that his life is as meaningless and empty as the white men who convicted him.

The judge condemns him to death.

This narrative is told in the first person: the voice of the schoolteacher. Grant Wiggins grew up in the quarter, a descendant of cane-cutting sharecroppers: poor and black. He played in the dust of the unpaved roads, and went to church and school in the same building where he is now teaching. He was raised by his aunt, Tante Lou. Grant has completed a university education and has returned reluctantly to teach in the quarter, "because it is the only thing that an educated black man can do in the South today." He does not enjoy it. He sees himself as trapped within a hopeless situation. Helpless in the face of recurring cycles. He is almost contemptuous of the dusty black sons and daughters of sharecroppers: the same mothers, fathers, sisters, brothers, neighbors, ministers, and classmates that he grew up with. Grant is frustrated and on the verge of defeat. Tante Lou and Jefferson's aunt, Miss Emma, manipulate Grant into visiting Jefferson in jail:

> "Called him a hog."
>
> She said that, and it was quiet again. My aunt looked at me, then back down at the table. I waited.
>
> She turned her head slowly and looked directly at me. Her large, dark face

showed all the pain she had gone through this day, this past weekend. No. The pain I saw in that face came from many years past.

"I don't want them to kill no hog," she said. "I want a man to go to that chair, on his own two feet."[4]

Grant, the teacher, is again trapped and obliged. He accompanies Miss Emma, Tante Lou, and Reverend Ambrose to visit Jefferson. Miss Emma has cooked fried chicken, corn bread, and sweet potatoes for him. The visit does not go well. And subsequent visits do not go well. Jefferson leaves his back to his visitors, facing the wall that he does not see, staring up at the ceiling that he does not see; he thrusts his entire face into a plate of his aunt's food, and does not eat: "corn for a hog." He is abusive and defiant, but slowly, painfully, the two men come to trust, and move into a profound shakedown. Jefferson comes to recognize his own beauty and strength as he prepares to die; an opportunity to give something basic and necessary to those left behind; the need of every member of the community to see him dignified and unbeaten, even as he sits strapped in that chair waiting; the need for him to confirm the faith in the face of overwhelming doubt. *I am a man.*

Grant receives an education. He comes to recognize its value and its cost. He comes to an understanding of just how much has been given to him: the struggles to plant and nurture a dignified life, where so much creeping death has been sown:

> "You think you educated, but you not. You think you the only person ever had to lie? You think I never had to lie?"
>
> "I don't know, Reverend."
>
> "Yes, you know. You know, all right. That's why you look down on me, because you know I lie. At wakes, at funerals, at weddings—yes, I lie. I lie at wakes and funerals to relieve pain. 'Cause reading, writing, and 'rithmetic is not enough. You think that's all they sent you to school for? They sent you to school to relieve pain, to relieve hurt—and if you have to lie to do it, then you lie. You lie and you lie and you lie. When you tell yourself you feeling good when you sick, you lying. When you tell other people you feeling good when you sick, you lying. You tell them that 'cause they have pain too, and you don't want to add yours—and you lie. She been lying every day of her life, your aunt in there. That's how you got through that university—cheating herself here, cheating herself there, but always telling you she's all right. I've seen her hands bleed from picking cotton. I've seen the blisters from the hoe and the cane knife. At that church, crying on her knees. You ever looked at the scabs on her knees, boy? Course you never. 'Cause she never wanted you to see it. And that's the difference between me and you, boy; that make me the educated one, and you the gump. I know my people. I know what they gone through. I know they done cheated themself, lied to themself—hoping that one they all love and trust can come back and help relieve the pain."[5]

When they finally lead him to the chair, put the sack over his head, and throw the switch, Jefferson is the strongest man in the room. Transformation and release.

Figure 2. Detail of the installation *A Prayer for My Son and Myself.* Photograph by Tom Van Eynde. Courtesy of the artist.

(Journal entry: July 1997)

On the day you came into the world, you sent flowers to your mother & your grand-mothers. . . . You lifted your head & smiled.

Young brother @ the market today told us—"my baby boy is due in the next two weeks. . . . I come all this way, yeah, I'm'a be there for him."

As I approach forty years of age, I still remember the stories of my youth: B'rer Rabbit, the *Odyssey, Aesop's Fables.* I recall the first time that I heard James Baldwin's voice slip off the page, the musicality of Maya Angelou's voice, the sight of Ellison's invisible narrator squatting in the glaring light of his cubicle under the streets of Manhattan—speaking the map of his becoming. I find myself engaged simultaneously within the telling, the spoken exchange, and the poetry of the presentation. I am drawn by the sounds of the voices, the silences, the overlay of the said and the unsaid, the smells in and of the place, the feel of the texture upon the floor. The rust or heat or glare . . . There is room for me to move.

Installation became my primary working environment because of its potential to exist within both physical and psychic spaces: to extend the written, spoken, and/or implied narrative into the realm of a physically engaged experience. Space is tangible, much like color, texture, form. It can be shaped to mean, to contain, to conjure . . .

In speaking of the Kienholzes' work, Thomas McEvilley writes:

> Space, the figure, and narrativity turn curiously onto and into one another as if they were almost one—or one possible triangulation of forces somehow perilously remaining in balance. Space is the medium that enables the figure to exist; the figure, in turn, is the agent that activates space. Their collaboration, finally, is the necessary cause of the special situation in which narrative can occur: where event horizons explode into events.[6]

Ed and Nancy Reddin Kienholz's images have consistently seduced the viewer into peeking across a shifting line of interior/exterior relationships: outward into specifically American spaces of marginalization and denial left festering. Unaddressed. We look through doors, windows, and bars—from one American landscape to another. The portraits are precise. Unsentimental.

With the tableau *Sollie 17*, the viewer again looks past a (slightly) open door into a space of abandonment and waiting. Time is fractured. Repetitious. The quick glance into this interior is frozen with concrete traces of Sollie's movements through the day. His image is repeated at three locations within the tiny room:

> One: Lying on top of the narrow bed: head and shoulder propped upon a filthy, uncased pillow. His face is obscured by the book that he gazes past: *A Handful of Men*. His left hand thrust into his briefs.

> Two: Sitting on the edge of the bed—unclothed, except for drooping (used-to-be-white) briefs. His neck and shoulders bowed into a concavity of apparent resignation. Sollie's head is in profile: a flat black-and-white portrait of a man cast aside.

> Three: Standing with his back to the door. He appears to be gazing out the window on the back wall. The space outside is literally flat and gray.

The voyeur follows the truncated arc of a pendulum: from the bed, to the window, then back again. "Space is an oppressive force." There is no exit (though the sign above the pay phone, right here, points back the way that we came). *Sollie 17* is another haunted stage set in an American script.

flophouse

you haven't lived
until you've been in a
flophouse
with nothing but one
light bulb
and 56 men
squeezed together

on cots
with everybody
snoring
at once
and some of those snores
so
deep and
gross and
unbelievable—
dark
snotty
gross
subhuman
wheezings
from hell
itself.

your mind
almost breaks
under those
death-like
sounds
and the
intermingling
odors:
hard
unwashed socks
pissed and
shitted
underwear
and over it all
slowly circulating
air
much like that
emanating from
uncovered
garbage
cans.

and those
bodies
in the dark

fat and thin
and
bent
some
legless
armless
some
mindless
and worst of
all:
the total
absence of
hope
it shrouds
them
covers them
totally.
(Charles Bukowski)[7]

Figure 3. Detail of the installation *A Prayer for My Son and Myself*. Photograph by Tom Van Eynde. Courtesy of the artist.

(Journal entry: August 1997)

Patching a slow leak: looking into tubs of reflected images. Bubbles rising.

Inner-(tube)-skins: my father's ties rising.

Provide a shelter. A circle of four chairs: talking drums and spoken prayer. A call and response set in a field of soil.

In August 1995, the Regional Artists Program (RAP) held its grant application review at Randolph Street Gallery. Artist Nanette Yannuzzi Macias was on the committee, ten weeks after giving birth to our son. We joined her in Chicago and hit the streets.

In September 1996 I submitted a proposal for RSG's project room. Randolph Street is one of a handful of alternative spaces still surviving in the Midwest. Of the shows here, 75 percent include at least one installation, providing a venue for artists on a community, regional, and national level. "If these walls could talk . . ."

Operating a nonprofit space has always been challenging: a balance of fund-raising activities, grant writing, property rentals, program scheduling, accounting, and final reports, but given the recent restructuring of the National Endowment for the Arts (NEA), many venues are struggling to reinvent themselves. RSG saw its general budget shrink drastically from $450,000 in 1996 to $180,000 for fiscal 1998. In previous years, grants from the NEA provided the bulk of the operating budget, supplemented by grants from large foundations (for example, Chicago Community Trust, Sara Lee, and Illinois Arts Council). The new guidelines limit funding to institutions only (no more individual grants), and each institution may apply for *one project only*, under *one* category: Creation and Presentation, Heritage and Preservation, Education and Access, or Planning and Stabilization. The already precarious fiscal landscape has become prohibitive. In fiscal year 1995, RSG was staffed with five full-time employees, two part-time employees, and five interns each semester. This number shrank to a combined total of one and one-half positions, and the gallery spent much of fiscal 1997 in hiatus. *Installation in the United States is dependent upon the survival of these spaces nationally. It is the not-for-profit spaces that provide the venue and resources for almost all of the installation work produced in this country.* With the demise of Individual Artists Grants (both regional and national), it is the alternative spaces that allocate monies to artists for materials, travel, and production. Museums are not available to the vast majority of artists (though these institutions are eligible for the same funding resources as struggling spaces: they are much more attractive and less controversial investments).

(Journal entry: September 1997)

—a circle of prayer: voices rising from the chairs—

. . . it's hot again today. I'm way out on Western just in front of San Luis Body shop. Across the street, a brother climbs back into the battered cream-colored pickup: the family landscaping business operates from there. . . . Glass crystal fragments lie in the spaces between square blocks of sidewalk—La Mejor Oficina, (West) North Avenue

1600 block, and the bus stop across the street. Iglesia Consejo Moral in a small two-story brick office building . . . & next door, two tiny black faces peer out from behind rusted bars: one window open in the triptych with green shades and a canary yellow shirt. Next corner, a fire fountain sprays relief into the street . . .

"Daddy, squirt me . . ."

It's hot, and sharp, and alive, my son. This is your world . . . laughter, joy, and tears. I'm here. From the beginning: this moment . . . Still arming & disarming myself . . .

You need weapons here: Spirit skin that resists, if not transforms assault . . .

You need scars that form, then heal . . .

You need a heart willing to risk (& lose) again. Long curious fingers to seek out the beauty . . .

(resilience & flow)

I hear the voices of so many circling back for me/you: cars stopped in traffic . . .

"Go 'head . . ."

in the park, the street, at the lake:

"That's it, baby—you show him who his daddy is . . ."

faces reflecting joy & hopefulness—approaching: we need each other with so much urgency. And the spoken ladder/nets of my elder brothers weave patterns of interlocking fingers—so many hands guiding my footsteps: your eyes open wide.

Mumia was all over the street that summer: Cleveland, Chicago, L.A., Philly. A collective countdown to stop the clock: tic tic—The hands move, and I'm in L.A. Monday afternoon, Geronimo Pratt is released after 27 years in a cage. And now, so much joy and hopefulness looking out . . . Tuesday morning I'm heading east on Adams just past Western: drivin' slow—so good to be right here . . .

Plainclothes detective flyin' too low for radar pulls up on my right & flashes a badge framed by a squeezed square leather wallet . . . and once again, your brother is holding his hands in plain sight: guns drawn with backup crouching behind the door.

Tic-Tic-Tic . . . shhhhhhhhh . . .

Son, push the tube into the bucket and look for bubbles rising in the water . . . there's the hole—you see it? Now go get the scissors from the kitchen drawer and I'll show you how we're gonna patch that leak . . .

That's it, Son, push the tube into the bucket and look for bubbles rising in the water . . . there's the hole—see it? Now go get those scissors and I'll show you how we'll fix it.

So, I pop the cover off the funny little cardboard box, and ruff-scrub up the surface of that tube all around the hole—then spread clear runny glue that was always cold to the touch. Sometimes, it was a slooow leak . . .

Gradual.

But, I'm here. Stumbling, and getting up again. Ven acá. Ven acá. I'll show you my uncertainty.

(Journal entry: November 7, 1997)
The candles are here by my side of the bed. You were conceived here. Your mother's contractions began here. You are lying here between us now . . .

(Late postscript)
As a final note, I am including this memo just received:

For Immediate Release Contact: Mary Murphy / Jane Saks
February 13, 1998

Randolph Street Gallery to Close

CHICAGO, February 13, 1998—Randolph Street Gallery announced today that it is closing, effective immediately. This decision by the Board of Directors to close the 19-year-old non-profit arts institution was due to a serious lack of financial and human resources, brought about by broader cultural changes that have impacted the viability of this and similar arts organizations nationwide.

Randolph Street Gallery, founded in 1979 as a way to advance contemporary arts and artists working beyond the scope of mainstream institutions, quickly grew into a leading center for progressive cultural practice. The artist-run organization presented and produced works by thousands of artists based in Chicago and beyond. Exhibitions, performances, multi-disciplinary arts projects, publications, public art, artist support programs, and a wide range of educational activities provided multiple opportunities for interchange between artists and a broad public on the relevant issues of the day.

In recent years, however, major changes in the art world—including large reductions in funding for contemporary artists and artist-run organizations, increased legal reporting requirements, and government pressures, along with a weakening in the market for progressive arts activities—caused the

organization to consider its future viability. In January 1997, the board and staff took a six-month hiatus from producing programs to focus their full efforts on re-inventing the gallery and gathering additional financial support.

Despite some success at these efforts, Randolph Street Gallery continued to be seriously limited by severe financial burdens. Given these conditions, the board concluded that continuing would have required fundamental changes beyond the core goals and purposes of the organization.

"The decision to close the gallery was not made lightly, nor without considering many other possible options through a lengthy process of examination and consultation with independent facilitators and peers," said Hamza Walker, chairman of the Board. "This difficult decision was made easier by recognizing the extraordinary dedication and creative approach of our many artists, arts workers and colleagues who created a unique artistic experience here. That will survive as RSG's legacy. We thank Chicago for nineteen good years."

Walker added, "While in many respects, Randolph Street Gallery achieved its goals, its closing means one less venue for artists and audiences. Chicago continues to need vital and visible organizations that support contemporary artists and artmaking practice. The individuals who have been part of RSG continue to encourage such efforts."

Thanks to Paul Brenner, director of RSG, for insights & assistance.

Notes

1. Ernest Gaines, *A Lesson before Dying* (New York: Knopf, 1993; reprint, New York: Vintage Books, 1994), 7.

2. The Kybalion is a text on the study of the Hermetic philosophy of ancient Egypt and Greece (Chicago: Yogi Publication Society, Masonic Temple, 1912).

3. Ibid., 8.

4. Ibid., 12, 13.

5. Ibid., 217–18.

6. Thomas McEvilley, *Kienholz: A Retrospective: Location and Space,* exhibition catalog (New York: Whitney Museum of American Art, 1996), 52.

7. Excerpt from "flophouse" copyright 1992 by Charles Bukowski. Reprinted from *The Last Night of the Earth Poems* with the permission of Black Sparrow Press.

9. Ordinary Gestures of Resistance

Ernest Larsen

Cold winter's day. Twenty-third Street in New York. Approaching home. I was having trouble breathing—as I often do. The frigid air cut into my lungs. I was crossing the densely trafficked spot where Fifth and Broadway merge. I made it to the first of the two traffic islands. The Triangle Building loomed on my left. A breathtaking building, if there ever was one.

The previous night the police had completely blocked traffic on Fifth Avenue at Twenty-third Street. A scene from the remake of the 1956 Japanese movie *Godzilla, King of the Monsters,* was being filmed. Last night it seemed all but certain that Godzilla had destroyed the Triangle Building, but somehow the next day it was still there.

Monsters, real estate, and the police are plain facts of everyday life. Since World War II all of us have been forced to believe in monsters. For the postwar Japanese a giant fire-breathing lizard was an apparently imaginary, ultimately reassuring displacement of an unimaginable terror—the real terror we visited upon Hiroshima and Nagasaki. Many sequels were made in the next few years, including my favorite: *Godzilla vs. the Sea Monster.* The new improved Godzilla, a fantastically superior— that is, infinitely more realistic—being compared with the old Godzilla, invades the island of Manhattan rather than the island of Japan. There's no telling why, except that at any given moment you can pretty much count on at least one fairly realistic monster being loose somewhere on this island.

I step onto the traffic island. There's a woman's red leather glove lying on the concrete. A fine fresh right-handed spot of color. I am not wearing gloves. My hands are cold. Mundane details. They belong here because this essay (only an attempt—to accord with the meaning of the French root *essai*) intends to lay hands on the relations between the province of the everyday and the province of installation. In any other

essay about installation I'd have to cut out such details, drop them—drop them delib-erately, not accidentally as this red glove was left behind, fugitive on the island. They would be extraneous, the mere minutiae of everyday existence that are never except by accident elevated into the realm of art-critical discourse. Here, however, such detail may turn out to be indispensable.

The vulnerable red glove turns out to be an installation of a glove, rather than the real thing. But the model is "realistic," probably even more realistic than the new Godzilla, who after all also exists only as a model or a projection—as far as we know. The installation by Ilya Kabakov is, with a trace of irony, titled *Monument to the Lost Glove*. From even ten feet away the small object in the traffic island is scarcely identifi-able. The whole point of a monument is to memorialize great events and great people. The ephemeral and the gestural—the movements most characteristic of the everyday—are not supposed to be worth remembering. Across the street in Madison Square Park, there's a monument to William H. Seward, a great man whom no one remembers. My guess is that *Monument to the Lost Glove* exists to invert whatever it is that people (passersby, pedestrians, the explorers of urban space) are supposed to think a monu-ment properly is when they encounter it. Scale, obviously, is the first thing. The glove is to the human scale what the human scale is to the average everyday overwhelming monument.

My first memory: age two, sitting at the foot of the Lincoln Monument. Lincoln was also sitting. We were both sitting, side by side. He was tired, apparently. He sure looked tired. First memories are probably in some vital unestablishable way determin-ing. But the main thing is that monuments situate the viewer in the physical relation of a child—a power relation, the stability and volume of the monument opposed to the fragility and insubstantiality of the human body. First memories are monumental.

Like many much more monumental monuments, *Monument to the Lost Glove* is supported by accompanying text, in four languages (English, Russian, Spanish, and Japanese), on nine etched-steel stanchions nearby. Deliberate overkill—nine to one. No fewer than nine texts memorialize the impermanence of an everyday act—the ac-cident of losing a red glove. They provide nine distinct subjective readings of the loss. Nine intersections, nine musing I's. Or is it more accurate to multiply the nine by the four languages to produce a sizable crowd of thirty-six distinctive fictional viewers speaking to us?

There is nothing official, nothing authoritative, nothing that speaks from a place of power in these multiply inscribed texts. Rather, they invert the legitimizing func-tion that such explanatory texts ordinarily assume, thereby calling into question monu-mentality itself, and the role that monumentality tends to play in art practice—which is to occupy a place for power, to inscribe power in a place. That legitimizing opera-tion is in practice and by definition singular rather than plural. The nine first-person lyric poems, which are inscriptions of a different unofficial kind, anticipate nine pos-sible encounters with viewers of the monumentally small glove. One such text reads:

Interest in the genuine, the real was lost long ago
And it is doubtful that it will return . . .
But don't those who say this think that everything will be of second
 quality as a result of this,
It will only be an appearance, a deception, and it will gradually change
 our nature,
Our values, our attitudes and we will become in the world surrounding us
Merely apparitions even to ourselves, murky shadows amongst other
 such shadows.

It seems that the installation aims to valorize the otherwise ephemeral subjectivity of the everyday. Already several aspects of the everyday have suggested themselves: the chance encounter, movement, loss, desire, multiplicity. I shall try to get closer to this, to fill out the idea, as a hand does a glove. The installation seeks out the place where the random attention of the casual passerby already localizes itself, in the movement across a busy intersection, that purposeful (from here to there) but otherwise apparently empty transit from one corner to another. Without pointing a finger, it seems to indicate that the power to ascribe meaning should not lie solely within the dubious province of authority. The anonymous subjectivity of the everyday: the niche in the anonymous viewer's brain into which Kabakov drops a glove. Kabakov positions the apparent randomness of viewing as constituting both a kind of action (movement, touch) and a kind of reflection (reading, hearing oneself and other voices). An act of meaning that is by definition partial and multiple, and thus always incomplete or unfinished. Every day you do some things you did the day before. So, yes, you repeat yourself, but you don't repeat yourself in the same way. The present is the repeated frontier of the unrepeatable.

Still closer to home I pass a new sushi restaurant named Godzilla. A month later it changes its name to Monster, though the name Godzilla still appears on the menu. I don't have to ask the owners why they changed the name of the restaurant. Corporate lawyers have swooped down on the little neighborhood restaurant, just as Mothra, the flying monster, once attacked Godzilla many years ago, when Godzilla was still Japanese. The name Godzilla is trademarked by a monumental corporate entity that is not about to share it with a Japanese restaurant. But—for the Japanese—Godzilla is part of Japanese popular culture. Which means that it has the status of a shared meaning held in common. For the corporate owners of the monster character, creating meaning is beside the point. Or value is the only meaning. The act of seeing can be or perhaps is an act of creating value. The value created is by definition unlimited (rather than partial). One owns a trademark in perpetuity. The trademark is a modern, late-capitalist form of monumentality that literally inscribes the everyday—the kitchen table, a pair of jeans, and so on—invades the moment of the everyday and steals it for permanence, which appears to be in cahoots with power. Power is not so interested in owning the impermanent—unless it's convertible to value. Which seems

to involve the operation of fixing a singular totalizing meaning on an object, a meaning that is true or visible at all times and all places.

A carpenter was at work in the doorway to the brand-new Barbara Gladstone Gallery, which had been relocated from Soho to what had been the warehouse district of West Chelsea, as part of the strategic migration of art capital in New York City. Needless to say, the new galleries are all monumental. I stepped around the carpenter and entered. The impression of a pristine space effectively unspoiled by human habitation, which is invariably the dominant impression constructed and conveyed by the contemporary art gallery, was slightly compromised by this carpenter's presence. The presence of the worker is subtly unsettling in an arena that favors product over process—and thus tends to squeeze out the experience of the everyday. In the background as I write this I can hear Karen Carpenter singing on television. Somewhere way back in her ancestry a carpenter took on the surname Carpenter, lending permanence to the relation between his labor and the inscription of his name. The song she's singing is "Long Ago and So Far Away."

The inaugural exhibition in the new gallery, a space roughly the size of a small museum, was also Gary Hill's first solo show in New York. Why has it taken so long for such a well-known artist to get a solo? His video installations in New York have long received considerable institutional support, especially from the Whitney Museum, which has the deep pockets required for the technology-dependent illusionism favored by Hill. On the other hand, private commercial galleries have long steered clear of video and video installation. Video, even when disguised as an installation, still resists commodification as an art object, thirty years into its history as an art form. Its electronic reproducibility, its immateriality, tends to flatten or negate value. This leveling tendency can even, rightly or wrongly, cast suspicion on the actual value of all art objects—a deliberate intention of most first-wave video pioneers, who disdained or actively opposed commodification. However, video artists who work in a gallery or museum context have increasingly tended to avoid distribution in single-channel formats. Clearly not unaware of video's marginal economic status, they make work that can be readily labeled as installation—and give the impression that they are making an object with some chance of permanence. Gary Hill's solo show in New York appeared to signify a break in the wall of resistance to a certain kind of video exhibition in the galleries of New York. And in fact the year after this show saw a deluge of video in private galleries—nearly always in the form of installation.

I came to see just one of Hill's pieces: *Viewer*. In the gallery's largest room three video projectors mounted at intervals on the ceiling produced a seamless image on the wall. A very long row of day laborers, seventeen men larger than life, standing there barely moving, shoulder to shoulder, staring straight ahead. Silent, waiting. Waiting for what? The longer the viewer stands there facing the seventeen laborers projected there, the larger that question looms. The room can feel very crowded after a while, even though there is only one person, one body, in it.

Monument to a Lost Glove inscribed a multiply subjective text into the installa-

tion, situated it in relation to an apparently random encounter, and thereby raised the question of the relation of subjectivity to the question of the real, to the role of subjectivity in perception, to public art and installation, to fear (or loss) and desire, to the instability of meaning, to the construction of meaning as a ceaseless human activity. It takes time to read those texts, and, in the course of reading, the glove changes. You feel the spatial succumb to the temporal. *Viewer,* on the other hand, leaves the problem of subjectivity entirely up to the viewer. Kabakov takes us in hand, gives us a tour. Hill is much cooler. *Viewer* situates the viewer within a suspended moment, or rather within an indefinitely extended moment. The laborers move very little, but they do move, and there's no telling how long they've been there or how long they will continue to stand there, waiting. Only the viewer can change the situation—by leaving.

The temptation when approaching that lost glove is to lean over and pick it up. I succumbed to the temptation. Not because I thought the glove was "real" but because I wanted to touch it, to know what it felt like—the soft leather turned out to be hard, probably some kind of plastic, I decided. You test things like that, as if you're still a small child, apprehending the world in an intellectual-sensual-emotional whole. What is real? What is fantasy? Is reality fantastic? Questions that children of a certain age tend to ask.

Suppose the moment could be indefinitely extended—and you were standing in front of a line of day laborers staring soberly ahead. This gives the moment a definite weight. The way you stand and the way they stand are very different. For one thing, there is no necessity in the way that you stand—while their bodies are filled with necessity, leaving little room for anything else. They will wait as long as they have to for work, won't they? And no matter how long they wait you're never going to put them to work. And that feeling of the moment of waiting that will never end is what seventeen men multiplied by the millions experience every day around the world in the abjectness of wondering whether they'll be able to make their living that day. It's as if they are saying: Are you going to put us to work or are you just going to keep on standing there, staring at me, with that quizzical expression on your face? Kabakov's *Monument to a Lost Glove* deliberately eschews *spatial* monumentality. *Viewer* builds *temporal* monumentality out of the meeting—the subtly confrontational dramatic content of the meeting—between the interested implicated standing body of the viewer, with its relative freedom, and the seventeen standing bodies of the day laborers, with their submission to the compulsory order of things. Within that tension, the category of the monumental turns out not to be irrelevant or absolutely contradictory to the experience of the everyday. The constitutive temporality of video produces this other kind of monumentality, an embodiment in solemnity that the statue of William H. Seward was perhaps intended to produce in its time. *Viewer's* solemnity is not about refiguration in the ennobling bronzed permanence of the body of the (now forgotten) great man, but about what's ordinarily (and repeatedly) forgotten about the anonymous bodies we encounter anonymously in everyday life—produced within the tremulous, breathy immateriality of video, with its convincing impression of present

tense. In Los Angeles, and throughout much of urban and suburban California, you often see day laborers in such groups, if you're up early enough. They stand there, often forming a ragged line, outside strip malls and suburban shopping centers, or at corners where everybody knows they will be. They wait until a shorthanded contractor or landscaper drives up and they pile into his pickup and they're gone. If you're not observant, or if you're not up early enough, you might never know that the day laborers, who are often illegal immigrants, were ever there at all. They are an abundant source of cheap, low-risk, no-obligation labor.

This association may be subjective. Or it might be inescapable. But it was triggered in part by my encounter with the carpenter outside the gallery. Video projection, much more than film projection, which has long been stabilized for viewer consumption in customary venues, plays on unsettling the phantasmatic relation of absence and presence: on the one hand, the bodily presence of the viewer; on the other, the physical absence of what is projected (which quite often are human bodies). Viewers walk into the space of video projection relatively uninstructed. They stand, lean, squat, circulate, but the protocol of viewing is not stabilized. (Consider in contrast the elaborate—elaborately restrictive and disciplinary—protocols developed for movie theaters and refined in multiplexes.) The actual unexpected physical presence of the worker at the entrance to the gallery oddly lent support to the representation of the physically absent workers inside the gallery—the chance encounter that is so characteristic of the everyday as one moves through the city, never sure who or what may be around the corner.

The viewer is not on a schedule. It's not to the profit of the galleries to put us on one—as it is to the profit of the museums during monumental blockbuster shows. It's as if the galleries have yet to learn the discipline of narrative. Video installation work using projection systems has become much more common, migrating from museum spaces to the galleries. When the human body is the crucial projected element, the illusion of presence becomes operative. Such illusionism is magical in a sense that is as old-fashioned as the magic lantern or the pioneer magical films of Georges Méliès. Much of Hill's video projection work depends on the deliberate removal (or sacrifice, in an almost religious sense) of context, of the factual, of much more than a phenomenological specificity, all of which tend to flatten the possibility of contradiction in either a dramatic or social sense in favor of a play between the physical and the metaphysical, the embodied and the disembodied. And it depends finally on the intimate relation of the viewer's bodily presence to the physical beings magically projected on the darkened wall of the museum or gallery. However, this last point can unexpectedly return video installation/projection to the lost moment of contradiction, to the extent that the viewer in his or her full, somewhat less disciplined bodily presence confronts these projected bodies (not present and yet present), bringing to the experience what's lacking in or has been suppressed by the projection—his or her own irreducible specificity, his or her everyday presence.

Such a moment of questioning, of contradiction, is heightened in *Viewer*. Hill's

minimalism, which has often tended to render or to refer to presence as a spiritual quality, is in fact politicized as soon as he brings the "real" world (in the form of the full-size projections of seventeen day laborers standing and facing the viewer) into the gallery space, making present what is ordinarily absent from the pristine space—and what was absent from all the other projection/installations in Hill's show. What this installation suggests is that contradiction, rather than, say, mystery or the spiritual (qualities that underline and reinforce the illusionism of projection), may be in fact well-nigh indispensable to any video installation that has any ambition to resonate in the "real" world, outside the representational spaces of the gallery and museum. Which indicates that this apparently disembodied electronic art form can be as material as any other art form when, like the action of picking up a lost glove on the sidewalk, it is able to fulfill the conditions of confrontation: the temporal clash of subjectivities. This involves such elements as action, presence, time, and deliberate intervention. That's not so much, really. The shock of a monster tearing your heart out is much more costly.

Today I ventured down the block to check the accuracy of a quote from Kabakov's text. It's handy to have the public art you're writing about only a block away. Next to the Triangle Building a two-story triangular billboard had been erected to advertise the upcoming premiere of *Godzilla* a full three months in advance. The billboard was so big it blocked part of the sidewalk and part of Fifth Avenue (at a moment when the city's "quality of life" mayor was inveighing against mere human beings who impede the flow of traffic by jaywalking). The billboard text wasn't as poetic or subjective as Kabakov's: "He's as tall as the Flatiron Building," read the lead line. Then: "from the creators of Independence Day," in smaller lettering above the title, "GODZILLA (TM)." Then the kicker: "Size Does Matter." This suitably self-conscious boast locates the psychic source of this completely unnecessary remake—a male fantasy of compensatory potency, castration anxiety. All of this while across the street there lies that small lost right-handed red glove. Kabakov couldn't have foreseen such a travesty, but it does put the ostentatious modesty of his approach in an even more apt antimonumental light. But this encounter also alerted me to how much alike the new *Godzilla* and *Monument to a Lost Glove* really were: the two works of art, each in their own way, were about the consequences of loss.

The material "abjection of those who must wait" is how Simon Leung, in his essay "Squatting through Violence," designates one side of the power differential that is the primary condition of everyday life.[1] He quotes Maurice Blanchot: "He who is sovereign is the one who does not have to wait." Leung's essay is framed by an anecdote told to him by his brother about seeing at a bus stop in San Jose, California, a number of Vietnamese immigrants squatting rather than sitting at the available seats. Following Marcel Mauss's "study of the technological education of the body," Leung develops a conception of the displaced body in the city that posits it as a possible mode of resistance within "the sovereign moment" and "against the servitude to utility that permeates the timescape of the modern world." To squat rather than sit is to

Figure 1. Simon Leung, *Squatting Project/Wien,* 1998, installation view. 131 black-and-white photographs, 131 blocks of text, and a rotating slide projection of 50 images in a room. Photograph courtesy of the artist.

show forth bodily that one is not on a schedule—one can outlast the sovereign in refusing the supremacy of the moment. However, the abjection produced by one's complicitous submission to, rather than resistance to, compulsion is a desolating state of being that overtakes every worker. Every job I've ever had produced that feeling throughout my body, sooner or later—and usually sooner.

All of which makes me think that it may be worthwhile to set the repetitive against the unique (or "the sovereign moment") as a way to produce an account of the specific temporalities that structure the everyday and that therefore would receive displaced if obsessive treatment in certain kinds of installation. My point is that any installation that concerns itself with the production and reproduction of the conditions of everyday life would probably be structured by these temporalities. In other words, the unique is represented by the moment (the particularity of which is by definition unrepeatable), while the repetitive (the accumulation of sameness) slogs through willy-nilly to represent that which is inescapable. Leung gets at this admirably in his meditation on squatting, particularly by framing the moment in its latent potential for resistance. The everyday is structured by unique and repetitive temporalities, and it's within the unique that one glimpses, if only for that moment, escape from the compulsory regimen of existence. In fact, however, abjection stalks both temporalities.

To take up the "abjection of those who must wait" I advert almost vertiginously to the era when I drove a cab in New York City for a living. The abjection of waiting was always a condition of this job. As an irregular I showed up to work and would be forced to wait several hours for a car, never knowing if or when I'd get one. At times I wouldn't

get one—and would have to return home empty-handed, not ab- but de-jected, which is to say thrown away. But even when I was lucky enough to secure a cab, the driver's seat still warm from the body of the day-shift cabbie, I would then experience the ab-jection of driving the empty cab manically up and down the same limited set of ave-nues, searching for fares for the next twelve hours, racing the same green lights, making inevitably predictable turns, sitting in the driver's seat while waiting in suspended mo-tion for someone to hail the cab. The inescapability of repetition lies at the heart of this abjection/dejection, and twenty-five years later I can still feel it, if I let myself.

To this I oppose or perhaps supplement my one true experience as a day laborer. I was absolutely penniless and abject. I showed up before dawn outside a storefront in Newhall, California. I'd barely slept that night. I had no idea what I'd be doing— I only knew that at the end of the day I'd be paid in cash. My lover and I were living for free in a state campground that was otherwise uninhabited, and we were at the point of stealing food from the local supermarket. If you haven't ever reached that point, you don't know what it is to live. This is the snobbery of the destitute. Anyway I showed up, along with a number of other miserable-looking men. We waited for several hours in a state of not-knowing. Then we were loaded into closed airless vans and transported to a Catholic church carnival in Santa Monica. We were worked for minimum wage without food or drink or a break and then loaded back into the vans and dropped off where we started. It was midnight. I had some cash in my pocket, but my abjection was so intense I scarcely knew my own name. I found my lover not far from the spot where we'd agreed to meet many hours earlier. She saw me, ran up to me, and walloped me across the face. She'd assumed I'd been dead for hours and had

Figure 2. Detail of *Squatting Project/Wien*. Photograph courtesy of the artist.

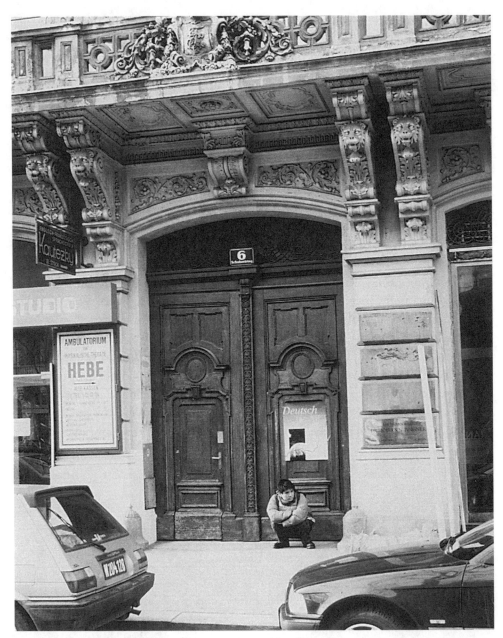

Figure 3. Detail of *Squatting Project/Wien*. Photograph courtesy of the artist.

given up all hope. The slap brought me back to life again. Suddenly you know who you are when your lover wallops you with the liberating violence of stored-up anguish. I decided to find work some other way.

These two true-life narratives encapsulate the poles of the everyday: the entrapment of the repetitive in its submission to necessity and the desperation of the moment. There's really no choice between the two. Most of humanity lives out both within the compulsions of the everyday. Which is, I suppose, why the work of a so-

Figure 4. Detail of *Squatting Project/Wien*. Photograph courtesy of the artist.

cially coherent or socially responsive installation in its own obsessive-compulsiveness reproduces this structure. The immense but latent violence of compulsion—the repetitive action of running a carnival ride for intolerable masses of laughing children—was crystallized by that slap. Resistance is nothing if it is only mental: we need to break out of the instrumental use of the body and to feel it as a break. Walk across the street. See a glove that isn't there. Walk into an immense room and confront with your body the seventeen bodies of the abject workers who are not working.

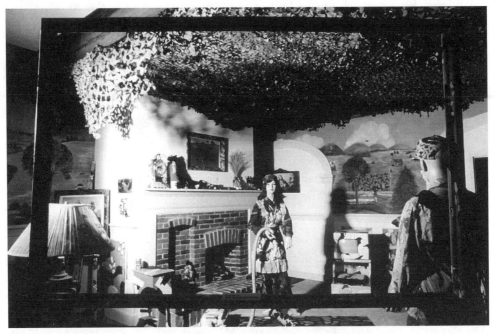

Figure 5. Sherry Millner, *Protective Coloration*, 1997. Installation detail. Courtesy of the artist.

The sanctioned public art site which *Monument to a Lost Glove* occupies—as a project of the Public Art Fund in New York—is built around the principle of the more or less random encounter that is itself a condition and major excitement of life in the city. The theorization of such encounters, especially as potential sites or modes of micro-resistance to things as they are, receives perhaps its most intellectually impassioned treatment in Michel de Certeau's *The Practice of Everyday Life*. Obviously, a gallery site, a private interior sanctioned space for the exhibition and consumption of art, cannot hope to be quite the same such rich site of encounter. It edits out much, if not all, of the apparent randomness, multiplicity, and heightened potential of contradiction, not to mention the potential for violence. A third, less sanctioned site, privately owned, like a gallery, but publicly traversed, like a city street, is the shopping mall.

As a site for installation, the shopping mall encounters viewers as consumers, ac-tive bodies intent on working to fulfill their desire, whether immediate or deferred, without really being entirely sure what concrete form that gratification of desire will take. Shopping, about which we tend to be dismissive for its significance in our every-day lives despite its obvious centrality, nevertheless involves looking, seeking, discov-ering the shape of desire in the form of a product or sometimes an experience. It tends to be purposive and even more actively sensual in ways that surpass or bypass the walker in the city or the viewer in the gallery.

I once helped to organize and produce an installation show in a small working-class mall in New England. The working idea for the show was encapsulated by its title: *ReSituations*. The notion of the creation of a situation in which installations might function as a point of intervention into the everyday lives of shoppers was to some

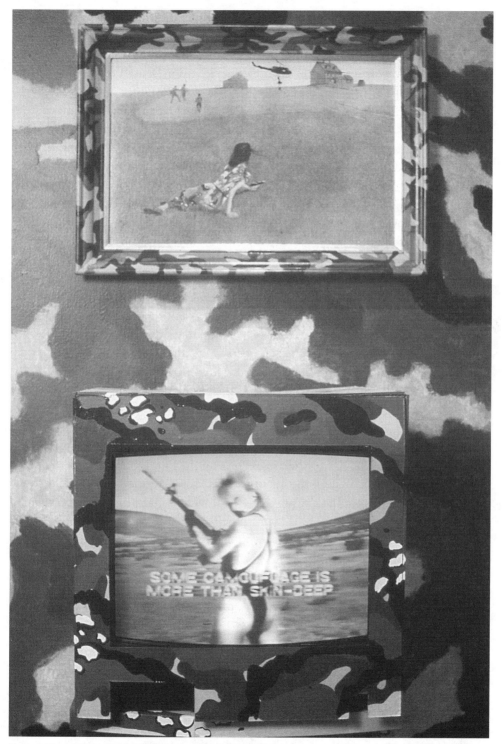

Figure 6. Sherry Millner, *Protective Coloration,* 1993. *Christina's World Order* and video monitor. Courtesy of the artist.

extent inspired by situationist concepts of cultural intervention. The situationists tended to be vague about what they meant by the creation of situations. Nevertheless, one situationist definition of a "constructed situation" is "a moment of life concretely and deliberately constructed by the collective organization of a unitary ambiance and a game of events."[2] Loosely speaking, the four artists (James Montford, Stashu Kybartas, Jacqueline Hayden, and Sherry Millner) involved, along with myself, adhered to this approach, which seems to be about introducing an active principle of fiction into an otherwise generally predictable "real-life" experience. Certainly we were all in favor of seeking out and stimulating that "moment of life" from the shoppers. And the installations provided something of a unitary ambiance—a tour through the unexpected that provided the participatory unpredictable outline of a game of events.

In a general way you always know what to expect from everyday life. It is, after all, your point of reference to everything that is not the everyday, but in the moments of specific encounter, you can't begin to know what is really going to happen. So the multivalent responses of consumers were often arresting. However, they're not what I especially remember about the experience. Instead what stays with me are the responses of the people who really inhabited the mall—not the consumers who drifted through the space (behavior that recalls what the situationists called the *derive*) and then left to pursue another ambience, perhaps—but the people who worked in the mall, those who intimately abjectly experienced the repetition of working every day in the mall. Those were the people who took up the installations as their own experience in their own terms, unpredictably. They broke through the unitary ambience of work to adapt the installations to their own game of events.

The people who ran the mall conducted their own personalized docent tours for people they invited, articulating their own takes on the four pieces, staking their own claim. Workers in the mall took the opportunity to avoid the food court during lunch breaks and repaired instead to the novel spaces provided by the installations, hanging out in particular within Sherry Millner's mock-ethnographic *Protective Coloration*, which, although comfortably furnished with chairs and a couch, depicted "the modern American family decked out like a warrior clan" in a full-size bunker/living room, with every element meticulously done up in one of four different styles of camouflage (to the degree that even the well-known Wyeth painting, *Christina's World*, has become *Christina's World Order*, with the eponymous heroine, now armed and dangerous and done up in desert camouflage, crawling toward a farmhouse beset by commandos and helicopter). Most startlingly, each day young soldiers who worked in the army recruiting station (downstairs from the defunct restaurant space we used for the exhibit) would appear in full camouflage regalia amid the *Protective Coloration* installation. They were indistinguishable from the four other camouflage-mannequins who occupied the family bunker room. Observers, naturally unable to tell whether the soldiers were in fact part of the installation as they stood within it, were startled by the uncanny contrast of presence and absence manifested by the living soldier and the nonliving camouflage-mannequin family. The violence of representation at the compulsory

heart of everyday life was here living and breathing—and also "dead," given the irony of the re-presented violence. The crossover from daily life to art was for a few moments complete.

The qualification "for a few moments" is crucial. The narratives of daily life and of art come alive only in such sovereign moments—in the absence of its permanent transformation, a project that the major theoretician of everyday life, Henri Lefebvre, speculates on briefly but evocatively at the end of *Everyday Life in the Modern World*: "From an intellectual point of view the word 'creation' will no longer be restricted to works of art but will signify a self-conscious activity, self-conceiving, reproducing its own terms, adapting these terms and its own reality (body, desire, time, space), being its own creation; socially the term will stand for the activity of a collectivity assuming the responsibility of its own social function and destiny—in other words for self-administration."[3] If these words, published in the watershed year of 1968, seem almost touchingly naive thirty years later, that response may be more a measure of our own distance from the potential of the moment than a commentary on Lefebvre's gallant refusal to turn his back on the prospect of change. The gesture, the look, the touch, the shudder, the laugh, the disguise, the intervention—these emblems of spontaneity are what mark the frontier of such change.

In Simon Leung's *Squatting Project/Wien* piece, the act of squatting marks that same frontier, though for him the act of squatting, as an activity of everyday life, is not marked by its spontaneity but by its repetitiveness within a particular cultural formation. For a show sponsored by the Generali Foundation, which has its headquarters in Vienna, Leung had himself photographed while squatting in front of no fewer than 131 buildings owned by the conglomerate the Generali Group. The Generali Foundation, despite its name, is not a true foundation. Far from being independent of the Generali Group, its budget, staff, building, and so on, are tied to the Generali Group, which is one of the oldest and largest insurance companies in the world. Generali is much bigger than Godzilla, the Asian-identified monster. Size does matter, after all.

It was in the Prague branch of the Generali that Kafka worked for some time. In one of the 131 photos the viewer sees Leung squatting under Kafka's name—a sign on a door announces a theatrical version of *The Trial* in the midst of being produced in one of the Generali-owned buildings. In a certain sense, then, it might be said that Kafka is still working for Generali. Given the size and the nature of Generali's holdings in Vienna and throughout the world and the massively increased value of Kafka as a commodity, Kafka will very likely be working for Generali as long as it continues to exist. Leung says:

My project, *Squatting Project/Wien,* was to squat in front of every building owned by EA-Generali in the city of Vienna, roughly following the logic that this collection of buildings, totaling in worth well over a billion dollars, is a "real collection" of "real estate" for EA-Generali, and can be depicted in relation to a collection of art, which the Generali Foundation also owns. The 131 photographs are installed at the exhibition

space of the Generali Foundation, at about 4 feet from the floor (at squatting eye-level). Each photo is accompanied by text directly below it, giving details of the address of the buildings, the year it was built, the year it was bought, its commercial, residential occupancy, etc. In the middle of this installation was a small darkened room, where I projected 50 slides, each an image of a real estate holding of the EA-Generali in Vienna. These fifty images were published in a real estate brochure by Generali (again, there is an echo of the art collection and the catalogue). Since the room is opened on three sides into the photo installation, one can see the large image of the projection simultaneously with the small photos through the doorways.[4]

A fragile human body posed against one monumental edifice after another. Difference posed against sameness, the one versus the many, the human being versus the collection. The subject versus the object. The mobile versus the immovable.

De Certeau dedicates *The Practice of Everyday Life* "to the ordinary man," saying in part: "This anonymous hero is very ancient. He is the murmuring voice of societies. In all ages, he comes before texts. He does not expect representations. He squats now at the center of our scientific stages."[5] Much as we might regret de Certeau's linguistic erasure of the ordinary woman, it's clear, given de Certeau's meticulous use of language, that his use of the verb *squats* is directly tied to a perception of time in which this ordinary man's physical being in the present tense is nothing if not persistent. Such persistence is itself a kind of mute resistance.

There is no longer in the world any efficacious logic opposed to the logic of the conglomerate. To the logic of the conglomerate is opposed the individual logic of the everyday. The measure and the scale of the everyday is the human body—the body first of all as mute witness in its specific gestural force and containment of violence and submission. The body waits. For food, rest, sleep, the elements, for change. Now what is Generali? Simply an insurance company. Insurance, as everyone knows, is a rigged game of chance. The insurance company always wins the game, always profits almost beyond imagining on the misery and privation of human existence—the frailty of the body. Isomorphism.

The logic of the collection—whether it's a collection of buildings or a collection of art—is the same. Ownership and value are based on the legitimation of violence. Art is no alibi. Art is an alibi nevertheless. Simon Leung ungraciously and yet still graciously bites the hand that feeds him. The presence of the body as witness guarantees us no redress. We are all insured. Everyone who can pay can pay to be insured. And yet. The question to be asked is to be asked about logic itself. Leung's piece is as simple as possible. And as quiet. There is no rhetoric. The text is purely factual. Facts speak for themselves. Some facts, once brought into the light, virtually have the ring of an accusation.

Looking at "the un(der)assimilated Asian body," we are encouraged to think about the everyday act of squatting. We wonder who squats and why—and for how long. Not only because all the photos depict the same squatter but because of the

height at which they are hung on the wall. Which means, for most of us, that to look at the photos we must lean over a bit, push our bodies into a slightly uncomfortable position, lean into the place of the squatter. We must enact another technology of the body. The posture we must assume puts us in a physical relation, not to the object (one of the 131 buildings), but to the subject (the squatter). We enact the relation of persistence to resistance. Our posture obeying the logic of the photographs disobeys the logic of the collection of real estate. It's as if the real estate collection were being cut down to size—which matters, of course.

Antimonumental resituations of the human body accumulate: leaning over to look and perhaps grasp a glove that isn't there, or to stand there being confronted by the long line of waiting laborers, or to find oneself detoured out of the embodied position of the shopper or freed for once from the physical choices available to the worker in the mall.

Protective Coloration resituates the aesthetic production of the logic of war within the zone of the reproduction of everyday life: the home. Ironically exploiting the glacial monumentality of the frozen moment of the ethnographic diorama, common to natural history museum display, the installation effectively defamiliarizes the familial, as if it had doomed itself to extinction because of its rapture with violence. The home and the battlefield become one: the home sheds its pacific costume and becomes the training ground for both sanctioned and unsanctioned violence. The metaphor/reality of camouflage, that which must be hidden from view, is pursued to the smallest possible detail, which oddly reveals to what extent the home itself is an ensemble of ritual objects, repetitively used in specific technologies of the body. The unstinting elaborateness of visual transformation produces the conviction of simultaneity. Even the camouflaged mom is caught in the lifeless posture of deploying her chosen weapon, the camouflaged vacuum cleaner.

Squatting Project/Wien resituates the vicious concentration of real estate wealth in the urban environment within the same conglomerate's art foundation. The collection of representations of the conglomerate's real estate fits snugly in the art container that fits snugly inside the conglomerate container. The repetitive difference of 131 photographs measures the abstraction of ownership and wealth against the bodies of viewers caught up in a physically determined but individual response to squatting, which they would need to repeat 131 times to understand fully.

Gary Hill, in an elegantly minimal video installation, *Viewer,* produces an unvoiced protest against totality, separation, absence, passivity, and the loss of subjectivity, resituating day laborers in a mute confrontation with the lone viewer. Each of these pieces insists on the viewer's active present temporal engagement, to produce their own physical response to the intolerable, to engage the physical present against the repetitive weight of history. The subjective is offered as antimonumental, various, multiple, unfinished, partial.

Monument to a Lost Glove produces its own thirty-six-voiced subjective commentary on itself, along the way demonstrating the ubiquity of the facility of making

meaning as an everyday activity and the inescapable partiality of that voiced subjectivity. Each of these installations demands or produces not only a mental but also an active physical engagement as a condition of participating in the terms of intervention with which they are engaged. "A self-conscious activity, self-conceiving, reproducing its own terms, adapting these terms and its own reality (body, desire, time, space)." Closing the gap, in other words: reclaiming the space colonized by Godzilla and the mayor, the shopping mall and the conglomerate—even the gallery.

Yesterday, which was Good Friday according to the Christian schema, I saw Jesus alive like you and me. Since that doesn't happen everyday, I stopped my rented Fiat right there at the edge of the village green just off the moor in Devonshire. I grabbed the video camera, got out of the car, and videotaped Jesus, dressed in a flowing white gown, as he carried a massive black cross on his back to the gnarled tree in the center of the green. There he stopped. It was raining, windy, and very cold. It had been snowing that morning. My hands were freezing. But I wanted to get some footage of Jesus. It was a moment that might never come again. I haven't been Catholic for a very long time but I knew Jesus when I saw him. Tomorrow is Easter Sunday. Redemption is at hand.

Notes

1. Simon Leung, "Squatting through Violence," *Documents* 6 (spring/summer 1995): 92–101.
2. Ken Knabb, ed., *Situationist International Anthology* (Berkeley: Bureau of Public Secrets, 1981), 45.
3. Henri Lefebvre, *Everyday Life in the Modern World* (New York: Basic Books, 1972), 149.
4. Leung, "Squatting through Violence," 92–101.
5. Michel de Certeau, *The Practice of Everyday Life* (Berkeley: University of California Press, 1984), 3.

10. Internal Exiles: The Interventionist Public and Performance Art of Asco

C. Ondine Chavoya

Asco (NAUSEA):

1. a feeling of sickness at the stomach, with an impulse to vomit.

2. disgust; loathing

3. Gronk, Patssi, Gamboa, Herrón

4. Collaborations 1972 thru 1976

—Harry Gamboa Jr. and Gronk in "Interview: Gronk and Gamboa"

Formed in the early 1970s by four Chicano artists from East Los Angeles, Asco set out to test the limits of art—its production, distribution, reception, and exhibition. As a collaborative creative corps, the original members of Asco, Harry Gamboa Jr., Gronk, Willie Herrón, and Patssi Valdez,[1] engaged in performance, public art, and conceptual multimedia art. The artists merged activism with performance in response to this turbulent social and political period in Los Angeles and within the larger international context of alternative youth cultures and radical politics of the late 1960s and early 1970s.

Asco created art by any means necessary, often using their bodies and guerrilla, or hit-and-run, tactics. The artists banded together through their shared sense of displacement and as an alternative to gangs, violence, and other negative elements affecting the community. Manifesting their ideas in the public arena of the streets, the artists recognized the power of public representation and documentation and expertly learned to circumvent traditional institutions by creating alternative methods of access and distribution. Their work critically satirized and challenged the conventions of modernist "high" art as well as those of "ethnic" or community-based art. The connotations of their self-adopted name, Asco, testifies to the initial effect of the group. *Asco*

189

is Spanish for nausea or repulsion with the impulse to vomit. The name acknowledges the response that their street and gallery work provoked, particularly from within the Chicano art movement. Throughout the 1970s and into the 1980s, the Asco group initiated urban street actions that critically interrogated the social space of Los Angeles. Formed in the early 1970s by four Chicano artists from East Los Angeles, Asco set out to explore and exploit the unlimited media of concept and, in this way, create "conceptual art in urban form" (Sandoval 1980).

This essay discusses the intersections of performance, interventionist public art, and media technologies in the work of Asco while focusing on what their early public art actions elucidate about public space and urban relations in Los Angeles.[2] After several years of collecting the traces and fragments of Asco's history of production,[3] I have come to understand that one of the most salient and dynamic characteristics of their public work was Asco's talent for situating social critique in contested urban spaces. The frequent object of their critical interventions was the normative landscape and official culture of Los Angeles that has repeatedly represented the city's Chicano population as an invisible "phantom culture" (Gamboa 1981: 15). Asco developed a sophisticated visual and theoretical language attentive to the specific geographies of Los Angeles and, in particular, the urban Chicano barrios. Through performance, the artists brought urgent attention to the urban spectacles of violence, police brutality, exploitation, and discrimination. It was here that the geographic and social space of Los Angeles became much more than the site of production; it became the very material for Asco's conceptual art.[4]

Asco and the Ethics of Combat

Without contextualizing Asco's public spectacles, it would be difficult to discern the dynamic interaction between critique and seduction, play and provocation, and activism and abstraction that characterizes them. Thus, I consider Asco's public art in relation to the historical surveillance, suppression, and erasure of Chicano public space and contextualize their aesthetic strategies and interventionist tactics within the practices and activities of the Chicano Civil Rights movement.

Between 1968 and 1973, Chicanos in southern California protested the disproportionate number of Chicano casualties in the Vietnam War and the relationship between this statistic and inequities of education and unequal opportunity for Chicano youth. Gamboa, Gronk, Herrón, and Valdez all attended Garfield High School in East L.A., the nation's largest barrio and a locus of political organization and violence.[5] Harry Gamboa Jr. helped revive *Regeneración,* a Chicano political and literary magazine first published by Mexican anarchist Ricardo Flores Magon in the early 1900s. Gamboa became an editor in 1971 and enlisted Valdez, Herrón, and Gronk to work on the publication. This was the first time the four artists came together to collaborate on a single project.[6] Without formal training, few available models, and even fewer venues for exhibition, *Regeneración* was Asco's collaborative training ground.

While in high school, the artists were involved in a clique of the Chicano youth movement that "rebelled against social victimization by adopting 'an extreme and flamboyant use of language and fashion'" (Dubin 1986: 2). Known as Jetters, members of this group were noted for their wild dress, tricky talk, and sardonic attitudes, and their "extravagance of dress and manner served as a placard for social impotence" (Gamboa 1985). As Gamboa recounts:

> With over three thousand predominantly Chicano students faced with unequal opportunities at home and probable overrepresentation in the fields of death in Vietnam, . . . [Garfield] high school gained notoriety as the trendsetter of Chicano fashion, etiquette, violence, and slang. . . . The mutual awareness of the musicians and artists in the midst of social and political change allowed them to convey their shared experience through personal and group expressions of music or art. (Gamboa 1991: 127)

On March 5, 1968, more than one thousand students walked out of five high schools in protest of the substandard educational system in East L.A. By the end of the week, sixteen high schools were involved, and over ten thousand students were on strike during the fifteen-day period. This student boycott for educational reform, known as the Chicano Blowouts, was the first major mass protest against racism undertaken by Mexican-Americans in the history of the United States. This organized, nonviolent student strike "brought the largest school system in the nation to a standstill and made news across the country; a *Los Angeles Times* reporter interpreted the strike as 'The Birth of Brown Power'" (Muñoz 1989: 64). Nonviolence, however, did not prevail. Students, demanding to address the board of education, assembled in a public park, where they encountered the newly instated Disaster and Riot Training (DART) forces. Student resistance was met with police hostility and violence.

On March 4, 1968, the day before the first planned blowout, FBI Director J. Edgar Hoover issued a memo to local law enforcement officials across the country urging them to place top priority on political intelligence work to prevent the development of nationalist movements in minority communities.[7] Gronk, the first to engage in performance and life action art, contributed to the political newspaper *Grassroots Forum* and Chicano nationalist student publications. Gamboa served as the vice president of the Garfield High School Blowout Committee and contributed to the activist news periodicals *Chicano Student News* and *La Raza*. Gamboa's role in organizing the Blowouts made him the target of surveillance by "New Left" internal subversives and un-American activities observers. In testimony before a U.S. Senate subcommittee in 1970, Gamboa was named one of the hundred most dangerous and violent subversives in the United States, along with Angela Davis, Eldridge Cleaver, and Reies López Tijerina; Gamboa's part in organizing the Blowouts was deemed "antiestablishment, antiwhite, and militant" propaganda (Committee on the Judiciary, U.S. Senate, 1970: 12).

The military resonances of the term "avant-garde" are dually relevant when discussing Asco. Asco's avant-garde strategies were "urban survival techniques" (Gamboa

in Brookman 1983: 6) that emerged from the organized protest movement against the use of Chicanos, and other people of color, as the literal avant-garde in the war in Vietnam. The emphatic characteristic integral to the diversity of work Asco produced is their "ethics of combat."[8] "Ethics of combat" is perhaps the most appropriate phrase to describe Asco's signature form of spatially politicized aesthetics. In the face of crisis, Asco engaged a transverse tactic of heterotopic resistance and deviation.

Through effectively engaged countersites, Asco actualized what several postmodern theorists have called for, and attempted to identify, in contemporary cultural practices. Scholarship in urban studies, cultural studies, and more recently art history has undertaken the analysis of the production of space as a conflictual process of domination and resistance to domination (under capitalism) (Deutsche 1992: 42). Marking the city as the most immediate locus for the production and circulation of power— "the headquarters of societal modes of regulation" (Soja 1989: 235)—much of this work either originates from or takes up the particularly overdetermined postmodern example of Los Angeles.[9] Chicano history, a history explicitly parenthetical in this work on postmodern cultural geography, is the story of territorial occupation through legal manipulation working in concert with violence (Gutiérrez-Jones 1995: 100).[10] Situated as an aesthetic coalition of politics and production, Asco's public art recognizes space as a terrain of political practices and enacts the emancipatory potential of a spatial, aesthetic imagination (Villa 1993: 36).[11]

Walking Murals and Other Defacements

On Christmas Eve 1971, Gamboa, Gronk, and Herrón performed their first walking mural, *Stations of the Cross,* and iconoclastically transformed the Mexican Catholic tradition of the Posadas into a ritual of remembrance and resistance against the deaths in Vietnam. The trio arrived at the corner of Eastern Avenue and Whittier Boulevard in outlandish makeup and costume. Carrying a brightly colored cardboard cross, Herrón led the procession as a stylized *calavera*-Christ wearing a long flowing white robe with an emblazoned sacred heart. Faithlessly following him were Gamboa, as a zombie altar boy wearing an "animal skull headpiece to ward off unsolicited communion" (Gamboa 1991: 124), and Gronk as Pontius Pilate in clownlike makeup, a burgundy velvet gown, and his signature accessories: a green bowler hat and an excessively large, beige fake fur purse.

Performing the "Stations of the Cross" along a one-mile stretch of Whittier Boulevard, the procession's final rite was held before the U.S. Marines Recruiting Center at the Goodrich Boulevard intersection. Gronk blessed the site with Kress dime-store popcorn and the trio observed a ceremonial five minutes of silence. The fifteen-foot cross was placed at the door of the recruitment center before they fled the scene. *Stations of the Cross* conceptually, if not efficaciously, staged an urban disturbance to symbolically block any further Chicanos from enlisting at the center that day.

Patssi Valdez joined Gamboa, Gronk, and Herrón for their encore Christmas Eve

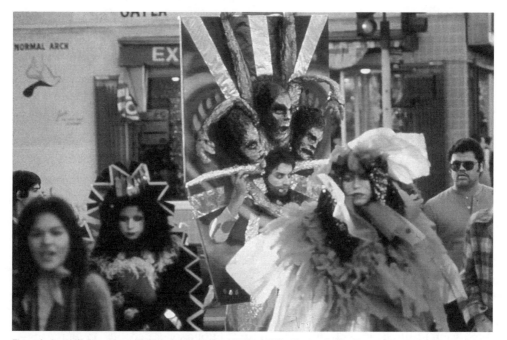

Figure 1. Asco, *Walking Mural*, 1972. Left to right: Patssi Valdez, Willie Herrón, Gronk. Photograph by Harry Gamboa Jr. Used by permission of the artist.

Whittier Boulevard performance in 1972, titled *Walking Mural*. As a result of the Chicano Moratorium against the Vietnam War (1970), a peaceful demonstration that turned into a police riot, and subsequent retaliations and urban disturbances, the Annual East Los Angeles Christmas parade had been canceled.[12] Assuming the traditional course of the countermanded parade, the artists staged a public spectacle in which they were both the participants and floats. In the process they advanced the convention of street murals from a static media to a moving performance medium.

Walking Mural was a counterspectacle intervention—a carnivalesque inversion of authority and a reclamation of social space. As public manifestations, *Stations of the Cross* and *Walking Mural* are more than reminiscent of social protest. "So much death had been occurring and does occur in East L.A. without any meaning attached to it," Gamboa said in an interview. "We wanted to give people a certain kind of almost gastro-intestinal response" (Sandoval 1978). Asco's theater of social engagement was a form of celebratory protest that merged aesthetics and activism. Improvising absurd imagery and environmental interventions was Asco's calculated tactic to disrupt the perceptual responses of the audience.[13] As Herrón states, "We wouldn't plan it so people could actually come and see it, we would just drop in on everything in its normal pattern" (Brown and Crist 1985). Even if startled spectators and unknowing participants could not precisely decipher their allusive critique, the artists hoped that the very occurrence of these bizarre and unorthodox activities in public thoroughfares would raise questions in the minds of viewers.[14]

When asked why Whittier Boulevard was so significant in their performances,

Herrón replied, "Because we felt we'd get maximum exposure there and also because that particular . . . stretch was the focal point of the riots. . . . To this day [1985] the police completely block the street after 10:00 p.m. on weekends so you can't drive through" (Brown and Crist 1985). Chon Noriega and I discussed this notion in relation to the multiple critiques that Asco's public performances actualized. Noriega, emphasizing the last point Herrón alludes to, positioned these critiques as follows:

> Part of what they were saying was that the Mural Movement and the Chicano Art Movement had become as frozen as the "frozen revolution" of Mexico that it was referencing, and that its icons had ceased to function in a flexible enough manner for either aesthetic or political ends. . . . [T]hey were also critiquing the fact that in 1971–72, Chicanos could not walk down Whittier Boulevard without being stopped by the police. . . . So they were situating their critique in a space that Chicanos did not have access to—public space.[15]

Momentarily retaking control of the landscape, the artists enacted an alternative interpretative practice from the position of those subordinated by urban spatial politics. As Rosalyn Deutsche reminds us, "The unity of public space depends on repressing— on establishing—as external to 'the public'—the differences and conflicts as well as outright injustices of urban life; public space becomes an appropriated territory subject to, rather than representing the limit of, regulatory power" (Deutsche 1992: 38–39). Underpinning the dominant social geography of Los Angeles is a disciplinary structure of containment and exclusion maintained by various policing activities and organizations (Davis 1990). The effectively enforced practices of containment and exclusion are accordingly racialized; the production of space for cultural hegemony in Los Angeles, manifest and maintained by its exclusionary and segregated spatial formation, has historically labored to implement and secure the systematic containment of the Chicano population, physical and otherwise. This technique of social-spatial control can be seen as an effort to relegate Chicanos "to a sphere outside the public, to bar admittance to the discursive construction of the public, and in this way, prohibit participation in the space of public communication" (Deutsche 1992: 38). The experienced effects of this prohibitive and disciplinary exclusion were poignantly epitomized in testimony presented to the U.S. Commission on Civil Rights investigating continued allegations of police brutality and violations of federal law by L.A. law enforcement agencies during the East L.A. riots of 1970. As one community representative proclaimed, "Whether the law knows it or not . . . we're the public, even if we are brown" (Commission 1970: 13).

Asco took the issues of "minority" representation, access, and inclusion in public institutions to an unprecedented, if mischievous, extreme with the 1972 performance *Project Pie in De/Face.* This event was incited by a confrontational meeting between Gamboa and a curator at the Los Angeles County Museum of Art (LACMA) concerning the absence of Chicano art in the museum's collection and exhibitions. The

curator's response was that Chicanos didn't make "fine art"; they only make "folk art" or they were in gangs. In reply, Gamboa, Gronk, and Herrón initiated *Project Pie in De/Face,* also known as *Spraypaint LACMA,* by signing their names to all the county museum entrances in gang-style fashion, thereby claiming the institution and all its contents as the artists' own conceptual piece—"the first conceptual work of Chicano art to be exhibited at LACMA" (Gamboa 1991: 125).[16]

Project Pie in De/Face crystallized the artists' collective identity as a collaborative performance group. The prejudicial practices of the arts institutions, coupled with directed spatial interventions into a new realm, the west side of L.A., fueled Asco's creative and subversive edge for the next ten years.[17] In 1973, the group began a series of midnight art productions, the *Instructional Destruction Projects,* by spray-painting billboards and walls on Sunset Boulevard with slogans such as "Pinchi Placa Come Caca" (Fuckin' cops eat shit), "Viet/Barrio," "Gringo Laws = Dead Chicanos," and "Yanqui Go Home." In one such incident, the artists were stopped, searched, and interrogated by three units and six deputies of the L.A. County Sheriff's Department (Gamboa and Gronk 1976: 33).

Symbolic Resistance/Spatial Interventions: Nonplace and the Symbolized Space of Place

> The space of non-place creates neither singular identity nor relations; only solitude, and similitude. There is no room for history unless it has been transformed into an element of spectacle.
>
> **—Marc Augé**

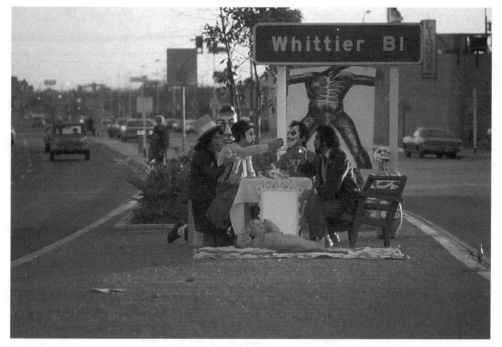

Figure 2. Asco, *First Supper (after a Major Riot),* 1974. Photograph by Harry Gamboa Jr. Used by permission of the artist.

First Supper (after a Major Riot) was performed on December 24, 1974, during rush hour on a traffic island at Arizona Street and Whittier Boulevard in East Los Angeles. In this performance Asco adopted the act of occupation in lieu of their previously mobile tactics. The traffic island the artists occupied had been built over a particularly bloody site of the East L.A. riots as a part of an urban "redevelopment" project in 1973. Following the riots, the surrounding buildings, sidewalks, and streets were leveled and rebuilt to prevent further public demonstrations.[18] The redevelopment of Whittier Boulevard is an example of urban planning administered as a preventive obstacle and punitive consequence for mass social protest. Transforming the traffic island into a stage for a macabre reenactment of the Last Supper, including elements from Days of the Dead celebrations, the artists memorialized the death and destruction that occurred at the scene years earlier.[19] Beyond identifying the site as a spatial symbol of subordination, *First Supper* enacts a counterspectacle to mitigate its transformation into a nonplace and spectacle of historical amnesia.[20]

Immediately following the occupation of the traffic island, Asco initiated another performance concerning forced immobility and bound constraints. Gronk invented the *Instant Mural* when he fastened Humberto Sandoval and Patssi Valdez to the exterior wall of a liquor store with masking tape. Gamboa's account of the performance provocatively suggests how this enigmatic happening was received: "Several anonymous individuals, concerned about their welfare, offered to help Valdez and Sandoval escape from the confines of low-tack masking tape. After an hour of entrapment, Valdez and Sandoval simply walked away from the visually intimidating, yet physically weak lengths of tape" (Gamboa 1991: 126).

Through Asco's spatial-aesthetic imagination, *Instant Mural* renders idiographic the "relations of power and discipline inscribed in the apparently innocent spatiality of social life" (Soja 1989: 6). *Instant Mural* can be interpreted as challenging the fragility of social controls while "actualizing the adhesive relations between society and space, history and geography" (Soja 1989: 223), with specific attention to the locations and functions of cultural identity and gender within this paradigm. In this way, Asco's ethics of combat can be seen as making us, in the words of Edward Soja, "insistently aware of how space can be made to hide consequences from us . . . how human geographies become filled with politics and ideology" (Soja 1989: 6). Given their spatial and historical contexts, *Walking Mural, First Supper,* and *Instant Mural* are simultaneously prophetic evocations of space, tactical forms of symbolic resistance, and spatial interventions. In this manner, the "symbolized space of place" constitutes the very material for Asco's urban performances.

When members of a local Chicano gang discover plutonium in cans of spray paint in *Lorena's Lament* (1981), East L.A. gangs enter into the nuclear age of atomic gang warfare. This fotonovela performance, also known as *Last Rites in the Left Lane,* occurred on the Fourth Street Bridge at Lorena Street. Twelve performers blockaded the center lanes of the bridge for over two hours; when three LAPD squad cars arrived at the scene, the only evidence of the disturbance found were discarded aerosol cans.

"The bridge," Michel de Certeau contends, "is ambiguous everywhere" and represents a "transgression of the limit, a disobedience of the law of place . . . [and] the 'betrayal' of an order" (de Certeau 1984: 128). The Fourth Street Bridge divides and connects East Los Angeles to downtown. Hollywood has imaged the bridge innumerable times as an abject zone of demarcation in film, as in *Boulevard Nights* (1979) and *Mi Familia* (1995), and television, as in the popular series *CHiPS*. The persistent representation of the Fourth Street Bridge as boundary and frontier has invested it with an iconic aura and metonymic power by which to signify the phantasmagoric threat of East L.A. and those who occupy it. Given de Certeau's uncanny interpretation of the bridge as an attack of state, the ambition of a conquering power, or the flight of an exile, the Fourth Street Bridge is the exemplary space, or nonplace, for a dystopic barrio rendition of global politics.

Media Hoaxes

Asco set out to promote an awareness of violence and the foolishness of promoting it (Gamboa in Rupp 1985). Seeing the problems and violence facing East L.A. "as problems because we were right in the middle of it; we wanted to change it. We wanted to reach inside and pull people's guts out" (Herrón in Benavidez 1981). It was this set of shared convictions that made it additionally imperative for them to shatter "people's preconceptions of what Chicano artists *should* do" (Gamboa in Benavidez and Vozoff 1984: 51).

Decoy Gang War Victim (1974) was both a performance and a media intervention. After closing off a residential city block with flares in the Li'l Valley area of East L.A., Gronk sprawled across the asphalt with ketchup all over him, posing as the "victim" of a gang retribution killing. As Gamboa explains, "We would go around and whenever we heard of where there might be potential violence, we would set up these decoys so they would think someone had already been killed" (Brookman 1983: 7-8). The performance's status as media hoax and counterspectacle depended upon the significantly different purposes to which the documentation was put to use. Asco distributed a photograph of the performance to various publications and television stations, which was accepted by the local media as a real scenario of violence. The image was broadcast, for example, on KHJ-TV L.A. Channel 9, as an "authentic" East L.A. Chicano gang murder and condemned as a prime example of rampant gang violence in the City of Angels. Whether the decoy restored peace to the barrio or was effective in canceling out the media's representation of an actual death is highly unlikely; however, the process exposed the possibility of media manipulation to artists.

Recognizing the power of documentation, the artists appropriated the spectacle of media publicity. This merger of performance and media manipulation became integral to future Asco activities. The artists were all too familiar with the power of photographic documents "to structure belief and recruit consent; the power of conviction and the power to convict" (Tagg 1994: 146). Not only did the mass media represent

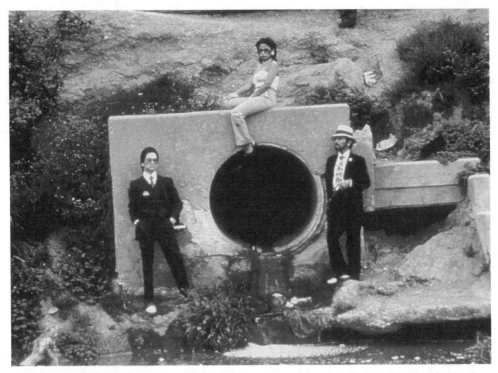

Figure 3. Asco, *Asshole Mural*, 1975. Left to right: Willie Herrón, Patssi Valdez, Gronk. Photograph by Harry Gamboa Jr. Used by permission of the artist.

crime and violence as East Los Angeles' "major gross product" (Brookman 1983: 8), but also the FBI's COINTELPRO agency targeted Gamboa for "internal subversives" surveillance. This was possible, Gamboa argues, because "they [the FBI] had pictures and I didn't have pictures to prove my point" (Noriega 1996: 214). Thus Gamboa characterizes Asco's work as "conceptually political" (Brookman 1983: 1); that is to say, its themes were often political or violent, or politically violent, or about violence against those who were political. As Kosiba-Vargas concludes, "Asco rendered new interpretations of the Chicano urban experience which emphasized the irrationality of an environment shaped by violence, racial oppression, and exploitation" (Kosiba-Vargas 1988: 4). The impetus was not to create spectacles per se but to bring attention to the spectacular condition of everyday life in the barrio and, through counter-spectacles, to destabilize the power of the media (to represent it as such).

Abject Space, Abject Actions

Asco's spatially politicized aesthetics embodied resistant meanings in order to mobilize resistant readings. In one performance series Asco members appointed themselves municipal officials to East L.A., an unincorporated county territory without a city hall. Asco toured their "municipality" on random site visits, designating various spaces and objects to be civic landmarks, monuments, and preservation zones. In one such

"No-Movie" performance, a storm drain was anointed with the illustrious title *Asshole Mural* (1975).

The sewer, Stallybrass and White suggest, beyond supplying the fundamental substructure for the city to manage and purify waste, is a symbolic system that functions as, and represents, "the conscience of the town" (Stallybrass and White 1986: 140–41). The social organization of the city's topography is structured by concepts of the body that are, in turn, mapped according to notions of dirt and cleanliness; these mediating ideologies "always-already" inscribe "relations of class, gender, and race" (Stallybrass and White 1986: 125, 130, 145). In *Asshole Mural,* Asco reverses the symbolic axis of the city's system of spatial purification and organization by memorializing its abject, orificial source.[21] The artists identify the city's waste disposal system as the city's asshole and claim it as a ready-made mural. By physically and conceptually positioning themselves at the permeable center of the system that demarcates the clean from foul, high from low, east from west, and city from slum, their bodies mediate the contaminant threat.

Traditionally monuments mark, embody, and make visible power relations. Steve Pile describes this process as making space incontestable "both by closing off alternative readings and by drawing people into the presumption that the values they represent are shared" (Pile 1996: 213). Asco's practice of spatially politicized aesthetics is an example of an enacted heterotopia that embodies and actualizes such alternative readings. Asco's performance demonstrates a process of recombinative simultaneity for critical resistance and dialogue: to read monuments as "grids of meaning and power" is also to recognize their active participation in the control and manipulation of space, both real and metaphorical (Pile 1996: 214), both the directly experienced spaces of representation and the conceptual representations of space (Soja and Hopper 1993: 198).

Asshole Mural is, perhaps most important, a performative intervention into the historical process that has produced Chicanas and Chicanos as the categorical blind spot—the "disposable phantom culture" (Gamboa 1981: 15)—of dominant institutions and media. The tactic utilized is to usurp the authority and power invested in the civic heritage industry as spectacle and transform it into a counterspectacle.[22] *Asshole Mural* is a performative, active invention of monuments, and in the process marks an absence. Asco's aesthetic strategies and interventionist tactics are a project of cultural invention emanating from neither the fragment nor the ruin, but from the absence. This is perhaps the crucial difference and theoretical site of resistance between Asco and the more traditionally defined Chicano art movement.

Asco did not adhere to the prescribed agenda for Chicano artists within the movement to unite and educate "the family of La Raza towards liberation with one heart and mind" (First Chicano National Conference 1969: 3). Neither obviously didactic nor consumable, their work was seen as an unproductive expenditure that did not fulfill the tenets of nationalism within the Chicano movement and potentially obfuscated a nationalist ideology.[23] A substantive distinction between Asco and other Chicano artists and collectives of the time relates specifically to their location within

identity politics and divergent investments in reclaiming cultural traditions and effaced histories. In this respect, Gronk contrasts Asco's work with identity-based and/or community-oriented work: "A lot of Latino artists went back in history for imagery because they needed an identity, a starting place. . . . We didn't want to go back, we wanted to stay in the present and find our imagery as urban artists and produce a body of work out of our sense of displacement" (Durland and Burnham, 1986: 57).

One of the tenets of the Chicano art movement was resistance, but for many *movimiento* artists what induced the response of "Asco" was the transgressive deviance of Asco's work. Transgression, as Tim Cresswell reminds us, "in distinction to resistance, does not, by definition, rest on the intention of the actors but on the results of the 'being noticed' of a particular action. . . . It is judged by those who react to it, while resistance rests on the intentions of the authors" (Cresswell 1996: 23).

Asco realized how their actions were deemed transgressive, and how they too were marked as abject; hence their name. Asco strategically aligned themselves with the response their work generated, and from it harnessed, but could not control, the power of the abject. Asco's multimedia works were viscerally inspired and intended to galvanize a response from the community (Gamboa n.d.: 2). In the words of Harry Gamboa Jr., the artists were simultaneously "attracted and appalled by the glitter and gangrene of urban reality" (Gamboa 1998 [1984]: 54). They recognized the psychic-social power of abjection to structure subjectivity and group identity and to regulate social hierarchies; in turn they appropriated this power to work toward social change. As a result, Asco expanded the social and cultural focus of Chicano politics and the public role of artists working within the Chicano movement.

Social Unwest: Psychogeography of a Phantom Culture

A whole new history remains to be written of *spaces*—which would at the same time be the history of powers (both of these terms in the plural)—from the great strategies of geopolitics to the little tactics of the habitat.

—Michel Foucault, "The Eye of Power"

I've been going to downtown L.A. as often as possible ever since I realized what public transportation was all about. Every time I get off the bus on Broadway, I lose my identity and spend the rest of the day trying not to find it. The personal void is overwhelmed by the impersonal vacuum of *social unwest* which splatters the environment like a bad choice of colors.

—Harry Gamboa Jr.

"Asco formed a distinct impression in the barrio that self determination was an active term" (Gamboa 1979). The performance and multimedia production of Asco is an aesthetic coalition of politics and production, performance and action; in this way Asco succeeded in creating and effecting social commentary in nontraditional form. Their bodies provided the most immediate form, and the social space of Los Angeles

provided the most effective forum for the materialization of their concepts (i.e., social commentary). In so doing Asco was able to oppose, in an attempt to transform, the terms *social subordination* and *spatial subjection* that conditioned their environment and restricted their experience. As a whole, Asco's work can best be characterized and understood as social, spatial, and aesthetic infractions of place (place here as a regulative and hierarchical location that is both social and spatial).

Foucault's concept of the heterotopia, where resistance is conceptualized and reactivated through local knowledges and enlisted in struggles against specific modern techniques of power (Gregory 1994: 297), is artfully performed throughout the work of Asco. Asco's public performance art demonstrates the enacted heterotopia's ability to "mobilize and stimulate a radical and postmodern politics of (spatial) resistance that redraws the boundaries of identity and struggle" (Soja 1996: 154). The point of departure and strategy of signification for Asco's performative work are the ways in which space and place are used to structure a normative landscape. Asco recognized the "city as a signifying practice itself productive of meaning and subjectivity" (Deutsche 1991: 56). Moreover, they recognized the cultural and subjective costs of this normative landscape; they refused the interpellative address of this normative landscape and challenged its power to reconstitute its cognitive foundations and effects.

Asco's spatial-aesthetic imagination, actualized through their ethics of combat, is an apt antecedent to Fredric Jameson's "call for" (and manifestly fulfills his "prediction" of) a "new aesthetic" founded on cognitive maps (Jameson 1988: 347). Jameson contends that each stage of capitalism has produced a unique spatial order. In the current third phase of late capitalism, capitalism is not "visible" in the same way it was in entrepreneurial or monopoly capitalism (Wolff 1993: 226). Condensed into a postmodern hyperspace, the alienated city produces alienated bodies that are "unable to map (in their minds) either their own positions or the urban totality in which they find themselves" (Jameson 1984: 89).[24] According to this logic, the cognitive map would provide an apotropaic for the symptoms and effects of the alienated city and supply the salve for "disalienation." Although Jameson persuasively prescribed and "wistfully yearned" for the "conceptual map" of postmodernism, he has not been able to supply it.[25] Had he known of the insurgent counterpractices undertaken by the subordinated (and relatively powerless) subjects of "Fortress L.A." (Davis 1990) when he viewed Los Angeles from the Bonaventure Hotel in 1984, this knowledge would have fundamentally conflicted with his formulation for a "practical reconquest of space"—dependent upon a class reductionism and myopia that subsumes the axes of ethnicity and gender.

The city is "lived and experienced in different ways" (Tagg 1996: 180); differentiations of power within the city and uneven positioning in relation to spaces of power result in significant differences in the perception of space (Zukin 1996: 46; Ghani 1993: 51). The control of spatial relations orders and localizes difference, and the spatial mechanisms of subordination mark and interpellate its subjects. The view from the Bonaventure Hotel and the Fourth Street Bridge at Lorena Street are radically

different. Obviously, they are different on account of differences in geographic location and vantage point, but most important, the perception of space is influenced by how the body of the individual viewer is viewed, surveyed, and interpellated in and through space (it affects and conditions what and how one sees.)

Asco's public art exposes the hegemonically enforced yet tacit limits and exclusions of urban space. John Tagg has described how urban planning and the emergence of the modern metropolis in the nineteenth century "systematized and demarcated" the various functions of the city "in a separation that controlled circulation and traced a pattern of dominance, but also orchestrated sights and opened up vistas that marked out a distinct function of the city as spectacle" (Tagg 1994: 84). If spectacle was a distinct function of the modern city replacing, or in opposition to, the city as practice (Suárez 1996: 25), then Asco appropriates the spectacle as their practice for counter-spectacle. Asco's (early) performance actions cognitively map the absence of Chicano public space by inventing it: reversing the terms of exclusion, even when unable to reverse the conditions of exclusion, with tactical hit-and-run interventions.

Notes

Earlier drafts of this essay were presented at Duke University; the Institute of Contemporary Arts, London; l'Université de Paris X; and the 1997 College Art Association Annual Conference. Research and writing were facilitated through the generous support of a Ford Foundation Dissertation Fellowship (1996–97) and a College Art Association Professional Development Fellowship (1996–98), and Visiting Scholar residencies at the UCLA Chicano Studies Research Center (1996–97) and the California Ethnic and Multicultural Archives and Art Museum at the University of California, Santa Barbara (1995). For access to archival collections I express grateful appreciation to Los Angeles Contemporary Exhibitions, the Los Angeles Municipal Art Gallery, and Stanford University Libraries Special Collections, where the Gamboa archives have been collected. Special thanks to Chon Noriega for editorial assistance, the University of Rochester Visual and Cultural Studies graduate faculty, Coco Fusco, Shifra Goldman, Roberto Trujillo, Elizabeth Tuttle, ALARMA, Harry Gamboa Jr., and Gronk. Portions of this essay also appear in "Orphans of Modernism: The Performance Art of Asco," *Corpus Delecti: Performance Art of the Americas,* edited by Coco Fusco (London: Routledge, 1999).

The source for my title is the Los Illegals' album *Internal Exile* (1983, lead singer: Willie Herrón). The band's new wave/punk rhythms and critical lyrical interrogations of the geographies of power and violence in Los Angeles are a vital counterpart to Asco's urban performance art.

Urban Exile: Collected Writings of Harry Gamboa Jr., written by Harry Gamboa Jr. and edited by Chon A. Noriega (Minneapolis: University of Minnesota Press, 1998), includes critical essays on visual culture, plays and performance scripts, fiction, poetry, and reproductions of mail art and No-Movies.

1. Humberto Sandoval has also been considered one of the original members of Asco, as he was involved in Asco performances as early as 1973. However, unlike the other core members, he is not and never has considered himself to be a visual artist.

2. For a detailed discussion and analysis of Asco's No-Movies, see C. Ondine Chavoya, "Pseudographic Cinema: Asco's No-Movies," *Performance Research* 3, no. 1 (1998): 1–14.

3. In his essay "Light at the End of Tunnel Vision," Harry Gamboa Jr. (1998) saliently issues a warning concerning the dangers of historicizing Asco's work: "The viewer must beware that several zombies do not constitute a living or relevant art group. . . . The tangible evidence that remains of Asco is supported by hearsay and conflicting memories of plausible events. The works of Asco were often created in transitory or easily degradable materials that crumble at the slightest prodding and fade quickly upon exposure to any glimmer of hope. It is unlikely that the objects, historical accuracy, or spirit of Asco will ever be recovered" (Gamboa [1994] 1998: 101).

4. Indeed, Asco's public performances not only challenged aesthetic traditions but also interrogated the sanctioned uses of public space and the public domain and how those sanctioned uses set the terms for communal relations, cultural identities, class, and cultural differences. To this end, I extend a new direction currently being mapped out in the analysis of Chicana/Chicano cultural production by scholars such as Jennifer Gonzalez, Carl Gutiérrez-Jones, Michelle Habell-Pallan, and Raúl Villa. Villa's literary analysis approaches the work of Chicano authors in terms of what their work reveals about the constraints and contestations of the hegemonically organized and enforced parameters of Chicano urban space; this approach has had a profound impact on my methodology and analysis.

5. In a city where only one-quarter of all Mexican Americans graduated from high school, Garfield High "boasted the highest drop-out rate in the nation, with 59 percent of students failing to complete the curriculum" (Gamboa 1987: 13). At a time when Chicanos accounted for less than 1 percent of the University of California's total student population, Chicanos, as a group, suffered the highest death rate of all U.S. military personnel (Guzman 1969). Of U.S. casualties in Vietnam between 1961 and 1969, 20 percent were Chicanos and other Latinos, who at the time accounted for only 10 to 12 percent of the population of the southwestern states and a much smaller percentage of the country as a whole. California was the home of the greatest number of Chicano casualties in the Vietnam War (Guzman 1969).

6. A 1974/75 issue of *Regeneración* (vol. 2, no. 1) is the first to identify Patssi Valdez, Willie Herrón, Harry Gamboa Jr., and Popcorn (one of Gronk's pseudonyms) as members of Asco. In the archives of Shifra Goldman it is indicated that between 1972 and 1974 they worked as Midnight Art Productions, taking on the name Asco in 1974.

7. At a national level, this was specifically directed against the Black Power movement; in California the political units of the Los Angeles City Police and County Sheriff's Office were additionally ordered to investigate the "Brown Power" strike (Muñoz 1989: 67–68). See also "Taking Back the Schools," part 3 of the video documentary series *¡Chicano! A History of the Mexican-American Civil Rights Movement* (produced by the National Latino Communications Center and Galán Productions in association with KCET/Los Angeles, 1996), which includes interviews with Patssi Valdez and Harry Gamboa Jr.

8. However appropriate the analogy "ethics of combat" may be to Asco, it is not specific to them; the term has a layered history. Tristan Tzara used it to describe the work of Rimbaud, according to Kristin Ross, who invokes the quotation to develop her critical hermeneutic of social space in *The Emergence of Social Space: Rimbaud and the Paris Commune* (Minneapolis: University of Minnesota Press, 1989), 8, and Raúl Villa (1991) finds Ross's sustained spatial reading of Rimbaud a suggestive model for his critical project on the social geographic imagination in Chicano literature.

9. Derek Gregory, *Geographical Imaginations* (Cambridge, Mass: Basil Blackwell, 1994); Edward Soja, *Postmodern Geographies: The Reassertion of Space in Critical Social Theory* (London: Verso, 1989) and *Thirdspace: Journeys to Los Angeles and Other Real-and-Imagined Places* (Cambridge, Mass.: Basil Blackwell, 1996); Margaret Crawford, "Contesting the Public

Realm: Struggles over Public Space in Los Angeles," *Journal of Architectural Education* 49, no. 1 (September 1995): 4–9; Donald Preziosi, "La Vi(ll)e en Rose," *Strategies* 1 (1988): 82–99; Dolores Hayden, *The Power of Place: Urban Landscapes as Public History* (Cambridge: MIT Press, 1995); Victor Burgin, *In/Different Spaces* (Berkeley and Los Angeles: University of California Press, 1996), in particular Mike Davis (1990), Rosalyn Deutsche (1996), and Fredric Jameson (1984).

10. See also Villa 1993, esp. chap. 1.

11. As David Harvey explains, "The evaluation and hierarchical ranking of place occurs . . . largely through activities of representation. . . . Struggles over representation are, as a consequence, as fiercely fought and as fundamental to the activities of place construction as bricks and mortar" (Harvey 1993: 22).

12. A sense of the general public attitude toward the Chicano protests, urban disturbances, and police riots that were centralized in, but not limited to, East L.A. during this period can be surmised in the following statements. An editorial in the *Los Angeles Herald Examiner* argued, "The attacks against people and property were planned by anarchists who have no respect for the country and the American system of righting grievances and obtaining justice" ("Riot Aftermath," *Los Angeles Herald Examiner,* September 2, 1970, 12). Los Angeles County Sheriff Peter Pitchess contended, "This was entirely a Chicano activity and they cannot control their own people" ("Violence Breaks Out after Chicano Rally in East L.A.," *Los Angeles Times,* February 1, 1971, part 1, 1, 3). Contrary to such popular and vehement statements, in October 1970 an advisory committee to the U.S. Commission on Civil Rights, assigned to study police-community relations in East L.A., concluded that "whenever police were present, disturbances erupted; when the police stayed away, the demonstrations were orderly and calm." Nearly everyone interviewed agreed, "It's ironic that the peace is kept best in East L.A. when the police aren't around" (Commission 1970: 11). As the preceding statements attest, the Chicano protests were characterized as un-American even as the allegations of police brutality continued and with the substantiated conclusions of police-inspired riots. The canceling of the parade and other restrictions on public space are examples of what José Angel Gutiérrez has described as the official legal and extralegal repression of the Chicano community particularly when public opinions and actions are enacted in protest of injustice (Gutiérrez 1986: 28, 30).

13. See Kershaw (1992: 68–70) for an elaboration on this concept.

14. Two accounts regarding the reception of *Walking Mural* significantly, and interestingly, contrast one another. While one member remembers that "several individuals converted in passing, joined their silent walk through the crowds," essentially producing "art converts" (Gamboa 1990: 125), Herrón remembers, "They ripped my cape. . . . They tore my tail off as they screamed 'putos' [faggots]" (Gamboa 1976: 30).

15. Chavoya, unedited interview transcription, published in slightly different form as "Images of Advocacy: An Interview with Chon Noriega," *Afterimage* 21, no. 10 (1996): 5–9.

16. See also Gamboa 1990 and Gamboa 1987.

17. Patssi Valdez's discussion of the West Side provides a sense of how significant this change was for the group: "I didn't know the West Side existed. Who had time to think about it? I had to take care of my little sister. I was like a mother in sixth grade. Willie had a car, but we just went from East L.A. to City Terrace, and that was a big deal. We'd have to coast the car. We'd look great, but we couldn't put gas in it" (Burnham 1987: 58).

18. Dolores Hayden has extensively analyzed programs of urban renewal and highway construction and the cultural costs of urbanization by differently affected communities. The "increasing sameness" practiced by U.S. urbanization programs, as Hayden outlines, has detrimentally affected the cultural landscapes of community history and identity. "These projects,"

Hayden argues, "use taxpayers' dollars to muffle history, pave geography, [and] standardize social relations" (Hayden 1995: 100).

19. In addition, Asco conceptually allied their resistance with the literal occupation of islands as an act of anticolonial protest, such as the Native American occupation of Alcatraz Island and the Chicano occupation of Catalina Island. Gronk's diptych painting *Terror in Chile,* attached to the street sign, generates yet another political alliance with the victims of the Pinochet regime.

20. Nonplaces are there to be passed through, not occupied, and Asco's occupation is a performative intervention against the non-place-making of Whittier Boulevard. Marc Augé identifies the nonplace as both a symptom and product of supermodernity. Augé's designation of the nonplace is neither prescriptive nor apocalyptic, realizing that the differential relation between place and nonplace is never absolute. The proliferation of nonplaces, however, is directly related to transnational capital and "supermodernity"; indeed, the nonplace is one of its products and mechanisms. Accordingly, the nonplace "designates two complementary but distinct realities: spaces formed in relation to certain ends (transport, transit, commerce, leisure) and the relations that individuals have with these spaces" (Augé 1995: 79). The danger within the nonplace, however, is that these seemingly seamless networks of mobility, transportation, and communication "put the individual in contact only with another image of himself *[sic]*." Nonplaces mediate a "whole mass of relations, with the self and with others" (Augé 1995: 79) and carry with them specific prohibitive, prescriptive, or informative instructions for use (Augé 1995: 96).

21. As Stallybrass and White explain, "The vertical axis of the body's top and bottom is transcoded through the vertical axis of the city and the sewer and through the horizontal axis of the suburb and the slum or of East End and West End" (1986: 145).

22. Jonathan Crary has described similar strategies employed by the surrealists and other Euro-American avant-garde artists as "turning the spectacle of the city inside out through counter-memory and counter-itineraries" (Crary 1989: 107). He argues that this strategy incarnates "a refusal of the imposed present" (Crary 1989: 107). But whereas such Euro-American avant-garde artists may have attempted to refuse an imposed present by reclaiming fragments of a demolished past in order to implicitly figure an alternative future, Asco's project is clearly not one of cultural reclamation.

23. El Plan Espiritual de Aztlán declared that "Cultural Values of our people strengthen our identity and the moral backbone of the movement. . . . We must insure that our writers, poets, musicians, and artists produce literature and art that is appealing to our people and relates to our revolutionary culture" (First Chicano National Conference 1969: 3). For a more extensive discussion of Asco in relation to Chicano nationalism, see Mario J. Ontiveros II, "ASCO: A Remedy for the Ill-Effects of an Identity in Crisis, or Strategically Walking Experimentally" (paper presented at the "New Perspectives on Chicana/o Cultures" symposium, UCLA, 1997).

24. Jameson laments that the postmodern body has lost its sense of place as a result of the "perceptual barrage of immediacy" (Jameson 1988: 351). An aesthetics of cognitive mapping, Jameson contends, would "endow the individual subject with some new heightened sense of place in the global system" (Jameson 1984: 92). Following Lynch's influential study the *Image of the City* (Cambridge: MIT Press, 1960), Jameson's idea of social totality decries the fact that "urban alienation is directly proportional to the mental unmapability of local cityscapes" (Jameson 1988: 353).

25. As Steven Connor argues, "Hitherto, Jameson has been able to offer only a map in the future tense, which can cling as a centring principle only to centrelessness itself" (Connor 1993: 229).

References

Augé, Marc. 1995. *Non-Places: Introductions to an Anthropology of Supermodernity.* Trans. John Howe. London: Verso.

Benavidez, Max. 1981. "Interview with Willie Herrón." Radio broadcast, KPFK-FM Los Angeles, June 8. Audiocassette, Gamboa Collection, Stanford University Libraries Special Collections.

Benavidez, Max, and Vozoff, Kate. 1984. "The Wall: Image and Boundary, Chicano Art in the 1970s," in *Mexican Art of the 1970s: Images of Displacement,* ed. Leonard Folgarait. Monographs on Latin American and Iberian Studies. Nashville, Tenn.: Vanderbilt University.

Brookman, Philip, and Brookman, Amy. 1983. "Interview with Asco." CALIFAS: Chicano Art and Culture in California, transcripts, book 3, Colección Tloque Nahuaque, University of California at Santa Barbara Davidson Library.

Brown, Julia, and Crist, Jacqueline. 1985. "Interview with Willie Herrón," summer 1985, unpaginated. Los Angeles: Museum of Contemporary Art.

Burnham, Linda Frye. 1987. "Asco: Camus, Daffy Duck, and Devil Girls from East L.A." *L.A. Style,* February, 56–58.

Certeau, Michel de. 1984. *The Practice of Everyday Life.* Trans. Steven Rendall. Berkeley: University of California Press.

Commission on Civil Rights, California Advisory Committee. 1970. *Police-Community Relations in East Los Angeles: A Report of the California State Advisory Committee to the U.S. Commission on Civil Rights.* Los Angeles: The Committee.

Committee on the Judiciary, U.S. Senate. 1970. *Extent of Subversion in the "New Left"; Testimony of Robert J. Thomas [and others]: Hearings before the Subcommittee to Investigate the Administration of the Internal Security Act and Other Internal Security Laws,* pt. 1. 91st Congress, 2nd session. Washington, D.C.: U.S. Government Printing Office.

Connor, Steven. 1993. "Between Earth and Air: Value, Culture, and Futurity." In *Mapping the Futures: Local Cultures, Global Cultures,* ed. John Bird, B. Curtis, T. Putnam, G. Robertson, and L. Tickner, 229–36. New York: Routledge.

Crary, Jonathan. 1989. "Spectacle, Attention, Counter-Memory." *October* 50:97–106.

Cresswell, Tim. 1996. *In Place/Out of Place: Geography, Ideology, and Transgression.* Minneapolis: University of Minnesota Press.

Davis, Mike. 1990. *City of Quartz: Excavating the Future in Los Angeles.* London: Verso.

Deutsche, Rosalyn. 1996. *Evictions: Art and Spatial Politics.* Cambridge: MIT Press.

Dubin, Zan. 1986. "Artist Won't Be Confined to Gallery." *Los Angeles Times,* June 6, pt. 6.

Durland, Steven, and Burnham, Linda. 1986. "Gronk" (interview). *High Performance* 35:57.

First Chicano National Conference. 1969. "El Plan Espiritual de Aztlán." In *Aztlán: Essays on the Chicano Homeland,* ed. Rudolfo A. Anaya and Francisco Lomelí, 1–5. Albuquerque, N.M.: Academia/El Norte Publications, 1989.

Gamboa, Harry, Jr. N.d. "Chicano Art of Los Angeles: Serpents, Shadows, and Stars." Manuscript, Gamboa Collection, Stanford University Libraries Special Collections.

———. 1976. "Gronk and Herrón: Muralists." *Neworld* 2, no. 3:28–30.

———. 1981. "No Phantoms." *High Performance* 14 (vol. 4, no. 2): 15.

———. 1985. *Jetter's Jinx* Playbill. Los Angeles: Los Angeles Theatre Center.

———. 1987. "Reflections on One School in East L.A." *L.A. Weekly,* February 6–12.

———. 1991. "In the City of Angels, Chameleons, and Phantoms: Asco, a Case Study of Chicano Art in Urban Tones (or Asco was a Four-Member Word)." In *Chicano Art: Resistance and Affirmation,* ed. R. Griswold del Castillo, T. McKenna, and Y. Yarbro-Bejarano, 121–30. Los Angeles: Wight Art Gallery, UCLA.

———. 1998 [1994]. "Light at the End of Tunnel Vision." In *Urban Exile: Collected Writings of Harry Gamboa Jr.,* ed. Chon A. Noriega. Minneapolis: University of Minnesota Press.

———. 1998 [1994]. "Urban Exile," in *Urban Exile: Collected Writings of Harry Gamboa Jr.,* ed. Chon A. Noriega. Minneapolis: University of Minnesota Press, 51–55.

Gamboa, Harry, Jr., and Gronk. 1976. "Interview: Gronk and Gamboa." *Chismearte* 1, no. 1:30–33.

Ghani, Ashraf. 1993. "Space as an Arena of Represented Practices." In *Mapping the Futures: Local Cultures, Global Cultures,* ed. John Bird, B. Curtis, T. Putnam, G. Robertson, and L. Tickner, 47–58. New York: Routledge.

Gregory, Derek. 1994. *Geographical Imaginations.* Cambridge, Mass.: Blackwell.

Gutiérrez, José Angel. 1986. "Chicanos and Mexicans under Surveillance: 1940 to 1980." *Renato Rosaldo Lecture Series* 2:28–58.

Gutiérrez-Jones, Carl. 1995. *Rethinking the Borderlands: Between Chicano Culture and Legal Discourse.* Berkeley: University of California Press.

Guzman, Ralph. 1969. "Mexican American Casualties in Vietnam." *Congressional Record.* 91st Congress, 1st session, October 8.

Harvey, David. 1993. "From Space to Place and Back Again: Reflections on the Condition of Postmodernity." In *Mapping the Futures: Local Cultures, Global Cultures,* ed. John Bird, B. Curtis, T. Putnam, G. Robertson, and L. Tickner, 3–29. New York: Routledge.

Hayden, Dolores. 1995. *The Power of Place: Urban Landscapes as Public History.* Cambridge: MIT Press.

Jameson, Fredric. 1984. "Postmodernism; or, The Cultural Logic of Late Capitalism." *New Left Review* 146:53–92.

———. 1988. "Cognitive Mapping." In *Marxism and the Interpretation of Culture,* ed. Cary Nelson and Lawrence Grossberg, 347–60. Chicago: University of Illinois Press.

Kershaw, Baz. 1992. *The Politics of Performance: Radical Theatre as Cultural Intervention.* London: Routledge.

Kosiba-Vargas, S. Zaneta. 1988. "Harry Gamboa and ASCO: The Emergence and Development of a Chicano Art Group, 1971–1987." Ph.D. dissertation, Department of American Culture, University of Michigan.

Muñoz, Carlos, Jr. 1989. *Youth, Identity, Power: The Chicano Movement.* London: Verso.

Noriega, Chon A. 1996. "Talking Heads, Body Politic: The Plural Self of Chicano Experimental Video." In *Resolutions: Contemporary Video Practices,* ed. Michael Renov and Erika Suderburg, 207–28. Minneapolis: University of Minnesota Press.

Norte, Marisela. 1983. "Harry Gamboa, Jr.: No Movie Maker." *Revista Literaria de El Tecolote* (San Francisco) 4, no. 2 (July): 3, 12.

Pile, Steve. 1996. *The Body and the City.* London: Routledge.

Rupp, Beverly Jones. C. 1985. "Harry Gamboa: Conceptual Artist." Television broadcast, Falcon Cable Company, Los Angeles. Videorecording, Gamboa Collection, Stanford University Libraries Special Collections.

Sandoval, Alicia. 1978. "Let's Rap with Alicia Sandoval." Television broadcast interview with Harry Gamboa, KTLA Channel 5, Los Angeles, April. Audiocassette, Gamboa Collection, Stanford University Libraries Special Collections.

———. 1980. "Let's Rap with Alicia Sandoval." Television Broadcast interview with Harry Gamboa, KTLA Channel 5, Los Angeles, Videorecording, Gamboa Collection, Stanford University Libraries Special Collections.

Soja, Edward W. 1989. *Postmodern Geographies: The Reassertion of Space in Critical Social Theory.* London: Verso.

Soja, Edward W., and Hopper, Barbara. 1993. "The Space That Difference Makes." in *Place and the Politics of Identity,* ed. Michael Keith and Steve Pile, 183–205. London: Routledge.

Stallybrass, Peter, and Allon White. 1986. *The Politics and Poetics of Transgression.* Ithaca, N.Y.: Cornell University Press.

Suárez, Juan A. 1996. *Bike Boys, Drag Queens, and Superstars: Avant-Garde, Mass Culture, and Gay Identities in the 1960s Underground Cinema.* Bloomington and Indianapolis: Indiana University Press.

Tagg, John. 1994. "The Discontinuous City: Picturing and the Discursive Field." In *Visual Culture: Images and Interpretations,* ed. Norman Bryson, Michael Ann Holly, and Keith Moxey, 83–103. Hanover: University Press of New England.

———. 1996. "The City Which Is Not One." In *Representing the City: Ethnicity, Capital, and Culture in the 21st-Century Metropolis,* ed. Anthony D. King, 179–82. New York: NYU Press.

Villa, Raúl Homero. 1991. "Tales from the Second City: Social Geographic Imagination in Contemporary Urban California Chicana/Chicano Literature and Arts." Ph.D. dissertation, Department of History of Consciousness, University of California, Santa Cruz.

Wolff, Janet. 1993. "On the Road Again: Metaphors of Travel in Cultural Criticism." *Cultural Studies* 7, no. 2:224–39.

Zukin, Sharon. 1996. "Space and Symbols in an Age of Decline." In *Representing the City: Ethnicity, Capital, and Culture in the 21st-Century Metropolis,* ed. Anthony D. King, 43–59. New York: NYU Press.

11. Scream IV

Laurence A. Rickels

The installment plan—the seriality and deferral—given in works of installation is always on location. *Scream IV* cites Stig Sjölund's January 1998 site-specific installation entitled *Titanic II*. Sjölund's site to behold fit the courtyard of the Hallwylska Museet, a private art and parts collection in Stockholm still housed in the manor for which it was custom-made. From the outside, out in the deep freeze, there was the totally Goth facade looking at you. Sjölund commissioned two top ice cream firms to set up shop in this setting in special booths designed to match the ornate or funereal look of the Museet and compete—against the elements—for consumers. But that was just the tip of the ice cream: *Titanic II* invited a symbol-clashing juxtaposition of separate flows or floes of our genealogy of media.

For 1998 Europe decided to take out Stockholm in the corporation or incorporation of its culture. Next, the cultural capitalists in Stockholm set aside the Hallwylska Museet for the setting of its special son. Sjölund pulled the emergency break on another European-culture forgettogether. He stalled the monumentalism of museum collection by installing on location the dislocation to which we owe all that crypt building. What was jamming at the intersection among juxtapositions that Sjölund's thought experiment has admitted and addressed? Hallwylska Museet as specific citation from the genealogy of collection, the *Titanic* as the liner notes accompanying a tension that's still on the record between collection and invention, between melancholia and catastrophe preparedness, and the winter's sale of ice cream as the caption that emerges from the white noise, the static, and the surf of drowning out.

Sjölund's image line through the eighties was rapt around an unidentified object. But the science fictive lines got crossed with modernism and short-circuited the work's reception or recognition as ultimate object of identification. Sci-fi modernism,

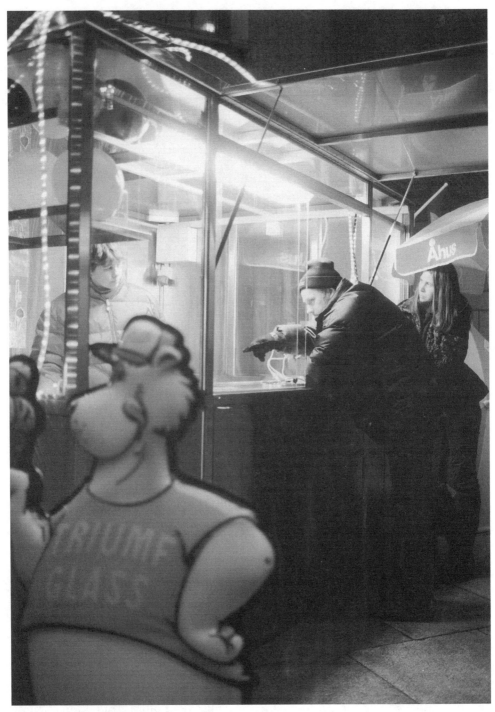

Figure 1. Stig Sjölund, *Titanic II* (detail), 1998. Courtesy of Stig Sjölund.

Figure 2. Stig Sjölund, *Titanic II* (detail), 1998. Courtesy of Stig Sjölund.

like any psychotic delusional system all on its own, never went the extra wavelength of invention to install its own reception, following, or understanding. For the nineties Sjölund reinstalled his work within postmodernism, within an outer space of reception. Sjölund's postmodernist performance and installation work gives owner's manual instructions, the law and the language for his earlier contextless glimpses of outer-space horizons somewhere over an imagescape boundary-blending with photography, film, painting. The installation of reception—of the other—is always site specific. For his breakthrough into the new decade, Sjölund strapped IKEA relics, like postwreck flotsam, next to the surviving cibachrome photos finishing his former luxury line of sci-fi modernist productions. Sjölund's nineties move to take part, performance-style, in the mass cultures of reception—one that also moved to take apart the interplanetary look of his eighties work—coincided with his first visit to California and his visitation there by New Age mass culture. It is definitely still a look, just another kind of inside view, one that is neither soulful nor antisoulful. The new look is at once psychic (or psychotic) and technological. In the nineties Sjölund's work entered round-the-world, round-the-clock reception of communications with the good spirits and unhappy ghosts making up as they go along with the mass-media sensurround. Without the ghosts in technology, absent and accounted for, there is no outer space of reception, no future, no bottom line.

The modern or modernist museum, which is determined by the departmental and disciplinary boundaries that must be kept intact and undisclosed, has a history coterminous with that of every other cultural institution sharing the Enlightenment fantasy of origin. But it has a prehistory, too, one that belongs to a century-or-two-older

Figure 3. Stig Sjölund, *The IKEA Show*, 1990. Courtesy of Stig Sjölund.

emergence of all-out collection that surrounded an interdisciplinary or eclectic mix of oddities, curiosities, and wonders. What passes as miracle or wonder metabolizes the wound of separation, dislocation, long distance. The age of discovery brought back a grab bag of wounds and wonders, both from the new frontier of our first outer space over there in the Americas and from another new inner-outer space opened up by techno vision. Now we could see our way clear to catching life where it breeds and is undone. Through these lenses, between the lines of the supernatural, we first got the picture of circulation, it was in our blood, and then followed Harvey's discovery of the circulatory system as model for all subsequent sciences and institutions of circulation, substitution, invention. But the vampiric conditions or conditionings of collection always bring up the arrears, the losses, the backfire of the look and march forward of techno invention. This was a tension that Freud mapped out in his first First World War essay "Thoughts for the Times on War and Death." The Great War was what Europe had been holding back, swallowing and never digesting, while resting in one peace in a mode of cosmopolitan forty-year-old self-collection. The *Titanic* catastrophe gave us the horror preview of what would be coming soon. The ship-size state of European collection was to be the ultimate in the techno invention and perfection of safety. Technology would keep us all calm and collected even following contact with catastrophe or accident. But then the unthinkable, I mean unsinkable, went down, near-missing the ultimate safety net, the media-technological rehearsal of the World Wide Web: the ship's catastrophic end ended up casting about our ongoing state of preparedness. In 1912, in response to the *Titanic* crash ending without rescue, twenty-four-hour wireless service was set up as the law for all ships passing in the night. Ever

since, we have been live, on-line, on-life-line. In the setting of the late-nineteenth-century Hallwylska collection, Sjölund's *Titanic II* reinstalled the tension that's still with us between collection and invention, between holding on and letting go in advance, between safety (for the dead or alive) and risk calculation.

Before he invented the phonograph, Thomas Edison was the survivor in childhood of a host of sibling deaths. By age twelve he was well on his way to being a deaf gadget lover and rescuer concerned with supplementing the audio range of all ear sets, both for those quick to hear and for the deaf. Deaf rhymes with death. Edison's works of invention represented an overcoming at least as much as an undertaking. Even at his most deaf, he could always still hear the tap, tap, tapping sounds of the telegraph. At first he sought to build a kind of recording machine for the messages transmitted by telegraph or by phone. Once upon a time, while testing the record he had made of a telegraphic transmission, he overheard sounds that sounded just like voices coming from the next room. The phonograph was born—out of the auditory hallucinations of one deaf gadget lover listening to his telegraphic recorder. The long distant, who are always also along for the connection going through across long distance, were receiving via the deaf safekeeper another voice of confidence and coincidence, another techno hold of storage and transmission. The votes that were thus in the deaf medium gave to his mother's undead children a certain majority share in the new techno cultures of safety that were coming soon.

The deaf and the deaf-mute have been doubling as model mediums or media at least since the eighteenth century. Their reduced sensorium brought them closer to the apparatus that inventors and scientists began supplying with extended senses, techno senses that were soon new properties for the rest of us, too. The deaf-mute, the premier experimental subject in modern-science labs, was at the same time our first projected automaton.

When Edison was born the telegraph was already wiring up long distances. At the same time the American craze for seances started up around tap sounds that we were beginning to make out as the outside chance that the dead were getting back to us. Everyone was doing this tap chance.

In 1877 Edison, who was into perfecting all the sparks of invention that were out there, added to Bell's invention his own invention of a carbon telephone transmitter, which was the practical piece missing from the realizability of the original phone. In 1885 Edison secured ways and means for the transmission of telegraphic signals between moving modes of conveyance and a station fixed in place. This was his essential contribution to Marconi's project, the invention of the wireless telegraph. The *Titanic* catastrophe would give the rescue signal across air waves top priority in the new order of technologization. Radio control, May Day, and the black box were on the way or wave.

By the end of the nineteenth century the new science of phonetics had started collecting examples of "juncture" in which the sameness of sound shapes could be seen to rely for their distinction on a time interval, the pause button pressed within the newly discovered domain of suprasegmental features. There's the example "night

rate/nitrate." Another one made it into the big lights of the Good Humor ad: "I scream for ice cream." Then there's a well-known "knock knock" joke that elaborates on a third example: "Iowa penny to the library." This collection of phonetic sameness and difference is unthinkable without the late-nineteenth-century introduction of media technologies of sound recording. At the same time a new system or science of phonetic notation was required to make the serviceable transcription: the audio record needed an owner's manual, a typewritten hard copy for access and organization. But how to indicate for the supplemental record the difference in the sameness that was on the record of hearing? After a kind of Morse code of suprasegmental features was added to the basics, the new science of phonetic transcription could take note of all the new techno oral histories of primitive languages, local dialects, and last words of the dying that were out there, expiring and ready for the recording. But then, somewhere between phonetics and semantics, within the danger zone of unconscious histories and meanings, what about the "accident" that in Sjölund's installment of our history of disasters makes ice cream scream?

What is in a name when, after all, it was the *Carpathia* that rescued what was left of the *Titanic,* leaving the greater portion of blame for all that was missing to the *Californian?* The *Titanic*'s posthumous legacy of nonstop wireless connectedness was addressed in the first place to the *Californian,* which, like a vampire, had been on for only one-half day's broadcasting. In Bram Stoker's *Dracula* (another late-nineteenth-century exhibition catalog or owner's manual introducing, alongside all the occult collectibles, the latest in techno communication and recording), the vampire count is outmaneuvered by his hunters because they can rely, nonstop, on telegraphic live transmissions while, for the better half of the day, the vampire must rest in his "earthly envelope" and thus rest in one piece with and at the same pace as his designated mode of conveyance. The *Titanic* disaster made the emergency of round-the-clock live transmissions a fact of life even or especially for the *Californian,* at once the leader and the pack within a growing in-group of vampire hunters who are, in effect, in efficacy, new-and-improved vampires. The vampire, like any old occult medium, never goes away; it just gets superseded by more of the same, only better. That is what technology and group psychology are all about or above. They are just one crucial heartbeat or wavelength ahead of the occult forces they at the same time double and contain.

The hope was that the internal compartmentalization going into the *Titanic*'s designs on the future like a succession of submarines would offer on impact with any accident out there the emergency plan of automatic shutdown of all the undamaged waterproof compartments or encryptments, which, all together now, could, like emergency flotation devices or batteries, keep the tight ship unsinkable. But the iceberg proved to be just the top of the mourning breaking into the crypt plans of technology.

They say that the more cavalier passengers used the shattered ice glittering on deck to chill their drinks. Think again: others claim the ice mountain was dark and stinking from all the prehistoric debris ripening on contact with the air, the air waves of first contact with the human species.

In 1985 the sunken *Titanic* was located. After several open seasons for relics, a first sampling was put on display in 1994. Among the mix and match of mundane artifacts could be observed dollar bills, pound notes, leather wallets, cigarettes, silver salvers, white crockery, white chamber pots, hip flasks, leather bags, portholes, telegraph sets, internal telephones, and fuse boards. "The Atlantic depths give birth and a ridiculous junk-heap emerges. The objects recovered have no intrinsic uniqueness: there is only the association with the *Titanic,* which viewers must sentimentally supply for themselves."[1]

I attended the opening of James Cameron's *Titanic* in Stockholm with Stig Sjölund right before the late-evening opening of his installation *Titanic II* that same day. It was odd that the representative immigrants in the film were overwhelmingly Swedish and largely spoke their native language in the American film for reality effect. But what's more, the whole movie is held together by a kind of Wagnerian faith in art as re-collection. But it's ambivalent, too, of course. There are two flagrantly sadistic ingredients in Cameron's film. First off, the passengers don't just fall into the ocean when it's time to sink or swim, they often also first hit a rudder or whatever on the way down, with a big splat sound on the track. And second, when the young lady soon to be seduced by Leonardo boards the *Titanic* she bears with her traveling trunks all the modernist masterpieces she picked up one-stop-shopping in Paris. But we recognize these paintings because they exist. And yet they go down with the ship. That's really sadistic. But it doesn't matter because art's about memories of a life, not our own, flashing before our eyes with each screening. But collection or recollection is indeed always an internal state, its materials ruinous, allegorical, and hence under the pressure of encryptment or preservation, all of which often adds up to an endeavor that's not always or necessarily so metaphysically comforting. But in Cameron's world it's the discovery by *Titanic* explorers of Leonardo's portrait of the old survivor from back then down in its watery safe that attracts the old woman's narrative frame of the moving picture. In the end she dreams or dies, it's not clear. But a memorial underworld opens wide to admit the reunion of all the fellow *Titanic* travelers who celebrate her couplification with the long dead but deeply frozen, cryogenically preserved, Leonardo.

Shortly after I returned to Los Angeles from Stockholm, Sjölund faxed me the news of another accidental connection that his installation had unconsciously received: "I also got information on that library on the East Coast we had talked about. It is called Gardner Memorial Library at Harvard University. A rich lady founded that. In memory of her son who went down with the Titanic. Poor little Henry loved ice cream. So the library staff gets ice cream daily for free. From what I heard they are sick and tired of it. The source here is Johan Fornäs, Professor at the University of Stockholm, Department of Journalism, Media, and Communication. Yours, Stig."

A certain Mudgett, whose original alias was Holmes, counts, *avant la lettre,* as America's first serial killer. At the time of Holmes's conviction, end of the nineteenth century, a Chicago journalist coined the term "multimurderer."[2] Holmes was in the first place a swindler who amassed several fortunes and built one formidable "Castle"

just outside Chicago all on credit he never paid back. When the time came for repossession he sold the goods and split for another location and into another alias. He married several wives; some he left alone, in unwitting bigamous survival, others he killed for the money. His last "marriage" was one more thing he kept balancing in the final acts of insurance swindle and murder. Whenever he needed to go where the wife must never follow or understand, he told her he was once again negotiating patent rights for his invention of the ABC Copying Machine.

On the inside, the Castle was labyrinthine in its layout, crowded with doors and hallways leading nowhere, and shoddy and makeshift in its construction. But Holmes had functionalized what otherwise suggested the allegorical services accorded the dead in ancient mortuary palaces. When investigators opened up the abandoned Castle in their search for more evidence of Holmes's insurance scams, they stumbled across the bottom line along which the swindler had been signing his double-dealings between life insurance and the other's death. "They were dumbfounded by what they encountered—a dizzying maze of unmistakably sinister design. Groping their way around the twisting passages, they came upon secret rooms and hidden stairwells, blind hallways and mysterious sliding walls, trapdoors opening onto tightly sealed chambers and camouflaged chutes feeding into the cellar." It was a "murder factory."[3] In 1893 Holmes rented out rooms in the Castle to visitors to the Chicago Exhibition, a major display of all states and departments of collection devised to celebrate the discovery of the New World. But at the bottom of some lubed chute, at the latest, many of the guests would discover that you may check in but you never check out of the "Horror Hotel."

As soon as the Castle was under investigation or excavation, the work of the police had to compete with the one-stop-collecting by curiosity seekers of the wonders of murder that will never cease. One investor recognized a good thing and turned the site to behold into the Murder Museum, which offered, for the price of admission, guided tours conducted by the detective who had been in charge of the investigation. In Philadelphia, where Holmes was on trial for murder, another investor turned the already profitable Dime Museum, which featured sideshow oddities or wonders, into the Holmes Museum, where visitors could contemplate a replica of the Castle, phrenological chartings of Holmes's cranial abnormalities, and a skull that was identical to one found by the police and attributed to another one of Holmes's murder victims. The case generated similar collections of sensationalisms between book covers. One bestseller, *Sold to Satan: A Poor Wife's Sad Story,* was quickly translated into many languages, "including German *(Dem Teufel verkauft Holmes!)* and Swedish *(Massemorderen Holmes, alias Mudgett)*."[4]

Holmes spent final days on death row arranging for the fulfillment of his lasting wish. The condemned man, who had produced all his special effects of invention, progress, and success only through interminable collection and recycling, right down to the skeletons of his victims, which he sold to medical colleges for mad money, just did not see his own corpus being in turn metabolized somewhere between collection

and disappearance. Safer even than a mummy's encryptment, Holmes's burial plan saw his executed body encased in an unexcavatable mound of cement. Any collection of his body, in parts or in whole, would remain—unthinkable.

According to the terms of Isabella Stewart Gardner's will power, nothing in her 1903 collection was ever to be replaced, moved, emended. Hence the frames of the works stolen in 1990 hang empty, marking the spot a collection is in without recourse to substitution or invention.

Sarah Winchester built the so-called Mystery Mansion in San Jose nonstop under orders she took down daily in a seance room deep inside another impenetrable web of blind-alley diversions. Here the alle-gory of relations with the already dead remained intact. Sarah Winchester came to build this last resort upon the crypt of a daughter, dead in childhood. The small-world-after-all proportions enfolding special stairways and corridors within the ongoing construction did not so much fit her own tiny size (as tour guides to this day reassure us). These were the little footnotes leading inside Sarah Winchester's immediate underworld. Her husband had been the guardian of the crypt. Once he was gone, too, the building projection in the land of the setting sun began. She switched coasts following advice from the Boston psychic she consulted after her husband died on her:

> You must travel to the West Coast and there build a beautiful home of the most costly materials in woods, crystals and metals. And . . . construction on this building must never stop day or night. . . . I'm saying that as long as work goes on continuously in making additions onto your house, just so long will you, Mrs. Winchester, remain alive. . . . I'm given to tell you that you, alone, can make restitution and balance the ledger for the thousands of men killed by Winchester firearms in the Civil War and in skirmishes all over the Country, and even in Wars to come in the near future.[5]

There were good spirits with standing room invitation to her open house, but there were unhappy ghosts, too. The good spirits were helping her outwit with their non-stop construction directives the vengeful ghosts that were out to get her. Like the suicide crawling out of the grave at the crossroads where he had been buried to protect the living, the angry ghosts who entered the fun house of defunctionalized passageways wouldn't know which way to turn to get a fix on a victim. A few days later yet another diversion would replace the one even a ghost might learn to avoid and circumvent.

Income calculated daily from her shares of Winchester Repeating Arms Company was recycled into a day's worth of building. Every morning it all started over again from scratch, the scratch in the daily record of what the good spirits told their haunted medium to add and take apart. The repeater or serial firing of guns had brought back serial hauntings. The open invitation to all the spirits had been extended by a little one, who had her foot in the door.

Down to certain details the construction was gadget-loving, too: the kitchen, for example, featured energy-saving innovations she even patented and marketed. Somewhere

between the crisscrossing lines of diversion and collection the mystery house was a lab space for invention.

In 1920 Wilhelmina von Hallwyl gave her Stockholm palace and collections to the Swedish government for safekeeping. The collections spanned the double movement of eclecticism and totalization: "I will include everything, brooms, dust mops, and the like, because the day will come when these items are unusual and remarkable once everything is done by electricity."[6] Even the impulse to collect, to supply souvenirs for whatever is gone, can be entrusted to the sparks of technologization. Thus she gives a future tense of push-button reanimation to the significance of her own archival project, her mummification of all the scenes of a lost, preelectric life. In 1921 her husband could die. From that point onward she was home alone inside the collections that she cataloged until her death in 1930. This doubling of the collection contained itself within a final set of seventy-eight leather-bound volumes. The collection had all along been about Wilhelmina's interests, which began collecting themselves in childhood. "Between 1853 and 1854 I received a small shell from my father. The shell had been found inside a quantity of raw hides. This shell was the start of my collection."[7] The palace was completed in 1898. The year 1998 marked the centenary of the house that Wilhelmina built on the crypt of her little girl who was dead, they said. Undead! Undead![8] The surprise shell that spilled out from unbound leather was the start of a collection that in turn would be bound up, seventy-eight times, in the catalog volumes. The catalog exceeds the collection in one item, another bit of stray unbound leather from an other's childhood. "The frozen moment captivates us. Not to add to or take away from it was another one of the donor's inspirations. Only one object was rejected—a pen dryer made of rat hide. . . . By tradition, the Christmas gifts from grandchildren and great-grandchildren should be handmade by the children themselves. Great-grandchild Hans solved the Christmas gift problem by killing a rat, preparing the hide, and making a pen dryer with the gray-brown skin mounted on a half circle of blue satin."[9]

Hallwylska Museet, a late arrival of the sixteenth- and seventeenth-century "cabinets of curiosities," or "wonder rooms," entered our era of more compartmentalized or departmentalized organizations of public collection tagging along on the margin. But like anything that survives under the force of displacement, this margin, too, was only awaiting the big blast of return. Now we can begin to recognize that there just is not so far to go between the eclecticism of contents collected by Wilhelmina von Hallwyl, or buried inside time capsules during the eighties, and what will be all aboard the space capsules taking off soon to launch colonization of the latest wide open outer spaces for the survival of the species.

The pop seriality of postmodernity addresses the tension going down between collection and invention on its own terms. Anything that is serial is also in language, like it or not, and therefore open to intervention and invention. But every mourning we chew on the serial order until it retains itself in all those volumes, compartments, capsules of collection and incorporation. The details of these mergers have been in-

evitably murderous. Sometimes the victims were alive first, alive to their collectibility, sometimes they were already undead.

Something like a historical change or chance can be seen to open up over the replicational interests and investments of those of us, of those parts of all of us, with both feet in the underworld. The frontiers of language—of the future—are expanding. The age-old dialectic of mourning, which guaranteed prospects for invention, progress, or civilization as long as couplification, reproduction, and future generations coming soon gave us same-old comfort, is now more than ever not the model going into or coming out of the future. It is not what the other has in store for us. The time to come, the time that is coming at us, has us scrambling for survival in a new eclecticism of bit parts. Only the melancholic chips on our shoulders are required for the future force of replication. The short circuit of merger and murder that kept replication from making a difference by limiting its realization to suicide belongs now to what the blastoff of autoreplication or autodivision has already left behind.

Notes

1. Robin Gardiner and Dan van der Vat, *The Titanic Conspiracy: Cover-ups and Mysteries of the World's Most Famous Sea Disaster* (Secaucus, N.J.: Citadel Press/Carol Publishing Group, 1997), 249.

2. Harold Schechter, *Depraved: The Shocking True Story of America's First Serial Killer* (New York: Pocket Star Books, 1996), 285.

3. Ibid., 281, 283.

4. Ibid., 309.

5. Genevieve Woelfl, *Sarah Pardee Winchester—A Driven Woman—Her Compelling Story* (Newport Beach, Calif.: Redwood, 1986), 1, 4.

6. Wilhelmina von Hallwyl, cited in *Hallwylska Museet: Historiska Myheter* 42 (1995): 3.

7. Ibid., 3.

8. Ella was poisoned by a paint set. Wilhelmina was henceforward and in short order more interested in preserving the species than in the collection or production of art. (Another daughter survived childhood to become the family scandal, banned from the mansion.)

9. *Hallwylska Museet*, 3.

12. Displacements, Furnishings, Houses, and Museums: Six Motifs and Three Terms of Connoisseurship

Kevin McMahon

Kennst du das Haus?

—Goethe, *Mignon*

Houses That Are Nowhere

In 1926, Philip Lovell wrote, "Los Angeles is truly a city of homes." A little later Raymond Chandler started writing about a "big dry and sunny place with ugly homes and no style." By 1944, Theodor Adorno, in Santa Monica, could write, "Dwelling, in the proper sense, is now impossible." Then in January 1945, *Arts & Architecture* announced the start of the Case Study Houses program:

> We can only promise our best efforts in the midst of the confusions and contradictions that confront every man who is now thinking about his post war home. We expect to report as honestly and directly as we know how the conclusions which must inevitably be drawn from the mass of material that these very words will loose about our heads. Therefore, while the objective is very firm, the means and the methods must of necessity remain fluid in order that the general plan can be accommodated to changing conditions and conceptions. . . .
>
> What man has learned about himself in the last five years will, we are sure, express itself in the way in which he will want to be housing in the future. Only one thing will stop the realization of that wish, and that is the tenacity with which man clings to old forms because he does not yet understand the new. . . .
>
> It becomes the obligation of all those who serve and profit through man's wish to live well, to take the mysteries and the black magic out of the hard facts that go into the building of "house."[1]

About twenty years after *Arts & Architecture* began its effort of rationalization, Universal Studios purchased all the homes of the Chavez Ravine neighborhood, whose inhabitants had been evicted to permit construction of Dodger Stadium. Everything was transported to Universal's lot, where it provided the set for the Gregory Peck vehicle *To Kill a Mockingbird.*

And more recently we find even more homes without places:

Paloma del Sol, an association financially supported by all residents, will maintain recreation facilities and common areas.

Some public facilities and roadway construction are funded by special tax assessments payable by homeowners. Ask sales personnel for details.

Not all financial arrangements required to ensure completion of the proposed development have been obtained or approved.

Availability of water could have a significant impact on future development. Photos are figurative and are intended to depict lifestyle only.

Models used in this ad do not reflect any racial preference.

The depictions of houses are Artists' Conceptions; actual construction or changed building plans may render the illustrations inaccurate.

Square footages are approximate.

The pool, basketball court and grape vine photos illustrate offsite public and/or private facilities in the general vicinity which may be available for use subject to fees, rules and regulations established by their owner or operator.

Prices and terms effective date of publication and may be subject to change without prior notice or obligation.[2]

Besides Paloma del Sol, this issue of *New Homes* features advertisements for more than 167 other new communities in southern California. Since they are located in regions far from other habitations, the ads include maps showing how to get to them. But the maps are deceptive—distances seem to be represented visually but are not. Each bears the caption "Map Not Drawn To Scale." They're conceptual.

Houses in Museums

Consider *Blueprints for Modern Living: History and Legacy of the Case Study Houses* at the Museum of Contemporary Art (MoCA) in Los Angeles, the first exhibition devoted to the program, which, in the years immediately after the end of World War II, focused international attention on Los Angeles as a home of thoughtful, innovative, and aesthetically refined domestic architecture.

While these houses are not to be considered as solutions of typical living problems, though meeting specific and rather special needs, some contributions to the needs of the typical might be developed. . . . These houses must function as an integral part of the living pattern of the occupants and will therefore be completely "used"

in a very full and real sense. "Houses" in these cases means center of productive activities. . . .

For a married couple both occupied professionally with mechanical experiment and graphic presentation. . . .

A place for a kind of relaxed privacy necessary for the development and preparation of ideas to be continued in professional work centers. . . .

Intimate conversation, groups in discussion, the use of a projection machine for amusement and education, and facilities for self-indulgent hobbies, i.e. cooking and the entertainment of very close friends.[3]

As with any exhibition of architecture, the question is, What to show? Besides photographs, drawings, and models, Craig Hodgetts and Ming Fung, the exhibit designers, built full-scale details of some of the structures under discussion. Museum patrons found themselves passing from conventional displays into, for example, a corner of the house Charles and Ray Eames built for themselves in the Pacific Palisades forty years ago. The handsome black steel structure was re-created in painted foamboard. Elsewhere, patrons passed through Ralph Rapson's *Greenbelt House,* a structure that, until then, had existed only as a drawing. Bisecting the pavilion were flat cutouts of cacti and flowers. On the mezzanine, patrons found themselves inside a tableau that re-created not only a room of a famous Pierre Koenig hillside house, but the room as it appears in the famous photograph by Julius Shulman. In the museum, the glass room floated above the glittering light of incandescent TVs suspended in blackness.[4]

Furnishings of Museums

A few weeks later, *Blueprints* was gone. Above the desk at the entrance hung an oversize photograph of Michael Heizer's *Double Negative,* the incisions into a Nevada mesa that, according to the identifying card, feature as an item in MoCA's permanent collection.

Young people tumbled out of Bruce Nauman's *Green Light Corridor* (on loan from Count Giuseppe Panza), through which they had squeezed on a dare. Some ran into a corridor blocked by Dan Flavin's glowing yellow and pink fluorescent tubes. Others hung out in rooms devised by James Turrell and Doug Wheeler; evacuated chambers where, with special lighting, the walls and floors seem to dissolve. The patron is overcome with vertigo, discovering the space impossible to negotiate—a sensation offered as euphoria. The diffused sense of distraction-as-entertainment contrasts strongly with the kind of distraction most adult viewers are required to maintain during the working day; it probably provides a degree of recuperation.

These artworks do not need to be read. Space is evacuated of the nonartistic, and so the patron assumes that the unspecified totality of whatever's happening is the significance. Experiencing, consuming, the artwork becomes its production. The only

labor recognized is the act of consumption. This displaces not only the producer but the possibility of expression.

It is an experience like an encounter in real life. A juxtaposition of material that, for an earlier artistic generation, would have provided the motif for a photographic still life, is rendered accessible directly by the installation. Here and in other installations the happy accident of the street photographer becomes available without waiting or maintaining vigilance, and in the flesh. A mandate to facilitate access to these experiences finesses all obstacles.

The history of the work becomes an arbitrary notation. Material scattered on the floor is identified by a card as a work completed twenty years earlier. The gap revealed whenever the nowhere of the museum would refer to places outside of it, which delighted Robert Smithson, has become an aspect of works that promised to overcome it. In the installation, nature isn't dead, but domesticated—brought into the house—as part of the theater of objects. And, as a theater, the stage becomes not only the most ephemeral of artworks, but also the most coercive.

The erosion of the object's integrity is not merely an aspect of some styles of installation, but it is characteristic of all objects in the contemporary art context, as can be illustrated by consideration of the old-fashioned exhibition practice of skying. Until the beginning of the century it was common to display pictures crowded together one on top of another, often so that a wall was covered with as many as could fit. Nothing could be less like the contemporary practice of isolating works, surrounding them with wide margins of empty wall. The gallery patron is offered the opportunity to savor his or her encounters, and to rest and reflect, and to brace him- or herself for more. Skying was possible because each picture was understood to comprise an entirely self-contained, independent, and bounded unit: its location—as long as it was visible—was irrelevant. But today, if two artworks are perceived to be within the same space, such a gesture is understood as either clumsy expediency or as an interpretive gesture on the part of the person responsible for the exhibition, the curator. The curator sets two artworks together, suggesting to connoisseurs that they are in the presence of an opportunity to exercise discrimination. But the foregrounding of the curator and of the exhibition context in institutional culture is increasingly apparent in situations that have nothing to do with pedagogy. Indeed, Dan Flavin's observation that "art is shedding its vaunted mystery for a common sense of keenly realized decoration" is demonstrating unexpected applications.[5]

Furnishings That Are Nowhere

Count Doctor Giuseppe Panza di Biumo, for example, has demonstrated that an aesthetic that insists on respect for the specificity of objects, materials, and situations is no impediment to perfect liquidity. On the contrary, it is site-specific or ephemerally experiential artwork that circulates with the least resistance—the perfect art commodity for globalism. In 1990 Panza authorized a Los Angeles gallery to fabricate sculptures

that, on exhibition, were identified as works by Carl Andre and Donald Judd, based on the certifications of authenticity and sole ownership that Panza was farsighted enough to extract from the artists. One reviewer admired the "unmediated physicality" of what was, in a sense, nothing more than a novel use of receipts.[6] A furious exchange of letters followed in the art press.[7]

The question of refabrication and ownership of ideas figured in the subsequent debates following the Guggenheim's acquisition of Panza's collection. This sale in 1990 was the end of a two-decade-long campaign by Panza to institutionalize his collection intact, as a whole. Panza stressed the integrity of his collection as something like an artwork itself, and insisted it would never be sold in pieces. Starting in 1973 it had been "placed" variously with the (then unbuilt) Mönchengladbach Museum, a proposed renovation of the stables of a Medici Villa in Poggio a Caiano near Florence, the (Sacher) Hoffman Kunstmuseum in Basel, a proposed renovation of the Venaria and Rivoli castles in Turin, a proposed renovation of the Arsenale in Venice, a proposed renovation of the Villa Doria Pamphili in Rome, a proposed renovation of an abbey near Parma, Williams College Museum of Art, a proposed renovation of an abandoned mill in Adams, Massachusetts, a proposed renovation of the Union Depot in Saint Paul, Minnesota . . . In April of 1990 the new director of the Guggenheim, Thomas Krens, announced that it was purchasing the bulk of Panza's minimal and conceptual collections—more than 300 works—for $32 million. The next month the Guggenheim put out at auction a Chagall, a Kandinsky, and a Modigliani, earning $47.3 million, to cover the Panza acquisition. As a gift, Panza would donate to the Guggenheim 105 more works and his villa, which would be maintained by the Guggenheim and the Italian government. As it turned out, the only curators would be Italian cultural authorities.[8]

Furnishings of Houses

Panza provides an example of how the most ambitious performance of domesticity—the most thoroughgoing pursuit of refined materialism, light, Mediterraneanism, specificity of *Heimat,* plus a whole panoply of historical resonance and romance—can devolve into travesty. He systematically betrayed his own aesthetic of sublime domesticity by denying his homeland his patrimony, by breaking the unity of his collection, by demonstrating the absolute fungibility of the most evanescent experience, and, in the end, by displacing the artist, and the artwork, with himself. It would be missing the point to explain his story in terms of grossness of character or greed or obtuseness. Unfortunately the case suggests that even the most penetrating critical vigilance—that of the artists, that of the works with all their value and promise—can forestall the collapse of the aesthetic into the financial, and the domestic into the institutional.

Panza's significance is further indicated by the fact that his self-appointed public antagonist, Donald Judd, devoted himself to the cultivation of his own version of the institutionalization of the domestic, and the collapse of the aesthetic into real estate, and of real estate into publicity.[9]

In 1979, at Judd's instigation, the Dia Foundation purchased Fort Russell, an abandoned army camp and World War II prison for German POWs located in Marfa, Texas, and began renovating it into a Kunsthalle centered around the world of Judd and a few of Judd's colleagues. Judd was retained on a salary from the foundation as curator of the collection—his own. When the Dia Foundation lost its oil-industry–based endowment it suspended work on Marfa. Judd threatened legal retaliation, and, in a 1987 settlement, Dia transferred ownership to the (Judd-instigated) Chinati Foundation. The Judd-supervised renovation of the sheds into spaces that stage, as he puts it, "the idea of large permanent installation, which I consider my idea," scrupulously avoids artificial illumination and provides a suitably inconvenient pilgrimage site.[10]

And so the artist equals the collector, who equals the artist. The cover of MoCA's inaugural exhibition catalog did not feature a work of art, but rather the names of the collectors whose collections made up *The First Show*. Likewise, the collection equals the collector. Los Angeles history is filled with collector-artists whose work takes the form of institutionalized real estate. The residences of railroad tycoon Henry E. Huntington, oil heiress Aline Barnsdall, and a subsequent oil heir, J. Paul Getty, became museums. For years, the home of Louise and Walter Arensberg was the best museum of modern art in southern California.[11] During the forties and fifties, the best venue for contemporary concert music was *Arts & Architecture* columnist Peter Yates's house. More recently, the purchaser of one of Frank Lloyd Wright's Los Angeles houses realized its upkeep was beyond his means and established a Trust for the Preservation of Cultural Heritage, as well as a friends committee (composed of relatives and business associates), to which he surrendered the title of the property and became officially the house's curator. Norton Simon appropriated the Pasadena Museum, providing a model for Armand Hammer's own vanity museum and the foundations of Eli Broad, J. Patrick Lannan, Peter Norton, Frederick Weisman, and others.[12]

Material

And where the collector-artist reigns, this is what remains of nature: the opportunity for an eye to discover beauty in raw materials and stock. And design philosophy that speaks of being based on the attributes of the material, as opposed to design based on an a priori idea. The painstaking joinery of luscious slivers of wood in the houses of Greene and Greene, the delirious sheen of glass and steel of Ellwood, or the alarmingly rusting steel of Morphosis or Michele Saee. Unarticulated planes of concrete and stucco function as a wall worth watching—in a trope combining references to the supposedly vernacular mission style and the modernists from Irving Gill, Rudolph Schindler, and Richard Neutra to Tadao Ando and Luis Barragán.

And the palette of materials includes sunlight—its ubiquity, brilliance, variability. It would seem that one of the primary goals of design is to stage performances of light

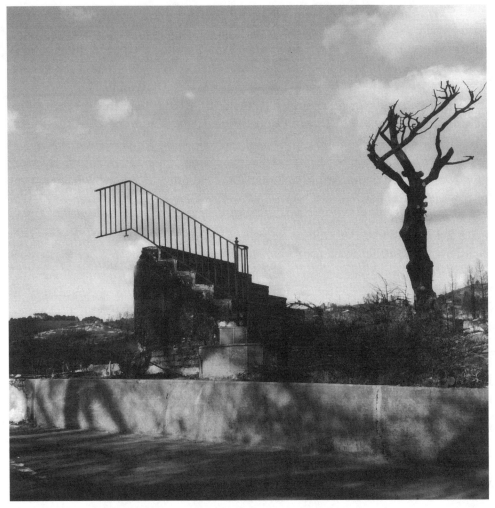

Figure 1. Erika Suderburg, *Home,* 1998. Black-and-white photograph. Courtesy of the artist.

and shadow. The audience is encouraged to address light as a material, not a medium—a substance to be enjoyed for its pure luminosity or obscurity. This material light is produced by translucent materials—glass bricks, frosted or etched glass panes, screens—or by apertures positioned where there is no view—as in skylights, or Schindleresque glass slits cut high up where the wall meets the ceiling. And if a view would only be of some unfortunate urban scene, the staging of material light permits the domestic space to be interpenetrated by the Spirit of the Place in a palatable form. The attraction of a nature without details provides not only southern California architects but a whole school of artists—Robert Irwin, Maria Nordman, Eric Orr, James Turrell—with a content that is literally beyond nature: "I've been reading these things written by an artist in New York named Hopkins who's been researching UFO abduction cases. In many cases the abductees give a much more powerful description of the light than exists in much of our literature."[13]

Openness

The theater of domesticity adorns itself in a nakedness so innocent it becomes the apogee of luxury. The fussiness of the traditional domestic interior is erased by architecture, the space is evacuated. Decoration in the sense of accumulation is superseded by the model of installation art. Likewise the physical and visual barriers defining inside and outside, public and private, are abolished because the frankness, guilelessness, and virtue of modernity in the field of social relations has rendered them superfluous. The home-dwellers are too occupied professionally with mechanical experiment and graphic presentation and self-indulgent hobbies to require privacy, or even enclosure. Schindler observed:

> The thick heavy wall has been abandoned and the room enclosures are designed subject to the principle of division of labor. . . . The feeling of safety created in dusky dens still gives us the illusion of coziness in darkened rooms. This remembrance, however, is rapidly overcome by our understanding natural phenomena, the pacification of the world, and our strong feeling for outdoor life.[14]

Figure 2. Erika Suderburg, *Home*, 1998. Black-and-white photograph. Courtesy of the artist.

The aesthetic of openness disassociates the experience of limit from physical obstruction, but the building retains its function of enacting and representing coercion and control.

> I would rather not look out to the conflicting panorama of everyone's fantasies. . . .
> One of the most unpleasant things I experienced when I first arrived here was driving down the street and seeing one fantasy creation after another. . . .
> I'm not a recluse, but I do have the desire to have my own environment.[15]

What's at issue is not scopophilia or spectacle but a kind of physical openness that functions to enforce passivity. The transformation of limit into behavior creates a new experience of spatiality. The field of extension nominally shared with one's fellow citizens becomes a cue for self-censorship and acquiescence. As the old distinctions between interior and exterior collapse, the option of even temporary or delusionary exemption from pacification is foreclosed. The vista becomes subject to the inhabitant's requirements for decor. As *Angeles* magazine commanded, "Make your yard the most elegant room in your home."[16]

Maximum visibility requires maintenance by both subtle and crude technologies of invisibility. Performances of openness must be defended against criminal or insane populations that fail to respect or recognize the boundaries meant to exclude them. Geographic isolation and segregation minimize the risk. The open houses, open cars, and open amenities found in certain locales provide aliens with a vivid demonstration of privilege. But when such neighborhoods are adjacent to less desirable ones—and they always are—their isolation is maintained through a multiplication of security systems. Patrolling municipal and private police lessen the necessity of defensive bulk, and technology enables the house to defend itself by equipping it with sensitivity to light, sound, and motion.[17]

Pain

Popular narratives of housing construction or renovation conventionally contain anecdotes about the client's difficulty in securing tradespeople who could perform the high-quality work demanded—such as "precision welding, impeccable stucco finishing." Of course the lament over the decline of craftsmanship constitutes a polite way of saying that it is not easy to exploit craftspeople to the degree one would like. Nevertheless, the complaint is significant as a sign of the leak of a curatorial sensibility into the sphere of ethics.

"Scrupulousness" refers literally to a small stone, or a tiny weight, that causes pain out of proportion to its size. To be scrupulous is to be a little mad. To be mad over the nuances of precision welding or stucco finishing suggests an investment of time and attention in excess of a simple desire to get your money's worth. This investment in the construction process suggests an ambition for domesticity that is supernatural. It has become a matter requiring the sacrifice of more than money:

The old bungalow looked questionable, but, Peggy maintains, "this was our chance to flex our muscles as architects." Like most remodelers, they woefully underestimated the challenge.

"As walls came down and comforts disappeared, our spirits waned," recalls Jeffrey.

"We were camping out in an empty shell and eating enough canned chili for a lifetime."

But as the house opened up and sunlight streamed in, "moments of exhilaration strengthened us."[18]

The steady investment of scrupulousness, if applied without stint to every object and relation, without regard to conventional notions of significance, can transform one's life (so the notion seems to argue) into something like a work of art. Encounters with sunlight and bathwater take on the air of a stroll through a museum, according to ads for bathwater and ads for museums.

Under the mandate of total scrupulousness even slight concessions made to necessity can be transformed into coups de théâtre. Los Angeles is a center for the production of art furniture; the concentration of craftspeople eases access to furnishings that are outside of the routine. Designers such as Peter Shire, Sam Maloof, and Robert Wilhite and moonlighting architects produce tables and chairs that are avidly collected as artworks. Wilhite's winning entry in a competition sponsored by the city of Santa Monica provided a curious recontextualization of art furniture into street furniture. On the curb, his bus-stop benches are elegant compositions of gray and black planes of concrete, rather contemptuous of the pedestrian's desire to rest.

And it is no surprise that shelter magazines regularly feature articles on diet and exercise, incorporating exercise facilities into the home, and restaurants whose fare is always described as consisting of the freshest ingredients and of the most scrupulous preparation. Self-imposed rules with regard to food, especially if they require sacrifice and inconvenience, are ubiquitous. Certain categories of food, or ingredients, are abstained from for medical, religious, or ethical reasons. In some cases, the defense of one's body against the substances that one has chosen to recognize as destructive becomes, in itself, a mechanism of self-destruction—a vain attempt to sustain vigilance of ever-expanding categories of hostile environmental conditions. As this ends in an impaired ability to consume, a whole industry has developed catering to the treatment and cure of such disorders.

The longing for a more scrupulously absolutist domesticity leads to the ritualization of labor in the form of quaint chores—homey activities such as cooking, gardening, and carpentry. The activity of recreation discards the referent and becomes an end in itself. Motifs of work are translated into sport. Along Santa Monica Boulevard in Beverly Hills, the path through the park is crowded not with joggers but with people engaged in a determined, demonstrative form of walking. They do not stroll, but stride forcefully, with upraised fists pumping rhythmically in the air. Once it is rescued from utility, the most ordinary of activities bathes the everyday in ecstasy. And

one becomes, in one's extraordinary ordinariness, an artwork. To be sheltered, to be healthy, to be beautiful, to be psychologically adjusted lie within the universal sentence to labor without end.

The Martha Stewart phenomenon can be seen as the most successful marketing of this peculiar conflation of aesthetics and ethics. In the carefully natural-lit photographs illustrating *Martha Stewart Living,* varieties of peppers and door handles and the gestures of washing a car become decor, performance art, sculpture. With breathtaking logic *MSL* readers have even been offered the spectacle of "Martha at Marfa."[19]

The End of Furnishings of Houses

Domesticity as contracting identity through contracting exclusivity: maintaining a family, *famulus,* a household. What is significant is not the struggle between new forms of family—gay and lesbian domestic partnership, multigenerational, collectivized—and old forms, but rather a change in the way domestic functions are fulfilled. The strategy of professionalization of domestic services—once a cornerstone of utopian feminism—has been realized, partially.

> Your child starts choking while you're at work. Does your housekeeper really know what to do? If your housekeeper is Hispanic, cultural or language differences could prevent her from knowing how to handle emergency and first-aid situations. Safe Kids, U.S.A. teaches your Spanish-speaking housekeeper what she needs to know about keeping your family safe while you're away. She'll learn things like Infant/Child CPR, fire and earthquake procedures, getting help (911), general home safety and more. Locations throughout Southern California.[20]

While everyone concedes the necessity of two incomes to support a family, in California a third of all children live with one parent only. This may explain why a child's career as beneficiary of the mother's or father's anxieties begins early. In an environment so hostile to the real needs of nonadults, there are gyms for those as young as three months, computer literacy courses beginning at three years, baseball tutors, training to prevent math anxiety. And professionally staged children's parties featuring bubbles, multiculturalism, petting zoos, marionettes, and live reptiles . . .

> *Merrymaking* decorates to create a magical environment around your child's interest (theme). We create games that highlight that idea and bring the fantasy to life.
>
> For example: an Alice in Wonderland/Mad Hatter party includes a tea party complete with Drink Me tea bottles, games of decorating top hats, painting rose gardens, and playing crazy croquet.
>
> The best part is that the host/hostess is someone who loves to dress up as your favorite character and never stops having fun with kids and makes your child feel ever so special at his/her celebration. . . .
>
> Vince and Kelly first met while teaching in Morocco as Peace Corps volunteers.

Seven years later, they re-met in Los Angeles and created *Inka-Neeto Good Things for Kids, Incognito. . . .*

Combining eclectic backgrounds in teaching, acting, singing and holistic health care, Vince and Kelly engage children in a variety of fun activities which promote self-esteem, multicultural and environmental appreciation—all disguised as just having fun.[21]

The fact that the most egregious acts of psychological and physical cruelty against children occur typically within the family is represented as a marginal phenomenon,[22] and public outrage over the condition of children has been orchestrated by those whose rhetoric is motivated less by concern for victimized children than for maintenance of the conditions that ensure victimization.

It is the pathos of the parents who will not be denied the gratification of possessing the child that was their dream:

Brainwave Retraining May Be Able to Help:

If your child . . . is easily distracted, has difficulty completing tasks, often acts before thinking, does not seem to listen, is unusually restless and fidgety in boring situations . . .

Brainwave retraining addresses the physiological basis of the above conditions with a non-invasive technique in which the child learns to regulate his own behavior and to approach his academic potential.

What some parents have said: "You have given us back the child we had always wanted."[23]

Or the pathos of an audience:

A festive crowd of more than 10,000 gathered here Friday night for a chance to see the purportedly miraculous image of a slain girl appearing on a blank, white billboard, prompting concern by police that the nightly event is turning into a public safety hazard.[24]

According to legend the dying poet chastised her daughter for crying—"mourning isn't appropriate inside a home dedicated to the muses."[25] Papery violet-red bougainvillea blossoms scrape the asphalt. Figures pass—skeptically, angrily, but compliantly—through spaces too beautiful for words. Do you know the house?

Notes

The epigraph is from Goethe's *Mignon.*

1. Charles Eames and Eero Saarinen, "Case Study Houses 8 and 9," *Arts & Architecture* 62 (December 1945): 43–51.

2. *New Homes* 24, no. 2 (June 1991): 119 (advertisement).

3. Eames and Saarinen, "Case Study."

4. See the catalog *Blueprints for Modern Living: History and Legacy of the Case Study Houses* (Cambridge: MIT Press, 1989); "Utopia in the Suburbs," Douglas R. Suisman, *Art in America* 78, no. 3 (March 1990): 184–93; and *Hodgetts + Fung: Scenarios and Spaces* (New York: Rizzoli, 1997), 74–93.

5. Dan Flavin, "Some Remarks," *Artforum* 5 (December 1966): 20–25.

6. Francis Colpitt, "Space Commanders," *Art in America* 78 (January 1990): 66–74.

7. "Artist Disowns 'Refabricated' Work," *Art in America* 78, no. 3 (March 1990): 31 (Andre), and "Artist Disowns 'Copied' Sculpture," in "Letters," *Art in America* 78, no. 4 (April 1990): 33 (Judd). The two works in question, Andre's *Fall* (1968) and Judd's *Galvanized Iron Wall* (1974) are featured in *Art of the Sixties and Seventies: The Panza Collection* (New York: Rizzoli, 1987), which is, unintentionally, one of the most absorbing documents of curatorial performance to date. Inside, one finds that Panza—and since 1991, the Guggenheim Museum—owns a large number of works by Judd. There are photographs of works installed elegantly in Panza's villa. In addition to the installation photographs, other documents are reproduced. For example, the photograph of DJ28 (Panza's system of identification combines the artist's initials with the number of the artwork by that artist acquired) on p. 162 is accompanied on p. 164 by illustration 2/A, a reproduction of a standard commercial purchase order form, on which are noted the dimensions of DJ28, followed by Judd's signature. It is not a receipt—for there is no price noted—so what is it: a certificate of authenticity? registration data? plans? the work itself? On the next page one finds examples of a different document, a typed form with blank spaces that have been filled in by hand. This item establishes that in 1974 a sale from Judd to Panza has taken place, that it involved exclusive ownership of a work that is described and that "has not been constructed or realized and its existence is presently evidenced solely by the following, which is hereinafter referred to as 'the Document.'" The document concludes, "I hereby grant Dr. Panza, his successors and assigns, the right to have the work constructed or realized, provided that this is made by reference to and in strict compliance with the Document and all of the details and instructions set forth therein and provided further that I, or my personal representatives or my Estate, am notified in writing of the realization" (165, ill. 17).

It is fortunate that this book permits readers to trace the stylistic development of the contracts Panza prepared for his artists to sign. Not every art collector would think of including actual gallery invoices for acquisitions or gallery responses to inquiries (219, ill. 8, concerning Robert Barry, and 234, ill. 3, concerning Joseph Kosuth). The care for establishing the rights to a work was probably suggested to Panza by the artists themselves. Certainly Sol LeWitt's elegant certification forms for his drawing formulae dating from 1969 (213–17) would encourage anyone to consider documentation an artistic genre. And the content of Douglas Huebler's *Duration Piece #12* of 1969 (210, ill. 5), imposing upon the artwork's owner an absurd and laborious task—transporting sand from the West Coast to the East Coast and vice versa in March every ten years until the year 2069—suggested perhaps that it would be possible for the owner to impose something similarly absurd upon the artist. And so, an early Panza contract such as that with Bruce Nauman for *Floating Room* (184, ill. 27) contains the phrase "I undertake not to do, realize, sell, or authorize the same work and or of similar work" (the last part of the phrase is scribbled out). Panza's estimation of the value of his contracts was such that he apparently took the trouble to secure them signed for works that he had purchased years earlier. In the contract illustrated on p. 219, ill. 10, Robert Barry agreed to terms of sale on December 1, 1975, for a work he actually sold to Panza in 1970. By 1976 Panza had refined his contract to an all-purpose certificate of ownership, receipt, and surrender of rights. The contract with James Turrell for *Wallen* (243, ill. 4) significantly omits any requirement of participation or notification of the artist when the work is fabricated.

Panza entered the Angelino institutional arena in 1984, when he refinanced his business

by selling MoCA a number of paintings from the fifties and sixties that were irrelevant to his collection of minimal and conceptual art. MoCA, besides producing the previously mentioned monograph, gave Panza a seat on its board of directors. He used this position to denounce his colleagues as barbarians because of a proposal to sell part of the recently purchased Panza collection in order to keep up payments to him. See "Controversy Mars MOCA Opening," *Art in America,* December 1986, and Richard W. Walker, "MOCA-Panza Dispute Settled," *Art News,* March 1987, 21.

8. See David Galloway, "Report from Italy: Count Panza Divests," *Art in America,* December 1984; Charles Giuliano, "Williams College Coup," *Art News,* summer 1987, 58–59; "Panzas for St. Paul?" *Art in America,* October 1987, 208; Walter Robinson, "Guggenheim Gets Panza Trove," *Art in America,* April 1990, 37–38; Philip Weiss, "Selling the Collection," *Art in America,* July 1990, 124–31; and Raphael Rubenstein, "Panza's Gift to Italy," *Art in America,* September 1996, 29. For critiques of Panza and Panzaism, see Ann Reynolds, "Reproducing Nature: The Museum of Natural History as Nonsite," *October* 45 (summer 1988): 109–27; Rosalind Krauss, "The Cultural Logic of the Late Capitalist Museum," *October* 54 (fall 1990): 3–17; and Yves-Alain Bois, "Panza the Idealist?" *Journal of Art,* October 1990.

9. See "A Portrait of the Artist as His Own Man," *House & Garden,* April 1985, 154–62, 220–22; and Patricia Failing, "Judd and Panza Square Off," *Artnews,* November 1990.

10. The Dia Foundation, founded by Philippa de Menil in 1974, provides a link between curatorial performance and the post-1975 economic restructuring variously termed post-Fordism or flexible accumulation. When its executive director speaks of it as "geographically dispersed, but conceptually focused," he adds that "Dia's far-flung structure and decentralization" oppose "the norm of the singular, all-enclosing museum building" with a "more flexible approach" (Michael Wise and Jillian Burt, "Museum as Multinational," *Blueprint,* October 1990). Dia maintains a collection of sites: a Kunsthalle in New York; two rooms for Walter De Maria installations in Soho and one of his projects in Kassel; spaces for Fred Sandback, La Monte Young, and Dan Flavin; cosponsorship of the Andy Warhol Museum in Pittsburgh; an artists' bookstore in Soho that sponsors formidably oppositional symposia, which are documented in elegant little pastel-bound paperbacks; and James Turrell's *Roden Crater* and De Maria's *Lightning Field* in Arizona. Access to this last is by reservation only: visitors are escorted to a cabin where they are required to stay for twenty-four hours. No books, TV, or other annoyances are permitted to distract from the giant knitting needles and the rattlesnakes.

Philippa's older sister Christophe began her career as a fashion designer by costuming a Robert Wilson production. Wilson also provided architectural interventions in her New York apartment. Frank Gehry supervised its renovation, Michael Heizer frosted the kitchen windows, and Doug Wheeler provided a table and the balustrade. Philippa and Christophe's mother, Dominique de Menil, was the patron of Houston's Montrose Avenue ensemble, featuring Philip Johnson's University of Saint Thomas campus, Howard Barnstone's pavilion for Mark Rothko's paintings-for-an-unspecified-deity, Renzo Piano's ensemble of museum pavilions, and the neighborhood's original bungalows, retained as outbuildings and guest quarters. All of them painted, by decree of Barnstone, the same dove gray. See Reyner Banham, "In the Neighborhood of Art," *Art in America,* June 1987, 124–29; and Charles Wright, "Almost No Boundaries: The Dia Art Foundation," in *Breaking Down the Boundaries* (Seattle: University of Washington, Henry Art Gallery, 1989). Dia's woes are detailed in "Dia Divided by Conflict," *Art Newspaper* 7 (March 1996): 1, and "New Day at Dia," *Art News* 95 (May 1996): 53.

The one traditional institution making the greatest effort to explore the possibilities of decentralization and flexibility is, obviously, the Guggenheim under the leadership of Thomas Krens. "The suggestion that the new Guggenheim projects might constitute the expansion of a real estate empire caused Krens to draw up his immense frame and tower over the table.

'That,' he said in a tone that could chill blood, 'is a very bad choice of words.'" Wise and Burt, "Museum as Multinational," 44–48.

MASS MOCA, Krens's project for North Adams, Massachusetts, opened in the summer of 1999. See Peter Schjeldahl's independent, observant, and hilarious "Minimalism Depot: MASS MOCA Makes a Theme Park out of Edginess," *New Yorker,* August 2, 1999, 81–82. This article is a companion to other discussions of installation art by Schjeldhal that render my contribution redundant. See his "Bonjour Ristesse: The Hugo Boss Prize," *Village Voice,* August 11, 1998, and "Festivalism: Oceans of Fun at the Venice Biennale," *New Yorker,* July 5, 1999, 85–86.

11. See Naomi Sawelson-Gorse, "Hollywood Conversations: Duchamp and the Arensbergs," in *West Coast Duchamp,* ed. Bonnie Clearwater (Miami Beach, Fla.: Grassfield Press, 1991).

12. For a comprehensive anthology of the range of museum experiences in L.A., see Ralph Rugoff, *Circus Americanus* (New York: Verso, 1995).

13. "James Turrell, an interview with James Lewis," *Flash Art,* no. 156 (January/February 1991): 113.

14. Rudolph Schindler, "Care of the Body," *Los Angeles Times,* April 4 and 11, 1926; reprinted in *Oppositions* no. 18 (Fall 1979): 60–85.

15. Charles Ward, quoted in Marie Moneysmith, "Time Lapse: A Contemporary House in Venice Echoes the Past," *Angeles,* February 1990, 64–75.

16. Ibid.

17. It is interesting to contrast the plein-air activities described in John Rechy's stories of Los Angeles in the fifties through the seventies with the case in 1991 of the elderly widow reprimanded by her condo's executive board for chastely kissing her beau good night at the front door—suggesting, among other things, pacification's characteristic emphasis on the regulation of the behavior of women. On the subject of Rechy, there is also a role of Los Angeles—the center of U.S. pornography production—as distributor of other forbidden images, whether of misbehaving movie stars, Rodney King, or the Dead Sea Scrolls.

18. "Met Home of the Year Contest Winners: Grand Winners Peggy Bosley and Jeffrey Biben," *Metropolitan Home,* February 1991, 97–101. Similar statements are ubiquitous in magazines and newspapers, along with the case studies that perhaps serve as inspiration: "As soon as her three children were asleep, Gail Claridge started wallpapering the nursery in her English Tudor doll house. When she was finished, she put the tiny crocheted rug her grandmother had made on the floor near the cradle and placed the lamp she made out of an old earring on a table near the armoire. Haunted by the lovely houses she'd seen on a trip to England, Claridge 'lived vicariously through this little doll house. I figured it was the closest I would ever come to having an English Tudor house. I never dreamed I'd have one.' That was in 1974. Today this soft-spoken redhead is a successful interior designer with a Horatio Algier story and a dollhouse-come-to-life in her own 5,000-square-foot English Tudor home on a picturesque lot in Chatsworth." Karen Back, "An English Country Manor," *Southern California Home & Garden,* February 1988, 48–55, 91.

"Producer Aaron Spelling and his wife Candy are making themselves at home in The Manor, their newly built, 56,000-square-foot chateau in Holmby Hills. . . . Now that the landscaping has been completed, the size of the megamansion—which includes a bowling alley and a full-size ice rink—is less apparent. . . . 'I think one of the most unique things about our home is a large, formal rose garden planted on top of the garage, with a stairway leading up to it,' [Candy Spelling] added. 'And another thing we've never mentioned is a lovely French wine and cheese room, furnished with sidewalk tables and chairs and French music. With my husband's work, we have no time to get to Paris, so it's a little touch of the Left Bank here.'" Ruth Ryon, "Settling into 56,000 Sq. Ft.," *Los Angeles Times,* June 9, 1991.

19. "Martha at Marfa," *Martha Stewart Living,* no. 42 (September 1996): 114–22, plus the

recipe section. "Martha Stewart, who has long admired Judd's work, meets Texas chefs Louis Lambert and Grady Spears. . . . Martha Stewart had always wanted to visit Marfa, and not because of the name. . . . As the party began, guests drank margaritas and ate pulled-chicken tamales while reminiscing about the mysterious Judd."

20. Ad in *L.A. Parent Magazine,* June 1991. Another indication of the professionalization of chores is the crisis over a proposed citywide ban on leaf blowers, covered by Bettina Boxall in "Leaf Blower Issue a Clash of Expectations, Realities," *Los Angeles Times,* January 11, 1998. "Gardeners, nannies, maids and car detailers have become standard fixtures of the middle class to a degree unknown a few decades ago—and still unknown in many other parts of the country."

21. Ad from the "Advertising Supplement Guide to Birthday Parties," *L.A. Parent Magazine,* June 1991.

22. "In Los Angeles, an average of one child was killed by its parents each week—a rate second only to New York" (Paul Dean, "A Home, a Family, a Prison," *Los Angeles Times,* October 20, 1991). "In the last five years, the number of children reported to authorities nationwide increased 16%, to more than 3.1 million. About one-third of the time, investigators confirm abuse has occurred. The increase in Los Angeles County has dwarfed the national average, soaring 63% in the last five years and seriously taxing child protection efforts" (James Rainey and Sonia Nazario, "Child Abuse Reports Swamp County System," *Los Angeles Times,* January 11, 1998).

23. Ad in *L.A. Parent Magazine,* June 1991.

24. "Billboard Crowds Seen as a Hazard," David Smollar, Patrick McDonnell, and Nora Tamichow, *Los Angeles Times,* July 20, 1991.

25. Sappho, fragment 150, in *Greek Lyric,* ed. and trans. David A. Campbell, vol. 1 (Cambridge, Mass.: Harvard University Press, 1990).

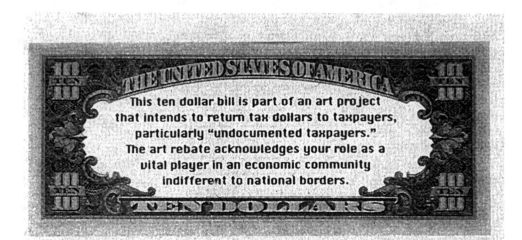

This ten dollar bill is part of an art project that intends to return tax dollars to taxpayers, particularly "undocumented taxpayers." The art rebate acknowledges your role as a vital player in an economic community indifferent to national borders.

- The economic growth of California and the Southwestern U. S. could never have happened without the labor of undocumented workers.

- Historically, the U.S. government, business and society have been willing to look the other way as long as they are enjoying the profits afforded by undocumented labor.

- Today, in a wrecked economy, the so-called "illegal alien" is once again blamed for the social problems of the region and portrayed as a drain on the economy. In fact, there is no credible statistical evidence that undocumented workers take more in social services than they give in combined local, state and federal taxes.

- Not only are the crucial economic contributions of the undocumented overlooked or denied, these workers pay federal income tax, social security, state income tax, DMV fees, sales tax and more.

- Undocumented workers are undocumented taxpayers.

- You pay taxes when you eat a taco at 'berto's, shop for socks at K-Mart, buy toilet paper, hand soap or razor blades at Lucky or fill up your tank at Thrifty Gas.

- Regardless of your immigration status, if you shop you pay taxes. Period.

REEMBOLSO ART REBATE

"Art Rebate" is a project by Elizabeth Sisco, Louis Hock and David Avalos. It is part of the "La Frontera/The Border" exhibition co-sponsored by the Centro Cultural de la Raza and the Museum of Contemporary Art, San Diego, and made possible, in part, through the generous support of the National Endowment for the Arts, a federal agency, The Rockefeller Foundation, the City of San Diego Commission for Arts and Culture, and the California Arts Council.

Undocumented Workers Taxpayers

Figure 1. Handbill in English and Spanish (English shown) accompanying the Art Rebate activity, 1993. Courtesy of Liz Sisco, Louis Hock, and David Avalos.

13. Public Art and the Spectacle of Money: An Assisted Commentary on Art Rebate/Arte Reembolso

John C. Welchman

[T]he author [Marcel Mauss] speaks of the thing given or exchanged, which is not inert, but always part of the giver ("to give something to somebody is always equivalent to giving something of one's own person"); he describes the gift as one element in a total system of obligations which are rigorously necessary and may cause war if disregarded, and which also contain a play or "sportive" element; he mentions the "guarantee" or token inherent in the object given, identified with the object itself and such as to constitute obligation "in all possible societies."

—Elvio Fachinelli, "Anal Money-time"

So money acts as a measure which, by making things commensurable, renders it possible to make them equal. Without exchange there could be no association, without equality there could be no exchange, without commensurability there could be no equality.

—Aristotle, *Nicomachean Ethics*

If there were once gifts, as Fachinelli remarks in the epigraph, with their threat of war and thread of play, and then there was money, with its posture of Aristotelian equality and guarantee of social exchange, could it be that in the mid-1990s we entered into an era of the *rebate?* Remembering the giving systems of non-Western cultures, it is clear that such a possibility cuts through the foundations of Western liberalism, with its attendant fiscal moralities, and into the domain of postcapitalist circulation, with its spectacular inversions and invisible flows. The theory and performance of the rebate imagines a new nexus of social relations predicated on the negative increments of capitalism's public record. As we follow this passage, the rebate emerges as both a critique and a renegotiation of the social "commensurability" reckoned by Aristotle to arrive with the exchange system of money.

In the *Nicomachean Ethics* Aristotle defines "magnificence in spending" not as some kind of profligacy or inappropriate "liberality," but as the "suitable expenditure of wealth in large amounts." Such expense should be properly relative to the conditions of the spender and the circumstances and objects of the expense, and without "any fixed measure of quantity." When there is propriety in these alignments the magnificent subject becomes, says Aristotle, a "connoisseur" with respect to [his] own social environment. Whether "directed towards the equipping and dispatch of a religious-state embassy, dressing a chorus, fitting out a warship, or furnishing a banquet, the giver will have performed his giving correctly, and at the same time successfully 're-veal[ed] his character,' if [he] spends 'not upon himself but on public objects' so that 'his gifts are a sort of dedication.'"[1]

Beginning in July 1993, and continuing intermittently for several weeks thereafter, an untitled group of artists comprising filmmaker Louis Hock, photographer Liz Sisco, and Chicano artist David Avalos[2] distributed some 450 pencil-signed ten-dollar bills to undocumented immigrant workers in Encinitas and other sites associated with undocumented labor in the vicinity of San Diego, California. The bills were photo-copied, and a receipt form was handed out to each recipient, who signed for a serially precise note. The money derived from a five-thousand-dollar commission awarded to the group by the Centro Cultural de la Raza and the Museum of Contemporary Art, San Diego, for the creation of a public art project as part of the exhibition *La Frontera/The Border*. National Endowment for the Arts and Rockefeller Foundation grant monies underwrote part of the project costs.

A press release headed "Tax dollars returned to undocumented taxpayers" claims that the project

> operates at the intersection of public space (the streets and the sidewalks), informa-
> tional space (radio, television and print media) and the civic space between the pub-
> lic and government officials. It activates a discourse that reveals the shape of contem-
> porary social thinking about immigrant labor. Conceptually, this art traces the
> network describing our economic community as it follows the circulation of the
> rebated $10 bills from the hands of the undocumented to the documented. "Arte-
> Reembolso/Art Rebate" is an art process that envisions public art as an engagement
> of the social imagination rather than the presentation of monumental objects.

The press release and interviews, editorials, and statements made by the participants in Art Rebate draw on the following claims and assumptions: Working immigrants pay considerably more taxes than they consume in public services and welfare. The fact of their labor poses no or little threat to the job security of other local workers. The immigrants take jobs and accept standards that are below the expectation thresh-old of citizen-workers. They are unjustly scapegoated for the economic fallibility of the State.

What we encounter in these parameters is an almost perfect negative—or shadow economy—of Aristotle's model of public munificence, which has endured through

the patronage systems of the West with remarkably few logical inflections for well over two millennia (several horizons of technological recalibration notwithstanding). Every term or indicator in the Aristotelian formulation has been inverted in Art Rebate. The project can thus be defined as the (officially) unsuitable redistribution of negative wealth—taken from the state, not bestowed upon it—in small amounts (and multiple instances) according to fixed measures of quantity (the ten-dollar bills). The measure and propriety imagined by Aristotle to extend between the contexts of the spender and the circumstances and objects of the expense is likewise baffled by the groups' pantomime of fiscal recirculation, so that the spending is not on public objects but illegal subjects and results not in a monument or dedication, but rather in an ephemeral fold in an immodestly outsized economic system and a relay of media-driven misinterpretations within whose logical aporias the piece finally dwells.

The scope of these negatives extends even to the sanctioned types of social magnificence itemized by Aristotle. In Art Rebate, then, we witness not the clothing of a theatrical group but the undressing of the choric apparatus of the state-mythology by offstage, extracivic, figures who are vivid only in their everyday appearance. We see not the augmentation of the instruments of seaborne warfare, for example, but rather a gesture that chips a plank—or a splinter—out of taxborne naval spending (in the largest military entrepôt in the world). We find not a sumptuous religious mission, but a tentative token of secular reparation; not a spectacular feast, but a diverted promissory note to assist in basic provisioning.[3]

It follows that the agents of this inversion cannot be imagined as the magnificent social "connoisseurs" of Aristotle's reckoning, but rather as anti-object-makers who smuggle issues and innuendos into the dark corners of public policy and force them as insinuations through the organs of social commentary. The group played the role of critic-artists, not patron-connoisseurs. Yet their performance is subject to another form of inversion that should introduce a note of caution—or, at least, irregularity—into the symmetrical figures of the quasi-anonymous Art Rebate set against the manifestly honorific Public Gift. Aristotle writes that the act of public giving has a corollary in a revelation of good character that is confirmed by the decision to spend outside, not on, the self. Suggesting a last reversal here might imply that the Art Rebate group acts as surrogate social workers distributing someone else's money in a trade that, while it buys their own celebrity, at the same time renders the subjects of the rebate—the undocumented workers—inert or transparent at the center of a swirl of exchanges, real and virtual.[4]

The Money Sign

With these signs of conventional wisdom in place as social silhouettes, I want to examine one of the key focal lengths of Art Rebate: its rearbitration of the money sign. For in addition to its sudden location in the politics and economics of migrant labor, *Art Rebate* also takes its place within the series of profiles through which twentieth-century

art has loosely engaged with the theory and practice of money and the systemic and social operations of market capitalism. Let me mark some moments in this history.

In *Obligations pour la Roulette de Monte-Carlo* (*Monte Carlo Bond*, 1924), a work that arrives with his relinquishment of "opticality," we find Marcel Duchamp doing steerage on the wheel of fortune. Raising subscription bonds of five hundred francs, Duchamp issued certificates of account featuring a diagram of the roulette board and wheel fringed by twelve interest coupons (*coupons d'interêt*) printed over a scripted feint background. A Duchamp self-portrait appears in the roulette wheel as a diabolic alter ego, doubled on his already gender-reversed persona, Rrose Sélavy. Written on the back of the bond are four "clauses" "extracted" from the Company Statutes outlining its terms and conditions—including details of annual income payments, property rights, and so on. In a letter to Francis Picabia written from the Café de Paris in Monte Carlo in 1924, Duchamp emphasizes the mechanical, repetitious character of his operation, its "delicious monotony without the least emotion." His effort is a kind of geometric abstraction, worked out between "the red and the black figure," in which, as he so curiously puts it, he is "sketching on chance."[5]

The social and cultural parameters of this piece need to be underlined. Duchamp dresses himself in the haute couture of the financial system, the carnival of excess and consumption represented by the casino at Monte Carlo. He evinces no interest in this wheel of fortune as a social construct, preferring to use the casino as a convenient abstract machine whose flows of capital and margins of profit he wishes to filter and interrupt. But *Monte Carlo Bond* and Art Rebate share one key strategy, though each imagines it differently: both take on the economic system through *investment*:[6] they rely on the supplemental function of the market economy as a machine that makes a return (for profit). Duchamp raises the stakes in the investment process by virtue of his conjugation of stockholding with gaming. But chance, investment, and return are overlaid by *system* in that the predicate of *Monte Carlo Bond* is the triumph of gambling knowledge and technique over normative probability as the house is pitted against the player. The casino plays white in a regulated encounter with modeled similarities to the chess match.

Art Rebate, on the other hand, functions to desupplementize the circulation of money. Like Duchamp, Hock-Sisco-Avalos offer the signature as an inscription of presence. But while Duchamp's self-writing is a paradoxical affirmation of a founding subject who is also split and disguised, Art Rebate returns a double signature—the bills themselves are signed, and then the recipients sign *for* the bills. The rebate functions not as an ostensible increment to a rule-bound investment tied in to the vicissitudes of "the table" or "market forces," but rather as a reparation that seeks to acknowledge the unaccounted contribution of an invisible sector of the tax-paying public, who are momentarily sedimented within the ceaseless flow of an abstract system. The piece allegorizes that which is *given back,* but never *accounted for.*

The pseudomonetary devil face of Duchamp looks forward, as Art Rebate looks back, onto Andy Warhol's irreal, serial re-presentations of dollar bills, gridded and

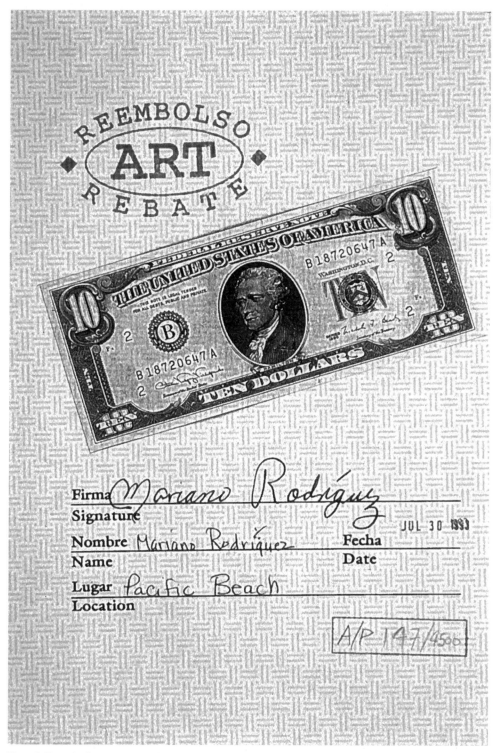

Figure 2. Example of a signed receipt for a unit of rebate, with photocopy of the related bill, 1993. Courtesy of Liz Sisco, Louis Hock, and David Avalos.

accumulated like the faces of his American celebrities, which they also contain. Warhol's repetitions are cunningly mimetic. The rows of bills look like an impossible forger's sheet: they take on the appearance of money before circulation. First made in 1962, they began as hand-stenciled images and were among the first works produced in Warhol's silkscreen technique. Accounts of his early career relate the legend according to which Warhol was searching at this time for another "new" subject matter following his appropriation of comic strip imagery in the late 1950s. Coming up with money marked the arrival of a profoundly different horizon for symbolic capital than that imagined, for example, in Mark Rothko's mythopoetic *Search for a Symbol* (1943), a painting that marks the abstract expressionist desire for an art subject fraught with biomorphic suggestion and bursting with metaphoric allusion. Seen in relation to the searches that preceded it, the conjunction of seriality, photography, and banality at this moment is crucial for Warhol, crucial for the art of the 1960s, and represents a key moment in the visual elaboration of the money sign in the twentieth century.

Warhol chose the dollar bill and Campbell's soup cans as the icons of his seriality precisely because they were tokens of commercial iteration and everyday exchange. They were emblems of the new subject matter that stared you in the face. In this sense they participate with the Fluxus conjugations that precede them and the photorealism to come as a central gesture in the U.S. postwar articulation of the *hypergeneric*—the ultimate genre art, the generic raised to a flashpoint. Even a piece as conceptual and documentary as Robert Morris's *Money* (1969), in which fifty thousand dollars put up by a trustee was briefly invested in the stock market, takes its place in the tessellation of trompe l'oeil "realities" that simulate the world as normality, and disdain, borrowing Baudrillard's formulation, the seductions of artifice.[7]

The suggestion that Art Rebate produced aftereffects of postmodern simulation was noted in newspaper reports. Responding to the handouts in the fields of Encinitas, one newspaper critic wrote that "each new $10 bill [is] as crisp and vivid as a work of hyperrealism." Like Warhol, Art Rebate journeys into the obscene visibility of the money sign. But what Warhol simply appropriates, repeats, and frames, the Art Rebate group fed back into the system that bore it. What is exhibited here is the whole issue of money—its release, holdups, and hidden consequences; the teeming archive of social pressures that move it through our hands and into an infinity of others'. Introduced and accepted some three centuries ago, paper money may be considered a key element of the differential specification of modernity. But it is only since the 1970s that gold convertibility has been abandoned in favor of an international monetary system. This system has progressively rendered visible parts of the money circulation system, such as checking and savings accounts, time deposits, money market funds, and the like, which had previously been unseen (or at least underknown) in a direct conversion economy in many respects still predicated on a literalist scale of weight and equivalence.[8]

If there is now an acknowledgement of postmodern money—which flows along the gradients between presence and absence (calibrated by expectation, probability, a futures market)—the differential functions of immigrant labor should also be recog-

nized. If we can account for the abstractions of the financial machine as they filter through the new accountancy of virtual monies, so the insufficiencies and literalist ir-realities of the immigrant labor question stand in need of critical reassessment. In both questions, what is unseen and unaccounted for still has vigorous social and economic effect. The present work attempts to force the sedimentation of an undocumented economy whose hitherto invisible balance sheet images the inverse of the media circus of reflex denigrations.

Of the few art-related projects that intervene in the postmodern reformulation of giving and reparation, Mike Kelley's postappropriational work with craft objects of-fers one of the fullest explorations of the psychological binds of the gift. His accumu-lations of stuffed toy animals, dolls, and rugs led to reflection on the enormous invest-ments of time in the production and then use of these profuse and singular objects. The result was *More Love Hours Than Can Ever Be Repaid* (1987), a cornucopic assem-blage of handmade stuffed animals and afghans hashed together furry cheek to stringy jowl in a giddily giant fractal mosaic of gaudy, secondhand fabrics. The piece focuses Kelley's retort to the 1980s debates on commodification and the redemptive value ar-gued for appropriation, which sometimes saw its preliminary "taking" as the mere dis-guise of a "gift":

> This is what initially led to my interest in home-made craft items, these being the objects already existing in popular usage that are constructed solely to be given away. Not to say that I believe that craft gifts themselves harbor utopian sentiments; all things have a price. The hidden burden of the gift is that it calls for pay-back but the price is unspecified, repressed. The uncanny aura of the craft item is linked to time.[9]

Writing specifically of the address in *More Love Hours Than Can Ever be Repaid* to "another form of false innocence . . . the innocence of the gift," Kelley elaborates on its giving routines:

> In this piece, which is composed of a large number of handmade stuffed animals and fiberglass items, the toy is seen in the context of a system of exchange. Each gift given to a child carries with it the unspoken expectation of repayment. Nothing material can be given back since nothing is owned by the child. What must be given in repay-ment is itself "love." Love, however, has no fixed worth so the rate of exchange can never be set. Thus the child is put in the position of being a perpetual indentured ser-vant, forever unable to pay back its debt.[10]

In the absence of craft's formal location, stranded outside a "normative" exchange sys-tem, Kelley here opens up the signifying terrain of the craft object onto a psychologi-cal economy predicated on "mysterious worth," intractable "guilt," and "emotional usury." In a thought that helps us understand his career-long commitment to both in-tensive and extensive reckoning with agendas that postmodernism often entertained on the surface, or in a political one-dimension, Kelley explores the discrepancy between

emotional and monetary value by separating "junk" art from craft production. The former "could be said to have value IN SPITE of its material; while the craft item could be said, like an icon, to have value BEYOND its material."[11] The values of this beyond were drawn out and recalibrated in other aspects of the three-part Chicago exhibition where *More Love Hours* was shown—notably in *Pay For Your Pleasure,* which evaluated the conjunction of criminality, art-making, and educational knowledge and included a number of collection boxes for donations to victims' rights organizations. "Since no pleasure is for free—a little 'guilt money' is in order," wrote Kelley. "A small donation to a victims' rights organization seems a proper penance to pay."[12] Having pursued the psychology of the gift into the laboriously repressed time of the craft object, Kelley offers it a socially extensive reconfiguration as a reparational payment by the art-going public for its voyeuristic pleasures.

Public Knowledge

Duchamp wrote of "delaying" ideas. Hock-Sisco-Avalos have found a means to funnel the production of their work into a gigantic scene of reception, from which point the "work" takes off as debate. In a sense this is postconceptualism at its most convincing (and least arcane). The group has assisted in the ready-made media convertibility of the project—which appeared on the front pages and in the editorial sections of more leading newspapers than almost any art adventure since the launching of futurism in *Le Figaro* in 1909, or the orchestrated height of the Life and Death of Pollock and Warhol. Yet, they have done so while remaining almost anonymous, thus engendering a wholly opposite mode of media infiltration to the ghoulish cults of personality variously brokered from Marinetti to pop.

 Reading through the extraordinary growth of media prostheses that supply the afterlife of the piece, it is striking that the Art Rebate group, their critical and write-in supporters, and the fiercest of their art world and media antagonists share one notable convergence: all claim that the project has had the effect of turning things upside down. This attitude is surely one of the many satellites fixed by the gravity of the avant-garde. Yet no longer are we confronted here by the kind of territorial expansionism according to which the artist or movement takes its gesture of practice *a little further into the unknown.* Instead, as we saw in the logical relation between Aristotelian liberalism and the defaults of the rebate, inversion is the order of the day: the other is the subject; the recto is glimpsed when looking at the verso.

 In a railing conjugation of war, domestic economics, and art that denounces Art Rebate as "the artists' version of the Pentagon's $600 toilet seat and the $7,000 coffeepot," an editorial in the *San Diego Union-Tribune* predicates its antipathy on a reversal of (newspaper) values, on what its writer(s) designates as the palpable absurdity that the action should be "front-page instead of art-page."[13] Seldom does the print media produce such a volumetric metacritique of its own spatial proprieties. But here an editorial from the sanctioned place of opinion in the middle of the

paper takes on the task of controlling its precincts, adjudicating first between "news" and "art," front and back, top and bottom, and then between the relative value of "real" and "surplus" news.

This reversal, acknowledged by the institutional organ of the press that actually resisted it, is one among many. As the group put it in the *Los Angeles Times,* "the politicians are acting like performance artists and we're trying to be political." "The art," they continue, "will ride these $10 bills through the circuits of a failed economy, entering a space where politics is fiction and conceptual art is attacked for being politically real."[14] The chain of these inversions is both crucial to the intervention in public art represented by Art Rebate and somewhat particular to the function of money. Michel Foucault noted that one of the founding reversals of modernity was a migration in understanding from the notion that "the sign coins bore—*the valor impositus*—was merely the exact and transparent mark of the measure they constituted" to the idea that "money (and the metal of which it is made) receives its value from its pure function as sign."[15]

Art Rebate bears this system of reversals into our postmodernity. For the shape of such tropes of camera obscura reversal evinces a postconceptual, postpolitical world turned upside down. For Marx, we recall, it was the fabrication of ideology by the status quo that caused the unfolding of "normative" events and relations to be understood as grounded, when they might, in fact, have been overturned, or up in the air. But while abstraction, inversion, and ideology are central problematics in Art Rebate, what turns things upside down here is not so much the making-seeming-being of the early capitalist state, but rather the entrapment of that inversion in the media machine of the 1990s, the informational hall of mirrors that simultaneously duplicates, corrugates, and blinds. While the new inversion may be stroboscopically fixed and virtually perceived, its unknowable auratic efficacy is symptomatic of what Anthony Giddens terms a culture of the "management of risk."[16] Its mesmeric opportunism measures the distance from the camera to the hologram.

These provisions oblige us to rethink the relation of Art Rebate to the filament of public visual culture that reaches from traditional memorial statuary through the outdoor sculptural monumentalism of the mid-twentieth century, from the radical and populist public art projects of the 1960s and 1970s and the "site-specific" work of the 1970s and 1980s, to what has recently been termed "New Genre Public Art." If Art Rebate's relation to the Aristotelian tradition and its vapor trail of classicist affirmations can be defined as logically antithetical, its position at the end of this genealogy is likewise locked in a fundamental dispute with the historical constitution of both "the public" and "art". To assess Art Rebate's management of this dispute, we can turn to two discussions of public art, organized around the seemingly antagonistic principles of the "local" and the collaborative, on the one hand, and endemic "violence," on the other. Lucy Lippard has gathered projects from the more recent side of the tradition of public art under nine headings. These include

246 — John C. Welchman

3. site-specific outdoor artworks . . .

5. performances or rituals outside of traditional art spaces that call attention to places and their histories and problems, or to a larger community of identity and experience.

6. art that functions for environmental awareness . . .

7. direct, didactic political art that comments publicly on local or national issues, especially in the form of signage on transportation, in parks, on buildings, or by the road, which marks sites, events, and invisible histories.

8. portable public-access radio, television, or print media . . .

9. actions and chain actions that travel, permeate whole towns or appear all over the country simultaneously to highlight or link current issues.[17]

Art Rebate is not the only recent project achieved in public space that seems to cut across all or most of these definitional brackets. But its multiple locations are more indecisive than usual (Lippard lists earlier work by the group under heading number 7), enabling the rebate to enter into a form of what I will argue is constructive contradiction with the dominant rhetoric of activist art. Many critics share Lippard's commitment to the insinuation of public art with a "resonant" notion of "place" and to radicalized, but more or less traditional, forms of image production (and circulation). Jeff Kelley, for example, argues that the collaborative "common work" of public art should be based on "a rejection of abstraction and an embrace of the particular. . . . Modernist utopianism dissolves into a landscape of what might be called a postmodern social realism. Abstract space becomes particular place."[18]

But Art Rebate is not predicated on the production of images, whether pictorial, photographic, or for alternative TV. Instead it is brought into being by the mainstream media's construction, reception, and misidentification of them. It is not fitted out with redemptive empathy for the loss of place. Instead it diverts flower and fruit workers from their counter-Edenic labor, literally buying moments of their time by asking them to sign a pact with the devilish dollar. Art Rebate is less a ritualized performance than an inverted business transaction, ordered by a desk, a chair, a pencil, and a signature. It deliberately collides and overlays the abstraction of Western systems of finance, "documentation," and media flow with conceptual minimization of form and the gray "indexical present" of the rebate scene.[19] Above all, the "political" in Art Rebate is not "direct" or "didactic." Its "commentary" is not shouted out from public signage, but fetched from the retaliatory clamor of real and art-world reaction. This move to force the surrogate completion of the work in an alien, even hostile, environment—here the mainstream media—is rare in contemporary art. However, writing of the strategies of abjection taken on in the 1990s, Hal Foster suggests that "just as the old transgressive Surrealist once called out for the priestly police, so an abject artist (like Andrés Serrano) may call out for an evangelical senator (like Jesse Helms), who then completes the work, as it were, negatively."[20] While the two projects

share a similar diagram of reversal effects, among many conditions that separate it from Serrano's cultivation of scandal, Art Rebate sets out an intervention in the territory of giving, repairing, and refunding that furnishes grounds for the work's extension in debate. With Art Rebate, the predicate of donation is borne into the media outcome, and effect becomes cause.

It follows, then, that while sharing a superficially similar connection to "sources," the giving of the rebate is different in kind from the "generosity" invoked by Lippard. "Art is or should be generous," she writes, "but artists can only give what they receive from their sources. Believing as I do that connection to place is a necessary component of feeling close to people, to the earth, I wonder what will make it possible for artists to 'give' places back to people who can no longer see them."[21] The locative commitment reaches a (utopian) crescendo in this formulation. Places themselves, Lippard suggests, should be the objects of giving in gestures symbolic of the ultimate reparation of humankind and the earth.

The conception of Art Rebate, the "events" that constituted its "action," and its complex afterlife in the media are ranged squarely against the idea that "of all forms of art, public art is the most static, stable, and fixed in space." It is countermonumental according to the same understanding, which suggests that "the monument is a fixed, generally rigid object, designed to remain on its site for all time."[22] And it intervenes differently within—in fact it insists upon a rearticulation of—the relation of artwork to Habermas's notion of "an ideal, utopian public sphere" somehow conceived against "the real world of commerce and publicity."[23]

One outcome of these differences may be found in the representation of violence, considered by W. J. T. Mitchell to be "repress[ed]" by public art, which "veil[s] it with the stasis of monumentalized and pacified spaces." Restricting his comments to the production of "images," Mitchell identifies three ways in which "violence may be in some sense 'encoded' in the concept and practice of public art":

> (1) the image as an *act* or *object* of violence, itself doing violence to beholders, or "suffering" violence as the target of vandalism, disfigurement, or demolition; (2) the image as a *weapon* of violence, a device for attack, coercion, incitement, or more subtle "dislocations" of public spaces; (3) the image as a *representation* of violence, whether a realistic imitation of a violent act, or a monument, trophy, memorial, or other trace of past violence.[24]

Imagined and performed outside the tradition of image or object production, Art Rebate recasts Mitchell's categories of corporal violence perpetrated on physical bodies by precipitating new figures in the passive, ever-present violence of everyday discrimination. Far from glorifying the militaristic values of the state or perpetuating the abstract violence of "radical autonomy,"[25] Art Rebate turns these values back against the power structures that bore them, replacing the signs of violence with the tokens of a relational reparation.

It is around the question of violence and its disapprobation that we can identify

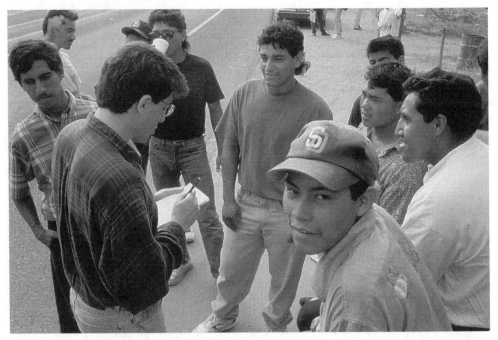

Figure 3. Sebastian Rotella of the *Los Angeles Times* interviews recipients of Art Rebate in Carlsbad, San Diego County, August 4, 1993. Courtesy of Liz Sisco, Louis Hock, and David Avalos.

one of the more significant destinies of the critical conjunction set in motion by Art Rebate between media commentary, mainstream and corporate culture, and local guerrilla activism. By late 1998, half a decade after the rebate of dollar bills in North County, the domain within which conceptual art could be identified with aspects of public culture had expanded to such an extent that the equation appears almost commonplace. Now, partly because conceptualism has a more settled and generalized location in recent visual history and partly because the conditions of radical intervention have clearly shifted, "conceptual art" is readily identified with the opposite of direct or violent action, becoming the metaphoric code name for a virtual politics of online disruption, blockage, shutdown, infiltration, and counter-sloganization. Writing of the new "hacktivism" in the *New York Times,* Amy Harmon, a "software engineer who designed the FloodNet program," anxiously distinguishes her commitment to "denial of service attacks" from the real-world violence of terrorism on precisely these grounds. "This isn't cyberterrorism," she observes. "It's more like conceptual art."[26]

In another register, Art Rebate also flirts with absurdity and reduction, teetering on the brink of its own dissolution. While its futuristic abstraction threatens the social reality it seeks to underline, this risk is reasoned. For you can't speak "information" back to the new inversion, using the language of "facts." You can't paint social oppression any more. You can't even photograph it. To film it or document it is to surrender to the facility of the newly invisible. To hook a point in the hyperspace of public opinion you have to go fly-fishing with social abandon. Here is an art of camouflage where nothing is covered up; a fickle portrayal of the nonrepresented. It is not a hymn to the

abandoned. Its sentimentality is actual, but accidental. It had to frighten the Left as well as appall the Right. It had to be a fake before it was born. It was destined to use the media as a hallucinogen. It had to refuse both means and ends.

What's most surprising, perhaps, is that in this Northwest Passage through the labyrinth of media complicity, Art Rebate also flirted with the fixed-rate interest of visual modernism: in one sense the project is as minimal and self-reflexive as the paintings of Morris Louis. It had to go out into the info-world as magically as Louis went into the canvas. They share a common staining. Both were born into their unknowable reach by the chatter of critics and commentators. Both are immaculate finalities, and impossible fictions. Both leverage the artist-critic relationship into the necessities of connoisseurship.

Look at it another way and you see the double funnel of the perspective diagram, reaching between the inner eye and the outer object. An instrumental cultural politics is not rejected here. It is assumed. This is an art action as social intervention: risking atrophy and courting dissolution, knowingly simulating the aura of avant-gardism, flaunting surface gesture in the face of historical depth, the pitch of the piece still comes through. Even as it problematizes the social clarities of what it seeks to challenge, Art Rebate helps us reimagine the parameters of a cultural politics for the nineties (without—like Duchamp and his progeny—being poker-faced).

The regime of avant-garde appropriation and its 1970s denouement have been stretched like a hologram, from all sides. Art-world funding, public art, critical opinion, newspaper commentary, real and virtual money—and money as a visual sign—have all been appropriated. But the project does not consist in the representation or relocation of any of these borrowed parts. It declares itself, instead, in the sum of their subtractions, as what is left over when they have all been taken away. Forcing us to witness the whirlwind of conflicting strategies that make up the social correlative of appropriation itself, Art Rebate came as close as anything I can imagine to a gesture of postappropriation—a subterfuge of taking where everything appropriated is inseparable from that which is given back. Remembering Bataille's distinction between excretory heterogeneity and appropriational incorporation, it is clear that Art Rebate's "heedless expenditure" is one of the "certain fanciful uses of money"[27] that expose the violence inflicted on the underside of the social body.

Notes

1. *The Ethics of Aristotle: The Nicomachean Ethics,* ed. and trans. J. A. K. Thomson (New York: Barnes and Noble, 1953), book 4, chap. 2, 99–102.

2. For a useful account of previous public art collaborations by this group and a number of other San Diego artists, see Robert L. Pincus, "The Invisible Town Square: Artists' Collaborations and Media Dramas in America's Biggest Border Town," in *But Is It Art? The Spirit of Art as Activism,* ed. Nina Felshin (Seattle, Wash.: Bay Press, 1995), 31–49.

3. Critics—hostile and supportive—noted the immediate use value of the rebated bills. Disparaging what he terms the "arts-babble" of the project description, George Will, for example,

writes: "It was also lunch, as some recipients rushed to a food truck to buy tacos with their wind-falls." George F. Will, "The Interaction of Space and Tacos," *San Diego Union-Tribune,* Sunday, August 22, 1993, editorial page, G-2, from the Washington Post Writers Group.

4. Several critics underline the perceived neglect by the Art Rebate group of the kind of community preparation, involvement, and follow-up that would have allowed the project to function as something more than a momentary interlude of surprise—or shock—and minor good fortune for the undocumented workers themselves. Michael Kimmelman finds in this lack the grounds for a sweeping dismissal: "By all accounts, that publicity stunt had nothing to do with serious collaboration between the artists and the workers; both as social service and as a mediation on the problems at the Mexican-American border it was laughably meager. Its real audience was the art world and its critics, among whom the gesture of giving away public money for the arts had precisely the intended incendiary effect. Had it not provoked a re-sponse from that group, the whole gesture would have been, on the face of it, empty." "Of Candy Bars, Parades, and Public Art," *New York Times,* September 26, 1993, section H.

5. *The Writings of Marcel Duchamp,* ed. Michel Sanouillet and Elmer Peterson (New York: Da Capo, 1973), 187.

6. Duchamp was not the only artist to investigate the art of investment. Robert Morris's *Money* (1969) was one of a number of conceptual projects from the late 1960s and 1970s that foregrounded the operations of market capital. Among younger artists, Linda Pollack's *The Art of Investment,* performed at the Dutch Art Fair (KunstRAI) in 1994, used an art subsidy grant-ed by the Dutch government as capital to be invested on the basis of advice solicited from seven Dutch financial experts in public interviews conducted during the course of the fair.

7. The work, consisting of correspondence and the stock certificate, was made for the *Anti-Illusion* exhibition at the Whitney Museum in New York, and was cited in various debates on the status of the art "object" in the late 1960s and early 1970s.

8. See Michel Foucault, "Exchanging," chap. 6 in *The Order of Things: An Archeology of the Human Sciences* (London: Tavistock, 1970).

9. Mike Kelley, "In The Image of Man," statement for *The Carnegie International 1991,* Carnegie Museum of Art, Pittsburgh, Pa.; cited from artist's MS, p. 1.

10. Mike Kelley, "Three Projects by Mike Kelley at the Renaissance Society at the Uni-versity of Chicago: *Half a Man; From My Institution to Yours; Pay for Your Pleasure,*" *Whitewalls* (a magazine of writings by artists), no. 20 (fall 1988): 9–10. In "Mike Kelley's Line," Howard Singerman underlines the emotional bind of the home-crafted gift: "What is asked for in ex-change for this excessive value is appreciation, devotion, love" in *Mike Kelley, Three Projects: Half a Man; From My Institution to Yours; Pay for Your Pleasure,* exhibition catalog (Chicago: The Renaissance Society at the University of Chicago, 1988), 10.

11. Kelley, "In the Image of Man," 1.

12. Kelley, "Three Projects," 12.

13. *San Diego Union-Tribune,* August 5, 1993.

14. *Los Angeles Times,* August 23, 1993. The same point is made by David Avalos in Robert L. Pincus, "'Rebate' Gives Good Return for a Minor Investment," *San Diego Union-Tribune,* August 22, 1993, E1, E8. In a different context, Guillermo Gómez-Peña suggests a similar ex-change: "Joseph Beuys prophesied it in the seventies: art will become politics and politics will become art. And so it happened in the second half of the eighties. Amid abrupt changes in the political cartography, a mysterious convergence of performance art and politics began to occur. Politicians and activists borrowed performance techniques, while performance artists began to mix experimental art with direct political action." Introduction to "Track IV: Performance Politics or Political Performance Art" of "From Art-Mageddon to Gringostroka: A Manifesto against Censorship," in *Mapping the Terrain: New Genre Public Art,* ed. Suzanne Lacy (Seattle,

Wash.: Bay Press, 1995), 99. For further examples of this reversal from street protests in Eastern Europe, see John C. Welchman, "APROPOS: Tune In, Take Off," *Art/Text*, no. 57 (May–July 1997): 29–31.

15. Foucault, *Order of Things*, 176.

16. Anthony Giddens, lecture at the University of California, San Diego, February, 1993.

17. Lucy R. Lippard, "Looking Around: Where We Are, Where We Could Be," in *Mapping the Terrain*, ed. Lacy, 122–23.

18. Jeff Kelley, "Common Work," in *Mapping the Terrain*, ed. Lacy, 147–48.

19. Adrian Piper laments the relative ineffectualness of "global political art," which, "however forceful, original or eloquent it may be . . . is often too removed from the indexical present to situate the viewer, him or herself, in the causal network of political responsibility." Adrian Piper, "Xenophobia and the Indexical Present," in *Reimagining America: The Arts of Social Change*, ed. Mark O'Brian and Craig Little (Philadelphia, Pa.: New Society, 1990), 285; cited by Arlene Raven in "Word of Honor," in *Mapping the Terrain*, ed. Lacy, 167.

20. Hal Foster, "Obscene, Abject, Traumatic," *October*, no. 78 (fall 1996): 116.

21. Lippard, "Looking Around," 129.

22. W. J. T. Mitchell, "The Violence of Public Art: *Do the Right Thing*," in *Picture Theory: Essays on Verbal and Visual Representation* (Chicago: University of Chicago Press, 1994), 183.

23. Ibid. Introducing a discussion of the relation between public art and commercial film, Mitchell is here characterizing—though not necessarily "accept[ing]"—Habermas's distinction between a "culture-debating" public (associated with the former) and a "culture-consuming" public (associated with the latter).

24. Ibid., 381.

25. This term is used by Suzi Gablik in "Connective Aesthetics: Art after Individualism," in *Mapping the Terrain*, ed. Lacy. See, e.g., p. 79: "What the *Tilted Arc* controversy forces us to consider is whether art that is centered on notions of pure freedom and radical autonomy, and subsequently inserted into the public sphere without regard for the relationship it has to other people, to the community, or any consideration except the pursuit of art, can contribute to the common good."

26. Amy Harman, "'Hacktivists' of All Persuasions Take Their Struggle to the Web," *New York Times*, October 31, 1998, A6.

27. Georges Bataille, "The Use Value of D.A.F. de Sade," in *Visions of Excess: Selected Writings, 1927–1939*, ed. Allan Stoekl, trans. Stoekl, with Carl R. Lovitt and Donald M. Leslie Jr. (Minneapolis: University of Minnesota Press, 1985), 94.

14. Video and Film Space

Chrissie Iles

The moving image always transforms the space it occupies. This transformative process has been a central tenet of film and video installations since their inception in the mid-1960s. From the early experiments of the sixties to the present widespread use of video projection, the spatial issues of video and film installation can be said to have evolved in three distinct phases. The first phase can broadly be termed the phenomenological, performative phase; the second, the sculptural phase; and the third, current phase, the cinematic. These remarks are limited to the first and third phases, and to the resonances between the two. Film and video installation is rarely discussed beyond the parameters of its own development, except at the point when it overlapped with performance during the seventies. Yet the distinct features of each stage of its maturation are inseparable from the wider context of the avant-garde contemporary art practice to which it belongs, and the issues of space that emerge are remarkably parallel.

The earliest video and film installations made from the mid- to late 1960s presented two different philosophical approaches to space, in what could be described as an overlap between the ending of one era and the beginning of another. Expanded cinema events echoed the dreamlike collage aesthetic of avant-garde sixties film in large-scale projected environments involving film and 35mm slide sequences. At the same time, an emerging body of video work with a rigorously conceptual approach to viewer participation and social space began to emerge, including installations such as Bruce Nauman's *Live/Taped Video Corridor* (1970) and video time-delay live feedback pieces such as Frank Gillette and Ira Schneider's *Wipe Cycle* and Les Levine's *Iris,* both made in 1969.

These two very different sensibilities epitomized the differences between the media of film and video. The expanded cinema events of the late sixties marked the final

gasp of abstract expressionism in moving-image-media terms. Large-scale film environ-
ments echoed the psychedelic sensibility of the sixties, with its mind-expanding light
shows, as well as the earlier Zen and Beatnik culture of the fifties. Aldo Tambellini's
Black Zero (1965), involving large-scale film and slide projection and sound, was one
of the first "electromedia" environments. In 1969, John Cage and Ronald Nameth pre-
sented *HPSCHD,* a multimedia environment, at the University of Illinois Assembly
Hall. Eight thousand slides and one hundred films were projected on eleven-hundred-
foot-wide screens in a circle around the space above the viewers, while fifty-two loud-
speakers transmitted the sound of seven amplified harpsichords around the auditorium.

These large projected film images transformed the space into a three-dimensional
image, a kind of communal dream space, or metaphor of expanded consciousness. As
Gene Youngblood remarked, "On the one hand, intermedia environments turn the
participant inward upon himself, providing a matrix for psychic exploration, percep-
tual and sensorial awareness; on the other hand, technology has advanced to the point
at which the whole earth itself becomes the 'content' of aesthetic activity. . . . Implicit
in this trend is another facet of the Romantic Age. The new consciousness doesn't
want to dream its fantasies, it wants to *live* them."[1]

These environmental spaces bore a direct relationship to the growing number of
commercial experiments with large-scale projection, such as those presented at the
World's Fair of 1964 in New York, which Bill Viola cites as an early influence on his
large-scale projected installations. Such commercial environments similarly spectacu-
larized the cinema viewing experience, moving large-scale projected images into a
three-dimensional space within which the viewer could wander at will. This relation-
ship to the large-scale panoramic moving image was first explored in early twentieth-
century cinematic experiments with large-scale viewing, but its origins lie further
back, in the German, French, English, and American experiments with large-scale cir-
cular panoramic paintings made during the late eighteenth and nineteenth centuries.

In contrast to film, the instant, real-time quality of the new video technology,
whose wider uses since its appearance in the mid-sixties had included live television
reporting of the Vietnam War and live feedback recordings of subjects in psychologi-
cal experiments undertaken in academic departments, presented, for the first time,
the possibility of observing human behavior as it occurred in real time. Live feedback
became a central formal and spatial strategy in a large group of video installations pro-
duced using this new equipment. Their development was intimately connected with
performance, conceptual art, and minimalism's radical shift of meaning from the
object to the viewer in space. Dan Flavin's site-specific constructions were important
for Bruce Nauman's phenomenological structures in both video and neon light, for
example. And Dan Graham's close friend Robert Smithson's writings on the architec-
turally entropic properties of the mirrored space were an important influence on
Graham's mirrored video environments.

These performative video installations of the late sixties and early seventies, in-
volving smaller-scale, black-and-white video images, often in live feedback recordings

of the actions of the viewer or artist or both, marked a new, antispectacular, analytical experience of space. The reductive, monochrome representations of the viewer or artist's presence in space, mediated through real-time feedback, were framed either within the video monitor or, in the case of Peter Campus, by a medium-sized glass screen containing a black-and-white video projection of the viewer. In a climate in which the broad concept of the autonomous self was breaking down, the boundaries between public and private space, between the artist's studio and the gallery, and between artist, artwork, and viewer were all called into question. Space became the primary site for this inquiry, and, as such, the viewer's relationship with space became introspective.

The single most important influence on the defining of space in all the video installations produced by Peter Campus, Vito Acconci, Bruce Nauman, Dennis Oppenheim, and Dan Graham during the period 1968–1975 was that of phenomenology and psychological theory. The properties of the new video technology lent itself to this inquiry. As Les Levine remarked, "Art has always been communication in its most eloquent form. But until television, artists have created things to be communicated. . . . But television is neither neither an object nor a 'content.' Television is the art of communication itself. . . . The self-feeding, self-imaging, and environmental surveillance capabilities of closed-circuit television provide, for some artists, the means of engaging in a phenomenon of communication and perception in a truly empirical fashion similar to scientific investigation."[2]

In 1968, Les Levine predicted the preoccupation with psychological theory by artists working with video and performance in his observation that "machines that show the human organism itself as a working model . . . may eventually destroy the need for psychology as we know it."[3] As Gene Youngblood remarked, in the two closed-circuit "teledynamic systems" that Levine built in 1968 and 1969, *Iris* and *Contact: A Cybernetic Sculpture,* Levine's primary interest was in the psychological implications of the extension of the superego suggested by the mirroring closed-circuit televisual image of the viewer.

Bruce Nauman pushed this psychological inquiry much further in his performances and corridor structures of the late sixties, in which the artist and the viewer experienced claustrophobic, uncomfortable situations involving physical restriction and video surveillance. These video spaces were highly influenced by Nauman's study of phenomenology, behaviorism, and gestalt psychology. As Kate Linker has argued, Vito Acconci was also heavily influenced by psychological theory, in particular the writings of Ervin Goffman and Kurt Lewin's "field theory," in which human behavior is understood "in terms of the relationship of the individual to the structure and dynamics of its situation and surroundings."[4] Acconci's use of Lewin's arguments that human behavior can be tested by stress and exhaustion echoes Nauman's use of tension, discomfort, and aggression to test both the viewer's and the artist's own reactions in a given space. Dennis Oppenheim, a close friend of Acconci, had met Nauman in Aspen in 1970 and was producing similarly confrontational video performances and

installations. In the video installations by all three artists, space was made deliberately adversarial.

In Nauman's video installations made between 1968 and 1970, including *Live/Taped Video Corridor* and *Corridor Installation (Nick Wilder Installation)* (both 1970), this adversarial space is created physically, in constricting architectural corridors through which the viewer is encouraged to pass, tracked by hidden closed-circuit video surveillance cameras and watching their own movement in time-delay. The viewer's movement through space, both encouraged and observed by the presence of the video camera, is dictated by the artist, in the role of surrogate psychologist; as Paul Schimmel remarks, Nauman's relationship to the viewer is always instructional. The corridors operate as "environments of controlled response."[5] Nauman's performative structures create an unease similar to that experienced in Robert Morris's labyrinths, through which the viewer moves in routes that are both prescribed and deliberately disorientating. A similar withholding of space from the viewer through the refusal of direct movement through space occurred in Dan Flavin's fluorescent barrier pieces. The phenomenological experience of immersion (in light) and restriction (in space) led Robert Smithson to remark that Flavin "turns gallery space into gallery time,"[6] a concept not dissimilar to Peter Campus's description of the gallery, transformed through his video installations, as "durational space."

In Vito Acconci's video installation *Command Performance* (1974), the viewer is similarly positioned in the performative role previously occupied by the artist (Nauman, like Acconci, had, previous to his video corridors, used the video camera to record his own physical discomfort in physically and psychologically demanding durational performative pieces in his studio). But Acconci places the viewer in a theatrical rather than an architectural space (a difference underlined by the title of the piece), and their psychological discomfort is provoked through language rather than through physical constraint. The artist appears on a video monitor opposite the stool on which the viewer is invited to sit, engaging the viewer in an often sexually provocative confessional monologue and switching between active and passive roles. As Kate Linker argues, Acconci's interest in the power field of Lewin's theories and in issues of control, power, and domination is played out through testing the psychological boundaries of the viewer's personal space. Acconci's confrontation through the spoken monologue belies his roots in poetry and narrative, just as Nauman's testing of the viewer's physical boundaries reflects his interest in dance and movement.

A marked difference in the construction of space occurs in a related film installation by Dennis Oppenheim, *Echo* (1973). Four large black-and-white images of a hand slapping the wall are projected on film loops onto all four walls of a room. Each hand repeatedly slaps the wall loudly at different intervals, creating an aggressive rhythmic cacophony that evokes the stamping, jumping, bouncing movements of Nauman's performative videotapes or the relentless banging of a silver spoon and rhythmically rolling vertical hold in Joan Jonas's videotape *Vertical Roll* (1972). Oppenheim's piece confronts viewers by surrounding them with images and sound rather than with physical

Figure 1. Bruce Nauman, *Live/Taped Video Corridor,* 1970.

walls. The artist's aggressive performative actions are abstracted into a single, filmic, close-up movement, magnified and multiplied to fill the space. The wall-sized film images anticipate the video projections of the nineties, in which the language of video and film have become conflated into a single cinematic aesthetic. The hands' relentless sound and movement both attract and repel the viewer into and out of the space, setting up a paradoxical psychological reaction.

A central tenet of the psychological investigation of the viewer in space in the installations of the seventies was the concept of mirroring. In Oppenheim's installation, film being incapable of transmitting images in real time, the mirroring occurs in the repetition of the hand on all four walls of the space, suggesting a metaphorical double reflection. In other, video, pieces, the mirror appeared either as a physical presence in space or as a metaphor, in the video camera and the real-time closed-circuit video image.

Deeply rooted in the long dialogue between painting and the mirror that, as Gregory Galligan has argued,[7] has existed since the sixteenth century, the use of the mirror by artists in the seventies in order to fracture and multiply space marks the collapse of the Cartesian paradigm of vision, which, as Jonathan Crary has argued, began with Cézanne's breaking down of the picture surface and the resultant merging of foreground and background.[8] The mirror in the seventies performative video space bears a direct relationship to experiments with the mirror in nineteenth-century realist painting, where, according to Galligan, the mirror "moved beyond its traditional role as mechanical tool to realize a self-portrait, and a metaphor for mimesis itself, and gained status as a sign of the essentially self-reflexive condition of *all* looking."[9]

Galligan, discussing Manet's self-portraits, cites the arguments of the psychologist James Gibson, by whom both Dan Graham and Peter Campus were strongly influenced during the seventies. According to Galligan, Gibson argued that "all vision was profoundly corporeal, and that the foreground of all visual perception is one's own body. Hence the continuous act of perceiving involves the co-perceiving of the self. Gibson replaced the passive model of the camera obscura with a principle of continuous movement by the viewer within an environment that the viewer occupies as a wholly self-conscious, embodied object amongst many others." As Galligan goes on to observe, "The success of visual perception depends on the perceiver maintaining a subliminal awareness of the self as object in the visual field."[10] This argument holds true both for the minimalist project, in particular the work of Donald Judd and Dan Flavin, and for the phenomenological video installations of the seventies. It can also be applied to certain more recent video installations, in particular the work of Gary Hill.

In an early video piece by the British artist David Hall,[11] the video camera and monitor operate as the mirror of Gibson's self-reflexive condition of looking in highly physical terms. Marshall McLuhan argued that television and video were not primarily visual media, but an extension of touch rather than of sight. Since the video image is low definition, the viewer fills in the spaces and completes the picture, which induces a more intense involvement with the screen. This tactility results in a kind of osmosis,

or what McLuhan described as a "tattooing" of technology directly onto the skin. David Hall engineered a reversal of this process through a radical experiment in which the viewer's image became imprinted directly onto the video screen.

Nam June Paik had already broken through the physical membrane between video monitor and external space in pieces such as *Magnet TV* (1965), in which the television image was distorted by applying a strong magnet to the *top* of the monitor. Hall took this a stage further in *Vidicon Inscriptions* (1975), by exposing the monitor's vidicon tube to strong artificial light via a closed-circuit video camera, triggered by a viewer's approach to the camera and monitor along a corridor. Filmed by the camera, in a process resembling flash photography, the viewer triggered a light to flash, causing his or her image to be burned directly onto the vidicon tube. The viewer appeared on the screen as a ghostly static image, layered over fading images of previous viewers. This fusion of the image with the technology, evoking Mary Lucier's *Dawn Burn*, made in the same year in New York, set in physical terms the mirror encounters of Campus's, Nauman's, and Graham's closed-circuit video pieces.

For both Campus and Graham, the use of the video camera as a perceptual tool to question the viewer's presence in space was inextricably linked to temporality. Campus described his concerns as being "durational space, and the accumulation of perspective . . . the retroflection of one's projected image and its accompanying sensations, and the balance and fusion of disparities whose unified origins cannot be perceived directly."[12] Campus's "accumulation of perspective" took place through the insertion of a screen into a darkened space. The fragmentation of time was achieved spatially, in a single real-time framework, through guiding the viewer's movement backward and forward in relation to the camera and screen. The placing of the camera and/or the screen at unexpected angles obliges the viewer to negotiate space more obliquely in order to discover his or her image. In some cases this spatial obliqueness introduces the shadow of the viewer as a third element, suggesting a filmic reference.

Campus's "durational space" correlates with Dan Graham's writing on video space: "Video is a present-time medium. Its image can be simultaneous with its perception by/of its audience. The space/time it presents is continuous, unbroken and congruent to that of real time, which is the shared time of its perceivers and their individual and collective real environments."[13] The additional spatial and temporal layers introduced by Graham's use of time delay were further multiplied by his use of mirrored walls, which render the space almost immaterial. The mirrored walls reflected and prioritized the viewer's body in real time, setting up a spatial and temporal juxtaposition with the fixed perspective on the video monitor alongside, replaying the viewer's image recorded a few seconds before. As Birgit Peltzer has argued, in these transparent environments "space is demonstrated to be less a function of sight than of movement; it is constituted through the body or, more precisely, the actions of a subject. . . . We thus return to an elementary topological precept: the deformability of perception. . . . It follows that space is less a thing than a force-field. As such, it comprises a temporal rather than a visual contiguity."[14]

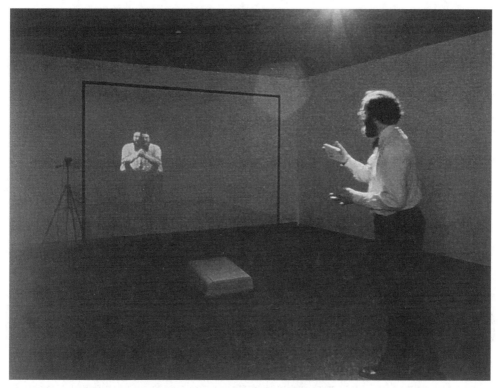

Figure 2. Peter Campus, *Interface,* 1972. Installation view at Cologne Kunstverein.

If a central strategy of all the video installations of the seventies involving a mirror, whether actual or metaphorical, was the fragmentation of the single temporal and spatial viewpoint, decentering also formed a central component of Joan Jonas's seminal video performances made during the early seventies, in which both the performance space and Jonas's own body were fragmented by the use of mirrors and the doubled video image. As Douglas Crimp observed, in Jonas's performances "there is no central self from which the work can be said to be generated or by which it can be received. Both the performer and spectator are shown to be de-centred, split."[15] As Christine Poggi has argued, in relation to Vito Acconci, the artist's critique of the self as an autonomous, centered subject produced a dichotomy between private and public space.[16] In the aggressive psychological disorientations evoked by Acconci, Nauman, and Oppenheim, this dichotomy was expressed in existential terms. The boundaries of the viewer, taking the place of the artist, were tested in solitary environments that provoked unease. In contrast to the isolation of the single person walking through Nauman's *Live/Taped Video Corridor* or sitting on Acconci's stool in *Command Performance,* the shared spaces of Jonas's video performances were inclusive and involved both viewers and performers in groups.

In Nauman's and Acconci's video environments, the viewer acted as a substitute for the artist's own performative presence, often encouraged to repeat in public an action that the artist had made previously in the private studio space. For example,

Nauman's *Performance Corridor* (1969) was originally a prop for his performative video *Walking with Contraposto,* shot in his studio in 1968. The corridor prop was represented as an artwork that the viewer was asked to enter. In *Live/Taped Video Corridor,* a video camera and monitors were added to a similar structure, making the viewer's sense of self-awareness and unease in the space more intense. Jonas, by contrast, performed live, often with several other artists and dancers. Simone Forti, Keith Sonnier, Charlemagne Palestine, Gordon Matta-Clark, Richard Serra, Susan Rothenberg, Julie Judd, and Jackie Winsor all participated in Jonas's performances, both indoors and outdoors. In her video performances, the self was not split between one action by the artist in the past and another by a viewer in the present, as in Nauman's and Acconci's work, but split simultaneously, between artist and other performers and, in two video performances, *Organic Honey's Visual Telepathy* and *Organic Honey's Vertical Roll,* between the artist and her alter ego, Organic Honey.

In all Jonas's video performances, live action took place alongside projected video and film images of taped performance action. This splitting of the image in space as a device to represent multiple time and space relates directly to Dan Graham's mirrored video environments. At one point during *Organic Honey's Visual Telepathy* Jonas, as Organic Honey, wearing a mask, feather headdress, pearls, and silk patterned robe, hit a mirror repeatedly until she broke her image. At the same moment, on the recorded video projection the audience saw a reflection of her face in the mirror without the mask. The split self was revealed by the inserting of mirror planes within a juxtaposition of real and recorded time and space.

There is a peculiar resonance between these pivotal works of the seventies and certain works by artists of a new generation working in the nineties using the projected film or video image, such as Gary Hill, Stan Douglas, Douglas Gordon, and Liisa Roberts. This resonance coalesces around the issue of space. In Gary Hill's *Tall Ships,* soft black-and-white projected video images of people appear on the walls of a long dark corridor, walking silently forward as the viewer approaches them. *Tall Ships* shares many of the properties of seventies video pieces: the viewer's uncertain movement through a disorienting space, instant feedback, psychological engagement, and a profound self-consciousness of one's physical and emotional reactions. But unlike the early, aggressive confrontational pieces, this installation is inclusive rather than existential. It creates another kind of confrontation: that of the self with a deeper level of consciousness, in which the specifics of one's own behavioral responses are overtaken by the awareness that "we are inseparable from this total space inhabited by other beings with whom we share the same field of possibilities. This is the field in which, ultimately, *we* are the actual medium of the piece."[17]

In the work of both Douglas Gordon and Liisa Roberts, by contrast, the image is contained within flat screens inserted as planes into a partially lit three-dimensional space. In Gordon's *Between Darkness and Light (after William Blake)* (1997), a site-specific commission for the Münster Sculptur Projekt, a large screen bisects the underground passage of a pedestrian subway. On each side, videotapes of two Hollywood

films are projected: *The Exorcist* (1973) on one and *The Song of Bernadette* (1943) on the other. Each film depicts the struggle between the opposing poles of good and evil, a recurrent theme in Gordon's work, and the imagery from both bleed into one another. The subway space functions as a metaphorical purgatory, in which the struggle is played out. It is not avant-garde film, but Hollywood, to which Gordon's video installation, cinematic in both content and format, refers. Unlike the utopian expanded film environments of the sixties, this installation appears democratic and pragmatic, operating somewhere between the living room, the cinema, and the street. In format, it echoes Michael Snow's film installation *Two Sides to Every Story* (1974), in which two 16mm film loops were projected onto both sides of an aluminum screen suspended in space. But the bleeding of Gordon's film images into one another appears to represent the collapse not only of the illusory wholeness of the film image, but also of the physical boundaries between the once opposite media of film and video.

In the installations of Liisa Roberts, constructed physical and conceptual spaces, of which film forms a central component, use the screen to suggest another, metaphorical space. In a reversal of the traditional cinematic experience, in which the viewer becomes absorbed by the image, Roberts reveals the viewing of the film to be a self-conscious act. In *Trap Door* (1996) this is achieved by a triangular sculptural construction of square screens, onto which three black-and-white images of women's hands moving in conversation, filmed in extreme slow motion, are back projected. The filmed hands echo the triadic communication on another, panoramic, screen opposite, in a slow circling black-and-white shot of a statue of the Three Graces, as though trying to reconstruct the image in another form. The perpetual attempt to reconstruct the image taking place on both screens prevents the viewer from entering either image fully. Roberts's use of space is both sculptural and conceptual. Although formally very different in structure, her installations bear some relationship to the phenomenological video constructions of the seventies, in her resituating of the viewer in order to question the structures underlying the organization of social space.

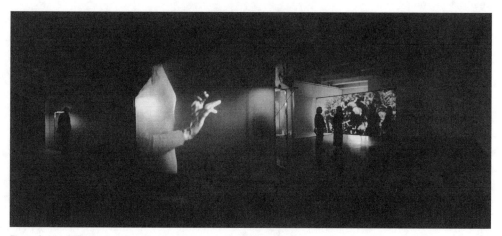

Figure 3. Liisa Roberts, *Trap Door,* 1996. Installation view at Documenta X.

While the utopianism of both the expanded cinema environments and the earliest experiments with video live-feed transmission of the sixties has metamorphosed into the interactive virtuality of Internet communication, the more pragmatic questions raised in the performative video structures of the seventies continue to exert a strong influence on a new generation of artists showing a rigorous concern with conceptual and spatial issues. As the languages of video and film have become increasingly conflated, the specific physical, perceptual, and spatial possibilities offered by both media in their original physical forms are being readdressed by a new generation of artists. As in the sixties and seventies, film and video space has become the location of a radical questioning of the future of both aesthetic and social space.

Notes

1. See Gene Youngblood, *Expanded Cinema* (New York: Dutton, 1970).

2. Les Levine, "Closed Circuit Television and Teledynamic Environments," in ibid., 337.

3. Ibid., 339.

4. Kate Linker, "On Language and Its Ruses: Poetry into Performance," in *Vito Acconci* (New York: Rizzoli, 1994), 18–63. Linker gives a thorough account of the importance of psychological writings for Acconci's work in performance and video.

5. Paul Schimmel, "Pay Attention," in *Bruce Nauman,* ed. Joan Simon (Minneapolis: Walker Art Center, 1994), 77.

6. Robert Smithson, "Entropy and the New Monuments," in *Robert Smithson: The Collected Writings,* ed. Jack Flam (Berkeley and Los Angeles: University of California Press, 1996), 11.

7. Gregory Galligan, "The Self Pictured: Manet, the Mirror, and the Occupation of Realist Painting," *Art Bulletin* 8, no. 1 (March 1998): 139–48.

8. Jonathan Crary, *Techniques of the Observer: On Vision and Modernity in the Nineteenth Century* (Cambridge: MIT Press, 1990), 95–96.

9. Galligan, "The Self Pictured," 140.

10. Ibid.

11. David Hall made a number of important video installations in London during the mid-1970s and is a highly significant figure for the history of British video installation and single-channel videotape.

12. Peter Campus, "The Question," in *Art-Rite,* no. 7 (autumn 1974), 15.

13. Dan Graham, "Essay on Video, Architecture, and Television," in *Dan Graham: Video, Architecture, Television* (Halifax: Press of Nova Scotia College of Art and Design; New York: New York University Press, 1979), 62.

14. Birgit Peltzer, "Vision in Process," *October,* no. 10 (fall 1979): 107.

15. Douglas Crimp, introduction to *Joan Jonas, Scripts and Descriptions, 1968–1982,* exhibition catalog (Berkeley: University Art Museum; Eindhoven, Netherlands: Stedelijk Van Abbemuseum, 1983), 8.

16. Christine Poggi, "Vito Acconci's Bad Dream of Domesticity," in *Not at Home: The Suppression of Domesticity in Modern Art and Architecture,* ed. Christopher Reed (London: Thames and Hudson, 1996), 237.

17. George Quasha in dialogue with Chuck Stein, "Tall Acts of Seeing," in *Tall Ships: Gary Hill's Projective Installations, No. 2* (Station Hill Arts, Barrytown, Ltd., New York: 1997), 24.

15. The Machine in the Museum; or, The Seventh Art in Search of Authorization

Bruce Jenkins

I don't believe in film as a medium for visual art.
—Jan Dibbets

One attends the cinema *en passant*.
—Arnold Hauser, *Naturalism, Impressionism, the Film Age*

Despite the precise parameters that define their rejections of cinema (as a medium for visual art or one for critical contemplation), the Dutch artist Jan Dibbets and the Hungarian cultural historian Arnold Hauser give voice, in the epigraphs to this chapter, to a much broader, systemic disavowal of the medium: film is undoubtedly visual, but is it art? This, of course, as Walter Benjamin understood more than a half century ago, is the wrong question. The right one asks, rather, how the existence of film has redefined the very way in which we understand the work of art. More than fifty years after Benjamin's death and a hundred years after the birth of cinema, however, film continues to reside—now in the company of video, holography, and new forms of computer-based imaging—on a fault line discernible only well below the surface of the art-world infrastructure. It periodically rises to the surface, as when it is briefly embraced by artists who, in their youthful defiance of the procedures and proprieties of art-making, intuitively take up moving images for their disruptive potential. But, intrinsically difficult to display, market, or collect in the manner of more traditional art forms such as painting or sculpture, these experiments invariably recede into that art-historical netherworld in which they may be occasionally viewed, "en passant."

On the eve of the centenary of the cinema, it is perhaps an appropriate moment to reassess the place of the moving-image arts within the wider body of visual arts

practice and to examine their access to the institutional resources of the museum. This inquiry is less about the actual presence (or more frequently absence) of film, film departments, or screening facilities within particular museums—although it is this, too—and more a reflection on the hoarse whisper of the cinematic (and in more recent times, the videographic) voice within the aesthetic discourse of the museum.

The desire for inclusion within the museum, for parity with contemporaneous visual and plastic arts, rarely has been articulated by filmmakers themselves, although they have often wrestled with and sometimes succeeded in subduing some of the most challenging aesthetic concerns facing the visual arts. Even among video-installation artists, relatively recent arrivals on the art scene who have on occasion found a measure of institutional acceptance, frustration often outstrips theory. Typical is the succinct syllogism of the Spanish installation artist Francesc Torres, who rather baldly assesses matters as follows:

> Despite the tools available to art through technology, the art world hangs on to its conventional practices and aesthetic strategies. Thus technology-based art exists in a marginal area in a technology-based society. Seen in light of this century's history, science and technology are perceived more as deliverers of death and ecological crime than as purveyors of insight and well-being. Within this perceptual frame, technological art is seen in an unflattering light while the traditional arts are viewed as a redoubt of the human spirit.[1]

Before the electronic age and the array of technology it has made available for art, however, there was the machine age, which gave rise to the cinema and its photographic predecessors. Film emerged in the final years of the nineteenth century and exhibited an endemic interest in the increasingly machine-laden landscapes of the early twentieth century, as the links between the kinetic and the cinematic, between this new communications medium and new modes of travel, forged a natural partnership. This fascination seemed to culminate in *The General* (1927), Buster Keaton's sublime reflection on the pitfalls and possibilities of the individual ("a minuscule dot encompassed by an immense and catastrophic milieu") in a mechanized world.[2] Nearly half a century later, the artist and cineaste Marcel Broodthaers reflected on this fundamental aspect of early cinematic practice by producing in 1972 a film fiction (a parallel to his museum fictions) in the form of a movie poster for an unmade film, *Ein Eisenbahnüberfall*. This work, appropriately produced as a multiple, consists of still photographs framed by sprocket-holed borders that picture specimen scenes in which the artist and an accomplice, in frock coats and hats, wait alongside a railroad crossing for the eventual arrival of a train.

Throughout the history of modernism in the visual arts, the machine has served as subject matter, but for the machine-based media (e.g., still photography, silk screen, metal fabrication, assemblage), institutional acceptance within the museum has been achieved only through a most ingenious array of disguises and dissimulations—elegantly abstracted in the photography of Paul Strand, caricatured in the sculpture of

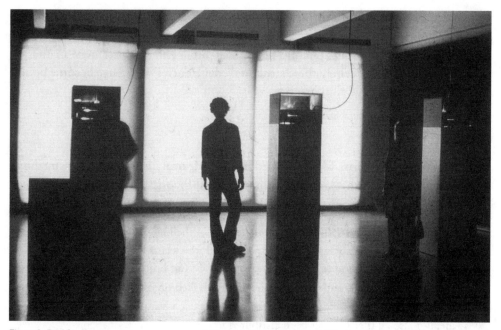

Figure 1. Paul Sharits, SYNCHRONOUSOUNDTRACKS, installation view from Walker Art Center, 1974. Courtesy of the Walker Art Center; reprinted by permission.

Jean Tinguely, appropriated as cultural iconography in the large canvases of James Rosenquist, in ruins and exhausted in the metalworks of John Chamberlain, and most recently, expressionistically caricatured in the sculptures of Anselm Kiefer. A revealing history of modernism could be told in the elaborate strategies employed by artists and institutions to counter and deform the machine and mass-produced culture in general.

There have been less than successful attempts, however, at bringing the cinema into the gallery and into the museum collection. Like still photography, film is a mechanically reproducible medium, but unlike the photograph, a film is not detachable from its machine source. Rather it can be seen only if it remains tethered to a version of the apparatus that originally produced the work. Unhooked from its machine, a film is lifeless and empty, as Joseph Beuys demonstrated when he created a multiple of lead-clad reels from Ingmar Bergman's *The Silence*. The occasions on which film has entered the collection of the art museum often find the ludicrous specter of its elements similarly exhibited in vitrines like moon rocks or relics from some alien culture, reduced to an objecthood ontologically at odds with its true aesthetic nature (be it Jean-Luc Godard's "truth twenty-four times a second" or Stan Brakhage's "visionary experience").

Film as a mechanical medium has been less than readily accepted within the museum or within the art-historical discourse of modernity, perhaps because of the ominous associations that Torres described in connection to the uses to which allied technologies have been put in this century and perhaps because of mainstream cinema's

undeniable complicity in the wholesale transmission of repressive ideologies dressed in the glamour of the silver screen. Beyond these global dispositions, however, there are a number of structural, systemic biases that hinder its advancement in the art world. Curiously, it is precisely these structural "deficiencies" that have become points of departure for advanced film practice.

Illusionism

As a camera-based art form, film is defined by the indexical illusionism of the medium and as such remains, as the American filmmaker and theorist Hollis Frampton noted, "ontologically manacled" to its referents:

> [W]e are accustomed to deny them [photographs], in their exfoliation of illusion, the very richness of implication that for the accultured intellect is the only way at all we have left us to understand (for instance) paintings. To put it quite simply, a painting which may be, after all, nothing but some paint splashed on canvas, is comprehended within an enormity which includes not only all the paintings that have ever been made, but also all that has ever been attributed to the painterly act.[3]

A photograph, however, is just a photograph, and by extension the products of the other camera arts are merely films and videotapes rather than, as Frampton posits for the plastic arts, "abundant metaphor[s] for one sort of relationship between the making intelligence and its sensed exterior reality."[4]

Marcel Duchamp's *Anemic Cinema* (1926) seized precisely on this aspect of film—its aesthetic void—through an extraordinary hyperbolization of both the spatial illusion of depth it achieves and the flat screen space of its projection. *Anemic Cinema* literalizes and cartoons the material workings of silent cinema—its mix of palpable three-dimensionality and the obligatory book-space passages of intertitles—suggesting a Faustian bargain in which the medium sacrifices interpretive depth for the visceral illusion of depicted depth. For Duchamp the cinema is a bloodless body, a spectral presence that has been robbed of both interiority and aesthetic dimension.

The legacy of Duchamp's critique can be seen in a number of underground films of the 1960s and, in particular, in the interest in "expanded cinema" forms that developed powerful renunciations of the necessity of illusionism. These films activated the space of projection and by emptying the content of the image focused attention on the presentational rather than the representational. Tony Conrad's stroboscopic *The Flicker* (1966), for example, which had its origins in the arena of Fluxus and concrete music, introduced a singularly nonillusionistic and yet powerfully kinetic film form. A similar cinema was referenced in Peter Kubelka's ironic, imageless "portrait" film, *Arnulf Rainer* (1958–60). The imageless cinema has remained an area of particular interest to both visual and conceptual artists, beginning with the "white films" of Takehisa Kosugi and Nam June Paik in the 1960s and continuing with more contemporary works, such as a totally overexposed "landscape film" by the Belgian artist Mark

Figure 2. Marcel Duchamp, *Anémic Cinéma,* 1925. Courtesy of the Museum of Modern Art/Film Stills Archive.

Luyten or the late English artist and filmmaker Derek Jarman's sublimely monochromatic autobiography *Blue* (1993).

Such film projects may have engaged issues of representation and materiality germane to the visual arts, but they have entered the museum only occasionally and, of course, "en passant." On rare occasion, a film has managed to make it intact into the gallery—in the form of installation, of course—as is the case in the Walker Art Center's acquisition in the early 1990s of a piece by the Irish artist James Coleman entitled *Box (Ahhareturnabout)* (1977). The work consists of a continuous projection of a seven-minute film loop made by adding segments of black leader to appropriated newsreel footage of a 1927 boxing match between Jack Dempsey and Gene Tunney. By adapting some of the extracinematic aspirations of expanded cinema, Coleman's rectified found footage creates a compelling metaphor for the experience of the medium. The presentational assaultiveness of the flicker highlights the materiality of the projection while the representational assault captured on the original footage metonymically references the ur-narrative of all illusionist cinema in the conflict of the boxers. But *Box* equally describes its own physical dimensions, which mime in miniature the specifications for all cinemas: the piece's sculptural dimension as a spatial configuration—an installation, a container, a "box"—brings spectator and spectacle together. It is here that the final element, the work's sound track, comes into play, introducing both the mediating figure of the artist (whose hoarse voice and breathing are heard throughout the piece) and the presence of the machine (given voice through a rhythmic thud marking each shot transition). Together, these announce the work's attempt to realize an enduring metaphor of avant-garde cinema in which this most exterior of art forms provides access to the depth of an artist's interiority and consciousness. In *Box,* as we watch an external historic moment flash past, we are simultaneously privy to the excited, libidinous voice of the artist responding to the imagery in a manner that is powerfully suggestive of the process of inner speech—that ongoing inner dialogue that gives voice to consciousness and maps the moment-by-moment attempts to interpret actuality within the matrix of memory and anticipation. At such moments, we are accorded an aesthetic experience as rich and varied, as visceral and intellectually engaging, as those proffered by the paintings and sculptures in the adjoining galleries of the museum.

Temporality

Film is as much a temporal art as it is a visual one. Within the simplest linear narrative, there are at least four determining temporal layers, including the story time, the time of its telling, the time of production, and the actual running time of the film. This multiple temporality is shared by video and remains one of the fundamental constraints on the reception and integration of film, video, and their installation forms into the galleries of art institutions. Media scholar Margaret Morse notes that "[a]s a spatial form, installation art might appear to have escaped the ghetto of time-

based arts into the museum proper," but even with the privileging of the visual over the temporal and the reduction of video elements to brief repeating cycles, moving-image installations maintain a temporality at odds "with the dominant mode of perceiving in museums and galleries."[5]

One of the first artists to address the issue of detemporalizing the cinema was the American Joseph Cornell. In his first collage film, *Rose Hobart* (1939), Cornell attempted to counter the dominant cinema's temporal structures, grounded as they are in Aristotelian unities (space, time, action), theatrical dramaturgy (conflict, repetition, resolution), and the patterned narrative of folktales (equilibrium, disequilibrium, equilibrium). Made by radically reediting a Hollywood B film, *East of Borneo* (1931), which features the actress Rose Hobart, substituting recordings of Caribbean-style dance music for the film's original sound track, and tinting the black-and-white footage a roselike hue, *Rose Hobart* reverses the typical relationship between decor and narrative (where the former is exhausted in its service to the latter) and shifts attention from plot and story to gesture, costume, and set design in creating a de-plotted, reversible meditation on the image.

This interest in film as decor is taken up again in the work of experimental filmmakers in the 1950s and early 1960s, particularly in the underground films (or what Jonas Mekas presciently termed the "Baudelairian" cinema) of Ken Jacobs, Ron Rice, and Jack Smith. Their work—particularly Smith's notorious *Flaming Creatures* (1963)—met with almost immediate resistance: they were as likely to be banned from the avant-garde circles at Knokke-Heist as busted by the New York City vice squad. This criminality had less to do with the depiction of male nudity and more to do with a full frontal assault on linearity, coherence, and closure. Films like Jacobs's *Blonde Cobra* (1958–63), Rice's *The Atom Man Meets the Queen of Sheba* (1963), and Smith's *Flaming Creatures* were by turns fragmented and endless, obsessive, and detached. Jacobs best characterized such work in terming *Blonde Cobra* "an erratic narrative—no, not really a narrative, it's only stretched out in time for convenience of delivery."[6]

A converse development in temporality, which also derived from Cornell, brought visual artists out of the gallery and into the cinema. The American painter Robert Breer, for example, conducted experiments (including *Image by Images I* [1954], a film loop in which every frame contained a different image) that temporalized his abstract compositions and led him into a career in experimental animation. The West Coast artist Bruce Conner began in the late 1950s working with found film material (much as he had deployed found materials into his sculptures and assemblages) and subsequently devoted much of his career to the production of collage-based experimental films. In addition to his reinvigoration of the found-footage film (a form that he redefined in his seminal *A Movie* [1958]) and prefiguring by two decades the emergence of music videos, Conner produced a key film installation, also recently acquired for gallery installation by the Walker Art Center, that may well emerge as the missing link between artist film and video art. *Television Assassination* (1963/1975) consists of an 8mm film projected onto the whited-out screen of a vintage 1950s television set; it

repeats in slow motion footage of the televised assassination of Lee Harvey Oswald, a shooting that appears choreographed for the camera and that captured the tele-attention of the nation. Like Andy Warhol's use of serialized imagery in works like *Sixteen Jackies* (1964), Conner probes the formal aspects of the medium—its reproducibility, its endless repetitive potential—to create a work that extends the implied temporality of Warhol's painting into a concrete temporality in the gallery space. By opting to explore these issues within the context of the originating moving-image media, and thereby effectively short-circuiting the art-making/art marketing network, Conner anticipates Dan Graham's early work with mass-circulation publications.

Collaborative Production/Multiple Products

The social historian Arnold Hauser recognized the challenge that film production posed to artists—namely the "unusual and unnatural" situation of an artistic enterprise based on cooperation—and pronounced it "the first attempt since the beginning of our modern individualistic civilization to produce art for a mass public."[7] While Hauser based his speculations on the workings of the commercial cinema, even a non-commercial, independent film made by an individual artist for a modest-sized public involves some measure of collaboration at each level of production—from the chemistry of the emulsion on the film stock to the optics of the camera lens to the lab work of developing and printing versions (work prints, answer prints, release prints) of the finished work.

The collaborative origins of the medium are matched in the nature of the finished work, which consists of unlimited multiples. Walter Benjamin prophetically read this aspect of the cinematic enterprise as changing the very nature of the work of art. It did not, however, change the nature of the art marketplace. It is not surprising, then, that film would be embraced most readily by artists associated with a loosely collaborative movement like Fluxus, which often engaged in comic combat with the forces most resistant to the Benjaminian shift, namely the commercial galleries, private and corporate collectors, and art museums. Fluxus impresario George Macunias, who had overseen the production and assembling of several dozen short Fluxfilms, recognized the corrosive potential of film when in attempting to find something of scale to install within the gallery spaces for exhibitions, he proposed in 1967 a multiscreen film-installation piece, a Fluxus *Film Wallpaper*, which would bring together within a single viewing area loops of the Fluxfilms, works that had already registered a significant assault on convention.

A different type of collaboration is evident in filmmaker Chantal Akerman's massive film and video installation *Bordering on Fiction: Chantal Akerman's D'Est*. Based on *D'Est* (1993), her feature-length observational film that focuses on aspects of daily life within countries of the former Soviet bloc, the work engages in a dialogue about film and ideology. Although conceived as a gallery-based, artist-produced work, Akerman, in choosing to speak in the language of the cinema, has had to make use of

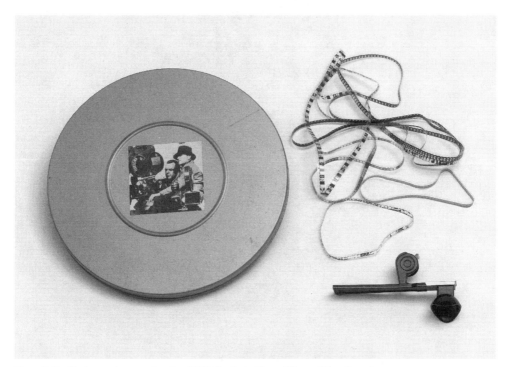

Figure 3. Fluxfilm loops, viewer, and reel, c. 1966. Courtesy of Larry Miller and Sara Seagull.

both the technology (cameras, tape recorders, lights, dollies, cables) and the techniques of the collaboratively produced film. This is not, therefore, sculpture that contains moving images, but rather a movie (with all that practice connotes) reconceived and deconstructed for spatial contemplation within the gallery.

In the early 1980s, the French director Jean-Luc Godard participated at the Walker Art Center in a dialogue about his films in which he screened excerpts of his work alongside clips from several Hollywood films. Following the presentation, someone in the audience raised a hand and acknowledged the significance of Godard's work, but questioned the logic of including the American films the questioner apparently found sadly lacking—the work of Otto Preminger being dated and boring and Jerry Lewis seen as silly. Godard responded that the audience member was mistaken and that Godard's own films were barely equal to the ones by the Hollywood directors. And he concluded with an analogy appropriate for the event's setting within an art museum: "Otto Preminger . . . is Monet," he proclaimed. "And Jerry Lewis . . . is Robert Rauschenberg."

Such a perspective, however extreme, can lead, nonetheless, to speculation on the expanded exhibitions (not to speak of art histories) possible when film enters the gallery—when René Clair and Luis Buñuel rejoin Marcel Duchamp and Max Ernst; when the kinetic abstractions of Mary Ellen Bute and Oskar Fischinger are shown with the canvases of Jackson Pollock; when Frank Tashlin's satires mingle with Robert Rauschenberg's combines; when Paul Sharits's kinetic film installations are placed ad-

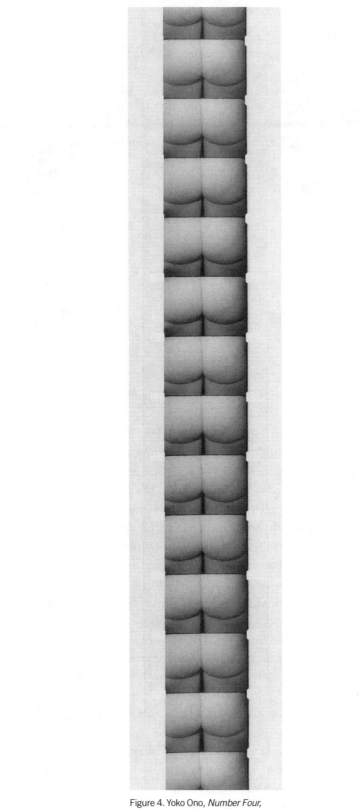

Figure 4. Yoko Ono, *Number Four,*
c. 1966. Courtesy of the artist.

Figure 5. Hollis Frampton, *A Cast of Thousands*, 1961, plaster cast. Black-and-white photograph from *The Nostalgia Portfolio* (1971). Courtesy of the estate of the artist.

jacent to the lightworks of Dan Flavin and James Turrell; when the works of Hollis Frampton converse with the texts of Joseph Kosuth; when the visual practice of Man Ray, Fernand Léger, Charles Sheeler, Paul Strand, Joseph Cornell, William Klein, Andy Warhol, Wallace Berman, Dieter Rot, Alfred Leslie, Bruce Conner, Jan Dibbets, Marcel Broodthaers, Lawrence Weiner, Richard Serra, Joan Jonas, and Kiki Smith reconnects with their filmmaking; when modernity and postmodernity are animated by the vitality of the seventh art.

Notes

This essay, based on a lecture given in January 1994 at the Witte de With Center for Contemporary Art in Rotterdam, originally appeared in *Witte de With Cahier No. 3* (Rotterdam: Witte de With Center for Contemporary Art; Düsseldorf: Richter verlag, 1995). The essay is dedicated to the memory of Paul Sharits (1943–93), an American artist and filmaker who created a body of extraordinary moving-image works for both the gallery and the screen. I wish to acknowledge the Jerome, Dayton Hudson, and General Mills Foundations for a travel and study grant and the Cité International des Arts in Paris for providing me a residence during the grant period. Finally, I wish to thank Chris Dercon, former director of the Witte de With, for the opportunity to formalize these ideas into an essay, the current director Bartomeu Mari and his assistant Barbera van Kooij for their kindness in approving this republication, and the critic Nelly Voorhuis for her good counsel.

1. Francesc Torres, "The Art of the Possible," in *Illuminating Video: An Essential Guide to Video Art,* ed. Doug Hall and Sally Jo Fifer (New York: Aperture, 1990), 208.

2. Gilles Deleuze, *Cinema 1: The Movement-Image,* trans. Hugh Tomlinson and Barbara Habberjam (Minneapolis: University of Minnesota Press, 1989), 173.

3. Hollis Frampton, "Meditations around Paul Strand," in *Circles of Confusion: Film, Photography, Video: Texts, 1968–1980* (Rochester, N.Y.: Visual Studies Workshop Press, 1983), 129–30.

4. Ibid., 130.

5. Margaret Morse, "Video Installation Art: The Body, the Image, and the Space-in-Between," in *Illuminating Video,* ed. Hall and Fifer, 166.

6. Ken Jacobs, "Program Notes," in *Films That Tell Time: A Ken Jacobs Retrospective,* ed. David Schwartz (Astoria, N.Y.: American Museum of the Moving Image, 1989), 16.

7. Arnold Hauser, *The Social History of Art, vol. 4: Naturalism, Impressionism, the Film Age,* trans. Stanley Godman (New York: Vintage Books, n.d.), 250.

16. "No Guarantees, They're Wolves": Structure, Movement, and the Dystopic in Diana Thater's *China*

Colin Gardner

Diana Thater's *China*, an installation for six synchronized video projections, including a pair of supplemental monitor works, derives its title from the name of the female half of two trained wolves—China and Shilo—who appeared together in the successful film *White Fang II*. Like most of Thater's projects, *China* pitted an element of "raw" nature[1]—the atavistic, savage animalism of wolves—against the controlled, structured environment of the man-made. In this case, the latter focused on the theatricality of the trained wolves as they were put through their thespian paces in a discrete, real-time "performance," as well as the complex structuring mechanisms of the recording and projection apparatuses themselves. In this sense *China* continues Thater's ongoing deconstruction of the tropes of the sublime by pushing its structural logic to the verge of collapse. It is out of the ruins of structured sublimity that the true art of Thater's work emerges.

China can be divided into at least four different movements, both in the sense of spatiotemporal multiplicities and as loose musical divisions. The first consists of the real-time, unmediated performance of the two wolves as they were asked to perform a specific instruction by their trainers under the controlled conditions of a fenced-in "park" where many animal sequences have been filmed. Thater asked the trainers to try to get the wolves to do the one thing that they find the most difficult: namely, to stand still for as long as possible. This act was recorded by Thater in simultaneous time on six video cameras that encircled the wolves. Each camera was placed exactly opposite another camera so that they composed three pairs. In this way every camera was always filming its opposite number within the circle.[2]

As for the performance itself, Shilo, the male, is much older than China and far more experienced as an "actor." He is also suffering from arthritis in his hind legs, so

that his incapacity actually made it much easier for him to perform the allotted task. China, in contrast, is young, frisky, and undisciplined. As Shilo stood stoically on his mark, China spent much of the shoot running around the perimeter of the circle, sniffing the legs of the camera operators. There are no guarantees here: after all, they're wolves. In fact, much of the wolves' theatrical "discipline" is achieved by providing them with a constant supply of meat. At one point, the trainers ran out of food, and like good members of the Screen Actors Guild, China and Shilo went "on strike" and refused to perform. Chaos ensued until more meat was brought. There was also a fight between the wolves when China's trainer inadvertently fed meat to Shilo, a serious breach of the exclusivity that exists between trainer and wolf. (Parallels to the contractual relationship between Hollywood actors and their agents comes to mind, yet another example of our tendency to anthropomorphize and socialize animal behavior in the light of human experience.) As the performance degenerated, the cameras began to run out of tape (each magazine lasted sixty minutes), the structural-durational cue for Thater to shut down the shoot.

The second and third movements of the work are the overt imposition of a narrative and spatiotemporal structure on the raw, unedited footage of the performance and its subsequent organization into a projected installation. The latter's spatial parameters took the form of six video projectors arranged in a circle facing one another. This setup clearly mimics the circular arrangement of the video cameras during the shoot, except in this case the images were projected across their opposite number in the circle onto the surfaces and walls of the gallery space itself. In this way, we achieve an inside-out inversion of the original shoot, so that the projectors—and by extension, the spectator—take the interior position of the wolves, while the projected images of Shilo and China are now on the outside periphery of the gallery space, akin to where the camera operators used to be. This allowed Thater to produce several overlapping spatial and temporal frames (multiplicities) as we moved from the performance through its recorded mediation to its eventual presentation as an installation, interactive with the spectator's body. However, instead of the conventional Hegelian "overcoming" of the dialectical conflict between the different movements within the work, *China* produced an impasse, a stalled movement that called for another type of reconstruction, as we find ourselves positioned spatially as a form of becoming-wolf. In order to literally become wolf however, we must think in terms of multiplicities of duration rather than space.

Thater divided the projection itself into three temporal segments, lasting a total of twenty-eight minutes. The first (four minutes) consists of footage shot by all six cameras as they were being set up on their tripods—a sort of Brechtian overture in which the structuring device is bared and the apparatus metacommunicates itself. The six projected images are displayed in full color and appear at first glance to be shown in real time. We see six different views of the park, swirling and swishing from upside down to right side up as the cameras are pulled from their cases and fixed and steadied on their tripods. However, we suddenly spot China running backward through two of

the images, suggesting that what we are actually seeing is not the beginning of the shoot in forward motion but its end projected in reverse. We are thus watching the end first, the cameras being dismantled, not set up. The Brechtian distantiation or *Verfremdungseffekt* is thus itself shown to be a deceit, the defamiliarization itself defamiliarized. We are thrust into a time frame that immediately announces itself as discontinuous, segmented, artificial. Moreover, closer inspection discloses that the six segments are not running at the same speed. In order for all six apparent "setups" to end at exactly the same moment, their durations had to be synchronized with the longest. What appears to be a uniform spatial multiplicity thus turns out to be a discontinuous durational flux.

The middle segment (nineteen minutes) begins as soon as the cameras are fixed on their tripods. The wolves are not yet visible, so we in fact see a projected circle of six camera operators, placing ourselves in the ostensible position of the wolves in the original shoot. The full-color of the "overture" now changes to six images separated into the primary and secondary colors of the video apparatus itself. We thus move around the periphery of the space through yellow, cyan, green, magenta, red, and blue as the wolves appear and the trainers attempt to make them stand on their marks. The effect is actually quite disconcerting, because apart from the multiplication of the image into six different colors, we find a number of discrepant spatial movements. While the camera operators and Shilo's attempts to stand on his mark ground us with six fairly fixed points, the peripatetic China's rotation around the circle of cameras creates an unstable movement that encourages us to follow. We move around the room to pursue her trajectory. Occasionally, we are surprised when she disappears and then reappears quite unexpectedly in and out of frame where the overlap of neighboring cameras' fields of vision is not quite seamless. All the while, the fixed points of the cameras keep us rooted to the structure of the circle, so that we get a type of vertigo akin to car sickness, where vehicular movement vis-à-vis the landscape and the stasis of the interior coincide.

We also discover a gestic parallelism in the structure of the apparatus itself. Given the circular arrangement of the projectors and their breakdown into primary and secondary colors, cyan appears to be in dialogue with its projected opposite, red, yellow with magenta, blue with green, as if the structural parameters of video's material makeup had been appropriated for the spatial segmentation of the piece as a whole. Shilo and China's bodily movements are thus not only structured by a social gest derived from the theatrical conventions of humans, but they are doubly determined by the representational breakdown of the apparatus as a whole. However, there is also a fourth movement going on in the work, produced by the duration of our own bodies. As spectators and participants in the installation, we intervene spatially between the projectors and the walls, casting shadows on the projected image, interjecting our own movements with those of China and Shilo. In fact, if we stand exactly in the center of the circle of projectors, we are projected into every shot, transformed literally into a multiplicity. This shared projected space is the second instance of our becoming-wolf,

in this case less through analogy than via inclusion in the same space-time image as the wolves.

There is a danger here of reducing Thater's strategy to a pure aestheticism, in the Nietzschean sense of an overcoming of difference through an expansion of art to include all states of being. However, the elements that constitute Thater's work, including the spectator's real body, the representational bodies of viewer, wolves, camera operators, and apparatus, are far from interchangeable simulacra within a hermetically sealed aesthetic artifice. We are never locked into an all-encompassing aestheticism that has no outside, because the exterior world is always willfully apparent in Thater's work. In this case, the uneven parameters of the gallery (a temporary interior wall disrupts the perfect symmetry of the four permanent walls), the refusal to mask off doors and windows, means that the projections always compete with the functional architecture of the building. In fact, at any moment we could walk to the windows and look out on the University of Chicago campus below. Yet, and this is an important point, the real world does not stay unmediated. Thater tints the glass of the windows so that the color-separated images can themselves mediate how we see the campus. The outside world might intrude on the installation, but the world of art recolors how we view the outside world. The dialogue is always a two-way expression between multiplicities.

The fight between China and Shilo is the structural cue for the beginning of the third and final segment (five minutes). Now, the images are no longer projected simultaneously but sequentially. The image swirls around the room once per second, so that each projector gives us five frames or one-sixth of a second of its individual color. The two wolves' return to more conventional atavistic behavior is thus the stimulus for the apparatus to "let its hair down" and break free from the static projections of its primary and secondary colors into a synchronized movement, an animated spatiality that creates a strobic effect. It's as if the apparatus had also partially become animal, at least as far as its rigid structure would allow.

In *Time and Free Will* (1889), Henri Bergson distinguished between *two* kinds of multiplicity: one objective, actual, spatial, and discontinuous, the other subjective, virtual, temporal, and continuous. When we touched on the subject of a multiplicity, it was defined largely in terms of spatial parameters,[3] whether it be the real time of the performative space (the park) or the discontinuous time of the installation space (the gallery). This multiplicity, related to our inclusion in the same space-time image as the wolves, clearly needs to be read as spatial *and* durational. Thater employs both types simultaneously in almost all of her installations, and an understanding of the second multiplicity, and its fluid imbrication with the first, is crucial in any analysis of her work.[4]

Becoming-animal with respect to the first, quantitative multiplicity primarily involves the static and simplistic substitution of ourselves for the wolves in front of the camera, implying only two states of being at any one time, either human or animal. Becoming-animal for Bergson (and by extension, Deleuze), however, would not entail

being caught in the extremes of either state, so that instead of a clear demarcation between man/transitional state/animal, there would be a dynamic movement of becoming in and of itself. Becoming other is never defined in relation to an outside identity but is always *internal* to itself, fueled by a creative evolutionary movement that Bergson variously called "intuition" or "élan vital." Unlike the Platonic or Hegelian model, where the motor of becoming other is external, determined by its destination—the Good as final cause—for Bergson, difference is the thing itself. There is no longer room for it to receive difference from its end or from its outside in dialectical fashion. In fact the dialectic is not needed at all because Bergson has no conception of opposites, merely internal differences-as-multiplicities.

Instead of the One and the Multiple, then, there are the two types of multiplicity. As Deleuze points out:

> One is represented by space. . . . It is a multiplicity of exteriority, of simultaneity, of juxtaposition, or order, of quantitative differentiation, of *difference in degree*; it is a numerical multiplicity, *discontinuous and actual.* The other type of multiplicity appears in pure duration: it is an internal multiplicity of succession, of fusion, or organization, of heterogeneity, of qualitative discrimination, or of *difference in kind*; it is a *virtual and continuous* multiplicity that cannot be reduced to numbers.[5]

In simpler terms, this second multiplicity is pure duration, a flow/becoming of internal mutation that cannot be carved up or segmented into isolatable units, the way, for example, we divide up duration into time units such as years, months, days, hours, and seconds.[6] It is what Bergson calls "a qualitative multiplicity, with no likeness to number; an organic evolution which is yet not an increasing quantity; a pure heterogeneity within which there are no distinct qualities. In a word, the moments of inner duration are not external to one another."[7] Virtual and actual, subject and object, are no longer posited as inside versus outside, but as attributes of interiority, qualified by this internal process of differentiation. Being differs with itself internally and transforms itself through creative affirmation. Within Deleuze's extended schema, the latter is as much libidinal and instinctual as it is consciously constructed.

Thater's project appropriates and uses these two types of multiplicity, playing off the characteristics of pure, qualitative duration (represented by the two wolves in real time) and those of segmented, spatial time (represented by the structuring powers of the apparatus). It is significant that in *A Thousand Plateaus,* Deleuze and Guattari, when discussing their notion of becoming-animal in terms of becoming-wolf, stress the fact that the wolf cannot be individuated as a subject, but only exists as part of a pack or multiplicity. Thus, "[i]n becoming-wolf, the important thing is the position of the mass, and above all the position of the subject itself in relation to the pack or wolf-multiplicity: how the subject joins or does not join the pack, how far away it stays, how it does or does not hold to the multiplicity."[8]

The wolf is part of the crowd but also completely outside it. Instead of a subject

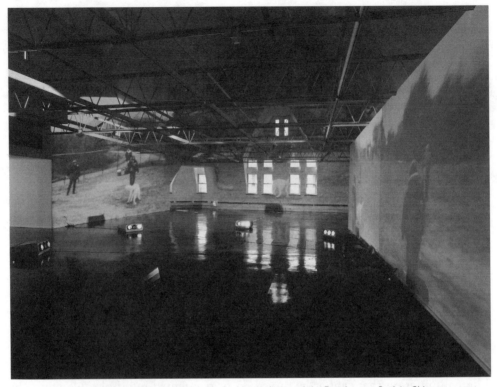

Figure 1. Diana Thater, *China*, 1995. Installation for six video projectors at the Renaissance Society, Chicago, March 12–April 23, 1995. Photographs courtesy of David Zwirner, New York, and the Renaissance Society at the University of Chicago. Photographs by Tom van Eynde.

regulated by the model of One and Multiple (individual versus pack), he is defined more in terms of a body-without-organs, charged with various multiplicities. He is a composite of intensities of speeds and slownesses, a product of different, indivisible distances, ceaselessly transformed to produce a change in nature each time (a virtual multiplicity). The wolf is thus a pack and a multiplicity at one and the same time: "A becoming-animal always involves a pack, a band, a population, a peopling, in short, a multiplicity."[9]

Deleuze and Guattari contrast this rhizomatic reading of becoming-wolf with Freud's famous diagnosis of Wolf-Man. Where Wolf-Man's becoming-animal dream spots five, six, or seven wolves standing in the tree outside his bedroom window, producing a pack, a multiplicity, Freud reduces them to one wolf—the father/castrator (Hegel's One):

> Who is ignorant of the fact that wolves travel in packs? Only Freud. Every child knows it. Not Freud. . . . Who is Freud trying to fool? The wolves never had a chance to get away and save their pack: it was already decided from the very beginning that animals could serve only to represent coitus between parents, or, conversely, be represented by coitus between parents. Freud obviously knows nothing about the fascination exerted by wolves and the meaning of their silent call, the call to become-wolf.[10]

Freud has to purge the wolves of their multiplicity in order to preserve the model of the One (Father) and the multiple: "On the verge of discovering a rhizome, Freud always returns to mere roots."[11] Freud instead constructs the Oedipalized wolf, the analyst's "bow-wow."

Applied to *China*, if we take this contrast between libidinal (the durational multiplicity of becoming-wolf) and numerical multiplicities (the segmented, spatialized becoming-apparatus) at face value, it is very difficult at first glance to see where the durational multiplicity of the wolves as intuitive intensities survives beyond part of the initial real-time performance in the "park." Isn't Shilo, wracked by arthritis, transformed into the trained puppy, performing tricks for Dr. Freud/Thater, a wolf in the process of becoming-man (not Wolf-Man but Man-Wolf), a former multiplicity become individuated ego? Similarly, isn't China, for all her disruptive movement, now artificially separated from the pack, individuated as an anomaly, a "bad actor" framed solely in relation to the "good actor," Shilo (admittedly now a bit typecast, given his age)? Moreover, is this not reinforced by the structural hegemony of the quantitative, numerical multiplicity of the becoming-apparatus? Is it in fact possible to rehabilitate the durational, nonsegmentable multiplicity in *China*?

The answer is a qualified yes, and the solution lies, as in all of Thater's installations, in the self-destructive nature of the quantitative multiplicity itself. Just as Thater's

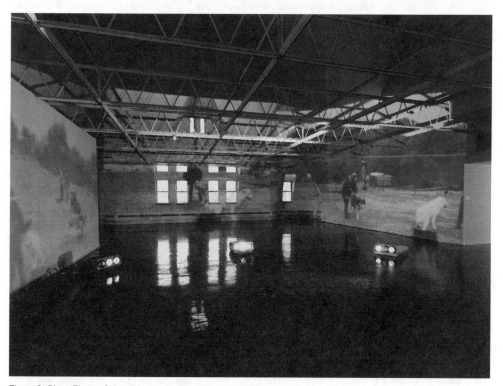

Figure 2. Diana Thater, China (blue and yellow wall view), 1995. Installation for six video projectors at the Renaissance Society, Chicago, March 12–April 23, 1995. Photographs courtesy of David Zwirner, New York, and the Renaissance Society at the University of Chicago. Photographs by Tom van Eynde.

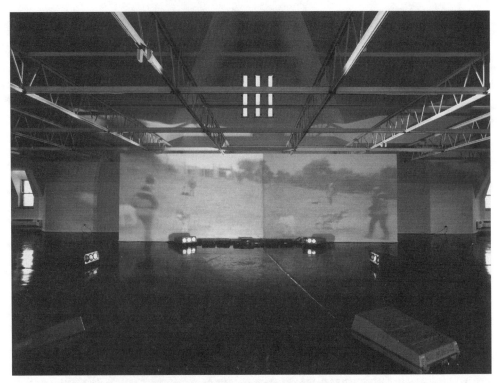

Figure 3. Diana Thater, *China* (red magenta wall view), 1995. Installation for six video projectors at the Renaissance Society, Chicago, March 12–April 23, 1995. Photographs courtesy of David Zwirner, New York, and the Renaissance Society at the University of Chicago. Photographs by Tom van Eynde.

art teeters on the brink of a numerical utopia (Hegel's "bad infinity"), where all instinct is strangled by sublimating structures, it mercifully collapses under the weight of its own logic and transforms itself into its own reaffirming incommensurability. This has been a common theme throughout Thater's career and manifests itself most fully in an earlier video installation, *Dogs and Other Philosophers* (1991). The title was taken from Thomas Hardy's novel, *Far from the Madding Crowd.* It refers to Hardy's meditation on "the untoward fate which so often attends dogs and other philosophers who follow out a train of reasoning to its logical conclusion, and attempt perfectly consistent conduct in a world made up so largely of compromise."[12] In Hardy's novel, logical conclusions are shown to be tragically wrongheaded, so that the earnest young sheepdog—"still finding an insuperable difficulty in distinguishing between doing a thing well enough and doing it too well"[13]—pursues his flock so diligently that he ends up pushing them over the edge of a cliff.[14] Unlike Hardy's dog philosophers, we learn through Thater's installations not to conquer space through false logic and false movement, but to act as Deleuze's wolf-philosophers, by transgressing (and being transgressed by) space temporally, through a logic of qualitative multiplicities. In this way, totalities cease to be marked by treacherously fixed limits (like the sheer edge of Thomas Hardy's cliff), but benign, ever-changing wholes, in a constant state of dispersal, like the wolf pack itself.

Figure 4. Diana Thater, *A Confusion of Prints,* 1995. Installation for two video monitors and two laserdisc players at the Renaissance Society, Chicago, March 12–April 23, 1995. Photographs courtesy of David Zwirner, New York.

Thater achieves this dystopia-out-of-utopia by fanatically pushing her work to its structural limits. This at first seems to resemble a form of structural fascism. Thus the instinctual input of the two wolves—they fight, the performance seemingly at an end—is simply a cue for another variation on what the apparatus can do—in this case, a strobing color separation. Similarly, not one frame of footage is wasted. Anything that didn't make it into the main installation was recycled and reused in a series of eight monitor pieces that became raw material for further variations on the

apparatus's bag of tricks. Thus, *A Confusion of Prints* extracts the fight scene from the last five minutes of the installation and reconstitutes it on two monitors. On one, the fight occurs in real time with the color change occurring every single frame. The second monitor slows the action down so that the color change occurs every five frames. Moreover, what was originally six different camera images is now reconfigured on a single plane.

Similarly, in *Shilo,* an "art spot" made for MTV, the male wolf is shown standing alone on his box for forty seconds while the cameras rotate around him. The effect is extraordinary, with Shilo anchoring the circular vortex of images at its hub, as if he were spinning around on his axis, while we circulate the periphery of cameras on a steady, parallel plane. However, because the terrain is so uneven, it gives an effect of a constant wobble, threatening to undo the equilibrium of the structured movement through a violent torque effect, as if it were a rogue fan belt threatening to break apart an engine's cooling system. For all of Thater's attempts to structure every last ounce of her material, there always seems to be a built-in instability that attaches itself to the spectator's body and allows the libidinal multiplicity to override the numerical. It is here that we, as intuitive rather than conceptual bodies, come closest to becoming-wolf ourselves. Significantly, when we literally become pack animals and several people occupy the installation at once, our collective bodies block out the projection beams, reducing large areas of the surrounding walls to shadow. The more packlike we become, the more we take on the characteristics of a qualitative multiplicity, the more annihilating our durational intensity. We literally obliterate and reconstitute the effects of the apparatus as a different kind of image entirely.

This active agency of the multiplicitous body is also true in the case of the wolves themselves. In *Shilo,* when Shilo steps off his box and moves to the periphery of the frame, he not only cues the end of the segment, but he is also suddenly split into six wolves, producing in effect a pack that is both a multiplicity and an individual wolf. As the numerical real time of the video itself unfolds, it produces and expresses a ghost of itself that is a mark of pure duration: Shilo as multiplicity as difference in kind, Shilo himself as pure duration.

A similar maverick quality occurs when the animals' performance breaks down. Although this is a cue to the structured last segment of the installation, there is a surprise in store. Just as the Hi-8 cameras were being packed away (the footage of which later becomes the reversed opening of the exhibit), China finally does what she is told and stands still on her mark, while Shilo stops performing and wanders off to dig a hole. The two wolves's performative roles have suddenly been reversed. Out of dystopic chaos, the possibility of utopia. But there are no cameras left to record it. Suddenly, Thater grabs a Super-8 camera and captures China's performance in all its improvisatory glory, as if it were a piece of bootleg film. This then becomes the raw material for part of two dual-monitor pieces (*From China to Shilo #1* and *#2*) where it is variously slowed down and color separated.

It is here that the true overcoming of the dialectic occurs in Thater's work. It is

the instinctual multiplicity of the wolves' behavior, their refusal to always perform to structured cues, that provides the raw material for further restructuring. However, it is not a structure that can follow what has gone before because the wolves have dictated a change of apparatus and consequently of image: Super-8, hand-held, grainy, non-projectable footage, instead of Hi-8, tripod-based, sharp, projectable material. What is seemingly dystopic, an impasse between one multiplicity and another, between durational, instinctual flow and its segmentability, overcomes itself creatively in the movement from one to another and back again. The dystopic becoming-animal of the wolves is itself the creative germ of further restructuring, not a nihilist reduction of order to chaos. The process is in this sense very Spinozan, for as Tony Negri states, "The Spinozian disutopia is the pleasure of the savage anomaly of being. . . . The disutopia is both a critique of what exists, of the components, and a positive, singular construction of the present. It is the complexity of the components and the simplicity of composition. It is the singularity of the expression of surfaces, to the point of becoming the pleasure and the sweetness of the world."[15]

No guarantees. They're wolves. Fortunately.

Notes

1. The scare quotes are essential when dealing with Thater's work, because the deconstruction of the nature/culture binary is intrinsic to her project. There is no more the possibility of a pure nature divorced from the hegemony of the structuring Logos than there is an identifiable culture reduced to a model of the Same. Both terms are necessarily slippery, imbued with a two-way expression of the multiplicitous, a movement of becoming that is as much temporal as spatial.

2. Thater also compensated for the uneven terrain of the "park" by adjusting the tripod legs of the cameras so that they were all positioned on exactly the same level plane.

3. Even when we have discussed duration, it has always been in terms of spatial segmentation. Strictly speaking, this is hardly a real multiplicity at all because we have always defined it solely in relation to a delimiting norm or a model of the Same (the unity of the One), rather than a vital force that transforms itself through becoming (the multiplicity of difference).

4. One of Bergson's objectives in defining difference in terms of types of multiplicity was to overcome the Hegelian tendency to delimit difference through a model of the One and the Multiple, by which all difference was classified negatively in accordance with a model of the Same (One, Unity). Hegelian identity is thus always *not*-something-else. Seeking a positive ontology rooted in time rather than segmented space, Bergson attempted to transform Hegelian difference into a positive movement of affirmation, an irreducible multiplicity of becoming.

5. Gilles Deleuze, *Bergsonism,* trans. Hugh Tomlinson and Barbara Habberjam (New York: Zone Books, 1991), 38.

6. However, because we largely live life through language (that of *parole, langue,* the language of cultural signs and apparatuses), we tend to superimpose a spatialized structure on top of this immanent multiplicity, what Bergson calls a numerical, quantitative multiplicity that produces simple differences in degree rather than qualitative differences in kind. As Bergson argues: "[B]elow the numerical multiplicity of conscious states, a qualitative multiplicity;

below the self with well-defined states, a self in which *succeeding each other* means *melting into one another* and forming an organic whole. But we are generally content with the first, i.e. with the shadow of the self projected into homogeneous space. . . . In other words, our perceptions, sensations, emotions and ideas occur under two aspects: the one clear and precise, but impersonal; the other confused, ever changing, and inexpressible, because language cannot get hold of it without arresting its mobility or fit it into its common-place forms without making it into public property." Henri Bergson, *Time and Free Will,* trans. F. L. Pogson (New York: Harper and Row, 1960), 128–29.

7. Ibid., 226.

8. Gilles Deleuze and Félix Guattari, *A Thousand Plateaus: Capitalism and Schizophrenia,* trans. Brian Massumi (Minneapolis: University of Minnesota Press, 1987), 29.

9. Ibid., 239.

10. Ibid., 28.

11. Ibid., 27.

12. Thomas Hardy, *Far from the Madding Crowd* (Harmondsworth: Penguin Books, 1978), 87.

13. Ibid., 84.

14. This is a Hegelian logic of pursuing the necessities of the Logos at all costs, which ultimately proves to be its own undoing. Out of the utopian project of the One/Other is born a dystopic multiplicity that would be more successfully born through an initial model of contingency and indeterminacy, in which a multiplicity of duration of perpetual change and becoming would play both a vectorial and delimiting role.

15. Antonio Negri, *The Savage Anomaly: The Power of Spinoza's Metaphysics and Politics,* trans. Michael Hardt (Minneapolis: University of Minnesota Press, 1991), 223.

17. The Space of Electronic Time: The Memory Machines of Jim Campbell

Marita Sturken

The installation form implies by its definition an engagement with the question of space. An installation both defines and contains space, situating, if not controlling, the viewer within it. In addition, installations that deploy such technologies as video and computer devices delineate time; they are constructed with particular concerns about the length of time viewers will stay with the work versus its cycle, as well as concerns about how to get viewers to move in particular ways in the space. Indeed, one could argue that for artists working in these media, control of the viewer in time and space is a primary and inevitable goal. The space of installations is inhabited not by the artist but by the viewers. Hence, as Margaret Morse has written, it is the visitor rather than the artist who performs the piece in an installation.[1] The role of the artist is thus to create the rules, limitations, and context for that "performance," as well as to create a context in which it can, perhaps, operate in unanticipated ways.

The meaning of the installation is thus created in the moment when a viewer is interacting with it—walking into and through it, standing within it, watching or even touching it. Those installation works that actually acquire the definition of "interactive" are more conscious of the extent to which the presence of viewers completes the work, either in supplying the raw image material for a piece or activating it in some way. An interactive work constructs a complex negotiation with its viewers, both anticipating their potential responses and allowing for their agency in some way.

The question of memory hovers over contemporary interactive installations. Through computers, the concept of memory has acquired an increasingly strong association with the notion of control. Computer memory is what we intentionally store, something we amp up, make more powerful, and deploy to create databases, which are seen in turn as essential and infinite realms of information. Human memory is now

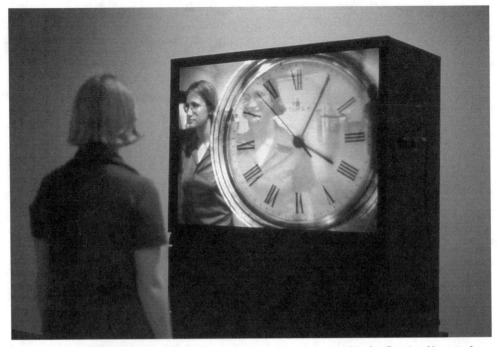

Figure 1. Jim Campbell, *Digital Watch*, 1991, interactive video installation. Collection of the San Francisco Museum of Modern Art. Used by permission of the artist.

commonly discussed in terms of the computer metaphor, with words like storage and retrieval, and increasingly seen as that which can be harnessed, reconfigured, sped up, and expanded. Little wonder, then, that the metaphor of computer memory has been coincident with a popular backlash against Freud and the concept of repression, a notion in which memory is decidedly unlike an easily retrievable database.

The relationship of the concept of memory to notions of electronic technology has always been one of paradox. The idea of the database, what could be seen as an aesthetic or fetishization of the concept of storage, works in tension with the fleeting aspects of the live, transmitted image, at once instant but then ungraspable and gone. We often experience memory as something that is transitory, something that has to be searched for, yet that often appears to us when we don't expect it. Memory is resistant to our control, both arbitrary and random. Indeed, it is possible that the fascination with memory in computer consumer culture is a reaction to the ways in which we experience our memory as so unlike the supposedly all-knowable database.

Jim Campbell's installations engage viewers in an edgy, often unnerving kind of negotiation with space, memory, and the machine. Comprising custom-designed computer devices and video screens, these works are constructed by Campbell as semiautonomous systems, programmed for controlled randomness. Most are designed to respond to the presence of the viewer in order to reinterpret the view of the viewer in a given space, or to restrict their vision of a desired object in some way. Campbell's work addresses the paradox of memory in the electronic realm in its evo-

cation of both the fleeting nature of memory and its haunting presence. These works are often elusive and seductive, drawing us in only to confront our desire to see. In their explorations of the relationship of the electronic to remembrance, interactivity, and voyeurism, they ask us in many ways to experience and then reconsider our relationship to the electronic. Many are devices that hold and replay memories in complex systems of retrieval and storage—systems that appear as capricious as memory itself. In these machines, questions of time and space are inextricably tied together. The movement of the viewer within the space of the installation is often monitored by the device itself, as it refigures a space of time, repetition, and memory.

Campbell, who has degrees in engineering and mathematics, approaches art through the construction of discrete devices, each unique and responsive. His work fits into few neat categories. It is neither simply video (often its screens are stripped down to their most elemental components, as if dragged in from an electronic workshop) nor simply computer (since the computer elements of the works are usually the most hidden and elusive). His works form discrete devices that invite us to examine the small details of, and memory in, the moments contained within them. If nothing else, Campbell's machines undermine our preconceptions about the electronic in that they seem to have an unconscious.

Time Passing

The measurement of time permeates this work, in ways that demonstrate both the aesthetics of the numeric marking of time as well as its fluid quality. Here the digital and the analog function as conceptual frameworks for time. In *Digital Watch* (1991), a large monitor displays the image of a pocket watch face. As viewers approach the monitor they see themselves in two worlds. Outside the circular watch face the monitor acts as a mirror of the surrounding space; yet inside the dial face images pass through a five-second delay in a staccato effect that is synchronized with the second hand. As the ticking hands relentlessly edge forward, the images of viewers appear and then pass through, as if the memory is established in an instant, returns, and then is gone.

Digital Watch is an interworking of both digital and analog elements of time. The hands of the watch face are decidedly analog, representing the movement of time forward in a geometrical form—time as the movement of hands, as the increments between lines, as something tangible that we can hold onto and symbolize. The inexactitude of the analog watch can be deeply comforting—we do not necessarily know the exact second but are reassured that we have a sense of time by the shape of the hands. Yet, it is a digital framework that intercedes with our image, capturing it, storing it, and replaying it through computer devices. Digital time is exact, atomistic, the opposite of the geometric image of the ticking hands. *Digital Watch* asks us to reflect on the ways in which the digital has reconfigured how we conceptualize time, moving from the circular watch face with its implication of cycles and renewal to the digital world of time relentlessly moving forward numerically.

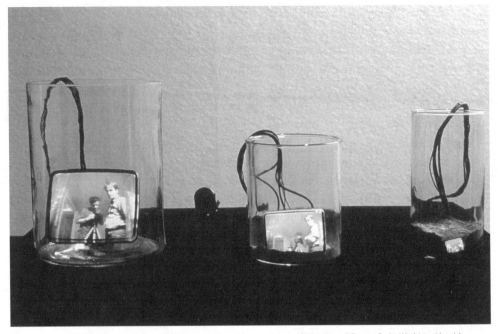

Figure 2. Jim Campbell, *Memory/Void,* 1990, interactive video sculpture. Collection of Susan Swig Watkins. Used by permission of the artist.

The representation of time passing is also examined in *Memory/Void* (1990), in which a series of monitors, stripped down to their bare screens, sit in ashes in a series of glass containers. The glass vials, which are reminiscent of hourglasses, evoke a predigital sense of time's passage. Still images of viewers appear successively on the screens in a time delay, each progressively more difficult to see as the screens become smaller and more deeply buried in the ashes. Time, the work implies, is relentless, and the fragile electronic image is not immune from its material deterioration. The recycled video image that reasserts itself here works in tension with the simple image of time as a kind of earthly burial, swallowing up the present and rendering memories difficult to read.

Memory is the fabric through which time is rendered continuous, through which the present and the past are interwoven and interdependent. Campbell deploys electronic configurations in ways that represent memory as both elusive and ungraspable yet at the same time ever present and assertive. In *Memory/Recollection,* a similar set of stripped-down monitor screens replays a series of paradoxically "live," yet still, delayed images, which fade in resolution from left to right. While standing before it, viewers see their image appear in time delay on the left and then move across the screens as additional images emerge. However, the piece usurps our expectations because other more distant images also recycle through it (it has stored images since its creation). As one stands before it, expecting to see the familiar space of the gallery, the image will shift and new people will appear arbitrarily within it. This has the effect of redefining the space in which one stands through presenting its past manifestations.

Once, as I stood alone in the gallery with this work, watching my image move through it and fade into a deteriorated memory, I was suddenly confronted with images of crowds standing and looking, a group of men in suits standing awkwardly in front of the lens, and other images from its past. It was as if the work itself were asserting its memory, replaying what it had "seen."

This kind of sly assertion of the machine is a common effect in Campbell's work. All of his works are obliquely described as being made up of "custom electronics" that he leaves unexplained. It is as if these works were given, through his construction of their interactivity, a kind of agency in which they seem to notice, evade, and survey viewers. Through their capacity of digital storage, which Campbell has programmed to "remember" randomly over time, these devices seem to be conduits for memory's assertions and evasions, its fading nature and its retellings.

Yet, what are the forms in which memory is manifested? We commonly associate memory with talismans such as photographs and perceive the memories themselves to take the form of an image or sound. In Campbell's series *Memory Works,* the question of personal versus collective memory is related to an examination of the forms in which memories exist. In each work in the series, an "original" memory is presented as electronically stored and contained within a metal box. This memory is then represented through another form or system. In *Photo of My Mother* (1996), the artist's breath, recorded for an hour, is the "memory" that mediates a faded image of his mother as a young woman, transforming it from foggy to clear. In *Portrait of My Father* (1994–95), the image of his father flashes on and off with the rhythm of his heartbeat recorded over an eight-hour period. The implication is that memory is always mediated by something, always filtered through another form that prevents it from remaining stable in any way.

Other memory works reveal an atomistic, one could say digital, view of the forms in which cultural memory resides. In *Typing Paper* (1994-95) the sounds of an old typewriter are presented to suggest the text of Martin Luther King's "I Have a Dream" speech; in *I Have Never Read the Bible* (1995) the "memory" of the Bible is evoked by the sound of a voice whispering the letters of the text of the Bible one by one next to a worn book, which turns out to be Webster's dictionary. These works are provocative in their reduction of these cultural memories to some kind of elemental form: letters, the sound of typing, the ASCII text. In many ways, Campbell is playing off the very essence of the digital. Unlike analog, the digital reduces all information (and in this case all memory) to bits, to ones and zeros, to elements that are infinitely changeable and malleable. What happens when you reduce the Bible to each letter—the digital Bible? It becomes, of course, meaningless, a jumble of letters. Campbell states, "In other words, even though I have not read the Bible, this work is a representation of me reading the Bible," a statement that asks us to think not of the meaning of the words but of the bitlike presence of the letters. It appears that the digital framework is playing a joke on language and philosophy—what after all is the Bible but a bunch of letters? Whose memory is it then? Here, the metal boxes evoke an anachronistic sense of storage—the metal box

that in its very form presents a kind of mortality—in relationship to the electronic storage of memory that is so ungraspable, so elusive as a physical object. Here, Campbell implies that the Bible actually undergoes a kind of data compression, and the very concept of storage is confronted—the database as a one-dimensional form of memory. Indeed, digital storage is revealed as potentially meaningless. Campbell plays this out further in *The End* (1996), in which a computer algorithm is used to generate all possible video images, and viewers see a blank screen with a small dot of light in its center. If all the images are containable, and the potential number of images is finite, then why bother to create more? In these works, Campbell is mocking the fetishization of storage and safekeeping that surrounds the contemporary database—what we end up with is archived yet essentially incomprehensible.

Interactivity and the Pleasures of the Response

The sly nature of many of these works, at once profound and provocative, is derived primarily through the almost secretive nature of the ways in which they reveal themselves to viewers. Because of the "black box" nature of Campbell's "custom electronics," viewers often engage with these works by trying to figure them out and bypass their systems; in the very least the experience of them is one of negotiating machine devices. That this never seems to work at the level of trickery is a testament to the self-consciousness and irony that Campbell has constructed in relationship to the viewer. It's as if Campbell sets up an exhibition space as a means to both seduce and deter the viewer. In the process he often forces viewers to examine the issue of desire, specifically our desire to see what we have been told we cannot see. What emerges is a carefully constructed electronic environment, or way of being, that is about surveillance and monitoring, qualities that, one could argue, form the essence of electronic media.

In *Hallucination* (1988–90), Campbell intervenes in a video "mirror" image in such a way that viewer expectations are confounded. Through a mix of live imagery and stored images, viewers are alternately mirrored by a video screen and seen in time delay, their silhouette set on fire within it, and they interact with a woman who appears randomly on the screen, tossing a coin and looking directly at them. At other times viewers simply disappear. There is a sense that this piece is constantly changing its rules, never quite following a set sequence, so that viewers are always a bit off balance if they try too hard to figure it out. Like many of Campbell's installations, one feels constantly reflected back by this work, unable to get away from its lens. Indeed, to go to a Campbell exhibition is to see one's image constantly and often uncomfortably, and never to be "left alone" as a viewer.

This sense of viewer surveillance pervades Campbell's work, and is often refined in such a way that viewers feel their movements are taken note of, perhaps judged. Nowhere is this more evident than in *Untitled (for Heisenberg)* (1995). In this work, viewers enter a long dark room that contains at the far end a platform resembling a double bed. The surface of this bed is covered with salt, shaped to resemble a rumpled

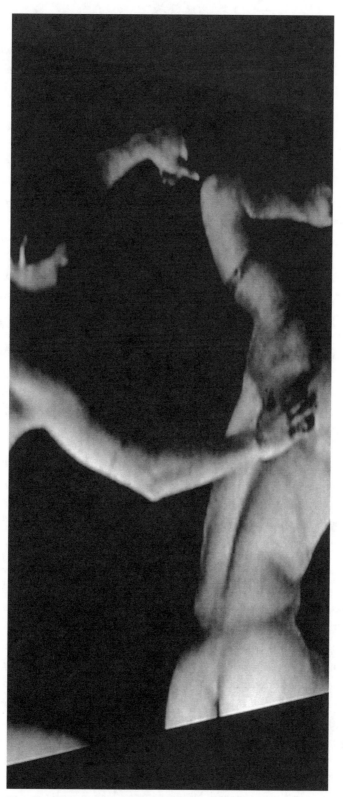

Figure 3. Jim Campbell, *Untitled (for Heisenberg),* 1994–95, interactive video installation. Used by permission of the artist.

set of bedsheets, and onto it is projected the image of a naked couple who are either sleeping, caressing, or in sexual embrace. As the viewer enters the space, this scene is visible yet distant, entreating people to move closer to get a better look. The room, as in many of Campbell's works, is wired to our response; as we move toward the bed the projector zooms in and the image becomes abstract to the point where we can only see blurred body parts. As we move away, the image readjusts to "show" us more. Campbell titles this work "for Heisenberg" as a reference to the Heisenberg Uncertainty Principle from quantum physics, which contends that the act of observation always has an impact on the object of observation; because of this one can never observe an object in its "purest" form. Here, however, he is deliberately transferring this concept to questions of desire and sight. As he puts it, "The more you want to see the less you see."

Untitled could easily be seen as either an exercise in frustration or a work of trickery, yet it succeeds in avoiding both. I have stood in the piece and watched people, after they understand how it "observes" their behavior, try to avoid detection by running to the bed or crawling along the walls (neither tactic works). Yet, what happens in those moments is that viewers are eventually confronted with their own behavior, caught trying to get a glimpse of an intimate scene, perhaps a potentially pornographic moment. In the process of revealing how our position as viewers affects what we see, this work also asks us to be conscious of the desire that propels us toward the image as if it would reveal something—our belief, for instance, that we could experience the intimacy presented on the bed.

The elements of interactivity that permeate almost all of Campbell's work are at their most obvious here in the push/pull between viewers and *Untitled.* Yet, what kind of interactivity is this? Campbell states that he wants to make a distinction between controllable systems and responsive systems and to create works in which the concept of interactivity is derived from the work itself:

> I've often wondered why most interactive work feels contrived and designed for a calculated response, like bad school art. I've seen so many CD ROMs and interactive video discs that have felt like my interaction was completely scripted and predetermined within the pretext of a few choices. . . . It's almost impossible for an artist creating an interactive work to not try and second guess the viewer. How else can an artist design the interface without seeing it from the other side? One of the ways that I've seen artists avoid this problem is to not put themselves in the viewer's shoes but instead to take the point of view of the work itself. Instead of saying as viewer what can I trigger? saying as program what can I measure? . . . Because the artist doesn't write the viewer's side of the interaction, the viewer can respond in a more open way. One of the consequences of this approach is that the work, like a painting and like a film, exists on its own. There is no attract mode. The work is not waiting for a person to complete it. In a way, the work becomes interactive not with people but with its environment.[2]

While it may be that Campbell's works are not "waiting" for viewers to complete them, they are works that change character in response to the presence of viewers. As such, they are often experienced by viewers as withholding and secretive works that operate through deferring viewer desire. Like *Untitled, Shadow (for Heisenberg)* (1993–94) reacts to the presence of the viewer in such a way that our ability to see further is impeded. Here, a transparent cube sits in a room; when viewers approach they can barely discern that the cube contains a Buddha figure who sits on a faded text of some kind. As they move closer to the cube, the surface fogs, obscuring the icon (as its shadow appears on the glass surface), preventing them from seeing the text (by implication, the wisdom) beneath it. Instead of being a mere exercise in frustration (why won't it let me see/read it?), this piece works by forcing viewers to reflect on their needs and wants—why is it that now that it is hidden, I feel I have to see it? This work can been seen as demonstrating, as psychoanalysis has suggested, the ways in which that desire is always deferred and unfulfilled, constantly beyond reach.

In *Simultaneous Perspective* (1997), the effect of the viewer's presence is equally subtle at first impression. The viewer enters a room containing a suspended candle, so that the slight shift in the air created by his or her presence affects the amplified sound of the candle's flame. The viewer then moves to an adjacent room in which a screen displays a stunning visual collage of images from several live cameras of the environment outside and within the gallery space (in this case, the NTT InterCommunication Center in Tokyo). Images of freeway traffic, pedestrians, and skyscrapers, combined with images of the candle and the viewers within the gallery, are infused into textured images of the sidewalk, the lines of the escalator steps, and fabric. These images move in and out in a fleeting sense, like figures of memory that fade and return. The viewer is thus invited to reexperience the trajectory of his or her journey into the gallery space as a highly textured two-dimensional image. As the images shift, with different elements gaining and lessening in intensity, the work invites viewers to stay and watch, which they often do. However, if they remain still in the space, the layers will gradually peel away until the screen is dark. Here, then, it is the absence of action that provokes a response from the work.

These discrete electronic devices, then, both circumvent and point to viewers' actions and reactions. They are intended to move toward a state of autonomous reaction, in which the presence of the viewers is merely one variable of many. As such, Campbell's work can be seen as allied with recent research in artificial life in which computer programs are designed to follow certain principles of evolution, that is, to move beyond their original programmed form into something else, something unpredictable. Time and memory are gauged and then set loose in these works. Viewers move in and out of them. Memories are recycled and return according to a random set of rules. Campbell appears to give his devices a certain amount of autonomy, yet he seems intent upon demonstrating the fragile and ultimately random nature of machine interaction. The world he creates is therefore a complex amalgam of the fluid analog world with the rigid and expansive digital realm. These are machines that seem

to retain and repress, to withhold and respond, to pose questions with no anticipation of an answer. They turn the lens back upon the viewer, asking us again and again not to reflect on the nature of the machine so much as on ourselves.

Notes

This article was originally published in a shorter version in *Afterimage* (November/December 1997).

1. Margaret Morse, "Video Installation Art: The Body, the Image, and the Space-in-Between," in *Illuminating Video: An Essential Guide to Video Art,* ed. Doug Hall and Sally Jo Fifer (New York: Aperture, 1990), 155.

2. Jim Campbell, "Delusions of Dialogue: Control and Choice in Interactive Art" (talk delivered at the Museum of Modern Art in New York, May 1996).

18. The Anthropologist's Shadow: The Closet, the Warehouse, the Lesbian as Artifact

Catherine Lord

In 1994, Millie Wilson and I spent a great deal of time in Santa Fe, New Mexico, looking for lesbians. Most of the time we did this across from the Inn of the Anasazi at the state photo archives. It tends to be either way too hot or way too cold in Santa Fe. Whichever, it was easier to look indoors. We had been invited to New Mexico to produce a project on lesbians, or as lesbians—the finer theoretical distinctions between these performances was and would remain bureaucratically unexplored—by an organization called Site Santa Fe. A contradiction in terms, which is to say a nonprofit corporation funded by wealthy Anglos to boost the market for contemporary art in northern New Mexico, Site Santa Fe proposed to serve as a locomotive of aesthetic gentrification. In the summer of 1995 it would, literally, put up a circus tent in the middle of town to host an avant-garde extravaganza, in addition to dispensing grants to young artists, sponsoring lectures, and taking over the entire fine arts museum and an abandoned warehouse for exhibition space. This last, which would garner in column inches equal parts resentment from locals and adulation from outsiders, was titled *Longing and Belonging: from the Faraway Nearby.* Only three of the artists belonged, if by that one meant they were residents of New Mexico, and two of them had arrived recently. The other twenty-nine, whether or not we longed, which not all of us did, came from somewhere else: New York, for instance, Los Angeles, Paris, London, Amsterdam, Berlin, Mexico City, Osaka, Havana. Et cetera.

We had been invited, then, from far away, to intersect with a region, to do something specific in a site, to "engage," according to the curators, "the rapidly changing relationships among individuals, communities, and global networks and institutions."[1] In a show that aimed to deliver a sly critique of U.S. identity politics to a fractiously multicultural community by going transnational—the catalog was careful to

list all countries that could adhere to each artist—our real nationality was lesbian, though that of course could not be included as a valid address.[2] We had entered the artists' service sector, the "site-specific project," a phenomenon evolved in response to the public service demands of funding agencies, museums' desire to expand their audience base, and the needs of those in rapidly growing curatorial ranks to find something distinguishing for artists to do.[3]

We passed many hours in the archives, a one-room affair adjoining the museum. "Lesbian" was not a category in the filing system. "Women" were barely there, in fact, though buildings, roads, livestock, landscape, politicians, soldiers, priests, and various stages in the destruction of indigenous cultures were well represented. The only solution, or the only solution that appealed to us, was to examine every photograph with a human being in it, looking for lesbians, or women who could, or might, or would have been lesbians, or women who might be seen as lesbians, or women who dressed like lesbians, or women in whom we, as lesbians, could take pleasure. Our standards for inclusion were conceptually generous, theoretically informed, and coated in protective irony. Nonetheless, we felt ridiculous, two middle-aged schoolteachers sitting side by side at a library table flipping through folders, taking notes, afraid to tell the archivist, a civil war buff with a photographic memory, what we were *really* after in case he wouldn't release *his* copy prints to *our* archive, wouldn't let our strategic fictions erode the bedrock of the history he was trained to conserve.

We never explained ourselves to the archivist, who kept pleading with us to be more precise in our search, to reflect more carefully on how to describe the object of our interest so that he could help us. Skeptical that the door to our closet actually opened onto his archive, we were instead methodical. We had salted the field. We knew no archive could withstand our fantasy, and so, of course, we found evidence of the culture we had already invented in order to be able to have our desire. These images we would crop to extreme, deliberately decontextualizing detail, and then greatly enlarge so as to evoke and construct an erotics of lesbian looking. We had in mind images that would make visible not the homosexual body, but homosexuality under construction, not the physiognomy or costume of the lesbian, but a means to suggest the conditions in which she might make herself visible, not her appearance but the circumstances in which she might be said to appear. We wanted to make visible not The Lesbian, reified, but the nexus of minor and material transgression that might enable the lesbian to be imagined. We used, therefore, images like the following: the soft bellies and breasts of a group of girls around the turn of the century, cross-dressed in suits and vests and pants; the suggestive proximity of the hands of two Santa Fe rodeo queens in the 1950s, doubtless grandmothers by now; the solitary figure of a woman in a tailored suit awkwardly clutching a small leather handbag; the trim torsos of a group of New Mexico anthropology professionals standing next to a filing cabinet, fractionally too close to each other; and, especially, a couple of images of passing women, one the wife of a prominent anthropologist engaged in a double transgression, a presumably private performance as a male, breasts strapped flat and, stripes

Figure 1. Millie Wilson and Catherine Lord, *Something Borrowed* (detail), 1995, mixed-media installation.
Color coupler print, 24 x 14 inches, photographic detail from anonymous, *Miss Rodeo de Santa Fe,*
Santa Fe, New Mexico, c. 1965. Photograph by Ken Marchionno; courtesy of Museum of New Mexico,
negative 29576.

painted across her chest, as the Pueblo ceremonial figure of a koshare, and the other, a civil war soldier identified only as "Davis, missing left hand," but unable to button the front of her jacket across her breasts and doubtless missing something else of central importance to the formation of the state and its archive.

I expect we could have found equivalent images in any large public collection. We were, however, in New Mexico, commissioned to make a project specific to the site that had invited us to mediate it, that is to say, a territory colonized for four hundred years, a territory whose natural resources had long ago been transported far away. Regardless, we were obliged, in some ineffable but distinctly contractual way, through our skill with "material and spatial means," our ability to "be sympathetic [to] a very specific regional context,"[4] to colonize the site all over again. We undertook to do this not only in spite of whatever skill and sympathy we brought to the region, but precisely because of these qualities. We were working in the service sector—that is, the arts—now deployed to temper processes of colonialism generated by the movement, accumulation, and relocation of transnational capital. If that sounds too abstract, let me ground it in a few of the realities of northern New Mexico: an escalation of real estate values that has rendered the majority of Santa Fe residents Anglo, displacing barrio inhabitants into rural ghettos; a burgeoning local economic sector devoted to various AIDS services and funded by an influx of gay Anglo men seeking "quality of life"; a proliferation of pueblo casinos designed to rectify a long-standing trade deficit by relieving Anglo tourists of their dollars; and, most lately, in the spring of 1998, the removal of the right foot of an equestrian statue of Don Juan de Oñate, a protest by the Acoma against festivities in honor of the man who had in 1599 ordered the amputation of the right foot of every man over the age of twenty-five in the pueblo as punishment for failing to provide food to Spanish soldiers.[5]

Under such circumstances, the figure of the anthropologist was bound to surface in our work, complicit as the discipline has been in the processes of American and European colonization. Interpreters, buffers, sympathizers, translators, entrepreneurs, informants, refugees, scholars, and artists, anthropologists in New Mexico, as elsewhere, have functioned as one of the region's extractive industries, along with mining, logging, and ranching. The nineteenth century saw not only the deforestation of New Mexico's mountains to make cattle fences and railroad ties, the scarring of the earth by removing from it those metals and minerals profitable to industrialization, but also the attempt to "clean out" the pueblos, "ethnologically speaking," so that one "tidy little collection" after another could be dispatched to the Smithsonian Institution.[6]

The photographs of one such figure, the anthropologist Matilda Coxe Stevenson, were well represented in the state photo archives, particularly the period of her residence in the Zuni pueblo, in western New Mexico, just before the turn of the century. A large woman who evidently never allowed conditions in the field to permit modification of her Victorian lady's costume, Stevenson produced her own amateur photographic documentation with an early Kodak camera, basically a lightproof box with a pinhole. You push the button, we do the rest. The consumer would mail the entire

contraption off to Kodak and get another one back in a few weeks, loaded, along with a set of small round prints. As a result of these twin technologies of memory and desire, whatever Stevenson believed she was photographing—pots, natives, ceremonies, ladders—was obscured by the ample shadow she cast across the subjects of her professional attention. There's no point in resisting the seduction of some metaphors, particularly when one is entirely complicit in their late-twentieth-century reincarnation. "Look," we said, whispering to each other under the watchful eye of the civil war buff, "if we crop out the top half they'll read like pottery bowls. Perfect." We smiled. It was a moment of mischievous intimacy between two women who had for almost ten years collaborated in love and in work. It was an intimacy that enabled us both to "be" lesbians for the context of an exhibition of the international avant-garde and to "see" lesbians outside that context. It was a moment in which it was personally and creatively evident that the project we had undertaken represented a serendipitous intersection between our lives, our work, and the theoretical foundations for our different practices, Wilson being primarily a visual artist and I primarily a writer and curator. "Public art" and "queer theory" were having intercourse around and through our lesbian bodies. We could perform, embody, register, and fabricate queerness on all sorts of levels.

It should be said now, in that case, that the various intimacies then existing between my lover, my friend, and my collaborator have ended. Change of person, meaning I lose that voice which renders conventional narratives of artistic collaboration. In describing our work, I have neither pronoun nor tense: to use the first person in either singular or plural is both necessary and a fable; I can't write in that fictive historical present that implies unbroken forward movement from the past.[7] Nonetheless, if it is obvious that the specificity of our project evolved from two regions, one located in the arid regions of the American Southwest and one located in our hearts, the erasure of one of these sites may productively denaturalize a narrative of place by bringing queer theory to bear, and denaturalize a narrative of queerness by bringing to bear a politics of place.

Back, then, to another relationship between women, involving Matilda Coxe Stevenson and We' wha, the Zuni *lhamana,* or berdache, the former carefully acknowledged by feminist anthropologists, the latter passionately embraced by some queer theorists.[8] I read it as an encounter of irreconcilable gender formations before the figure of the homosexual, only then being invented in American and European cities, had been able to colonize New Mexico. A formidable woman, eulogized after her death as "able, self-reliant, and fearless, generous, helpful, and self-sacrificing,"[9] that is, by an inventory of attributes arguably gendered male, Stevenson first arrived in the Zuni pueblo with her husband in 1879, under the aegis of the U.S. Bureau of Ethnology. She made numerous return visits, continuing even after her husband's death in 1888. One of the first American women anthropologists, Stevenson in 1904 produced a massive monograph on the Zuni.[10] She was also, to engage in a calculated anachronism, a ballbuster, criticized for high-handedness, throwing her money around,

disrespecting pueblo peoples, pushing her way into activities restricted to Zuni males, and photographing where she shouldn't. The sickly but sartorially uninhibited Frank Hamilton Cushing, her anthropological competitor in mining Zuni culture, received a letter from a male colleague that caustically forewarned him of "her fair face" and "gentle voice."[11] ("Not!" we would now add.) Stevenson accused Cushing of being an embarrassment to his gender, among other things. "Frank Hamilton Cushing," she wrote on the back of a photograph of the anthropologist, "in his fantastic dress worn while among the Zuni Indians. . . . He even put his hair up in curl papers every night. How could a man walk weighted down with so much toggery?"[12] The Zuni, allowing the two anthropologists more room to maneuver than the anthropologists could imagine reciprocating, had a pragmatic solution to these delicate frictions of gender and nation. Cushing they allowed to dress up as a Bow priest, helping him to become the "White Indian."[13] To Stevenson they allotted the prayer sticks used by Zuni men, telling her: "Though you are a woman you have a head and a heart like a man, and you work like a man, and you must therefore make offerings such as men make."[14]

These are the circumstances under which Stevenson entered into a relationship with We' wha, a potter and weaver, not to mention the tallest, strongest, most prosperous, and most intelligent person in Zuni. We' wha became Stevenson's protector, informant, friend, and laundry woman. Stevenson took We' wha to Washington with her in 1886, where the Zuni "princess" stayed for six months at the Stevenson house. Notwithstanding her "masculine look" and generally "massive" style, We' wha turned her "sweet smile" onto Washington,[15] dazzling everyone from President Cleveland to the ladies of the Women's Anthropological Society, which Stevenson had founded the year before. Back in Zuni, Stevenson would attend We' wha's deathbed, displacing the family in order to record those last, precious words. It is impossible to determine when Stevenson, who in her magnum opus accounted for her friend as both "she" and "he,"[16] learned definitively that We' wha was biologically male. That Stevenson had the courtesy to gender her dying friend female has bolstered the interpretation that her revelation occurred after We' wha's death, in some sort of epiphany over the dead body of the "transvestite." Certainly, jokes about Stevenson's letting a six-foot Zuni "maiden" infiltrate the best boudoirs in Washington were making the rounds by the early 1900s.[17]

I'm not suggesting that Stevenson and We' wha were having a lesbian fling out in the pueblo, or that We' wha would be rendered intelligible by the term "transgender," or that Stevenson and We' wha were narrative foremothers of M. Butterfly or The Crying Game. Or Driving Miss Daisy. It's undeniable that they got (it) on, impenetrable what they got on, and indecipherable what "(it)" might be in that impossible relationship, at once granted by colonialism the conditions in which it might appear and annihilated by the visibility of that encounter. I was interested in the fact that these two women of intelligence, strength, and learning were partially illegible to each other—as women. This compelled because it suggested a trope, a way to destabilize relations between "women," and from thence, the cultural specificity of "lesbian" (i.e., a white, twentieth-century thing) in the various sites we were mediating, a way to fabri-

Figure 2. Millie Wilson and Catherine Lord, *Something Borrowed* (detail), 1995, mixed-media installation. Color coupler print, 20 x 24 inches, photographic detail from Matilda Coxe Stevenson, *Women and Children, Zuni Pueblo,* c. 1891–96. Photograph by Ken Marchionno; courtesy of Museum of New Mexico, negative 82367.

cate into the project the knowledge that things are not what they seem, to suggest a racing of female, and thence an erasing of the firm boundaries of the category "lesbian."

Millie Wilson and I positioned this encounter between the anthropologist and the berdache in various ways, in addition to the photographs that revealed little more of a people's "culture" than the shadow of a large woman whose Victorian costume owed the crisp edges of its outline to that untranslatable gender possibility she had hired to do her laundry. Using the form of a printed type work, free for the taking, we put the story out as a fiction, a compilation contrived from phrases appropriated from Stevenson's anthropological lapses in objectivity: "You brought improvements, soap and glass and candles. She refused to wash your clothes, at first. She was still more averse to ironing, but you persuaded her. You compared the color of her skin to that of the Chinese." There was something irresistible about launching into circulation a kind of uncredited, unanchored, unsettling language about identities that are not heterosexual.[18] I fantasized this deviant litter defacing tidy Santa Fe when tourists missed the trash can, or going home with curious children to corrupt the family values. Too, there was something appealing about housing these anonymous notes in a pun, a nonfunctional table, a table titled *Soft Parts,* designed to supply stories from drawers perpetually open and painted in the most corrosive of Santa Fe–style colors.

Most saliently, though, we tried to fabricate the berdache story into the exhibition by sending a cloud through the blue New Mexico sky, that is, by placing a large sculptural white wig against a blue wall and titling it in a way that might mark and thus limit the status of those responsible for producing it.[19] *White Girl* made the room pivot against a six-foot-tall, white, weird, excessive, hairy THING—in other words, a kind of bleached version of the monstrous feminine. *White Girl* was festooned with the various white blanks—pots, feathers, beads, fur, and so forth—sold in craft stores

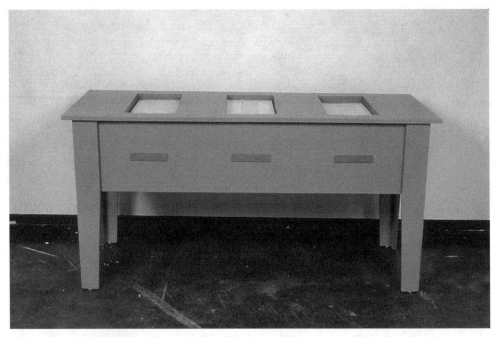

Figure 3. Millie Wilson and Catherine Lord, *Something Borrowed* (detail), 1995, mixed-media installation. Soft parts (painted wood table with false drawers, take-away fictions). Photograph by Ken Marchionno.

and used in the manufacture of "native" tourist goods in New Mexico. Her central axis appropriated the most obvious element of the headdress of the Kolhamana, the Zuni ceremonial figure that represents the berdache. In the headdress, this stylized division of hair, one side down as a male would wear it, one side looped up as a female would wear it, forms a representation of both/neither man/woman that has become an icon and symbolic focus for various cultures: queer academics, gay organizers, gay artists, and Native Americans of sexual preferences that include gay, lesbian, and various forms of "berdache."

These elements, then—photographs, wig, and take-away texts—were intended to color and to queer the central and most complex part of the installation. It never got a title, as I remember, but it came to be called, conversationally, The Wall. When we—to return to that problematic pronoun—were developing a proposal for Site Santa Fe, the logic was, as far as I can reconstruct it, that if we had to spend a lot of time on the road, we might as well not spend most of it with straight people. I suppose we turned ourselves into *faux* anthropologists, as we ironically described ourselves and as the curators later made official, both as an escape from our straight work worlds and in protest against a genre that Hal Foster has called "pseudo-ethnographic reports in art that are sometimes disguised as travelogues for the world art market."[20] If the request was to produce a project about lesbians specific to a geographical region, the challenge was to truck the dirt into the museum in a way that would perhaps reduce the ethnographic gaze to a squint. Our proposal to Site Santa Fe, then, written with lesbian tongue well inside lesbian cheek, was to go to New Mexico, find fifty to one hundred

individuals who "lived outside the institutions of heterosexuality," and borrow from them an object of personal significance, entirely of their choosing, that they had not themselves made.[21] These we proposed to install in the Museum of Fine Arts, along with a text written by the lenders addressing the significance of each object.

New Mexico is a big state. Suffice it to say that we drove thousands of miles, distributed flyers, advertised, attended gatherings that ranged from gay youth groups to church services, women's night at the hot springs to pueblo dances, incurred a huge phone bill, and after about a year's work persuaded eighty-three individuals to lend to the Museum of Fine Arts for six months an inanimate object that would fit inside a twelve-by-twelve-inch box.

The lenders to *Something Borrowed,* as the project came to be called, almost all from northern New Mexico, ranged in age from seventeen to eighty-three. They included Anglos, Hispanics, members of various indigenous nations, and African Americans. Their occupations were various: a good sprinkling of artists, writers, students, and professors, a few anthropologists and schoolteachers, as well as a psychologist, a lawyer, a fireman, a waiter, a chiropractor, a *curandera,* a builder, a rancher, a judge, a janitor, an electrician, a singer, a baker, a community organizer, a clerk, a manufacturer of sex toys, an ex-prostitute, and an ex-cop. The idea, however, was neither to "out" the lenders nor to interpellate them to visibility under the culturally specific label "lesbian." Nothing in the framing devices of the installation, therefore,

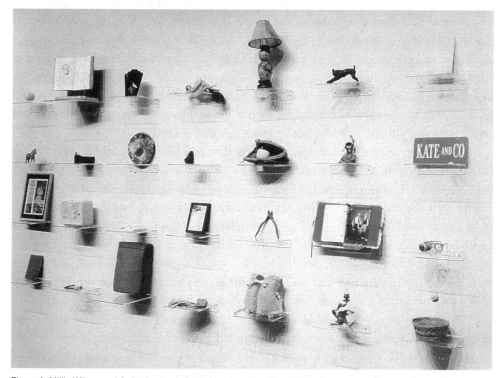

Figure 4. Millie Wilson and Catherine Lord, *Something Borrowed* (detail), 1995, mixed-media installation of borrowed objects, Museum of Fine Arts, Santa Fe. Photograph by Ken Marchionno.

said "lesbian." Nothing in the loan requirements dictated that a lender be publicly identified by her full name, her legal name, her place of residence, or her occupation. Nothing in the loan requirements obligated the lender to be "a lesbian," or even a woman. Indeed, *Something Borrowed* netted a few practicing heterosexuals who didn't mind associating with lesbians, as well as two men, one straight and one gay, who lent an object in memory of women who had lived in long relationships with women but who they insisted would never have described themselves as lesbian. It also included objects lent by women of various ages who found the label repellent, irrelevant, or simply less central than other adjectives. I hope that we invented a structure of visibility that allowed the category "lesbian" to dominate while at the same time undermining the predictable essentializing reactions by fogging exactly that visibility, instead foregrounding revelations that had nothing to do with sexuality or intimacy, encouraging the use of codes, making spaces for silences, allowing the name withheld to function as both shield and provocation.

If this structure was a means to withhold the object of the ethnographic gaze by selectively obscuring the legibility of an essentializing category, it was countered by displaying the borrowed objects in a way that would titillate with the promise of exactly such a reading, a reading made inevitable by the site in which we were working. In New Mexico, a state where anthropology and its effects are ubiquitous, anything on a shelf with a label reads as a sign of culture, a material trace, probably stolen, of a group already declared to be other. (The fifty thousand tourists who visited the Museum of Fine Arts that summer did so on the same ticket that admitted them to the anthropological museum up the hill.) An eighty-foot wall of objects on plexiglass shelves, arranged in a grid, was a strategic tease, anthropology conceived so that it could not help but fail, so that any disciplinary hopes for order would be buried under material specificity. There was no conceptual rationale whatsoever for the arrangement of the objects, besides the formal commitment to create a nonhierarchal visual field and putting anything really expensive out of reach.

There were, as one would expect, objects that more or less clearly signaled a lesbian identity: the 1927 Victory edition of *The Well of Loneliness,* lent by a retired and still closeted schoolteacher; a motorcycle helmet with a pink triangle, lent by a nineties dyke, and a motorcycle helmet with a woman's symbol, lent by a seventies lesbian; two brown-skinned Barbies having at it, lent by a young Chicana-about-town; a certificate of marriage from the Metropolitan Community Church, lent by a recovering alcoholic; a coming-out journal; a blank journal, a gift from the lender's first lesbian lover, a gift in turn received from her mother; and the world's first functional and reasonably priced dildo harness, made by two young entrepreneurs.

There were objects explicable as "lesbian" only in terms of the lender's story: one of the rings exchanged by two thirteen-year-old girls, who remained lovers for five years; the basket in which a prostitute used to keep her condoms; a tassel that marked the moment of a lawyer's graduation as well as her return to the closet; the worn cloths with which a mother had washed the backs of her daughter and her daughter's

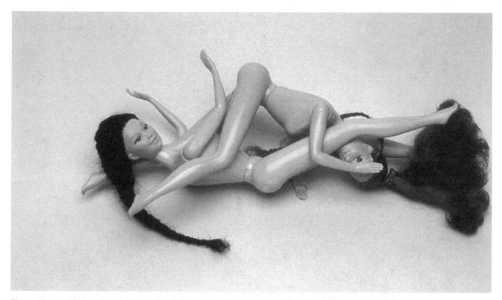

Figure 5. Millie Wilson and Catherine Lord, *Something Borrowed* (detail), 1995, mixed-media installation. Two brown Barbie dolls, 1993–94, loaned by "Pan-fila," Albuquerque, *curandera*, age 29. Photograph by Ken Marchionno.

lover, signaling her reluctant acceptance of the relationship by offering them the same gesture of sensual intimacy that had been a ritual in her relationship to her husband; the plastic bucket used to haul water by the dykes on a separatist back-to-the-land collective; the kente cloth doll two middle-aged professionals gave to their recently adopted African American infant son; a videotape of the *Sound of Music* with Julie Andrews on the cover; the vanity license plate that two New York stockbrokers put on the RV in which, having cashed in their options, they fled the rat race; the coffee pot used by the photographer Laura Gilpin and her "companion" Betsy Forster on their camping trips in the 1930s around the Navajo reservation, the place where they could be most themselves; a hand-made card given in 1975 to the homecoming queen at the University of New Mexico, the only such queen in history to arrive at her festivities in a dykely three-piece suit; the pink plastic lunch box carried by a house painter to her jobs with all-male crews; a scrapbook page that memorialized the lender's mother, who ran Santa Fe's only gay bar for twenty years and on her deathbed had the pleasure of having her daughter come out to her; the Othello sheath knife acquired by a young tomboy; the jacket patches worn by the Sirens, Albuquerque's lesbian bikers; a glove used by the Baby Ruths in their softball games in the hot desert sun; and a spinster's ring on a rubber monster woman, lent by an eminent folklorist.

There were tributes of all kinds to love and family and death: Aunt Nelly's cup and saucer, from the daughter of a family that talked things out over coffee; the gardening gloves, one of his and one of hers, used by one artist's parents; the wool comb made in the 1970s by an uncle who went to Vietnam and didn't come back the same; the lures used by a grandfather who taught the lender to fish in silence and killed himself one Valentine's Day; the seamstress's tool used by a musician's mother to pull the

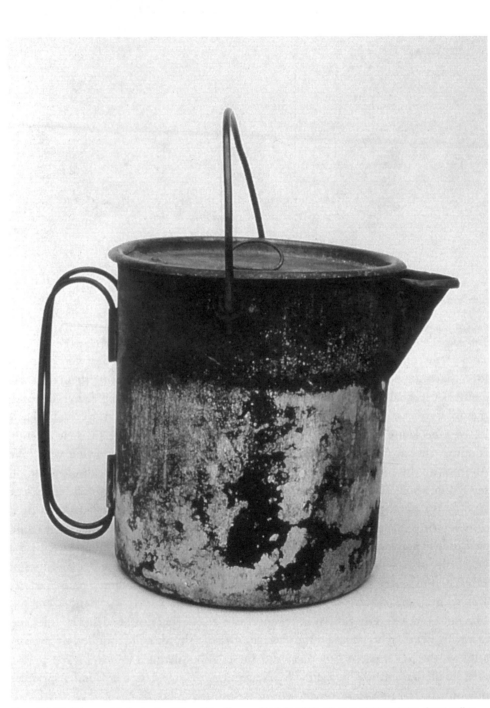

Figure 6. Millie Wilson and Catherine Lord, *Something Borrowed* (detail), 1995, mixed-media installation. Camp coffee pot, c. 1920, loaned by Jerry Richardson, Santa Fe, administrative judge, age 45. Photograph by Ken Marchionno.

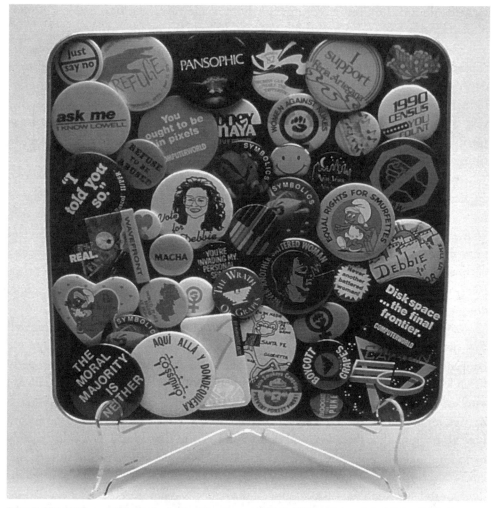

Figure 7. Millie Wilson and Catherine Lord, *Something Borrowed* (detail), 1995, mixed-media installation. Political buttons, 1975–95, loaned by Marion Martínez, Glorieta, psychotherapist, age 41. Photograph by Ken Marchionno.

buttons through denim fabric in the jeans factory in El Paso where she worked for thirty-five years; a sliver of bone in a silver Navajo box, saved by one student from her mother's cremated remains; the music box to which a couple in Oklahoma used to dance, a gift to them from their children, who saved pennies to buy this luxury; a notebook of songs loaned by a cowboy, part of a collection he inherited from a woman who had seen him through his childhood in the ranch country south of Santa Fe by teaching him to play the banjo and whom he hesitated to disrespect by naming her a lesbian; the tourist guide produced by a woman who passed as a man, lent by her companion of twenty years; a toy given by a grandmother; and a drawing of a cat lent by a woman who still mourned the child who had made it.

There were testaments to hate: the photograph and medals of a woman dishonorably discharged from the Air Force for homosexuality; a book on the right wing, lent

by two Albuquerque businesswomen; a homemade toy abandoned after a homophobic mother had ended her daughter's friendship with an older woman; and a baseball glove lent by an engineer whose father had raised her as his son but, when she confessed to an interest in girls, bragged about pushing a queer under the wheels of a truck. There were tributes to finding a self: a runner's medal, that last pack of cigarettes, a collection of political buttons, an artist's keys, an adobe brick, a child's life vest; a doll made of a soda bottle and sea grass, so that its nappy hair would be as splendid as the lender's; a paperback copy of Paula Giddings's *When and Where We Enter: The Impact of Black Women on Race and Sex in America.*

And finally, there were fables, riddles, and admonitions: the pair of dykes lent by an electrician who had the daily pleasure of cutting wire with a pun; the joke glasses lent by a teenager who didn't want to go below the surface; the photograph of a woman in a bouffant hairdo amid a sea of uniformed men, lent by a woman who had been the only female graduate in the 1964 class of the Albuquerque Police Academy; and, lent anonymously, by an anthropologist, an empty shelf "to stand for the manifest but elusive range of invisible and unnamed women who live together or alone, among all classes, everywhere in New Mexico."

It was a queer place, this wall informed by the closet, or more accurately, this wall that performed and formed the closet, which is of course hardly ever a closet, in the conventional sense of an architectural receptacle for those kinds of private property intended for rotating display, but rather a bedroom, a studio, a garage, a trailer, a kitchen, a bar, an office, a classroom, a casita, a cabin, a hogan, or a file cabinet, a drawer, an *armorio,* a locker, a wallet, a tool chest, a basket, or just an old cardboard box. To imagine that these assorted doors and lids and flaps could or would possibly open onto one piece of queer territory called lesbian, one coherent community, one culture, was to catch oneself sweating to invent a fiction both reductive and redundant, or so I still hope. It is also to suggest the delicate, often treacherous, negotiations around issues of visibility that hounded the project. The price of visibility is high for queers and other deviants, since it provides both the solace of community and the curse of pathology. We neither wanted to pay that price, at least in full, or ask our collaborators to do so. At least we wanted to haggle. We were trading in paradox. We had gathered a collection of artifacts from a finite set of individuals who could not be accommodated under the label our presence as lesbians, especially a brace of domesticated lesbians, was supposed to authenticate. Verifiably lesbian in part because we were coupled, able to find the members of our tribe because we performed coupledom by flaunting it as both bait and camouflage, our role in the site-specific recuperation of identity politics was to reveal insider information, to serve as native informants, to solicit and to certify a singular culture to which we were said to belong, to which we had to belong in order to have a nationality legible to the terms of the exhibition. In other words, the artists needed strategies that would at least postpone their capture as ethnographic objects. In this sense, the wall was a collaborative performance between two rogue anthropologists[22] and a motley band of natives who at the least wanted to

represent themselves and at the most didn't want someone else's culture to manifest it-self as a by-product of their pleasure.

In this intersection between queer theory and site-specific art, between the vener-able institutions of the domestic closet and the museum warehouse, between "private" storage space and public treasury, between two theorized queers and a specific pomo market, there were bound to be slippages. It was clear every step of the way that *Something Borrowed* ran the risk of either being expelled from visibility altogether or corrected so that it could register in a heterosexual field of vision. It was more than once suggested that we might like to locate our project in a site out of the mainstream, usually in one of those (innumerable) houses way out in the country where two women used to live together. On other occasions, meetings with the museum staff sparked paranoia about putting "uncurated" material on public view. "This is a con-servative town," it would be said. "There are lots of lesbians and gays in New Mexico. People are very tolerant here, but they don't want it shoved in their faces." The real fear, I would say, was that the lesbian phallus would penetrate the museum. But it was too late. We had already strolled in through the barn door. We were sitting at the con-ference table. The museum therefore had to achieve a bureaucratic sublimation of its fears, which engendered a panic attack about the possibility that someone might lend us a dildo (though it seemed unrealistic to expect that anyone would give up her dildo on a six-month museum loan) or that someone might use "obscene" language in her text (though it remained unclear whether obscene meant the f-word, the c-word, the p-word, or whether just the l-word would suffice). These discussions were, mercifully, rendered moot when one of the museum's chief curators suddenly left town. Though the story may well be apocryphal, local scuttlebutt had it that the departure involved the accidental demolition of a pottery bowl while engaged in the on-site practice of heterosexuality with one of the museum guards.

During the process of installation, we were asked by the museum director to con-sider the possibility of putting one piece in the show on a pedestal, so that children couldn't see it easily. The piece in question was a case of artifacts titled *Flirt,* full of the lesbiana that came from our drawers. No one could explain exactly what it was that would be so dangerous to children: surely not a medical textbook, a work by Ruth Benedict, a picture of a woman in uniform, a snapshot of women playing baseball, a couple of bridesmaids kissing, a rubber stamp with the letter Q, two friends in an af-fectionate embrace, or some of the right-wing hate mail we received during the course of the project. We declined to raise *Flirt,* explaining that since we had in fact designed it low precisely to give access to the gay children in our audience, altering the design would compromise our intentions.[23] I expect this small act of resistance made us the only artists to be honored with a warning label, installed just outside our exhibition space. (In a serendipitous act of hypercorrection, this placed the label next to an enor-mous, round, velvety, maroon orifice by Anish Kapoor.) Installed after the private opening but before the influx of tourist "families," the sign advised that some materi-al in *Something Borrowed* might be more appropriate for adults. Mysteriously, no one

in the museum could recall who had directed that the label be installed. We asked that the sign be moved to the museum's front door, so that its pall would be cast upon every artist exhibiting in the museum, whereupon it disappeared entirely.

Other frictions between the closet and the warehouse revolved around the fascination generated by particular, strategic knowledges and their obverse—particular, strategic ignorances. As Eve Sedgwick has eloquently argued in her deconstruction of the closet, ignorance is never just ignorance but rather "ignorance *of* a knowledge," and such ignorances, "far from being pieces of the originary dark, are produced by and correspond to particular knowledges and circulate as part of particular regimes of truth."[24] Considered from a slightly different angle, it's generally a privilege not to have to learn, and so calculated blindnesses in our audiences became part of the work.[25] Entrenched heterosexuals, so to speak, had the hardest time, frequently dismissing the work as a debased version of women's history or obsessing about the audacity of certain cultural borrowings. ("Julie Andrews?" I heard one woman say. "They can't just *have* Julie Andrews!") Gay and lesbian people, or those familiar with gay and lesbian cultures, tended to gravitate to objects that could yield familiar readings about alternate gender identities or positive self-representations—baseball gloves or pocket knives or figures that could be read as spiritual icons—but often didn't stop to attempt to decipher what they couldn't immediately understand. Millie Wilson and I, of course, hadn't a clue as to the entire significance, if any, of our borrowings. I think that as artists, we wanted to foreground surface readings as a way to decline certain anthropological rituals. Our corruptions of disciplinary standards disappointed anthropologists along with artists: evidently, we had managed to achieve amateur status on both counts. And with few exceptions, the art press declined to notice what we believed we had made visible, that is, the fluidity of identity formations.

Something Borrowed was a performance in many senses of that word. As a work of art, it was specific to its two sites, impossible to duplicate, and absolutely ephemeral. At the same time, it was a performance of queered identities. I don't want to underestimate the fact that in any American city it would have been a performance to put an object on that wall, for it entailed outing not into a specific space but into the kind of visuality that allowed the possibility of glimpsing the lesbian, or of being glimpsed as lesbian, and positioning oneself in relation to those eventualities. At the same time, it was a performance that by its revelations installed other closets, relying for its effect on creating a group declared to be "in" by being "out" to varying degrees as lenders, while foregrounding their decisions to withhold disclosure about whatever they wished, to draw their own boundaries about public revelation.[26] What could it possibly yield—about identity, about evidence, about self-representation, about materiality—to choose one object to stand for oneself on a museum wall? What could an artifact hope to reconstitute about "a lesbian"? If lesbian is a performance, a gender, a kind of necessary drag, what sort of identity formation could these objects support? If the artifacts were "lesbian," in any culturally resonant sense, what would that imply about those who owned the identical banal objects—a washcloth, a ring, a journal, a doll, or a bird's nest found on a beach?

Something Borrowed turned both "lesbian" objects and "lesbian" lenders into de-coys that revealed the museum warehouse—in reality nothing more than an expensive renovation of a late Renaissance *Wunderkammer,* a cabinet designed to house curiosi-ties collected in "foreign" parts—to be identical to the closet of the domestic house,[27] especially when the door to that closet opens not just onto the utopian master bed-room in which heterosexuality is said to be practiced for the natural ecstasy of repro-ducing itself, but onto the allegedly democratic, inclusive, free meeting ground of a gallery in which, of course, public space has already been sexualized and colonized by making it normatively heterosexual, in the process not only privatizing but *articulat-ing* the realm of intimacy (observe that the master bedroom can no longer get by on just one closet), eliciting and banishing sexuality to the realm of a private rather unimaginatively conceived as a bedroom and building in that bedroom a closet, in other words, a small dark inferior dirty trivial space in order to contain its fears of pol-lution so that it can maintain the immense landscape of the public as a space with which and within which it can flaunt its desires, its memories, its rites, its little cere-monies of exclusion. The door to the closet never shuts properly, both because of the curiosity from which it is fabricated and because of the requirement that those stored behind it open the door over and over and over again to reassure the masters of the bedroom that they have a location in which they can always be found, to which they can always be returned. As all queers know, you can't step into, or out of, the same closet once, or even twice. The point about closets is that the door must constantly be kept in motion, and as we all know, one can never have too many closets, and they are never ever big enough. Is it really any wonder that the burgeoning market niche for or-ganizing systems for heterosexuals (check it out: there's always space for "his" clothes and "her" clothes) is exactly contemporaneous with a pitched battle for civil rights based on sexual orientation? That the closet would or could or should "hold every-thing," to appropriate a trademark that precisely contains the problem, is a fantasy of consumption engineered to give certain intimacies public credence and to criminalize others, a trick that otherwise and more drearily goes by the name "heteronormativity."[28]

Notes

1. Bruce W. Ferguson and Vincent J. Varga, "Longing and Belonging: from the Faraway Nearby" (curators' essay), in *Longing and Belonging: from the Faraway Nearby,* by Ferguson et al., exhibition catalog (Santa Fe: Site Santa Fe, 1995), 131.

2. Other artists in the exhibition included Marina Abramović, Chema Avargonzalez, Francis Alys, Robert Ashley, Rebecca Belmore, Barbara Bloom, Imre Bukta, Carlos Capelan, Thomas Joshua Cooper, Braco Dimitrijevic, Felix Gonzalez-Torres, Ann Hamilton, Gary Hill, Jenny Holzer, Rebecca Horn, Anish Kapoor, Chie Matsui, Jakob Mattner, Gerald McMaster, Bruce Nauman, Marta Maria Perez Bravo, Alison Rossiter, Meridel Rubenstein, Andres Serrano, Lorna Simpson, Valeska Soares, Pietrick Sorin, Trinh T. Minh-ha, and Tseng Kwong Chi.

3. I rely here on Andrea Fraser's deconstruction of rhetoric and history in "What's

Intangible, Transitory, Mediating, Participatory, and Rendered in the Public Sphere?" *October* 30 (spring 1997): 117–48.

4. Ferguson and Varga, "Longing and Belonging," 132.

5. For an account of the mutilation, see Ramon A. Gutierrez, *When Jesus Came, the Corn Mothers Went Away: Marriage, Sexuality, and Power in New Mexico, 1500–1846* (Stanford, Calif.: Stanford University Press, 1991), 52–55.

6. The phrases are Frank Cushing's, from an 1882 letter to Joseph Stanley-Brown in which he describes his plans for Oraibi. Quoted in Jim Ostler, "Discourse," in *A Zuni Artist Looks at Frank Hamilton Cushing*, with cartoons by Phil Hughte and discourse by Ostler (Zuni: Pueblo of Zuni Arts and Crafts, 1994), 109.

7. In any complex collaboration, it is impossible to separate the individual contributions of equal partners. After all, the point of collaboration is that the whole is greater than the sum of its parts. That I am the author of this account, produced without the participation of Wilson, is in no way intended to diminish her role or her work. Neither is it intended to suggest that Wilson should bear any responsibility for my speculations about, or readings of, our project.

8. *Berdache*, derived from Arabic and Persian words for the boy in a male homosexual relationship, is a term popularized by North American anthropology. Vividly and literally an orientalizing term, it does not account for the specificity of cross-gender roles in nearly 150 North American societies, roles that do not derive from the sort of Western traffic in gender that produced the figure we would describe as "homosexual." Almost all, which is to say 120, of the anthropological descriptions of the berdache attest to biological males assuming female social roles, making the fleeting references to biological women performing male social roles extremely tantalizing, for instance, the "manly hearted women" of the Plains tribes. Unsatisfactory and contested as the term *berdache* is, no other word so easily opens complex perspectives on multiple genders in relation to social roles. Literature on the berdache is enormous and uneven, but see especially Will Roscoe, "How to Become a Berdache: Toward a Unified Analysis of Gender Diversity," in *Third Sex, Third Gender: Beyond Sexual Dimorphism in Culture and History*, ed. Gilbert Herdt (New York: Zone Books, 1994); Charles Callender and Lee M. Kochems, "The North American Berdache," *Current Anthropology* 24, no. 4 (August-October 1983); and Harriet Whitehead, "The Bow and the Burden Strap: A New Look at Institutionalized Homosexuality in Native North America," in *Sexual Meanings: The Cultural Construction of Gender and Sexuality*, ed. Sherry Ortner and Harriet Whitehead (New York: Cambridge University Press, 1981). Will Roscoe, *The Zuni Man-Woman* (Albuquerque: University of New Mexico Press, 1991), is the seminal celebration of the Zuni berdache.

9. W. H. Holmes, "In Memoriam: Matilda Coxe Stevenson," *American Anthropologist* 18 (1916): 552–59.

10. Matilda Coxe Stevenson, "The Zuni Indians: Their Mythology, Exoteric Societies, and Ceremonies," in the *Twenty-Third Annual Report of the Bureau of American Ethnology* (Washington, D.C.: Government Printing Office, 1904).

11. Washington Matthews to Cushing, August 8, 1881, quoted in Curtis M. Hinsley, *The Smithsonian and the American Indian: Making a Moral Anthropology in Victorian America*, rev. ed. (Washington, D.C.: Smithsonian Institution Press, 1994), 197. See 195–99 for a summary of Stevenson's reputation.

12. Quoted in Hughte, *Zuni Artist*, 94.

13. Hinsley, *Smithsonian*, 195.

14. Quoted in Roscoe, *Zuni Man-Woman*, 9.

15. These phrases appear in press accounts of We' wha's tour, and are quoted in ibid., 59–60. Roscoe's book, esp. chaps. 1–3, is the best account of this relationship.

16. Stevenson, "The Zuni Indians," 123, 311–12.

17. Stevenson's estranged friend, Clara True, proposed to the Smithsonian in 1908 that the We' wha story would be the "cream" in her humorous write-up of the aborigines for a charitable affair that would benefit hospitals: "I should of course leave out all the objectionable features for instance 'We-wha' being employed as lady's maid for a time by an ethnologist and being around the dressing rooms where pompadours were being 'done,' which happened." Roscoe, *Zuni Man-Woman,* 72.

18. There were, altogether, three take-away texts, one on the anthropologist and the berdache, one on coming to voice, and one that appropriated newspaper accounts of an event that took place in Santa Fe in the early 1950s, when a doctor called Nancy Campbell kidnapped for ransom a little girl, the daughter of a prominent local businessman, who was in a day or so found unharmed at a Santa Fe motel now popular with budget-minded families. Campbell, convicted by an Albuquerque court that denied her insanity pleas, was tried in the press by language that named her as, and convicted her of being, a lesbian, within once using the word: "She was a prominent woman. She was boyish. She was businesslike. She was a mannish type. She had short hair. She had broad hips and narrow shoulders. She was strong willed. She was fired with ambition. She was educated. She was as normal as any other woman."

19. *White Girl,* designed mainly by Wilson and executed by theatrical wig mistress Lee Burnette, should be seen in the context of Wilson's various spectacular hairpieces. For a partial description of these, see Miriam Basilio, "Corporal Evidence: Representations of Aileen Wuornos," *Art Journal* 55, no. 4 (winter 1996): 56–61.

20. Hal Foster, "The Artist as Ethnographer," in *The Return of the Real* (Cambridge: MIT Press, 1996), 186. Foster's essay, a provocative, often scathing, critique of "ethnographer envy" among artists, generally fails to imagine the possibility of the artist as trained insider, or an insider capable of using paradox and making double-edged comment.

21. We did not want to privilege the access of artists, as skilled object producers, to the museum, and we did not want to curate a lesbian art show. Though the decision was undemocratic, and doubtless unresponsive to part of the "very specific regional context" we had been asked to address—that is, the number of lesbian artists unrecognized by the New Mexico mainstream—if I had it to do all over again, I'd make the same decision.

22. Foster, "Artist as Ethnographer," 182, uses this term dismissively—"rogue investigations of anthropology, like queer critiques of psychoanalysis, possess vanguard status: it is along these lines that the critical edge is felt to cut most incisively." Personally, I find the connection between these two social formations of the nomad tantalizing: both typically structure escapes from the nuclear family into another field altogether.

23. Neither of us, as I remember, had in fact been so prescient, but the fiction was our best recourse.

24. Eve Kosofsky Sedgwick, *Epistemology of the Closet* (Berkeley: University of California Press, 1990), 8.

25. I still take especial delight in the hidden labor that only a curator, or another artist, could infer. For example, it cost the state plenty to receive these "lesbian" artifacts into its warehouse on temporary loan. Each object had to be described, measured, identified by the materials that constituted it, photographed, assigned a monetary value, and inventoried as to cracks, foxing, fading, wrinkling, and other signs of degeneration. The process yielded a few emblematic collisions between the warehouse and the closet, as when the museum's registrar filled in all the necessary data on the dildo harness—black leather, metal ring, stitching, etc.— but then described it on the loan form as a garter belt. We were speechless: Warehouse 1, Closet 0.

26. We were not anxious to provide a list of eighty-three targets in a state then battling its

version of "special rights" amendments. The label for the wall of objects—a large panel that gave name, occupation, age, residence, and story—was an intricate web of pseudonyms, false residences, aggrandized occupations, and stories that addressed absolutely everything but the obvious. Anonymous, in this wall, was definitely a lesbian and usually poor, not a rich person secreting his property, as is usually the case when a museum agrees to withhold the identity of a lender.

27. I think Judith Butler's "Imitation and Gender Insubordination," in *The Lesbian and Gay Studies Reader,* ed. Henry Abelove, Michele Aina Barale, and David M. Halperin (New York: Routledge, 1993), is foundational for subsequent discussions of the closet and the public sphere. See also Lauren Berlant and Michael Warner, "Sex in Public," *Critical Inquiry* 24, no. 2 (winter 1998): 558–59.

28. Or perhaps *Something Borrowed* did nothing of the sort. Perhaps I'm simply projecting the reception of a collaborative work in order to assert intention, refabricating in order to lay claim to agency. I am, after all, leading this narrative toward closure by the declarations of special knowledge for both artists and natives. Neither artists nor lesbians nor former lovers of any sort are supposed to control the spectacle they make: the privilege of interpretation is assigned elsewhere. But that, it should be evident by now, is simply to open the door to the site of another closet.

19. Imaging Community:
Video in the Installation Work of Pepón Osorio

Tiffany Ana López

Pepón Osorio is a mixed-media artist whose work is grounded in Latino popular culture. He was born in Santurce, Puerto Rico, and moved to the South Bronx, New York City, in 1975. From approximately 1988 to 1987, his work approached Puerto Rican identity from the perspective of one living on the island. During this time he worked primarily with objects of Latino popular culture and exhibited his work in Puerto Rico and at ethnic-identified museums in New York.[1]

In 1985, after a decade of living in the South Bronx, Osorio changed his visual and thematic vocabulary to address a need for cultural reaffirmation as a means of defining and validating self-identity.[2] By integrating a culturally specific visual vocabulary with his lived experience of social realities, Osorio further challenged prevailing notions about Latino art, including that held by many intellectuals who define popular culture (seen by the community as everyday artistic expression) as "kitsch." This change in Osorio's vocabulary culminated in 1987 with his most widely recognized work, *La Cama* (The bed).[3] This piece marks another shift in Osorio's artistic practice, in which he began to focus on exhibiting in group shows while working as a set and installation designer primarily in collaboration with choreographer Merían Soto, as part of evolving his visual and thematic vocabulary to more directly address and make visible the Latino body, both individual and social. Osorio tried to answer the question of where the body is in his work by supplementing art pieces with performance and dance. By physically performing as part of the work, Osorio juxtaposed the implied but physically absent body in pieces such as *La Cama* with his own stated and physically present body in performance. In 1991 El Museo del Barrio commissioned from Osorio *El Velorio, AIDS in the Latino Community* as part of a major retrospective of his work at El Museo. This exhibition further characterized his use of art as a form of community

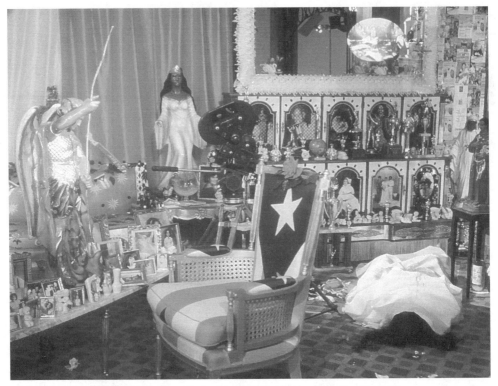

Figure 1. Pepón Osorio, *Scene of the Crime (Whose Crime?)*, 1993. Used by permission of the artist.

outreach designed to foster dialogue around important issues affecting the Latino community.

It was in the early 1990s, however, that Osorio began to incorporate video into his mixed-media work about Latino popular culture, beginning with his installation *Scene of the Crime (Whose Crime?)*, shown in the 1993 Whitney Biennial. His selection marked his entrance into the mainstream art world, and, significantly, it also marked his shift to the use of video, from his own performing body, as a cultural mediator. His *Scene of the Crime (Whose Crime?)* was featured in the *New York Times* review of the biennial, which tied Osorio's work in with the major criticism launched against the show. The controversy around the biennial concerning what kind of works—and by extension, which social groups—could enter the dominant cultural museum space influenced Osorio's decision not to show new work in mainstream museums until it had been first shown in his community.[4] This decision was also influenced by his realization that though his contribution brought the museum's attention to the artistic cultural production of Puerto Ricans, it did not in and of itself bring Puerto Ricans into the museum. In other words, the focus in his work on the Latino body did not necessarily guarantee the increased visibility of that social body.

This presents a source of anxiety for the artist that often surfaces in his attempts to stage, and thus make visible, the relationship between representations of the body (imaging) and the imagining of community. For example, *La Cama* represents the

Latino body and culture through a structured absence and an implied body.[5] In *The Scene of the Crime (Whose Crime?),* the body is that of a woman who, we are led to speculate, has been murdered by her husband. Her body (a mannequin "corpse" lying facing down on the floor) is roped off by police tape with the instructions "police line: do not cross," and the only access to the Latino body (individual and social) is by means of objects in the domestic space (personal photographs, sentimental bric-a-brac, trophies, patron saints) that signify the presence of "real" Latino bodies as having once inhabited this staged cultural space (see figure 1). As the title of the work suggests, however, there are the questions of whose crime scene this is and why the Latino body must necessarily be represented as an implied body.

Yet Osorio's installation immediately deconstructs any initial reading of the scene as a "typical" representation of Latino domestic space. This is achieved by Osorio's having roped off the scene, only allowing the viewer to enter the space conditionally. The welcome mat to the exhibit reads, ". . . only if you can understand that it has taken years of pain to gather into our homes our most valuable possessions; but the greater pain is to see how in the movies others make fun of the way we live." Osorio thus redefines the issue of Latino domestic violence raised by the crime scene to directly confront the way U.S. Latinos are represented in mainstream American culture primarily as violent criminals. Osorio establishes a direct connection between the wounded body of the crime scene and the imaging/imagining of Latino bodies in dominant cultural production, especially in Hollywood film, by using video to underscore the relationship between representation and the real. Actual videotape boxes of

Figure 2. Detail from *Scene of the Crime*. Used by permission of the artist.

films depicting Latino stereotypes are used to frame the space and the various ficti-
tious portrayals of Latinos (see figure 2). Each box presents a "statement" made by
people in the Latino community whom Osorio interviewed about how they are af-
fected by representations of Latinos in Hollywood film:

> We are either seen as violent, horny, or on welfare. They never show our humanity or
> our struggles and empowerment.

> You see the negative stereotypes portrayed in the movies so many times that at some
> point you start believing them yourself.

> The more I see the stereotypes, the more I feel excluded from the world, almost as if
> I'm living a reality that is not common to others.

> You would expect that by now they would be more conscientious. We've grown, why
> can't they?

By using mirrors in the installation Osorio confronts the viewer to look at his or
her participation in this cycle of cultural wounding and cultural healing. Directly
above the body is a mirror. Inside is a video monitor that continuously plays a tape of
a blood-filled urn breaking (see figure 1). In slow motion the urn falls to the floor,
shatters, and then pulls itself back together again. This repeated cycle of shattering
and reconstruction represents the assault on Latino culture by mainstream media and
signifies the repeated strategies of cultural resistance enacted by Latinos—including
those presented in Osorio's *Scene of the Crime (Whose Crime?)*.

Following this period, Osorio shifts his use of video to even more directly bring
the body into the work. Video transforms into a form of writing the body. This cor-
poreal ascription of agency is significant because historically the body has been
marked as the site for constructing differences of race, gender, and sexuality, as well as
for signifying conquest, community, and nationhood. Osorio's *Angel: The Shoe Shiner*
(1993) shows this use of video in its formative stages. In this piece Osorio constructs
an elaborate altar that presents a life-size image of Angel as a producer of cultural
meaning. Osorio's video punctuates the currents of cultural tradition and respect that
inform Angel's work and Osorio's work on Angel. The video monitor at the bottom of
Angel's feet recreates the process of the shoe shine; we see spit fall on black shoes and
the shiner's hands quickly rubbing them in his characteristic back-and-forth sawing
motion. The hands we see in the video indeed belong to Angel (see figure 3).

Through the medium of video, Osorio takes his own body out of the museum
space and instead posits video as a point of mediation between himself and the com-
munity. In looking at the trajectory of his work, one might ask what video does that
the physical presence of the artist/performer did not. As a practical matter, once
Osorio's work gained more attention and with it more invitations to shows, it became
almost impossible for him to go to every exhibition site to physically establish the visi-
bility of the Latino body as he metonymously represents it. As an aesthetic matter,

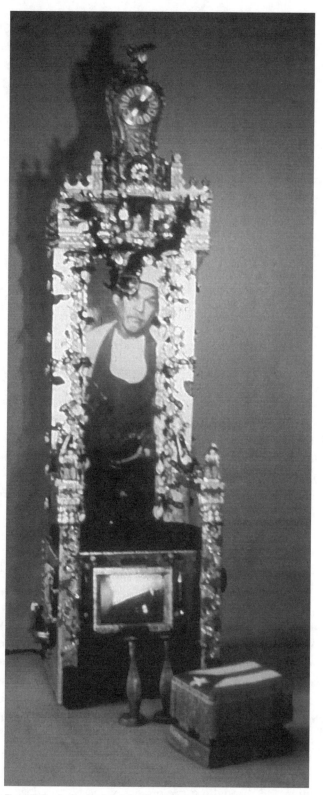

Figure 3. Pepón Osorio, *Angel: the Shoe Shiner,* 1993. Used by permission of the artist.

video is a form of mediation that merges the arts, mass culture, and community-based activism. The bodies appearing in Osorio's video work tend to be the bodies performing or suggested in the context of his art but otherwise absent from the museum or overdetermined in the mass media. Osorio's use of video deals not so much with the issue of the "authentic" Puerto Rican body but more so with the body of the arts audience he's trying to reconstitute. Implied is a fairly reformist agenda to integrate Latino cultural production, community, and agency into a mainstream civic or arts space. Osorio came to realize that the presence of a Puerto Rican artist's work in and of itself will not bring Puerto Ricans to such a museum as the Whitney. Therefore, he incorporates the use of video to move into a new space of cultural negotiation, one of constituting and mediating community within the community itself *first*.

Osorio's most recent community-oriented installation makes use of video as an open-ended project, one that Osorio still grapples with. *En la barbería, no se llora* (No crying allowed in the barbershop) was commissioned in 1994 by Real Art Ways (RAW) of Hartford, Connecticut (now in its twentieth year), for its RAW Specifics Program. RAW Specifics commissions three public artworks a year and invites the artists to create a work specific to Hartford that also addresses issues affecting outside communities.[6]

Osorio chose Park Street, a large Puerto Rican neighborhood, as the site for this installation piece. The issues he decided to address began with his thinking about how Latino community is constructed around the notion of cultural space and how these spaces, in turn, shape behavior in both the private and public spheres. He recalled that during his childhood in Santurce, Puerto Rico, the barbershop was central to the imagining of community because it provided "a place for men to go on Saturdays, outside the family. It was a social club, a place to play dominos and do business."[7] In reflecting on his first haircut in the barbershop, Osorio remembered that, as a five-year-old boy, it was a frightening rite of passage into Latino masculinity:[8] the electric razor, with its menacing sound and sharp teeth, aggressively pulling the hair from his scalp. His father admonished the young and terrified Pepón, "En la barberia, no se llora." As a distinctly male space that excludes women, the barbershop prohibited crying, or anything else perceived as "feminine." Recalling this experience as the foundation for his thinking of the exhibition, Osorio says that "teaching boys not to cry is perhaps the most primary lesson of learning to be a man."[9] Because he saw the issues most affecting the community—gang activity, domestic violence, homophobia, the refusal to use condoms in an age of AIDS—as rooted in the concept of masculinity, Osorio thus decided to create an installation that would use the culturally specific and gendered space of the barbershop to explore the construction of Latino masculinity, *machismo*.[10]

For the installation site Osorio chose an abandoned building on Park Street that had at one time been a church and, coincidentally, at another time a "beauty parlor." From the beginning and throughout the project, video was used as a springboard for building community. Osorio invited men of various ages from the community to be

featured in the videos created for the installation. These men were aware that their images would be shown to the community to help instigate a dialogue about the issues of machismo; they consciously participated in the project as a form of activism. Osorio's collaborations included young men who allowed their bodies to be video-taped in various "masculine" poses. He also videotaped older men from Casa del Elderly, a Puerto Rican retirement home across the street from the exhibit, conversing about how machismo in Puerto Rico had shaped their lives. Later these same men—with whom visitors to the barbershop were already familiar—came and conducted workshops with Osorio and younger men in the community to discuss how the concept of masculinity determined the kinds of relationships they were able to have with other people. Women, as well, were invited to examine the effect of machismo in their lives. Osorio brought women into the installation as part of his goal to deconstruct the barbershop as a gendered social space. For example, he conducted a workshop with Cuidate Mujeres, a group of single mothers who brought the fathers of their children together to discuss their conceptualizations of machismo and its influence on their perceived roles as partners and fathers. Most of the women in the community who had never before been allowed to enter the male-dominated space of the barber-shop ended up constituting the majority of the exhibition's visitors.

It took nearly a month to set up the installation and over a year and a half of community planning with Hartford's RAW. Osorio brought his assistants from New York, but once in the community he also hired two Park Street regulars to help him with the installation. Those on Park Street were at first highly suspicious of Osorio's presence. There was already one barbershop on the block, and Osorio was initially perceived as a rival business. Once the community understood, however, that what he was doing was a form of community outreach, they gave him their full support. The barbershop, in fact, became a local hangout where people sat on the front steps with sodas to cool off during the summer's early evenings.[11]

Osorio painted the front of the building to resemble a Puerto Rican barbershop (see figure 4). Inside, sixteen video monitors presented the Latino male body, individual and collective, engaged in physical and emotional displays of masculinity. A color monitor in each of the two front windows played a continuous video of men crying, their images advertising to the passerby the work's thematic content of deconstructing machismo.[12] Osorio removed the sound track from each tape so that the viewer was forced to focus on the emotions the men conveyed through their body language. This provided an outlet for both male and female viewers to look freely at the Latino male body. RAW's community outreach liaison, Luis Cotto, reports that many women were completely disgusted with the men crying, while other women expressed that seeing men cry like that was "the saddest thing in the world." Osorio reports that some men who came to the installation responded to the video empathetically by showing their tattoos or otherwise engaging in identificatory acts of physical display.

Inside Osorio's barbershop each wall stood covered to excess with male iconography. The wall closest to the entrance was filled entirely with portraits of Latino men:

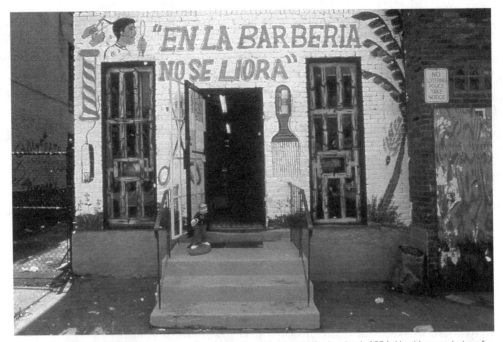

Figure 4. Pepón Osorio, *En la barbería, no se llora* (No crying allowed in the barbershop), 1994. Used by permission of the artist.

such politicians, athletes, and entertainers as Fidel Castro, Roberto Clemente, Ruben Blades. The largest portrait among them, which appeared as if it were trying to emerge from the wall and physically enter the installation space, was that of Benjamin Osorio, the artist's father. These photographs established a kind of Latino Hall of Fame that paid tribute to Latino men as political and spiritual healers of their community, something quite antithetical to dominant cultural representations of Latino men as either violent criminals or Latin lovers. Watching over these portraits was a statue of Saint Lazarus, known as a downtrodden and empathetic healer of the community (see figure 5). Osorio prominently displayed near these representations a fish tank containing a miniature tableau of the Last Supper, a scene like that of the barbershop, which, because it is devoid of the presence of women, reinforces full male control over social space. These representations of men, while signifying the healing of community, also mark Latino cultural space as exclusively male. All of this was placed against a contrasting "feminine" backdrop of floral wallpaper, pink at the receiving area and yellow throughout the rest of the barbershop, to emphasize how color is used to assign gender.

The walls of the barbershop were so excessive in male iconography that the space ·threatened to close in on itself because of the stress of such rigid and weighty definitions of gender roles. On the ceiling was a silk-screened pattern of sperm under a microscope. The wall opposite the entrance was studded with a collection of fake ears and small oval photographs of gaping mouths framed by a string of pearls. Above, speakers blared Latino salsa music. The wall came alive with these images, the mouths

crying out to be listened to above the din of overdetermined Latino masculinity that characterized the installation space. Beside the haircutting stations ran a counter space overstocked with brushes, picks, colognes, hair sprays, lotions, and photographs of male barbers cutting the hair of other men who presumably left the barbershop satisfied customers. The display of these products called attention to the way capitalism participates in and reinforces machismo through the promotion of hair products and vitamins (such as Osorio's own brand of Vigo Macho), the social culture continually reinforcing masculinity as domination and power by ritualizing the daily manipulations of the male body.

Osorio's visual vocabulary thus underscores how entering the barbershop is about much more than a haircut. The installation questions cultural presumptions about the construction of masculinity through its self-conscious associations between "masculine" objects and subjects. For example, old car seats served as waiting area chairs, and car parts were strewn throughout the barbershop. The barber chairs were a plush red and covered with tiny, phallic straw hats, baseballs, miniature cars, male action figures, and the Puerto Rican national flag. Ivy leaves wound around the foot- and armrests, threatening to restrain the chair's inhabitant. The headrest at the top of each chair was replaced by a color video monitor repeatedly playing images of voiceless Latino men crying: they were literally voiceless because Osorio removed the sound track, but they are also voiceless in their cultural marginalization. Osorio's signature use of toy dolls in this work signifies the boyhood lost when the young male takes the seat for his first haircut. He silk-screened each barber chair with the image of a nude adult male body. In Osorio's social script a boy takes this seat, is embraced by this

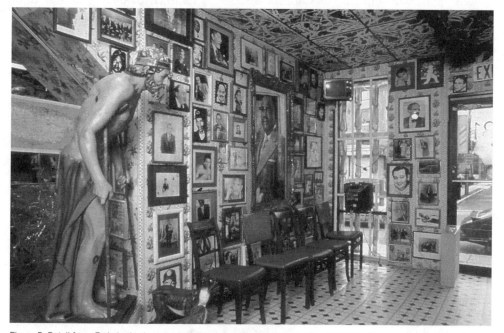

Figure 5. Detail from *En la barbería, no se llora* (No crying allowed in the barbershop). Used by permission of the artist.

image of masculinity, and, through the rituals of the barbershop, eventually emerges a likeness of the silk-screened shadow of a man (see figure 6).[13]

Inset into the mirror space spanning the row of haircutting stations were video monitors, one beside each station; the mirror's backing was removed and replaced with monitors (see figure 7). Viewers were thus implicated as participants in machismo as they watched themselves watching the video, consisting of Latino men posing in various ways: a middle-aged man pumps iron; men get dressed in casual, work, and formal clothing; young men show off their tattoos and flashy jewelry; a guy on the street grabs his crotch while hanging out with other guys; men walk together at the annual New York Puerto Rican Day Parade. The only male child present in the video is a baby boy crying out at the moment of circumcision. Osorio varied his series of Latino men crying by reintroducing one of them into the video-installed mirror images. Here he becomes angry and lashes out, his hair flailing about his face, his body language exploding from years of repressed emotion. Intercut between these images is that of a young male wearing the Puerto Rican flag around his neck like a Superman cape. He runs throughout the barrio, chased by the camera standing in for the viewer's gaze. When, at the end of the video, we finally catch up to him and get a close-up of his face, he turns to the viewer and, draped in that symbol of Puerto Rican nationalism, defiantly flips us the bird, a confrontational gesture that says "fuck you" to the viewer's expectations of Latino masculinity. What had we, male or female, Latino or non-Latino, been expecting from these Latino male bodies?

Osorio's use of video literally brought the communal body into the work, facilitated community outreach, and instigated social change. Some male exhibition-goers were moved enough to join one of Osorio's workshops for men to discuss the effect of machismo on their lives. Twenty-eight-year-old Pedro Flores, a recovering alcohol and drug abuser and former gang member, said that the exhibition had helped him to open up to his wife and explain the feelings he was trying to work through, what he described in the workshop as a sense of "loneliness" about having to act like a man. He told the group that he planned next to bring his father to the barbershop: "I want to see him walk around and tell me what does he think about this form of art. Does he get the message or not, and, if he don't . . . I'm going to explain it to him and tell him what I think of that person on the TV crying. I'm going to tell him that was me when I was small, and that's me right now, also. He's the same, but he doesn't want to admit it, you know?"[14]

Luis Cotto, the outreach liaison from RAW who worked with Osorio and various community groups throughout the duration of the exhibit, lives in the neighborhood. He says that even today when he walks down Park Street, people ask, "When are they going to come and do that again?" Within this question, there are other implied questions: What will happen when residents of Park Street have to go to a museum in New York or Puerto Rico to experience *En la barbería, no se llora*? How will two different cultural spaces bring two different people together? As Osorio's work shows, the artwork alone cannot make this happen; there must be the commitment of intervention from arts and community organizations themselves.

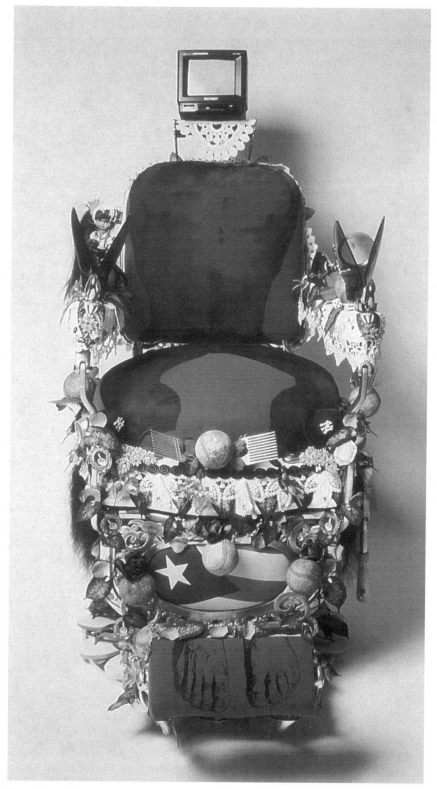

Figure 6. Detail from *En la barbería, no se llora* (No crying allowed in the barbershop). Used by permission of the artist.

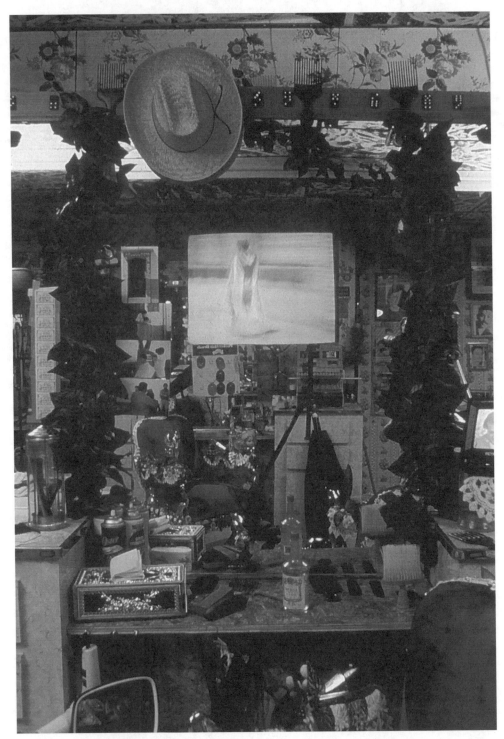

Figure 7. Detail from *En la barbería, no se llora* (No crying allowed in the barbershop). Used by permission of the artist.

There is a real need for an active construction of both symbolic and physical bridges between and among communities and cultures, spaces that currently remain worlds apart. The geography of Hartford testifies to this. Though Park Street provides the fastest route from Hartford to the predominantly white and wealthy suburb of West Hartford, most suburban commuters opt for the longer, more congested route of the freeway—thus daily communicating to those on Park Street that, given the choice, they will even choose inconvenience in order to avoid any contact with Hartford's Puerto Rican community.

Osorio's work in the 1990s continues its focus on site-specific installations designed to take viewers to a heightened vantage point from within their own communities. For the Home Show II exhibit sponsored by the Santa Barbara Contemporary Arts Forum, Osorio upholstered the entire contents of a room in a comfortable, middle-class home. "Badge of Honor," his work on the relationship of an incarcerated father with his son, debuted in a storefront neighborhood in Newark, New Jersey. More recently, he presented his piece "Transboricua" in the Youngworld Children's Department Store in East Harlem. Osorio was awarded a 1999 MacArthur Foundation Award in recognition of his career-long commitment to visually intensify the familiar and move us as viewers to think critically about our presumptions about the environment and other people with whom we live.

Notes

I'd like to thank Chon Noriega, who suggested this project and whose ideas have significantly influenced my thinking about this and other writing; Diana Taylor for her ongoing mentorship and friendship; John Hanhardt for his support of this project and others in Latina/Latino arts; J. Anderson, curator of Real Art Ways, Luis Cotto, Patricia Herrera, and Brenda Bright for sharing their insightful readings of Osorio's work, which helped to inform this piece; Matt Garland for his wonderful way with words; and, especially, Pepón Osorio himself for sharing his work and generously providing articles, slides, videos, conversation, *cafecito, y corazón.*

1. Osorio exhibited *Hasta Ahora* at Cayman Gallery, New York, in 1982; *Escombros* at Arch Gallery, New York, and at Instituto de Cultura Puertoriqueña, Puerto Rico, in 1983; *Escalio* at El Museo del Barrio, New York, in 1984; and *¡Ay Gran Poder de Dios!* at Hostos Community College, New York, in 1985.

2. For a historical overview of Puerto Rican artists and a discussion of their shift in visual vocabulary following community involvement in New York, see Mirimar Benítez, "The Special Case of Puerto Rico," in *The Latin American Spirit: Art and Artists in the United States, 1920–1970,* exhibition catalog (New York: Bronx Museum of the Arts, 1988). For further discussions of Osorio's work, see Joan Acocella, "Pepón Osorio's Plastic Heaven," *Artforum* 30 (January 1992): 64–67; Hovey Brock, review of "Pepón Osorio, El Museo del Barrio," *Artnews* 90 (October 1991): 136; Coco Fusco, "Vernacular Memories," *Art in America* 79 (December 1991): 98–103, 133; and Jonathan Mandell, "Extravagance and Sadness: The Nuyorican Art of Pepón Osorio," *New York Newsday,* June 20, 1992, 68–69.

3. *La Cama* is in the permanent collection, El Museo del Barrio, New York. An installation in homage to Juana Hernández, his "second" mother, *La Cama* was inspired by a dream in

which he introduced Hernández to his fiancée, Merían Soto. For the artist, the piece represents a coming to terms with Hernández's death from cancer. For further contextualization of this piece within Osorio's other work, see Susana Torruella Leval et al., *Con to' los hierros: A Retrospective of the Work of Pepón Osorio,* exhibition catalog (New York: El Museo del Barrio, 1991).

4. Pepón Osorio, interview by author, New York, January 26, 1995.

5. Osorio's *La Cama* is a Latino bed of baroque ornamentation. There are no physical bodies in the bed; (Latino) bodies are instead implied through Osorio's use of *recuerdos/capias* (Latino mementos of special events) that entirely cover the bed. In Spanish, *recuerdo* carries the double meaning of "memory." Because *La Cama* is entirely covered with *recuerdos*—souvenirs from baptisms, baby showers, birthdays, weddings, anniversaries, and so on—it becomes transformed into a representation of Latino cultural memory itself.

6. Recent projects include Ellen Driscoll's *Passionate Attitudes,* which focused on the notion of hysteria and women as placed within the discourse of science. This was exhibited in the windows of Hartford area shopping malls. Lillian Sue Flanders's socially graphic work *The Red Sweater Project* comprised eighty-six hand-knit red children's sweaters made by various people in the community. This project's small and strikingly red sweaters lined City Hall as an emergency call to stop the poverty and homelessness that most affect the children in the community.

7. Steve Starger, "A Latino Barbershop, a la Osorio," *Journal Inquirer,* July 15, 1994.

8. The experience also raised the issue of intracultural racism for Osorio, who is a black Puerto Rican with curly hair. He recalled that the white-skinned barber with straight hair did not know how to cut curly hair and was therefore threatened by Osorio's hair as representative of the intracultural differences that exist between men. As such a signifier, Osorio's hair confronted how, in that cultural context, the visual coherency of gender became conflated with that of race; to be a man in the barbershop was to be a "white" man.

9. Pepón Osorio, quoted in Victoria A. Brownworth, "The Machismo Myth," *Metroline,* August 25–September 14, 1994.

10. I want to emphasize that I, like the artist, am using this term to refer to the construction of masculinity within the specific context of Latino culture. Many writers in the dominant culture indiscriminately use the term *machismo* to describe all sexist behavior per se. The term is most often used without distinction as if patriarchy and sexism were somehow unique to Latino men and not something in all patriarchal cultures—including the United States. The Spanish gets invoked in a way that marks patriarchal behavior as an exclusively Latin cultural phenomenon, as if it did not exist in the dominant culture by any other name.

11. Many in this community are without jobs; most women with children are single mothers; many young men turn to drugs, crime, and/or gang activity. A year prior to the installation, sixteen children in the area were killed in relation to street warfare between two local gangs. Despite the fact that the installation was in a high-crime area and a vulnerable location, it remained completely undisturbed during the three months it was exhibited—something the Hartford police found absolutely incomprehensible considering that Osorio had sixteen VCRs and monitors, as well as other audio and visual equipment, prominently displayed inside the installation. Those involved in the project saw this as a testament to how much public interactive art is needed and valued by the community. Luis Cotto, the community outreach liaison from RAW who was at the exhibit for eight hours a day throughout the duration of the installation, reported that the street people on Park Street in particular gained a great source of pride from Osorio's barbershop and guarded it during off-hours. One woman in the neighborhood, a recovering addict, was motivated by the installation to move to another city and enter a recovery program.

12. Despite the conspicuous title of the work and the presence of video monitors, Osorio's rendering of a Puerto Rican barbershop was so familiar to the community that people initially

came to the exhibit because they believed that it was actually a Puerto Rican barbershop. The prominence of appropriation and transformation within Latino popular culture is such that Osorio's work was immediately adopted into the cultural landscape. At the opening of the installation, Hartford barbers provided free haircuts to the community while Osorio handed out fake mustaches.

13. For a powerful exploration of the influence of social space on the construction of Latino masculinity, see Cherríe Moraga's play *Shadow of a Man,* in *Heroes and Saints and Other Plays* (Albuquerque, N.M.: West End Press, 1994). Also recommended are Cherríe Moraga, *The Last Generation* (Boston: South End Press, 1993), and Tomás Almaguer, "Chicano Men: A Cartography of Homosexual Identity and Behavior," *differences: A Journal of Feminist Cultural Studies* 3, no. 2 (1991): 75–100.

14. Phyllis Joffe, "Latino Men Focus of Photography Exhibit," *Weekend Edition,* National Public Radio, October 22, 1994.

20. The 1970s "Situation" and Recent Installation: Joseph Santarromana's Intersubjective Engagements

Amelia Jones

In January 1980 *Artforum* magazine published a series of artists' statements in "Situation Esthetics: Impermanent Art and the Seventies Audience." As the title suggests, these discussions, prompted by a series of questions posed by Nancy Foote, retrospectively took account of the 1970s, in particular the major shifts that had occurred in the way in which art was produced and received. Foote's questions are exemplary of the kinds of deep thinking being done at the time vis-à-vis the relationship of art to the social arena and to particular spectating subjects. She begins by stating:

> At the end of the 1970s many artists are dissatisfied with the exclusive posture of the traditional avant-garde and seem to be seeking ways to extend the art audience. . . . It could be argued that '70s, as distinct from '60s, art is characterized more by this change in attitude toward the audience than by a change in actual forms, or even content. The increase in the '70s of "project," performance, film and video art, all of which have their origins in the '60s, would seem to bear this out.[1]

I want to take off here from this early historicization of projects involving narrative and space in order to contextualize recent installation practices. In particular, I will focus on the work of Joseph Santarromana, which involves video, still photography, computer technologies, and, of particular interest to me, his own body as well as those of various colleagues and friends. The goal of the essay is twofold, reciprocal, in fact: to illuminate Santarromana's works (and, by extension, other recent practices involving new visual technologies in large-scale installation formats that bodily engage spectators) by placing them in a historical trajectory of interests, anchored in such discursive moments as the 1980 *Artforum* piece, and, correlatively, to come to a greater understanding of the modes of thought that have served to locate such works in dis-

course and define their social and aesthetic/phenomenological impact. I will insist here that we can best comprehend the complexity of effects put into play by the work of artists such as Santarromana by placing what we now call "installation art" in relation to its conceptual foundations in minimalism, body art, and conceptualism. As part of my broader project of studying body art,[2] I will focus especially intently on the links between installation art and body art, with side trips to the latter's closely related, phenomenologically invested cousin, minimalism.

This dual goal proposes from its motivating premises, which are informed by a phenomenology inflected by feminism and poststructuralism, that the works and the writings have mutually informed and defined one another, as if in a metaphoric staging of the ways in which the artwork engages and in turn is engaged by the spectator. In this sense, I am arguing that the very mode of effectivity that installation and its discourses propose—that of involving the spectator bodily and psychically (in phenomenological terms, the two are mutually constituted) in a chiasmic relation with the work—is paralleled by the intertwining of discourse (writing, exhibitions, and other modes of articulating the works) and practice (the objects/sites, themselves inseparable from their discursive framings) which provides the context that gives art meaning.

The spaces of discourse, like the spaces of art production and reception, are equally sites of meaning production where subjects engage socially, through circuits of desire that mitigate or thwart our continued fantasy that we are whole or self-sufficient. Through exploring installation and the related historical practices that open up the spectatorial relation, pointing to rather than veiling the fact that we are constituted in relation to otherness (other subjects and objects and other discourses in the world), I argue that what is at stake in the experience of visual artworks is the very problem of the contemporary "subject" and how this subject is culturally and discursively (through text, visual image, object, and so on) spoken or understood. Installation art, extending a trajectory initiated by minimalism, body art, and conceptualism, opens out who we (think we) are. It is no accident, then, that many younger artists—following the impetus of the rights movements—have drawn on the phenomenological effects of installation to explore the body/self in its ethnic, class, racial, sexual, and other particularities. Santarromana's work exemplifies these trajectories in the creative opening up of self-other relations, the interrogation of how "identities" are adopted and performed, via highly charged *situations* engaging the spectator with the "others" of the artist and the colleagues he includes in his work.

A Trajectory of Ideas: Theorizing Situation Aesthetics

The *Artforum* questions return us to an earlier moment in the theorization of situation aesthetics, or, in its other manifestations, "dematerialized" art, earthworks or site-specific art, minimalism, or conceptualism.[3] One of the key moments in the development of a phenomenological model of art production and reception occurred in the

late 1960s. From 1966 to 1967 both Michael Fried and Robert Morris published major articles in *Artforum* theorizing minimalism in terms of its phenomenological effects. Fried's now infamous article, "Art and Objecthood" (1967), is an important object of analysis not because he is supportive of minimalist discourse and practice (which he disparagingly calls "literalist" art) but rather because, in his vehement attempt to devalue the new work, he brilliantly outlines its powerful phenomenological effects.[4]

The spare, minimal objects of Fried's denunciation include pieces such as Robert Morris's *Untitled (Ring with Light)* (1965–66), a huge (ninety-seven-inch-diameter) circular form in gray fiberglass, with fluorescent light gleaming from two vertically cut slices in the substance of the circle, and Tony Smith's *Die* (1962), a six-foot cube in steel. It is these objects and their kind that Fried labels "literalist" and deems "ideological" (as opposed to the "wholly manifest" objects of modernism), "anthropomorphic" (versus the putative self-sufficiency of "good," i.e., modernist, art), "corrupted and perverted by theatre," and, ultimately, "antithetical to art." In order to stage this oppositional hierarchy of good and bad, art and nonart, and to naturalize it as compelling and truthful, Fried explicitly conflates ontological questions with aesthetic ones: "I would argue that what modernism has meant is that the two questions— What constitutes the art of painting? And what constitutes *good* painting?—are no longer separable."[5]

With this gesture, Fried strategically veils his own assumptions by conflating the *ontology* of the objects, their properties as objects that are to be considered as art, their self-evident "art-ness" and "thing-ness," with their value, thus implying that the value (which is, I would stress, determined through a set of highly motivated assumptions on Fried's part) is somehow inherent in the ontological structure of the works themselves. I want to suggest that this implication actually contradicts his rather profound insights about minimalist works' engagement of the spectator in a complex phenomenological relation. The minimalist insistence on "objecthood," on producing a situation in which "[t]he shape *is* the object," produces a relation of theatricality vis-à-vis the spectator: minimalist sensibility is, as Fried himself notes, "theatrical because, to begin with, it is concerned with the actual circumstances in which the beholder encounters the literalist work. . . . [T]he experience of literalist art is of an object *in a situation*—one that, virtually by definition, *includes the beholder.*"[6] If the work "includes the beholder," then, by definition, neither its meaning (its phenomenological and semiotic effects) nor its value can be inherent, as Fried's assumption of interpretive authority (designating, in a final way, works as "good" or "bad") would suggest. The work is *contingent* on the beholder, who completes its circuit of signification. Fried's a priori assumption of "quality," which tautologically subtends his attributions of aesthetic value, thus undermines his own observation that the minimalist work "includes the [—presumably every and any—] beholder."

As Fried's rhetoric suggests (he contemptuously cites Morris and Judd throughout),[7] the minimalists themselves were deeply informed by phenomenology and proposed minimalism explicitly as a radical rethinking of subject-object relationships.

Morris's original "Notes on Sculpture" series was written in three installments and published from 1966 to 1967; a fourth part historicizing minimalism and process art was published more recently in his collected writings.[8] As Morris writes in part 2 of this series, from 1966, "The awareness of scale is a function of . . . comparison. . . . Space between the subject and the object is implied in such a comparison. . . . it is just this distance between object and subject that creates a more extended situation, for physical participation becomes necessary." Morris continues, arguing for the large scale of minimalist works as a strategic method of spectatorial engagement: "Things on the monumental scale [place] . . . kinesthetic demands . . . upon the body."[9]

If we take Morris's phenomenological ideas as exemplary, it is clear that by the mid- to late 1960s artists and writers had begun to theorize art (both through the works and the writings) not as a static object fixed through authoritative interpretations (as Fried wants to do) but as a process of *intersubjective engagement* among and between objects and subjects. The minimalists, in particular Morris, link up closely with body artists (such as Carolee Schneemann and Vito Acconci, both more recently involved in installation projects) in their positing of a coextensiveness of body and mind, of self and other—both as articulated by the artist and through the work of art as it extends to the interpretive subject. Within this model, works of art are situated in space in such a way that they engage the body as, in Judith Butler's phenomenological terms, an "essentially dramatic structure which can be 'read' in terms of the more general life that it embodies. . . . the 'place' in which possibilities are realized and dramatized, the individualized appropriation of a more general historical experience. . . . a modality of reflexivity."[10]

Minimalism, body art, and their corollaries (among which I am including the later development of installation) draw on this notion of the body/self as a "modality of reflexivity" in order to propose the interpretive relation as a reflexive exchange among embodied (and so desiring, rather than—as Fried would have it—disinterested subjects). In the words of Maurice Merleau-Ponty, "[M]y body . . . is what opens me out upon the world and places me in a situation there. . . . [it] opens itself to others . . . to co-existence";[11] these works provide a "situation" of intensive engagement that encourages the acknowledgment of the *contingency* of the body/self on its environment (Merleau-Ponty's "situation," which he calls elsewhere "the flesh of the world")[12] and thus, correlatively, of the environment as it comes to mean through the experience of the embodied subject. Acconci and other body artists were also drawn to the work of American sociologist Erving Goffman, who in his 1959 book *The Presentation of Self in Everyday Life* instrumentalized French phenomenology to theorize the self as a *performance* in relation to others, a negotiation involving complex intersubjective cues and behaviors. The self, Goffman argues, "does not derive from its possessor, but from the whole scene of his action. . . . A correctly staged and performed scene leads the audience to impute a self to a performed character, but this imputation—this self—is a *product* of a scene that comes off, and is not a *cause* of it. The self, then, as a performed character . . . is a dramatic effect arising diffusely from a scene that is presented."[13]

In Morris's and Acconci's models, strongly reminiscent of the work of theorists such as Merleau-Ponty and Goffman, this kind of performative engagement, which defines the subject in a general sense, is extended to the artwork-viewer relation, which itself becomes a kind of intersubjective communication.[14] Acconci is typical of body artists in his increasing policitization of this exchange beyond the philosophical abstractions of minimalist discourse, in his articulation of the exchange of subjectivities put into play in the art situation as explicitly social. Thus, in his contribution for the "Situation Esthetics" article, Acconci states that "[t]he gallery . . . could be thought of as a community meeting-place, a place where a community could be formed, where a community could be called to order, called to a particular purpose."[15] Acconci thus proposes a model of spatial politics revolving around the gallery as a "community" space, noting that this "community" is engaged phenomenologically through the structure of the environmentally oriented work of art (the body art work or installation piece). It is crucial for Acconci, here as well as in his own body art practices, to "treat the gallery as a model space, as a sign of the particular cultural space—historical/economic/political space—it was in," such that he, as the acting "subject" or artist, could expose the "exchange-system" of art production and reception, pointing to the viewer as a participant in the making of meaning.[16]

For Acconci, Schneemann, Hannah Wilke, Adrian Piper, and other body artists active around 1970, especially in New York, the phenomenological coconstituency of self and other staged through the artwork-viewer relation (itself a mirroring of the artist-artwork and artist-viewer relations) is increasingly overtly marked as a highly charged act of subjective constitution. Situation aesthetics, I would like to propose, thus became a mode of enacting self-other relations in such a way as to highlight, even exacerbate, the *particularity* of all subjects involved in the art "situation" (the maker[s] of the work, those included within it, the viewers/interpreters). From minimalism and body art to installation, artists increasingly enact the body as a means of asserting the particularity of each subject as it is expressed and experienced in relation to the work of art. Given the long, tenacious history of Anglo-patriarchy in U.S. and European modern and postmodern culture, this becomes an especially charged gesture as played out in the practices of highly politicized artists of color, queer artists, and feminist artists.

Adrian Piper's self-displays in the *Catalysis* series (1970–71)—parading the streets and public places of New York in various states of repulsive disarray (with clothing saturated in smelly substances such as vinegar and eggs or smeared with white paint; emanating belches from a tape recorder while sitting in a library; blowing sticky bubble gum all over her face or choking on a large towel while walking down the sidewalk—exemplify the exaggerated opening out of the self-other relation through an embodied art practice that engages audiences, in terms of their specific racial and sexual identifications, in public situations. As Piper has written, this work "exists only as a catalytic agent between myself and the viewer" and consists of a situation in which "the art-making process and end product has the immediacy of being in the

same time and space continuum as the viewer. This process/product is in a sense internalized in me, because I exist simultaneously as the artist and the work. I define the work as the viewer's reaction to it."[17]

In the *Catalysis* series, by making herself disgusting—transgressing codes of "proper" femininity and acquiescent blackness—Piper corrupts the illusory "neutrality" of the interpretive relation. Piper's work stages her insistence on her body's social specificity (perceived, perhaps, as light-skinned black or passing as white; certainly as female)[18] as marked within art discourse and the broad social arena of the streets of New York. At the same time, Piper also performs the impossibility of fixing her identity through one or another *apparent* category of identity that we, as viewers, might engage. In the *Catalysis* performances, Piper projects outward the threat and repulsiveness of her race/gender identity to the Anglo-American public (and, again, especially the New York art world); she also constructs her body/self as homeless or insane, in order to confront people with their fear of the class other.[19]

Experimenting with her black female objecthood—in her words, "transforming it sculpturally . . . [taking] it into the street, confront[ing] others with the end products, and watch[ing] the effects on my social relations"[20]—Piper actively, as subject, interrogates the self-other relation through the communicative medium of her body as it means within the social spaces of New York City, exacerbating the racial, sexual, and class tensions at work in the intersubjective exchange. These performative public works thus collapse the distance that aesthetic judgment claims as a basis of its "objectivity." Piper aggressively involves the interpreter (the other) in her various constitutions of self, politicizing art making as well as art viewing as social acts, as acts of intersubjective identification and disidentification: this is situation aesthetics at its most powerful and most overtly political.

The Situation Aesthetics of Recent Installation

Returning to situation aesthetics, it is notable that a white male body and public artist such as Dan Graham also expresses a great deal of insight regarding philosophical shifts differentiating 1960s and 1970s art and art discourse (but it is surely not surprising that his insights are far more abstract than those of artists who are forced to grapple daily with racial and sexual discrimination, such as Piper). Graham argues that 1960s U.S. art practice focused on a phenomenological relation that exacerbated the Cartesianism and romanticism at the core of abstract expressionist rhetoric by replacing the fixed art object with "the individual [as] . . . the center of the art experience," denying the "inter-subjectivity of the observer(s) and the artwork," and replacing "the physical object . . . [with] another object (veiled): the spectator's consciousness." Conversely, he notes that in the 1970s art began to extend the phenomenological model to "address itself to social-political contradictions in the actual world," situating itself "between formal art categories and nonart categories: between art *and* architecture or between television, film, photography *and* art. . . . It is conscious of history,

as well as memory. Although it is not utopian, it is political."[21] These insights would describe Piper's work in its insistence on both the intersubjectivity of the art-world exchange and, if only implicitly, the way in which her work insistently highlights the *particularity* of the identities (individual identifications and desires) each of us sustain relative to our various others. And Piper's project, her *specification* of the intersubjective politics that Graham only outlines abstractly, thus leads us directly into Santarromana's.

Installation art, I am suggesting, is one of many heirs to the insights of the minimalist, body art, situation aesthetics trajectory I have outlined here. With installation art, which I define here as large-scale environmental works still positioned in some relation to an official "art" setting (the museum or the gallery), the spectator is exposed as inevitably *interested* rather than objective and, furthermore, as highly particular in her or his investments. Installations *engage* spectators, affording them a heightened awareness of the ways in which they negotiate the politics of the gallery space (and the subjectivities that are articulated there). It is for this reason that installation—like its corollary, body art—has provided a ripe medium for those interested in challenging the exclusions put into place by the modernist status quo (from Adrian Piper to Renée Green and James Luna).[22] Working (as Acconci has described) "*in* a public rather than *in front of* a public," artists such as Joseph Santarromana create new communities of more politicized spectators who are bodily engaged and so made more aware of their own investments and their consequences.

Take Joseph Santarromana's piece *It's Alive* (1997), for example.[23] We walk in, shoes squeaking on the highly polished gallery floor, to be confronted by a monstrous head, frozen (a still photograph) but mobile in its effects. The torso is only a gap, the gallery wall itself, but a pair of feet are imaged on a video screen, standing in real time—almost, but not quite, motionless. This is apparently a "portrait," yet not a recognizable rendition of an individual subject (we do have the uncomfortable feeling that it might bear some relation to the artist); an installation, and yet really almost two-dimensional; a "movie," but almost entirely still. Our relationship, as spectatorial bodies/selves, to this artwork is, first and foremost, a staged encounter (which marks, if not exaggerates, our role as consumers of artworks—our bodies positioned within the gallery space and reflexively marked within the piece itself). It is precisely this set of relationships that calls forth our assumption of our own naturalness as viewers who would conventionally engage the visual artwork (and, correlatively, the artist) through a relation of domination, projecting a particular coherence onto the face in the work/the face of the artist. Our role as interpreters of art, as interpreters of the other individuals with whom we interact, is highlighted. (We remember Goffman's point that the self—here both artist and viewer—derives "from the whole scene of [the subject's] action" and, as a "performed character, is not an organic thing that has a specific location . . . [but, rather] a dramatic effect arising diffusely from a scene that is presented.")

Beginning with the head, we cannot complete the suture of identification that we

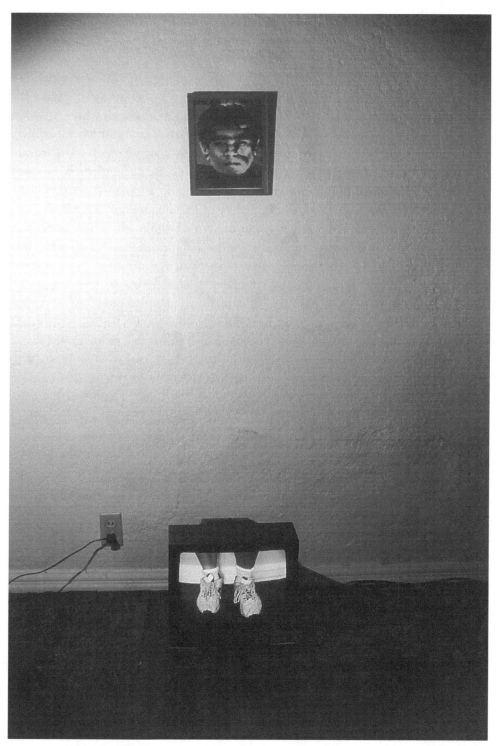

Figure 1. Joseph Santarromana *It's Alive,* 1997. Courtesy of the artist and Post Gallery, Los Angeles.

so desire, precisely because of this contingency of the work/the artist on our "presence" here through his strategic staging of "presence" (face and feet, mediated through technology) and absence (gap): the artist has *built this contingency into the work itself.* The face is grotesque, smeared, out of register—like a piece of meat hammered by a mallet, its features are rearranged. The face, it turns out, is a computer morph of the visage of the artist and the grimace of Frankenstein's beast, as played by Boris Karloff in the 1931 Hollywood movie. Expanding upon a century of composite facial imagery (from Francis Galton to Nancy Burson), Santarromana enacts himself as monstrous or grotesque.[24] He is, like Frankenstein's monster himself, made up of gruesome body parts (from "[t]he dissecting room and the slaughter-house")[25] mashed together into a "self." It is *I,* the viewer, who momentarily unify this figure into one "monster."

I project myself into Santarromana as he has projected himself for me: this is how the work comes to mean for me through the act of interpretation. And my projection entails a particular racial, ethnic, and national set of identifications and disavowals: I see "Santarromana" as both "like me" (human, a member of the Los Angeles art world, interested in installation from a phenomenological point of view) and terribly "unlike" (he is round, I am angular; he is brown, I am white; he was born in the Philippines and displaced several times, I was born and have stayed in the United States; he is ethnically "other" to the white culture by which I am implicitly embraced).[26] I thus imagine this facial image as an enactment of the monster that Santarromana is perhaps very often made to feel living in the United States and participating in the mainstream art world. But the gap that he leaves on the wall and the blurriness of the head point to the fact that it is certainly *my own* monstrousness—my anxiety vis-à-vis the differences of other people—which I am projecting onto him. The body/self is itself reversible (inside and outside are a Möbius strip–like continuum of flesh; I am a deeply monstrous and split subject myself), but the body/self is also an "intercorporeal being," fundamentally open to the other.[27] It is the intertwining of self and other (the contingency of each on the other) that Santarromana's project brings so powerfully to mind.

Further, Santarromana's use of multiple media and his deployment of the phenomenological space of the viewing arena points again to the body as a supplement that, far from guaranteeing fixed, singular identity ("presence"), exposes the very lack that is, in Jacques Lacan's paradoxical terms, at its core. Santarromana's act is this abyss, that omnipresent gap between me (as perceived by the other) and I (as perceiver); as I engage the piece, it exposes the fact that this primary gap mirrors the secondary gap between self and other. And yet, rather than dwell on Lacan's pessimistic scenario of loss and lack, Santarromana, it seems to me, encourages a more optimistic, or at least less lugubrious, notion of this gap as a site of intersubjective engagement—more along the lines of that proposed by Merleau-Ponty:

> My body as a visible thing is contained within the full spectacle. But my seeing body subtends this visible body, and all the visibles with it. There is reciprocal insertion

and intertwining of one in the other. Or rather, if, as once again we must, we eschew the thinking by planes and perspectives, there are two circles, or two vortexes, or two spheres, concentric when I live naïvely, and as soon as I question myself, the one slightly decentered with respect to the other.[28]

As Merleau-Ponty's formulation suggests—and as artists such as Piper and Santarromana have shown us through their work—this engagement is one that can politicize subjects by pointing to their entwinement in others. If, on the one hand, I (as a privileged white person) oppress or marginalize Santarromana, he becomes a monster who returns to haunt me (as otherness infects the norm that attempts to exclude it). Or rather, more to the point, I become the very monster whose image I ward off by projecting it onto Santarromana. If, on the other hand, I view myself as imbricated in his self-enactment through his performative staging of the piece, I am forced to recognize the importance of my behavior in terms of how he *acts* (comes to mean) in relation to myself. This is not just a question of acting well so as to avoid being hounded or mistreated in turn. It is a question of understanding my position—as well as his—in the world. When I act, others are affected. When I perceive and attribute meaning, this changes who Santarromana "is" in the world. When Santarromana projects himself toward me (as monster artist), he transforms my identifications. *This is the supreme political act, the potential of which situation aesthetics proposed in the 1970s.*

The entwinement of self and other is perhaps even more explicitly fully engaged in *The Little House That I Live* (1992), a twenty-two-foot-long crude, houselike corridor,

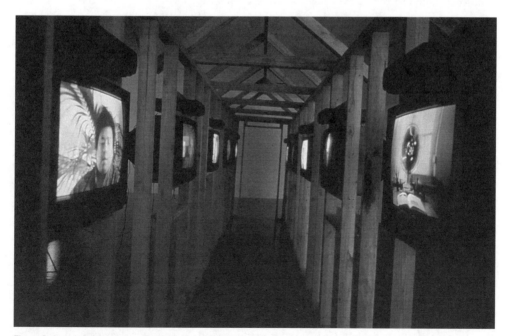

Figure 2. Joseph Santarromana, *The Little House That I Live,* 1992, video installation. Courtesy of the artist and Post Gallery, Los Angeles.

Figure 3. Joseph Santarromana, *The Little House That I Live,* 1992, video installation. Courtesy of the artist and Post Gallery, Los Angeles.

made of two-by-fours, along which are hung five sets of video monitors. We enter to find ourselves embraced by each pair, caught in the middle of intensive subject-object relations staged in the video imagery. We are thus intertwined in five different circuits of desire, some already intersubjective (making us a "third wheel"), others contemplatively individual: a white woman whose face flickers with candlelight across from a candle burning; a black man with dreamy face and closed eyes facing a bucolic landscape; a white man across from a hand-held mirror in which we see his reflection; a Filipino man (the artist), eyes closed and hair ruffled by a breeze seemingly blown across the corridor by a fan on the opposite monitor; and a black man and white woman flirting ostentatiously with one another from across the "house." In each case, we find ourselves engaged in a moment of human activity that is particularized in racial and sexual terms. In the case of the white man and the mirror, for example, his whiteness becomes unnatural, marked—narcissistically so, and thus, paradoxically, as feminine. A female viewer such as myself identifies with this narcissism and wonders why she can't see herself in his mirror; as such, she is unsutured from the identificatory play at this moment. In the case of the black man and white woman, a viewer might find her or himself wanting to *be* the white woman or the black man, wanting to be *desired by* the person on the opposite side; the viewer will feel embarrassed at her or his intrusion in this intimate sexual foreplay, highly charged as a kind of forbidden miscegenetic voyeurism.

The Little House That I Live stages our relation to the world as one of both estrangement and inclusion, of identification(s), alienation, and (often thwarted) desire:

we become engaged (with the gallery, with the world) as the "house" that Santarromana "lives" (not "lives in"; that would imply a too easily separated relation of inside and out). As he "lives" this house, so we "live" his work, and it makes us aware of our own particularity vis-à-vis not only this artist (if we even know to identify the fan-blown man as the Filipino-American artist) but also the infinitely diverse and uncodifiable world of subjects we continually find ourselves among. This is a decidedly unhomely— *uncanny*[29]—experience, especially for those people who can usually disavow their particularity (people like me in the art world: white, privileged); it is an experience at once both extremely familiar and terribly remote. At some moments I find myself aware of my whiteness, my privilege, the awkwardness of my attempts to empathize with other people's bodily experiences; at other moments, I feel sutured into the scene, momentarily "at home," invisible in my skin.

At no moment, however, do I feel I can encompass this work with my language. This friction of text versus visual experience (of my "inner" versus "outer" selves, as it were) marks the friction of subjects relating every day in the (art) world. Santarromana has set up a compelling and complex aesthetic situation that politicizes the experience of making meaning of works of art and, correlatively, the experience of being (as a particular, rather than universal, subject) in the world: he makes us experience ourselves as both *subjects and objects* at once. Merging aspects of body art and minimalism—the fleshy performances of bodies, the aggressive engagement of spectators—Santarromana applies new technologies to environmental situations that grab us in a relation of intersubjectivity as well as one of what Vivian Sobchack has called *interobjectivity*: we experience ourselves as viewing subjects (the privileged position allotted by the conventional

Figure 4. Joseph Santarromana, *The Little House That I Live,* 1992, video installation. Courtesy of the artist and Post Gallery, Los Angeles.

art-viewer relation) but also as *objects of* Santarromana's embodied situations.[30] As I engage with it here, Santarromana's work parallels what Sobchack identifies as "the dual structure of passion and the subjectively-grounded reversibility of body and world" that necessarily entails politicized subjects—subjects who acknowledge their own immanence, their own capacity for being objectified in relation to the world. Santarromana's works exemplify the capacity of installation to provide the possibility of engagements that might change the way we understand ourselves as subjects (and, as noted, objects) in the social arena—of which the art world is resolutely one part.

Notes

1. Nancy Foote, introductory questions to "Situation Esthetics: Impermanent Art and the Seventies Audience," *Artforum* 18, no. 5 (January 1980): 22.

2. Some of the language and conceptual territory of this essay have been drawn from my book *Body Art/Performing the Subject* (Minneapolis: University of Minnesota Press, 1998), and my essays "Art History/Art Criticism: Performing Meaning," in *Performing the Body/ Performing the Text,* ed. Amelia Jones and Andrew Stephenson (London: Routledge, 1999); "Acting Unnatural: Interpreting Body Art," in *Decomposition: Post-Disciplinary Performance,* ed. Sue-Ellen Case, Philip Brett, and Susan Leigh Foster (Bloomington: Indiana University Press, forthcoming); and "Interpreting Feminist Bodies: The Unframeability of Desire," *The Rhetoric of the Frame: Essays on the Boundaries of the Artwork,* ed. Paul Duro (Cambridge: Cambridge University Press, 1996).

3. See Lucy Lippard's important early theorization of work that goes beyond the conventional staged relationship between picture and viewer in her *Six Years: The Dematerialization of the Art Object from 1966 to 1972* (Berkeley and Los Angeles: University of California Press, 1997), originally published in 1973.

4. Michael Fried, "Art and Objecthood" (1967), reprinted in *Minimal Art: A Critical Anthology,* ed. Gregory Battcock (New York: Dutton, 1968), 116–47.

5. Ibid., 145, 128, 136, 125, 124.

6. Ibid., 119, 125; Fried's emphasis.

7. Fried conflates their writings, devaluing their specificity by stating unconvincingly in an early footnote that to differentiate these two very different thinkers would have been to "litter the text with footnotes" (117).

8. All four parts are published in Robert Morris, *Continuous Project Altered Daily: The Writings of Robert Morris* (Cambridge: MIT Press; New York: Solomon R. Guggenheim Museum, 1993), 1–40, 51–70. The first three were originally published as follows: "Part 1," *Artforum* 4, no. 6 (February 1966): 42–44; "Part 2," *Artforum* 5, no. 2 (October 1966): 20–23; and "Part 3: Notes and Non Sequiturs," *Artforum* 5, no. 10 (June 1967): 24–29.

9. Morris, "Notes on Sculpture, Part 2" (1966), as reprinted in *Continuous Project Altered Daily,* 13–14. For an excellent overview of the phenomenological dimension of Morris's work, including his dance/performance works, see Maurice Berger, *Labyrinths: Robert Morris, Minimalism, and the 1960s* (New York: Harper and Row, 1989).

10. Judith Butler, "Sexual Ideology and Phenomenological Description: A Feminist Critique of Merleau-Ponty's *Phenomenology of Perception,*" in *The Thinking Muse: Feminism and Modern French Philosophy,* ed. Jeffner Allen and Iris Marion Young (Bloomington: Indiana University Press, 1989), 86, 89.

11. Maurice Merleau-Ponty, *Phenomenology of Perception* (1945), trans. Colin Smith (New York: Routledge, 1995), 165.

12. Maurice Merleau-Ponty, "The Intertwining—the Chiasm," *The Visible and the Invisible* (ca. 1959–60), trans. Alphonso Lingis, ed. Claude Lefort (Evanston, Ill.: Northwestern University Press, 1968), esp. 144.

13. Erving Goffman, *The Presentation of Self in Everyday Life* (Garden City, N.Y.: Doubleday, 1959), 252–53.

14. Thus Morris, in "Some Notes on the Phenomenology of Making," states the following: "[T]he entire enterprise of art making provides the ground for finding the limits and possibilities of certain kinds of behavior, and . . . this behavior of production itself is distinct and has become so expanded and visible that it has extended the entire profile of art. This extended profile is composed of a complex of interactions involving factors of bodily possibility, the nature of materials and physical laws, the temporal dimensions of process and perception, as well as resultant static images." Originally published in *Artforum* (1970) and reprinted in Morris, *Continuous Project Altered Daily,* 75.

15. Acconci in "Situation Esthetics," 22.

16. Scott Burton expands upon this a few pages later, arguing that "[t]he very idea of audience is reappearing. . . . A new kind of relationship seems to be beginning to evolve . . . [such that art] will place itself not in front of but around, behind, underneath (literally) the audience—in an *operational* capacity" (Burton, in ibid., 23).

17. Adrian Piper, "Concretized Ideas I've Been Working Around," written January 1971 and published in Adrian Piper, *Out of Order, Out of Sight, vol. 1: Selected Writings in Meta-Art, 1968–1992* (Cambridge: MIT Press, 1996), 42–44.

18. See Piper's comments on identity politics in Maurice Berger, "The Critique of Pure Racism: An Interview with Adrian Piper," *Afterimage* 18, no. 3 (October 1990): 5–9, including her statement that "I use my own experience—my own selfhood. . . . Interpersonal interactions are really the key to political transformations" (9). See also her description of her embeddedness in the particular social and political events of her time and place in "Flying," in *Adrian Piper: Reflections, 1967–1987,* exhibition catalog, curator Jan Farver (New York: Alternative Museum, 1987), 21. It is important to note that Piper's work questions the tendency to see racial or sexual identity as lodged within the body image, throwing in doubt the epistemology of vision as determinative of subjectivity. Peggy Phelan has written of her work that it "consistently dramatizes the failure of the visible to represent race," in Phelan, *Unmarked: The Politics of Performance* (New York: Routledge, 1993), 98.

19. The boundaries broken down were also, for Piper, internal; she has stated that through her *Catalysis* series, "I seem to have gotten more aware of the boundaries of my personality, and how much I intrude myself upon other people's realities by introducing this kind of image, this façade, and a lot of things happen to me psychologically. Initially, it was really hard to look people in the eye. I simply couldn't overcome the sense that if I was going to keep my own composure and maintain my own identity, it was just impossible. I would have to pretend that they weren't there, even though I needed them. . . . / here I am, or was, 'violating my body'; I was making it public. I was turning myself into an object." In Lippard, "Catalysis: Interview with Adrian Piper," originally published in *The Drama Review* (1972) and reprinted in Lippard, *From the Center: Feminist Essays on Women's Art* (New York: Dutton, 1976), 169, 170.

20. Piper, "Flying," 21.

21. Graham, in "Situation Esthetics," 25.

22. Dozens of other artists could be cited here, including Maureen Connor, Dorit Cypis, Robert Gober, Mona Hatoum, Daniel Martinez, Amalia Mesa-Bains, Yong Soon Min, Pepón Osorio, and Bruce Yonemoto; I discuss some of these artists in *Body Art/Performing the Subject.*

23. Related works that invite the spectator into a one-on-one engagement with Santarromana include *Portrait of the Artist Dreaming of Flying* (1996), which consists of a floral-upholstered Victorian chair under which a monitor plays an almost still, real-time image of Santarromana's feet and lower legs; *The Tears That Is My Body #106* (1993), which consists of a screen on which a video image of Santarromana (water being poured over his head) is projected upside down (the water thus appearing to run against gravitational force) and a pair of shoes below, into which actual water pours from the bottom of the screen.

24. Santarromana has also produced several series of static photographic works involving morphs, including his 1990s images merging his face with the visages of famous figures as well as friends and colleagues—from Marilyn Monroe and Mickey Mouse to friends "Kristen," "William," and "Erika."

25. Mary Shelley, *Frankenstein* (1818), published in *Three Gothic Novels,* ed. Peter Fairclough (Harmondsworth: Penguin Books, 1968), 315.

26. My knowledge of Santarromana's ethnic and cultural background is based on personal contact with the artist, but his apparent (visible) racial "difference" produces him as "monstrous" within certain cultural contexts (including the mainstream art world, still).

27. On the "intercorporeal being," see Merleau-Ponty, "The Intertwining—the Chiasm," 143.

28. Ibid., 138. Merleau-Ponty also writes, "[B]etween the two 'sides' of our body, the body as sensible and the body as sentient (what in the past we called objective body and phenomenal body), rather than a spread, there is the abyss that separates the In Itself from the For Itself" (136–37).

29. This is a play on Freud's notion of the uncanny, the *unheimlich,* which would translate into English literally as "unhomely." Freud himself is playing with the words *heimisch* (familiar) and *Heim* (home), the latter of which he links to the first "home" of "all human beings," the womb. The *unheimlich* is about estrangement and the human sensation of being a "subject . . . in a foreign land, alienated." Sigmund Freud, "The 'Uncanny'" (1919), in *The Standard Edition of the Psychological Works of Sigmund Freud,* ed. James Strachey, trans. James Strachey et al., vol. 17 (London: Hogarth Press and the Institute of Psycho-Analysis, 1955), 245.

30. Vivian Sobchack, "The Passion of the Material: Prolegomena to a Phenomenology of Interobjectivity," in her *Carnal Thoughts: Bodies, Texts, Scenes, and Screens* (Berkeley and Los Angeles: University of California Press, forthcoming), manuscript pages 12–13; I thank Sobchack for sharing this manuscript with me.

Contributors

C. Ondine Chavoya teaches in the program of visual and critical studies at Tufts University/School of the Museum of Fine Arts, Boston, and has previously taught in the department of film and television at UCLA and the media arts program at University of New Mexico.

John Coleman is a sound and installation artist whose work focuses on an exploration of personal and cultural history as viewed through the specificity of his own experience as an African American male. He is currently teaching in the art and African American studies departments at Oberlin College.

Sean Cubitt is reader in video and media studies at Liverpool John Moores University, England. He is the author of *Timeshift: On Video Culture* and *Videography: Video Media as Art and Culture*. His most recent book is *Digital Aesthetics*.

Colin Gardner is a critic and theorist specializing in film, video, and contemporary art practice. He has written for several journals and magazines, including *Artforum, Arts, Tema Celeste, Iris,* and the *Los Angeles Times*. He is assistant professor of art theory and criticism at the University of California, Santa Barbara, and has recently completed a critical study of the films of Joseph Losey.

Chrissie Iles is curator of film and video at the Whitney Museum of American Art. Her specialization is the history of video and film installation and performance art in the sixties and seventies, and she writes and lectures regularly on avant film, video installation, and performance. For nine years she was head of exhibitions at the Museum of Modern Art Oxford, where she curated exhibitions of Gary Hill, Louise Bourgeois, Marina Abramović, Donald Judd, Sol LeWitt, Yayoi Kusama, and John Latham; her group

shows of film and video installation at MOMA Oxford featured work by Tony Oursler, Douglas Gordon, Liisa Roberts, Marijke van Warmerdam, Sadie Benning, and Isaac Julien. Her retrospective exhibition of Yoko Ono is currently touring Europe.

Bruce Jenkins, curator of the Harvard Film Archive and senior lecturer on visual and environmental studies at Harvard University, has specialized in the interface between cinema and the visual arts. His writings on such artist-filmmakers as Hollis Frampton, Marcel Broodthaers, the Fluxus group, and Bruce Conner have appeared in *October* and *Millennium Film Journal* and in museum catalogs for the Albright-Knox Art Gallery (Buffalo), Centre Georges Pompidou (Paris), Museum of Contemporary Art (Los Angeles), and Fundació Antoni Tapies (Barcelona). Jenkins directed the film program at Media Study/Buffalo and for fourteen years was curator of film and video at the Walker Art Center in Minneapolis, where he organized international touring retrospectives of the films of John Cassavetes, Derek Jarman, and Dennis Hopper; curated gallery exhibitions of work by Mary Lucier, Paul Kos, David Hockney, Chantal Akerman, and William Klein; and co-curated the touring exhibition *2000 BC: The Bruce Conner Story, Part 2.*

Amelia Jones is professor of art history at the University of California, Riverside. She is the author of *Body Art/Performing the Subject* (Minnesota, 1998) and *Postmodernism and the En-Gendering of Marcel Duchamp.* She organized the exhibition *Sexual Politics: Judy Chicago's "Dinner Party" in Feminist Art History* at UCLA's Hammer Museum in 1996 and edited and contributed to the exhibition catalog. Most recently Jones co-edited the anthology *Performing the Body/Performing the Text.*

Miwon Kwon is assistant professor of art history at the University of California, Los Angeles. Her research and writings engage several disciplines, including contemporary art, architecture, public art, and urban studies. She is a founding coeditor and co-publisher of *Documents,* a journal of contemporary art and visual culture, and a faculty member in the MFA in Visual Art program at Vermont College.

Ernest Larsen writes political fiction and detective novels in addition to media criticism. His fiction and criticism have been published in *Minnesota Review, Transition, Exposure, Fishdrum, Jump Cut, Art in America,* and the *Village Voice.* He has also produced scripts and videotapes on such subjects as archaeological fraud, the Gulf War, literacy, domestic violence, and the mummy complex in cinema. A recipient of the Blumenthal Foundation Award for video criticism, he has also received grants from the Jerome Foundation and the Robeson Foundation.

Tiffany Ana López is assistant professor at the University of California, Riverside, where she teaches American drama, Latina/o literature, performance, popular culture, and Chicana/o children's literature. She is editor of *Growing Up Chicana/o* and literary curator for the Riverside Art Museum and Self-Help Graphics' Art-to-Go! program, which brings original Latino art works into local elementary school classrooms. Cur-

rently she is completing her book "Bodily Inscriptions: Representations of the Body in U.S. Latina Drama."

Catherine Lord is professor of studio art and women's studies at the University of California, Irvine. She is a writer, artist, and curator whose work addresses issues of feminism, queer identity, cultural politics, and colonialism. Her critical essays and fiction have been published in *Afterimage, Art & Text, Artcoast, New Art Examiner, Whitewalls, Framework, Documents,* and *Art Paper,* as well as the collections *The Contest of Meaning, Illuminations: Women Writing on Photography from the 1850s to the Present, Reframings: New American Feminisms in Photography, The Passionate Camera,* and *Hers 3: Brilliant New Fiction by Lesbians.* Her curated exhibitions include *Pervert, Trash, Gender, Fucked,* and *Memories of Overdevelopment: Philippine Diaspora in Contemporary Visual Art.* She is a former dean of the School of Art at the California Institute of the Arts and was director of the Art Gallery at the University of California, Irvine. She has received fellowships from the New York State Council on the Arts, the Humanities Research Institute of the University of California, the Rockefeller Center for Arts and Humanities at Bellagio, and the Banff Centre for the Arts.

Kevin McMahon has been on the staff of the Southern California Institute of Architecture since 1984. His novel *Weekend in Silverlake* is forthcoming.

James Meyer is assistant professor of art history at Emory University. He is the author of the exhibition catalogs *What Happened to the Institutional Critique?* and *Ellsworth Kelly: Sculpture for a Large Wall, 1957,* and has written on such topics as the work of Mel Bochner and Mark Dion and AIDS activist art. The editor of *Minimalism,* he is the author of the forthcoming *Minimalism: Art and Polemics in the Sixties.*

Alessandra Moctezuma is a visual artist and public arts manager of Metro Art, Los Angeles Metropolitan Transit Authority. She is a member of Collage Ensemble, a multidisciplinary arts collective, and is cofounder of ADOBE LA (Architects, Artists, and Designers Opening the Border Edge of Los Angeles), where she managed public art projects, designed exhibitions, and lectured widely on issues of art, Latino culture, and vernacular architecture. She has produced the videos *A Two-Flavor Portrait, Andale, Andale, Frida,* and *Urban Revisions.* She teaches at the Southern California Institute of Architecture.

Leda Ramos, director of Technology and Education at the Central American Resource Center (CARECEN), is a visual artist and arts educator. In 1996–97 she was the first College Art Association Fellow in Studio Art at the Getty Research Institute and from 1997 to 1999 she was the coordinator of the For Families Project at the Museum of Contemporary Art in Los Angeles. She has been a member of two community design/architecture collaboratives: Alessandra Moctezuma + Leda Ramos (1997–99) and Artists and Architects Opening the Border Edge of Los Angeles (ADOBE LA, 1995–97). She teaches at the Southern California Institute of Architecture.

Laurence A. Rickels is professor of German at the University of California, Santa Barbara. He is the author of *Nazi Psychoanalysis* (forthcoming), *The Vampire Lectures* (Minnesota, 1999), *Aberrations of Mourning: Writing on German Crypts, The Case of California,* and *Der unbetrauerbare Tod.* He is editor of *Looking after Nietzsche,* Gottfried Keller's *Jugenddramen,* and *Acting Out in Groups* (Minnesota, 1999).

Barbara Maria Stafford is William B. Ogden Distinguished Service Professor at the University of Chicago. She is an imagist. Her books on the visualization of knowledge include *Symbol and Myth, Voyage into Substance, Body Criticism, Artful Science,* and *Good Looking.*

Susan Stewart is the Regan Professor of English at the University of Pennsylvania. She is the author of numerous volumes of poetry, art criticism, and theory, including *On Longing: Narratives of the Miniature, the Gigantic, the Souvenir, the Collection* and *Crimes of Writing: Problems in the Containment of Representation.* Her most recent work is a book of poems, *The Forest.*

Marita Sturken teaches at the Annenberg School for Communication at the University of Southern California. She is the author of *Tangled Memories: The Vietnam War, the AIDS Epidemic, and the Politics of Remembering* and, with Lisa Cartwright, the forthcoming *Practices of Looking: An Introduction to Visual Culture.*

Erika Suderburg is an artist and writer who works in film, video, installation, and photography. Her work has been exhibited internationally at the Pacific Film Archives in Berkeley, Capp Street Projects in San Francisco, the Museum of Modern Art in New York, the American Film Institute in Los Angeles, Kunstlerhaus in Stuttgart, the Collective for Living Cinema in New York, the International Video Festival in Bonn, and the Simon Watson Gallery in New York. She is the coeditor with Michael Renov of *Resolutions: Contemporary Video Practices* (Minnesota, 1996). She is professor at the University of California, Riverside, and has been on the faculties of the California Institute of the Arts and Art Center, Pasadena. She is currently at work on a feature, *Los Angeles: Topographies, Histories, and Remnants.*

John C. Welchman is professor of art history and theory in the visual arts department of the University of California, San Diego. He is the author of *Modernism Relocated: Towards a Cultural Studies of Visual Modernity; Invisible Colours: A Visual History of Titles;* and *Art after Appropriation: Visual Culture in the 1990s,* and the editor of *Rethinking Borders* (Minnesota, 1996). He has written for *Artforum, Screen, Art & Text, Third Text, Art International, ArtNews,* the *New York Times,* the *Economist,* the *International Herald Tribune,* and the *Los Angeles Times.*

Index

ABC Copying Machine, 216
Absolute Beauty, 66
Acconci, Vito, 17, 19, 260, 335, 338; installation by, 254, 255, 259, 262n4; model of, 336; on performance art, 61n30
Ace Gallery, 49, 50
Activist art, 23
ACT UP, 28
ADOBE LA. *See* Architects, Artists, Designers Opening the Border Edge of Los Angeles
Adorno, Theodor, 220
Adorno's Hut (Finlay), 112
Aeneas, 12, 114, 128n60
Aesthetics, 26, 49, 228; politicized, 198, 199; situation, 333–37, 337–38, 340–44
Aggregation: One Thousand Boats (Kusama), 8
AIDS activism, 28–29, 31, 43, 300, 322
Aircraft Carrier, Bird Table, and the Temple Pool (Finlay), photo of, 121
Akerman, Chantal, 17, 270
Alberti, *statuae ridiculae* and, 88
Alcatraz Island, occupation of, 205n19
Alexander the Great, 73
Alix, Pierre-Michel, 112
Allais, Louis-Jean, 112
American Deserta (Banham), 130

American Fine Arts Gallery: Dion at, 59n15; Green at, 34; Müller at, 34
"Anal Money-time" (Fachinelli), quote from, 237
Anatomies of Escape (Green), 37n33
Anaximander, 103
Anderson, Laurie, 93
Ando, Tadao, 225
Andre, Carl, 224, 232n7; on authorship, 50; letters by, 49
Andrews, Julie, 307, 312
Andy Warhol Museum, 233n10
Anemic Cinema (Duchamp), 266–67
Angel: The Shoe Shiner (Osorio), 320; photo of, 321
Angelique et Medor (Finlay), 126n37
Angelou, Maya, 163
Anti-Illusion, 250n7
Antimonumental resituations, 187
Antiquities of Cornwall (Borlase), 67
Antoninus, 104
Apollo, 108, 115, 118, 120, 125n23, 128n60
"Apollo in Picardy" (Pater), 108
ARC, Finlay and, 103
Architects, Artists, Designers Opening the Border Edge of Los Angeles (ADOBE LA), 156n1; Moctezuma and, 143; Ramos and, 144

Architectural Interventions, 148

Architecture: as *Gesamtkunstwerk,* 6; soft, 20n2

Architecture douce, 2

Architecture of Tolerance/Continuance (Moctezuma + Ramos), 145, 156n1

Architecture parlante, 73

Arensberg, Louise and Walter, 225

Ar e pedra (Clark), 11

Aristotle, 122; public munificence and, 238–39; social commensurability and, 237

Arnulf Rainer (Kubelka), 266

Arsenale, 224

Art: community-based, 59n13, 189; culture and, 44; dematerialized, 333; ethnic, 189; fine, 9, 195; folk, 2, 7, 9, 195; high/low, 9, 189; labor and, 10; life and, 1; nature and, 113–15; object and, 1; outsider, 9; participatory element of, 156; primitive, 9; process, 335; public role of, 46; site-oriented, 43, 45; spaces of, 333; war and, 123. *See also* Installation art; Performance art; Public art

"Art and Objecthood" (Fried), 334

Arte Joven en Nueva York, 59n14

Arte Povera, 2, 7

Artforum, 332, 333; Fried in, 334

Art in America, Andre/Judd letters to, 49

Art Institute of Chicago, 27, 43

Artist: centrality of, 53; environmental, 7; as narrator-protagonist, 53; public role of, 46

Art of Investment, The (Pollack), 250n6

Art Press, Finlay and, 103

Art Rebate/Arte Reembolso, 17, 238, 242, 246; absurdity/reduction and, 248; conception of, 239, 240, 245, 247; criticism of, 244, 249, 250n4; focal lengths of, 239–40; handbill for, 236; recipients of, 248 (photo); sample of, 241 (photo)

Arts & Architecture, 221, 225; Case Study Houses program by, 220

Asco, 16; avant-garde strategies of, 191–92; Chicano movement and, 189, 198, 200; creativity of, 195; defined, 189–90; ethics of combat and, 190–92; *First Supper* and, 196; historicizing work of, 203n3; issues for, 194–95; media hoaxes and, 197–98; multimedia works of, 200; performance actions and, 202; politicized aesthetics of, 198, 199; public art and, 190, 201, 202, 203n4; *Regeneración* and, 190; self-determination and, 200; social engagement and, 193, 200; social subordination/spatial subjection and, 201

Asher, Michael, 5, 13, 25–27, 39, 42, 43

Asociación de Venededores Ambulantes (Street Vending Association), 148, 156

Assemblage, Environments, and Happenings (Kaprow), 10

Asshole Mural (Asco): phantom culture and, 199; photo of, 198

Athenaeum, Schlegel in, 65

Atom Man Meets the Queen of Sheba, The (Rice), 269

Auer, Roxanne, 157n7

Augé, Marc, on nonplace, 205n20

Aupetitallot, Yves, 32, 34

Avalos, David, 17, 238, 240, 244

Avant-gardism, 249, 301

¡Ay Gran Poder de Dios! (Osorio), 329n1

Bachelard, Gaston: quote of, 134

"Badge of Honor" (Osorio), 329

Baldwin, James, 163

Banham, Reyner, 130

Bann, Stephen, 86, 124n6

Barbara Gladstone Gallery, 174

Barnsdall, Aline, 225

Barnstone, Howard, 233n10

Baroque, new, 84, 85, 86

Barra, Joseph, 115

Barragán, Luis, 225

Barres de Bois Rond (Cadere), 28

Barruel, Abbé Augustin, 128n55

Barry, Robert, 232n7; on wire installations, 39

Bataille, Georges, 249

Batteux, Abbé, 7

Battle of Midway, 117, 128n56

Bauhaus, 6, 9

Baumgarten, Lothar, 45

Bell, Alexander Graham, 213

Bellori, Giovanni Pietro: on perfection/ancient art, 66

Benedict, Ruth, 311

Benjamin, Marina: on Goddard, 89

Benjamin, Walter, 17, 263, 270; on civilization/barbarism, 113
Berdache, 301, 303, 304, 314n8
Bergman, Ingmar, 265
Bergson, Henri, 279; Hegelian difference and, 285n4; on multiplicity, 278, 279, 285–86n6
Berman, Wallace, 273
Between Darkness and Light (after William Blake) (Gordon), 260
Between Home and Work (Common Threads, UNITE), 149, 151; collaboration on, 156; photo of, 155
Between House and Home: Theorizing Architecture as a Cultural Practice (Moctezuma + Ramos), 145, 156n1
Beuys, Joseph, 250n14, 265
Bhabha, Homi, 58
Biemann, Ursula, 23, 37n27; *Platzwechsel* and, 27
"Birth of Brown Power, The" (*Los Angeles Times*), 191
Black Zero (Tambellini), 253
Blades, Ruben, 324
Blanchot, Maurice, 177
Blonde Cobra (Jacobs), 269
Blue (Jarman), 268
Blueprints for Modern Living: History and Legacy of the Case Study Houses (MoCA), 221, 222
Bochner, Mel, 25, 26, 36n8, 40
Body art, 333, 335, 336, 343
Bordering on Fiction: Chantal Akerman's D'Est (Akerman), 270
Borlase, William, 67
Bottle Village (Prisbrey), 10
Box (Ahhareturnabout) (Coleman), 268
Brainwave retraining, 231
Brakhage, Stan, 265
Branfman, Judy, 157n7
Breer, Robert, 269
Brenner, Paul, 170
Breton, André, 11
Bronx Museum, 50
Broodthaers, Marcel, 13, 25, 39, 264, 273
Brookwell, Keith, 112
Brosnan, Peter, 140
Brown, Capability, 111
Browne, Thomas, 120, 122

Brydone, Patrick, 75
Buchloh, Benjamin, 36nn7, 8, 53, 60n17; quote of, 3
Bukowski, Charles, 15; poem by, 164–66
Buñuel, Luis, 271
Buren, Daniel, 5, 13, 25, 26, 27, 39, 43; on art/politics, 40; on site-specificity, 3, 40
Buried Capital (Finlay), photo of, 107
Burlington, Lord, 82n7
Burnette, Lee, 315n19
Burr, Tom, 23, 25, 31, 32, 34, 37n27, 45; *Platzwechsel* and, 27
Burson, Nancy, 340
Burton, Scott, 345n16
Bus/Civil Rights, The (Moctezuma + Ramos), 145, 156n1
Bute, Mary Ellen, 271
Butler, Judith, 335

Cabinet des merveilles, 84
Cabinets de curiosité, 7
Cadere, André, 28
Cage, John, 8, 85, 253
California Institute of Arts, the, 50
Camden, William, 73
Cameron, James: *Titanic* and, 215
Campbell, Colen, 82n7
Campbell, Jim, 18, 290–91, 293, 295; custom electronics of, 292; Heisenberg and, 294; on memory, 288–89
Campbell, Nancy, 315n18
Campus, Peter, 17, 255, 257, 259; accumulation of perspective and, 258; durational space of, 258; video installations by, 254
Campus Martius, 113
CARECEN. *See* Central American Resource Center
Casa del Elderly, 323
Case Study Houses program, 16, 220
Cast of Thousands, A (Frampton), photo of, 273
Castro, Fidel, 324
Catalina Island, occupation of, 205n19
Catalysis series (Piper), 336–37, 345n19
Cathedral of Light (Speer), 12
Caws, Mary Ann: Finlay letter to, 118
Celtic Druids, Brimham Craggs (Higgins), reproduction of, 67

Celtic Druids, Monument of Carnac (Higgins), reproduction of, 68

Celtic Druids, Stonehenge (Higgins), reproduction of, 72

Centers for Disease Control, AIDS activists at, 28

Central American Resource Center (CARECEN), 144, 156

Centro Cultural de la Raza, 238

Cézanne, Paul, 103, 257

Chamberlain, John, 265

Chamfort, Sebastien, 119

Chandler, Raymond: on Los Angeles, 220

Charles II, 70, 72

Charleton, Walter, 14, 68, 71, 74, 82; on Charles II, 72; Jones and, 70, 73; Stonehenge and, 64

Chavez Ravine, Universal Studios purchase of, 221

Chavoya, C. Ondine, 189–208; Chicano art movement and, 16

Cheval, Ferdinand, 10

Chicago Community Trust, 167

Chicago Exhibition, Holmes and, 216

Chicano Moratorium against the Vietnam War, 193

Chicano movement, 190; nationalism within, 199; public attitudes about, 204n12; resistance by, 200

Chicanos, public space and, 194, 202, 204n12

Chicano Student News, Gamboa and, 191

China (Thater), 17–18; movements of, 275; multiplicity in, 281; photo of, 280, 281, 282

Chinati Foundation, Judd and, 225

Chorea Gigantum; or, The Famous Antiquity of Great Britain, vulgarly Called Stone-Heng, Standing on Salisbury Plain, Restored to the Danes (Charleton), 68, 70

Chorographical Description of Wiltshire (Camden), 73

Christina's World (Wyeth), 184

Christina's World Order (Millner), 184

Cicero, 72, 73

Circa 1977 (Burr), photo of, 31

Circus of Maxentius, 72

Clair, René, 271

Claire Copely Gallery, Asher installation at, 42 (photo)

Claridge, Gail, 234n18

Clark, Gordon Matta, 13

Clark, Lygia, 11

Claude (Lorrain), 103

Cleaver, Eldrige, 191

Clemente, Roberto, 324

Clerk, John, 109

Cleveland, Grover: Stevenson and, 302

Cloud Board (Finlay), 126n37

Cobham, Lord. *See* Temple, Richard, Lord Cobham

Cockcroft, Eva, 157n7

COINTELPRO, Gamboa and, 198

Coleman, Ayo, 158

Coleman, James: *Box* and, 268

Coleman, John, 15, 158–70

Collaborative production, 144–45, 270–71, 273

Collins, George, R.: on soft architecture, 20n2

Cologne Art Fair, Fraser at, 34

Cologne Presentation Book (Fraser), 34

Column of Erotic Misery (Schwitters), 11

Command Performance (Acconci), 255, 259

Common Threads Artists Group, 149, 151, 156, 157n7

Communication, 65; globalization of, 56, 262; intersubjective, 336

Community Redevelopment Agency Downtown Cultural Trust Fund, 157n7

Complex One (Heizer), 133

Conceptualism, 23, 248, 333

Condensation Cube (Haacke), 40, 42

Confusion of Prints, A (Thater), 284; photo of, 283

Conner, Bruce, 269, 270, 273

Connor, Steven: on Jameson, 205n25

Conrad, Tony, 266

Constable, John, 82

Constable, Maria, 82

Constructed situation, defined, 184

Construction of a Traditional Rural Oven for Making Bread (Grippo), 10

Contact: A Cybernetic Sculpture (Levine), 254

"Contesting the Public Realm: Struggles over Public Space in Los Angeles" (Crawford), 145

Continuous and Related Activities: Discontinued by the Act of Dropping (Le Va), 60n22

Cornell, Joseph, 17, 273; Rose Hobart and, 269

Corner, Philip, 8

Corridor Installation (Nick Walter Installation) (Nauman), 255

Cotto, Luis, 323, 330n11; Osorio and, 326

Crary, Jonathan, 205n22, 257

Crawford, Margaret, 145

Cresswell, Tim: on transgression, 200

Crimp, Douglas, 6, 60n17; on idealism/modern art, 58n1; on install, 5; on Jonas, 259; on minimalism, 4–5, 26; on site specificity, 25

Critical Regionalism, 56–57

Crocheted Environment, 50

Cubitt, Sean, 14, 84–99

Cuídate Mujeres, machismo and, 323

Cultural hegemony, space for, 194

Cultural landscape, 145–46

Cultural transformations, 1, 54

Culture: art and, 44; high, 34; public, 248, 251n23. *See also* Phantom culture

Culture in Action, 59n13

Cushing, Frank Hamilton, 314n6; Zuni culture and, 302

Cycles (Keegans), 94

D'Alembert, Vaucanson and, 94

Dallas Museum of Art, 37n33, 62n39

DART. *See* Disaster and Riot Training forces

David Brinkley's Journal, 139

Davis, Angela, 37n33, 191

Dawn Burn (Lucier), 258

DaZiBaos (Group Material), photo of, 46

Death: as Gardener, 119; gardens/war and, 100

Death is a Reaper (Finlay and Hincks), 119

De Certeau, Michel, 182; on bridge, 197; *Practice of Everyday Life* and, 186; practiced space of, 20

Declaration of the Rights of Man, garden for, 102

Decoy Gang War Victim (Gronk), 197

De Dolomieu, Déodat, 77

De Duve, Thierry, 55

De Girardin, Marquis, 127n41

De Historia Romana (Sextus Rufus), 73

Deleuze, Gilles, 18, 32, 37n29, 278, 280; on identity/spatiality, 57; on multiplicity, 279; wolf-philosophers of, 282

DeLillo, Don, 130

De Lingua Latina (Varro), 73

De l'Isle-Adam, Villiers, 89

De Literis Runicis (Wormius), 74

De Maria, Walter, 15, 130, 132, 133–34, 135, 233n10; Heizer and, 133

De'Medici, Cosimo, 120

De Menil, Christophe, 233n10

De Menil, Dominique, 233n10

De Menil, Philippa, 233n10

DeMille, Cecil B., 140

Dempsey, Jack, 268

Dem Teufel verkauft Holmes!, 216

Dendrites (Knorr), reproduction of, 80

D'Est (Akerman), 270

Deterritorialization, 56, 57

Détournement, 19, 22n21

Deutsche, Rosalyn, 194; on assimilative model/site specificity, 58n3

Devil's Arrow (Stukely), reproduction of, 66

D'Hancarville, Baron, 67

Dia Foundation, 225, 233n10

Dibbets, Jan, 273; on film, 263

Dido, 112, 114, 128n60

Die (Smith), 334

Die Brücke, 9

Diedrichsen, Dietrich, 37n33

Die Griechen und Römer: Historische Versuche über das klassische Alterthum (Schlegel), 64–65

Difference, identity and, 57

Digital Watch (Campbell), 289; photo of, 288

Dime Museum, 216

Diocletian's Baths, 72

Dion, Mark, 23, 25, 32, 34, 44–45; *Platzwechsel* and, 27

Disaster and Riot Training (DART) forces, 191

Discourse, spaces of, 333

Dissipate (Nine Nevada Depressions 8) (Heizer), 133

Divine Comedy (Dante), 117

Division of Labor: "Women's Work" in Contemporary Art, 50

Divola, John, 15, 132, 135–37, 140
Documenta IV, pop at, 34
Documentation, 145; mass media and, 197
Dogs and Other Philosophers (Thater), 282
Domesticity, identity and, 230
Door: 11, rue Larrey (Duchamp), 12
Double Negative (Heizer), 132, 140, 222
Douglas, Stan, 17, 260
Dracula (Stoker), 214
Dream of Aeneas, The (Rosa), 109
Driscoll, Ellen, 330n6
Druids, 64, 67, 72
Duchamp, Marcel, 8, 12, 17, 141n6, 249,
271; on delaying ideas, 244; legacy of,
266; *Obligations* and, 240; readymades
of, 3
Duration Piece #12 (Huebler), 232n7
Dürer, Albrecht, 103, 112
Durham, Jimmie: on site-specific practice, 45

EA-Generali Foundation, 185, 186; Fraser
and, 61n34
Eames, Charles, 222
Eames, Ray, 222
East L.A. riots (1970), 194, 196, 204n12
East of Borneo, Hobart in, 269
Echo (Oppenheim), 255, 257
Eclogues (Virgil), 115
Edison, Thomas, 213
Ein Eisenbahnüberfall, 264
Eingang/The Way In (Reeves), 93, 94
"Elegy" (Gray), 116
Ellison, Ralph, 163
El Mirage Dry Lake, 133
El Museo del Barrio, 317, 329n1
El Plan Espiritual de Aztlán, on cultural
value, 205n23
El Rescate, 156
El Velorio, AIDS in the Latino Community
(Osorio), 317
End, The (Campbell), 292
En la barbería, no se llora (Osorio), 326;
commission for, 322; photo of, 324, 325,
327, 328
Enlightenment, 101, 104, 112, 116, 131, 211
Epicurus, His Morals (Charlton), 70
Ernst, Leslie, 157n7
Ernst, Max, 271
Escalio (Osorio), 329n1

Escombros (Osorio), 329n1
Esperanza Community Housing
Corporation, 156
Essai d'une théorie sur la structure des cristaux
(Häuy), 77
Et in Arcadia Ego (Poussin), 119
"Et in Arcadia Ego: Poussin and the Elegiac
Tradition" (Panofsky), 119
Euclid, 107
"Event, The" (Kaprow), quote from, 1
Everyday Life in the Modern World
(Lefebvre), 185
Exorcist, The, 261
"Exploding Deserts" (*Los Angeles Times*), 140
"Eye of Power, The" (Foucault), quote of,
200

Fabris, Peter, 75, 77
Fachinelli, Elvio: quote of, 237
Fairfax, Thomas: Marvell on, 108
Fall (Andre), 232n7
Far from the Madding Crowd (Hardy), 282
Faust (Goethe), 119
FBI, Gamboa and, 198
Federal Plaza, 24; *Tilted Arc* at, 25, 39, 45
Feminist Art Program, 50
Fernandez, José Gabriel: *Arte Joven* and,
59n14
"Festina Lente" (Johnson), 120
Film installations: language of, 262; space
and, 252; video installations and,
252–53, 262
Film Wallpaper (Macunias), 270
Fine art, 195; folk art and, 9
Finlay, Ian Hamilton, 14–15, 86, 88, 92,
101, 104, 109, 112, 114; allusion of, 104;
art and, 113; career of, 103; garden of,
106–7, 108, 113, 123, 123n2; on Little
Sparta/World War II, 122; muses and, 87;
one-word poems of, 87; quote of, 84;
supporters of, 102 (photo)
Finlay, Sue, 101
"First Satire of the Second Book of Horace
Imitated, The" (Pope), 109
First Show, The, 225
First Supper (after a Major Riot) (Asco): as
counterspectacle, 196; photo of, 195
Fischinger, Oskar, 271
"Fisherman's Cross" (Finlay), 129n76

Five Conic Displacements (Heizer), 133
Flaming Creatures (Smith), 269
Flanders, Lillian Sue, 330n6
Flavin, Dan, 26, 27, 222, 253, 255, 257, 273; on art/decoration, 223
Fleury, Cardinal, 94
Flicker, The (Conrad), 266
Flirt, 311
Floating Room (Nauman), 232n7
"flophouse" (Bukowski), text of, 164–66
Flores, Pedro, 326
Fluxfilms, 272; photo of, 271
Fluxus, 6, 266, 270
Folk art, 2, 7, 195; fine art and, 9; popular art and, 9
Follies, 8–9, 13
Follies Battle (1987), 102
Fontana, Bill, 8
Foote, Nancy, 332
Fornäs, Johan, 215
Forster, Betsy, 307
Forti, Simone, 260
Fort Russell, Dia purchase of, 225
Foster, Hal, 36n18, 60nn16, 17, 246, 304; on installation/ postmodernism, 37n26; on Serra, 3
Foucault, Michel, 27, 29, 93, 245; quote of, 200
Foundation for Art Resources, 148
Found objects, 15
Fourth Street Bridge, 197, 201
Frampton, Hollis, 266, 273–74
Frampton, Kenneth: Critical Regionalism and, 56–57; on cultivation, 56; on double mediation, 57
Frankenstein (Shelley), 112, 126n33
Franklin, Aretha, 161
Fraser, Andrea, 23, 25, 28, 32, 34, 37n27
French Revolution: A Study in Democracy, The (Webster), 117
Freud, Sigmund, 88, 89, 212, 346n29; backlash against, 288; multiplicity and, 281; Wolf-Man and, 280
Fried, Michael, 19, 26, 38, 334, 344n7
Friedlaender, Walter: on Poussin, 126n35
"From Space to Place and Back Again" (Harvey), quote from, 56
"From the Revisited Desert to the Invisible City" (Pettena), quote from, 132, 134

Full Moon Gallery, 148
Functional sites, 24, 25, 45; literal sites and, 14
Furnishings, 224–25; end of, 230–31; nowhere, 223–24

Gablik, Suzi: on *Tilted Arc* controversy, 251n25
Gaia movement, 141n5
Gaines, Ernest, 160
Galligan, Gregory, 257
Galton, Francis, 340
Galvinized Iron Wall (Judd), 232n7
Gamboa, Harry, Jr., 203n6; Asco and, 189, 198, 203n3; Blowouts and, 191; on *Decoy Gang War Victim,* 197; multimedia and, 200; *Project Pie in De/Face* and, 194, 195; quote of, 189, 200; *Regeneración* and, 190; *Stations of the Cross* and, 192–95; *Walking Mural* and, 193
Garden of Cyrus or the quincuncial, lozenge, or network plantations of the ancients, artificially, naturally, mystically considered (Browne), 120
Gardens: art/war and, 115–19; death and, 100; as *lachrymae musarum,* 101; making, 100; memory and, 122–23; nature and, 100–101, 107–8; as transformation of nature, 103–4, 106–7
Gardens of the Hesperides, 107
Garden Temple, 101, 102, 106; photo of, 105
Gardner, Colin: on Thater, 17–18, 275–86
Gardner, Isabella Stewart, 217
Gardner Memorial Library, 215
Garment Industry of Southern California (Racho), 157n9
Garment Workers Union UNITE, 157n7
Geffen Museum of Contemporary Art, 147
Gehry, Frank, 233n10
Genealogy, mausoleum and, 131–32
General, The (Keaton), 264
Generali Foundation, Leung and, 185–86
Gentle Surprises for the Ear (Knowles), 8
George II, 111
George III, 119
Germinal (Zola), 34
Gessner, Salomon, 31
Getty, J. Paul, 225

Getty Research Institute, Ramos at, 144
Giarda, Christophoro, 87
Gibson, James, 257
Giddens, Anthony: on management of risk, 245
Giddings, Paula, 310
Gill, Irving, 225
Gillette, Frank, 252
Gilpin, Laura, 307
Gilpin, William, 111
Gish, Lillian, 132
Globalization, 56, 84, 97
Godard, Jean-Luc, 265, 271
Goddard, Judith, 14, 91, 95; installation by, 88
Godzilla, 171, 172, 173, 185, 188
Godzilla, King of the Monsters, 171, 177
Godzilla vs. the Sea Monster, 171
Goethe, Johann Wolfgang von, 119; quote of, 220
Goffman, Ervin, 254, 335, 336, 338
Goldberg, Rube, 139
Gombrich, E. H., 86–87
Gómez-Peña, Guillermo: on Beuys, 250n14
Good Humor, ad for, 214
Gordon, Douglas, 14, 17, 92, 260; video installation by, 261
Gorky, Maxim, 92
Gotch, J. Alfred, 71
Graeme Murray Gallery, exhibition at, 107
Graham, Dan, 17, 253, 257, 260, 270, 337, 338; video installations by, 254; video space and, 258
Grassroots Forum, Gamboa and, 191
Graw, Isabelle, 52–53
Great Piece of Turf (Dürer), 103
Green, Renée, 23, 25, 32, 34, 33, 54, 338; on site-specific practice, 45
Greenbelt House (Rapson), 222
Greenberg, Clement, 26, 93; on modernism, 86
Green Light Corridor (Nauman), 222
Grimm, Baron, 67
Grippo, Victor, 10
Gronk, 190, 203n6; Asco and, 189, 200; *Decoy Gang War Victim* and, 197; photo of, 193, 198; *Project Pie in De/Face* and, 195; quote of, 189; *Stations of the Cross* and, 192–95; *Terror in Chile* and, 205n19

Gropius, Walter: on architecture, 6
Grotesque, 75, 340; in French Revolution, 116; natural, 67
Grotto of Aeneas and Dido, 112
Grotto of Venus (Schabet), 6
Group Material, 46; on site-specific practice, 45
Guardi, Francesco, 74
Guattari, Félix, 18, 32, 37n29, 279, 280; on identity/spatiality, 57
Guercino, 119
Guggenheim Museum: Judd and, 232n7; Krens and, 233n10; Panza collection and, 224
Gutai group, 13, 22n20
Gutiérrez, José Angel, 204n12

Haacke, Hans, 5, 25, 39, 40, 42, 43
Habermas, Jürgen, 93; utopian public sphere and, 247
Hacktivism, 248
Hadleigh Castle (Constable), 82
Hadrian, 104, 108
Hall, David, 257, 258; video installations and, 262n11
Hallucination (Campbell), 292
Hallwyl, Wilhelmina von, 16, 218, 219n8
Hallwylska Museet, 209, 213, 218
Hamilton, Ann, 62n42, 313n2
Hamilton, William: descriptions by, 75
Hammer, Armand, 225
Hammons, David, 15, 62n42, 158, 160; *Rousing the Rubble* and, 159
Hapgood, Susan: on site-specific, 49
Happenings, 6, 22n20, 28
Hardturm, 31
Hardy, Thomas: dog philosophers of, 282
Harmon, Amy: on hacktivism, 248
Hartford Wash: Maintenance, Outside (Ukeles), photo of, 41
Hartman, Geoffrey, 120
Harvey, David: on place, 56, 204n11
Harvey, Michael, 124n15, 128n56; *Midway Inscription* and, 117
Hasta Ahora (Osorio), 329n1
Hatoum, Mona, 8, 14, 96, 97
Hauser, Arnold: on cinema, 263; film production and, 270
Häuy, Abbé, 77

Hayden, Dolores: on urbanization/cultural costs, 204–5n18

Hayden, Jacqueline, 184

Heart-Shaped Shell (Knorr), reproduction of, 78

Hegel, Georg Wilhelm Friedrich, 123, 282; One and, 280

Hegelian difference, 285n4

Hegelian identity, 285n4

Heimat, 224

Heim/heimisch, 346n29

Heisenberg Uncertainty Principle, 294

Heizer, Michael, 130, 133–34, 135, 233n10; *Double Negative* and, 222; quote of, 132; Tinguely and, 140

Helms, Jesse, 246

Heraclitus, 108, 112, 118, 119

Hercules, 120, 122

Hercules (Rysbrack), 109

Hernandez, Sandra, 151–52

Herrera, Juan de, 83n12

Herrman, Bernard, 92

Herrmann, Wolfgang, 127n42

Herrón, Willie, 190, 203n6; Asco and, 189; photo of, 193, 198; *Project Pie in De/Face* and, 195; *Stations of the Cross* and, 192; on *Walking Mural*, 193

Heterotopias of the Latino Cultural Landscape (Villa), 144

Hidden Labor: Uncovering L.A.'s Garment Industry, 149; Common Threads and, 157n7; photo of, 155

Higgins, Godfrey, 67, 72

Higher Goals (Hammons), 160

High/low art, 9, 189

Hill, Gary, 16, 17, 187, 260, 260; video installation of, 174–77

Hincks, Gary, 126n41; *Death is a Reaper* and, 119

Historiae (Polybius), 107

Hitchcock, Alfred, 92

Hoare, Henry, 109

Hobart, Rose, 269

Hock, Louis, 17, 240, 244; ten-dollar bills and, 238

Hodgetts, Craig, 222

Hoffman Kunstmuseum, 224

Hoffmann, E. T. A., 67

Holmes, 215–16; burial plan of, 217

Holmes Museum, 216

Holt, Nancy, 15, 131, 135, 140

Holzer, Jenny, 29, 313n2

Home (Suderburg), photo of, 226, 227

Home Show II exhibit, 329

Homosexuality, 298, 301

Hoover, J. Edgar: on political intelligence, 191

"Horatian Ode" (Marvell), 120

Houel, Jean, 76, 77

House (Whiteread), 92

Houses: construction/renovation of, 228–30; furnishings of, 224–25, 230–31; in museums, 221–22

Housing for People with AIDS (Moctezuma + Ramos), 145

HPSCHD (Cage and Nameth), 253

Huebler, Douglas, 232n7

Hughes, Mary Linn, 157n7

Hugo, Victor, 67

Human memory, computer memory and, 287–88

Hunt, John Dixon, 111, 125n23

Huntington, Henry E., 225

Huntington Library Ephemera Collection, 149

Hybrid Marketplaces in the Montage City (Moctezuma + Ramos), 145, 156n1

Hyperboreans, 108, 124–25n17

I Ching (Cage), 8

Idea, beauty and, 66

Idealism, 39, 40; modern art and, 58n1; site specificity and, 25

Identity, 333; destabilization of, 57; difference and, 57; domesticity and, 230; multicultural community and, 297; multiple, 57; place-bound, 56

Idyll Pursuits, 61n39

Idylls (Theocritus), 115

I Have Never Read the Bible (Campbell), 291

IKEA Show, The (Sjölund), photo of, 212

Iles, Chrissie, 17, 252–62

Illegal Border Crossing between Austria and Czechoslovakia (Müller), photo of, 51

Illegal Border Crossing between Austria and Principality of Liechtenstein (Müller), photo of, 29

Illinois Arts Council, 167

Illusionism, 266, 268
Image by Images I (Breer), 269
Image of the City (Lynch), 205n24
Immaterial Objects, 48
Import/Export Funk Office (Green), 37n33, 61n39
Individual Artists Grants, demise of, 167
Inka-Neeto Good Things for Kids, 231
Inn of the Anasazi, 297
Installation (Asher), photo of, 42
Installation art, 6, 163–64, 171–72, 209, 333, 336; as case study, 145–46; constitution of, 6; cross-referencing, 3–4; decoration/ accumulation and, 227; defining, 2–3, 4, 10, 287; participation in, 187–88, 338; site of, 5; situation aesthetics of, 337–38, 340–44; in United States, 167. *See also* Film installations; Video installations
Instant Mural, 196
Institute for Contemporary Art P.S. 1, *Rousing the Rubble* and, 159
Instructional Destruction Projects, 195
Interactivity, response and, 292–93
Interest coupons *(coupons d'interét),* 240
Interface (Campus), photo of, 259
Interobjectivity, 343
Inter-pellations (Müller), 34
Intersubjective engagement, 335
"Interview: Gronk and Gamboa" (Gamboa and Gronk), quote from, 189
Iris (Levine), 252, 254
Irwin, Robert, 226
Isolated House series (Divola), 132, 135–38; photo of, 136, 137, 138
Itinerarium Curiosum (Stukely), 67
It's Alive (Santarromana), 338, 340; photo of, 339

Jacob, Mary Jane, 62n42; *Places with a Past* and, 54; on site-specific art, 54–55
Jacobs, Ken, 269
James I, Jones and, 68
Jameson, Fredric, 32; Connor on, 205n25; postmodernism and, 201; on urban alienation, 205n24
Jarman, Derek, 268
Jenkins, Bruce, 17, 263–74
Jesus Is the Light (Hammons), 158, 160

Johnson, Samuel, 120
Jonas, Joan, 17, 255, 273; performances by, 259, 260
Jones, Amelia, 19, 332–46
Jones, Inigo, 14, 70, 72, 73, 82n7; Stonehenge and, 64, 71; theories of, 66, 68
Jonson, Ben: on fountains, 88
Judd, Donald, 232n7, 235n19, 257, 334; on authorship, 50; Fort Russell and, 225; letters by, 49; Panza and, 224
Judd, Julie, 260
Julian, Emperor, 87
Juntos Creamos la Ciudad, 150–52
Jus Grew Orchestra, 160

Kabakov, Ilya, 16, 172, 173, 175, 177
Kafka, Franz, 185
Kahn, Douglas, 87
Kant, Immanuel, 85, 93; Reason and, 26
Kapoor, Anish, 311, 313n2
Kaprow, Allan, 10, 13; quote of, 1
Karloff, Boris, 340
Kawamata, Tadashi, 28
Keaton, Buster, 264
Keegans, Rita, 94
Keeney, Gavin, 116
Kelley, Jeff: on public art, 246
Kelley, Mike, 243–44
Kent, William, 82n7, 109, 111
Kiefer, Anselm, 265
Kienholz, Ed, 15, 158, 164
Kienholz, Nancy Reddin, 15, 158, 164
Kimmelman, Michael, 250n4
King, Martin Luther, Jr., 291
Klein, William, 273
Klein, Yves: gallery air and, 12
Knight, Richard Payne, 67
Knorr, George Wolfgang, 76, 78, 79, 80, 81
Knowles, Alison, 8
Koenig, Pierre, 222
Kolbowski, Silvia, 62n40; on site-specific practice, 45
Koons, Jeff, 86
Kosiba-Vargas, S. Zaneta: on Asco, 198
Kosugi, Takehisa: white films of, 266
Kosuth, Joseph, 232n7, 273; on literal sites, 24
Krens, Thomas, 224; Guggenheim and, 233n10; MASS MOCA and, 234n10

Kruger, Barbara, 29
Kubelka, Peter, 266
Kunsthalle, 7, 27, 30, 31, 225, 233n10
Kusama, Yayoi, 8
Kwon, Miwon, 14, 38–63
Kybalion, 161, 170
Kybartas, Stashu, 184

Labor, art and, 10
La Cama (Osorio), 317, 318–19, 330n5
Lacan, Jacques, 340
LACMA. See Los Angeles County Museum
 of Art
L.A. Freewaves Video Festival/Exhibition,
 147–48; photo of, 152, 153
La Frontera/The Border, 238
Lambert, Louis, 235n19
Landscape with Pyramus and Thisbe
 (Poussin), 112
Lannan, J. Patrick, 225
L.A. Parent Magazine, advertisement in,
 235n20
La philosophie minéralogique (de Dolomieu),
 77
La Raza, Gamboa and, 191
Larsen, Ernest, 171–88; on found objects,
 15; on Kabakov, 16
L'art conceptuel, une perspective, 48
Las Mil Mascaras of L.A. Land/Insurgent
 Urbanism (Moctezuma + Ramos), 145,
 156n1
Last Rites in the Left Lane, 196
Latino stereotypes, filmic, 320
Laugier, Abbé, 108, 114, 127n42
Leasowes, The: Little Sparta and, 109
Le Corbusier, 34
Lefebvre, Henri, 56, 140, 185; quote of, 1
Le Figaro, 244
Léger, Fernand, 273
Lesbians, 298, 302, 305–7, 310–12;
 artifacts, 315n25; looking for, 297;
 phallus, 311; queer place and, 310
Leslie, Alfred, 273
Les magiciens de la terre, 86
Lesson before Dying, A (Gaines), 160
Leung, Simon, 16, 177, 178; on Squatting
 Project, 185–86
Le Va, Barry, 60n22
L'Eve future (de l'Isle-Adam), 89

Levine, Les, 17, 252; on art/communication,
 254
Lewin, Kurt, 254
Lewis, Jerry, 271
LeWitt, Sol, 60n26, 232n7
"L'idylle des cerises" (Finlay), 124n15; photo
 of, 110
Life and Death of Pollock and Warhol, 244
Light at the End, The (Hatoum), 96
Lightning Field (De Maria), 233n10
Light Sentence (Hatoum), 8
Light-Space Modulator (Moholy-Nagy), 12
Lindell, John, 45, 60n16
Lines to Points on a Six Inch Grid (LeWitt),
 60n26
Linker, Kate, 254, 255
Lippard, Lucy, 20n4, 247, 344n3; on
 dematerialization, 2; on public art,
 245–46
Literal sites, 24; functional sites and, 14
Little House That I Live, The (Santarromana),
 341–43; photo of, 341, 342, 343
Little Sparta, 14–15, 87, 88, 101, 102, 107,
 114, 116; influences on, 108–9, 111,
 122; map of, 104; photo of, 105, 106,
 107, 110, 121; understanding, 120, 122;
 visiting, 123n2
Lives of the Modern Painters, Sculptors, and
 Architects (Bellori), 66
Live/Taped Video Corridor (Nauman), 252,
 255, 259, 260; photo of, 256
Living Room, 147, 151; photo of, 152, 153
Living Sculpture (Vautier), 8
Logos, 89; pursuing necessities of, 286n14
Long, Richard, 28
Longing and Belonging: from the Faraway
 Nearby, 297
López, Tiffany Ana, 18, 317–31
López Tijerina, Reies, 191
Lord, Catherine, 18, 297–316
Lorena's Lament, 196
Los Angeles County Museum of Art
 (LACMA), 27, 194
Los Angeles Museum of Contemporary Art,
 37n33, 50
Los Angeles Times, 140, 191, 245, 248
Louis, Morris, 249
Lovell, Philip: on Los Angeles, 220
Lucier, Mary: Dawn Burn and, 258

Ludwig II, 6
Luna, James, 338
Lutyen, Mark, 266, 268
Lycurgus, 108, 111, 125n23

Machismo, 322–23
Macias, Nanette Yannuzzi, 167
Macunias, George: Fluxus and, 270
Mad Jack's Fuller's Folly, 10
Magnet TV (Paik), 258
Magon, Ricardo Flores, 190
Maloof, Sam, 229
Man Ray, 273
Mandel, Ernest, 32
Manet, Jules, 257
Manifesto of Surrealism (Breton), 11
Man-Wolf, 281
Marble from Saltzburg (Knorr), reproduction of, 81
Marfa, 225, 230, 235n19
Marshall Plan, 34
Martha Stewart Living (MSL), 230
Marvell, Andrew, 88, 108; on Cromwell, 120; mower of, 120
Marx, Karl, 245
Maryland Historical Society, 52; Wilson at, 28
Massemorderen Holmes, alias Mudgett, 216
Mass media, documentation and, 197
MASS MOCA, Krens and, 234n10
Matta-Clark, Gordon, 260
Mausoleum, genealogy and, 131–32
Mauss, Marcel, 177, 237
McEvilley, Thomas: on Kienholzes, 164
McLuhan, Marshall, 26, 257–58
McMahon, Kevin, 16, 17, 220–36
Measurements (Bochner), 26, 36n8, 40
Medici Villa, 126n36, 224
Meigh-Andrews, Chris, 14, 92
Mekas, Jonas, 269
Méliès, Georges, 176
Memory: computer/human, 287–88; concept of, 288; gardens and, 122–23; time and, 290; work/death and, 119–20
Memory/Recollection (Campbell), 290
Memory/Void (Campbell): photo of, 290; time passing in, 290
Memory Works (Campbell), 291
Merleau-Ponty, Maurice, 336, 346n28; on

body, 335; phenomenology of, 26; on visible body, 340–41
Merzbau (Schwitters), 11–12
Metro Art, Moctezuma and, 144
Meyer, James, 23–37, 61n38; on functional site, 14, 45; site-oriented art and, 60n17
"Michael Asher and the Conclusion of Modernist Sculpture" (Buchloh), quote from, 3
Midway Inscription, The (Finlay), 117
Mignon (Goethe), quote from, 220
Mile Long Drawing (De Maria and Heizer), 133
Mile of String (Duchamp), 12
Millet, Catherine: Finlay and, 103
Millner, Sherry, 16, 182, 183, 184
Milton, John, 113
Ming Fung, 222
Minimalism, 4–5, 23, 29, 38, 39, 42, 333–36, 343; aesthetics of, 26
Mining the Museum (Wilson), 28, 52
Mise en scène, 61n39
Mitchell, W. J. T.: Art Rebate and, 247; on culture-debating/ culture-consuming public, 251n23; on public art/violence, 247
Miti (Saar), 9
Miti Receives (Saar), 9
Mobilization, 57; resisting, 51; specificity and, 58
MoCA. *See* Museum of Contemporary Art
Moctezuma, Alessandra, 143–57; education/ career of, 143–44; on site specificity, 15
Modernism, 4, 26, 38, 139, 246, 334; art-historical discourse of, 265; history of, 264; problematic of, 93; Schlegel on, 65–66; sci-fi, 16
Moholy-Nagy, László, 12
MoMA, 34
Mona antiqua restaurata (Rowlands), 67
Mönchengladbach Museum, 224
Moneo, 73
Monet, Claude, 271
Money, postmodern, 242–43
Money (Morris), 242, 250n6
Monstrare, 88
Monstrous, monstrance and, 88–92
Monte Carlo Bond (Duchamp), 12, 240
Montford, James, 184

"Monument for the Third International" (Tatlin), 3
Monuments, 74; site-specific, 15
Monument to a Lost Glove (Kabakov), 16, 172, 174–75, 177, 182, 187–88; spatial monumentality of, 175
Moondoc, Jameel, 160
Moralia (Plutarch), 117
More Love Hours Than Can Ever Be Repaid (Kelley), 243, 244
Morris, Robert, 19, 26, 27, 131, 242, 255, 335; Fried on, 334; model of, 336; Nazca line drawings and, 141n2; on primary structure, 4; quote of, 1
Morse, Margaret, 268; on installation, 287
Morse code, 213, 214
Most Notable Antiquity of Great Britain, The (Jones), 68
Movie, A (Conner), 269
Moving-image arts, 263; space and, 252
MSL. *See Martha Stewart Living*
Müller, Christian Philipp, 23, 25, 28, 29, 32, 34, 51; concrete plinth by, 30–31; cross-cultural fantasies and, 35; *Platzwechsel* and, 27; on site-specific practice, 45
Multiplicity, 270–71, 273, 279–80; durational, 278; instinctual, 285; numerical, 285–86n6; objective/subjective, 278; qualitative, 279, 285–86n6; quantitative, 278–79; spatial, 278; types of, 279
Münster Sculptur Projekt, 260
Murals, walking, 192–96, 204n14
Murder Museum, 216
Murphy, Mary, 169
Musée d'art moderne de la ville de Paris, 48
Museum as Site: 16 Projects, 27
Museum of Contemporary Art (MoCA), 61n39, 159, 238; *Blueprints* at, 221; exhibition catalog of, 225; Ramos and, 144
Museum of Fine Arts, 305, 306
Museum of Jurassic Technology, The (Wilson), 8
Museums: furnishings of, 222–23; houses in, 221–22
Mystery Mansion, 217

N°34 07.301' W°115 51.412' Looking North (Divola), photo of, 136

N°34 07.324' W°115 49.825' Looking West (Divola), photo of, 137
N°34 11.185' W°116 06.725' Looking Northwest (Divola), photo of, 138
Nameth, Ronald: *HPSCHD* and, 253
National Endowment for the Arts (NEA): *La Frontera* and, 238; restructuring of, 167
National Institutes of Health, AIDS activists at, 28
National Monument, 108
National Trust Book of Follies, 102
Naturalism, Impressionism, the Film Age (Hauser), quote from, 263
Nature: art and, 113–15; gardens and, 100–101, 103–4, 106–8; imitation of, 113–15; as source of terror, 111–12
Nature Over Again after Poussin (Finlay, Sloan, and Paterson), 103
Nauman, Bruce, 17, 222, 252, 253, 255, 256, 258; Oppenheim and, 254; video installations by, 254, 259
Nazca line drawings, 131, 141n2
NBC, 139
NEA. *See* National Endowment for the Arts
Negri, Tony, 285
Neoclassicism: Finlay and, 127n43; neo-baroque and, 86
Neutra, Richard, 225
New American Painting (MoMA), 34
New Arcadian Dictionary (Finlay), 120
"New Genre Public Art," 245
New Homes, advertisements in, 221
New Sculpture, 1965–75: Between Geometry and Gesture, The, 48
New York State Bureau of Tropical Conservation, Dion and, 59n15
New York Times: on hacktivism, 248; on Osorio, 318
New York World's Fair (1964), 253
Ngo, Viet, 141n5
Nicomachean Ethics (Aristotle), 238; quote from, 237
Nietzsche, Friedrich, 123
Noguchi, Isamu, 132, 139; quote of, 138
Nomadism, 56, 57
"No-Movie" performance, 198–99
Nonplaces, proliferation of, 205n20
Nonsite, site and, 4

Nordman, Maria, 226
Noriega, Chon: on Mural Movement/ Chicano Art Movement, 194
Norton, Peter, 225
"Notes on Sculpture" (Morris), 335
NTT InterCommunication Center, 295
Nuclear Sail, 122
Number Four (Ono), photo of, 272

Obelisk, photo of, 106
Object, 334; art and, 1; dematerialization of, 2; subject and, 343
Obligations pour la Roulette de Monte-Carlo, 240
Old Sarum, 82
One and the Multiple, 279, 280, 281, 285n4
Ono, Yoko, 272
On Tropical Nature (Dion), 44–45; photo of, 44
"Openings and Conclusions" (Lefebvre), quote from, 1
Oppenheim, Dennis, 15, 132, 133, 135, 140; installation by, 254, 255, 257, 259; Nauman and, 254
Organic Honey's Vertical Roll, 260
Organic Honey's Visual Telepathy, Jonas and, 260
Orlando Furioso (Ariosto), 126n37
Orozco, Gabriel, 32
Orr, Eric, 226
Osorio, Pepón, 18, 318, 321, 324–26, 330nn6, 11, 345n22; award for, 329; machismo and, 323; RAW and, 323; self-identity and, 317; site choice by, 322–23; visual vocabulary of, 325–26; work of, 317, 319–20, 322, 329n1, 330n3, 330–31n12
OSSO (Finlay), 103, 111
Oswald, Lee Harvey, 270
Ovid, 118, 119
Owens, Craig, 25, 55, 37n27, 60n17, 62n47; site specificity and, 36n10; on Smithson, 30

Paik, Nam June: *Magnet TV* and, 258; white films of, 266
Palais idéal (Cheval), 10, 11
Palestine, Charlemagne, 260
Palimpsests (Hamilton), 8

Palladio, 68
Pan, 108, 113
Pannini, Giovanni Paolo, 74
Panofsky, Erwin, 119
Panza di Biumo, Giuseppe, 222, 223–24; collection of, 49, 224, 232–33n7; domesticity and, 224
Parker, John, 140
Park Street, installation piece on, 322
Partially Buried (Green), 37n33; photo of, 33
Partially Buried Woodshed (Smithson), 37n33, 62n47
Participation, 156, 187–88
Pasadena Museum, 225
Passionate Attitudes (Driscoll), 330n6
Pater, Walter, 108
Paterson, David, 103
Patton, Cindy, 29
Patton, George, 140, 141
Paulson, Ronald, 114; on grotesque, 116
Pay for Your Pleasure, 244
Payne, Patricia, 159
Peck, Gregory, 221
Peckinpah, Sam, 93
Peltzer, Birgit, 258
Performance art, 22n20, 52, 93; commitment to, 61n30; identity-based, 23
Performance Corridor (Nauman), 260
Perspective, accumulation of, 258
Petrifaction (Knorr), reproduction of, 79
Petrified Wood (Knorr), reproduction of, 76
Pettena, Gianni: quote of, 132, 134
Phantom culture, 190; *Asshole Mural* and, 199; psychogeography of, 200–202
Phelan, Peggy, 345n18
Photo documentation, 46, 151
Photo of My Mother (Campbell), 291
Physiologica Epicuro-Gassendo-Charltoniana (Charleton), 70
Piano, Renzo, 233n10
Picabia, Francis, 240
Pile, Steve: on incontestable space, 199
Ping Body (Stellarc), 96
Pinkel, Sheila, 157n7
Piper, Adrian, 19, 336–37, 341, 345n16; black female objecthood of, 337; on *Catalysis* series, 345n19; global political art and, 251n19; particularity of, 338; specification by, 338

Piper, Keith, 14; work of, 93–94

Place: differential function of, 56; evaluation/hierarchical ranking of, 204n11; nonplace/symbolized space of, 195–97

Placelessness, 56, 58n1

Places with a Past, 54, 55

Plans of Druid Temples (Stukely), reproduction of, 69

Platzspitz Park, 27, 31, 32

Platzwechsel, 27, 32; installations at, 30–31

Pliny the Younger, 109

Plutarch, 118, 125n23

Poetics of Space, The (Bachelard), quote from, 134

Poggi, Christine, 259

Poggioli, Renato, 115; on Apollo/Pan, 108

Points of Entry, 59n13

Pollack, Linda, 250n6

Pollock, Jackson, 271

Polybius, 107

Pope, 109, 125n23

Popular art, folk art and, 9

Portrait of My Father (Campbell), 291

Portrait of the Artist Dreaming of Flying (Santarromana), 346n23

Postmodernism, 192; conceptual map of, 201; pop seriality of, 218–19

Poussin, Nicholas, 103, 109, 112, 119, 126n35

Practice of Everyday Life, The (de Certeau), 182, 186

Pratt, Geronimo, 168

Prayer for My Son and Myself, A (Coleman), 15, 158; photo of, 159, 163, 166

Preminger, Otto, 271

Presence, 52; phenomenology of, 26

Presentation of Self in Everyday Life (Goffman), 335

"Present Tense of Space, The" (Morris), quote from, 1

Primary structure, 4

Prina, Stephen, 32; on site-specificity, 23

Prisbrey, Grandma, 10

Proclus, 107

Project Pie in De/Face, 194, 195

Project Unité, Green at, 32, 34

Protective Coloration (Millner), 184, 187; photo of, 182, 183

Public art, 249; common work of, 246; queer theory and, 301; site-specific art and, 59n13; violence and, 247–48

Public Art Fund, *Monument to a Lost Glove* and, 182

Public space, 203n4; Chicanos and, 194, 202, 204n12; utopian, 247

Pulquerías, 146

Quarles, Frances: Hieroglyphicks and, 97

Queer identity, 312, 313

Queer place, lesbians and, 310

Queer theory: public art and, 301; site-specific art and, 311

Quinceañera, 146, 150, 152

Ra, Sun, 160

Racho, Susan, 157n9

Ramos, Leda, 143–57; education/career of, 143–44; photo of, 155; on site specificity, 15

Ramses II, statues of, 140

Randolph Street Gallery (RSG), 158; closing of, 169–70; employees at, 167; RAP and, 167

RAP. *See* Regional Artists Program

Rapson, Ralph, 222

Rationalism, 86, 87, 221

Rauschenberg, Robert, 271

RAW. *See* Real Art Ways

Reading Position for Second Degree Burn (Oppenheim), 133

Real Art Ways (RAW), 326, 330n11; *En la barbería* and, 322; Osorio and, 323

Realidades, 157n9

Recherches sur l'orgine, l'esprit, et le progres des arts de La Grece (d'Hancarville), 67

Rechy, John, 234n17

Recontextualization, 49, 54, 229

Recuerdos/capias, 330n5

Red Sweater Project, The (Flanders), 330n6

Reeves, Daniel, 14, 93, 94

Regeneración, Gamboa and, 190

Regional Artists Program (RAP), RSG and, 167

Reservoir (Goddard), 88, 90, 91, 95

ReSituations, 182

Response, interactivity and, 292–93

Reynolds, Joshua, 119

Ribner, Jonathan, 125n23
Ricci, Mario, 74
Ricci, Sebastiano, 74
Rice, Ron, 269
Richter, Jean Paul, 67
Rickels, Laurence A., 16, 209–19
Rilke, Rainer Maria, 93
Roberts, David, 132
Roberts, Liisa, 17, 260, 261
Robins, Kevin, 55
Rockefeller Foundation, *La Frontera* and, 238
Rockenschaub, Gerwald, 37n22
Roden Crater (Turrell), 233n10
Rodia, Simon, 6
Roosevelt, Theodore, 37n33
Rosa, Salvator, 109
Rose Hobart (Cornell), 269
Rosenquist, James, 265
Rosler, Martha, 32
Ross, Kristin, 203n8
Rot, Dieter, 273
Rotella, Sebastian: photo of, 248
Rothenberg, Susan, 260
Rothko, Mark, 233n10, 242
Rousing the Rubble, 159, 160
Rousseau, Jean-Jacques, 106, 114, 117, 122, 126n41
Rowlands, Henry, 67
Royal Academy of Painting and Sculpture, 66
RSG. *See* Randolph Street Gallery
Rubens, Peter Paul: Banqueting House ceiling of, 83n12
Rufus, Sextus, 73
Runae/rune, 64, 74
Ruskin, John: on natural grotesque, 67
Rysbrack, Michael, 109

Saar, Betye, 9; *Saar Dust* and, 21n15
Saee, Michele, 225
St. John's Rotary (Serra), 35n3
Saint-Just, Finlay allusions to, 117
Saint-Just Vigilantes, Finlay and, 101, 102
Saks, Jane, 169
Sala Mendoza, 59n14; Dion at, 44–45
Sala RG, 59n14
Salvi, Nicola: on fountains, 88
Sandback, Fred, 233n10
San Diego Union-Tribune, on Art Rebate, 244

Sandoval, Humberto, 196, 202n1
Santa Barbara Contemporary Arts Forum, 329
Santarromana, Joseph, 19, 332, 338–43; ethnic/cultural background of, 346n26; installation art and, 333; as monstrous/ grotesque, 340; objects of, 344; phenom- enological space and, 340
Saret, Alan, 48, 60n22
Sax, Klara: quote of, 130
Scene of the Crime (Whose Crime?) (Osorio), 318, 319–20; photo of, 318, 319
Schabet, Fidelis, 6
Schimmel, Paul, 255
Schindler, Rudolph, 225, 227
Schlegel, Friedrich, 64–65, 77; on Absolute Beauty, 66–67; on grotesque, 75; on modernism, 65–66
Schmidt, Clarence, 10
Schneemann, Carolee, 335, 336
Schneider, Ira, 252
Schwitters, Kurt, 11–12
Scottish Arts Council: Finlay and, 102; photo of, 102
Scream IV, Sjölund and, 209
Sculpture: deconstructing, 3; discourse of, 21n7; history of, 20–21n6; modernist, 38
Sculpture to Be Seen from Mars (Noguchi), 132, 139
Search for a Symbol (Rothko), 242
Seasons, The (Thomson), 112
Seattle Art Museum, Wilson at, 52
Secret (Green), 32, 34, 37n33
Sedgwick, Eve, 312
Sélavy, Rrose, 240
Self-sufficiency, 40
Serra, Richard: Foster on, 3; on history of sculpture, 20–21n6; on large-scale works, 35n3; monument of, 31; relocation of, 48; removal of, 5–6; sculptures of, 24–25; site specificity and, 35n2, 37n23, 59n7; *Tilted Arc* and, 39, 60n24
Serrano, Andres, 246, 247, 313n2
73rd American Exhibition, Asher at, 43
74th American Exhibition, 27
Seward, William H., 172, 175
Shaftesbury, Lord, 7
Sharits, Paul, 265, 271
Sheeler, Charles, 273

Shelley, Mary: Frankenstein and, 89, 112, 126n33
Shenstone, William: *ferme ornée* of, 109
Shift (Serra), 35n5
Shilo (movie), 284
Shire, Peter, 229
Shulman, Julius, 222
Silence, The (Bergman), 265
Silver Cloud (Finlay), 113
Simon, Norton, 225
Simpson, Lorna, 62n42, 313n2
Simultaneous Perspective (Campbell), 295
Singerman, Howard, 250n10
Sisco, Liz, 17, 240, 244; ten-dollar bills and, 238
Sites, 13–20; cultivating, 56; definitions for, 46; deterritorialization of, 57; exploration of, 23; functional, 14, 24, 25, 45; interpretation of, 46; nonsite and, 4; primary, 45
Site Santa Fe, 297, 304
Site-specific art, 3, 4, 23, 298; early, 39; institutionalization/ commercialization of, 48–49; itinerant artists and, 51–55; mobilization of, 46–51; originality/authenticity of, 54–55; poststructuralist, 57; promotion by, 55; public art and, 59n13; queer theory and, 311; relocation of, 48; unhinging of, 46
Site specificity, 26, 32, 38, 56; assimilative model of, 58n3; desert floor and, 131, 135; displacement of notion of, 35; early conception of, 49; idealism and, 25; interruptive model of, 58n3; legal definition of, 59n7; locational identity and, 55; as nomadic practice, 51–55; unhinging of, 14
Siting, 13; institutional, 43
Situation aesthetics, theorizing, 333–37
"Situation Esthetics: Impermanent Art and the Seventies Audience" *(Artforum)*, 332
Situationism, 22n21, 28
Sixteen Jackies (Warhol), 270
Sjölund, Stig, 16, 210, 212, 214; image line of, 209; postmodern performance by, 211; *Titanic II* and, 213, 215
Sjöstrom, Victor, 132
Sloan, Nicholas, 103, 114–15
Smith, Jack, 269

Smith, Kiki, 273
Smith, Tony, 334
Smithson, Robert, 6, 25, 29–30, 39, 42, 44, 130, 223, 253, 255; monument to, 31; on site/nonsite, 4
Smithsonian Institution, 300
Snow, Michael: film installation by, 261
Sobchack, Vivian, 343, 344, 346n30
Soft architecture, 20n2
Soft Parts, 303
Soja, Edward, 196
Sold to Satan: A Poor Wife's Sad Story, 216
Sollie 17 (Kienholz and Kienholz), 158, 164
Something Borrowed (Wilson and Lord), 18, 305, 306, 311–12, 316n28; lesbian objects/lesbian lenders and, 313; photo of, 299, 303, 304, 305, 307, 308, 309
Song of Bernadette, The, 261
Sonnier, Keith, 60n22, 260
Soto, Merían, 317, 330n3
Southern California Institute of Architecture, Moctezuma + Ramos and, 144–45
Space, 20n2, 222–23; abstract, 246; behavioral, 21n6; durational, 258; electronic, 60n18; environmental, 253; moving image and, 252; perception of, 202; as practiced place, 19; question of, 287; video, 258
Spatiality, 195–97, 201; destabilization of, 57
Spears, Grady, 235n19
Speer, Albert, 12, 127n48
Spelling, Aaron, 234n18
Spelling, Candy, 234n18
Spiral Jetty (Smithson), 30, 35n5, 62n47
Spirit of the Place, 226
Splashing Piece: Casting (Serra), 5; photo of, 48; relocation of, 48
Splitting: Four Corners (Clark), 13
Spraypaint LACMA, 195
Squatting Project/Wien (Leung), 185, 187; photo of, 178, 179, 180, 181
Stafford, Barbara Maria, 7, 14, 64–83
Stallybrass, Peter, 199, 205n21
Stations of the Cross, 192–95
Statuae ridiculae, 88
Steamline (Meigh-Andrews), 92
Stellarc, 14, 96

Stereotypes, Latino, 320

Sterne, Laurence, 120

Stevens, Wallace, 101

Stevenson, Matilda Coxe, 303, 315n17; We' wha and, 301, 302; Women's Anthropological Society and, 302; at Zuni pueblo, 300–301

Stewart, Martha, 16, 230, 235n19

Stewart, Susan, 14, 15, 100–129

Stoker, Bram, 214

Stonehenge, 14, 68, 70–74, 83n12; interpretation of, 64; watercolor of, 82

Stone-Heng Restored (Jones), 68, 70, 82n7

Stoneypath/Little Sparta, map of, 104

Stourhead, garden at, 109

Strand, Paul, 264, 273

Strong, Roy, 71, 83n12

Study for Floating Island to Travel around Manhattan Island (Smithson), reproduction of, 30

Study for the End of the World no. 2 (Tinguely), 139

Stukely, William, 65, 66, 67, 69

Sturken, Marita, 18, 287–96

Suderburg, Erika, 1–22, 130–42, 226, 227

Sulfur Falls (Saret), relocation of, 48

Summerson, John, 71

Sun Tunnels (Holt), 135

Swiss National Museum, 27, 31

Symbolical Language of Ancient Art (Knight), 67

Symbolic Images, 87

Symbolic resistance, 195–97

SYNCHRONOUSSOUNDTRACKS (Sharits), photo of, 265

"Synfonismus der Fragmente" (Schlegel), 65

Tactics: Cavalry and Artillery, Oppenheim and, 133

Tagg, John, 202

Talismans and Signifiers, 107

Tall Ships (Hill), 260

Tambellini, Aldo, 253

Tashlin, Frank, 271

Tears That Is My Body #106, The (Santarromana), 346n23

Technology: electronic, 288; globalization of, 56; video, 253

Television Assassination, 269–70

Temple, Richard, Lord Cobham, 109, 111

Temple of British Worthies, 111, 115–16, 125n30

Temple of Flora, 109

Temple of Philemon and Baucis, 118

Temple of Ramses II, 132

Ten Commandments, The (DeMille), 140

Terror in Chile (Gronk), 205n19

Testa, Nicola, 95

Teutonic Mythology (Grimm), 67

Thater, Diana, 17–18, 275, 276, 280, 281–82; built-in stability for, 284; China and, 284–85; multiplicity and, 279; scare quotes and, 285n1; strategy of, 278; structural fascism and, 283

Theater of Marcellus, 72

There-then, here-now and, 92

Thesiger, Wilfrid, 93

This Tortured Earth, Noguchi on, 138

Thomson, James, 109, 112

"Thoughts for the Times on War and Death" (Freud), 212

Thousand Plateaus, A (Deleuze and Guattari), 279

Three Standard Stoppages (Duchamp), 8, 141n6

Tilted Arc (Serra), 35n3, 36n10, 45; controversy over, 59n7, 251n25; described, 24–25; photo of, 24; removal of, 5–6; Serra on, 39, 60n24

Time and Free Will (Bergson), multiplicity in, 278

Tinguely, Jean, 15, 139–40, 265; Heizer and, 140; quote of, 138

Tiravanija, Rikrit, 32

Titanic: legacy of, 212, 214; location of, 215

Titanic II (Sjölund), 16, 209, 213, 215; photo of, 210, 211

To Kill a Mockingbird, 221

Tombeau de Rousseau au Pantheon (Finlay), 126n41

Torres, Francesc, 264, 265

Tour through Sicily and Malta (Brydone), 75

"Towards a Critical Regionalism" (Frampton), quote from, 56

Townsend, Andrew, 112

Trace, 158

Trade Winds (Piper), 93

Trangmar, Susan, 14, 92
"Transboricua" (Osorio), 329
Trap Door (Roberts), 261; photo of, 261
Treichler, Paula, 29
Trial, The (Kafka), 185
Triangle Building, 171, 177
True, Clara, 315n17
Trust for the Preservation of Cultural
 Heritage, 225
Tunney, Gene, 268
Turner, J. M. W., 112
Turrell, James, 222, 226, 232n7, 233n10,
 273
Tusculanum Disputations (Cicero), 73
24 Hour Psycho (Gordon), 92
Twickenham: Little Sparta and, 109; Pope's
 grotto at, 125n23
"Twickenham" (Pope), 108
Two Sides to Every Story (Snow), 261
Typing Paper (Campbell), 291
Tzara, Tristan, 203n8

UCLA Chicano Studies Center, 156
Ukeles, Mierle Laderman, 39, 41
*Unconnected Sentences on Gardening, More
 Detached Sentences on Gardening in the
 Manner of Shenstone* (Finlay), 92, 109
"Unconnected Thoughts on Gardening"
 (Shenstone), 109
Underworld (DeLillo), quote from, 130
Union of Needletrades, Industrial, and
 Textile Employees (UNITE), 149, 151;
 collaboration with, 156
Unité d'Habitations, 34
U.S. Bureau of Ethnology, Stevenson and,
 301
U.S. Commission on Civil Rights, East L.A.
 riots and, 194, 204n12
U.S. Information Agency, 34
Universal Studios, Chavez Ravine and, 221
Un jardin revolutionnaire (Finlay), 124n6
Untitled (for Heisenberg) (Campbell), 292,
 294; photo of, 293
Untitled (Ring with Light) (Morris), Fried on,
 334
"Upon Appleton House" (Marvell), 108
Urban space, Chicano, 203n4
Use value, 9, 15
Utile et dulce, 65

Valdez, Patssi, 190, 196, 203n6; Asco and,
 189; photo of, 193, 198; *Stations of the
 Cross* and, 192–93; on West Side, 204n17
Vanbrugh, John: Cobham and, 111
Varro, 73, 74
Vaucanson, 94
Vautier, Ben, 8
Venice Biennale, 28
Verfremdungseffekt, 277
Vertical Roll (Jonas), 255
Vico, Giambattista, 113
Video installations, 176–77, 264; film instal-
 lations and, 252–53, 262; language of,
 262; space and, 252
Vidicon Inscriptions (Hall), 258
Vietnam War, Chicano casualties in, 203n5
View of Stanton Drew, A (Stukely), reproduc-
 tion of, 65
Viewer (Hill), 174, 176–77, 187; temporal
 monumentality of, 175
Views from Abroad, 61n37
Villa, Raúl, 144, 203n4
Villa Doria Pamphili, 224
Vindication of Stone-Heng Restored (Webb),
 70
Viola, Bill, 253
Violence, public art and, 247–48
Virgen de Guadalupe, 147
Virgil, 107, 115, 122; transformation model
 of, 108
Visible body, Merleau-Ponty on, 340–41
Visionary art, 7, 9, 265
Vista/Vision: Landscapes of Desire (Green),
 37n33
Vita activa, vita contemplativa and, 116
Vitruvius, 68, 83n7
Vitruvius Britannicus, 83n7
Vostell, Wolf, 10

Wagner, Richard, 6
Walker, Hamza: on RSG closing, 170
Walker Art Center, 268, 269; Godard and,
 271
Walking Mural, 192–95, 196; photo of, 193;
 reception for, 204n14
Walking with Contrapposto, 260
Wall, The, 304
Wallen (Turrell), 232n7
Walpole, Horace, 111

War: art and, 123; death and, 100
Ward, Frazer, 61n30
Warhol, Andy, 240, 273; seriality of, 242, 270
Watney, Simon, 29
Watts Tower (Rodia), 6
We Are Vendors, Not Criminals/Somos Vendedores, No Criminales, 148–49, 151, 156; photo of, 154
Webb, John: flattery by, 70–71; Jones compilation by, 68, 70
Webster, Nesta H., 128n55; on Saint-Just, 117
Weiner, Lawrence, 26, 40, 273
Weisman, Frederick, 225
Welchman, John C., 237–51; Art Rebate/Arte Reembolso and, 17
Well of Loneliness, The, 306
We' wha: Stevenson and, 301, 302; story of, 315n17
Whale, James, 89
Wheeler, Doug, 222, 233n10
When and Where We Enter: The Impact of Black Women on Race and Sex in America (Giddings), 310
Whirlpool Eye of the Storm (Oppenheim), 133
White, Allon, 205n21; on sewer, 199
White Fang II, 275
White Girl (Wilson), 303, 315n19
Whiteread, Rachel, 92
Whitney Museum of American Art, 48, 61n37, 322; *Anti-Illusion* and, 250n7; Biennial at, 61n39, 318; Hill and, 174
Whittier Boulevard: Chicanos on, 194, 196; non-place-making on, 205n20; redevelopment of, 196; *Walking Mural* on, 192, 193–94
Wiggins, Grant, 161, 162
Wilding, Faith, 50, 60n28
Wilhite, Robert, 229

Wilke, Hannah, 336
Will, George, 249–50n3
Williams College Museum of Art, 224
Wilson, David, 8
Wilson, Fred, 28, 36n19, 52; on site-specific practice, 45
Wilson, Millie, 18, 297, 299, 303–5, 307–9, 312, 315n19
Wilson, Robert, 233n10
Wimshurst arcs, 89
Winchester, Sarah, 16; Mystery Mansion and, 217
Winchester Repeating Arms Company, 217
Winckelmann, Johann Joachim, 7, 65
Wind, The (Sjöstrom), 132
Winsor, Jackie, 260
Wipe Cycle (Gillette and Schneider), 252
Within and beyond the Frame (Buren), 40
Wolf-Man, 280, 281
Wolf-philosophers, 282
Womanhouse project, 50
Womb Room, 50
Women's Anthropological Society, Stevenson and, 302
Worcester Art Museum, 61n39
World Tour (Green), 37n33, 54, 61–62n39
Wormius, Olaf, 74
Wright, Frank Lloyd, 225
Wunderkammern, 7–8, 8–9, 13, 18, 21n11, 313

Yates, Peter, 225
Young, La Monte, 233n10
Youngblood, Gene, 253, 254

Zola, Emile, 34
Zukin, Sharon, 62n46
Zuni: Cushing and, 302; Stevenson and, 301–2
Zurich Kunsthalle, exhibition at, 27